Giotto's Arena Chapel and
THE TRIUMPH OF HUMILITY

In this book, Henrike Lange takes the reader on a tour through one of the most beloved and celebrated monuments in the world – Giotto's Arena Chapel. Paying close attention to previously overlooked details, Lange offers an entirely new reading of the stunning frescoes in their spatial configuration. The author also asks fundamental questions that define the chapel's place in Western art history. Why did Giotto choose an ancient Roman architectural frame for his vision of Salvation? What is the role of painted reliefs in the representation of personal integrity, passion, and the human struggle between pride and humility familiar from Dante's *Divine Comedy*? How can a new interpretation regarding the influence of ancient reliefs and architecture inform the famous "Assisi controversy" and cast new light on the debate around Giotto's authorship of the Saint Francis cycle?

Illustrated with almost 200 color plates, including individual images of each scene in the narrative cycle, this volume invites scholars and students to rediscover a key monument of art and architecture history and to see it with fresh eyes.

Henrike Christiane Lange is Associate Professor in History of Art and Italian Studies at the University of California, Berkeley. Lange completed her Magister Artium at Universität Hamburg, Germany, before earning her PhD at Yale University. The present book is the culmination of two decades of research at sites, archives, and collections across Europe.

Giotto's Arena Chapel and

THE TRIUMPH
OF HUMILITY

HENRIKE CHRISTIANE LANGE
UNIVERSITY OF CALIFORNIA, BERKELEY

Shaftesbury Road, Cambridge CB2 8EA, United Kingdom

One Liberty Plaza, 20th Floor, New York, NY 10006, USA

477 Williamstown Road, Port Melbourne, VIC 3207, Australia

314–321, 3rd Floor, Plot 3, Splendor Forum, Jasola District Centre, New Delhi – 110025, India

103 Penang Road, #05–06/07, Visioncrest Commercial, Singapore 238467

Cambridge University Press is part of Cambridge University Press & Assessment,
a department of the University of Cambridge.

We share the University's mission to contribute to society through the pursuit of
education, learning and research at the highest international levels of excellence.

www.cambridge.org
Information on this title: www.cambridge.org/9781316511046

DOI: 10.1017/9781009036450

First published 2023

Printed in the United Kingdom by TJ Books Limited, Padstow Cornwall

A catalogue record for this publication is available from the British Library.

Library of Congress Cataloging-in-Publication Data
NAMES: Lange, Henrike Christiane, 1981- author.
TITLE: Giotto's Arena Chapel and the triumph of humility / Henrike Christiane Lange, University of
 California, Berkeley.
DESCRIPTION: Cambridge : Cambridge University Press, 2022. | Includes bibliographical references and index.
IDENTIFIERS: LCCN 2022025077 (print) | LCCN 2022025078 (ebook) | ISBN 9781316511046 (hardback) |
 ISBN 9781009005227 (paperback) | ISBN 9781009036450 (epub)
SUBJECTS: LCSH: Giotto, 1266?-1337–Criticism and interpretation. | Giotto, 1266?-1337. Legend of St. Francis.
 | Cappella degli Scrovegni nell'Arena (Padua, Italy) | Mural painting and decoration, Gothic–Italy–Padua.
 | Mural painting and decoration, Italian–Italy–Padua. | Bible. New Testament–Illustrations. | BISAC: ART /
 General
CLASSIFICATION: LCC ND623.G6 L36 2022 (print) | LCC ND623.G6 (ebook) | DDC 759.5–dc23/eng/20220714
LC record available at https://lccn.loc.gov/2022025077
LC ebook record available at https://lccn.loc.gov/2022025078

ISBN 978-1-316-51104-6 Hardback

Für Hinrich und Annegret,
für Anni und Martin.

A lever.
We lower when we want to lift.
In the same way, 'He who humbleth himself shall be exalted.'
SIMONE WEIL, *GRAVITY AND GRACE*

CONTENTS

FIGURES

PREFACE

Giotto's Triumph

SPE DE FUGA SURGENS DURA
DESIGNATUR QUOD MENS PURA
SPE FULCITA NON CUM CURA
TER FERRUM CLARIDITUR.
SET A CRISTO CORONANDA
SURSUM UOLAT SIC BEANDA
ET IN CELIS SUBLIMANDA / FORE FIRMA REDDITUR.

Hope, from taxing flight ascending,
Pure of mind by God's designing –
Hope sustains her; never doubting,
Triply her endurance burns.
Ready now for joyful crowning,
Up she soars to win Christ's blessing.
Exalted, heaven now attaining, / Resolute, she soon returns.

<div align="center">

INSCRIPTION UNDER GIOTTO'S *HOPE* IN THE ARENA CHAPEL
(VERSE TRANSLATION BY ANDREW STEWART)

</div>

Since its rediscovery in the nineteenth century, Giotto's Arena Chapel (Figs. P.1–P.8) has sparked fervent responses by artists, poets, and scholars.[1] Following in the footsteps of a wide-ranging historiography that has discussed "Giotto's Wit,"[2] "Giotto's Profundity,"[3] "Giotto's

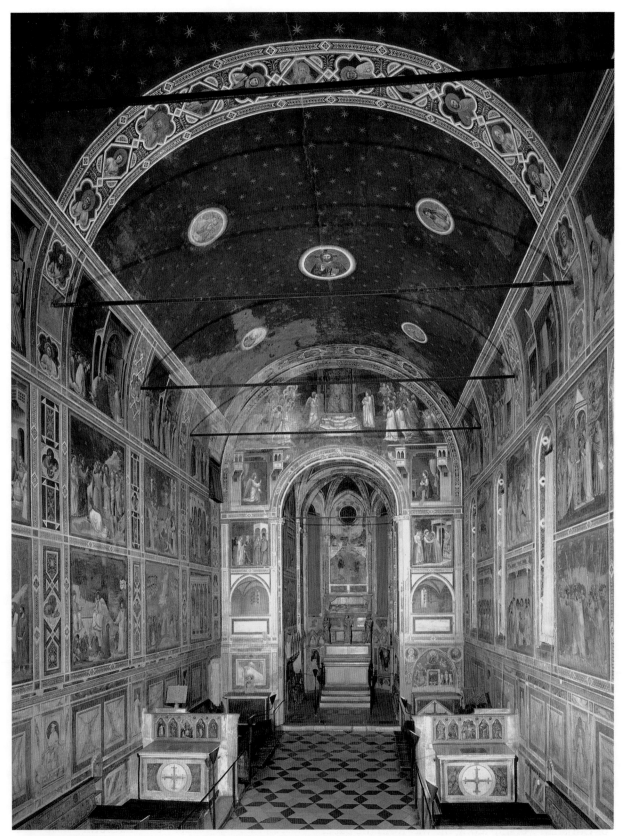

Fig. P.1 Giotto di Bondone, Santa Maria della Carità (Scrovegni Chapel / Arena Chapel), Padua, interior east. Scala / Art Resource, NY.

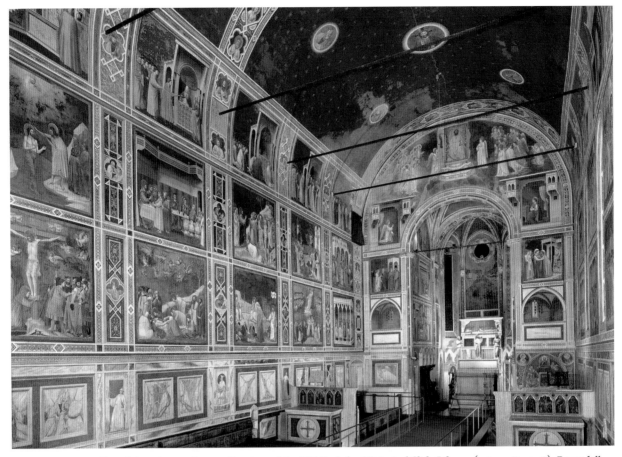

Fig. P.2 Arena Chapel, interior north-east. Courtesy of the UC Berkeley Historical Slide Library (est. 1938–2018), Baxandall & Partridge Collection, Doe Memorial Library in Berkeley, California, USA.

Eloquence,"[4] "Giotto's Harmony,"[5] and "Giotto's Circumspection,"[6] this book is about "Giotto's Triumph" – a theme with many implications for this unique space of transformative painting. Building on widely accepted accounts of the Arena Chapel's form and content, this study offers a new way of looking at its shape, frescoes, program, and place in history by considering its connection to ancient Roman triumphal arches (Figs. P.9 and P.10). The historical stage is set by the Roman Jubilee of 1300 and by a practice focused on triumphal themes and monuments such as the urban Roman honorific arches of Constantine and of Titus – the medieval procession tracing the route of the ancient triumph, connecting stations of Christian worship along the way from the papal Lateran to the Forum Romanum (Fig. P.11).

While the historiographic record of the chapel is characterized by long phases of silence between the fourteenth century and the nineteenth century, a few themes emerge as constants in certain phases of its discussion and analysis since the age of Giotto (†1337) himself. Writings on Giotto's art first celebrated, in contemporary and early modern literature, its astonishing representation of "nature"; next, in the nineteenth century, its "humanity" and "morality"; and then, in the early twentieth century, its "plasticity." Integrating all of these themes – nature, humanity, morality, and plasticity – the proposal put forward here is that the chapel purposefully plays with the idea and painterly representation of Roman triumphal relief sculpture in order to transform itself into a monument to the Christian triumph of

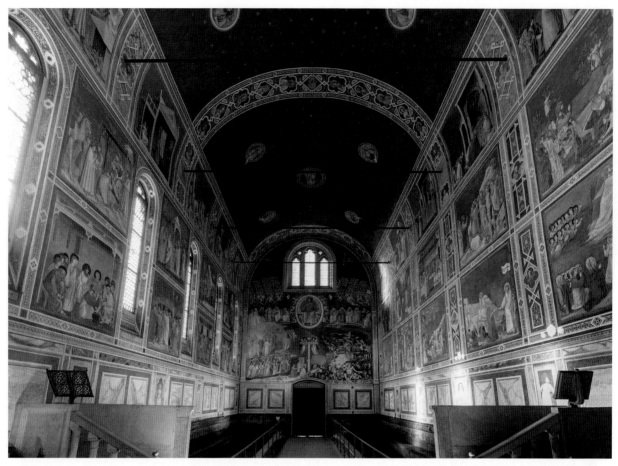

Fig. P.3 Arena Chapel, interior west. Courtesy of Steven Zucker.

humility – and, given that it was planned as a place of burial, to celebrate an eventual triumphal entry of the donor Enrico Scrovegni into the afterlife (Fig. P.12). This reading of the chapel – as embodying the idea of the triumph of humility primarily via relief effects created by Giotto in painting – integrates all of these perennially quoted qualities (the chapel's astonishing representation of nature, its humanity, its plasticity) in fulfillment of the ambitious promise of Alpatoff's famous dictum that Giotto "succeeded in showing the moral basis of the legend, and the spiritual significance of its events; and at the same time he sought to emphasize their visual resemblances."[7] In short, this book aims to explore how Giotto succeeded in contextualizing and negotiating his heritage of art and theological-political context of classical antiquity, Roman Christianity, Byzantium,

and the theology of Augustine in order to visualize the invisible mysteries of the story of Christ. His medium – painted relief – is the message.

One common denominator unites diverse writings on Giotto. As Laurie Schneider puts it: "Perhaps the most constant theme in Giotto's *fortuna critica* is the feeling that he has in one way or another made an important contribution to the representation and perception of reality."[8] This perception of reality in a work of art, its recognition, and its rational and emotional assessment, is always the job of the individual viewer. Giotto's process of perception is one that merges identification of a form and its individuation for the viewer, making his figures seem in some way relevant to the observer, who can recognize in them a sense of shared experience that establishes connections across the multiple

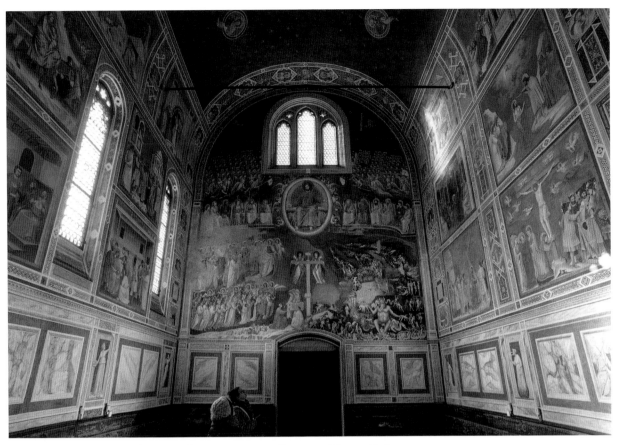

Fig. P.4 Arena Chapel, the *Last Judgment* in context. Courtesy of Steven Zucker.

kinds of otherness inherent in great historical distance. That said, the present study is about the potential of this Chapel's transformative offerings to the viewer, about its highest aspirations rather than a claim that any of these envisioned connections were broadly successful in terms of creating a more just society. To the contrary, we will see that Scrovegni's own life, Dante's exile, and the crisis of the papacy shortly after the Jubilee of 1300, are all indications of an age marked by profound collective and individual suffering. Cardinal Giacomo Caetani Stefaneschi, counsellor to Pope Boniface VIII, recalls in his treatise on the first Christian Jubilee how the years before it were defined by war and plague.[9] Dante wrote the *Divine Comedy* precisely in response to these crises, and Giotto can similarly be thought of as having painted the chapel in order to oppose the ugliness of the conditions of

its time – like the *Comedia*, the chapel is not an illustration of a reality but a space in which a spiritual battle between virtues and vices unfolds. *Hope* appears in the most prominent and final position under the *Last Judgment*, a pioneer among the virtues as Giotto paints them. While the historical political reality of the Middle Ages was marked by violence and social injustice, the chapel hosts a constellation of creative possibilities for any viewer who might want to contemplate its commentary on the world of the here and now.

Giotto's triumph rejects triumphalism. As a self-conscious and self-deconstructing work of art that reflects its own making and unmaking, the chapel might even be seen as a remedy against the hazards of human nature. Humility is central to the Hebrew Bible, the teachings of Jesus Christ, and Christian liturgy and theology.

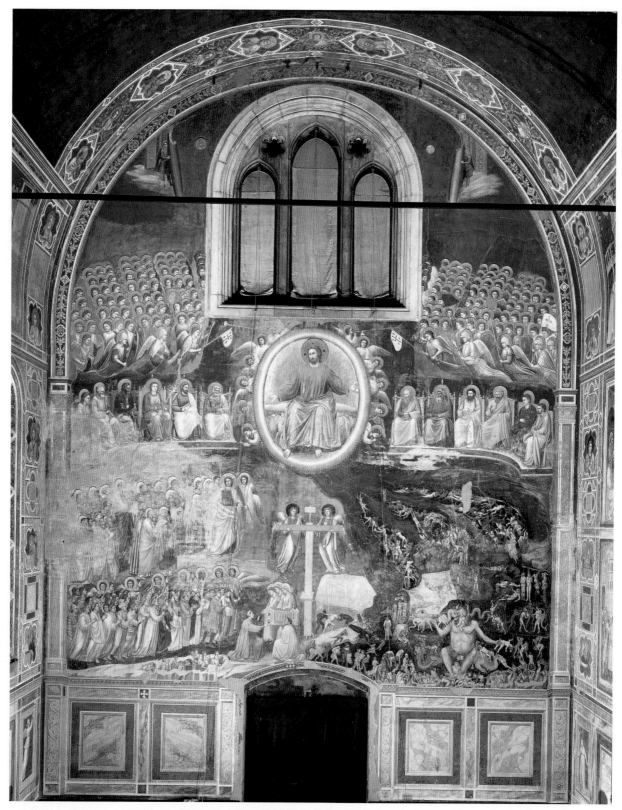

Fig. P.5 The *Last Judgment*. Scala / Art Resource, NY.

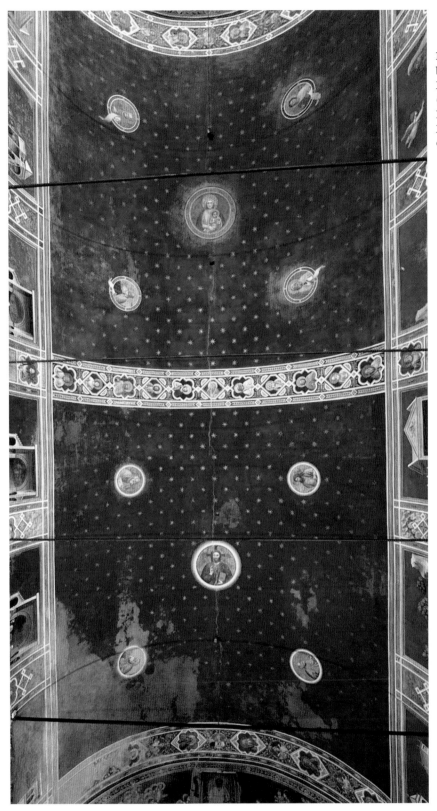

Fig. P.6 Arena Chapel, the barrel vault. Courtesy of the UC Berkeley Historical Slide Library (est. 1938–2018), Baxandall & Partridge Collection, Doe Memorial Library in Berkeley, California, USA.

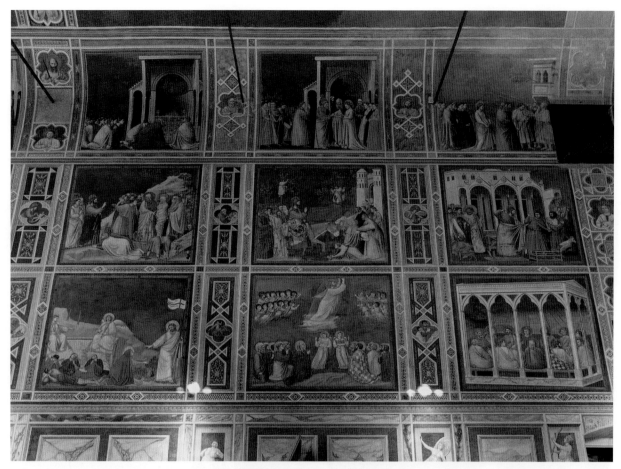

Fig. P.7 Arena Chapel, detail from the north wall (east). Courtesy of Steven Zucker.

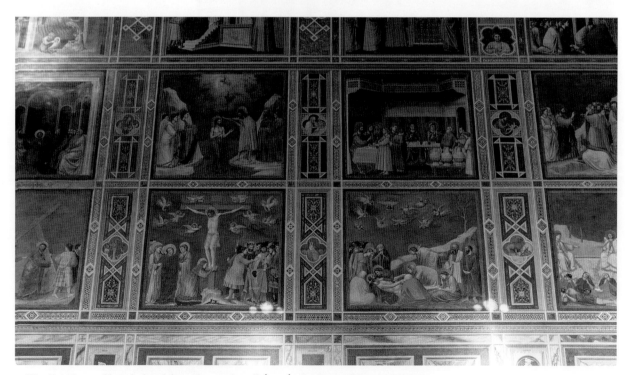

Fig. P.8 Arena Chapel, detail from the north wall (west). Courtesy of Steven Zucker.

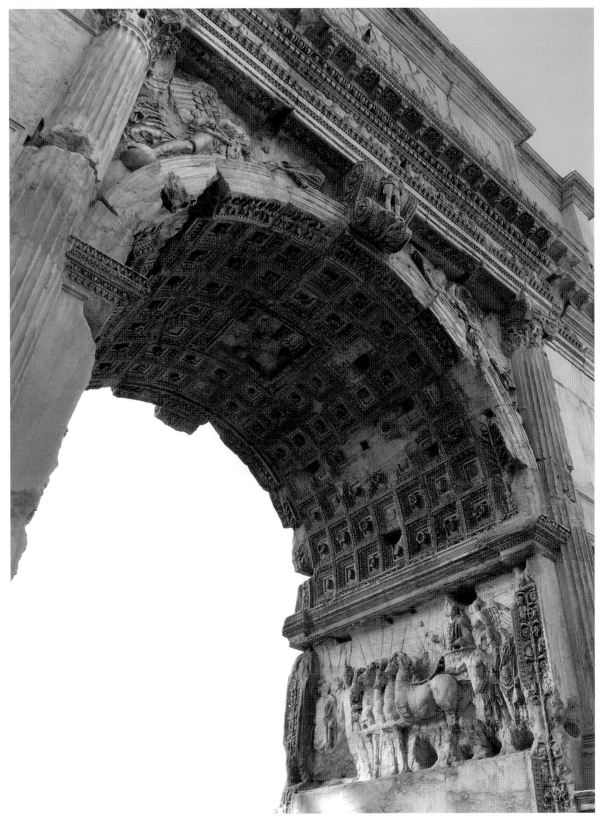

Fig. P.9 Arch of Titus, Rome, interior of the bay. Courtesy of the UC Berkeley Historical Slide Library (est. 1938–2018), Baxandall & Partridge Collection, Doe Memorial Library in Berkeley, California, USA.

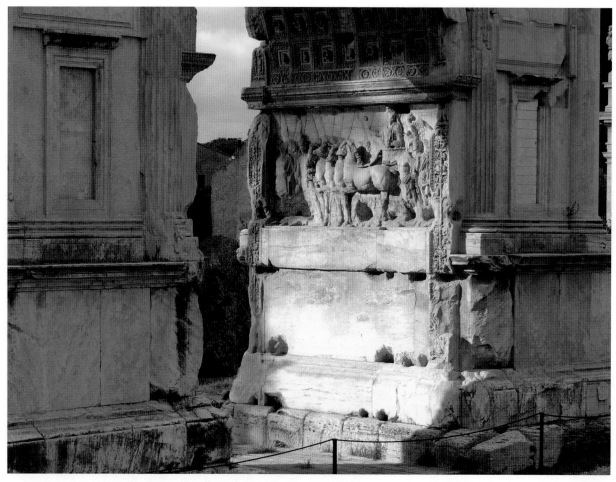

Fig. P.10 Arch of Titus, interior of the bay seen from a distance (2018). Photo by the author.

The triumph of humility through the models of Mary and Jesus is so central to Christian belief that the chapel has never been an exclusive space of "high iconography" available only to a few elite scholars and theologians.[10] Its core theme, identical with the central thoughts of the New Testament and Christian liturgy, could be understood not only by pilgrims returning from Rome in the early 1300s but also by everyone familiar with the basic story of Mary's humility expressed in her response to the Annunciation and of Christ's self-sacrifice for the Salvation of humankind. The chapel is also universally accessible on a basic human level, engaging with unconditional love, grief, the pursuit of virtues that lead to a more just and peaceful society, and the hope for reunion, peace, and eternal joy beyond this world. The chapel, in other words, was devised as a narrative sequence about the lives of Mary and Jesus; as a psychomachia and remedy against moral dilemmas on the level of the virtues and the vices; and as an all-encompassing creed, representing the entire cosmos as working towards a victory of the transcendent spirit over matter and death through the optics of faux relief represented on frescoed flat walls.

This book explores Giotto's Arena Chapel in the light of the dynamics between the Christian reframing of ancient triumphal arch reliefs as a triumph of humility and relief as a pictorial

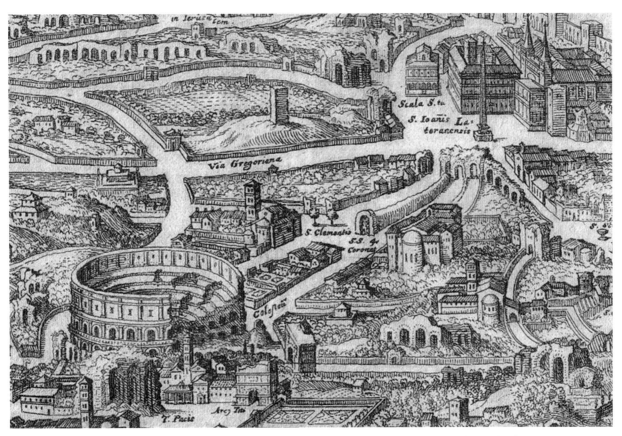

Fig. P.11 The Colosseum with Santa Maria Nova and the enclosed Arch of Titus as well as the Arch of Constantine, San Clemente, Santi Quattro Coronati, and the Lateran in a detail from Matthus Merian's map of Rome (1640s). CC BY-SA 4.0.

device in Christian art. My study was made possible by generations of scholars who have worked on Giotto's chapel in original ways; I owe them all thanks, especially Eleonora M. Beck, Hans Belting, Francesco Benelli, Joanna Cannon, Donal Cooper, Philippe Cordez, Anne Derbes, Francesca Flores d'Arcais, Eva Frojmovič, Chiara Frugoni, Julian Gardner, Wolfgang Kemp, Andrew Ladis, Alexander Nagel, Giuliano Pisani, Joachim Poeschke, Janet Robson, Serena Romano, Mark Sandona, Michael Victor Schwarz, and many others who have commented brilliantly on the chapel from the perspective of many fields and disciplines. This project is also deeply indebted to the admirable work of the conservators and the documentation of their campaigns by Giuseppe Basile and Valerio da Gai and their teams, as well as to Davide Banzato's extraordinary dedication to the chapel, which has taken form in sensitive restoration accompanied by multidisciplinary research initiatives.

Throughout the centuries, scholars and lovers of Giotto celebrated the optical consolidation of the narrative paintings at the Arena Chapel (Figs. P.13–P.55). These were lucidly described by Marvin Trachtenberg when he wrote that the "greatness of Giotto resides partly in the utter finality and absolute density of his images. One can never look *through* an image by Giotto; one looks *at* it."[11] This book proposes that the reason for this phenomenon, a key to Giotto's triumph, and a fundamental point of departure in the history of art, is relief.[12]

Fig. P.12 Arena Chapel, detail of Scrovegni's donor portrait in the *Last Judgment*. Courtesy of Steven Zucker.

Fig. P.13 *Joachim Rejected from the Temple.* Courtesy of the UC Berkeley Historical Slide Library (est. 1938–2018), Baxandall & Partridge Collection, Doe Memorial Library in Berkeley, California, USA.

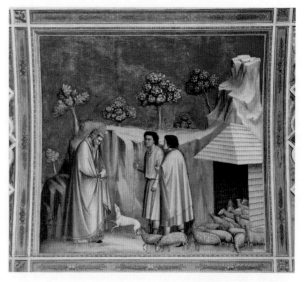

Fig. P.14 *Joachim Entering the Wilderness.* Courtesy of the UC Berkeley Historical Slide Library (est. 1938–2018), Baxandall & Partridge Collection, Doe Memorial Library in Berkeley, California, USA.

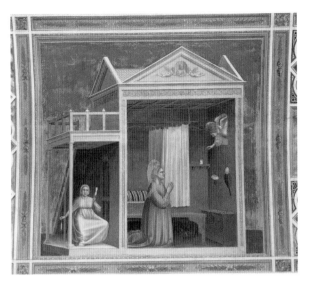

Fig. P.15 *The Annunciation to Anne.* Courtesy of the UC Berkeley Historical Slide Library (est. 1938–2018), Baxandall & Partridge Collection, Doe Memorial Library in Berkeley, California, USA.

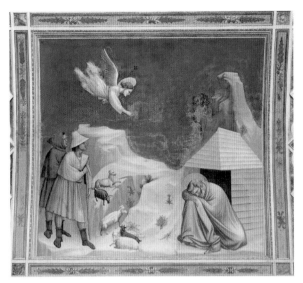

Fig. P.16 *Joachim's Dream.* Courtesy of the UC Berkeley Historical Slide Library (est. 1938–2018), Baxandall & Partridge Collection, Doe Memorial Library in Berkeley, California, USA.

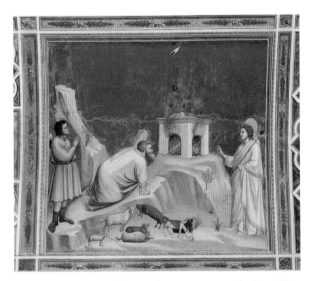

Fig. P.17 *Joachim's Sacrifice.* Courtesy of the UC Berkeley Historical Slide Library (est. 1938–2018), Baxandall & Partridge Collection, Doe Memorial Library in Berkeley, California, USA.

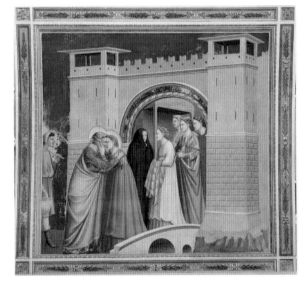

Fig. P.18 *The Kiss at the Golden Gate.* Courtesy of the UC Berkeley Historical Slide Library (est. 1938–2018), Baxandall & Partridge Collection, Doe Memorial Library in Berkeley, California, USA.

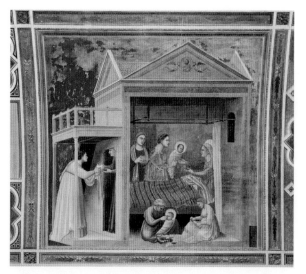

Fig. P.19 *The Birth of Mary.* Courtesy of the UC Berkeley Historical Slide Library (est. 1938–2018), Baxandall & Partridge Collection, Doe Memorial Library in Berkeley, California, USA.

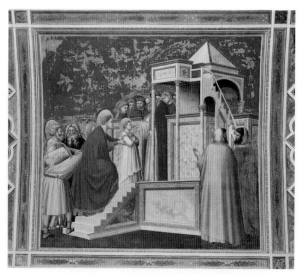

Fig. P.20 *The Presentation of Mary into the Temple.* Courtesy of the UC Berkeley Historical Slide Library (est. 1938–2018), Baxandall & Partridge Collection, Doe Memorial Library in Berkeley, California, USA.

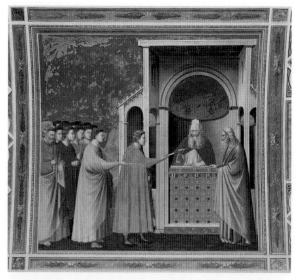

Fig. P.21 *The Submission of the Rods. Courtesy of the UC Berkeley Historical Slide Library (est. 1938–2018), Baxandall & Partridge Collection, Doe Memorial Library in Berkeley, California, USA.*

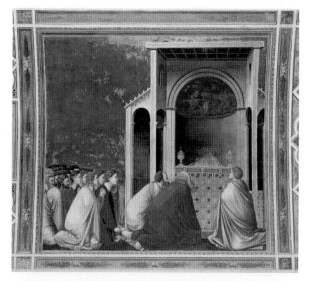

Fig. P.22 *The Prayer before the Rods.* Courtesy of the UC Berkeley Historical Slide Library (est. 1938–2018), Baxandall & Partridge Collection, Doe Memorial Library in Berkeley, California, USA.

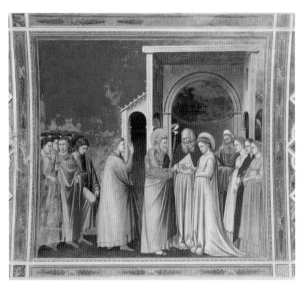

Fig. P.23 *Mary's Betrothal.* Courtesy of the UC Berkeley Historical Slide Library (est. 1938–2018), Baxandall & Partridge Collection, Doe Memorial Library in Berkeley, California, USA.

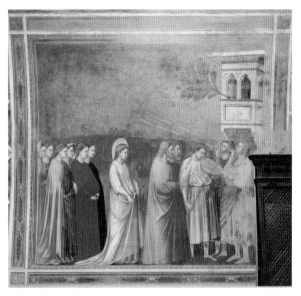

Fig. P.24 *Mary's Nuptial Procession.* Courtesy of the UC Berkeley Historical Slide Library (est. 1938–2018), Baxandall & Partridge Collection, Doe Memorial Library in Berkeley, California, USA.

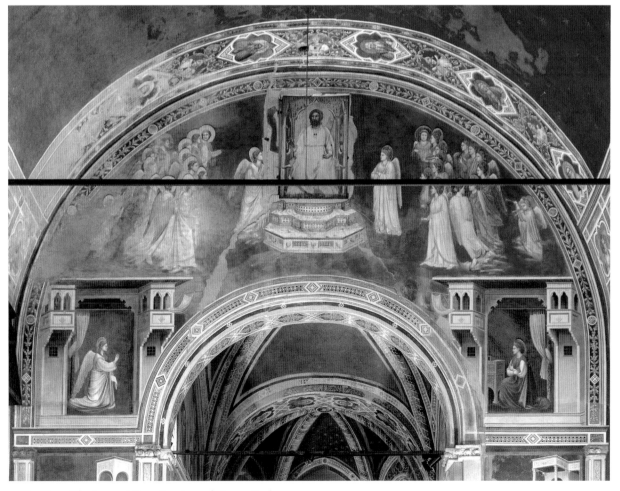

Fig. P.25 *The Annunciation.* Courtesy of Steven Zucker.

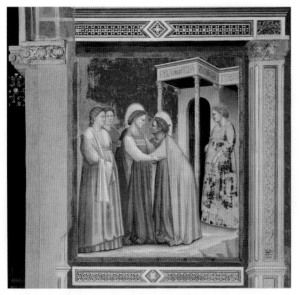

Fig. P.26 *The Visitation.* Courtesy of the UC Berkeley Historical Slide Library (est. 1938–2018), Baxandall & Partridge Collection, Doe Memorial Library in Berkeley, California, USA.

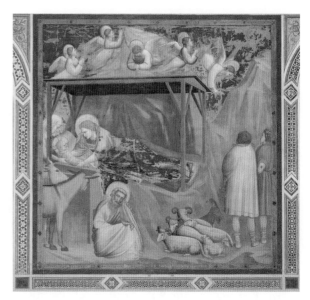

Fig. P.27 *The Nativity.* Courtesy of the UC Berkeley Historical Slide Library (est. 1938–2018), Baxandall & Partridge Collection, Doe Memorial Library in Berkeley, California, USA.

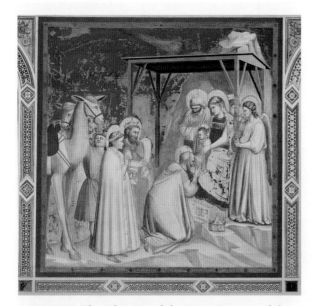

Fig. P.28 *The Adoration of the Magi.* Courtesy of the UC Berkeley Historical Slide Library (est. 1938–2018), Baxandall & Partridge Collection, Doe Memorial Library in Berkeley, California, USA.

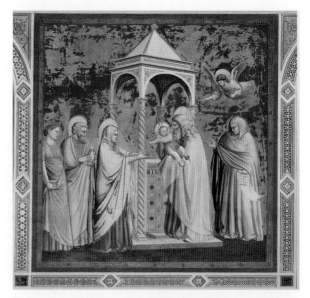

Fig. P.29 *Presentation of Christ into the Temple.* Courtesy of the UC Berkeley Historical Slide Library (est. 1938–2018), Baxandall & Partridge Collection, Doe Memorial Library in Berkeley, California, USA.

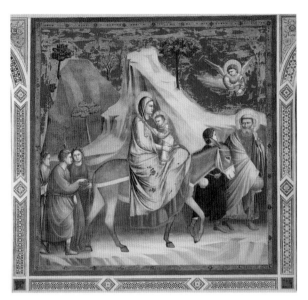

Fig. P.30 *The Flight into Egypt.* Courtesy of the UC Berkeley Historical Slide Library (est. 1938–2018), Baxandall & Partridge Collection, Doe Memorial Library in Berkeley, California, USA.

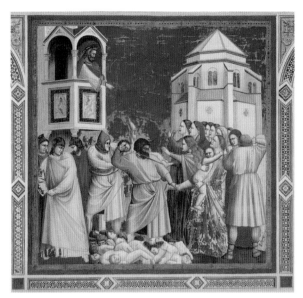

Fig. P.31 *The Massacre of the Innocents.* Courtesy of the UC Berkeley Historical Slide Library (est. 1938–2018), Baxandall & Partridge Collection, Doe Memorial Library in Berkeley, California, USA.

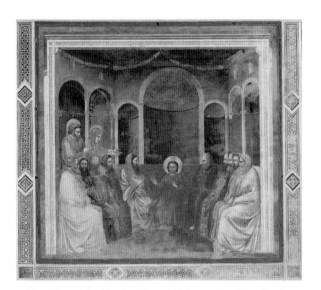

Fig. P.32 *The Twelve-Year Old Jesus Teaching in the Temple.* Courtesy of the UC Berkeley Historical Slide Library (est. 1938–2018), Baxandall & Partridge Collection, Doe Memorial Library in Berkeley, California, USA.

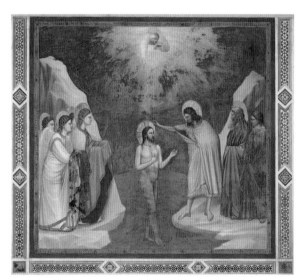

Fig. P.33 *The Baptism of Christ.* Courtesy of the UC Berkeley Historical Slide Library (est. 1938–2018), Baxandall & Partridge Collection, Doe Memorial Library in Berkeley, California, USA.

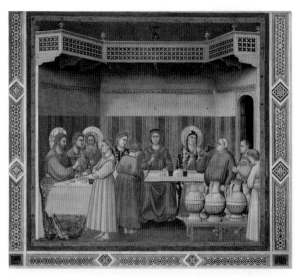

Fig. P.34 *The Marriage at Cana*. Courtesy of the UC Berkeley Historical Slide Library (est. 1938–2018), Baxandall & Partridge Collection, Doe Memorial Library in Berkeley, California, USA.

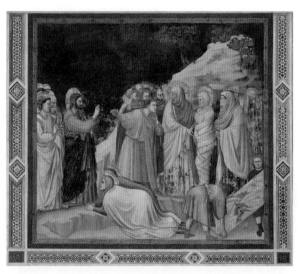

Fig. P.35 *The Raising of Lazarus*. Courtesy of the UC Berkeley Historical Slide Library (est. 1938–2018), Baxandall & Partridge Collection, Doe Memorial Library in Berkeley, California, USA.

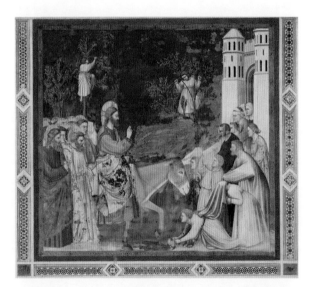

Fig. P.36 *The Entry into Jerusalem*. Courtesy of the UC Berkeley Historical Slide Library (est. 1938–2018), Baxandall & Partridge Collection, Doe Memorial Library in Berkeley, California, USA.

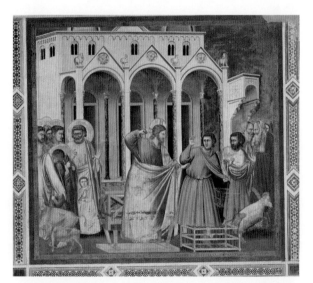

Fig. P.37 *Jesus Chasing the Merchants and Moneychangers from the Temple*. Courtesy of the UC Berkeley Historical Slide Library (est. 1938–2018), Baxandall & Partridge Collection, Doe Memorial Library in Berkeley, California, USA.

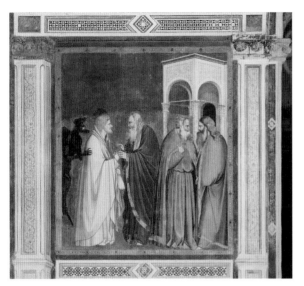

Fig. P.38 *The Pact of Judas.* Courtesy of the UC Berkeley Historical Slide Library (est. 1938–2018), Baxandall & Partridge Collection, Doe Memorial Library in Berkeley, California, USA.

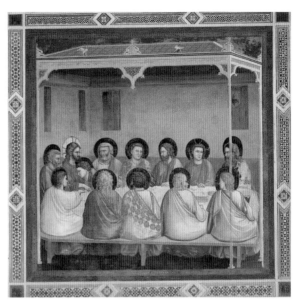

Fig. P.39 *The Last Supper.* Courtesy of the UC Berkeley Historical Slide Library (est. 1938–2018), Baxandall & Partridge Collection, Doe Memorial Library in Berkeley, California, USA.

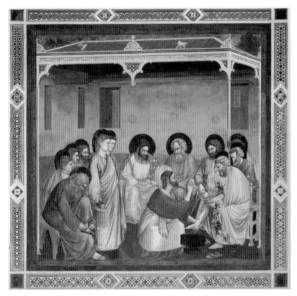

Fig. P.40 *The Washing of the Feet.* Courtesy of the UC Berkeley Historical Slide Library (est. 1938–2018), Baxandall & Partridge Collection, Doe Memorial Library in Berkeley, California, USA.

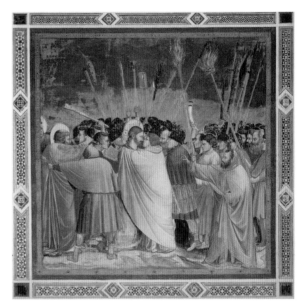

Fig. P.41 *The Arrest of Christ (Kiss of Judas).* Courtesy of the UC Berkeley Historical Slide Library (est. 1938–2018), Baxandall & Partridge Collection, Doe Memorial Library in Berkeley, California, USA.

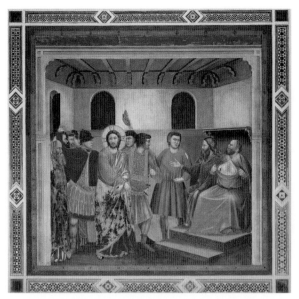

Fig. P.42 *Christ before Caiaphas.* Courtesy of the UC Berkeley Historical Slide Library (est. 1938–2018), Baxandall & Partridge Collection, Doe Memorial Library in Berkeley, California, USA.

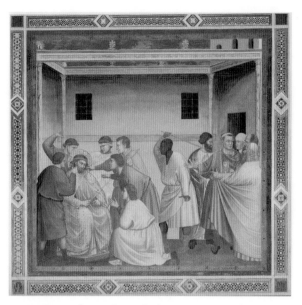

Fig. P.43 *The Mocking of Christ.* Courtesy of the UC Berkeley Historical Slide Library (est. 1938–2018), Baxandall & Partridge Collection, Doe Memorial Library in Berkeley, California, USA.

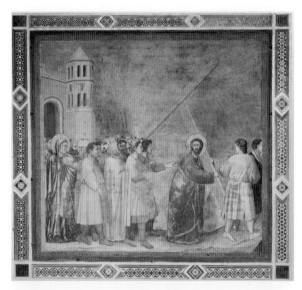

Fig. P.44 *The Procession to Calvary.* Courtesy of the UC Berkeley Historical Slide Library (est. 1938–2018), Baxandall & Partridge Collection, Doe Memorial Library in Berkeley, California, USA.

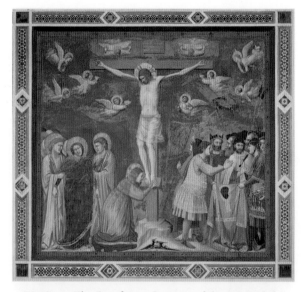

Fig. P.45 *The Crucifixion.* Courtesy of the UC Berkeley Historical Slide Library (est. 1938–2018), Baxandall & Partridge Collection, Doe Memorial Library in Berkeley, California, USA.

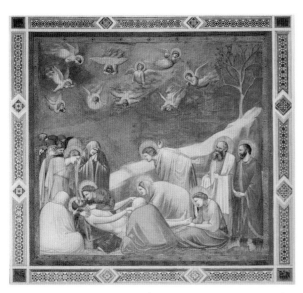

Fig. P.46 *Lamentation (The Mourning of Christ).* Courtesy of the UC Berkeley Historical Slide Library (est. 1938–2018), Baxandall & Partridge Collection, Doe Memorial Library in Berkeley, California, USA.

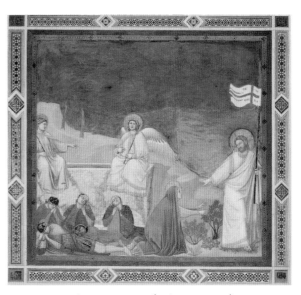

Fig. P.47 *The Resurrection (Noli me tangere).* Courtesy of the UC Berkeley Historical Slide Library (est. 1938–2018), Baxandall & Partridge Collection, Doe Memorial Library in Berkeley, California, USA.

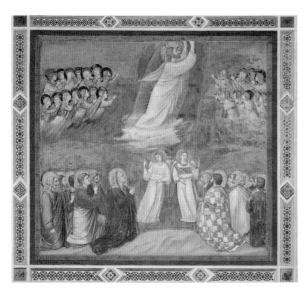

Fig. P.48 *The Ascension of Christ.* Courtesy of the UC Berkeley Historical Slide Library (est. 1938–2018), Baxandall & Partridge Collection, Doe Memorial Library in Berkeley, California, USA.

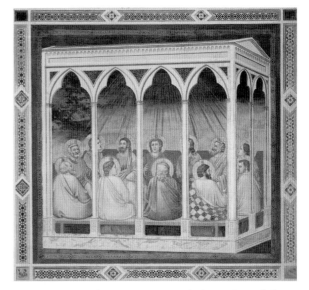

Fig. P.49 *Pentecost.* Courtesy of the UC Berkeley Historical Slide Library (est. 1938–2018), Baxandall & Partridge Collection, Doe Memorial Library in Berkeley, California, USA.

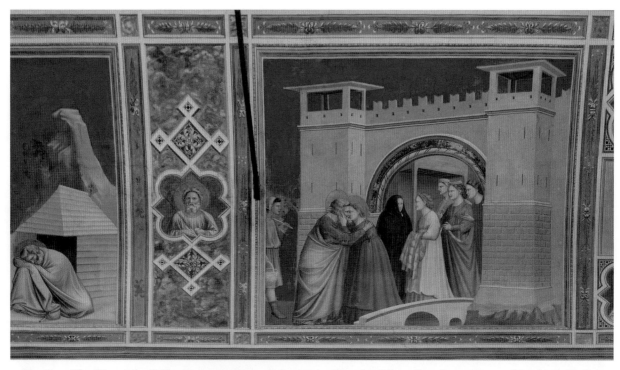

Fig. P.50 The *Kiss at the Golden Gate* in its faux relief context with a detail from the adjacent scene of *Joachim's Dream*. Courtesy of Steven Zucker.

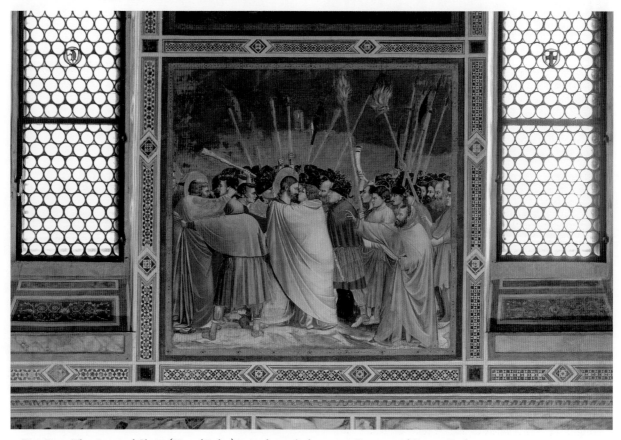

Fig. P.51 The *Arrest of Christ (Kiss of Judas)* in its faux relief context. Courtesy of Steven Zucker.

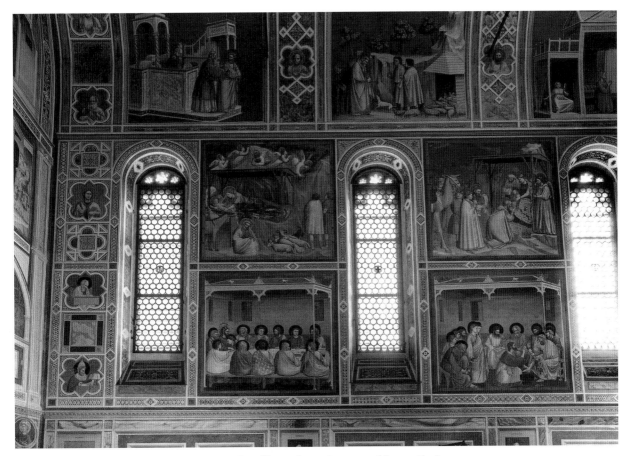

Fig. P.52 Sunlight entering through the south wall's windows. Courtesy of Steven Zucker.

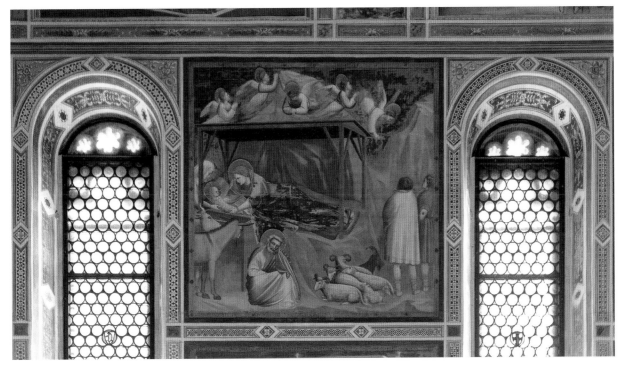

Fig. P.53 The *Nativity* in its faux relief context. Courtesy of Steven Zucker.

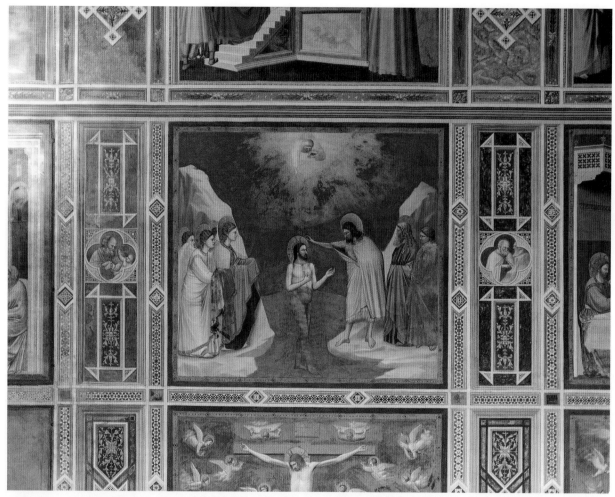

Fig. P.54 The *Baptism of Christ* in its faux relief context. Courtesy of Steven Zucker.

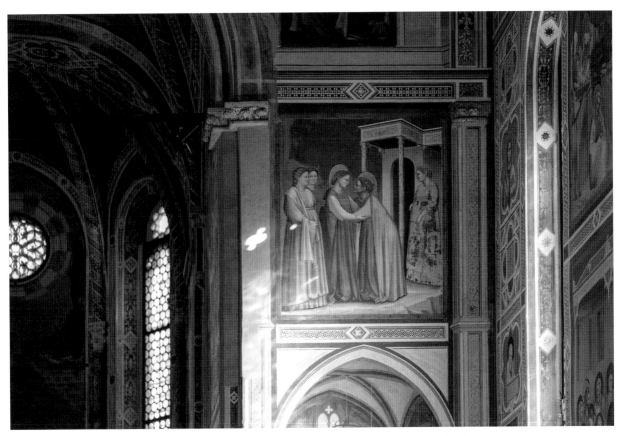

Fig. P.55 Sunlight entering the chapel's corner around the *Visitation*. Courtesy of Steven Zucker.

Fig. 2.6 ... the Vorticity Centre of these ...

ACKNOWLEDGMENTS

The research for this book has been supported by my loved ones, friends, and many dear colleagues for over two decades. My gratefulness far exceeds these pages. Giotto's triumph could not have been written without the kind attention and enduring support of Laurence B. Kanter, Giuseppe F. Mazzotta, and Randolph R. Starn – my constant interlocutors in Italian art, literature, theology, politics, and history over the past decade. Their interest in my work, their patient and magnanimous feedback on my writing, and their nuanced conceptual awareness of the triumph of humility were no less than existential. I will forever be grateful for having experienced, as a young scholar, such reliable and genuine intellectual friendships.

Close friends and trusted colleagues provided encouragement, inspiring conversations, and detailed feedback on manuscript drafts. I am especially grateful to Beatrice Arduini, Federico Barbierato, Tim Barringer, Peter Casarella, Anne Derbes, Patrick Griffin, Wolfgang Kemp, Joseph Leo Koerner, Anne Leone, Bernard McGinn, Tom McLeish FRS, Fr. Edward J. Ondrako OFM Conv., Charles Rosenberg, Kaya Şahin, Brenda Deen Schildgen, Brian Stock, Martin Warnke, John R. White, and Robert Williams. Very special thanks for their support of and contributions to my Giotto conference in Berkeley in spring 2020 to external guests Mario Biagioli, Thomas Dandelet, Roberta Morosini, Alexander Nagel, Alessandro Nova, Ulrich Pfisterer, Kriss Ravetto-Biagioli, Jonathan Sheehan, and Michael Subialka, as well as to my students Daisy Ament, Alice Fischetti, and Sean Wyer, and to Sam and Barbara A. Forbes.

I could not have surveyed Giotto's visual discourse on power, temporalities, and relief without crucial feedback provided by Joost Keizer, Spyros Papapetros, Gerhard Wolf, and Christopher S. Wood. Koby Fine, Steven Fine, and Donald H. Sanders from the Arch of Titus Project at Yeshiva University in New York City

kindly welcomed me into their insightful discussions of the Arch and its afterlives, creating a variety of hypothetical polychrome versions of the Titus reliefs as visual aids. Suzanne Boorsch, Milette Gaifman, Jacqueline Jung, Diana E. E. Kleiner, and Alexander Nemerov supported my work with great kindness and critical feedback throughout my time at Yale and in the Yale University Art Gallery, as well as at Stanford and in Palo Alto. Carl Strehlke offered essential comments at some of the project's most decisive moments in New Haven, New York, and Philadelphia.

At Berkeley's Department of History of Art, I owe very special thanks to Whitney Davis for crystalline comments on the theoretical stakes of relief and medium effects and for supporting my project since 2014 with essential feedback as both colleague and then Department Chair. I am grateful to former Chair Patricia Berger and to former Acting Chair Bonnie Wade – and, in particular, for the extensive feedback on my manuscript provided at the 2020 conference and beyond by Diliana Angelova, Julia Bryan-Wilson, Beate Fricke, Aglaya Glebova, Darcy Grimaldo Grigsby, Atreyee Gupta, Christopher H. Hallett, Imogen Hart, Elizabeth Honig, Jun Hu, Lauren Kroiz, Anneka Lenssen, Gregory Levine, Margaretta M. Lovell, Ivy Mills, Todd Olson, Loren Partridge, Lisa Pieraccini, Sugata Ray, Andrew Stewart, Lisa Trever, and Justin Underhill. Many thanks to Judith Butler for a new office complete with furniture, computer equipment, and printer which facilitated my last year of writing on the fourth floor of Doe Library.

Down Campanile Way, in the Department of Italian Studies, I am grateful to Chair Mia Fuller, Diego Pirillo, Rhiannon Welch, former Chairs Albert R. Ascoli and Barbara Spackman, former Acting Chair Ignacio Navarrete, and Dean of Arts and Humanities Anthony J. Cascardi for their enthusiastic and generous support of my work

at Berkeley. Steven Botterill, my spirited and trusted companion on the intersection of Dante, mysticism, and critical theory, offered insights on *De Vulgari Eloquentia* in relation to Giotto's chapel that were pathbreaking for this book. Warm thanks also to art history and classics head librarian Lynn D. Cunningham, librarian for Romance Language Collections Claude H. Potts, and to the members of staff in my two departments at Berkeley, especially Faith Enemark and Moriah VanVleet.

I am particularly grateful to the Prytanean Honor Society Alumnae Association for the 2020 Prytanean Faculty Award in support of my research, teaching, and service for students at Berkeley. The unique generosity of the Alumnae supported the production of this book with almost 200 color plates covering the complete mural cycle in individual images. Among the Prytaneans, I want especially to thank Chancellor Carol T. Christ wholeheartedly for her guidance and support as well as for her scholarship on Dante and Giotto in the Victorian vision of the Pre-Raphaelites.

As a Distinguished Fellow of the Notre Dame Institute for Advanced Study (2017–18), I experienced the kind hospitality of Director Brad Gregory, Associate Director Donald Stelluto, and Carolyn Sherman as well as the company of NDIAS fellows, staff, and research assistants. The book benefitted from conversations with friends and colleagues at the peaceful lakes of St Joseph and St Mary, and in Giotto's medieval quarter of San Giovanni in Rome, especially from feedback on the manuscript offered by Zygmunt G. Barański, Philip Bess, Theodore J. Cachey, Francis X. Clooney S.J., Marika and Thomas Gordon Smith, Monsignor Tomáš Halik, David Bentley Hart, Marius Hauknes, Robin Jensen, Christian Moevs, Hildegund Müller, Mark W. Roche, and Ingrid Rowland.

I extend heartfelt thanks for their varied support to Francesco Benelli, Jean Campbell, Christopher

S. Celenza, T. J. Clark, Joseph L. Clarke, Fiona Cole, Matthew Collins, Alison Cornish, Kate Driscoll, Susanna Elm, Kurt W. Forster, Giuseppina Forte, Chiara Frugoni, Alberto and Caroline Di Giovanni, Bernhard Huss, Christian Kleinbub, Evelyn Lincoln, John McChesney-Young, Amyrose McCue Gill of TextFormations, John Marciari, Maureen Miller, Christopher J. Nygren, Roberta J.M. Olson, John Onians, Luca Palozzi, Gabriel Pihas, Giuliano Pisani, Lucia Re, Heather Reilly, Jon Snyder, William Tronzo, James G. Turner, Jane Tylus, Shannon Wearing, Karl Whittington, Julie A. Wolf, and Steven Zucker. Having presented my findings widely since autumn 2013 across North America, the UK, Italy, and Germany at conferences, invited lectures, informal talks, and interdisciplinary workshops, I have received much helpful feedback from many colleagues and students in those audiences. Translations into English from Latin, Italian, French, and German are mine unless otherwise indicated. Very special thanks to Andrew Stewart for contributing a verse translation for the inscription under Giotto's *Hope*.

The roots of this book go back much deeper in time. I remain forever grateful to Jeanne and Harold Bloom for a home filled with books, for music, tea, and *The New York Times* on weekend afternoons in New Haven during my first five years on the East Coast. At the basis of my Giotto research are my earliest studies in art history, languages, and literature at Universität Hamburg and in the Warburg-Haus. Once more I owe the most cordial thanks to Martin Warnke for providing constant encouragement and for having restored the Warburg-Haus with its archives and the "Bildindex zur Politischen Ikonographie." The house in the Heilwigstraße became my intellectual and spiritual *Heimathafen* where I learned everything I needed to know for formulating my initial questions in the Arena Chapel. In Vienna, Michael Viktor Schwarz's spring 2004 Giotto lectures introduced me to a theory of visual media in the tradition of Christian art that established a turning point for my critical approaches to Trecento art, art history, and art theory. Years later, my own students at Yale and Berkeley inspired me to find new ways of expressing why Giotto's triumph is ever so relevant and topical.

The most recent forces setting the result of two decades of research and reflection between book covers are my editor, Beatrice Rehl, from Cambridge University Press, with whom it has been wonderful to work on this project thanks to her enthusiasm, expertise in ancient Roman as well as Trecento art, and love for Giotto, and my knowledgeable anonymous reviewers, to whom I am grateful for constructive criticism of the manuscript. Thank you.

As this study relied, more than anything else, on the time that I spent in Giotto's Santa Maria della Carità, I will always be thankful to Davide Banzato for granting me unlimited access to Enrico Scrovegni's chapel.

Following much on-site reflection and research in the chapel over many years, the color plates in this book have been carefully chosen to craft an authentic encounter with Giotto's work from many points of view while reducing the interference of ever-changing photographic technologies. Its iconography apart, the chapel represents its own visual-spatial technology, creating a truly immersive sensory experience. With this comprehensively illustrated book, I have sought to produce a resource for interested readers, colleagues, and students alike that not only explores the chapel in its entirety from less familiar perspectives, but also gathers all the narrative cycle's individual scenes in one place. Given the importance of these usually underillustrated details for the main argument about the interior space and its various painted surfaces, it was crucial to show the curving vault in real space *dal sotto in sù*, the patches of faded polychromy on the dado zone in close-ups, and the

ornamental surroundings of the scenes from a variety of oblique angles that reflect the precision and virtuosity of Giotto's murals on all levels of the chapel.

To preserve the chromatic syntax of the scenes, I have illustrated the frescoes in groups selected from three major image sources. The reader can thus evaluate them on a coherent tonal scale across the fresco cycle, section by section, and also follow their changing appearance at different times of day and under different combinations of daylight, evening light, and artificial light. Readers can also compare these grouped plates with others in the book. The differences among them reveal also the emphasizing or flattening effects of light on the *appliqué* low relief of the haloes (Giotto used the only genuinely three-dimensional relief in the fresco cycle's narrative scenes for these most immaterial components), the many different shades of "Giotto blue" produced by time and water-damage, the more or less robust gilding of the stars in the vault, and the results of the various

conservation efforts over the decades. Among the three core groups of images from Padua, Steven Zucker's are the most recent, taken under natural light conditions with a high-resolution Sony ILCE-7RM3 camera and a Voigtländer NOKTON 40mm F1.2 aspherical lens on December 10, 2019.

The production of the manuscript was one endeavor, that of the illustration program quite another – especially during an unprecedented global health crisis. Almost everyone involved in this project has lived in an epicenter of the pandemic at some point since March 2020. I owe my warmest thanks to the helpful staff of *fototeche*, offices, libraries, and archives in Padua, Venice, Florence, Rome, Hamburg, New York, and Berkeley, and to everyone on the brilliant teams of Cambridge University Press in the UK, US, and India – all too numerous to list individually, but appreciated with sincere gratitude for their invaluable assistance under extremely challenging circumstances. Thank you – *mille grazie!*

INTRODUCTION

The Metaphysics of Triumphal Arches

RES ET TEMPUS SUMMA CURA [...] / [...]
[...]UIDENTIS MEMORATU[R] [...]

Things and time with the greatest care [Prudence] notes and
[...] remembers the eyewitnesses [...].

<div align="right">

FRAGMENTARY INSCRIPTION UNDER GIOTTO'S
PRUDENCE IN THE ARENA CHAPEL

</div>

THIS BOOK ON Giotto's Arena Chapel in Padua – the Cappella degli Scrovegni, circa 1300–1307 – takes its cues not so much from the familiar aspects of a celebrated and intensely studied monument as from its inbuilt surprises. Some of these are visual puzzles; some depend on mostly forgotten circumstances of the chapel's creation and reception; still others challenge academic boundaries and conventional assumptions about its place in the history of Western art. These lines of inquiry, taken sequentially and together, enable a decoding – and, I shall argue, a recoding – of the structure, visual appeal, and significance of the chapel. As an investigation of the different zones and historical styles represented in the chapel, this book constitutes an exercise in escaping from the quicksand of history that so quickly swallows important local and temporal context for art and architecture.

The starting point is the chapel's spatial structure. From top to bottom, this elongated, barrel-vaulted tunnel of a chapel is covered entirely with murals that

Fig. I.1 Arena Chapel, detail of the wall curving into the vault with *Joachim in the Wilderness*. Courtesy of Steven Zucker.

purposefully deceive the eye with their depictions of specific materials – for instance the uninterrupted faux stone frames throughout the interior and around panels of marble relief in the dado zone, where faux relief sculptures of the *Virtues* and *Vices* alternate with ingeniously painted faux polychrome stone. The frames hold stony allegorical figures at the bottom, blue-grounded scenes with polychrome figures of the *Lives of Mary and Jesus* above, and an overarching blue barrel vault with golden stars.

The decoding of the structure begins with a simple observation: In Giotto's Arena Chapel, the architectural simulation of the painted sidewalls is painted on the wall itself so that the uppermost scenes curve into the vault (Figs. I.1–I.9). Why is this so? The curvature of those walls into the barrel vault emphasizes the classical character of the room, which is shaped like the bay of a Roman

arch. The painted scenes in the uppermost register illustrate the lives of Mary's parents, Joachim and Anna, and the early life of Mary from her birth to her triumphal Nuptial procession into the house of Joseph. The strict geometry of the cornice clashes with the curved radius of the arch, creating a dilemma for any systematic scene-by-scene reproduction of the full cycle of images. The painted scheme is counterintuitive to the actual architectonical shape and to the relationship of walls to vault: The curved edges of the uppermost register on the walls compress the images, resisting conformity to the format of rectangular fields (see Figs. P.13–P.24). The lower scenes, in contrast, adhere to the flatness of the wall (see Figs. P.27–P.49). They can therefore easily be reproduced in two dimensions, while the first twelve polychrome stories from the top register are forced to bend in real space up into the vault's

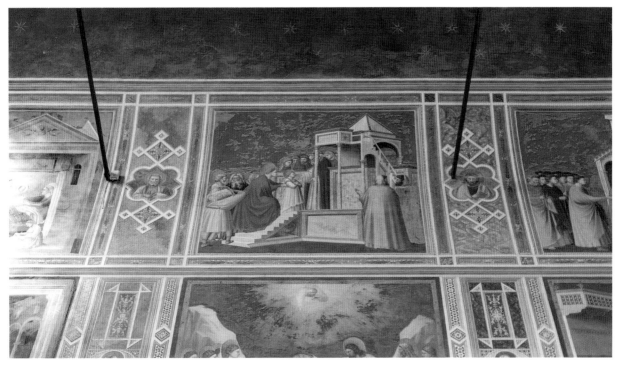

Fig. I.2 Arena Chapel, detail of the wall curving into the vault with *Presentation of Mary into the Temple*. Courtesy of Steven Zucker.

embrace. Since the beginning of the age of photography, anyone who might try to fit those curved scenes together with the ones from the lower two registers, reproducing them in a flattened layout, had either to crop them all in order to obtain a unified rectangular shape, erasing the frames for the entire cycle, or to cut into the curved shapes of the upper scenes while maintaining clean cuts for the lower ones. More recently – to be precise, since the beginning of the age of digital image processing – it has become possible to distort the entire image or wall in order to make the subtle curve appear as flat as the page.

Another rupture in the visual regime derives from the striking placement of a faux architectural element in the center of the interior space that disrupts the orderly stars arranged on the two pieces of sky visible in the two halves. This piece of illusionistic painting simulates a richly ornamented marble transverse arch, with framed polychrome panels and prophets looking out of quatrefoils. The painter could have easily adjusted the fictive transverse arch or avoided

bending his scenes into that strange curve over the upmost register. Yet every corner and every fictive stone proves exactly matched to other parts as much as to the whole system. From painted pilasters to panels, from faux capitals to fictive frames, everything is calculated to fit to the square inch. Why, then, would Giotto bend those walls into the vault of the tunnel-shaped interior, awkwardly slanting the blue backgrounds over the scenes of *Joachim in the Wilderness* (see Figs. I.4–I.5) and the *Kiss at the Golden Gate* (see Fig. I.6); of the *Birth of Mary* (see Fig. I.7), her entry into the Temple in the *Presentation* (see Fig. I.8), the scenes around her *Betrothal*, and her *Nuptial Procession* (see Fig. I.9)? Like the coved edges deforming the upper fields, the disruptive placement of the transverse arch in the center of the barrel vault looks arrestingly, even provocatively strange. The system and its layered elements seem to communicate much more meaning than can be deciphered by the standard task of identifying a chapel's sum total of iconographies, scenes, symbols, and

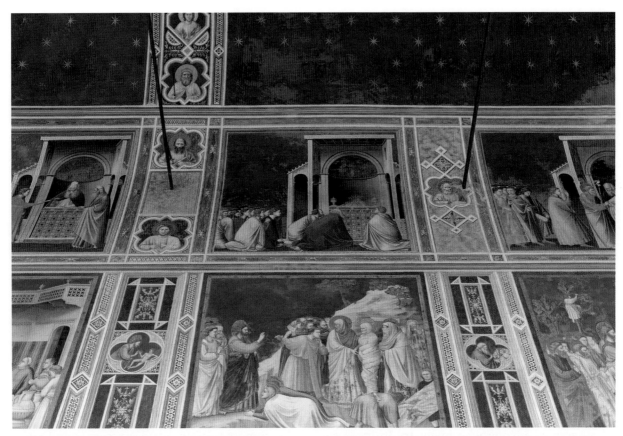

Fig. I.3 Arena Chapel, detail of the wall curving into the vault with *The Prayer before the Rods*. Courtesy of Steven Zucker.

saints. Separate elements of the interior appear to speak in a language of which one might know the words but not yet all its syntax. Tropes are elusive. Some kind of visual surplus hovers beyond the mere level of the familiar story of Salvation, some communication uniquely embedded in the spatial configuration of the whole, with space, placing, and even distortion of the images being part of their message. What is that visual surplus, and what might it signify?

The most productive answers to this question lie in the fraught relationship between motifs, forms, and themes in the Arena Chapel and in the triumphal arches of ancient Rome. Multiple clues point to such correlations and connections, too many to be random or incidental. To begin with the visual: the chapel's assertively rounded fictive and structural arches *alla romana*; the peculiar arched coving of the sidewalls into the

blue barrel vault; the romanizing style of the dado base painted to look like marble, with niches framing relief-like sculptural panels representing the *Virtues* and the *Vices*. Historical ties between the Paduan commission and Rome were especially close around the time when the Arena project began. The first Jubilee decreed by Pope Boniface VIII (1294–1303) in his bull *Antiquorum habet fida relatio* of 22 February 1300 drew more than 200,000 pilgrims to Rome, among them Giotto, who had been summoned to the Holy City by the Pope soon after his election and, most likely, also Enrico Scrovegni, who commissioned the chapel.[1] Benedict XI, eventual successor to Boniface, had conferred privileges on the Paduan chapel as the bishop of nearby Treviso and would see them confirmed during his brief tenure as Pope (1303–1304). Padua boasted of an ancient legacy in myth and history, a city

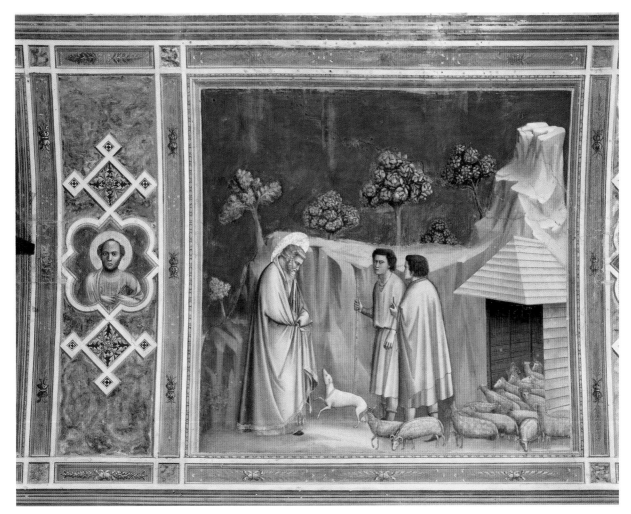

Fig. I.4 *Joachim in the Wilderness.* Scala / Art Resource, NY.

supposedly founded by Antenor, hero of the *Iliad*, and reputedly the birthplace of the Roman historian Livy. Shortly before and long after 1300 Padua was also home to groups of scholars whose studies of antiquity foreshadowed Renaissance humanism; in large part through its university, the city was a cosmopolitan intellectual and cultural center. And should these connections to the Rome of antiquity not suffice, we must not forget that the chapel arose from the ruins of Padua's ancient Roman arena, evoking the spirits of the place by location and by name.

The central proposition of this book is that precisely this interlacing network of possibilities is coded into the chapel as a response to Roman

triumphal arches as they were experienced by pilgrims (including Giotto) during the Jubilee of 1300. Specifically, I argue that the chapel follows the model of the Arch of Titus and the Arch of Constantine in and adjacent, respectively, to the ancient Roman Forum – the chapel's fictive marble paneling and sculptural relief recalling traces of polychrome stonework on the arches as evidenced today by digital reconstructions. This tribute to Roman antiquity has important implications for a fresh understanding of the combination of "classical" sculptural qualities and the "realistic" and "lifelike" illusionism that have been canonical in commentary on Giotto since Giorgio Vasari. In the sixteenth century, Vasari noted that

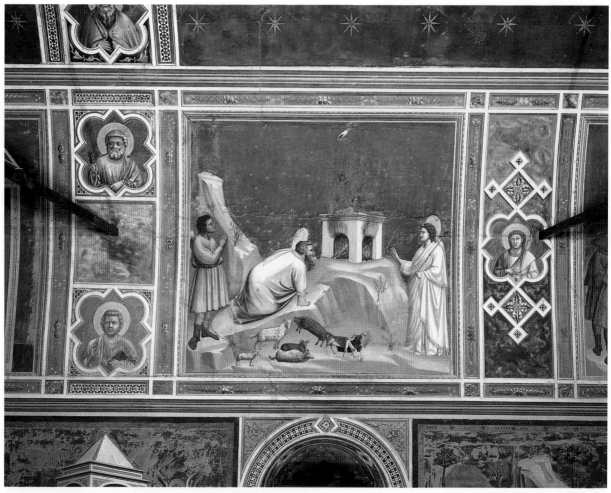

Fig. I.5 *Joachim's Sacrifice.* Scala / Art Resource, NY.

Giotto's work constituted a unique intellectual and aesthetic watershed for the late Middle Ages and the early modern age in Europe. The two greatest achievements often cited by Vasari – and endorsed ever since – are Giotto's innovative development of an extremely naturalistic style and his seemingly instinctive connection to sculptural models from ancient Rome. Giotto's naturalism, on the one hand, and his subtle sense of history, on the other, have indeed kept art historians and theorists occupied to the present day. Yet these are two answers to a single problem that, once seen in its entirety, opens entirely new perspectives on the intellectual environment around Giotto and ultimately challenges the art-historical periodization of the Italian Renaissance.

But the tribute and its implications are surely incomplete and therefore somewhat inadequate without considering the theological implications of the Christian conversion of military triumphalism, conquest, and the apotheosis of victorious emperors characteristic of ancient Rome and its monuments. At the heart of this reversal stands the ideal of peacefulness as embodied in Jesus Christ and his self-sacrifice for the Salvation of all. Ancient arches that would have been seen by Giotto, Scrovegni, and their contemporaries were all surrounded, walled, and incorporated by Christian places of worship built into or over the ruins of pagan Rome. The Arch of Titus itself listed in medieval sources as one of the most prominent station churches of Rome.

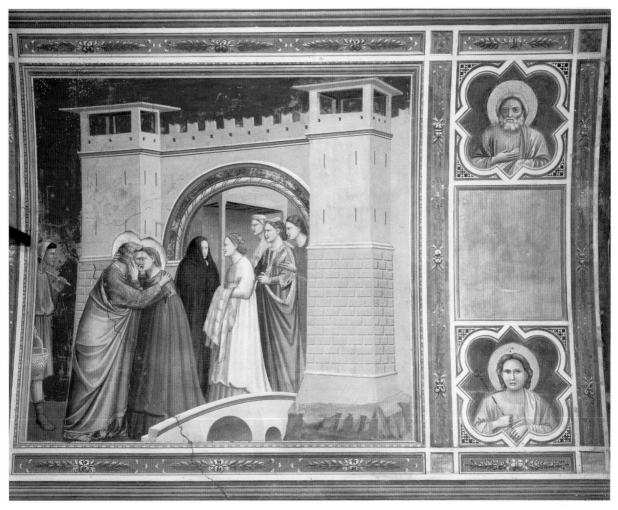

Fig. I.6 *The Kiss at the Golden Gate*. Scala / Art Resource, NY.

Among the many Roman arches still present in Giotto's time, the spiritual and historical charge of the Arch of Titus is indeed unique with its direct historical and visual connection to the Judaica, to the holy city of Jerusalem, to the Roman-Jewish war, and to the historical looting and transfer of the Menorah into Rome, as well as with its central bay relief of the emperor's apotheosis. Christians in medieval Rome worshipped under the Arch of Titus; this arch was the focus and destination of the papal Jubilee procession in 1300.[2]

The entire Jubilee, meant to confirm the triumph of the Roman church, was staged on a processional route connecting the Lateran with the Forum, incorporating the Colosseum, the Arch of Constantine, and the Arch of Titus. This last was the most important, as it transported the imagery and spiritual charge of the yet more ancient Holy City of Jerusalem into the heart of the city of Rome with its relief showing the Menorah, the Shewbread Table, and the Torah Ark from the Temple that Titus had destroyed. To connect the Arena Chapel to the Arch of Titus is thus to link Padua not only to Rome but also to Jerusalem, tracing the triangulation of Christian history with the Judaic tradition from which it emerged as well as with the pagan Roman tradition it superseded in the era of the Holy Roman Empire.

An entire ensemble of ancient monuments in the center of Rome stands to be considered as a

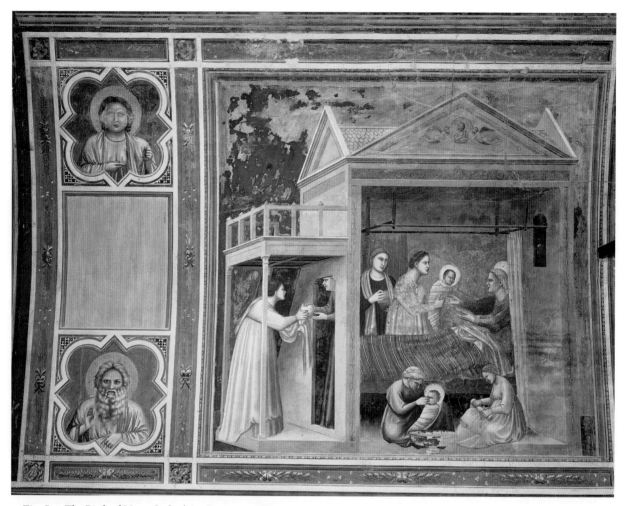

Fig. I.7 *The Birth of Mary*. Scala / Art Resource, NY.

typological template for Giotto's satellite project in Padua, namely, the Colosseum, the Arch of Constantine, the fortress and family towers of Palazzo Frangipani, and the Arch of Titus incorporated therein. Here it is important to register what exactly "pagan" meant for Christians after the historical decline of ancient Roman state religion, and why the term and concept endured long after any actual pagan threat had been overcome: On the one hand, following the historical shift from the old Roman state religion to Constantine's embrace of a Christian Rome, paganism came increasingly to be more broadly understood as any kind of oppressive and violent worldly power. On the other hand, the importance of the historical moment of Mary, Christ, and the Crucifixion under Roman occupation – as well as the later efforts of Paul's mission, which took place in the context of pagan Roman persecution of Christians – have been continuously reactivated in Christian liturgy to the present day on the macro- and micro-levels of meditative and devotional practices built into the church calendar. In addition to annual celebrations of central moments such as Palm Sunday, which returns believers mentally and ritualistically to the Entry of Christ into Roman-occupied Jerusalem, liturgies and daily rites pronounce the idea of the "pagan" in Catholic, Anglican, and Lutheran Bible readings, hymns, and prayers. Because of their biblical role as historical enemies of Christ

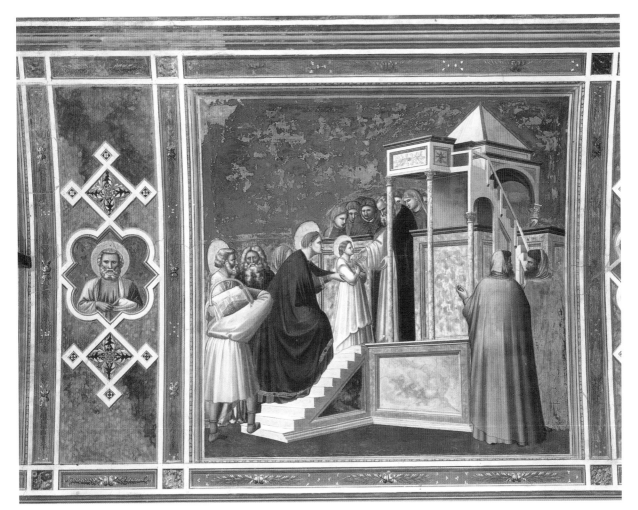

Fig. I.8 *The Presentation of Mary into the Temple.* Scala / Art Resource, NY.

and subsequently as personified antithesis of Christian values, the pagans had not become any less relevant just because they had disappeared from the stage of world history.

Halfway between the historical moment of Christ and today, in the late Middle Ages, these concepts were as relevant as ever. Specifically commemorated with the celebration of the Roman Jubilee in 1300, ongoing struggles with the ghosts of the past are clearly expressed in the most relevant written source that survives for the chapel. It is the only extensive textual source that has accompanied the chapel through time to today, fortunately recorded in the archives of Bernardino Scardeone's collection of Paduan inscriptions published in 1559 and 1560. This document states

Enrico Scrovegni's motivations and intended role as a donor in the context of historical change and transformation from the ancient Roman pagan to a Christian world, and from Christ's Entry to Jerusalem on Palm Sunday to the current celebrations of the Annunciation in Padua:

This ancient place, called by the name Arena, becomes a noble altar, so full of divine majesty, to God.

Thus God's eternal power changes [earthly] fortune, and converts places filled with evil to honest use.

Behold, this was the home of abominable heathen, which was destroyed and sold over many years, and is [now] wondrously [re]built.

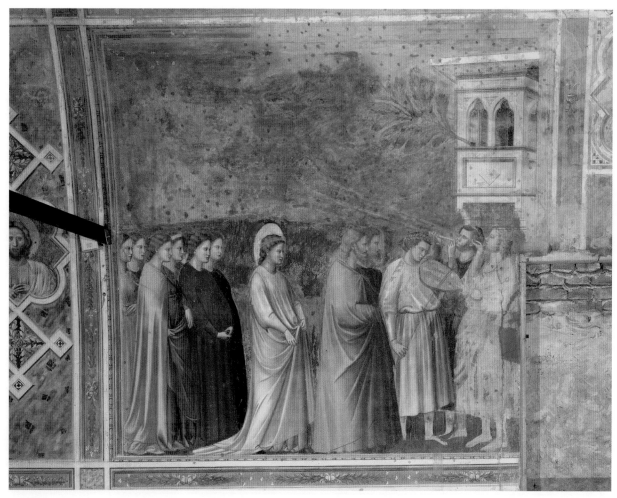

Fig. I.9 *Mary's Nuptial Procession.* Cameraphoto Arte, Venice / Art Resource, NY.

Those who led a life of luxury in happy times, their wealth now lost, remain nameless and mute; but Enrico Scrovegni, the knight, saves his honest soul; he offers a revered festival here.

And indeed he had this temple solemnly dedicated to the Mother of God, so that he would be blessed with eternal mercy.

Divine virtue replaced profane vices; heavenly joys, which are superior to earthly vanities, [...].

When this place is solemnly dedicated to God, the year of the Lord is thus inscribed:

In the year 1303, when March had conjoined the feast of the blessed Virgin and the rite of the Palm.[3]

More than simply adding yet another case study to the long history of medieval renascences,

the notion of a Christian recoding casts the chapel's spatial-visual "surplus" in a new light. Most immediately, it suggests that the double triumphal arch of the chapel's vault was meant to be seen as broken – a ruin opening onto an intensely and supernaturally blue heaven filled with golden stars (see Fig. P.6). Fictive roundels appear in this nocturnal sky, showing Christ the King and Mary with the infant Jesus surrounded by prophets. Echoing the organization of the central relief in the arch showing the Apotheosis of the ancient emperor, this symmetrical arrangement of heavenly apparitions on each side of the chapel's central transverse arch becomes a rhetorical gesture from the past towards the future. The ruins here, therefore, are redemptive – filled

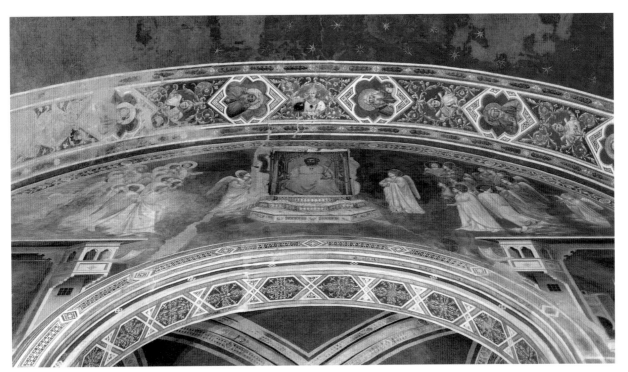

Fig. I.10 Arena Chapel, the triumphal arch with the throne of God the Father and angels. Courtesy of Steven Zucker.

with new color, new light, and the emblems of a new faith. This is not simply a reframing – a reinstallation of the same old imperial triumphalism – but one gesture in a sophisticated visual critique that opens up perspectives larger than any single component could.

The ideal of a reversal of worldly values and the heritage of aniconic traditions in Christian art are thereby brilliantly set against the ancient pagan triumphalism of brutal leaders such as Titus; the Romans' destruction of the Jewish Temple; and the historical turn from a pagan to a Christian Roman Empire with all its ethical and psychological consequences. Considered in this context, the entire interior space of the chapel may be seen as a theological, metaphysical, and aesthetic response to a specific constellation of ancient pagan monuments and their glorification and spiritualization of war, positioning God the Father and the Annunciation within the chapel's interior triumphal arch (Figs. I.10–I.12).[4] Its medium – painting simulating relief – is central to this message (Figs. I.13–I.20). The chapel with

its faux relief optics, then, constitutes Giotto's critique of ancient Roman sculpture and architecture – a subtle response to the pagans' unabashed celebration of the classical pantheon's materiality as well as to the hubris of the ancient Roman gods, demigods, and humans. With the identification of specific, heretofore unacknowledged sculptural and architectural models, historical connections, theological references, and conceptual links, the motivation behind Giotto's creation of a *maniera latina* in Padua becomes recognizable, I argue, as a demonstration of a Christian triumph over pagan antiquity by emulating, quoting, transforming, transubstantiating, and ultimately surpassing antiquity's own most triumphant examples of architecture and sculpture.

The theme of transubstantiation as expressed through the visual transformation of matter, embedded in a commentary on Christian self-sacrifice, bridges the medial discourse of faux relief and the understanding of the triumph of humility, inextricably linked with the concept of trauma overcome. Only suffering and the overcoming of

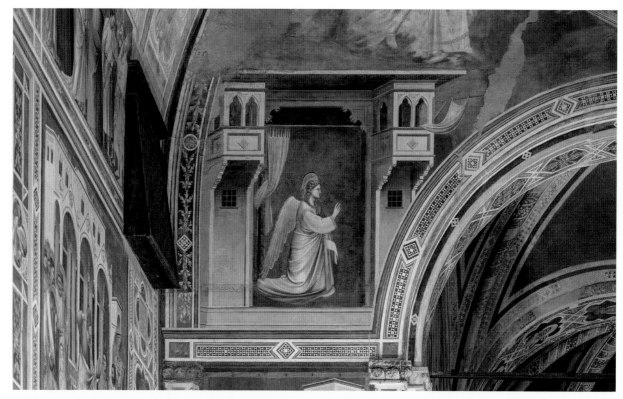

Fig. I.11 The *Annunciation*: The Angel Gabriel. Courtesy of Steven Zucker.

Fig. I.12 The *Annunciation*: Mary. Courtesy of Steven Zucker.

Fig. I.13 The fictive *coretto* on the north-east corner in context. Courtesy of Steven Zucker.

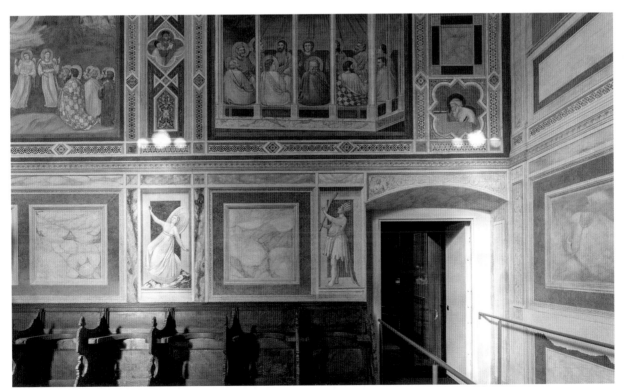

Fig. I.14 The faux marble around *Inconstancy* and *Folly*. Courtesy of Steven Zucker.

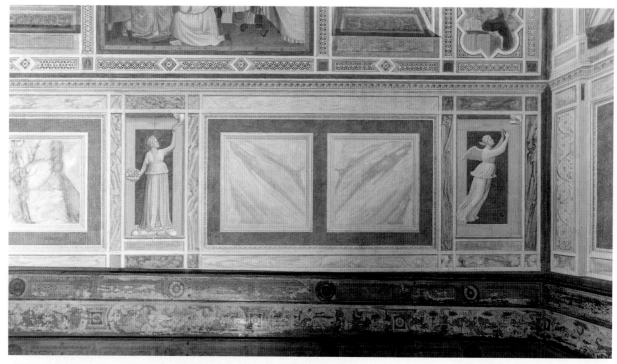

Fig. I.15 The faux marble around *Charity* and *Hope* in planparallel view. Courtesy of Steven Zucker.

one's self – "superare noi stessi," as Saint Francis put it, not long before Giotto – can facilitate the triumph of humility that can only be celebrated for someone or something distinct from the ego. What sounds like a modern psychological concept is in fact at the core of ancient Christian doctrine. In its faux architectural-material semantics, Giotto's fictively broken vault is a commentary on the metaphysical gulf that lies between the pagan and the Christian understanding of how divinity and holiness can be achieved: through living in *caritas* and *spes* (love and hope). Or, in other words, to triumph through the peaceful overcoming of suffering and through humility rather than through military victory and brutality. The paradoxical notion of a triumph of humility thus emerges as a key theme of the chapel – a core concept of Christian Salvation history that links the story of Christ's passion to the personal experiences of endurance and resulting transformation of believers. In contrast to the violence of the triumph of Titus depicted inside his arch on the

Velia, healing is the principle of the triumph of humility. Any Christian triumph – even Christianity's historical victory over ancient Roman Empire religion – must be characterized by humility, given the nonviolent ideals that Jesus Christ modeled and the reversal of worldly values that he proclaimed in his Sermon on the Mount. In visualizing this, shortly after the First Roman Jubilee of 1300, Giotto provided an intellectually rich Christian response to the ancient arch, to Roman militarism, and to the emperor's apotheosis by rethinking, visually, Christianity's historical triumph over the Roman Empire as an ultimate, peaceful triumph of the humility of Mary and Jesus both personalized and generalized for the community of spectators. Their triumph, positioned amid ancient ruins, is framed as a medial problem, going hand in hand with the rejection of ancient idolatry as visualized attributes of both *Faith* and *Idolatry* in the dado zone. Indeed, not all parts of the chapel seem to be aiming at the same degree of simulated reality. While the frames

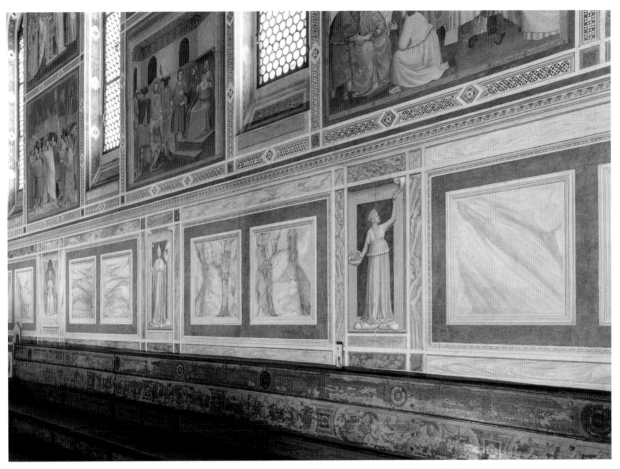

Fig. I.16 The faux marble around *Charity* and *Hope* in a tilted view. Courtesy of Steven Zucker.

and dado zone fully deceive the eye, there seems to be a more ambiguous play in the blue-grounded scenes, oscillating between the possibilities of painting and relief sculpture. Taking these nuances into account, this study investigates ways in which the painter–architect Giotto engages with the theological investment that both ancient Roman state religion and the Christian tradition made in images of paint and of stone as well as images of painted stone, especially in the context of the performativity of triumphal arches.

Of course, under the name "Giotto"[5] this book includes, implicitly, also the larger circle of collaborators, assistants, and interlocutors who helped envision and execute this particular project.[6] In accordance with the most recent studies, the theological finetuning of the Arena program is seen in the context of an intellectual collaboration that was paid for by the patron, moneylender Enrico Scrovegni; conceptualized by Giotto and the canon depicted shouldering the chapel in Scrovegni's dedication portrait; and painted by Giotto as the director of a workshop that included about ten pairs of helping hands.[7] Since, as we will see, the faux marble is essential to the theological program's core, and every marginal figure and vignette has specific importance for the iconographic system, the collaboration between painter and canon must have been extremely close. In recent years, Giuliano Pisani's textual and historical research convincingly narrowed down the authorship of the theological program to Alberto da Padova; other names suggested for the memorable figure next to Scrovegni are Altegrado dei

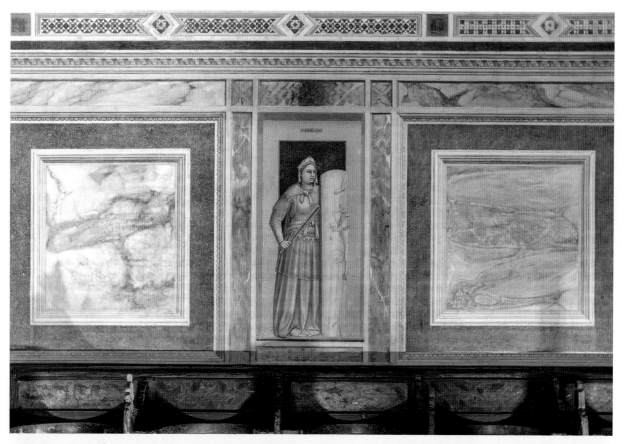

Fig. I.17 *Fortitude* in context. Courtesy of Steven Zucker.

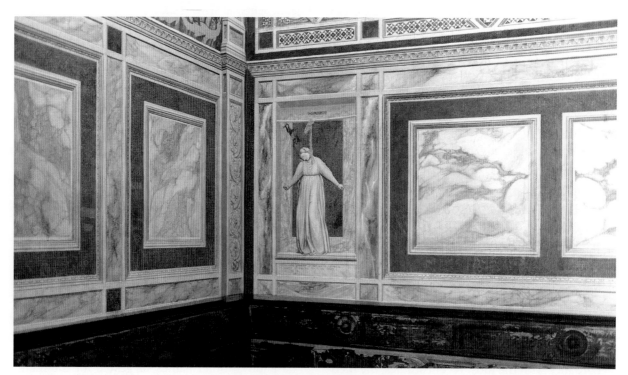

Fig. I.18 The north-west corner with *Despair* in context. Courtesy of Steven Zucker.

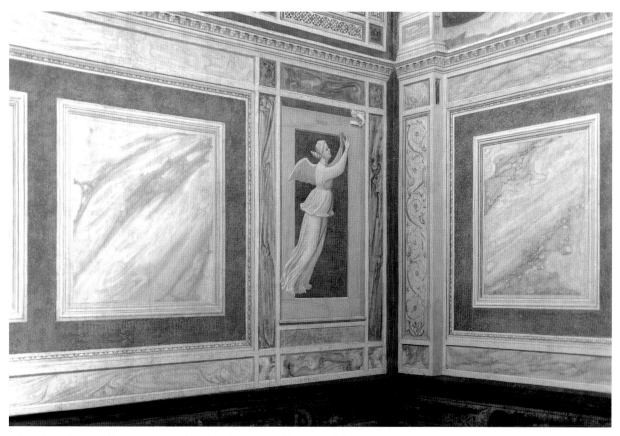

Fig. I.19 The south-west corner with *Hope* in context. Courtesy of Steven Zucker.

Cattanei and the chapel's first priest, Tommaso degli Aguselli.[8] All of these figures were familiar with the fundamental Christian concept of the triumph of humility, as was the religiously homogenous society around Giotto.

It is a truism that the world of visual, spatial, temporal, and cultural experiences for Giotto and his contemporaries was entirely different from that of today's visitors, who have an additional seven centuries of art history in their eyes, including almost two hundred years of published descriptions of this particular chapel. But it is crucial to recall that the visitor to the chapel at the time of its construction had a visual horizon of art formed by the densely packed remnants of Greco-Roman classicism, the Byzantine, and the Duecento (possibly even Etruscan imagery), as well as practical knowledge of urban Roman topology – especially after returning from the massive pilgrimage event

of the Jubilee in 1300.[9] Coming from Rome, like Giotto himself, or from any part of the former Roman Empire, a visitor in early Trecento Veneto would have seen the most significant places of Christian worship always surrounded by and often constructed within the skeletal ruins of classical pagan antiquity. The Arch of Titus itself, which plays a leading role in what follows, slowly continued to change appearance according to its environment.[10] Canaletto and visitors on a Grand Tour, for example, would have seen the Arch still somewhat integrated into medieval walls. The Arch in situ appears thus in the historical representations by painters like Canaletto himself (1697–1768, painting the arch around 1742), Charles-Louis Clerisseau (1721–1820, representing the arch around 1753), and later Franz von Lenbach (1836–1904, painting the arch in 1860), (Figs. I.21–I.23).[11] The visual record of the Roman

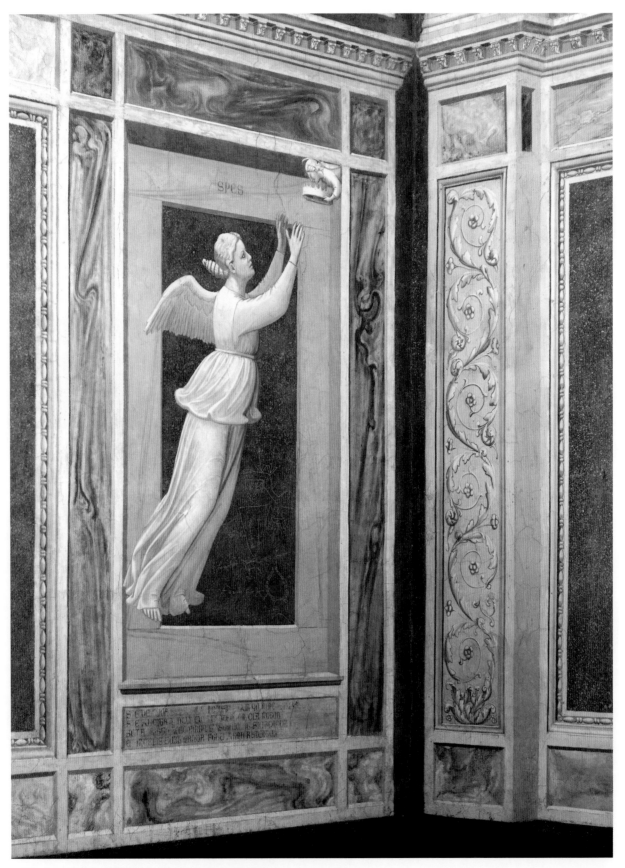

Fig. I.20 Detail of *Hope*. Courtesy of Steven Zucker.

Forum since the age of the Grand Tour indicates how greatly visions of the Arch have differed over the centuries – not to mention the fluid chiaroscuro constantly changing the arch and its relief in the cycles of daylight, weather conditions, and seasons (Figs. I.24–I.26).

In order to imagine an approximation to a Trecento version of this vision, we must attempt the impossible and try to free ourselves as best one can from the sediment of more than seven hundred years of interpretative accretions and the impact of technical reproduction that has fragmented the chapel into postcard-sized pictures. In our time, the initial impression of the chapel is often determined before the first visit by art books with details that appear larger than life and entire walls that are reduced to the page of a small paperback. This was not the case around 1300. No one would have heard about *"valori plastici"* or "tactile values," nor would anyone have tried to identify what the *Blue Guide* or the *Guida rossa* or the *Baedeker* point out. No slide frame would have cut the cycle into convenient rectangular pieces, nor any photograph separate out and reproduce, single file, the scenes of *Joachim's Dream*, the *Lamentation*, and *Noli me tangere*. There would yet have been no retrospective attempts to attribute elements to Giotto, non-Giotto. No fighting over Assisi. No myth of white antiquity. No diagrams. No woodcuts. Instead, Enrico Scrovegni's chapel would have introduced itself by an inscription emphasizing Christian triumph over the ancient local ghost of the pagan Roman Empire, calling the oratory a "temple," lauding Enrico for turning the "home of abominable heathens" into a "noble altar to God," and echoing the spirit of Rome 1300. It was so obvious in one age's zeitgeist – after the Jubilee, no explanation was needed – that it has been forgotten and almost rendered invisible in another. The triumph of humility is, I propose in this book, key to the chapel's Christian recoding of triumphalism and, at the same time, an anticipation of the chapel's

continuing appeal to modern sensibilities beyond Christian communities of viewers. As we will explore herein, this statement encapsulates the entire theology of the Janus-headed chapel both as a critical response to ancient Roman materiality and as a portal to the modern world of new generations of critical and self-reliant viewers.

Reconsidering the genesis of this monument demands a rethinking of art-historical assumptions about the role of relief sculpture in the history of art and religion; about the emergence of mimesis and optical illusionism in the early Renaissance; and about the triumph as a literary, visual, and theological topos. This surprising act of Christian appropriation and manipulation of pagan media is an act, not of copying the form, but of inserting the old form – merged with new elements – into an innovative system. Communicating "the content of the form" in that brilliant structure across broken vaults and the central transverse arch, the chapel is a rhetorical gesture from the past towards the future.[12] It considers its own making and unmaking, and invites the humble visitor to do the same.

Humility and the ego have already been crucial concerns of modern approaches to the chapel in critical theory. Julia Kristeva delivered the most influential modernist reading of the chapel in her classic essay on "Giotto's Joy."[13] Phenomenological, scientific, and psychoanalytic considerations are combined in her approach. Kristeva considers Giotto's blue as a phenomenological force – the first and fundamental formal-perceptual effect experienced by a beholder actually entering the chapel, the eyes gradually adjusting to the dim interior light. Slowly, as she rightly apprehends, the architectural structure and the images are perceived by the human eye as though in liminal twilight conditions such as the hours of sunset and sunrise, when objects lose their solid recognizability. Kristeva comes to an ingenious psychoanalytical interpretation of the resonance of this environment and its perceptual

Fig. I.21 Rome, Arch of Titus in situ circa 1742, still integrated in the remaining medieval walls in a historical representation by Canaletto (1697–1768). CC BY-SA 4.0.

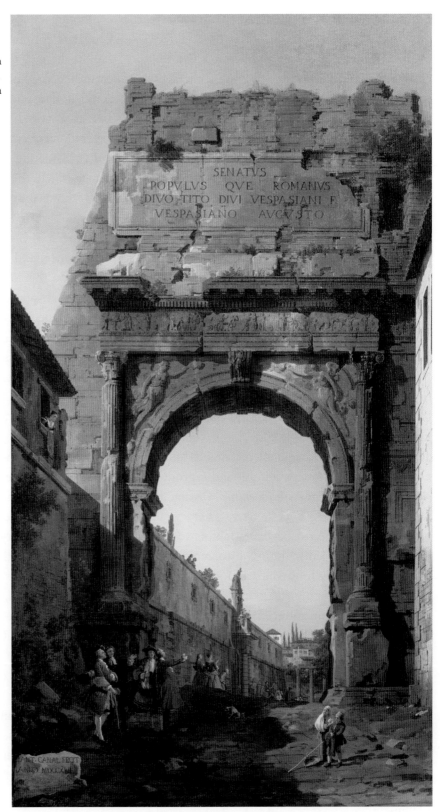

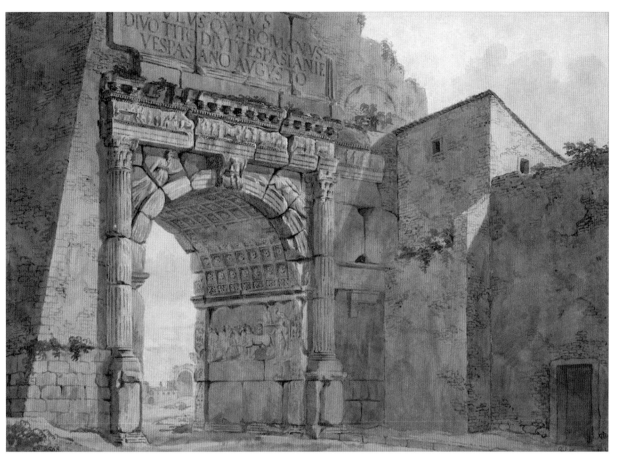

Fig. I.22 Rome, Arch of Titus in situ circa 1753, still integrated in the remaining medieval walls in a historical representation by Charles-Louis Clerisseau (1721–1820). Courtesy of the UC Berkeley Historical Slide Library (est. 1938–2018), Hallett Collection, Doe Memorial Library in Berkeley, California, USA.

conditions, which she locates within unconscious states of narcissistic plenitude and ego-anxiety. This book is written from the different perspective of the historian of art and literature, and firmly rooted in the historical conditions of the moment of 1300. My argument, however, corresponds in significant ways with Kristeva's. The visual play inherent in the relief-painting problem laid out in my study, in which the destabilizing, oscillating character of the upper scenes contrasts with the more stable and more clearly relief-imitating zones (e.g., dado, transverse arch), is compatible with Kristeva's account. The mental readjustment to the habitual 'flattening' of blue illumination contributes to the activation of the fictive surfaces and depth perception. Especially fruitful with respect to overlap between Kristeva's

text and the present study is the working out of sculptural volume, for example in her passages on "Oblique Constructions and Chromatic Harmony."[14] I see Giotto creating not a simulation, but a creative engagement with relief in painting, and it is precisely the oscillation between media that allows the spectator to critically engage with the spirituality of the painted relief effects as a response to the Titus reliefs. Kristeva's findings on the ego in "Giotto's Joy" work well with the idea of the triumph of humility that is established in Giotto's *Virtues* and the triumphal arch design. These two entirely different methodological roads eventually arrive at the same destination: After all, with its line of selfless, self-checking, and empathic virtues so demonstratively opposed to the self-

Fig. I.23 Rome, Arch of Titus in situ in 1860, still integrated in the remaining medieval walls in a historical representation by Franz von Lenbach (1836–1904). CC BY-SA 4.0.

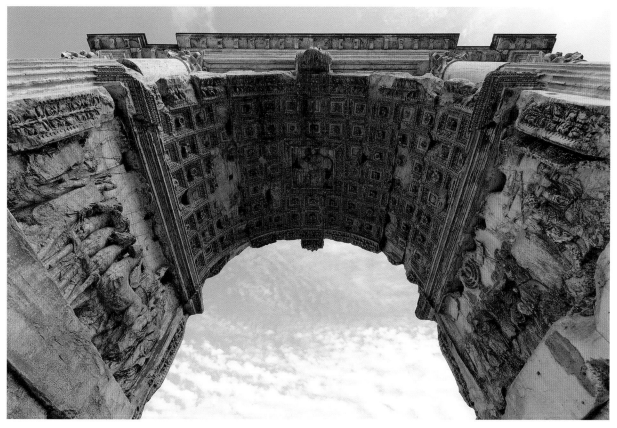

Fig. I.24 Rome, Arch of Titus, bay interior. CC BY-SA 4.0.

involved, self-injuring, and narcissistic vices and with its model of altruistic Charity and the ultimate, supreme rising of Hope, the chapel provides a remedy against narcissism.

The most helpful resource for Giotto's debt to Roman relief sculpture, which is central to this study's notion of "Giotto's Triumph," is Serena Romano's *La O di Giotto*.[15] Chiara Frugoni's *L'affare migliore di Enrico* delivers a thorough account of Enrico Scrovegni's and Giotto's intentions.[16] Michael Victor Schwarz's research into every question regarding Giotto's life, works, and implicit media theory are crucial to any work in this area and have focused my eyes especially to the issue of fading polychromy on the *Virtues* and *Vices*.[17] Francesco Benelli's studies of Giotto and architecture have provided central answers to my questions.[18] Laura Jacobus includes the consideration of theatrical aspects in the chapel.[19]

Anne Derbes and Mark Sandona thoroughly explore the chapel's and Scrovegni's interreligious and historical depth.[20]

This is about relief as strategy. The relief effect in painting – the medium effect enabled by pictorial relief – in the center of this book is focused on the discussion of *simulated* relief and not the figures' projecting haloes. Conforming with standard practice for murals of that period, those are the only elements in the scenes with material protrusions from the painted surface. Besides the early modern sources on relief and *rilievo*, the more recent historiography of relief as artistically determining force since Hildebrand's 1893 *Das Problem der Form in der bildenden Kunst* establishes the background of this study, especially the two most relevant systematic studies *Real Spaces* by David Summers and *Visuality and Virtuality* by Whitney Davis.[21] This book likewise

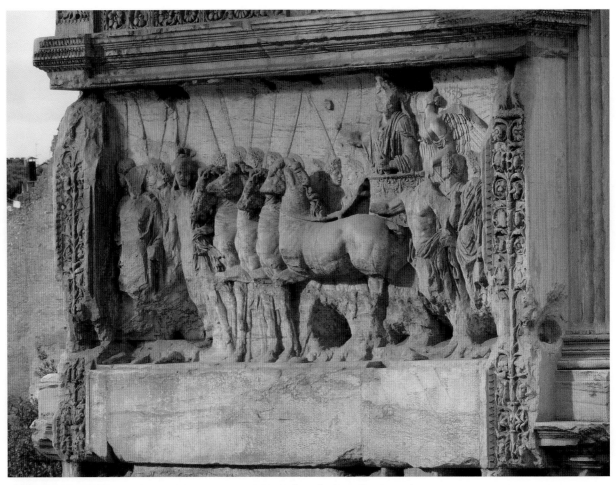

Fig. I.25 Arch of Titus, chariot relief in subdued daylight (2018). Photo by the author.

benefits from historiographical interventions on the "modernity" of painting, sculpture, and relief around Giotto such as Alexander Nagel's *Medieval Modern: Art Out of Time*.[22] Christopher Lakey's work on medieval and early modern relief theory and practice in Italy offers critical insights on the literary response to relief as well as a sophisticated vocabulary of "sculptural seeing" and relief in its different contemporary iterations, with important revisions to the temporalities of the early modern age as it has been heretofore defined.[23] Similarly focused on early modern Italy, Robert Brennan has recently recast the question of modernity for the generations around Giotto in extremely fruitful ways.[24] Péter Bokody defines Giotto's "reality effects," embedding one medium within another, in

Images–within–Images in Italian Painting (1250–1350): Reality and Reflexivity.[25] While engaging with a historiographical landscape that has been more and more in flux, the present monograph offers new ways out of some deep-rooted conflicts in Giotto attribution history. Considering the model of polychrome relief sculpture for the *Lives of Mary and Christ* as the motor for a conscious stylistic shift within Giotto's work, the argument proffered here finally permits a novel revisiting of Richard Offner's controversial study, "Giotto, non-Giotto," regarding the riddle of Giotto's presence in Assisi and Padua despite the visible stylistic differences in terms of style, pictorial space, and pictorial *rilievo* between the Scrovegni cycle and the *Saint Francis* cycle in the Upper Church in Assisi.[26]

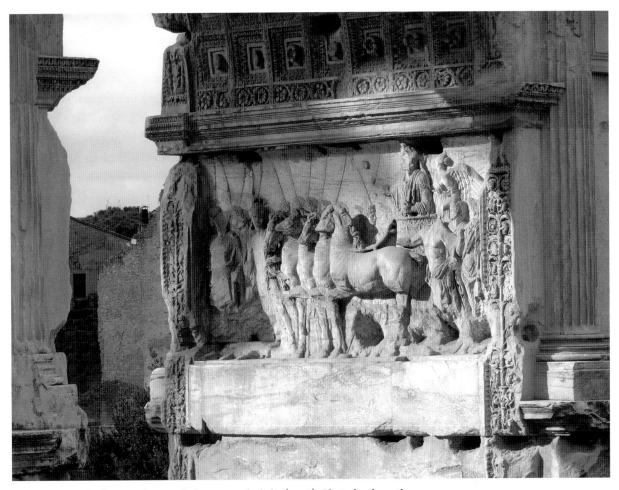

Fig. I.26 Arch of Titus, chariot relief in sunny daylight (2018). Photo by the author.

This book is structured in five chapters. Chapter 1, "A Venetian Dream of Rome and Jerusalem," introduces the chapel design, its non-Roman nuances, its classically pagan-Roman aspects, and its historicizing elements of style. This art-historical and architectural study of the chapel moves from questions of visuality and iconography to a discussion of the context between Rome and Padua and the two cities' relationship to the central notion of a triumph of humility, based upon the chapel's complex visual regime. Chapter 2, "1300: The Moment of the Jubilee in Rome and Padua," situates the chapel in the specific historical context of the first Roman Jubilee – Easter 1300 – focusing on the evidence of surviving documents and on topographical and performative connections to

Rome. Chapter 3, "The Powers that Were: Scrovegni, Dalesmanini, Frangipani," centers upon the most visible yet most elusive donor of his generation – Enrico Scrovegni – who commissioned the chapel and is represented multiple times in its imagery and interior. Potential motivations as well as his relationship to the Paduan social elites – including the formerly powerful Dalesmanini family – are considered in the context of his documented acts of status elevation.

Chapter 4, "Giotto's Painted Reliefs," moves back into the chapel for a detailed study of the murals, focusing on the discourse on personal ethics presented at eye-level to the viewer. With these emblems, Giotto opens a spiritual arena, constructing a framing device for the chapel's history scenes as well as for its visitors. Replacing

the ancient Arena with a Christian chapel's churchyard, the *Virtues* and the *Vices* establish that the triumph of humility is a spiritual battle. This chapter offers a new reading of the programmatic breaks in illusionism that pierce the chapel's visual regime by the deployment of two-dimensional imitations of relief sculpture. Introducing the concept of "medium effects," this chapter highlights the importance of the ceiling and the *Last Judgment* for establishing and rupturing the chapel's template in relief effects in light of the eternal triumph of humility. That these particular "relief effects" are conceived in painting – adding a level of micro-pictoriality on top of their simulated volumes – complicates the material and medial dimensions of the chapel's simulated reality and gives additional insight into Giotto's observation and rendition of the visual world around him – a world filled with polychrome Christian relief sculpture and ruinous, formerly polychrome ancient statuary.

Chapter 5, "Triumph and Apotheosis from Augustine to Dante," opens up a larger cultural history around the themes established in the two previous chapters. Among potential sources of inspiration is Augustine of Hippo, whose theological visions of history and of God resemble those presented in the chapel. Saint Augustine's writings are probed in relation to several of Giotto's iconographical decisions. Around the Incarnation (God becoming human as Christ), a central topic in the chapel, the themes of visibility and invisibility are merged with those of ancient imperial pride versus Mary's and Christ's humility as well as with the transubstantiation through the passion and self-sacrifice of Christ. Conceptualizing the visual effects of relief in painting as encouraging spectatorial engagement in fact requires a self-reliant, critical viewer, understood as the visual counterpart of the Augustinian concepts of the reader and the integrated self. This constellation of themes and contexts helps us join our understanding of the modern reader (in the sense of Brian Stock's

Augustine the Reader) with that of Giotto's modern spectator.[27] Equally important is a consideration of Dante Alighieri, who himself relates in many ways to Augustine, to the Jubilee of 1300, to his compatriot Giotto, to the merging of personal virtues and the triumph of the church, and to the themes of personal responsibility and transformation evoked in the Arena Chapel – as well as to the figure of Titus and the San Silvestro Chapel, a monument which we will encounter as a kind of stepping stone between the Arch of Titus and the Arena Chapel. A focused reading of Dante's slightly later *Divine Comedy* (ca. 1308–1320) helps foster an understanding of the chapel's affinities to themes in Dante's work. With Dante, the interpretation of Giotto's chapel as a response to the Jubilee procession through the Arch of Titus is not without contemporary comparison. Giotto's oratory and Dante's poem both embody systems of artistically engaged dialogues between ancient-pagan and modern Christian styles. These include the theological import of relief sculpture as a Divine medium in Christian art (*Purg.* 10) and the association of vividly animated, lifelike relief and humility (*Purg.* 10–11) as well as the staging of triumphs of humility (*Purg.* 29), as we will see.[28]

The Epilogue, "Relief, Triumph, Transcendence," explores the *coretti* in relation to the miniature architectural portrait of the chapel in the *Last Judgment* and the stakes of this pairing for ultimate questions of matter and illusion. The Appendix addresses the Assisi Controversy (the so-called Assisi Problem) – the fierce, century-long debate around Giotto's authorship of the frescoes in the Upper Church of San Francesco in Assisi – in the light of the core themes of this study. The Appendix and the book close with a Franciscan text from the *Fioretti* (written about one and a half centuries after the death of the Saint in 1226) that is most resonant with the triumph of humility, namely the definition of *perfetta letizia*, of perfect joy, as the spiritual principle of overcoming one's self that results in *imitatio Christi* and the proliferation of peace.

The challenge this book faces is to defamiliarize the viewing experience of such a famous monument in preparation for seeing it anew while contextualizing it in its historical environment. Before turning to the chapel's spatial-visual messages, it is beneficial to consider briefly other, related structural models for the critical engagement of form, medium, and the physical container in which a spiritual message critically materializes in a medium. An author with crucial importance for Giotto's chapel, as we will see, Augustine could conceive of his own greatest work, *De civitate Dei contra paganos* (*On the City of God Against the Pagans*), only via the material condition of the codex as opposed to the ancient scroll, "so that the physical form of the codex reinforced his arguments about history" (as Susanna Elm puts it).[29] Just as the codex provided a speaking format for Augustine's *City of God*, Giotto's all-embracing chapel structure delivers the artist's distinctive presentation of Salvation in a unique technology. The chapel, like the codex, bypasses a linear sense of reading, viewing, and history. The typological mechanics of the chapel are premised on the embedded arch. Its elements are to be read across the distinct levels of walls and vault as much as Dante's *Divine Comedy* encourages parallel, vertical, diagonal, and reversed readings between *Hell*, *Purgatory*, and *Paradise*.

With the framing presence of the ancient arch comes a discourse on ruins and restoration at Giotto's time and from here to eternity. The broken vault, moreover, oscillating between nature and artificiality, destabilizes our assumptions about interior and exterior, matter and spirit. Very much like Augustine's self-conscious use of the codex, Giotto's reworking of the arch model links form and meaning so that materiality and the historical order of things are subverted by the chapel's spatial statements: its striking, self-reflexive illusionism and its brilliantly visualized metaphysics and medial self-criticism. At the convergence of these themes in Giotto and

Augustine as well as at the core of this book stands the principle of the *sermo humilis* – as Erich Auerbach characterizes the new style demonstrated by Augustine in his sermons.[30] The *sermo humilis* marks one of the cultural changes initiated by early Christianity, together with the codex and a symbolic imagination radically different from that of either Hebrew and Greco-Roman tradition, though making use of both. Perhaps Giotto and his interlocutors understood this, since Dante surely did, as evidenced by his written approaches to a metaphysics of history and triumphs. Augustinian thought can be seen as a hinge between Giotto and Dante when it comes to religious traditions, historical ages, and media discourse. We will trace several ways in which Augustine's person, his theology, and his heritage in the late middle ages were significant for Giotto's chapel project. After all, the chapel pays special homage to the church father: He appears in the southwest corner, situated in a quatrefoil right above the highest virtue, *Hope*. Augustine is the only figure in the chapel with extended legible innerpictorial text, here painted into one of the books propped up on his desk. Only the evangelist Luke has a scroll showing only the words "Ave Maria"; Augustine's volume contains the full prayer to Mary.

Connecting the details with the entirety of the project results in more than a sum total. The cultural moment at the center of this book is bigger than any single one of its elements. A classically art-historical act of identifying models and reformulations of forms and themes is our starting point, but this volume engages theology, literature, and history. The chapel is a critical reappropriation of its own time and heritage – a visual critique, not a reinstallation, of empire. This is what distinguishes Giotto's masterpiece from earlier forms of medieval reappropriations of antiquity and imperialism. To give one slightly earlier example that played out between southern Italy and the North,

Frederick II (Holy Roman Emperor 1220–1250) was imperial in his gestures and artistic campaigns, and yet, without an illusionistically perfected intermedial critique of the kind that Giotto envisioned in Padua, Frederick's projects were fragmentary copies – slightly reframed reinstallations of single aspects of the Roman Empire, more like isolated gestures with a less comprehensive feel for the historical and human dimensions, depths, and meaning. Giotto instead channeled ancient relief sculpture to declare, like Augustine in the *City of God Against the Pagans*, the mystical rule of eternal forces beyond the visible, thus offering an entirely different way to look at the world – and, simultaneously, through the world – beyond appearances and history towards a higher truth.

Observing Giotto's work for Enrico Scrovegni in an attentive, openminded, probing, and explorative way is not more and not less than to be mindful of the greeting under the first virtue to a visitor entering through Scrovegni's door. The fragments from the almost entirely effaced inscription under *Prudence* encourage the awareness of things and times, of vision and memory ("Things and time with the greatest care [Prudence] notes and [...] remembers the eyewitnesses [...]").[31] Quoted in the epigraph for the introduction of this book, the fragment is still meaningful and in accordance with the image of *Prudence*, a figure depicted with a feminine face looking forward into a mirror and a masculine one looking back, Janus-headed as the chapel itself. As we are about to explore, painted relief sculpture offers the ideal material and critical medium for this experiment in cognitive finetuning because it relates to the senses of sight and touch: to the eye and to the entire body in real space. The role that Giotto has foreseen for the viewer is one of a self-reliant, self-aware, and critical spectator, called to decide about the nearness, distance, and materiality of the multichromatic fictive matter emerging in front of Giotto's blue, and about the meaning of this form. In a future where even a space mission was to be named after Giotto, his works keep transcending time and place as striking commentaries on the human condition.[32]

Chapter 1

A VENETIAN DREAM OF ROME AND JERUSALEM

ANNORUM DOMINI TEMPUS TUNC TALE
NOTATUR: ANNIS MILLE TRIBUS TERCENTUM
MARCIUS ALME VIRGINIS IN FESTO
CONIUNXERAT ORDINE PALMAE

When this place is solemnly dedicated to God, the year of
the Lord is thus inscribed: In the year 1303, when March
had conjoined the feast of the blessed Virgin and the rite of
the Palm.

<div align="right">

FROM ENRICO SCROVEGNI'S INSCRIPTION,
FORMERLY AT THE ARENA CHAPEL[1]

</div>

PADUA'S SLEEPING BEAUTY

H IGHLIGHTING ITS PROMINENT location on the site of the
ancient Roman arena in Padua, the oratory of Santa Maria della
Carità has traditionally been called the Cappella dell'Arena or
Arena Chapel (Figs. 1.1–1.2). Part of a new family palace commissioned by Enrico Scrovegni, the chapel was built and decorated by Giotto in the years following the Roman Jubilee of 1300, after the Tuscan painter had worked for Pope Boniface VIII as his papal court artist in Rome. The construction of

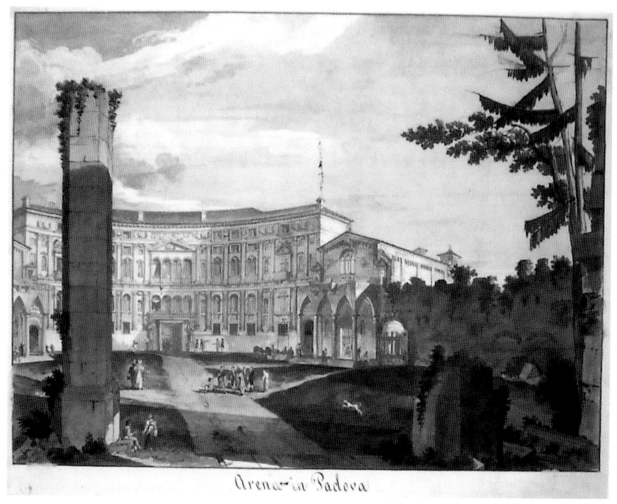

Fig. 1.1 Watercolor (circa 1801) by Marino Urbani of the Arena in Padua before the demolition of Palazzo Scrovegni. Courtesy of the UC Berkeley Historical Slide Library (est. 1938–2018), Baxandall & Partridge Collection, Doe Memorial Library in Berkeley, California, USA.

Santa Maria della Carità, so closely connected to Giotto's murals, was most likely masterminded and supervised by Giotto himself. The building can be dated between 1300 and 1303, and the parameters for the frescoes have been set between 1303 and 1307.[2] The overall structure and proportions of the Arena Chapel's nave are akin to two triumphal arches placed in succession.[3] The barrel-vaulted core interior is divided into two precincts – public and private – with two respective entrances. Formerly adjoining Palazzo Scrovegni, the chapel stands projecting out from the elliptical plan of the ruins of the ancient Roman arena.[4] The chapel's building history, based upon some documented and some obvious physical alterations undertaken during construction, has been profoundly debated.[5]

Walter Euler describes the effect of the interior as surprisingly grand for its height, which is only about one-and-a-half times its width. In this simple geometry of the classical barrel vault, the cross section equals a square with a semicircle on top of it.[6]

Only a few documents regarding the commission are known to have survived: On 6 February 1300, Enrico Scrovegni bought land around the ancient arena in Padua from the Dalesmanini family, and with it their family palace and possibly an older chapel from the eleventh century.[7] Scrovegni's own, newly constructed oratory, Santa Maria della Carità, is traditionally thought to have been dedicated on 25 March 1303. A papal bull granting indulgences was issued as early as 1 March 1304. On 9 January 1305, the neighboring

Fig. 1.2 The Arena in Padua with Scrovegni Chapel after the demolition of Palazzo Scrovegni in a photograph by Luigi Borlinetto from around 1870. Courtesy of the UC Berkeley Historical Slide Library (est. 1938–2018), Baxandall & Partridge Collection, Doe Memorial Library in Berkeley, California, USA.

Eremitani monks formally complained about Scrovegni's project: It threatened to become too pompous, exceeding by far the unassuming private chapel originally announced and approved in the permit.[8]

Almost absent from the early records of art history, the chapel would continue its deep slumber until the dramatic events of its near demolition in the early nineteenth century, when only a last-minute intervention by Pietro Estense Selvatico (an architectural historian from a local aristocratic family) and the citizens of Padua saved it from imminent destruction.[9] The adjacent Scrovegni palace, however, was erased from the face of the arena, ripping deep wounds into the chapel's sidewall, which would expose the frescoes to water damage.[10] Selvatico continued his mission to safeguard the cultural heritage of Padua as the first author of a monograph on the chapel.[11] Inspired by the enlightened interests of his time such as individual virtue and personal

responsibility, he dedicated his attention almost exclusively to the allegorical cycle of the *Virtues and Vices* in the chapel's socle zone and to the targeted fashioning of Giotto as an Italian national hero in the spirit of the Risorgimento.

The first two English-language monographs to discuss the chapel were published, respectively, in 1835 by Maria, Lady Callcott, and in 1854 by John Ruskin, when the Arundel Society promoted the desired acquisition of the frescoes for the South Kensington Museum in London – today's Victoria and Albert Museum.[12] As a commentary to woodcuts of the single scenes, Ruskin's text gives a biblical-iconographical account, unintentionally furthering a standard perception of the scenes as fragments, page by page deprived of their architectural context and spatially suggestive properties. Through these tone-setting publications, the chapel – and the enigmatic figure of Giotto – began to interest scholarly and artistic circles in Italy and England. From the nineteenth-

century awakening of interest to the present day, Giotto's chapel has remained at the center of art-historical research and speculation. To see it anew for considering its embedded architectural iconography, we must first examine the structure and the extraordinarily systematic decorative scheme that it was built to contain.

THE CHAPEL DESIGN

The fresco scenes narrate the *Lives of Mary and Jesus* in almost forty fields. As a prologue to the Mariological cycle appear the *Stories of Joachim and Anne*, Mary's parents. These stories, popularized by Jacopo de Voragine's *Golden Legend*, emphasize the immaculate conception of Mary herself. When focusing on the iconographic sequence of history scenes, the viewer in the chapel faces the problem of fragmentation that Ruskin describes, quite rightly, as endangering the perception of the whole.[13] Each of these moments is but one wheel in the expansive yet extremely fine iconographic clockwork of the chapel.

The narrative begins with the *Stories of Joachim and Anne* (*Joachim Rejected from the Temple, Joachim Entering the Wilderness, Annunciation to Anne, Joachim's Dream, Joachim's Sacrifice*, and the *Kiss at the Golden Gate*, see Figs. P.13–P.18). These are depicted on the south wall's upper tier, and continue on the north wall's upper tier with stories of Mary's infancy and engagement (*Birth of Mary, Presentation of Mary into the Temple, Submission of the Rods, Prayer before the Rods, Mary's Betrothal*, and *Mary's Nuptial Procession*, see Figs. P.19–P.24).[14] These scenes culminate in the bipartite *Annunciation* on the second tier of the chancel wall (see Fig. P.25), moving one step down into a narrow field showing the *Visitation* (see Fig. P.26) on the right side of the chancel arch. From there, the story weaves seamlessly into scenes from the life of Jesus on the middle tier on the south wall. These appear in chronological order beginning with

events of his birth and infancy on the second tier of the south wall and of Christ's baptism, teaching, and mission on the second tier of the north wall (see Figs. P.27–P.37). The line of stories along the walls is once again interrupted on the chancel arch by the *Pact of Judas* (see Fig. P.38), which appears on the left side, opposite the *Visitation* scene. The *Pact*'s format is similarly narrow; the field is smaller and reduced to the representation of five figures but retains the same figure scale and spatial mode of relief. The passion cycle follows the *Pact of Judas*, dropping into a darker phase on the lowest tier of the south wall with the *Last Supper, Washing of the Feet, Arrest of Christ* (*Kiss of Judas*), *Christ before Caiaphas*, and *Mocking of Christ* (see Figs. P.39–P.43). On the lowest tier of the north wall the *Procession to Calvary, Crucifixion*, and *Lamentation* are followed by the *Noli Me Tangere, Ascension*, and *Pentecost* (see Figs. P.44–P.49). The chronology of Salvation again requires the repositioning of the spectator into the middle of the nave, facing west to see the ten-meter-tall *Last Judgment*.

Down to the square inch, the entire mural design is set accurately into the chapel's interior space, including the spatially complex and puzzling *coretti*, the two fictive side chapels painted under the chancel arch (Fig. 1.3). Over this precisely structured closed system, the coves between the sidewalls and the ceiling bend themselves purposefully in the perfectly calculated system of fictive marble that Giotto optically built for framing the scenes of the *Lives of Mary and Jesus*. High in the blue of the vault, the coved edges of their uppermost register recall the one other architectural place where such coves over interior walls with history scenes can be seen – inside the bay of triumphal arches (Fig. 1.4) – and, by extension, inside the few monuments that structurally and systematically refer to such triumphal arch bay interiors – such as the fourth-century Cubiculum Leonis in the Domitilla Catacombs in Rome (Fig. 1.5) or the San Silvestro Chapel in the church of the Santi Quattro Coronati in Rome

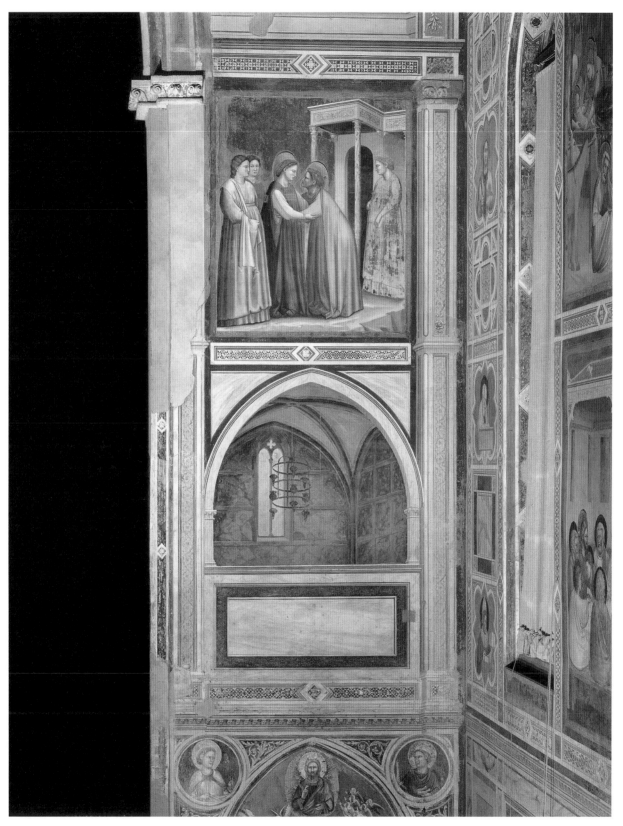

Fig. 1.3 Arena Chapel, the *Visitation*, and the fictive *coretto* on the south-east corner in context. Scala / Art Resource, NY.

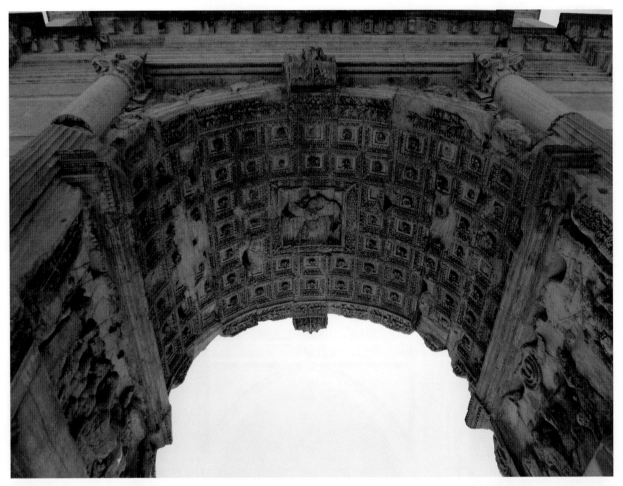

Fig. 1.4 The bay of the Arch of Titus with the chariot relief, the Menorah relief, and the Apotheosis relief in the apex of the vault. CC BY-SA 4.0.

(Fig. 1.6), an interior from the 1240s that would have been visible to Giotto, who was employed in Rome in the 1290s and in 1300 before his work in Padua.

Much like the relief-laden ancient Roman arches, Giotto's chapel is structured by modular systems of encased panels and stories that link the frames and the ground level of the dado: Painted to imitate reliefs, the famous seven *Virtues* and their respective *Vices* optically detach themselves from their polychrome background in eye-deceiving faux marble. The affinity of Giotto's Paduan figures to the ancient Roman style on the one hand and to sculptural relief on the other has been noted countless times in almost two centuries of European and global

Giotto historiography. But what if the upper registers also refer to the idea of sculptural relief, playing with the idea of polychromy as of the colorful surface of *painted* stone? After all, Giotto scholarship has always characterized those scenes in particular as featuring relief-like volumes and light effects so that they appear made in relief sculpture rather than in pigments on the flat wall, as documented by an impressive number of sources from the 1830s to the present day by a diverse set of authors.[15] Giotto's Paduan scenes seem to be compressed like actual *rilievi* – optically approaching the quality of relief sculpture. What if we were to take that effect of optical relief as seriously as the framing elements and the dado zone with its fictive relief figures of the

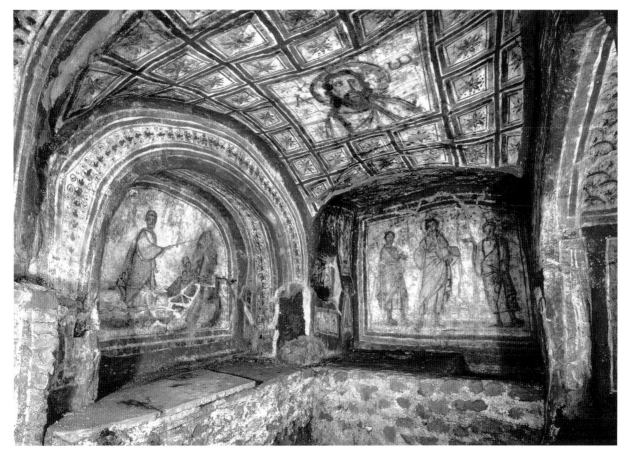

Fig. 1.5 The *Cubiculum Leonis* in the catacombs of Rome. Courtesy of the UC Berkeley Historical Slide Library (est. 1938–2018), Baxandall & Partridge Collection, Doe Memorial Library in Berkeley, California, USA.

Virtues and the *Vices*? To look at the entire space with the invited and necessary suspension of disbelief that Giotto suggests through the frames and dado such that we are challenged to consider which parts are painted and which paneled with stone, relief, and polychrome relief?

Expanding upon that solid sense of materiality, it is puzzling that the fictive structure ends only above the arcuation of the coves. The painted cornice demarcates the semiotic border of the vault, beyond which it shows no additional imitation stone surfaces but instead two separate parts of the open sky, scattered with golden stars and apparitions of Mary and Jesus, Christ as Pantocrator, and eight prophets. Trusting the painted illusionism, we see a broken vault with one lone transverse arch left standing at its center. In the idea of its painted faux-marble

skeleton, the chapel becomes recognizable as an open interior, only the sidewalls and central transverse arch standing, with two additional skeletal arches at each end of the barrel vault and the spanning vaults between them seemingly gone – perhaps collapsed in ruins. This often happened historically to ancient buildings and monuments, their vaults disintegrating before the supporting – and much more stable – transverse arches would cave in.

The lone transverse arch in the center of the chapel's interior separates one half of the space from the other, further insisting upon the ruin-like state of the painted faux-marble illusion of the vault's fictive structure. The two additional fictive transverse arches that frame the birdcage view into the sky support this reading: The first one demarcates the west and the other the east

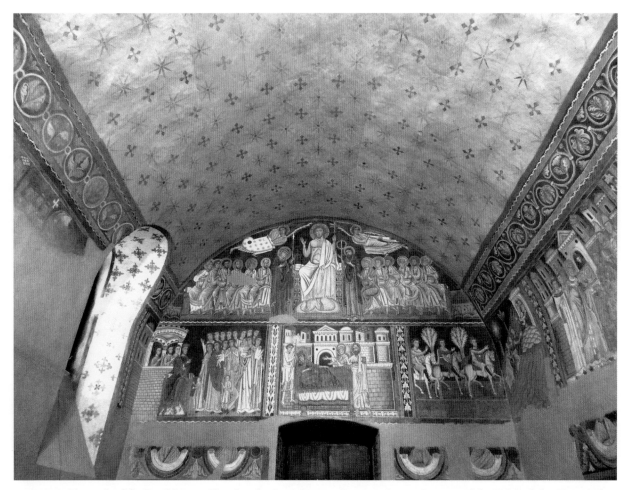

Fig. 1.6 The vault of the San Silvestro Chapel at the Santi Quattro Coronati, Rome. Courtesy of the UC Berkeley Historical Slide Library (est. 1938–2018), Baxandall & Partridge Collection, Doe Memorial Library in Berkeley, California, USA.

end of the barrel vault. Together these three fictive arches frame two rectangular openings through which to see a sky filled with orderly lines and patterns of golden stars and one central medallion surrounded by four smaller roundels in each half. Once again, the ancient arch comes to mind. One arch in particular, the Arch of Titus, bears a similar grid of ornamental precision around a central piece of figurative art. The ornaments run left to right and top to bottom in a coffering with carved rosettes, evoking the accurate organization of the stars in the chapel's semi-real, semi-stylized vault (Figs. 1.7–1.11). Where the two precincts of the vault in the Arena Chapel hold the images of Madonna and Child (west) and Christ as Pantocrator (east), the Arch of Titus

displays a relief with the Apotheosis of Emperor Titus (Fig. 1.12). Reading the sacred iconography of this mono-arch downward, a simple argument is made by visual means, illustrating the emperor's earthly deeds followed by a heavenly reward. The triumphal scenes from the Roman-Jewish war on the walls stand in a causal relationship to the emperor's apotheosis at the center of the vault (traditionally understood to be Titus, though the original iconography might have intended to show his father Vespasian – both are deified and named as "Divus" on the arch's inscription). The same rhetoric of metaphysical causality is at work in the chapel: The walls show the lives of Mary and Jesus, while the bipartite vault presents their spiritual essence and identities as Virgin Mary

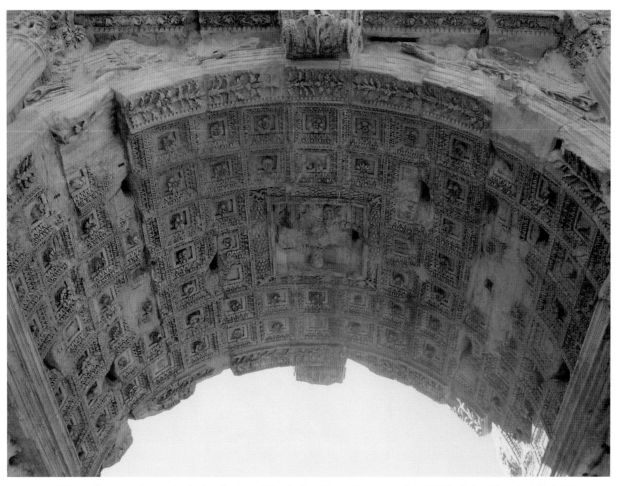

Fig. 1.7 The coffering and central relief in the bay of the Arch of Titus. Courtesy of the UC Berkeley Historical Slide Library (est. 1938–2018), Baxandall & Partridge Collection, Doe Memorial Library in Berkeley, California, USA.

with Son of Man on one side and Son of God on the other.

Here, Mary and Jesus Christ as *verace homo et verace Dio* are venerated via a double arch system that responds to the hubris of the ancient emperor's apotheosis by dismantling its entire system of material relief. The vaults here, fictively broken, frame a chapel that is not simply a relief-laden material copy of an arch; it also engages with the moral aesthetics of ruins. In our present repertoire of surviving Italian architecture, these openwork aesthetics are best compared to a site on the Forum just down Via Sacra and in close proximity to the Arch of Titus: the broken vault structure of the Temple of Antoninus and Faustina which, from the seventh century

onwards and through Giotto's time, contained the Church of San Lorenzo in Miranda inside the embrace of the Temple's architrave with its formerly polychrome relief frieze (Figs. 1.13–1.14). There, as in so many places across the early medieval Roman Empire, a church was built into the temple's ruins, leaving its skeleton architrave standing against the sky, much like the mock marble skeleton stands against the frescoed sky in the Scrovegni Chapel. A similar view also appears not far from Rome in the ancient Temple of Hercules in Cori (Fig. 1.15). As shown in Jakob Philipp Hackert's gouache drawing *The Temple of Hercules in Cori near Velletri* from 1783, the Cori Temple is another ancient ruin located on the pilgrims' Via Francigena that Giotto

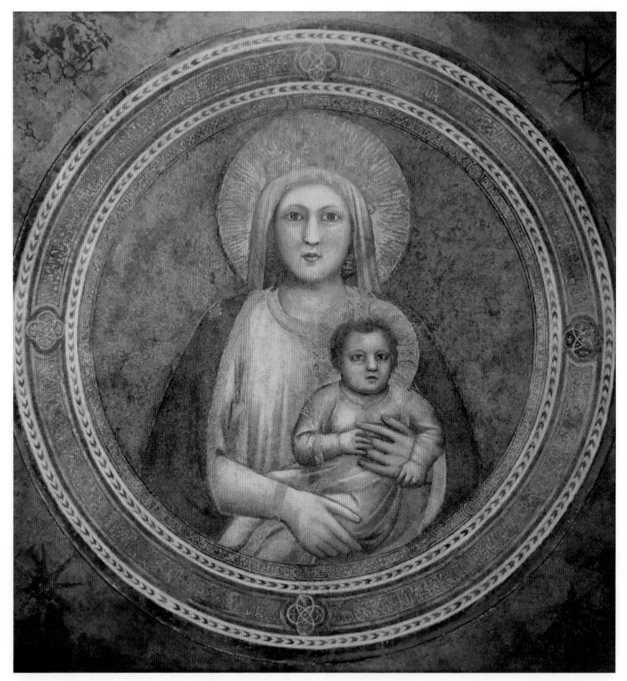

Fig. 1.8 Arena Chapel, the tondo with Mary and the Infant Jesus in the center of the western half of the barrel vault. Scala / Art Resource, NY.

potentially saw during his travels. Such places exhibit the same framing of the sky by means of the bare structure of a formerly closed building. Making a specific, spiritual point about the ruins of the past empires and religions, such exposed structures regularly signify a transition from ancient to Christian places of worship.

GIOTTO'S CLASSICISM IN THE VENETIAN-BYZANTINE CONTEXT

The structure of the chapel's faux marble interior under the faux open sky contains Giotto's famous cycle of images. Those individual paintings recruit pagan and Christian models

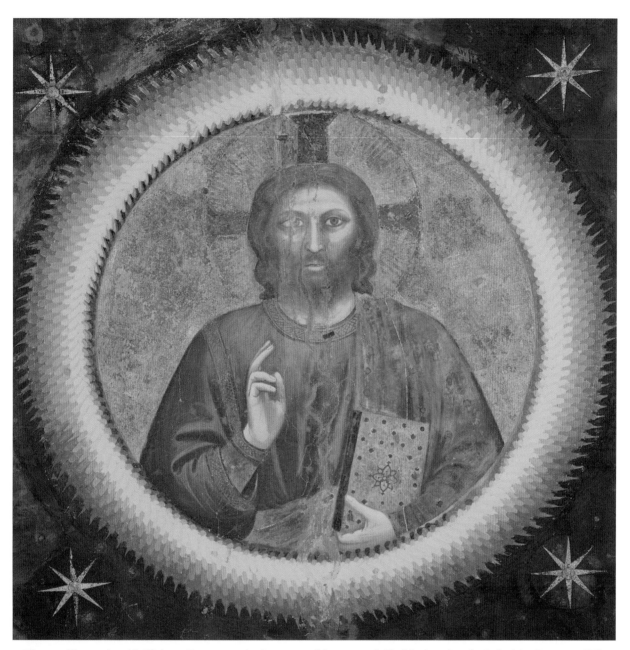

Fig. 1.9 The tondo with Christ as Pantocrator in the center of the eastern half of the barrel vault. Scala / Art Resource, NY.

and compress them into compact visual stories around a specific, actively represented moment. Correspondingly, Giotto's chapel decoration is a surprisingly early precursor to Leon Battista Alberti's fifteenth-century concept of the modern image that formally comes alive with the help of excellent ancient models. A strong tradition in Giotto scholarship has deployed the narrative scenes of the cycles as prototypes of the modern autonomous image[16] in the sense of the *storia* (or *Ereignisbild*, in the German art-historical tradition).[17] This was theorized by Alberti more than a century after Giotto. Giotto, in turn, is the only modern artist mentioned by the Florentine humanist – modern here in the sense of not being ancient, as Alberti's usual heroes Phidias or Praxiteles or Zeuxis. Alberti's ideal *storia* can be imagined as a perfect union of space, time,

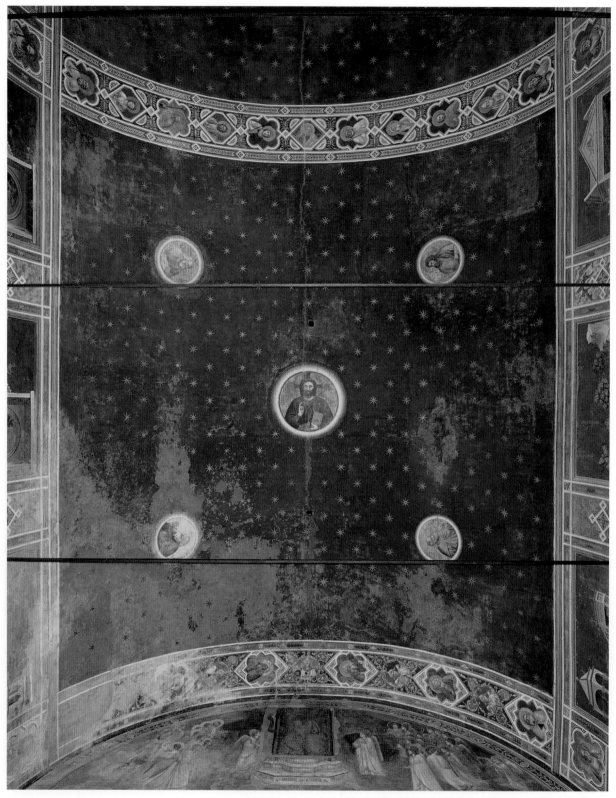

Fig. 1.10 The eastern half of the barrel vault with Christ as Pantocrator surrounded by four prophets. Scala / Art Resource, NY.

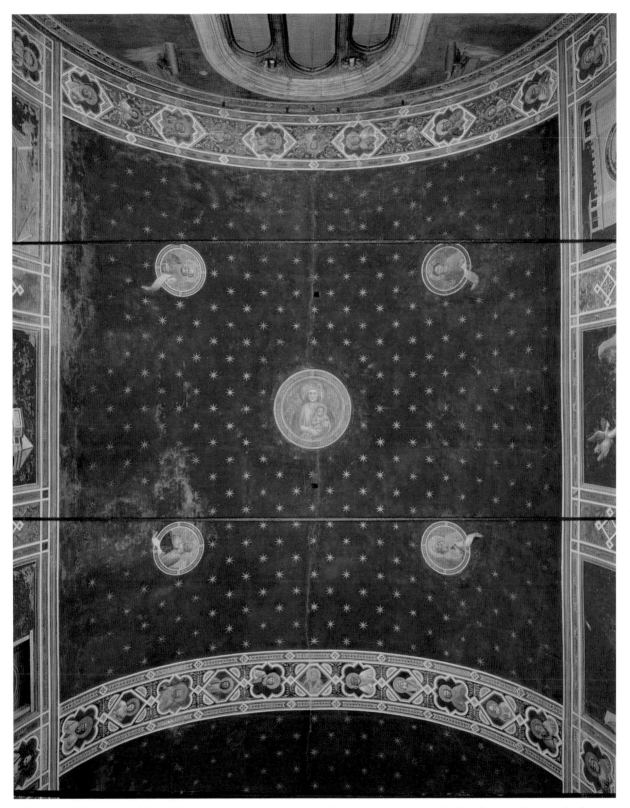

Fig. 1.11 The western half of the barrel vault with Mary and the Infant Jesus surrounded by four prophets. Scala / Art Resource, NY.

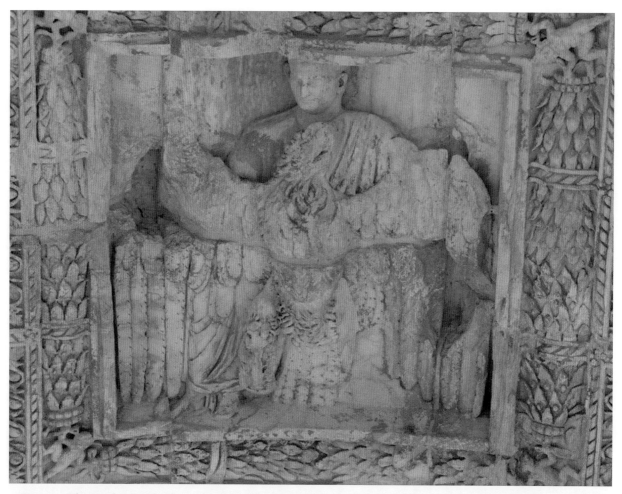

Fig. 1.12 The Apotheosis relief from the center of the bay in the Arch of Titus. Courtesy of the UC Berkeley Historical Slide Library (est. 1938–2018), Baxandall & Partridge Collection, Doe Memorial Library in Berkeley, California, USA.

and effective narrative in an artwork. It is Giotto's *Navicella*, the lost mosaic for the Atrium of Old Saint Peter's in Rome, that features in Alberti's *Della Pittura* (1420s) as the only modern example of an excellent *storia*, a work likewise admired by the protagonists of Giotto's second revival in the early twentieth century, such as Theodor Hetzer, for realizing the compact and efficient interweaving of plane and volumes.

With his work for the Scrovegni Chapel, Giotto put relief back into *storia*. The successful image, or rather painted relief, in the chapel is a phenomenon that unfolds between space and place. An essential aspect of the striking lifelikeness of the frescoes is the precise *where* and *when* of the figures shown, and the precise *how* of the

action represented, in a temporal sense of the narrative. Giottesque "unity" seems to be best described as the spontaneous, natural effects of a composition that produces the impression of a scene stopped in mid-motion, engaging space and time in harmonious and intentional ways. Several decades after Hetzer, Imdahl noted that Giotto's images organize the complex interrelations among the painted body in space, the image's scenic choreography, and the overall governing structure of the image.[18] Rintelen acknowledges the reciprocal dependence of figures and surroundings in the frescoes when he suggests that Giotto portrays not a stage, but a moment.[19] The commanding presence of the fields in real space has been described by Oertel

Fig. 1.13 The Church of San Lorenzo in Miranda inserted into the ruins of the second-century Temple of Antoninus and Faustina, Forum Romanum, Rome. CC BY-SA 4.0.

as both "modern" and "monumental."[20] Smart sees the images' density and tightness around a "single dramatic moment"[21] resulting from that inner balance of figures and place – their monumental inner architecture. Even apart from acknowledging the overwhelming dominance of ancient models as potential sources for this new art, Giotto's images, with their well-calibrated surface tension, remain impossible to translate into two dimensions except through this monumentalizing compressed mode of optical relief.

The basic ingredients are volume, surface tension, and gravity. In terms of relief structures, planes and volumes represent the two extremes of the medium. Each of these seems to manifest itself in Giotto's scenes by plunging into their most extreme materializations – appearing as protruding relief or as solid, hefty matter.[22] Gosebruch defines the word "plane" in Rintelen in order to explain his own ideas on surface tension in relation to the Vasarian *rilievo*.[23] Indeed, Gosebruch's approach is yet another attempt to capture, with words, Giotto's creation of entities with volume on a flat plane. Such an optical emergence of form is rendered possible only through more clarity of and more firmness among distinct relief zones by the energies of directed movement enclosed within those planes. This is how Giotto forms his figures, drawing desire or rage into their fingertips; their movement engages with their limited frame and pushes their limited possibility of extension to

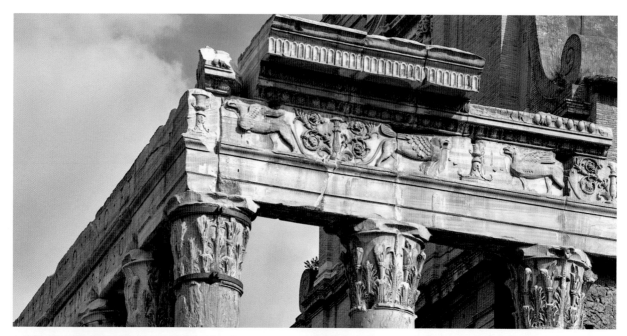

Fig. 1.14 The Relief Frieze of the Temple of Antoninus and Faustina. Courtesy of the UC Berkeley Historical Slide Library (est. 1938–2018), Hallett Collection, Doe Memorial Library in Berkeley, California, USA.

Fig. 1.15 Historical representation of the ruins of the Temple of Hercules in Cori by Jakob Philipp Hackert (*The Temple of Hercules in Cori near Velletri*, gouache drawing, 1783). CC BY-SA 4.0.

the maximum. Only complete coherence in building the intentions of bodies through movement can express this much inner life. It is to this end that Giotto needed the reciprocal permeation of relief planes and the compression of living, moving bodies, as Hetzer noted.[24]

The ambivalent engagement with painted relief in the scenes and the commitment to illusionistic relief in the larger structure reinforce each other across the walls and into the vault of the chapel. In order to build, in paint, an illusionistic system of pilasters, recessed panels, and simulated cosmatesque stone inlays, Giotto works with "suspension of disbelief," as Coleridge might say were the chapel a novel – an illusion the viewer enters as if entering an alternate cosmos.[25] The overall impression is not a simple *trompe-l'oeil* aiming at a more comprehensive deception. On the contrary, the themes of creating illusion and suspending illusion constitute a central point of this program. Giotto encourages viewers to believe their eyes, then discourages them; encourages them and discourages them again and again. This is unsettling – cruel, even – as it frustrates the recipients; the provocation can also be singularly productive, however, for viewers who assume a position of intellectual potency and self-reliance. In connection with an Augustinian argument, as we will explore later in this book, this could mean recognizing the sensual world for what it is – experiential matter bound in space and time but still fugacious in nature.

For specific moments that alter Salvation time – like the *Annunciation* and *Last Judgment* – the illusionistic system breaks open to reveal an invisible truth beyond its appearance. This can only happen in an altogether different representational context: The alternate syntagma created by the shift into high relief, figures extending themselves into space more freely than those in the scenes on the long walls. Such eschatologically timed illusionism does not rely on being complete but, instead, plays with creating a fiction that lifts

almost as soon as it is established. The flattening oxblood border around each field compromises the spatial-illusionary effect of the whole – some kind of apocalyptically charged self-destruction of painterly illusion so patiently achieved. The inherent struggle with the newly resurrected classical style is evident when one looks for what these frescoes owe to the *maniera greca* and Byzantium. Only by knowing and incorporating both Western Christianized Rome and Mediterranean Eastern Rome could Giotto question and destabilize the pagan model, breaking the vault in order to fill it with new meaning.

Giotto was working in a late medieval Italian environment saturated with inspiration and influences attained via objects and imagery not only from Rome but also from the Holy Land and Byzantium. While this study focuses primarily on the neglected Roman architectural grid and polychrome relief source that determine, in my view, the chapel's structure and at least one of its ideological-artistic purposes, all this can only be understood in the context of a multitude of Byzantine motifs, iconographies, and stylistic features. There are the angels in the *Lamentation*, four of them vested in robes adorned with delicate fishbone ornaments in hatched gold paint; two also feature golden lines that reinforce the shape of their wings. There is the structure of *Hell* that is not so different from the mosaics of Torcello's Cathedral; the *Baptism*'s *photismos* employing a specifically Byzantinizing light phenomenon; and the unclassical ornamental frames of the east vault and *Pantocrator*. Finally, Mary herself in the *Madonna and Child* medallion in the west vault appears like an icon on gold ground, not crossing the frame like the actively judging Christ, her counterpart in the mandorla on the west wall. In her frontal and liminal status, comparable to the embedded tabernacle tradition, the relief-framed Madonna of the chapel's west vault is firm and static, self-contained, Byzantine, and circumscribed by four finely ornamented circles, marble

and gold, fixed like a star as she fixates the viewer below with her unblinking gaze.[26]

Around 1400, Cennino Cennini would claim that Giotto transformed the traditional *maniera greca* to generate a new *maniera latina*.[27] For some strongly classical aspects of his art this is true. However, with nearby Venice and the Byzantine traditions governing Christian art and iconography during the Italian Duecento, Giotto's Paduan work appears in a wider, richer, and more complex ultra-marine context that would not simply abandon sublime Byzantine models to resurrect an ancient pagan predecessor. Nothing would have been further from the breaking of the mold of ancient triumphs that Giotto proposes with the chapel; he needed the Byzantine and Holy Land backdrop and aesthetics for his historically critical endeavor. Not only does Giotto's blue speak of faraway lapis lazuli quarrels. His saints and arrangements of scenes tell a distinctly Mediterranean story.[28]

The important artistic and cultural exchanges between the early modern Venetian-Paduan traditions and Byzantium are usually seen as epitomized by fifteenth-century scholars or by Graecophile painters such as Andrea Mantegna, but this particular Byzantine-Paduan proto-Renaissance starts with Giotto in a continuing series of medieval exchanges between Italy and Byzantium. What has been dramatized in later art history as a revolutionary break with the *maniera greca* could not have been produced without an awareness and integration of the glittering optics of Byzantine *poikilia*[29] and the constant reintroduction of elements from Venice, Byzantium, and the Holy Land – the historical place of the lives of Mary and Jesus. Through the Roman arch with the carved image of the stolen Menorah, the Torah Ark, and the Shewbread Table, the narrative leads from Padua to Rome and then on to Jerusalem. The point of the chapel seems to be an invocation, a summoning of all of these holy places.

A ROMAN CHAPEL IN PADUA

The chapel is clearly situated in its Venetian, Byzantine, and Mediterranean context, but Giotto is engaging specifically with the spiritual significance of Rome and Jerusalem. The chapel implicates all three cities on its walls, and the complex relationship between medieval Rome and ancient Jerusalem is part of Giotto's program. Before considering the figurative and actual presence of the Judaica in Rome and the implicit integration of Jerusalem into Rome (as evoked by the holy objects stolen by the Romans under Titus), it is important to see what elements of the chapel are decidedly ancient and pagan Roman in style. Shaped like two ancient Roman arches joined in succession, the Arena Chapel's core structure encompasses twice the general proportions of the bay of the Arch of Titus. Each half of the nave measures about 10.5 meters long and 8.5 meters wide, with a maximum height of 12.8 meters. These proportions resonate with those of the inner bay of the Arch of Titus in Rome, which is 8.30 meters high, 5.36 meters wide, and 4.75 meters deep.[30] In Padua and in Rome respectively, both built environments around the chapel and the arch have experienced significant alterations in the ground level with some impact on the exact measurements for the height of the interiors.[31] Another formal relation is established by the natural daylight illumination of the interior walls in both places. In the Arena Chapel, the fictive reliefs and narrative fields appear on the north and south walls. As the sunlight moves along the east-west axis, it continually animates and changes the appearance of the painted reliefs throughout the day. The light moves in the same manner through the interior of the Arch of Titus in Rome as the day progresses, with a similar animation of the reliefs, which are also positioned on the north and south walls of the arch. The chapel's general *romanitas* further extends from

the simulated system of marble framing to a variety of heavily Roman features seen in the socle zone's special technique of smoother murals imitative of unpainted stone; formal models of classical bas relief sculpture; and pictorial details of ancient-inspired figural types and their classical attributes. Poignantly, one formal and material exception in this system of Romanizing illusionism manifests itself on the chancel arch's *Annunciation* spandrels: The images of Mary and the Angel Gabriel each appear in projecting architectural casements on red ground and over four thick capitals seemingly supporting the chancel arch. Two of stone, two of stucco relief, these are the only actual – not painted – material architectural ornaments in the interior (see Figs. P.51 and Figs. I.11–I.12).[32]

Art historians have long described the volumetry of the figures on blue ground in specific terms of sculptural technique and materiality: "Each line therefore is created as formation *out of* the plane or into the plane, like the chisel's blow into marble";[33] "Like a "sleeping rock" in the landscape, so one with it rests Joachim huddled on the ground";[34] "Fire like marble."[35] These three quotes by critics as diverse as Hetzer, Ueberwasser, and Luisi all respond to the striking physicality of marble in order to define central features of Giotto's Arena Chapel style. Sprouting from the roots of classical ruins, in the Scrovegni Chapel more so than anywhere else, the relief-like history painting (*Historienbild*) developed by Giotto for the narrative scenes emerges as at once old and new: It has an ancient model and plastic volumetry from which it derives new Christian aesthetics.

The general *romanitas* of the chapel is immediately apparent in the simulated system of marble substructures that frame the entire room, enhancing the form of the Roman arch and barrel vault. Roman features also define the socle zone's appearance in technique, form, and pictorial

detail: The faux marble in the socle (or dado) zone is not made of only one kind of stone imitated in paint; it depicts polychrome marble imitated in fresco to form the background for a different kind of simulated stone – a classicizing relief sculpture. While standard fresco technique sets the pigments into layers of wet plaster, these fictive marble slabs display a notably smooth surface quality, evoking the hardness of polished marble.[36] These parts of the wall constitute a stunning simulation of actual stone on a plaster layer over a stone wall. They display such a wide range of specific colors, patterns, and veining, that one can produce a *lapidarium* of Giotto's painted marble that accurately documents individual kinds of stone, such as *serpentino verde* (green serpentine) and porphyry.[37] Romano identifies this anti-grisaille as the precise portraiture of a material: "A colour with beige-ivory shades, not grey ones, a warm tone in which the relief effects have been most carefully elaborated, with deeper brown-ochre shades and touches of white. It is the colour of marble."[38] Romano also brilliantly reconsiders these stone portraits' status as being more than *bassorilievo* and a little less than a true statue in the round.[39]

In addition to this Romanizing technique, many details in the murals' figures recall ancient Roman types and models. A total of fourteen reliefs: Seven *Virtues* oppose seven *Vices*. All detach themselves from the background stone in flat niches at floor level with a polychrome marble background and monochrome marble low reliefs of their respective personifications. The figure of *Spes* (Hope), lifting herself up towards a Heavenly Crown, owes her lightness to thinly veiled models of ancient Roman Nike, victoriously ascending. Other classical elements appear in the herculean figure of *Fortitudo* (Fortitude), who appears with a lion skin over her head and shoulders, the cross on her armor,

and her *scutum Romanum* (Roman shield) riddled with the points of spears and arrows like battle scars, trophies from the assaults of the past. In contrast, *Inconstantia* (Inconstancy) on the opposite wall glides off a disc from a steep plane of fiery yellow and red marble like an ancient image of a mercurial *Fortuna* (Fortune). The classical figure of stoically towering *Temperantia* (Temperance) keeps her sword secured, indicating self-command and composure. Most important for my argument concerning Giotto's awareness of the iconographic import of historical styles, the opposed figures of *Iusticia* (Justice) and *Iniusticia* (Injustice) in the center of the chapel evince an architectural opposition between Gothic and Romanesque arched thrones, each featuring scenes of the consequences of good and bad government in yet two other kinds and styles of faux relief, as we will see in detail in Chapter 4. There is a remarkable finesse of formal and iconographical awareness in this room.

But it is not only *Justice* and *Injustice* and the respective reliefs under their thrones that are distinguished by different styles. The entire simulated architectural system characterizes itself by two contrasting designs for different eons, confirming that this chapel presents a unique view of history as the history of Salvation. The painted framework opposes old and new ornaments; simulated ancient reliefs with garlands for the top register versus simulated Cosmati work for the two registers below.[40] The green ornaments around the ancient-style register are painted with tiny flowers growing out of each with a precision not unlike that of flowers painted in lively, naturalistic manuscript margins or later by Gentile da Fabriano – another indication that Giotto's work tends to predate conventional art-historical chronologies.[41] Optically close to Second-Style Roman wall decoration, the frames of the uppermost registers alternate warm curry and saffron colors with rich and dark turquoise while the

lower Cosmati frames set themselves apart in cooler, silvery tones.[42] The decoration *alla cosmatesca* is, of course, a telltale Christian Roman technique famously covering altars, columns, and floors such as those of San Clemente, the Lateran's Sancta Sanctorum, Santa Maria in Cosmedin, the Santi Quattro Coronati complex, and other places of early Christian and papal significance in Rome. These examples would have been familiar to those who made the pilgrimage to Rome, but there are enough other Byzantine Christian places in the Veneto, Venice, and Torcello with similar versions of this application of broken ancient marble fragments that habitually make the same point. Repurposing fragments of ancient marble, Cosmati work in Rome and beyond can be itself interpreted as a spolia technique (Fig. 1.16). The entire system governing the long walls in Giotto's chapel is structured to distinguish the style and color of the ornamental frames between the story of the lives of Mary and Jesus, with the former evincing ancient Rome and the latter a new, Christian Rome. The illustrated shift in framing subtly visualizes the difference between the times *sub lege* and *sub gratia*, under the law of Moses and under the period of Grace initiated by the Incarnation of Christ in Mary.

The shift towards a Christian-Roman stylistic key, visible on the level of the framing details, is also detectable on the all-governing level of the chapel's architectural structure. In contrast to the Gothic pointed arches that define Giotto's other, earlier fresco cycle for San Francesco in Assisi, the Arena Chapel is defined by round-headed Roman arches, such as in the chancel arch and the barrel-vaulted ceiling (Fig. 1.17). This is relevant since not only Giotto's authorship as a painter is at stake in Padua but also his potential presence as an architect.[43] While San Francesco Superiore in Assisi presented itself to the young Giotto as a cathedral with walls to be structured with frescoes only after the fact of its construction, the Paduan

Fig. 1.16 A detail from the *cosmati* floor at the Santi Quattro Coronati, Rome (2018). Photo by the author.

site's condition and chronology suggest that Giotto was intimately involved in the architectural design of the entire structure.

The unique interior at the Paduan arena was famously commissioned by Enrico Scrovegni. His family chapel contains in its architectural form and pictorial decoration an unparalleled surplus in historical-theological information and artistic self-reflection through the medium of fictive ancient Roman marble. Ordering a most sophisticated project that would illustrate a theological concept of history visualized in ancient Roman and early Christian Roman spatial and pictorial terms, Scrovegni entrusted those whom he employed to realize this vision in the form and decoration of the chapel. As mentioned above, based upon

social and art-historical evidence, the most likely scenario is that we are looking at the collaborative effort of an architect (most likely Giotto himself), Giotto (as inventor, designer, and painter), his workshop, and most likely a theological advisor or advisory committee, all working for the financing donor Enrico Scrovegni. All the agents involved in the creation of the chapel have left some traces behind, but only one became the face of the chapel, and indeed one of the most recognizable and famous faces in Western art history, and that was the donor himself. The *Last Judgment* includes Enrico Scrovegni's portrait next to an Augustinian canon shouldering the chapel's model. This canon appears in such a central position (between Scrovegni and

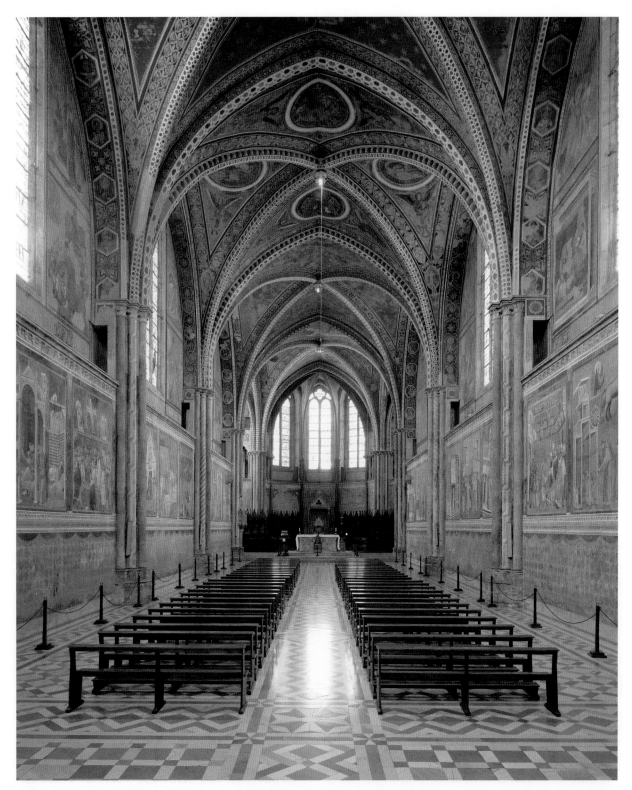

Fig. 1.17 Assisi, San Francesco Superiore, interior. Erich Lessing / Art Resource, NY.

the Virgin Mary) and in such a precise mode of depiction that he must have been in some way fundamentally important for the chapel's generation. The dedication portrait of Scrovegni with Saints (probably John, Mary, and Catherine) is one of three likenesses of the donor in the chapel: The famous fresco; a polychrome standing statue in the act of perpetual prayer; and a *gisant* effigy – in addition to Scrovegni's own physical remains, a fourth instance of his presence in the space.

In this context, Scrovegni's visual appearance does not provide much evidence for the nineteenth-century legend that this commission was a penitent act of Enrico motivated solely by feelings of guilt and dread relating to his moneylender father, Reginaldo Scrovegni.[44] However, his father's death in 1288/9 or 1300 might nevertheless have been one factor in Enrico Scrovegni's plans for memorializing the family, as Derbes and Sandona have suggested in their discussion of Scrovegni's personal motivations.[45] My argument does not negate the role of personal motivations in the project; indeed it seems entirely feasible that young Scrovegni's motivation might have elegantly merged the personal and the political. Recent scholarship indicates that the project was an attempt to foster connections with Roman noble families and the *curia* by establishing a personalized all-in-one site of pilgrimage, family monument, and chapel.[46] In his suspiciously short family tree, Enrico Scrovegni was himself only the second generation of a new but extremely wealthy dynasty of moneylenders. Lacking nobility and elite connections – possibly as well as being interested to deflect the suspicion of the sin of usury – he might have tried to elevate his societal and religious status by joining the lay brotherhood of the local Cavalieri Gaudenti (Order of the Blessed Virgin Mary, whose members follow a rule based on that of the Augustinians) and by associating himself through marriage with the Este family and

the Roman *curia*.[47] Prestigious local commissions might have helped the young Scrovegni to make up in status what he lacked in pedigree. If present, the legendary earlier chapel from the eleventh century that Scrovegni might have bought along with the arena would have offered a perfect opportunity for him to insert his own architectural project into already established local traditions of worship while also associating himself with a more noble Roman pedigree.

In any case, the mute portraits are fortunately still supported by one extensive written statement, dated March 1303. The original inscripti, quoted in full above in the introduction, may have been on the façade or inside the chapel and is lost in situ, but was diligently copied in the sixteenth century by the local antiquarian Bernardino Scardeone, who published it in his *De antiquitate urbis Patavii, et claris civibus Patavinis libri tres, in quindecim classes distincti: Ejusdem appendix de sepulchris insignibus exterorum Patavii jacentium*. After the text had vanished from the chapel, it also disappeared from Scardeone's subsequent record of local inscriptions, but remains available in the Latin editions of 1559 and 1560, associated with Scrovegni Father "Reginaldus" and Son "Henricus," rhymed, and beginning with "Hic locus, antiquo de nomine dictus Arena, / Nobilis ara Deo fit multo numine plena." The entire text plays on themes of antiquity ("This ancient place"; "home of abominable heathen"; "this temple"), historical change ("becomes"; "converts"; "[re]built"; "destroyed and sold over many years"; "their wealth now lost, [they] remain nameless and mute" versus "replaces" and "substitutes"), and moral values ("Divine virtue"; "heavenly joys, which are superior to earthly vanities"; Scrovegni "[saving] his honest soul"). The explicitly transitional vocabulary reinforces the clusters of ancient motifs in

relation to the present as well as the insistence on Scrovegni's positive transformation of a historical site for spiritual benefit and local prestige. We shall return to Scrovegni and his personal investments in Chapter 3.

The historical context for such acute awareness of one Paduan moneylender's own, personal place in Christian history and Salvation is that of a triumphant Roman church celebrating herself in relation to her ancient past in Rome on Easter 1300, with the First Roman Jubilee. The fact that Scrovegni bought the entire arena early that very year (6 February 1300), two weeks away from the day of the official announcement of Boniface's bull *Antiquorum habet fida relatio* (22 February 1300), suggests that he may have seized the moment as an opportunity to connect himself to the prestigious event. Since Giotto was in Rome at the time and already working for Boniface VIII since around 1296/7, the papal court painter was himself in the center of the

Roman aristocratic circles. Those were the circles that Scrovegni had slowly approached through marital alliances. In keeping with the evidence, other scholars have already identified the Jubilee's formative importance for Giotto and generative impact for Scrovegni's project.[48] Following this line of argument, it is my contention that the spiritual momentum of the Jubilee and its transformational visions of antiquity through its processional reformation of Roman topography enabled the minds of those involved in this project to visualize a similar shift in an explicitly triumphant manner and to conceptualize a honorific arch-chapel. Most of the characters, including Giotto himself, are documented as having participated in the event or were at the very least aware of its celebration. Whoever was able to travel to Rome in the spring of 1300 would have made the effort to be there among the hundreds of thousands of pilgrims in the eternal city to visit its stational churches and to celebrate the triumph of humility.

Chapter 2

1300: THE MOMENT OF THE JUBILEE IN ROME AND IN PADUA

Roma onde Cristo è romano

Rome where Christ is a Roman

<div align="right">DANTE, <i>PURGATORIO</i> XXXII, 102</div>

GIOTTO IN ROME

IMMEDIATELY BEFORE WORKING for Enrico Scrovegni in Padua, Giotto served Boniface VIII as painter to the papal court in Rome and was in Rome for the Jubilee in 1300 before moving to the Veneto.[1] Without any extensive written documents on the chapel's gestation or preparatory drawings, modern scholarship mostly takes the precise correspondence between illusionistic frescoes and architecture in the chapel as testimony of Giotto's direct involvement with its design, planning, and construction.

Giotto's confirmed presence as papal painter from circa 1295/7 to 1300 is one of few documented facts about Giotto's Roman period, preparing for the celebration of the first Jubilee. The end of Giotto's long stay in Rome is therefore exactly contemporaneous with Scrovegni's acquisition of the Paduan arena and subsequent planning of the Arena Chapel and Palazzo Scrovegni. The cultural impact of the Jubilee and its engagement with the Roman urban landscape and monuments was considerable. This is the moment Dante later records in the *Divine Comedy* – his own vivid recollection of the pilgrims' well-organized traffic on Ponte

Sant'Angelo (the ancient Aelian Bridge, Pons Aelius) giving testimony to the greatness of the event in terms of universal, massive participation and astute urban-logistical planning.[2] While Enrico Scrovegni's presence is not confirmed by known surviving documents, it seems probable that he would have joined his social circles in Rome for such a unique occasion instead of remaining in Padua, where most of his business was already in connecting with the elites of larger Italian cities. Considering Scrovegni's excellent connections to the *curia*, it is most likely that he knew about the great event early on. And whoever the canon holding the chapel next to Scrovegni in the *Last Judgment* donation vignette is meant to represent (whether Alberto da Padova,[3] Altegrado de' Cattanei,[4] or Tommaso degli Aguselli),[5] all of these eminent spiritual leaders would have been informed about an event as significant as this first installation of a Roman Jubilee.

As Serena Romano has recognized, Roman imperial reliefs from urban monuments in the city of Rome are highly relevant to Giotto's pictorial design, figures, and chiaroscuro in the Arena Chapel. She also notes that the medieval *Mirabilia* and a description of Rome by Magister Gregorius record eleven triumphal arches still standing in Rome around 1300.[6] Most compelling is her identification of the core of Rome – the region of the Fori between the Capitol and the Colosseum – as the specific locus of Giotto's inspiration. Romano mentions the Arco di Portogallo, the Arcus Novus, the Arcus Pietatis, and the Arch of Titus, the Arch of Septimius Severus, and the Arch of Constantine, the latter with its assemblage of spolia reliefs: Trajanic, Hadrianic, Aurelian.[7] With all these monuments available nearby during his tenure at the papal court, Giotto could have studied imperial polychrome relief sculpture showing histories carved into walls at about the same height as his Paduan frescoes, over a dado zone or socle, and in

varying relief depths of low, middle, and high. From these experiences, I argue, he was able to develop a new form of immaterial image on the basis of a very ancient, material one.

Furthermore, Giotto's connection to Pope Boniface, a member of the Caetani family, strengthens his historical links to the San Silvestro Chapel in the Santi Quattro Coronati architectural complex in the quarter of San Giovanni, between Lateran and Forum Romanum – another arched interior, also of Augustinian relevance. This institution, maintained until today under the care of a female Augustinian order, belonged then to the Caetani. With the San Silvestro Chapel in its center, the Santi Quattro Coronati complex features another chapel that is also structured like a broken arch interior filled with Christian meaning (see Fig. 1.6). In this case, the barrel vault was reclaimed for a papal program, another difficult negotiation between worldly and heavenly powers as required throughout Scrovegni's project.

In addition, through his travels to and from Naples, Giotto would most probably have been familiar with the Arch of Trajan in Benevento and other ancient Roman monuments along the road.[8] From the Benevento arch he might have taken inspiration for creating tiers with several superimposing scenes.[9] However, in order to see, in 1300, ancient models that provide the best match overall for his Paduan fresco reliefs, including the iconography of apotheosis as reward for deeds of a life on earth, Giotto would not even have to leave Rome's *mura*. In the end, he had to go no farther than the very center of Rome, to a space no larger than five square metres that nevertheless contained all the essential imagery he would need to fabricate his complex Arena Chapel program and stylistic registers: the interior of the Arch of Titus on the Via Sacra, a key monument and destination for the papal procession of the First Jubilee.

GIOTTO AS AN EYEWITNESS
OF HISTORY

Etymologically, the word Jubilee appears to stem, via Latin, from the Hebrew "Yobel" – another word for the Shofar, the ram's horn blown for the announcement of the Jewish Holy Year. Parallel to this suggestive terminology, the historical Judaic roots of Christianity itself were particularly relevant for artistic commissions and celebrations around 1300. During the Roman Jubilee, a heightened sense of history was expressly cultivated via meaningful dramatizations of the ancient city through Christian processions. Two key elements of the nocturnal papal procession from the Lateran to the Forum Romanum were the dramatically illuminated triumphal arches from the reigns of Constantine and Titus next to the Roman Arena – the Colosseum. Herbert Kessler and Johanna Zacharias, in their study of the 1300 Jubilee and its performative spaces in Rome, note how the perception of the Arch of Constantine and the Arch of Titus is intensified under the flickering light of large processional candles approaching from the side of the Colosseum. In their reconstruction, the line of pilgrims moved up the Via Labicana from San Clemente. As the Ludus Magnus might have blocked the Via Labicana route, Cesare d'Onofrio describes an alternative route as passing the complex of the Santi Quattro Coronati and the Shrine of Papessa Giovanna across the street from San Clemente.[10] Coming around the Colosseum either from the left or the right, as the pilgrims "round the great, abandoned amphitheater, the light of thousands of candles brings into view the massive Arch of Constantine [...]. The arch commemorates the triumph of Christianity over the pagan empire."[11]

The crowd of clergy and pilgrims was not going alone along those stations of the Cross. Ahead of all of them, the icon of Christ Pantocrator known as the *Acheropita* was carried in candlelit procession from the Sancta Sanctorum in the Lateran to the Forum, to meet the icon of Madonna and Child in front of Santa Maria Nova, just after passing through the Arch of Titus (Fig. 2.1). Kessler and Zacharias imagine the procession's slow ascent to the Arch:

> The pilgrim can see that something not far ahead has slowed the progress of the procession. Word travels back that the bottleneck is the procession's mandatory movement through a much older and much smaller arch that commemorates the deeds of the Emperor Titus [...]. Passage through the narrow opening of the Arch of Titus [...] marks a fundamental point in tonight's procession; first, the *Acheropita* must be paraded through the arch, and then every participant in the procession follows.[12]

The Arch of Titus bears its three large figurative reliefs in a triangulation that is both sequential and causal: The chariot relief showing Titus riding in his chariot on one side wall and the Menorah relief showing Roman soldiers carrying holy objects from the Temple of Solomon into the city as spoils on the other side are completed by the third image in the apex of the barrel vault, where a garlanded rectangular panel frames the relief of the emperor carried upwards on an eagle (Figs. 2.2–2.3 and see Fig. 1.12). Kessler and Zacharias argue that the "relief of the emperor's victorious entry into the Forum offered an ancient parallel for the Pope's triumphal procession."[13]

If, as I am proposing, the genesis of the Arena Chapel in Padua is connected to the experience of standing under an ancient triumphal arch, looking up and around at polychrome relief – "[high] reliefs hewn into the walls"[14] – it is this moment, when pilgrims process under the Arch, that joins the spatial-visual experiences of viewers in the Roman bay of Titus in 1300 and

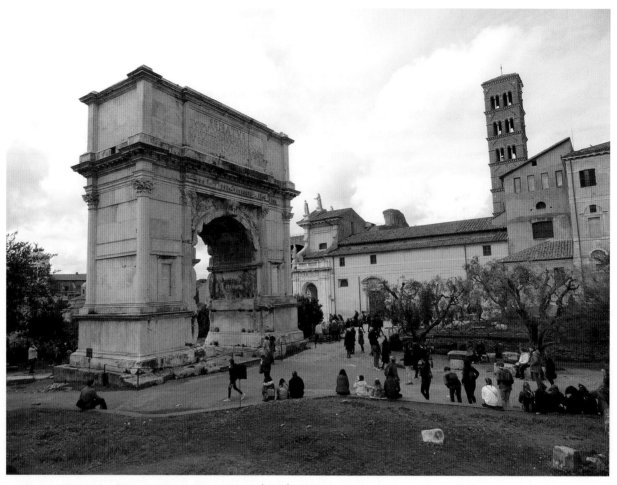

Fig. 2.1 The Arch of Titus with Santa Maria Nova (2018). Photo by the author.

in the Paduan double bay of Mary and Jesus. Pilgrims would have been standing and slowly moving through the ritualistically appropriated Arch of Titus; visitors also slowly move into and through the Scrovegni Chapel, a sacred space that has been transformed by Giotto's frescoes into the equivalent of a fictive doubled, broken, and dematerialized Christian triumphal arch. This dematerialization occurs twice: once in the channeling of polychrome relief via the flat, purely optical medium of paint; and then also via the idea of the ruin as structurally embodied in the chapel's complete interior with its seemingly broken vault, the stylized starry sky shining around the lone central transverse arch.

The martial iconography of the Roman Arch's reliefs furnish an ideal occasion for the theological mandate that a Christian "triumph" distinguish itself from ancient Roman traditions – as a concept and in its material representation, especially in contrast to the Roman military triumph that was inextricably linked to violence, enslavement, and death, as Augustine noted in Book 5 of *The City of God*. In particular, the second history relief within the Arch of Titus displays a merciless image of Jewish trauma. It shows the fall of Jerusalem from the Roman imperial perspective of the Flavians, the destruction of the Temple of Jerusalem, and the stealing of the Menorah. Kessler and Zacharias emphasize the historical importance of these relics from

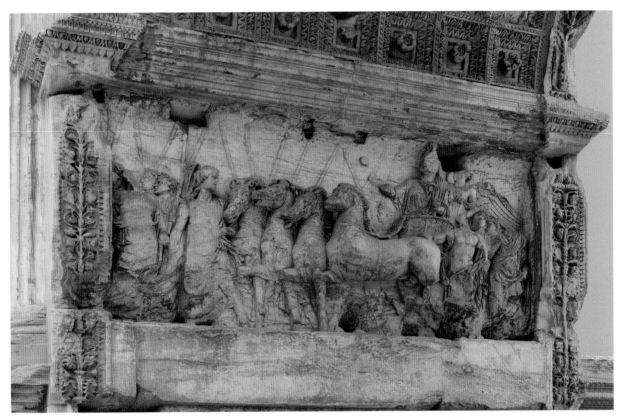

Fig. 2.2 The chariot relief on the interior wall in the bay of the Arch of Titus. Courtesy of the UC Berkeley Historical Slide Library (est. 1938–2018), Baxandall & Partridge Collection, Doe Memorial Library in Berkeley, California, USA.

Solomon's Temple in relation to the Flavian arch in the collective imagination of Christian Rome, circa 1300:

> [Most of the Judaica and trophies are] kept at the Lateran beneath the altar in the basilica of St. John. Legend has it that the *Acheropita* was originally among these spoils; moreover, when brought to Rome, the icon is said to have cured Vespasian, Titus's father, of a grave illness. The procession [...] thus recapitulates the original event but inverts its meaning: God's Chosen People are now the victors. And they bear a different palladium.[15]

Adding some more detail to the verbal reenactment by Kessler and Zacharias of the dramatic illumination of the arches with processional candlelight and the new palladium of peace, I propose that another, often overlooked factor would have inflected Giotto's impression of the arch reliefs in 1300, either directly by surface residue or indirectly by the experiental knowledge in a late-medieval world of painted sculpture: the fading remnants of polychromy on the Titus reliefs. About twelve centuries distant from the application of their original pigments and gilding, still untouched by modern pollution, more likely than not the bay reliefs would have still shown some traces of colors at Giotto's time. In recent archaeology and technical studies of ancient sculpture, a necessary shift in perception from the classicistic myth of white antiquity to a new interest in polychromy has thrown new, colorful light on many objects familiar to us as pure, pristine, almost uniformly white marble reliefs – such as the newly presented reconstruction of colors on the Menorah relief produced by Steven Fine and his team (Fig. 2.4). With the Yeshiva University's Arch of Titus project, Fine has recovered traces of original pigments. His

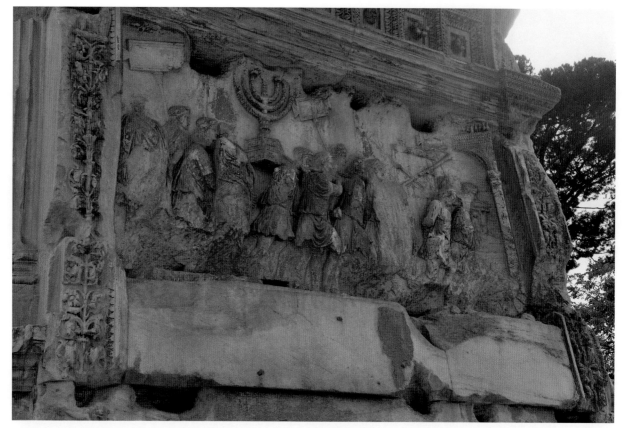

Fig. 2.3 The Menorah relief on the interior wall in the bay of the Arch of Titus. Courtesy of the UC Berkeley Historical Slide Library (est. 1938–2018), Baxandall & Partridge Collection, Doe Memorial Library in Berkeley, California, USA.

scholarly and visual reconstructions of the Menorah relief open up a discussion about the original condition as well as the state of potential discoloration in the Duecento.[16] Among a variety of digital versions that account for the wide spectrum of options, Donald Sanders has produced one hypothetical rendition of the recolored Titus relief with Giotto blue as a visual aid (Fig. 2.5).[17] There is a larger trend in archaeology and museum studies to reconstruct polychromy on ancient sculpture, in turn contributing to a heightened sensitivity for questions of color in the middle ages and in Giotto's works, such as the reconstructed colors in Assisi.[18] In regard to the remnants of ancient polychromy in the middle ages I do not claim that the reconstruction of the blue is what Giotto would have seen; he probably would have rather seen largely damaged areas and fading colors.

Digital reconstructive archaeology of ancient polychromy operates with parameters of greatest likelihood according to additional archaeological research and is always based on an approximation of original colors or most plausible ranges of hues; I include the visual aid reconstruction for illustrative purposes only and to bring attention to the range of potential blues, including bright blue, Giotto blue, and all shades in between. There is no proof for these kinds of reconstructions except in terms of probabilities for the representation of certain timeless natural staples in the Roman environment such as sky, grass, the trodden stones of Via Appia. But the confirmed presence of blue is not essential for establishing the multiple connections between the ancient Roman arch and the chapel in the call-and-response relationship that I see at work between the Roman and the Paduan monument in their

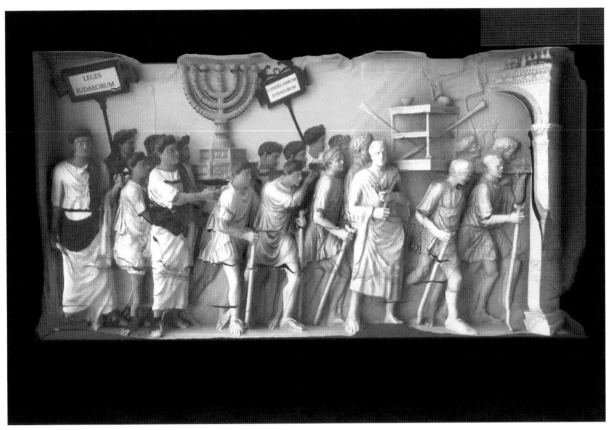

Fig. 2.4 Replica of the Menorah relief with a projection of changing reconstructions of polychromy in 2017 in the Yeshiva University Museum, New York City (2017). Photo by the author.

social, religious, and liturgical functions around 1300. For my argument, it is sufficient that Giotto was aware, that he had a concept of polychrome sculpture, which is the case, and clearly expressed in the Arena Chapel itself as we will further explore in great detail below when we will have a closer look at the seemingly random color patches applied by Giotto on his *Virtues* and *Vices*. Not only was Giotto himself living in a world of polychrome sculpture, there he ingeniously painted rests of fading polychromy on the figures with the closest proximity to the spectator (e.g., the blonde length of hair hanging down from *Ire*'s head, the faded red patches on *Folly*'s robust leg, the fading red on the palm of *Hope*'s hand). The myth of white antiquity is our problem; Giotto would have seen residues of ancient color on this and many other reliefs. Educated in

the multidisciplinary workshops of his time, he was familiar with the processes of coloring statues and reliefs, frames, and capitals.

It is a challenge to reimagine this layered shadow of polychrome awareness when looking at the Titus reliefs in the 2020s. Never before have they been so drastically damaged, so far away from both their original state and the in-between state that Giotto saw them in. Disfigured and weathered by acts of iconoclasm and centuries-long deterioration, the relief panels in the Arch of Titus make it hard to envision their former states and appearances, especially since the industrial age has brought on massive amounts of smog and acid rain, dramatically accelerating the substantial loss over the past two centuries. To approximate Giotto's original vision of the monument and its imagery,

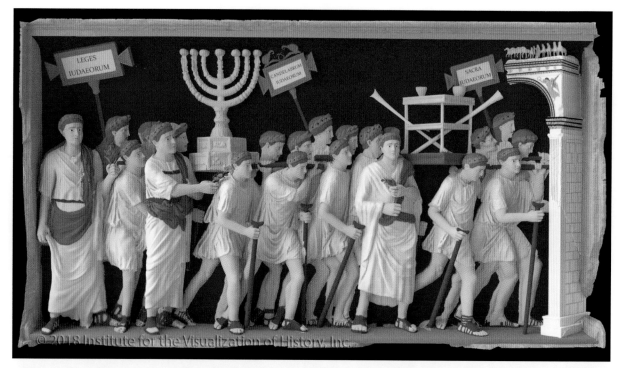

Fig. 2.5 Hypothetical reconstruction of polychromy with Giotto blue background of the Menorah relief by Donald H. Sanders (President of the Institute for the Visualization of History, Williamstown, MA). The Institute for the Visualization of History, copyright 2018.

however, one must try to reimagine potential states of the reliefs around 1300. The interior bay of the arch offers protected conditions for the reliefs' colors. In this particular case of imagery from the Holy City of Jerusalem in Rome, between Jewish, pagan, and Christian Empires, not rain, but iconoclasm seems to have done the most extreme damage to these reliefs, especially the loss of the emperor's head and face.[19]

The poor state of the Arch's reliefs today can, however, not entirely obfuscate that the sculptures still masterfully interlace low, middle, and high relief (*basso*, *medio*, and *alto rilievo*) in a manner similar to the condensed spatial effects in Giotto's scenes from the lives of Mary and Jesus. In both places, relief provides the figures with sufficient depth for that secure stance of the human body that is often described as typical for each style – the so-called Flavian Baroque and Giotto's Latin manner.[20] Moreover, the images appear in both interiors at the same level in

relation to the spectator. The framing uninterrupted ornamental bands reach similarly over several registers in arch and chapel.

The physical presence of the viewer under the arch and in the chapel can fully verify this affinity, especially with respect to the chapel's highest registers, where the concave blue background planes most clearly reveal the murals' indebtedness to the material quality of arch bay reliefs. The distinctive curving of those upper fields in Giotto's chapel, hitherto unexplained in scholarship, were most likely inspired by the curve of the arched Roman relief fields, their concave edges so typical for, and indicative of, interior reliefs in triumphal arches. The affinities of the painted scenes with polychrome reliefs are particularly apparent when actual sunlight falls in the same direction as the light painted by Giotto in the narrative fields. Corresponding to the natural light of the interior – just as the reliefs in Rome engage with the variations of natural light in the

Arch of Titus throughout the day. Giotto's attention to a uniform, natural light source emphasizes the connection between fictive and natural space – an intrinsic characteristic of sculpture, which always depends on a consistent exterior light source.

It remains for us to consider the triumphal arch's function in antiquity – and how it was transported and transformed across the Middle Ages, prefigured in Constantine's appropriations of forms, in adaptations of pagan rituals after his victory, and as a core theme in the turn of the Roman Empire to Christianity. Not all ancient arches, of course, were equally involved in religious discourse. Ferdinand Noack's study "Triumph und Triumphbogen"[21] from the Bibliothek Warburg lectures underscores the unique religious charge of the Titus reliefs that were not made to commemorate a mere mortal as in other triumphal arches but to laud someone who was expected to ascend as a god.[22] The highest and clearest expression of this deification process is the relief showing Titus carried heavenwards by an eagle in the barrel vault's center. Henner von Hesberg remarks upon the demonstrative effectiveness of this aesthetically questionable deification relief, while its forced compression and small scale do not give any visual sense of a joyful or at least dignified ascent.[23] It seems plausible that Giotto, the theological advisors of the program, and probably most pilgrims too, would have immediately understood the visual statement: This was a man being elevated to a divine position. Such an image – such an idea – was, from a Christian perspective, inappropriate to the point of blasphemy. Furthermore, literate pilgrims would not only have seen but also read this bold assumption of power. The inscription underscores the divinization of Titus as much as that of his father: "SENATUS POPULUSQUE ROMANUS DIVO TITO DIVI VESPASIANI F[ILIO] VESPASIANO AUGUSTO" (The

Roman Senate and People to the Deified Titus Vespasian Augustus, son of the Deified Vespasian). As the arch was built into the fortress at its sides, its archway open for passage, there is no reason to suspect that the inscription would not have been visible circa 1300. Barbara Eberhardt points out that this arch's main function was to demonstrate the apotheosis of Titus in word and image.[24] Even the physical positioning of the viewer looking up when walking under the arch plays out this association. One finds oneself in the role an active participant in Padua, where the viewer needs to wander with eyes and mind to get the message – a required visual-mental-corporeal mobility that Alpatoff and Ladis have shown to be the basic requirements for perception in the Arena Chapel.

The staging of a mortal's apotheosis in the Arch of Titus still seems to have fulfilled its function in Giotto's times, appearing obscenely supercilious and offensive not only to the Roman Jews and to the entire Diaspora, but also to Christians and to their belief in a humble God incarnated, executed, and resurrected in Jesus Christ. Before and after Giotto, some have reacted to the arch with unhinged anger and physical aggression to which traces of iconoclasm testify – and impair our vision of the reliefs today.[25] But Giotto and the chapel's theological advisors seem to have recognized the aesthetic and rhetorical effectiveness of triumph. Instead of demolishing or ignoring this false celebration, they decided to use it to their advantage in a brilliant act of appropriation and reversal that effectively exorcizes any lingering powers of the ancient ghosts of the past and puts them to good use. After all, the commission for Scrovegni was not so different from what the arch was for the ancient imperial family in terms of dynasty and ultimate status: Eberhardt shows that, in the Roman reliefs, the theological implications indicate that the Flavian family's fortune came with divine approval.[26] Likewise multigenerational in

concept and dedication, the Arena Chapel also served an increasingly powerful family's interest in presenting itself to the public as having a special association with the divine. And finally, there is the possibility that the Arch of Titus served as a burial for Titus, matching Scrovegni's intention to be laid to rest in his chapel.[27]

A THEOLOGY OF THE IMMATERIAL AMIDST THE RUINS OF ROME

The relationship between the Arena Chapel and the Arch of Titus surpasses simplistic modes of material imitation. Considering the monuments' structural, visual, and conceptual links, this is not a matter of original and forgery, model and copy, or the mechanical doubling of a system. The chapel and its program rather constitute a highly reflected structural response filtered through the complex interplay of material and optic shifts, reflections on the actual decay of the model with time passing, and quoted bits and pieces rethought, reformulated, and rearranged in surprising ways. With these links in mind, it is worthwhile returning to the iconographical charge of Giotto's Arena project in relation to Rome, particularly to the question of the specific significance of the Arch of Titus in the Jubilee procession. The argument presented by Kessler and Zacharias focuses on the importance of the spoils from the Temple in Jerusalem as these were thought to be scattered across Roman Christian sites such as San Giovanni in Laterano and Santa Croce in Gerusalemme (the Church of the Holy Cross in Jerusalem) and, at least according to legend, incorporated into local church treasures. Long-established practices around the idea of the Jewish Temple connected Roman sites and spaces of worship to specific moments in the calendar, binding legend, place,

and local monuments such as the Christianized Arch of Titus back to the Holy Land. But Kessler and Zacharias also acknowledge something especially significant in the inner visual logic of this monument: This particular arch was well-suited to marking the culmination of the Jubilee procession to the extent that it visualizes the process of a Roman ruler ascending as a new god to the heavens of the pagan gods. The relief image of Titus carried up by the imperial eagle is the very image of the self-proclaimed apotheosis of the ancient Roman emperor – a highly offensive concept for Jewish and Christian viewers – that was reinforced at the exterior gateway by the inscription "DIVO TITO DIVI VESPASIANI F[ILIO] VESPASIANO AUGUSTO." The monument on the Velia, known today as the Arch of Titus, was not a triumphal arch (the triumphal arch for Titus stood at the Circus Maximus). It was rather a family commission by the brother of Titus, Domitian, to commemorate his and his father Vespasian's deification. The Arch's system of images therefore emphasize triumph as the idea of worldly deeds on the walls resulting in a spiritual reward in the vault. At Padua, two triumphal arches are combined to form the classical vault, causing the building's elongated tunnel shape. Keeping the Arch's proportions in each half, the chapel multiplies the bay of the ancient apotheosis to visualize its own double concept of a Christian deity with its dualism of Jesus, Son of Man, and Christ, Son of God, in the figure of Jesus Christ (see Fig. P.6). With this understanding, I argue that the chapel doubles the classical Roman vault system in order to display a true deification that responds critically to the pagan hubris of linear ascent from emperor to new god.

As was the case with the frescoes below on the walls, the frames above that surround the images of Christ, the Virgin and Child, and the accompanying prophets in the east and west precincts of the chapel's bay-nave, carry additional

significance. In particular, Mary with the Infant Jesus and her four prophets show themselves approachable in naturalistic fictive stone frames, while Christ as Pantocrator and his accompanying prophets appear in more abstract, symbolic fiery haloes (see Figs. P.6 and Figs. 1.8–1.11).[28] The four prophets around Christ in the east vault share this distanced, abstract mode; they appear rather symbolic, not palpably naturalistic like the stone frames. And whereas the prophets around Mary and Jesus invite the spectator to participate in some kind of visual communication by turning their gazes downward, connecting to the real space by letting their scrolls flutter down into the chapel, the four prophets around the Pantocrator all have their eyes fixed on him. These two vaults visualize the double nature of Christ: Son of Man and Son of God. The image of God becoming Man through Mary, which implies an ultimate Resurrection after the earthly suffering of Jesus and the triumph of the human God through the humility of Mother and Son, symbolically rejects the Roman emperor's transgression. In the context of the Jubilee this would represent the triumphant moment of a church that had remained victorious in Rome since the age of Constantine. The staging of triumphal Jubilee processions serves the function of highlighting and celebrating a physical union of the triumphs of humility of Christ and Mary by joining their icons in the vicinity of the arch.

Other Roman ruins around the Via Sacra might have helped inspire the idea of a double sanctuary. Long before the Scrovegni Chapel's pairing of the double glorification of Mary and Christ, there was the ancient Double Temple of Venus and Roma, right next to the Arch of Titus. The very specific ruinous state indicated by the chapel's broken vault, with a view of the starry sky opening so ambiguously over the marble brace, is thus familiar: Only the marble band between the two halves – between the two arches – stands in the fiction of the chapel. As

mentioned above, this birdcage aesthetics creates a view of a starry sky, evoking the experience of standing in the midst of architectural ruins on a moonlit night, for instance below the Arch of Titus on the Forum Romanum at the former Temple of Antoninus and Faustina – another Christianized ancient monument. In fact, any temple-church – such as the Church of San Lorenzo in Miranda, which had inserted itself into the ruins of the Temple of Antoninus and Faustina – could have given Giotto this idea, had it not already been applied in so many other reformulations of ancient structures for the purpose of Christian sacred imagery.

While the Arch of Titus reliefs would be a significant counterpart for the chapel's fictive narrative fields and chancel arch, the chapel's dado zone with its fictive polychrome marble panels and with its lingering traces of polychromy on the figures (Figs. 2.6–2.10) would be rather reflective of either the original state of the dado in the Arch of Titus or possibly another base source. Reliefs from more remote Roman places such as the then-buried Ara Pacis and the Forum Transitorium have already been discussed as possible models.[29] With the Arch of Constantine (Figs. 2.11–2.13), I propose the source might well be even more accessible. As much as the interior Titus reliefs can be considered the polychrome blueprint for high, middle, and low relief in the Arena Chapel's narrative scenes – but not for the dado figures – the Constantinian base reliefs (Figs. 2.14–2.20) deliver a probable template for the Arena dado figures (see Figs. 2.6–2.10) – but not for the narratives (see Figs. P.13–P.49). This distinction is crucial for seeing the relative relief effects in Roman models and Paduan quasi-simulacra. This difference manifests Giotto's ability to visualize the active material and historical change of painted surfaces on fictive stone and sculptural matter.

It is possible that the Arch of Titus itself, in a now-lost thirteenth-century state, served as a

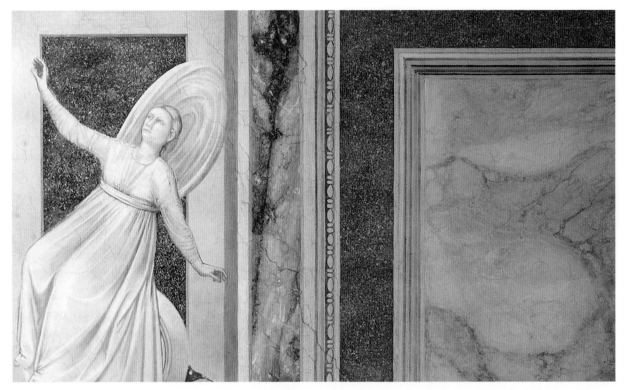

Fig. 2.6 Arena Chapel, fictive relief and marble incrustations around *Inconstancy* on the north wall. Courtesy of Steven Zucker.

model for the dado zone. Due to the radical interventions in the early nineteenth century initiated by papal architect Giuseppe Valadier (1762–1839), who unshelled, dismantled, moved, and reassembled the entire Arch of Titus, it is no longer possible to know what the original appearance of dado zone of the Flavian arch was like in Giotto's time. The remaining upper portions of the framing ornamental pilasters around the reliefs break off halfway between the level of the intact fields and the former dado zone. The continuation of similar bands in Giotto's chapel may indicate that the framing pilasters still reached the floor when Giotto saw them in 1300, potentially embracing a now-lost marble paneling.

In contrast, the dado relief panels of the Constantinian arch are still available: Rather stern, essentially monofigural reliefs cover the base at the eye level of the spectator. These reliefs do not apply the weaving integration of low, middle, and high relief zones that appears in the upper-level Flavian Baroque fields inspired by

the Arch of Titus. Instead, they consist of single figures in measured half relief emerging clearly around their outlines from a nondescript planar background, just as in the Arena Chapel's dado. The similarities of the Constantinian dado figures to Giotto's *Virtues* and *Vices* in Padua are even more striking.

Similar not only in size and position but also in their reduced bas-relief depth – and in the isolation of a single figure against a plane without any depicted environment – the chromatic patches on the figures around the base of the Arch of Constantine still visible today display similarities to Giotto's as-yet unexplained coloristic effect of semi-grisaille with traces of color on, for example, *Ire*'s blonde hair (see Fig. 2.10) or the hands and face of *Hope* (see Fig. 2.9) and *Folly*'s legs (see Fig. 2.8).

Painted "in dead color"[30] – "chalky"[31] – Giotto's figures sit uneasily at the presumed beginning of the history of grisaille, puzzling scholars for centuries.[32] Romano identifies this "anti-grisaille" as the precise

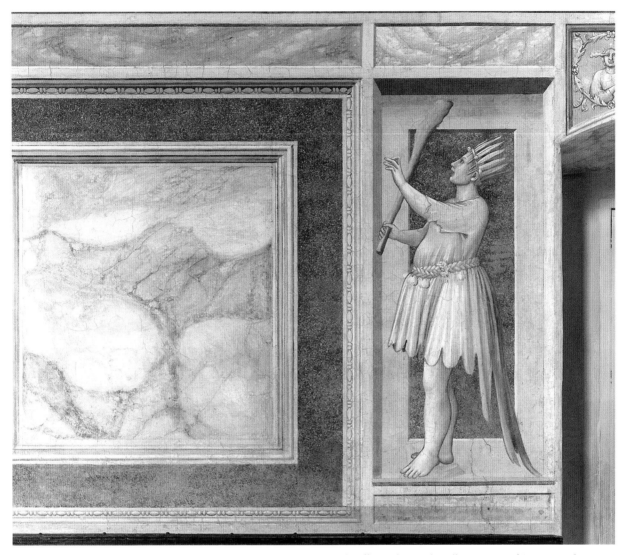

Fig. 2.7 Arena Chapel, fictive relief and marble incrustations around *Folly* on the north wall. Courtesy of Steven Zucker.

portraiture of a material – of beige marble[33] – reconsidering their implied status as *bassorilievi* that are bound to the ground as well as to the tradition of ancient sculpture.[34] Focusing on the heart of Rome, Romano proposes a number of imaginable sculptural inspirations for the *Virtues* and *Vices*: the *Nationes*; the *Colonacce* from the Temple of Minerva in Rome's Forum Transitorium; even fragments from the Pantheon.[35] Accepting all such possibilities for general inspiration, I propose that the figures' washed-off stone optics (as in the German term *Steinsichtigkeit*, regarding the visibility of the actual stone substance in opposition to

a covering or applied surface treatment)[36] also carry meaning.

As has been noticed in *Ire*'s traces of blonde hair below the surfaces, Giotto's figures show traces of color only on the salient parts of a figure where, in an actual relief figure of the same shape and depth, they would be less exposed to rainfall when installed on the exterior of an arch. The odd bits of polychromy that appear in Giotto's dado relief figures may thus reflect the presumed remains of pigments that would have been visible on the ancient relief figures of arches around 1300. By including these touches of color on his

Fig. 2.8 Arena Chapel, detail of the legs of *Folly* with visible traces of former polychromy. Courtesy of Steven Zucker.

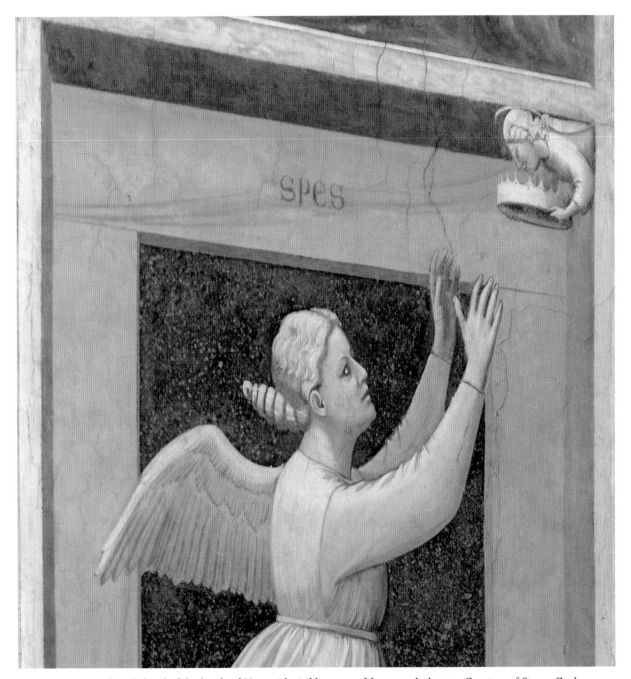

Fig. 2.9 Arena Chapel, detail of the hands of *Hope* with visible traces of former polychromy. Courtesy of Steven Zucker.

otherwise stripped stony relief figures, Giotto was not only creating highly illusionistic Roman socle figures in his dado reliefs but also trying to reproduce the weathered appearance of ancient models with their fading remnants of original paint. In that sense, the leucistic, washed aesthetics have parallels in the exterior reliefs from the Arch of Constantine's dado pedestals, such as

Victory and a Barbarian from 312–15 (see Figs. 2.12–2.15)[37] – exterior reliefs which, one has to imagine, retained more traces of original or later color application around 1300 – only about a thousand years after their production – and were not quite as blank as we see them today.[38] While the narrative scenes inside the bay were naturally better protected from rain and wind, the exterior

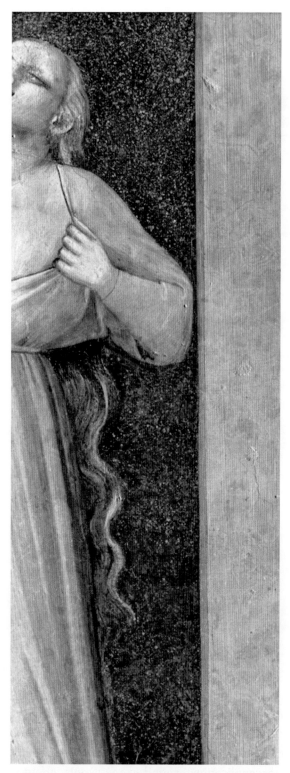

Fig. 2.10 Arena Chapel, detail of the colorless hair on top of *Ire*'s head and the blond length on the undercut parts of the figure with visible traces of former polychromy. Courtesy of the UC Berkeley Historical Slide Library (est. 1938–2018), Baxandall & Partridge Collection, Doe Memorial Library in Berkeley, California, USA.

reliefs are likely to have lost most of their original polychromy by 1300. But strong areas of comparison still remain clearly visible on the Arch of Constantine even to the present day (see Figs. 2.11–2.20, photos taken in 2018), for example on the legs of the troops (see Figs. 2.15–2.16) – compare the fey reddish streaks on the calf of Giotto's *Folly* and on the lower, better protected parts of *Nike* (see Fig. 2.17–2.18) situated in slightly tilted areas under her wings and below her abdomen (compare, again, the blonde in the undercut lengths of hair in Giotto's *Ire*). Other examples of harshly abraded *Nike* reliefs (see Figs. 2.19–2.20) illustrate the same principle, with a tiny amount of underpaint surviving just on the tips of her wings, also better protected from the elements. Such observations, translated into the spiritually invested iconographies of the Arena Chapel, could have inspired the reddish glow inside the hand of Giotto's *Hope* (see Fig. 2.9).

Giotto applied his idea of fading traces of color subtly to the lowest of the vices (*Folly*), to the highest of virtues (*Hope*), and to *Ire* close to the center of the chapel, as if giving three well-placed signals throughout the interior for bringing attention to the temporal state of the dado's stone. With these details, some of the most stunning painterly touches in the chapel speak directly to the themes of historical, religious, and material change and decay of the old pagan empire. They also work in perfect material logic and with the knowledge of the craftsman and painter-sculptor, so the traces of blonde on *Ire*'s long tresses that would be, in real space and on real sculpture, representing the undercut parts of the figure. These undercut areas are better protected from rain, as still visible in the dado relief figures on the Arch of Constantine, ranging from entirely washed figures to those examples with patchily pigmented legs and wings.

In the Arena Chapel, Giotto makes a virtue of these different stages of deterioration, activating them in specific areas of the interior's scheme and its iconographic system. The color of the

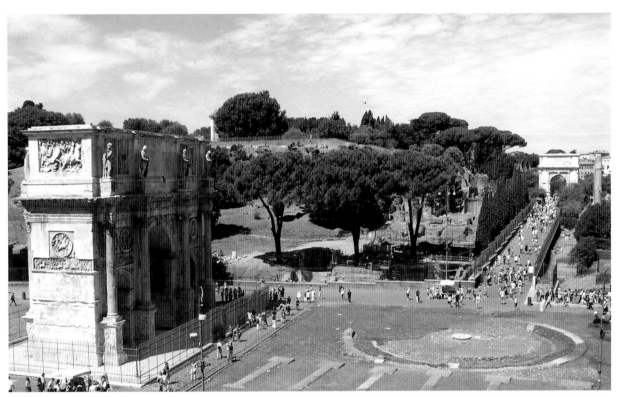

Fig. 2.11 View of the Roman Forum with Arch of Constantine, Via Sacra, and Arch of Titus, Rome. Courtesy of the UC Berkeley Historical Slide Library (est. 1938–2018), Baxandall & Partridge Collection, Doe Memorial Library in Berkeley, California, USA.

upper levels seems to be inspired by the interior Titus reliefs, which likely had better-preserved polychromy in Giotto's time. The washed-out, almost lost polychromy of the exterior reliefs, such as the socle figures, on Constantine's arch (or, potentially, their lost equivalents that may have adorned the Arch of Titus among others) that were exposed to the elements provide the model for the visibility of stone underneath surface treatments, with occasional shadows of color, again like the little bit of faded red on the thick calves of *Folly*.[39] The crucial difference structuring the chapel allocates the fading mode of representation to the allegories at eye level, while scenes from the lives of Mary and Christ in the upper registers glow in fresh colors. Even the hitherto unexplained choice of polychrome marble for the dado backdrops[40] – the porphyry behind *Fortitudo*, *Invidia*, *Iniusticia*, and *Incostantia* in particular – might have a

Constantinian source: His arch's uppermost roundels were framed by rectangular panels of porphyry, some of which still remain (see Fig. 2.13); polychrome marble might have been used, as well, as backgrounds behind the reliefs on the level of *Victory and a Barbarian* that, because of their location, appear to have been an easy target for further acts of spoliation.

The dado zone is filled with subtle ancient details. The seemingly carved inscriptions that once accompanied the moral allegories like ancient *tituli* resonate with ancient statuary (while once more Giotto goes beyond simple imitation, merging styles and ages by using capitals in a graceful Gothic calligraphy). The vast array of specific ancient attributes and *maniera latina*, Latinized motifs in the *Virtues* and *Vices* further strengthen this point: *Infidelitas* monumentalized with a Mercurial helmet;[41] the aforementioned Herculean lion's skin on *Fortitudo*[42] and her Roman legionnaire's *scutum*;[43]

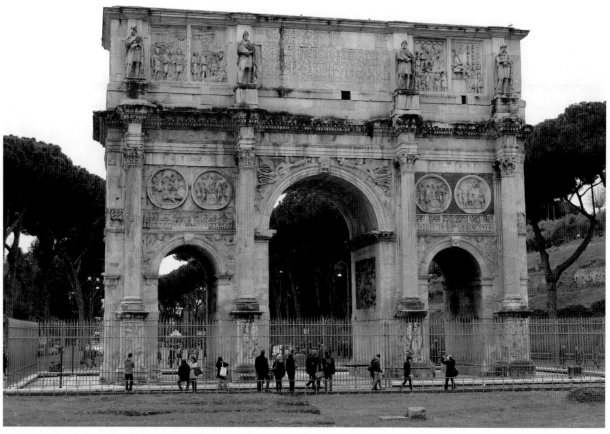

Fig. 2.12 Arch of Constantine, seen from the area between the Colosseum and the Arch of Titus (2018). Photo by the author.

the sculptural wings of *Spes-Nike*; and the shattered Roman idol under *Fede*.

The Roman male nude torso deserves a second look (Fig. 2.21). Not only is the small statue held down as if pierced by the point of *Faith*'s triumphal cross – the positioning of both objects in tension with one another suggests that the act of iconoclasm is happening at this moment in time, in front of the specator's eyes. More precisely, the small statue's head has just been severed and has rolled a few inches forward, towards the niche's edge, towards the spectator. The cross is still stabilizing the tiny figure exactly where the head and neck are now missing, and since the torso is shown from behind, it is obvious that the small head has

fallen with a 180-degree rotation. Giotto has paid attention to paint all fragments that complete the torso as if to emphasize that this vignette within his ruin aesthetics is not the result of natural weathering over time, but actively produced by *Faith*'s punishment of the pagan idol. While it is easy to identify several body parts around the torso such as the small hand and foot, the detached head in the foreground is much harder to recognize. The reason for its poor visibility is historical and relates to the centuries between Giotto and us, when visitors where able to touch, test, and scratch the dado zone in the chapel (see also the damaged faux marble around *Hope* for some of the worst examples). As if to emphasize the ongoing

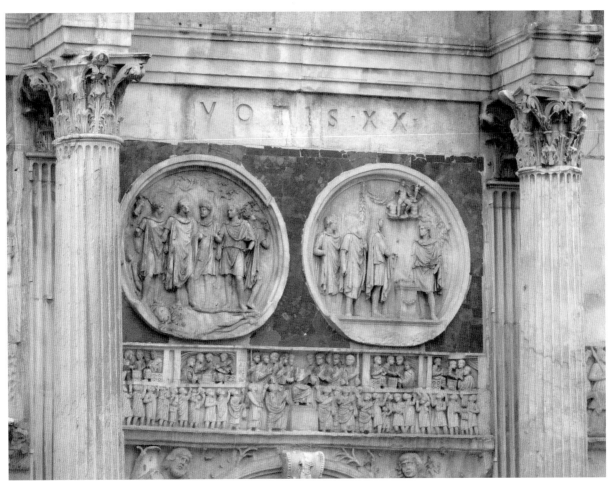

Fig. 2.13 Arch of Constantine, detail of remaining porphyry incrustations behind relief tondi (2018). Photo by the author.

haunting of ancient spiritual powers, some later iconoclast has scratched out the tiny idol's head from the surface of Giotto's mural. This compares to the targeted damage on the demon in the niche of *Despair* and on the ghastly claw and face of *Envy* on the other side, just across the chapel on the wall of the *Vices*. We can, however, make a few observations as visual archaeologists of this ancient fragment that has been doubly disfigured (once by Giotto in the logic of its image, and later by iconoclastic audiences in its material integrity): Giotto painted the head as fallen on its right cheek; around the damaged area we can still identify the chin, the left nostril, and part of the left eye under a head of hair typical for some Roman deity. In the ancient Roman Pantheon, he is most likely

to be thought of as a young Bacchus with his handsome youthful face, and dark, longish hair, while Apollo would often have sported blonde, golden hair, and Mercury a pair of wings on his head. Another detail pointing to Bacchus are the remains of a broad white headband, wound around the top of the forehead, but below the fringe. If this is a correct reading of the damaged surface around the head, it would be a mitra, only worn by Bacchus.[44] As perfectly as Giotto had placed the fragments under the blow of the heavy triumphal Cross directed by the strong hands of *Faith*, the later iconoclasts who damaged Giotto's miniature, fragmented ancient Roman nude eventually retranslated his visual brilliance back into historical time and space, and carried it over into the actual damage of

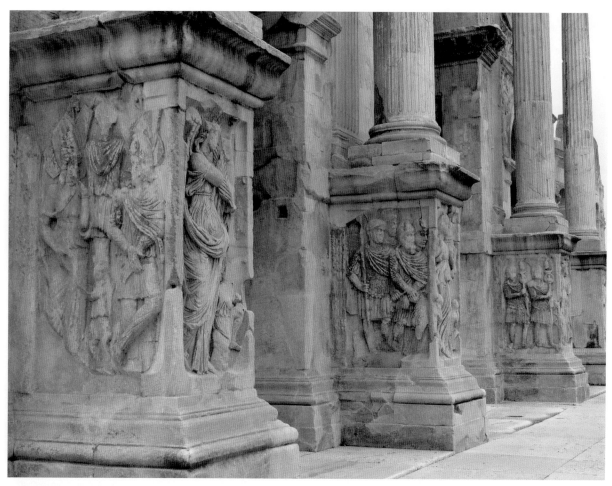

Fig. 2.14 Arch of Constantine, base reliefs (2018). Photo by the author.

the murals, trying to scratch it out, thus proving the point that the historical obsession with paganism and the spirits of the ancient past continued not only beyond the Constantinian shift of circa 312–315, but far beyond 1300. The iconoclasts could not even bear to look at the painting of a destroyed pagan statue: This is how effectively Giotto had transmitted his visual commentary on Roman idols and ancient statuary of the pagan Gods.

Returning to the Arch of Constantine, the first pagan, then Christian emperor represents both problem and solution in relation to the issues of reworking, reframing, and outdoing the ancient pagan heritage in all personal humility as well as with the enthusiasm and mission awareness of a new Christian Rome. Once again, the process of

quotation exceeds mere formal reference and again it becomes accessible through Giotto's source's specific place in Roman-Christian history. The Constantinian triple-bay arch marks an intermediate step between the ancient world and newly developing Christian aesthetics. Erected between 312 and 315 to honour the emperor's decennalia and his victory over Maxentius at the Battle of the Milvian Bridge, the arch demarcates the crucial moment for Rome's Christianization.[45] "Roman art was eclectic from its beginnings,"[46] Diana Kleiner remarks of this encyclopedic monument. Tripling the mono-arch by creating three bays – a large central passage framed by two smaller ones – and piecing together *spolia* reliefs from different periods, the first Christian Roman emperor incorporated

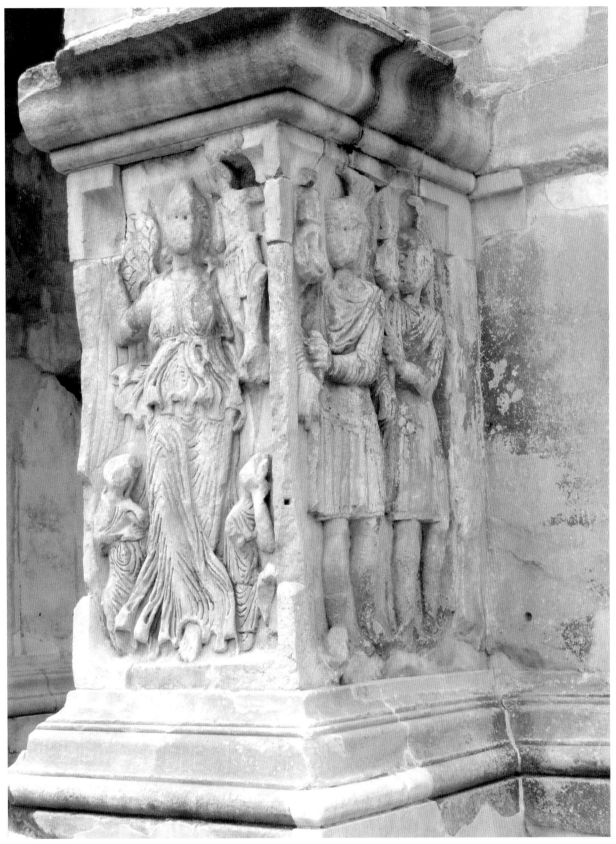

Fig. 2.15 Arch of Constantine, base reliefs with Nike and soldiers with visible traces of former polychromy (2018). Photo by the author.

Fig. 2.16 Arch of Constantine, detail of the base reliefs of the soldiers' legs with visible traces of former polychromy (2018). Photo by the author.

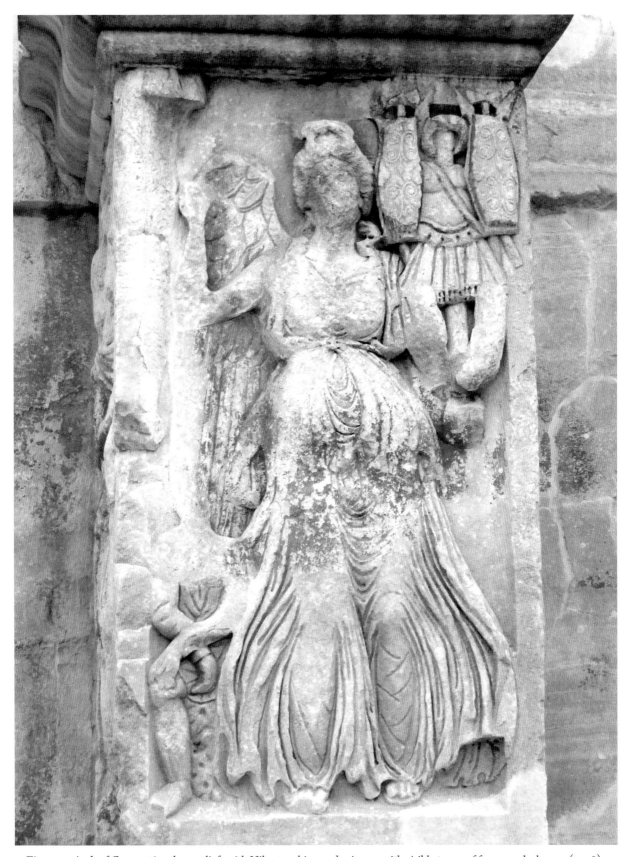

Fig. 2.17 Arch of Constantine, base reliefs with Nike, trophies, and prisoner with visible traces of former polychromy (2018).
Photo by the author.

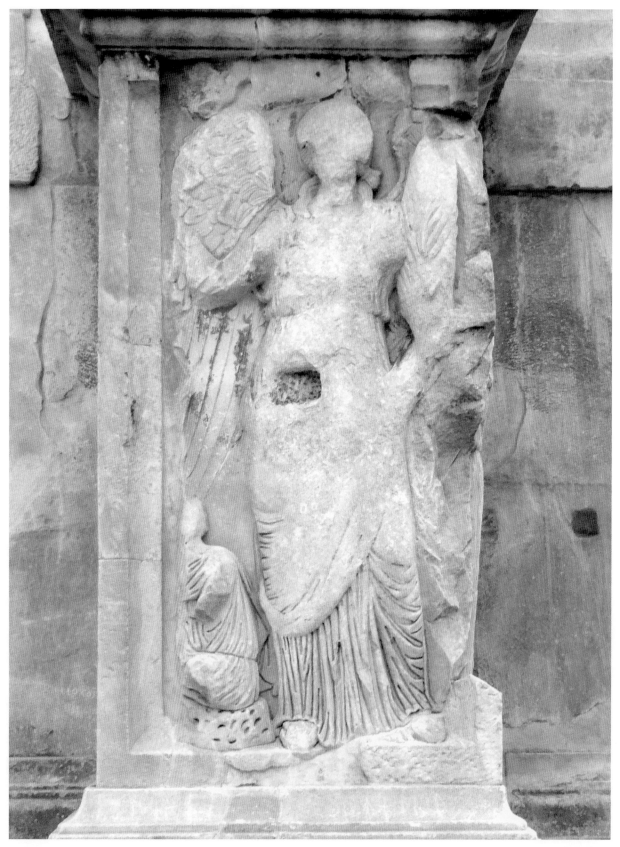

Fig. 2.18 Arch of Constantine, base reliefs with Nike, trophies, and prisoner with visible traces of former polychromy (2018). Photo by the author.

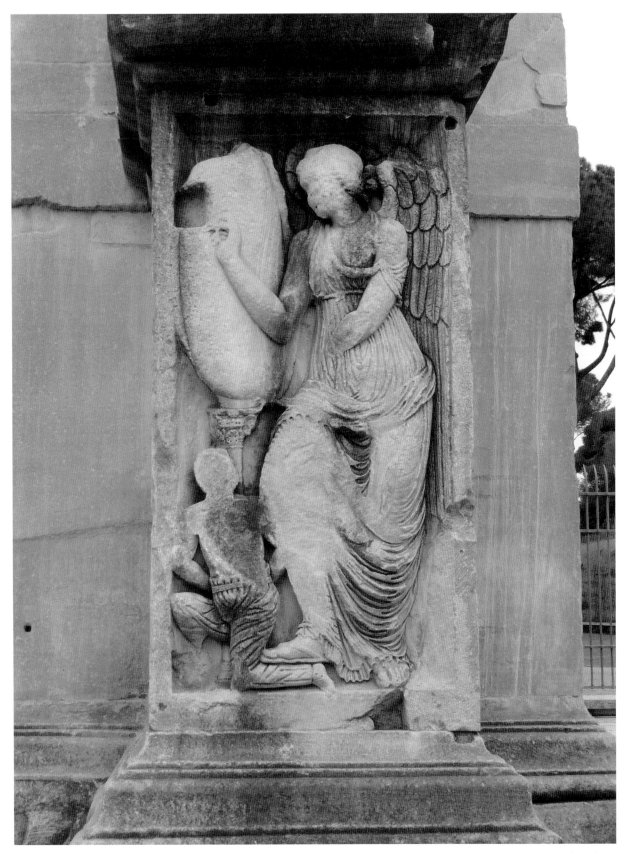

Fig. 2.19 Arch of Constantine, base reliefs with Nike, trophies, and prisoner with visible traces of former polychromy (2018). Photo by the author.

Fig. 2.20 Arch of Constantine, base reliefs with soldiers and Nike, trophies, and prisoner with visible traces of former polychromy (2018). Photo by the author.

Fig. 2.21 Arena Chapel, detail of the fictive base under *Faith* with the fragments of the broken male nude Roman idol. Courtesy of the UC Berkeley Historical Slide Library (est. 1938–2018), Baxandall & Partridge Collection, Doe Memorial Library in Berkeley, California, USA.

reliefs from the time of Marcus Aurelius as well as from second-century imperial monuments. My argument raises the possibility that the Arena Chapel aims at outperforming even the Constantinian project, both artistically and ideologically: In place of the material *spolia* incorporated into the Constantinian monument in Rome, Giotto creates visual *spolia* channeled through his masterful imitation of media, techniques, and materials. As illusions of actual material, these optical *spolia* make a point about the different, distinctly non-pagan, understanding of matter, materiality, word, and vision in the world of Christian doctrine.

Such layered reworking of antiquity seems to be rather unique. The Arena Chapel's strategy, not ignoring or erasing the hubris of Roman imperial self-deification but appropriating it while changing it, shifts its material essence by shifting media. Quite uniquely in the history of spoliation, this act follows

neither the Constantinian strategy of physical reinsertion and appropriation of local objects nor the integration of imported matter exemplified by the Byzantine porphyry tetrarchs at Saint Mark's in Venice. Instead, Giotto introduces a method that borders on yet surpasses both modes of appropriating *spolia in re* and *spolium in se* as defined by Richard Brilliant – relating to the actual object as well as to the transposed idea.[47] Spolia can function in a physical sense, in a metaphorical sense, and in both combined. Giotto seems to have undertaken a unique reframing of spolia by recreating his own on the basis of actual monumental models and by filtering the medium of sculpture through perfectly painted illusionism – with the twist of his additional attention for the painterly reproduction of historical styles, iconoclasm, and loss of polychromy over the centuries.

What becomes visible here is a fundamental philosophical and political change between the pagan Arch of Titus and the Christianized Arch of Constantine, a watershed clearly manifest in the substance and tone of their dedicatory inscriptions. According to Richard Krautheimer, the Constantinian project of Christianization was never fully realized by the emperor in Rome itself, but only in the creation of a new capital for the now Christian imperium: Constantinople.[48] The Jubilee's staging of the papal procession around the ancient arches offered a new way of Christianizing Rome in the late Middle Ages. But it is only the Scrovegni Chapel that presents a complete and systematic Christian critique of the principles of pagan antiquity in language founded on a sophisticated theological conversion and on a reframing of the fictive remains of a then discredited ancient culture.

This represents both a revival and continuation of Constantine's Roman-Christian project, a story told by the inscription on the Arch of Constantine. Like the proud text on the Arch of Titus, the fading letters on the Arch of Constantine also proclaims the emperor's status. But in contrast to "DIVO TITO," Constantine is lauded in humble terms: "pious" and "blessed"; "inspired by the divine"; "founder of peace."[49] Between Rome and Padua circa 1300 one can see unfolding a reaction to what Krautheimer has baptized the "Christianization of Rome and the Romanization of Christianity." However, Krautheimer comes to the conclusion that things changed for late antique Rome with Constantine's departure: "Equally ambitious was the Christian identity of Rome. Constantine had failed to turn her from a pagan city into the Christian capital of a Christian Empire. That role was given to Constantinople, the New Rome and the new imperial residence."[50] Giotto fulfills this turn. Scrovegni's initiative, which displays the

walls and Temple of Jerusalem on the walls of his *cappella*, reinforced both the Roman and the Paduan position in this long history of emulation and appropriation.

The chapel thus unveils itself as a critical response to its ancient models and a self-conscious reflection on artistic media: not a copy but a complete transformation of the ancient arch. The inversion of media through illusionistic murals turns the hubris of the ancient arch into a complex Christian system for visualizing a double triumph of humility – the crucial concept at the center of the likewise challenging, paradoxical story of a Jesus Christ caught between and inhabiting both the human and the Divine. The stable-birthed infant savior, the humility of his mother Mary, and the humility of Christ in accepting isolation, derision, and a brutal death on the cross all lead eventually to his self-sacrificial triumph over death.[51] To design a chapel as a double triumphal arch for Mary and Jesus Christ in response to hubristic ancient arches with imperial self-celebrations such as the deification relief in the Arch of Titus was thus an ideal spatial-visual realization of the essence of Christian faith – especially since the two ancient arches next to the Colosseum were unmatched in importance during the Jubilee and its processions.[52] In all this, a little chapel in Padua could become a parliamentary chamber for the Roman celebrations. The historical moment of the First Roman Jubilee sought to fold into itself the entire history of Christianity in Rome and Jerusalem. It projected Jewish-Christian history onto the ancient Roman arches and the topography of Rome from the time of the Flavian emperors, the war of Titus and his triumph which brought Jerusalem to Rome. Those stations of the *via crucis* all over the city of Rome

defined the processional route and milestones for pilgrims in medieval Rome as a staged, slowly progressing meditation on, and exercise of, perpetual historical appropriation.[53]

URBAN TOPOGRAPHIES, PROCESSIONS, AND TRIUMPHAL CROSSES

Much like the lost polychromy, the architectural context of the monuments in Padua and in Rome has also been erased. Reimagining now the local buildings at the time of Giotto around the arch and around the chapel once again renders the Roman–Paduan connection clear and powerful: One must imagine not ancient but medieval Rome at the center of the medieval Forum Romanum. Around 1300, the Arch of Titus was not a freestanding monument. Cork models of the arch made for Grand Tourists by Antonio Chichi (1743–1816), predating Valadier's architectural intervention on and around the Arch of Titus, still illustrate this amalgam of ancient and medieval building substance.[54] A medieval portal more than an ancient arch, the emperor's honorific monument was firmly integrated into the medieval fortress of the Frangipani family.[55] So firmly, indeed, that the arch would not have appeared as much more than its own relief-covered bay. It served as a gateway to the fortress and, as such, was experienced by the pilgrims as an interior space. Similarly, the Arena Chapel was entirely integrated into the new Palazzo Scrovegni and its walls. All but the chapel was torn down in the nineteenth century, but some renditions of the complex show the close relationship between palace and chapel, amalgamated behind a unifying façade as in likewise close symbiosis (see Fig. 1.1). If Enrico Scrovegni were indeed

considering this a unified building project of palace and Christian chapel that would echo the Frangipani's palace and its embedded Christianized ancient arch, it would make sense for the ambitious Paduan newcomer to not just move into the established medieval structures left by the Dalesmanini family, but to capitalize on a much more ancient and nobilifying tradition.[56]

Envisioning the Arena Chapel as an occasion, as a synecdoche of the ancient Roman arches of Titus and of Constantine, offers a set of historical, iconographical, theological, and topographical explanations for the creation of the chapel, its position, and its appearance. This interpretation is supported by architectural, decorative, and stylistic relationships between these ancient models and the fourteenth-century palace chapel. Recalling the local situation in the ancient Roman city of Padua, including the parameters of performative spaces, routes, and rituals, strengthens these connections further: The most prominent procession in Padua was held on the Feast Day of the Annunziata. It has been traditionally assumed that there was already an eleventh-century chapel in the arena. If that earlier chapel indeed existed, Scrovegni would have acquired it along with the arena from the Dalesmanini, and with it, probably, the traditional destination of these established local processions.[57] On the day of the Annunciation, locals celebrated two children dressed as Mary and the Angel Gabriel, who would walk through the arena into the chapel. Surpassing the Frangipani's Jubilee moment when their Arch of Titus hosted a particularly important papal procession, Scrovegni's commission set into motion a perpetual activation of his personalized sacred space that was scheduled to continue renewing itself every year with the certitude of the church calendar until Judgment Day. In both cities, such performative rituals elevated the

stakes of the triumph as a rite of passage convert-ing one state of affairs or belief into another.[58] The highlight of the celebrations involved the flight of a *colombina,* either emerging from behind the wooden door on which God the Father was painted in the apex of the chancel arch, or, as Frugoni convincingly argues, the artificial dove would have taken flight outside, in the arena, similar to the Easter rites between the Baptistery and Santa Maria del Fiore in Florence.[59] Either place, the emergence and extension of the Holy Spirit in the compounded spaces of the arch-chapel or the arena fulfills the typological-iconographic needs formulated in the inscription on the divine Christian virtues and their effective exorcism of the demons of the ancient pagan past. We may interpret, then, the small white dove of the Holy Spirit as a supreme Christian response to the ancient, imperial Roman eagle of Titus. Now even the last phrase of the inscription explains itself, with its oddly elaborate insistence on the date of dedication: "When this place is solemnly dedicated to God, the year of the Lord is thus inscribed: In the year 1303, when March had conjoined the feast of the blessed Virgin and the rite of the Palm." Hitherto unacknowledged, this sentence recalls the signifi-cance of Palm Sunday, the day commemorating Christ's entry into Jerusalem. Humility is key in both events, when Mary is described as having been chosen for her humility and Christ mani-fests his humility through the implied contrast between his entry – riding upon a jennet – and the traditional imperial triumphal entry centered upon the emperor on his noble white horse. The contrast is even more emphatic in Giotto's own depiction of that triumphal procession of Christological humility within the Arena Chapel itself, as Christ on the jennet is accompanied by her tiny foal, both particularly benign with their friendly facial expressions, and is greeted by jubi-lant children with palm leaves. The final sentence in the inscription, therefore, conceptually merges

the entry into Jerusalem and the Annunciation – the triumph of Mary's humility – and registers them as united by their proximity in the church calendar 1303. Two triumphs of humility are thus conjoined and perpetually celebrated in the Scrovegni Chapel, as already enacted with the Roman procession of the icon of Christ from the Lateran to the icon of Mary on the Via Sacra next to the Arch of Titus in 1300. Furthermore, the Virgin's unusual gesture in the chapel has been understood as an expression of her humility in connection to the Humiliati order, for whom Giotto would later work.[60]

Ironically, given that it has the theme of humil-ity at its very core, the iconography of the Arena Chapel's program generated one of the most spectacular ecclesiastical spaces in the Veneto with the most extensive Marian cycle of images. For the Eremitani and other critics of Enrico Scrovegni, the architectural and artistic ostenta-tions of the chapel threatened to undermine its core message of humility with the employment of Giotto, the most prominent painter of his time, as well as with Scrovegni's provocative character and his triple portraiture within the chapel.[61] One might fruitlessly speculate about the honesty or dishonesty of the project on the part of the donor, but either way, Scrovegni's enterprise would indeed be a good "investment" – a notion empha-sized by Frugoni's book title *L'affare migliore di Enrico* in relation to the long-confirmed import-ance of indulgences in the chapel's history and iconographic program.[62] Scrovegni's larger inter-est might have pointed at inserting the chapel into the pilgrimage road to Rome, attracting more people to Padua from the Via Francigena. Indeed, as noted above, indulgences were granted when the chapel was almost finished.

The Christianization of an ancient triumphal arch was at the time a standard appropriation. For instance, famously, in the Arch of Augustus in Aosta (renamed Saint-Voût after the image of Christ installed therein) the crucifix hovered on

a horizontally installed rod in the Arch's bay.[63] Indeed, this concept was most clearly pronounced in the Arena Chapel's own large crucifix: Giotto painted a triumphal cross for the chapel, today in the adjacent museum (Fig. 2.22).[64] Suggesting more than a conceptual similarity, the crucifix originally situated in the chapel reinforces our view of it as a modern refiguration of an ancient and appropriated space. The wooden crucifix, also painted in stone-imitating relief, was probably installed either on an iconostasis or in the center of the interior, between the bay of Christ and the bay of Mary.

This is a good moment to pause and to ponder the set of historical and metaphorical relationships that link people, events, and monuments in the web of meaning from which the chapel emerges. The people are Enrico Scrovegni, the Dalesmanini, most likely Alberto da Padova, Giotto, Pope Boniface VIII, the Frangipani, Augustine (as is argued in detail in Chapter 4), Constantine, Titus, and the Jewish people. The events are the First Jubilee, the Constantinian shift, the Triumph of Titus, the Jewish War, and the lives of Christ and Mary. The monuments are the chapel and the two arches. All these appear to be collectively interconnected in this singular project for Scrovegni's unique and well-planned purposes.

That the chapel and the arch have not yet been considered together over several centuries of Giotto scholarship seems to result primarily from the completely altered architectural environment in both places; it might also reflect necessary conditions in the production and categorization of knowledge. As I discuss further in Chapter 5, art history as a discipline was in a nascent state at the time of the chapel's resurrection into public view. Emerging from a post-*paragone* academy, the history of art in the eighteenth and nineteenth centuries was occupied with attributions and periodizations. At this time, the academic *paragone* had split the disciplines

and eras, making it harder to imagine ancient relief sculpture as a model for a frescoed chapel from circa 1300, especially as the polychromy had continued to wear off the arch. The predominant imagination of a single file of styles in art history and the Vasarian promotion of a superior Quattrocento and a most excellent Cinquecento, minimizing Giotto's clever and precocious Trecento responses to ancient art, disadvantaged any recognition of the many links between Giotto and ancient Roman sculpture and monuments. In Rome, between 1819 and 1822, Valadier had dismantled, moved, and reassembled the Arch of Titus. When Giotto had seen it around 1300, the arch was embedded in the medieval tower, palace, and wall architecture of the Frangipani fortress, to be experienced as a gate rather than as an excavated relic. By the Ottocento, it was once again an isolated, freestanding monument on the Velia, and as such it would become an emblem of Rome.[65] The epic Titus reliefs were registered in the archives of the new discipline as the first representations of historical narrative scenes in Roman art history and could not have been filed away further from the maps holding pictures of Giotto's medieval painting. The continuing loss of their polychromy would have made it easy to cast them in engraved and three-dimensional reproductions as refined examples of cleansed classical art.[66] The reliefs' printed and sculpted doubles not only refurbished lost heads and hands to undo their iconoclastic destruction but also suppressed their true colors.

The specific modes of reproduction in the age of Goethe and, most importantly, the insistence on the distinct and dialectically opposed character of medieval versus classical art conspired to conceal the possibility that there could be an ancient precedent for the Arena Chapel to which it responds in structure, political iconography, theological message, and pictorial detail. Yet even without acknowledging its Roman-classical

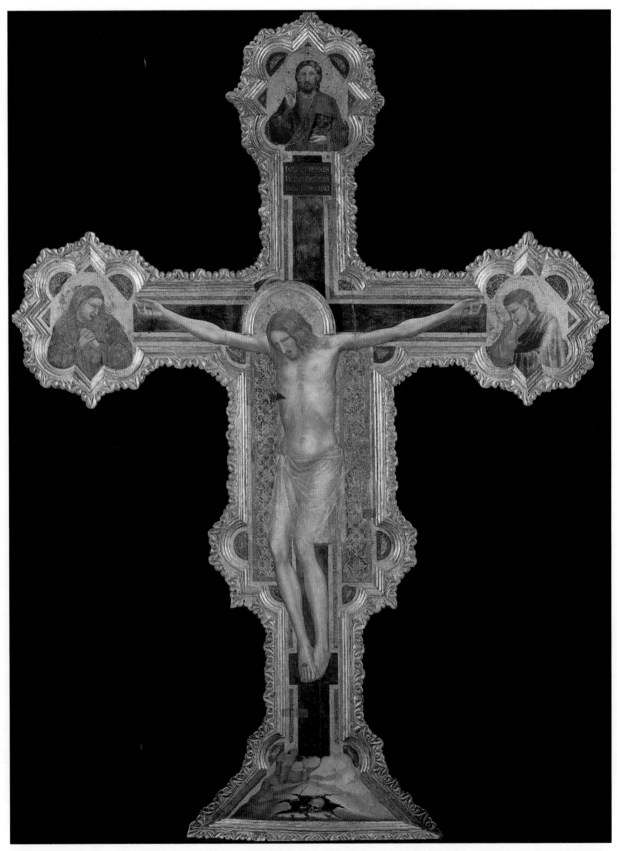

Fig. 2.22 Giotto di Bondone, Crucifix, recto, Padua, Museum. Courtesy of the UC Berkeley Historical Slide Library (est. 1938–2018), Baxandall & Partridge Collection, Doe Memorial Library in Berkeley, California, USA.

dimensions, art history has placed Giotto's chapel at the beginning of early modern painting, recognizing it as an exceptional and paradigm-shifting endeavor on the threshold of what has been called The Renaissance. The chapel's local significance had waned during the Counter-Reformation, bringing an end to the annual processions and the mystery play. Just as the procession of the infant Mary and Angel Gabriel in Padua was appropriate for maintaining the memory of the Roman Jubilee as a celebration of the living staged among the ruins of pagan antiquity, proclaiming a new, Christian Rome, so would its termination cause the core reference of the chapel to a triumphant Christian Rome to get lost along the way.[67] How can we recreate, from the ruins of the historical record around Enrico Scrovegni, a panorama of Padua and Rome, circa 1300, that will help us understand the role of the donor in this context?

Chapter 3

THE POWERS THAT WERE

Scrovegni, Dalesmanini, Frangipani

QUI LUXUM VITAE PER TEMPORA LAETA
SECUTI / DIMISSIS OPIBUS REMANENT SINE
NOMINE MUTI / SED DE SCROVEGNIS HENRICUS
MILES HONESTUM / CONSERVANS ANIMUM
FACIT HIC VENERABILE FESTUM. / NAMQUE DEI
MATRI TEMPLUM SOLEMNE DICARI / FECIT UT
AETERNA POSSIT MERCEDE BEARI.

Those who led a life of luxury in happy times, their wealth
now lost, remain nameless and mute. But Enrico Scrovegni,
the knight, saves his honest soul. He offers a revered festival
here. And indeed he had this temple solemnly dedicated
to the Mother of God, so that he would be blessed with
eternal mercy.

FROM ENRICO SCROVEGNI'S INSCRIPTION
FORMERLY AT THE ARENA CHAPEL[1]

SCROVEGNI AND THE TRIUMPH OF HUMILITY

IN THE LATE DUECENTO VENETO and Lazio, a faint memory of two other families weaves itself into the long history of the Scrovegni Chapel: the Dalesmanini, a Paduan banking family and the former owners of the arena, and the Frangipani, an old noble Roman family whose name is

connected with papal history. In the north of Italy, the Dalesmanini family palace was situated in Padua's ancient Roman arena until Enrico Scrovegni financially ruined his rivals and eventually acquired the arena, complete with their residence. Down in Rome, several branches of the Frangipani resided in their prestigious urban estate over the Velia in at least three family towers. Positioned between the Colosseum and the Frangipani family church, Santa Maria Nova, their palace's walls incorporated the Arch of Titus. This architectural ensemble would provide a model that Scrovegni could simulate in Padua for himself, both materially-visually – when he merged Scrovegni Palace with his chapel in the ruins of the Paduan arena – and verbally – when the extensive text of the inscription celebrated his act of triumphing over ancient heathen forces as well as his local predecessors.

It is not surprising to find strong connections between Padua and Rome around 1300. Architecturally and ideologically, Padua had remained essentially Roman in the Middle Ages. Scrovegni's commission could thus insert itself into the context of a proudly neo-classical Padua *felix, dottissima, et alter Roma*.[2] The chapel's singular shape and decoration – as we have seen, a sophisticated transformation of models from ancient Roman architecture – naturally connected with the still visible structure of the ancient Roman city grid and the remaining ruins of ancient Patavium. This resonance was so evident thanks to Padua's own cultivation of its Roman origins. Its reputed ancient heritage as a city founded by Antenor of Troy himself and the tales about its mythical kings Dardano and Antenor associated medieval Padua with ancient Rome and Troy.[3]

Enrico Scrovegni, entering the late medieval stage of Paduan local history out of nowhere, had succeeded to establish his family name and image by the time of the Jubilee. With Giotto's help, Scrovegni then rapidly secured a lasting home for the House of Scrovegni. His chapel was conceptualized as a burial place for himself and his descendants. In *Giotto's O*, Serena Romano describes Scrovegni's singular personal presence in multiple portraits as the "kernel" of the oratory, expressing his ambition for social representation among Padua's political and banking elite.[4] The different versions of himself represented in the chapel appear in a spatial, material, and visual spectacle with images displaying life stages from worldly aging and decay towards the projection of eternal spiritual triumph in the *Last Judgment*.

In one instance, Enrico Scrovegni's eyes stare into the void from his standing statue; then they are closed under heavy eyelids of bleak stone with deep lines on the surrounding face of his visibly aged *gisant* sculpture; a third time, his pair of eyes is firmly focused on the Virgin Mary (Figs. 3.1–3.3).[5] Since this final portrait displays a profile view of Scrovegni's head, only his right eye is visible; yet Giotto painted it so that its gaze gives it the most intense presence among all three likenesses.[6] Scrovegni is not alone in that key scene, yet his image is usually isolated for the sake of photographic reproduction. His would become the face of the Italian proto-Renaissance, often presented as the first naturalistic, lifelike, individual portrait in the post-classical Western tradition.[7] Giotto painted the face carefully, devoting an entire *giornata* to the pale features, as he did also on the adjacent physiognomy of the canon as well as on the face of Christ himself.[8] Scrovegni's other two portraits appear in the context of sculptural memorials: the polychrome standing statue in perpetual oration, probably from the time of the chapel's donation shortly after 1300, and the *gisant* effigy from a rearranged funerary monument a few decades later.[9] Changes in his body reflect the passing of worldly time, but Scrovegni is recognizable at these different moments, wearing the same clothes and buttons. In the standing statue, the hooded chaperon stands out from the back of

Fig. 3.1 Arena Chapel, gisant sculpture of Enrico Scrovegni. Courtesy of the UC Berkeley Historical Slide Library (est. 1938–2018), Baxandall & Partridge Collection, Doe Memorial Library in Berkeley, California, USA.

his head; on the funerary monument, it has been sculpted so to appear as if carefully placed onto the pillow behind his head.

The west wall fresco portrait, the least material version among the three images, submits the most compelling and lively picture of Scrovegni. Not only does its scale indicate how close Scrovegni is positioned to the edge of the fictive marble door-frame, but the entire figure group of Scrovegni, the canon, Mary, and the saints is set altogether into a hyperrealistic key as the canon's painted hem appears to be hanging over the faux frame (see Fig. P.12). The image demarcates the border between world and paint, shifting the latter into the real space of the interior.[10]

Debates about the categorization of Scrovegni's post-apocalyptic likeness as a portrait continue while it has been used as one of the first examples of a new, early modern, self-confident kind of portraiture – portraiture understood not just as a genre but also as an act of individualization.[11] Far from being a regular devotional or votive portrait, Scrovegni's image is spectacularly positioned in the context of a large-scale iconography of the Apocalypse. The donor is portrayed in the act of giving not during his lifetime in the early fourteenth century but at a final moment beyond worldly time when his gift is measured and weighed for the good of his soul. More than a portrayal, this is a projection of Enrico Scrovegni

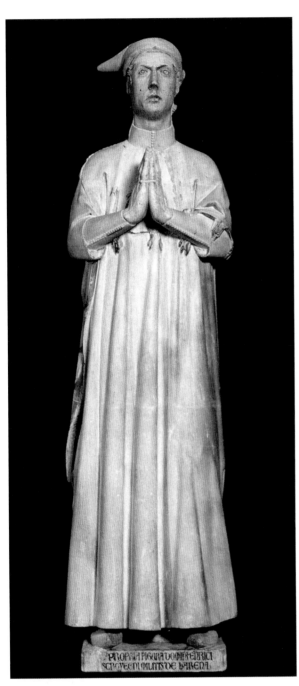

Fig. 3.2 Statue of Enrico Scrovegni. Courtesy of the UC Berkeley Historical Slide Library (est. 1938–2018), Baxandall & Partridge Collection, Doe Memorial Library in Berkeley, California, USA.

into a future state of perfection. Still hauntingly naturalistic in style, down to the eyelashes and the thinnest transparent textile stretched over the moneylender's ear, as an apocalyptic image it must also be more perfect than a portrait of the man in life. This image illuminates itself in the context of Scrovegni's self-fashioning funerary campaign and the efforts of his heirs after his death. The project was nothing if not ambitious: setting stage for an artistic personality cult, an investment for the boldly individualized celebration of Scrovegni's life, death, and afterlife.

Three decades before his death Scrovegni had made preparations to position himself and his family for the rest of time in this space of promised eternal blessings. One of the few certain facts about Scrovegni's roots is that his father Reginaldo had acquired a large fortune through moneylending.[12] Enrico's political ambitions were controversial, as one learns from Giovanni da Nono's unflattering descriptions of Scrovegni's dramatic performances before the Paduan councilmen. A citizen and occasional inhabitant of Venice as well as of Padua, in 1320 he fled the latter voluntarily, briefly and unsuccessfully returning in 1328, just to leave again. He lived in Venice until his death in 1336, but never gave up on the idea of his final resting place in his chapel in Padua.[13] He eventually succeeded in arranging for his body to be transported back there, postumously finalizing his great campaign of visual-material memory.[14] The chapel, in the end, allowed the parvenu moneylender to stabilize his power and legacy.

Alongside the indulgences granted by the Pope already in 1304, the chapel presented Scrovegni's greatest triumph in asserting his own legitimacy and justifying his financial business. Blending personal and family ambitions, the chapel celebrated the Scrovegni and presented them as moneylenders, yes, but as moneylenders with morals and virtues – despite some of the telling coats of arms on one of the disemboweled sinner's money sacks painted in Hell. The chapel was thus yet another negotiation; it had to bridge the ideals of humility – as exemplified in Mary and Jesus – and Christian poverty with the pride and riches of the earthly Scrovegni. The dedication as "Santa Maria della Carità" serves this purpose, insisting

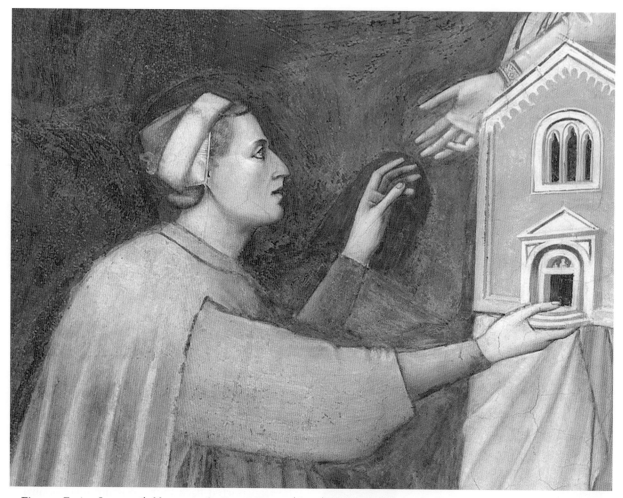

Fig. 3.3 Enrico Scrovegni's likeness in the *Last Judgment* (detail). Courtesy of Steven Zucker.

on the idea of *caritas* as the most generous kind of love and antidote to greed, envy, and jealousy that lead to sinful, self-destructive behavior.[15]

The Scrovegni family appears in the chronicles with a suspiciously short family tree, naming only Enrico and Reginaldo.[16] Ascending the social ladder, Enrico married the daughter of Bonifacio da Carrara.[17] After her death, he espoused another well-connected noblewoman, Iacobina d'Este, daughter of Orsina degli Orsini.[18] Through these family connections, Scrovegni's second marriage associated him with the Roman *curia* around Pope Boniface VIII.[19] His spiritual social climbing was no less ambitious. Scrovegni had probably joined the lay brotherhood of the Cavalieri Gaudenti – which was based on an Order inspired by

Augustinian rule – and was already donating to the Augustinians in Padua.[20] His lack of an ancient, refined, or even just socially acceptable ancestry, alongside his questionably acquired wealth, ultimately targets Padua's cultural pretensions towards the local ruins of the ancients. Enrico's investment in a classicizing monument accorded with all the standard measures and models of personal tradition building of his times. The look of ancient nobility in his chapel strengthens the entire family's position with the explicit integration of his personal individual and genealogical imagery into a powerful collective narrative of Padua's own inherited ancient Roman grandeur. One can thus see the multiple materializations of the donor within the chapel as

promoted by his living self (and continued by his successors) within a larger narrative of historical change, *translatio imperii*, and conflicting tales of pride and humility.

Scrovegni's three effigies manifest their subject matter – their model – in different materials, media, and places within the chapel, in two and three dimensions. With both the standing statue and the fresco, it becomes apparent that Scrovegni had planned to surround his corpse with numerous likenesses as if to illustrate and to project different versions of himself, each signifying a different state in the sequence of spiritual progress made by his body and soul through life and beyond death. Equally multi-layered is the text of the inscription from Scardeone's collection of Paduan epigraphs, which speaks about his choice of the ancient arena as the ideal place for his project; about his status (knight) and his soul (saved); and about his and his family's ultimate claim for legitimacy (celebrating a feast for the Virgin Mary). The inscription, rhymed in dactylic hexameter couplets, is both classicizing and medieval in style and affords invaluable insights into this commission. It declares Scrovegni's ambition and intentions – desire for a lasting place in history; intended religious legacy – in five essential steps. First, the Roman triumphal theme reveals the powerful place and cultural capital he was appropriating ("This ancient place, called by the name Arena, becomes a noble altar, so full of divine majesty, to God. / Thus God's eternal power changes [earthly] fortune, and converts places filled with evil to honest use. / Behold, this was the home of abominable heathen, which was destroyed and sold over many years, and is [now] wondrously [re]built.").[21] Second, the triumph over earlier local elites – such as the now defeated Dalesmanini, who erst had let the arena fall into ruination altogether ("Those who led a life of luxury in happy times, their wealth now lost, remain nameless and mute") – emphasizes his moral superiority over

others who had neglected to adequately convert the ancient site. Third, in this same passage, the idea of being responsible for a better use of the Roman arena resonates and aligns with the model set by the Frangipani at the Colosseum. Fourth, the self-fashioning as a knight ("But Enrico Scrovegni, the knight, saves his honest soul. He offers a revered festival here. / And indeed he had this temple solemnly dedicated to the Mother of God, so that he would be blessed with eternal mercy.") enables him to preemptively assume a status to which he aspired. And fifth and finally, the explicit phrasing of rededicating the "temple"[22] demonstrates an awareness of the Christian appropriation in the act of converting ancient traditions – a literal building upon the illustrious ruins of Patavium.

While, after the death of the man, Scrovegni's decaying body was out of view, visitors to the chapel could admire him as he had been in life (standing statue), as he was in death (tomb statue), and as he would be one future final day under the eyes of Mary and Christ (mural). This is where Scrovegni's chapel portraiture conceptually shifts into the realm of projection. The strategically placed and materially diverse effigies function as a group in their diverse placement and media. With all of them at once in one place, as may have occurred in the late Trecento, Scrovegni's presence would have been almost overwhelming – a quasi-omnipresence of the *pater familias* in the Palazzo Scrovegni's chapel. The extraordinary combination of painterly and statuary programs would lead the visitor's gaze back and forth between sculpted and painted portraits. Giotto's frescoes were not intended to be seen alone – now long deprived of the polychrome standing sculpture, the *Man of Sorrows* relief (Fig. 3.4), and the large painted triumphal cross (see Fig. 2.22). These objects commented upon one another through their presence, materiality, and subtle illusionism, and, in turn, reflected upon the hyper-illusionistic stone painted on the walls.

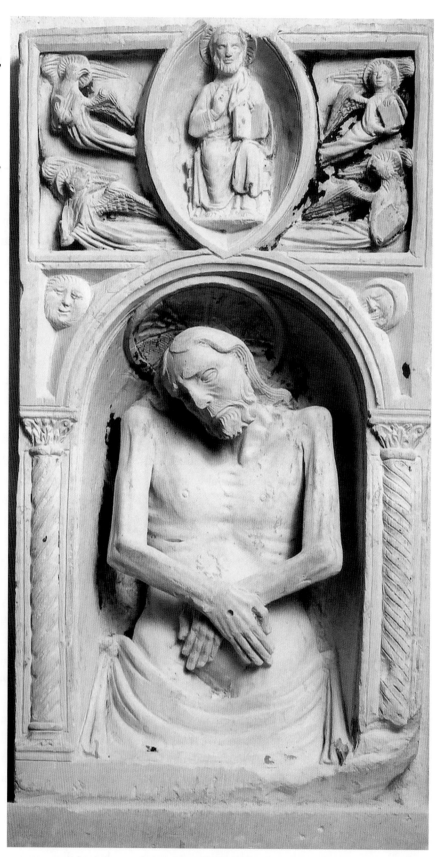

Fig. 3.4 *Man of Sorrows* relief, Arena Chapel (Sacristy), Padua. Courtesy of the UC Berkeley Historical Slide Library (est. 1938–2018), Baxandall & Partridge Collection, Doe Memorial Library in Berkeley, California, USA.

The inscription raises the themes of wise investment, pride, and humility.[23] This necessitates a conceptual triangulation of Scrovegni's subject position: the significance of financially produced prestige in relation to pride and in relation to humility. "A lever," as Simone Weil writes in *Gravity and Grace*: "We lower when we want to lift. In the same way, 'He who humbleth himself shall be exalted.'"[24] Following the upside-down reversal of worldly values in Christ's Sermon on the Mount, when pride goes down, humility goes up, and vice-versa. This action is a spiritual effort, but Scrovegni, like so many medieval patrons, attempted to activate and to sustain the process with money – to buy Salvation. Scrovegni was particularly in tune with the papal initiatives of his time, especially with the first Jubilee, which hinged on the payment of indulgences.[25] Contemporary trends seem to have provided some justification for presenting an unabashedly stylized image of himself – an ambitiously staged concept of humility perfectly projected onto the walls of the most "pompous" private chapel interior of his time, to recall a well-chosen word from the Eremitani neighbors' complaint.

This leads ultimately to the value of perfection in Scrovegni's orchestration of his image (or images) and public persona. The inscription's voice aspires to humility and discloses the contradiction of this undertaking – "*he* had this temple solemnly dedicated to the Mother of God, so that *he* would be blessed with eternal mercy."[26] While this passage leaves little room for interpretation, the final four lines contain an overlooked detail with their remarkable insistence on the date of the consecration: "When this place is solemnly dedicated to God, the year of the Lord is thus inscribed: / In the year 1303, when March had conjoined the feast of the blessed Virgin and the rite of the Palm." The extraordinary importance of this statement for the entire program relates to the coincidence (or rather marriage – *coniunxerat* in the original Latin) of two ecclesiastical feasts.

These recognize the Annunciation and the entry into Jerusalem on Palm Sunday – two moments that represent the highest triumphs of humility of Mary and Jesus, a perfect illustration of how the apparent contradiction in terms between triumph and humility is essential to Christian doctrine, ironically now serving Scrovegni's attempt to insert himself into established Paduan processional rituals.[27]

How could Scrovegni, the power-driven moneylender, have related to Mary and Jesus? Through the act of donation and through the act of perpetual prayer, as symbolized in his standing oratory statue, certainly. But Jesus Christ is not as extreme a reference for Scrovegni, preparing for his own afterlife, as it might seem. Jesus, after all, served as a model for every Christian believer. Scrovegni would have shared the same general hope for Salvation that Jesus promised for everyone, sealed with the most painful moments of his life as commemorated on the walls of the chapel. A famous passage in Colossians 2 promises that sins will be nailed on the cross "like legal indebtedness," connecting the cross and the forgiveness of sins with a monetary metaphor – that of disarming worldly powers and authorities, and ultimately of the triumph of the cross:

> 13 When you were dead in your sins and in the uncircumcision of your flesh, God made you alive with Christ. He forgave us all our sins, 14 having canceled the charge of our legal indebtedness, which stood against us and condemned us; he has taken it away, nailing it to the cross. 15 And having disarmed the powers and authorities, he made a public spectacle of them, triumphing over them by the cross.[28]

Jesus, too, is of course depicted by Giotto multiple times in life and in death in the chapel: most vital as a social revolutionary chasing the merchants and moneychangers from the Temple (Fig. 3.5), and most still as a statue in the

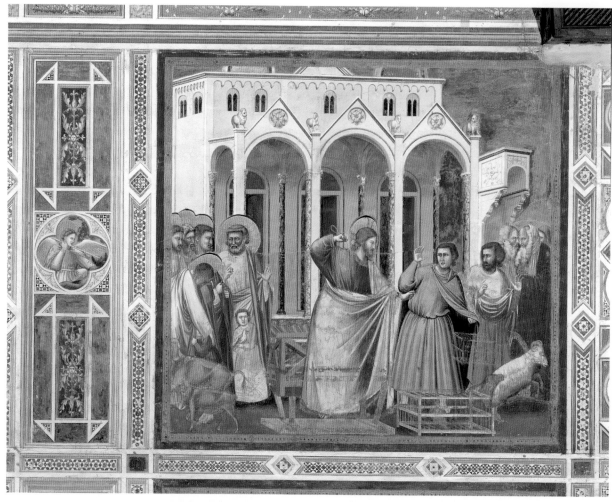

Fig. 3.5 Arena Chapel, *Jesus Chasing the Merchants and Moneychangers from the Temple.* Scala / Art Resource, NY.

Lamentation – like a *gisant* figure – where his petrified body is surrounded by the palpable horror of those he left behind (Fig. 3.6). As Jesus appears on Earth in a human body, lives, fulfills his mission, suffers, and takes on his predicted brutal death on the cross to overcome death, his Resurrection is the path of every soul following him; the joyful outcome for the Blessed is illustrated in their serene smiles on the chapel's west wall. The *Last Judgment*, however, also emphasizes the difference between Jesus as man and as heavenly emperor who went through the whole cycle of existence and experience before human beings could follow him: Centrally positioned, giant, he appears as a judge dividing the Blessed from the damned.

Housing the donor three times in multiple effigies and finally also in the form of his physical remains, the chapel builds momentum and legitimacy for Scrovegni's own legend. The alignment of Padua with Rome and the local cultural interest in its pagan heritage offered an ideal environment for anchoring this private ambition in collective memory. It seems quite likely that Scrovegni's pronounced interest in his own personal association with the Roman roots of the Paduan site, as an inhabitant of the Paduan arena, would have suggested to himself and others an association with the noble Roman family of the Frangipani as the rulers at the Colosseum. This connection with the Roman arena would have raised Scrovegni over the former local nobility in

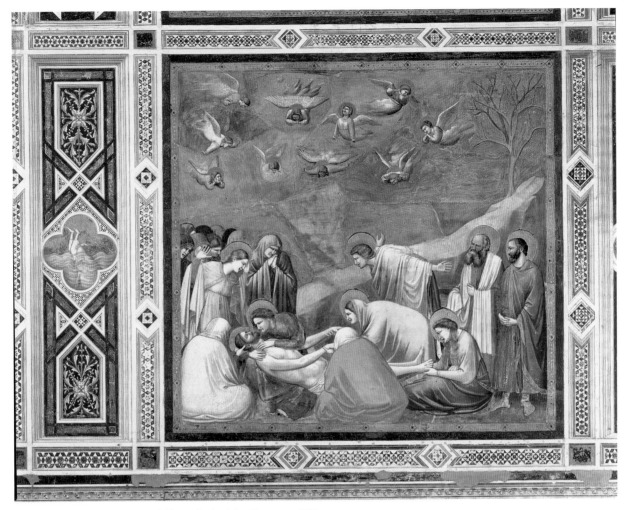

Fig. 3.6 *The Lamentation of Christ*. Scala / Art Resource, NY.

Padua such as the unlucky Dalesmanini, the former rulers at the Paduan arena. Scrovegni, we might imagine, born a relatively small fish in a small pond, would be transformed through the magnificence of antiquity to his desired status – that of families such as the Frangipani – and, thereby, to close association with ancient Roman pomp, power, and permanence.

Scrovegni's moment coincides with a particular phase of establishing neo-classical culture throughout the universities in Italy – a development that stood in tension with the dominating ecclesiastical powers – and the emerging financial system that enabled common Christian families, such as the Scrovegni, to participate not only in the business of moneylending but also in the complex realms of social and liturgical trade. In the chapel's original inscription such sentiment is expressed in the imperative of making good use of the remains of antiquity via moral superiority and an exorcism of the demons of the pagan past.

If he acknowledged and sought to associate himself with the glories of bygone empires, Enrico Scrovegni was equally oriented towards the future, building a palace to house his family in life and a chapel to house the next generation in death. The artistic enterprise of the chapel, Giotto's triumphal cross, the fresco, the statue, and the funerary monument would ultimately

highlight this ambitious father's *imago* for his heirs in the first place. Yet Scrovegni's gesture would be understood centuries later, in traveler's accounts and history books, as the shrewd opportunism mocked by tourist guides up to the present day. The man is central, and it is his likeness in fresco that makes him so: present and available to the gaze as if seen by some improbable eyewitness to the Apocalypse. The standing statue, with its seemingly naïve polychromy, has been deemed old-fashioned and pushed out of sight. Raised high on the tomb monument, the peaceful *gisant* was always less available to the gaze. Ultimately, Giotto's fresco – presenting the least material and most perfected, idealized image of Scrovegni – has visually superseded all other representations. This particular triumph of painting, however, is to the detriment of the subtle messages sent by the multiple Scrovegnis, which together comment on matters of time and materiality in the faux relief space when seen in their original contextuality.

Giotto depicts Scrovegni's personal last judgment, the moment of weighing the sums of his good and evil deeds against one another. Here the businessman can offer God what he has to show for himself: The chapel, shrunken to the size of an architectural model but complete with fine white stone ornaments on its sandy brick façade, Scrovegni holding it so intimately that his thumb enters the front door under a minuscule lunette relief of the Madonna and Child. The Augustinian canon holds the model up on his shoulder so that Scrovegni can kneel freely, appearing in the act of humbly lowering himself but maintaining eye contact with Mary and the saints who appear on the same scale. Neither of the two men appears dwarfed before the majestic saints as is usually the case in medieval paintings of donor figures. Scrovegni thus shows himself as the inscription describes him – proud of his humility and certain of his

eternal profit. Giotto portrays not the man, but what the man will be in perfected form. Scrovegni's flawless features on the wall barely resemble those on the naturalistically conceived standing statue. It is as if the less than perfect statue's perpetual act of prayer for Scrovegni and his family's souls is imagined as already fulfilled in Giotto's daring iconography – *Last Judgement with Humble-Proud Donor*. The flaws of the moneylender and his shrewd actions, as proto-Machiavellian as the chapel is proto-Renaissance, are cleansed from the vision of him in which he encounters the Virgin Mary. He cannot be his earthly self – an accumulation of virtues and vices – anymore but is depicted as good as he will get beyond world, time, and history, in a painter's vision commissioned to make the labor of the afterlife appear as if it has already been accomplished.[29]

By now, the collective memory keeping Scrovegni alive is global. This best version of him has long become an emblem of medieval art and beauty, naturalism and power, to be taught in Western art history surveys as the first portrait of a Renaissance (or a proto-Renaissance). It is this outrageously self-righteous scene that would be critically quoted, undermined, and reversed in Pier Paolo Pasolini's *Il Decameron* (1971), in the dream of the painter with Pasolini himself in his self-portrait role as Giotto. The perfected projection of Enrico Scrovegni participates in early modern as well as modern art and art history, the UNESCO world heritage, and modern theory on "Giotto's Joy"; it is indeed appearing in academic discourses far removed from medieval Padua. The historical Enrico Scrovegni confidently anticipated "eternal mercy" for himself. Paying Giotto in life to show him after death, the young Scrovegni, more beautiful and pure than he had ever been, he succeeded in being seen and remembered as that better version of himself to the present day. His

classicizing campaign, most likely constructed in a bid for acceptance among the noble families in Padua, in Venice, and in the Veneto – as well as at the elites around the papal court and other visitors to his new oratory – now reaches far beyond the ancient cities of Padua and Rome.

RUINING THE DALESMANINI

Seen through the lens of Scrovegni's historical ambition, his chapel's history can be told as a tale of two cities and three families: Rome and Padua, harboring the memory of the Frangipani and the Dalesmanini respectively, and the Scrovegni – still without a place and without roots – moving between both cities and turning this very mobility into an assumption of legitimacy. Scrovegni's short family tree, lacking glorious tales of any actual connection to the ancient heritage, and his attempts to compensate for this lack suggest his chapel as a satellite project to "Roma 1300," aimed at connecting him and his heirs to the venerable cities' nobility and at establishing a sense of visual and monumental – if not actual – nobility in the local environment. The few surviving documents attest to this, specifically with respect to the close temporal connection to the Roman Jubilee; to the association with the Roman papacy; and to the theme of humility, with Scrovegni's documented acquisition of the arena on 6 February 1300 and by the early papal approval for indulgences of 1 March 1304. The social mobility of Paduan banking families and their complex relationship to Rome suggest that, for someone like Scrovegni, the act of replacing an older and well-established local family via financial ruination was only possible by the way of appropriating the entire city, or more precisely, the idea of the entire city.[30] Rome and Padua, their ancient *castrum* grid with the local ruins of their respective *arene* establishing an undeniable set of

references, claim mutual continuity and legitimacy through the visual and spatial mirroring of spaces, places, and monuments. With people still moving through those spaces, this is by no means a bloodless rhetorical maneuver, but a powerful living connection.

As mentioned above, Scrovegni's patronage of ancient Roman ruins takes place in the context of a local cultural-intellectual movement. At the time, Padua outclassed Florence in terms of classical studies: The roads leading to Rome also led to other Roman and Roman-heritage cities, which were by the thirteenth century university cities – Bologna, Paris, Cambridge. This Europe-wide network of medieval universities and the mobility of scholars among them enriched the discourse of local theologians. Thus, through Alberto da Padova and his teachers there were further connections to monumental and distant intellectuals such as Duns Scotus and Robert Grosseteste, also as sources and inspiration for the astrological knowledge visualized in the Arena Chapel and Giotto's scientific program for the Palazzo della Ragione.[31] In the chapel, the artificiality of the faux relief scenes is interspersed with hyperrealism: The sudden appearance of Halley's comet on the sky of the *Adoration of the Magi* (Fig. 3.7) captures a contemporary naturalistic phenomenon observable in 1301/1302.[32]

The University of Padua had its early, cosmopolitan proponent of philosophical, medical, and astrological materialism – topics for which the university would become a renowned center in the fifteenth century – in Pietro d'Abano (c. 1257–1316). Pietro studied and taught in Constantinople, Paris, and Padua, where he died in 1315, apparently in an Inquisition cell. This might be all the more reason to imagine an Augustinian like Fra Alberto da Padova steering the chapel towards an Augustinian rebuff against Aristotelian presumption as recycled by Aristotle's Arabic and scholastic followers (Pietro d'Abano had published works on

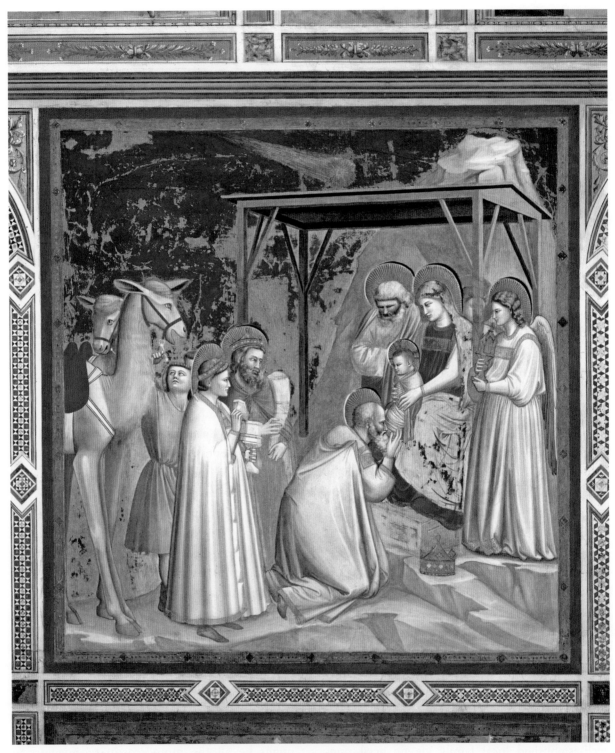

Fig. 3.7 *The Adoration of the Magi.* Alfredo Dagli Orti / Art Resource, NY.

Alessandro d'Afrodisiade, Aristotle, Galen, Dioscorides, and delivered a Latin translation of Abrāhām ibn ʿEzrāʾs astrological texts). There is obviously much more to say about the famous proto-humanists reviving antiquity in Padua, like Lovato Lovati (c. 1240–before 1281) and Albertino Mussato (1261–1329), and about the political precariousness of Padua (and Scrovegni), caught

between Verona and Venice. In any late medieval Italian city, but especially in Patavium/Padua, the contemporary worldly, scholarly, and ecclesiastical powers with their varying kinds of financial, intellectual, and spiritual investments all benefitted from an understanding of the Roman city they inhabited as a gateway to its formidable ancient ghosts. This dynamic informs William Bouwsma's influential 1975 essay "The Two Faces of Renaissance Humanism: Stoicism and Augustinianism in Renaissance Thought." Bouwsma's Renaissance culture is not a breakthrough to a Brave New World but a culture of tensions and contradictions, something recognizable in Scrovegni's push and pull with power and tradition under the rubric of Augustinianism:

> With Stoicism we must begin with the cosmos, and this in turn implies with a certain view of man. But with Augustinianism we must begin with man; the nature and experience of man himself limit what can be known about the larger universe to which man belongs and how he can accommodate to them. Man is not to be seen in a system of objectively distinguishable, discrete faculties but as a mysterious organic unity riven in different directions.[33]

Giotto's Scrovegni project is indeed based on the experiential dimensions of the beholder moving into and through the space, looking closely, verifying by touch the actual matter of the painted reliefs at eye level – in short, the chapel displays a degree of sophistication that suits the intellectual context of the old university, disputing elements engaged with theology, history, philosophy, and art.

There is a tradition of visual thinking in Padua that seems to have enabled this kind of work of the eyes – an insistence on visual intelligence in the intellectual environment around 1300. The university already had a pre-history of scholarly endeavors before its official founding in 1222,

eighty years before the planning of the Arena Chapel.[34] As this is the university with the oldest teaching museum collection in the world, one can expect sophisticated visual thinking and an appreciation of objects in the production of knowledge.[35] More importantly, the Agostini were responsible for teaching in pre-university Padua. The local libraries kept copies of the relevant texts. Padua thus reveals itself as an intellectual environment with the capacity to inaugurate a unique renaissance of a classical triumph set within a self-conscious Christian system of thought. The use of artistic objects in the university's curriculum shares the underlying idea of visual didactics aimed at the educated general public.[36] Their eyes and minds would have been ideally prepared for the Arena Chapel's challenge to the Arch of Titus in terms of materiality, visuality, and embedded natural history, with its details and strategically placed visual ruptures leading the spectator from recognizing the optical illusion of palpable matter to the idea of the invisible.

Even without recognizing the Arena frescoes' potential for visualizing a specific Augustinian content, Michael Alpatoff senses the spirit of the Apostolic Age – of early Christianity – which was revived at the same time in Padua.[37] This wider theological trend conveniently interlocks with Scrovegni's ambitions and the papal celebrations. As detailed above, the moneylender was not known as a humble man. Yet the many themes represented in this interior and the chapel's stylistic kaleidoscope all align in visualizing *humilitas*. Independent of its patron's personal history, the chapel offers once again a profoundly Augustinian theme: grace as a check on pride.[38] A then widely dispersed pseudo-Augustine axiom maintains indeed that it is pride that turns angels into demons, and humility that turns humans into angels: "Humilitas homines sanctis angelis similes facit, et superbia ex angelis demones facit."[39]

THE JUBILEE IN ROME AND SCROVEGNI'S SATELLITE PROJECT IN PADUA

The visual, liturgical, and ritualistic aspects that link the Jubilee and Scrovegni's satellite project are so strong that they can be disentangled historically and thematically beyond the tracing of precise social relationships and personal responsibilities. The connection hinges on the idea of a triumph amid ruins, in tune with the core themes of the New Testament as well as with the local intellectual trends of the Paduan proto-Renaissance. This kind of paradoxical celebration lends itself to the creative reenactment of Christianity's inherent dynamics of trauma and transcendence, suffering and redemption. As innovative as the chapel is in its broken vault aesthetics and implicit illusionistic reflection on media, its core rhetoric follows the most basic theological norms and standards. As early as the fourth century, Christians had responded to the hubris of Titus's apotheosis with a remodeled arch vault that holds a central image of a God, now showing Christ with the Alpha and the Omega in the Cubiculum Leonis (Catacomb of Commodilla, see Fig. 1.5). Popes in medieval Rome had learned to fashion themselves as the ultimate victors of history by performative humility. In her book *Imago Triumphalis*, Margaret Zaho notes that a predecessor of Pope Boniface had already "usurped [. . .] the classical triumph" a century earlier: "The triumphal procession of Pope Innocent III in 1198 exhibited a concentrated effort to revive the style of the classical triumph" – in his case, riding on horseback through the city.[40] It becomes more and more apparent that Boniface's procession in Rome and Giotto's conceptual triumph in Padua both insert themselves into a long trajectory of Christianized enactments of the Triumph of Humility. The most surprising aspect is that a wealthy donor in the North, lacking a noble or deep-rooted family tree, could make use of such traditional systems of visual communication to undertake a carefully orchestrated satellite project that would connect him and his city to ancient and Christianized Rome. In the end, however, he was simply following long established practices of pilgrimage.

Further mechanisms of medieval pilgrimage and placemaking can be unpacked in the material and liturgical context that relates Rome and Jerusalem. As described in Chapter 1, the Menorah was thought to be kept in Rome under the altar of the Basilica of Saint John. Kessler and Zacharias connect the Judaica relief and the prophecies of Christ rebuilding the Temple:

> The New Testament justifies the conquest of the Jewish Temple. In his Gospel, the Evangelist Mark reports that Christ vowed to "pull down this temple, made with human hands, and in three days build another, not made with hand" (in Greek, *acheiropoieton*; 14.58). And Mark introduces the dramatic image of "the curtain of the temple torn in two from top to bottom" at the moment of Christ's death (15.38). When the *Acheropita* passes beneath the arch depicting Titus's victory each year, it thus states the message that Christ had fulfilled the prophecy recorded in Mark's Gospel. In so doing, it also recalls the supersession of the temple cult of the Jews by Christ's sacrifice and reminds the citizens of the "New Jerusalem" that pagan Rome, too, had a preordained role in God's sacred plan.[41]

This problematic passage leads to the appropriation of the Judaica in the Lateran's shrine. The "idea of constructing a Holy of Holies at the Lateran" forms yet another link to the construction of biblical-Roman sites in Padua, on the one hand working within a chain of references of equivalence and, on the other, building on formal and historical-geographical

appearances.[42] No other place or object, however, offers such a sophisticated, coherent, and absolute response to Flavian imperial pride combined with such a degree of self-reflexive media criticism as does Giotto's chapel.

As Marie Champagne has demonstrated in her studies on the medieval rites around the Arch of Titus, all these acts of appropriation of Jewish holies in a Roman context happen on the basis of twelfth-century assertions of papal authority over this particular arch that would have been most obviously exerted when the Pope led his *Adventus* through the relief-laden bay. The Via Papali route, taken for papal elections and pilgrim itineraries as well as later Jubilees, habitually included passage through the arch with the Menorah relief. Given the typological charge of the movement of the Pope and his followers through the city and through the Arch of Titus, impressions gained from a ceremonial vantage point appear to provide the most accurate understanding of what the arch meant to viewers in the Middle Ages.[43] The station churches and associated stational liturgy served to reinforce the entire system of narratives (travel guides, itineraries, clergy, pilgrims, papal liturgies) framing the Arch of Titus in its Roman-Christian context. Early churches built in the Roman Forum since the fifth century include Santa Maria Antiqua al Foro Romano (right next to the Arch of Titus), Sant'Adriano al Foro, San Teodoro al Palatino, and Santi Cosma e Damiano (formerly Temple of Romulus). In addition to these, the Gregorian stational liturgy from the early seventh century onwards also lists Santa Maria Maggiore, San Giovanni in Laterano, Old Saint Peter's, and the Arch of Titus as stational churches.[44] According to liturgical records on the Lateran Basilica as the New Temple, since the fourth century there was a palpable connection to Judaic tradition in form of the wooden altar that Saint Peter had used – which bore a similarity to the Ark of the

Covenant, as the *Descriptio Lateranensis Ecclesiae* claims that both Ark and Menorah were within or beneath the altar. Mass on a Holy Thursday was described as being celebrated after the removal of the table top from the altar, the opening of an ancient wooden box, and the display of relics; the celebration of the Eucharist on the closed box could be read as an intentional transforming of Ark into altar.[45] Once again transubstantiation is the leading principle that connects the discourse of Christian rites in relation to ancient Roman pagan and ancient Jewish traditions.

The strong Mariological tendencies of the Scrovegni Chapel are gathered in its name, Santa Maria della Carità. These ultimately merge with a central moment in the Roman Jubilee procession when the Marian highlight of the procession took place, right after the icon of Christ passed through the Arch of Titus. This moment presented the processional reenactment of Christ's meeting with his mother, which was celebrated with these two most sacred icons immediately after turning from the arch's bay towards the nearby church of Santa Maria Nova. Since the earthquake of 847, Santa Maria Nova had replaced the fifth-century church of Santa Maria Antiqua al Foro Romano, the oldest Christian monument in the Roman Forum. Today dedicated to Santa Francesca Romana, the building partially covers the platform formerly bearing the double Temple of Venus and Roma. These monuments – in conjunction with the nearby Basilica of Maxentius and Constantine – make the Velia one of the most prominent areas in Rome for the display of the uneven seam between pagan and Christian Rome, and their complex and layered material relationship. The historical transition shows in the basilica's double naming after the pagan emperor, Maxentius, who began the building, and the first Christian emperor, Constantine, who finished it after having triumphed over

Maxentius at the Milvian Bridge in 312. Significantly, in the experience of Jubilee pilgrims, at this end of the Velia was the place (Kessler and Zacharias continue) "to catch [...] a first glimpse of Pope Boniface and to witness a first reenactment of Christ's meeting with his mother."[46] I propose that the idea of this meeting of the *Acheropita* with the ancient image of the Virgin and Child is translated in the two vaults of the Arena Chapel, and that Giotto's design responds to the entire Jubilee procession as much as to the Arch of Titus.

Christianized temples from antiquity are still visible all over Rome – most prominently in the Pantheon's dedication to all martyrs. The transformative, triumphant act of rededication is memorialized in church names such as Santa Maria sopra Minerva on the Campus Martius or Santa Maria in Aracoeli on the Capitol, at one end of the Forum, and in the processional point of arrival, Santa Francesca Romana, at the other. No Roman temple could be left as such across the increasingly Christianized former empire. A living memory of heathen antiquity overcome was thus preserved all over Italy in 1300 as it is, if more remotely in time, today.[47]

In terms of Christian architectural iconography, the Arena Chapel project stands very much in conventional accordance with other medieval campaigns to establish a political or theological connection to Rome as a historical power and to Rome's prime sites of pilgrimage. *Padua alter Roma* boasts the same classical distinction of historical relevance that Florence, Siena, and Paris would claim for themselves. The building of Holy Sepulcher sites with actual architectural objects or even just by gesture was furthermore a common practice in medieval Europe, often echoing Jerusalem in image or in symbol.[48]

In Scrovegni's Padua, indulgences to be granted by Pope Benedict XI as early as 1304 indicate that his arena project was envisioned as part of the Roman pilgrimage system. Perhaps the

initiative was even geared towards its inclusion in the north-eastern route to Rome,[49] with the Santo in Padua already well established as a center of reliquary veneration for Saint Anthony. The high symbolic value of the ancient site – for its Roman legacy, local liturgies, and the former owners' usurped prominence – has been acknowledged in scholarship.[50] It might not be a coincidence that the Eremitani's complaint is indeed phrased in the wording of ancient triumphal rites: "contra opere *ad pompam et ad vanam gloriam*,"[51] a telltale for the association with "tota illam pompa."[52]

The triumphant theme appears more and more as a historical constant from late antiquity through the Middle Ages into modern times,[53] and Giotto places triumph at the very center of the Arena Chapel with his commanding *Crux Triumphalis* mentioned above (Fig. 3.8 and see Fig. 2.22). Based on images such as the Assisi *Presepio di Greccio* as well as on the archaeological evidence, there are several hypotheses about where and how this triumphal cross would have been suspended or attached to an iconostasis: right under the chancel arch or in the middle of the chapel – that is, under the painted marble transverse arch and therefore between the two precincts of the vaults, between the two arches. An argument for the latter is that a position in the middle would have enhanced the visibility of the cross's unusual and extremely carefully painted reverse side. Amplifying the chapel interior's systematic language of stone, the back of the wooden crucifix was also painted with imitation moldings and faux stone panels holding the Mystical Lamb and Evangelists. This decoration, unique among such crosses, is in absolute synchrony with the chapel's marbled incrustations, as one can see in the remaining patches of the paint and its reconstruction. The cross thus assumes the same faux marble covering displayed on the dado zone, the painted framework, the lintels, and the windows. Its

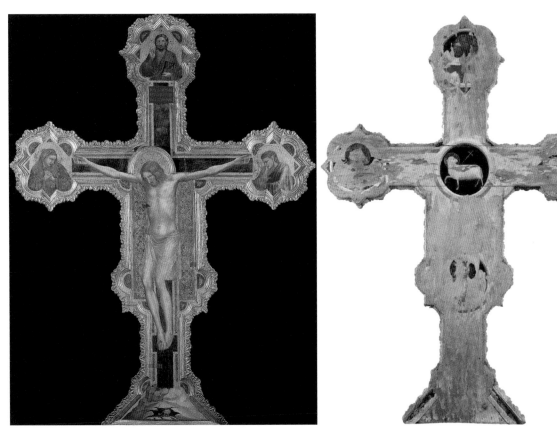

Fig. 3.8 Giotto di Bondone, Crucifix, recto and verso, Padua, Museum. Courtesy of the UC Berkeley Historical Slide Library (est. 1938–2018), Baxandall & Partridge Collection, Doe Memorial Library in Berkeley, California, USA.

positioning in the center of the chapel's bay would, furthermore, have recalled the sight of many Christianized ruins of triumphal arches across the former Roman Empire.

Via its multi-faceted Roman references, the Paduan oratory hence repeats what Roman Christians and Christian Romans had been establishing for centuries, namely, the integration and synthesis of their pagan imperial heritage with a Christianized vision of history in architecture, ritual, liturgy, poetry, and rhetoric.[54] The aspiration to a *translatio imperii* through Roman triumphal imagery, in particular, is not a new phenomenon circa 1300. The theme of the triumph was rather passed down in numerous waves of Christianized "Renascences" (in the Panofskyan sense) throughout the Middle Ages.[55] With local processions through the arena leading into the chapel, the Scrovegni project

interlocks with what Paul Zanker has identified as the core function of ancient feasts, detecting the central importance of the public celebration of the Roman emperor's apotheosis in the transformation of spaces and monuments that, in turn, keep the memory of the feast alive through ongoing ritual.[56] In light of Scrovegni's alliance with papal Rome, his project participates in a specifically Roman way of appropriating and monopolizing the heathen past, similar to the Pantheon in architecture and musical liturgy,[57] as described by Susan Rankin in her essay "Terribilis est locus iste: The Pantheon in 609."[58] The Arena Chapel as a *coup de maître* organizing a visual Christian-Gothic cosmology under the integration of Byzantine elements within the formal conventions of an ancient Roman model would then be not much more than new wine in old bottles. The chapel is

absolutely unique, though, in its perfected technique of optically simulated relief in painting with total consequence throughout the entire room and its fictive opening, enabling a synthesis of styles and media that turns the interior space into a most sophisticated tuning system of appropriation. The simulation of painted relief as a self-referential and self-deconstructive medium employed for Giotto's triumph of humility iconography is what turns space, motif distribution, scale, and degree of simulation into vital quasi-iconologies – not to be read in a written format, but to be accessed by experience in space and time as factors in the structure of a monument. Giotto's appropriation in Padua is one not of matter but of reconciled statements and restored appearances. Instead of copying the ancient monuments, the chapel responds to them with its own vision of life, history, and eschatology.

The idea of the arch as a portal and passageway makes way for further symbolism. While the underlying typology of the Roman triumphal arch most probably derived from Etruscan portals,[59] Noack argues for the religious significance of the arch as a structure speaking to "sacral dimensions."[60] Elements of that sacrality can be found in the arch of the Arena Chapel as well. This new, illusionistic arch system can thus represent the portal that is the corporeal world and life, both of which need to be passed through in order to reach a higher spiritual level.

There are further parallels between the chapel and the arch insofar as each employs diverse modes of portraiture for depicting the heroes of their stories (Christ in the murals and Emperor Titus in the reliefs) at specific moments in their lives, spiritual development, and divinization. Comparing the appearances of Christ and Titus in these two monuments, we see walls that show the heroes of their stories in life and in their respective battles and triumphs in historical time; these literally and figuratively uphold the vaults with the images of the protagonists' timeless divinity. Diana Kleiner recognizes the coffered vault of the Arch of Titus as the "first apotheosis in monumental Roman state relief sculpture" (see Fig. 1.12).[61] The square penal at the apex of the vault, says Kleiner,

> includes a scene of Titus, dressed in tunic and toga, borne to heaven on the back of an eagle with outstretched wings. It is a representation of Titus's apotheosis because it depicts the emperor's soul carried heavenward by the eagle that was let go by an imperial slave at the very moment of the emperor's cremation. And it is this very apotheosis scene that is the true subject of the Arch of Titus because the arch is a consecration monument, not a victory monument or "triumphal" arch.[62]

Kleiner also points to noticeable differences in portrait style and idealization between Titus on the wall versus Titus in the vault:

> In the vault panel, his distinctive facial characteristics have been somewhat smoothed over, [...] the curly hair has been replaced with straight comma-shaped locks forming a cap [...]. [The] idealization and increased abstraction of the portrait of Titus can be more convincingly explained as the result of the emperor's new status as divus.[63]

This observation returns us to the different levels of portraiture in the walls and vaults of the chapel. There, historical apparitions versus eternal imagery determine the fashioning of central characters: The historical Christ on the walls, for example, contrasts with the Pantocrator in the vault. In a different context, Schwarz has recognized the distinctive styles that distance the wall-Christ from the vault-Christ: They look as if painted by different hands, yet both are surely the work of Giotto.[64] I distinguish multiple levels of portraiture within the chapel, following those within the arch. For the Titus reliefs, Kleiner

determines that "there is a portrait of Titus as a god in the vault of his arch and one of him at the high point of his life in the chariot scene just below."[65] In addition to the double portraiture of the chapel's spiritual hero, Jesus Christ, there is the bold, quadruple act in which Enrico Scrovegni eternalizes himself: frescoed, sculpted as a young man, sculpted as an aged dead man, and, finally, the fulfillment of his insistent testament: his own bodily remains, brought back from Venetian exile *et in Arena ego*.[66] Each of these instances – Titus in his reliefs, Christ in the frescoes, and Scrovegni in his effigies around the *Last Judgment* portrait – account for the changes in a human lifetime that connect a human being to their personhood in concrete manifestation and to their individual place in history. The lower registers of the arch show Titus and Jesus as men in the context of their respective worldly deeds; the vaults show them in a deified or divine status after having accomplished their triumphant acts.

The distinction between the two portraits of Enrico Scrovegni as a young man – the fresco and the statue *en orant* – and the two aged bodies of the man after death – his *gisant* and his bones – demarcate the difference between the deified status of Titus in Roman ideology and Christ in the context of Christian worship. The earthly man makes sure that the stages of his aging are registered: He will have to wait until the Last Judgment to participate in eternal life. It is a bold act of self-representation, but it does not present Scrovegni as a deity, a Saint, or God. Rather, all appearances of Scrovegni are superseded by Christ's own multiple and larger apparitions in the chapel: as baby Jesus incarnate in the west vault; as a historical figure in the many scenes along the walls; as the Pantocrator in the east vault; and as the Apocalyptic Judge on the west wall. This complex disposition is a riposte to the simple auto-deification of Titus. The topic of the chapel is the grace and hard-won sequential triumph of Incarnation, Ascension, and transcendence of

Christ as celebrated by Scrovegni – a Christian Scrovegni who aims to be held in high esteem by his fellow citizens, expected pilgrims, and illustrious visitors.

DYNASTIES AND RELIGIOUS CONFLICT FROM ROME TO JERUSALEM

The connection between these specific monuments – a chapel and an arch – is much less surprising in the medieval context of the arch. Then and there, it was serving the practical function of a gateway, bracketed by thick walls, and the spiritual function as a much-frequented stational church. The Arena Chapel stood in the same relation to the adjacent Scrovegni palace as the Arch of Titus did to Frangipani palace; the Arena Chapel points by direct proximity to the Paduan arena just as the Arch of Titus and the Arch of Constantine do to the Roman arena, the Colosseum (Fig. 3.9).

With this set of references from the heart of ancient Rome, from the height of the Via Sacra, and from the eminent authority wielded by the papal celebration of the First Christian Jubilee in 1300, the Arena Chapel could make a specific historical and theological point, suitable for Scrovegni's intentions to emulate the noble Roman Frangipani family in lifestyle, personal association, profitable marriages, and artistic commissions – of which the chapel, of course, was the absolute crown. History is always also family history. The family relations between Scrovegni's second wife Jacopina d'Este and the *curia* consolidate the documented Roman frame of reference. But through the notion of usury, Scrovegni's personal family interests appear to be engaged not only with the noble history of Rome and its contemporary families, but also with the spiritual power of Jerusalem, appropriating it to enact a Christian narrative that, in reality, performed

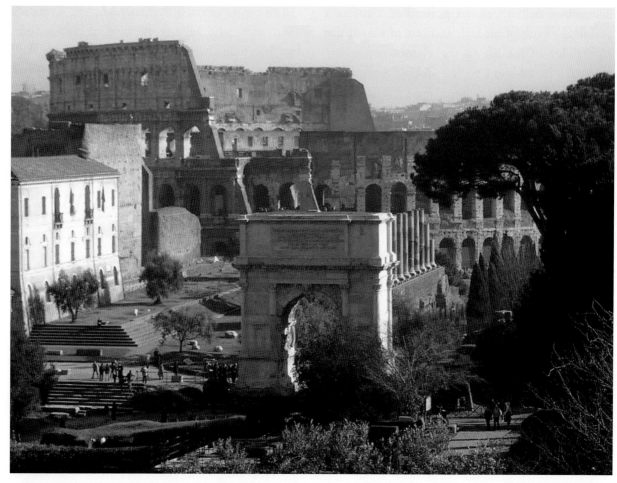

Fig. 3.9 View of the Roman Forum with the Arch of Titus and the Colosseum as seen from the Capitoline Hill, Rome. Courtesy of the UC Berkeley Historical Slide Library (est. 1938–2018), Baxandall & Partridge Collection, Doe Memorial Library in Berkeley, California, USA.

extreme injustices upon the Jews. As a notorious usurer, and appropriating a monument on the theme of the Roman-Jewish war, Scrovegni might have emphasized this interreligious conflict by highlighting the role of Judas as the most prominent opponent of Christ. This is most visible in the fraught kiss during the arrest of Christ and under the Annunciation on the chancel arch, where the *Pact of Judas* directly opposes the *Visitation* Scene, as Derbes and Sandona have shown so lucidly and convincingly.[67] The chapel has been shown to engage with the brutal ancient triumph over the Jewish people who continued to be subject to persecution in medieval times. The Duecento saw increasing anti-Judaism and anti-Semitic sentiment amidst worsening conditions overall for

the Jewish Diaspora in Italy and across Europe under Innocent III (1198–1216) and the Fourth Lateran Council of 1215. While the Menorah, stolen by the Romans under Titus, was thought to be held as a relic in the Lateran, the Menorah's sculpted image in the Arch of Titus became one of many symbols of Roman imperial power within the arch's iconographic scheme. In the light of orthodox Jewish aniconism, the relief panels within the arch showing the Menorah constitute a double offense to the Roman Jews. The Menorah's sculpted image marks the origin of this long established Jewish community's forced exile by the Tiber river.[68]

Recent exhibitions exploring the historical coincidence of Renaissance art and the

emergence of the modern financial system have opened the field for new research on the role of the Italian Jews in the financial market, their cultural importance, and their exposure to blood libel and accusations of usury in the Middle Ages.[69] In Scrovegni's chapel, the issue of *usura* appears to be merged with the iconography of the blind Synagogue (this detail depends on accepting Virginia L. Bush's identification of the veiled woman in black as Synagoga). In front of the *Golden Gate* (see Fig. I.6), she is the only one excluded from the joy around Joachim's and Anna's kiss:[70]

> If Giotto's two women are personifications of Synagoga and Ecclesia, they appear at a moment that precedes but anticipates Christ's mission. This explains why the dark-robed woman is in the process of blinding herself – to the Christian message – and withdrawing as if giving her place to the light-robed woman.[71]

With the *Altercatio Ecclesiae et Synagogae*,[72] the juxtaposition of Church and Synagogue is a fundamental topos in Christian art. Its iconography appears as early as the fourth-century paleo-Christian lost relief of the cross emerging from the Menorah, as scratched on a column fragment from Laodicea.[73] The conflict, soon visualized as two contrasting women around Christ or framing the Crucifixion, moves through medieval manuscript illuminations into Gothic sculpture.[74] The imagery of triumphs seems, as Nina Rowe has shown, to have been a preferred way for illustrating the relationship between Ecclesia and Synagoga, as in the famous case of the portal at Bamberg Cathedral.[75] In this case, it is a more fragmentary, object-based iconography in which the Bamberg version of Synagoga holds a broken triumphal banner in her hand.[76]

Giotto's frescoes depict clear divisions among different members of the Jewish people. This complicates a standard interpretation of the chapel as simply discriminating against pagans and Jews, or as stating a brutal Christian triumph over Judaism as well as over the Romans. Jacobus notes the variation in Giotto's depiction of members from the Jewish upper class,[77]

> [distinguishing] between those who have retained their innate nobility and those who have descended into coarseness. Jews who recognise the workings of God's plan or act in furtherance of it behave in a dignified manner, while those who oppose God's plan behave like brutes and villains.[78]

In this specific way of dividing the Jewish community – as recipients of representational empathy only according to their relationship to Jesus – the chapel's program suggests once again an Augustinian influence. Only Augustine defines the protection of the Jewish people as witnesses in *The City of God* XVIII, 46, referring the directive of Psalm 59:12: "Slay them not." His doctrine on the Jewish witness was fundamental for any potentially reconciliatory or tolerant attitudes of Christian authorities in Europe towards the European Jewish Diaspora.

To what extent can the Arena Chapel be understood as a statement about religious conflict? The Roman model behind the chapel's decorative scheme might have been chosen simply as a general emblem of triumph that could bear significance as showing the triumph of Christianity over the major spiritual competitors in the ancient world. However, the Titus reliefs specifically depict the atrocious pillaging of the Temple of Jerusalem, and one can expect from the devisor of such a historically complex program a full awareness of the knowledge of the Italian Duecento about the destruction of the Temple. By taking inspiration from the only arch in Rome that is the monument to the destruction of the Temple in Jerusalem, Giotto touches an open wound. With how much sensitivity would

an analogy have been drawn between the inherently brutal triumphalism of the Arch of Titus, that of the spolia-bearing first Christian Arch of Constantine, and that third way of the chapel's reconciling double arch of humility? In the absence of written documentation by the inventors of the chapel's program, this question cannot be answered, only explored.

There were church political interests that somehow would have had some direct or indirect bearing on this project. The Church at the time of the Jubilee would programmatically figure itself as triumphing in history over both Judaism and Roman paganism – and probably doing so especially as the contemporary Roman papal powers were themselves heading towards a historical disaster that would soon bring about the Avignonese exile. Then there was the idea of universality in the sources. In the place of the brutal, terrestrial, imperial apotheosis, one sees two instances of actual Apotheosis in the Christian account: Incarnation and Resurrection, as shown in the west and east vaults. One features the Son of Man, revealed in a physical stone frame through the earthly-human humility and maternal body of the *Madonna della Carità*; the other the Son of God, revealed only by spiritual vision, bridging the gaps between world, art, and eternity. Such doubling and replacement of the ancient apotheosis appear to be a necessary condition for Giotto's entire program. Only by debasing himself to the human level of existence, visualized in the west vault, can Jesus ascend as Christ, as visualized in the east vault. This implies a vision of all human beings united beyond divisions in the spirit of Paul's letter to the Galatians: "There is neither Jew nor Greek, there is neither bond nor free, there is neither male nor female: For ye are all one in Christ Jesus."[79]

Given its historical context, however, the chapel might also have constituted a specific, strategic gesture of disrespect and hostility towards Judaism and the Jewish people. It is possible, though no conclusive evidence survives to document this, that Giotto worked these unacceptable passages into the scheme in response to Scrovegni's interest in differentiating his own status as a (Christian) moneylender from the accusation of (Jewish) usury, contrasting the figure of Judas with himself, Scrovegni, as modelling a just investment and submitting the chapel like a monumental letter of indulgences.

If the Jubilee of 1300 was an inspiration for Padua and a success for Boniface VIII in Rome, it was also the Pope's last triumph before his utter humiliation and that of the Church and Christendom. Boniface was elected by hook, crook, and bribery after "il gran rifiuto" of Celestine V, the mystic monk, who resigned in 1294. In a series of escalating papal bulls, starting in 1296, Pope Boniface picked a losing fight with Philip the Fair of France that peaked in *Unam Sanctam* of 1302 with his claim for an imperial church in temporal as well as in spiritual affairs. In 1303 Boniface was arrested by the king's agents. He was imprisoned and tortured, and died ignominiously on 3 October 1303. By 1309, the papacy entered its seventy-year-long "Babylonian Captivity" in Avignon after further defeats of Boniface's short-lived successor, Scrovegni's debtor and patron for the chapel, Benedict XI (1303–1304), Niccolò Boccasini of Treviso (1240–1304).

Hubris and nemesis for the Church could then be considered part of the central figures' own social context when the Arena Chapel was being constructed. Could we perhaps think of the triumph of humility as an antidote to all this? Plausibly all the more so in the midst of theological overreach, besetting conflicts, and schisms. No fewer than 219 theses had been condemned in the infamous 1277 syllabus of errors issued by the Bishop of Paris, who was also Chancellor of the preeminent center of theology in Latin Christendom. Among them: the eternity of the world; the collective, transcendent human soul

and intellect; the double death of the individual soul with the death of the body; God's indifference to single, discrete phenomena; the gap between Providence and human affairs. This was anything but a humble brief – it was more like resistance born of panic and academic one-upmanship, militating or mutinizing against gathering anxieties throughout the thirteenth century around the translation, teaching, and incorporation of Aristotle and his Arabic interpreters into theological faculties. We know from long-standing, often controversial scholarship that the impact was widespread.[80] One effect was a split of theological syntheses on the spiritual and the material that confounded philosophical and theological discourse up to and through the Reformation.

In all this turmoil across the late European middle ages, Jerusalem remains the nexus of history. Its walls are symbolically and visually reconstructed on the walls of Cappella Scrovegni, most strikingly in the urban scenes featuring the Temple and the kiss at the Golden Gate. Jerusalem is the third city hidden in the Rome–Padua axis, the root of both monuments. Encapsulating the rise and fall of religious and personal empires, the whole cosmos of Scrovegni's Arena Chapel was and continues to be a self-contained, self-sufficient, self-reliant machine for the man's own perpetual construction and deconstruction. Yet as Giotto tells Scrovegni's story on the basis of ubiquitous questions about the human condition in the world, the chapel's imagery achieves a surprising degree of universality and shared experience for the viewers across space and time. I argue that this systematic play with the ideas and optics of ruins and renovations depended upon Giotto's careful calibration of relief effects, as a closer look at the chapel's detailed visual recreation of matter and illusion suggests in the next chapter.

Chapter 4

GIOTTO'S PAINTED RELIEFS

Non tener pur ad un loco la mente [...]

Keep your mind not focused upon one place alone. [...]

VIRGIL TO DANTE AS THEY CONTEMPLATE GOD'S RELIEFS
WITH THE EXAMPLES OF HUMILITY CARVED INTO THE
SIDE OF MOUNT PURGATORY, *PURGATORIO* X, 46

PORTALS AND LAST JUDGMENTS

THIS CHAPTER TAKES an in-depth tour through the chapel, scrutinizing first the painted relief system of the entire space, the doorways, the west wall's *Last Judgment*, and the *Virtues and Vices* with their washed-off polychromy. A detailed discussion of the stories of the *Lives of Mary and Jesus* will then be followed by an analysis of the chancel arch, the *coretti*, and, finally, the fictive broken double vault with its starry sky. The focus is upon specific classicizing or Romanizing elements on the one hand, and the significance of optical relief on the other. This shifting of gears, precipitated by an integrated analysis of different parts of the system, is a process of calibration – adjusting a system's range and aspects according to their own standards.

Required for observing the Arena Chapel's relief effects, such perceptive fine tuning begins with an element that is habitually overlooked, namely the

stunningly naturalistic system of bands and arches painted as faux pilasters, sculpted ledges, consoled dentils, fillets, and moldings containing ornaments and figural vignettes. This structure runs over the entire surface of the chapel, framing and "physically link[ing]"[1] all its figural elements on the red ground.

The upper vertical bands and the highest horizontal cornices are painted over that startlingly curved surface, as discussed in earlier chapters. The actual architectural barrel vault, accordingly, stretches down into the system of the images, bending the border between wall and vault. While barrel vaults are familiar to today's viewers from the later tradition of early Quattrocento perspective paintings and drawings, as perspectival tunnels of receding depth, Giotto adopts the Roman organization of elements as a whole. Instead of projecting the tunnel onto a wall, as Masaccio would later do with the faux architectural setup for his frescoed *Trinity* in Florence's Santa Maria Novella, Giotto recreates in its entirety the integral idea of an ancient Roman interior, filling it, however, with Byzantine and Duecento elements. Like its arch-portal model, the oratory is a space to stand and move in, but here it delivers Christian symbols, allegories, and narratives.

The south wall contains architectural window embrasures and obliquely inserted sills that do, indeed, recede in space. These real sills are, however, painted with additional fictive ornament: three slabs, one plain, one ornamented, and another plain, in Giotto's polychrome marble colors. As much as blue dominates the narrative scenes, red is the foil against which the fictive stone elements stand out. There is an entire tradition in scholarship that divides the dado from the rest of the system. As Bruce Cole comments: "The red strip [. . .] is a demarcator between the real and fictive. By putting it in, Giotto, it seems to me, is saying: Here you see the line that delineates two levels of reality."[2] Likewise, in his 1937 study, Isermeyer did not consider the possibility that

Giotto was deliberately simulating niche-like installations for polychrome reliefs, making them appear flatter than they are in order to compare them to cartoons or tapestries.[3] In her studies on *grisaille*, Krieger argues for a breach in illusionism between the dado and the polychrome narratives, even though she sees the system's relevance for the later fictive niches in the Bardi Chapel in Santa Croce, Florence.[4] Again, Giotto's holistic vision and illusionistic capacities seem to be underrated.[5]

This virtual system and its visual consequences for the Arena Chapel's program have been most carefully studied by Isermeyer. He is one of few authors to mention the existence of a plane behind the plane: In each corner of the room, there is what he calls a slim brown band. The "brown" appears rather dark red, its oxblood intensity in accordance with the frequently recurring juxtaposition of red ornament to dominant blue ground and equal in quality to the red bands framing each scene of the *Life of Christ* beginning with the *Visitation*. The very limited background behind the vignettes and portraits is, once again, blue. In addition to the miniature scenes, quatrefoils embedded in rhomboids hold the portraits of Apostles and Saints.[6] They are either paired around a geometrically structured middle panel or stand alone in the center of a single panel, with adorned marble panels below and above.

A section comparison of the Arch of Titus to the Arena Chapel (Figs. 4.1–4.4) illustrates the structural echoes of the ancient arch in Giotto's Paduan oratory. In the chapel, this system is most pronounced at the beginning curve of the architectural vault, which signals the inherent tension between painting, architecture, and relief sculpture; between material wall and effective, simulated wall. In a similarly ambivalent way, the narrative fields of the second and third register from the top are each framed by a neutral red band and a green frame once bearing fine golden ornaments, as if to suggest a green-golden lithic or enamel quality.[7] I argue that the simulated reality of the bands and

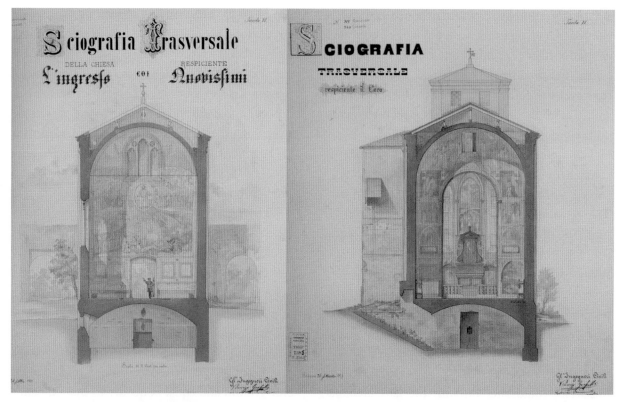

Fig. 4.1 Transverse sections of the Arena Chapel facing west and east in 1871 watercolor by B. Lava (Benvenisti and Grasselli survey). Courtesy of the UC Berkeley Historical Slide Library (est. 1938–2018), Baxandall & Partridge Collection, Doe Memorial Library in Berkeley, California, USA.

the socle permeates the entire interior, the red bands around the images being the only spatially ambiguous elements on a macro-scale.

Among these perfect frames, the wider bands that separate the typologically relevant scenes of the *Passion of Christ* are unique in the chapel's formal-architectural vocabulary.[8] Most of them open on a miniature quatrefoil vista, their frame finely adjusted to the spectator's viewpoint. Painted according to their height respective to the viewer, a lower frame reveals more of its inner embrasure to the left and upper right, but none of the lower embrasure. The upper frame allows no glimpse of the embrasure, thus enhancing the illusion of being materially cut into the wall. If it were an actual architectural element, it would indeed recede into invisibility just like that, subtly acknowledging the viewer's position for the sake of increased optical *verismo*. The frames aim to show themselves as cut in actual,

sculpted moldings, appearing just as real in fields of fictive cosmatesque work that are further embedded in upright panels of ornamental relief with thin frame ledges and floral ornaments. Their contained imagery is commentary on the larger histories that they frame, their iconography footnoting the adjacent blue ground fields.

Examples of this system are the typological imagery of *Jonah Swallowed by the Whale* (Figs. 4.5–4.6) and the *Lioness Reviving her Cubs* (Fig. 4.7) that comment on the scenes of the Passion and Resurrection. Together, they build the sequence *Crucifixion – Jonah – Lamentation – Lion – Resurrection / Noli Me Tangere*. The vignette with *Elijah on the Fire Chariot* traveling heavenwards is contiguous with the *Ascension* image of Christ lifting himself up to an invisible Heaven beyond representability (we return to the detail of his fingertips in Chapter 5). Derivatives of earlier Gothic ornamental systems,

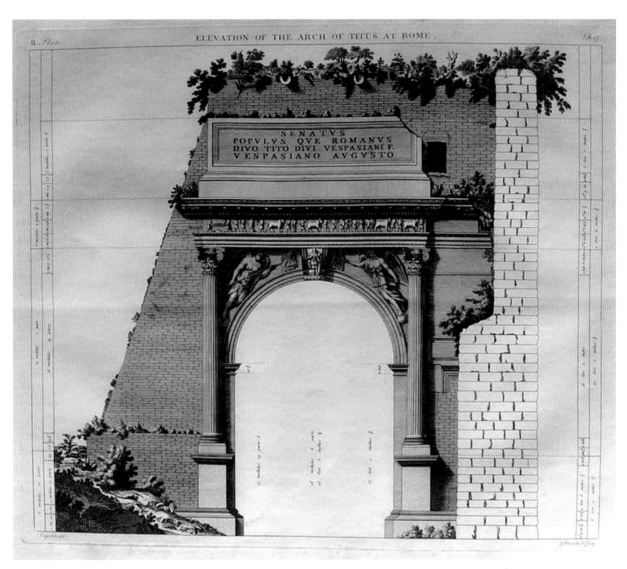

Fig. 4.2 Section of the Arch of Titus on the west-east axis in a folio copper plate by Antoine Desgodetz (published in London in 1795 for *Les Edifices Antiques de Rome*). Courtesy of the UC Berkeley Historical Slide Library (est. 1938–2018), Baxandall & Partridge Collection, Doe Memorial Library in Berkeley, California, USA.

these faux pilaster bands become one of the most highly copied and reformulated elements of Giotto's relief effects in the generation of his pupils and epigones, connecting his time with that of Donatello and Mantegna.[9] They are crucial for negotiating material and optical realities, safeguarding the fields that emulate the style of classical reliefs and potential idols in a Christian frame. It is well known that Christian art had faced the problem of representation and idolatry from the earliest times of its expression in visual media. In Chapter 5, I explore further

to what extent this could be one of the safety nets against the suspicion of reviving, with the language of so-called Flavian Baroque,[10] an excessively daring mode of representation – a mode that is almost too real and too close to pagan art. Exploring pagan alternatives to the sanctioned visual language of the *maniera greca*, the underlying conflict goes back to the fear of reviving the idol.

The individual scenes from the *Lives of Mary and Jesus* on the long walls are likewise not imaginable without the thoughtful integration of

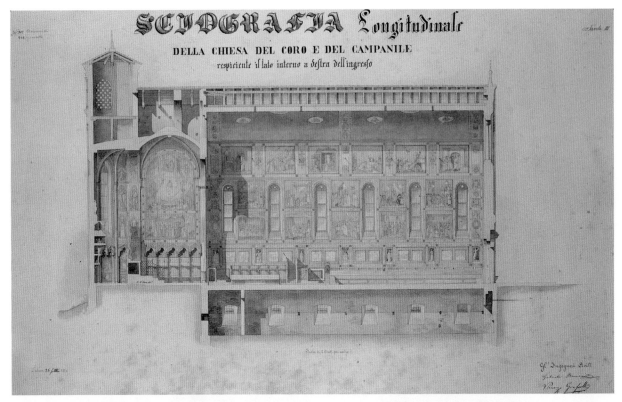

Fig. 4.3 Longitudinal section of the Arena Chapel facing south in 1871 watercolor by B. Lava (Benvenisti and Grasselli survey). Courtesy of the UC Berkeley Historical Slide Library (est. 1938–2018), Baxandall & Partridge Collection, Doe Memorial Library in Berkeley, California, USA.

classical forms with Byzantine-Christian conventions. From the Titus reliefs, Giotto seems to take the height of the space as well as the figure size in relation to the field as in the *Flight into Egypt* (Fig. 4.8) and *Entry into Jerusalem* (Fig. 4.9); the proportional height of the narratives in relation to a socle; and the embeddedness of the fields in a wall that has a flat profile as the reliefs are entirely carved into the wall. Furthermore, he takes the sunken horizon, he variegates a mix of high, middle, and low relief, and he captures the processional style by grouping figures into isocephalic groups. The full aesthetic potential of the interplay between simulated stone and fresco extends to their theological messages in relation to other perspectival modes in the chapel. This approach resulted in a quandary for much twentieth-century art-historical literature on Giotto, which led to the general underestimation of the chapel's unifying scheme.[11] For Irene Hueck the curve of the vault

has no compositional function.[12] She concluded that neither the framing system nor the single images constitute a coherent whole.[13] Neglecting the context of the interior with all its interrelated parts, Euler considered only a few separate illusionistic elements.[14] Giotto, however, has been precise in integrating the different elements of his structure in even more pronounced illusionism. This is most visible on the edges and around the thresholds of the system.

Being liminal phenomena, those subtleties express themselves clearly around the transitional checkpoints of any interior, namely passages and doorways. Scrovegni's chapel is divided into a public and a private precinct; the two entrances once provided open access from the center of the arena and limited entry from the now-lost family palazzo. The simulated reality is particularly emphasized over each of these doors. I focus first on Scrovegni's door (Fig. 4.10) – the side entrance next to the altar room. The door's fictive lintel is

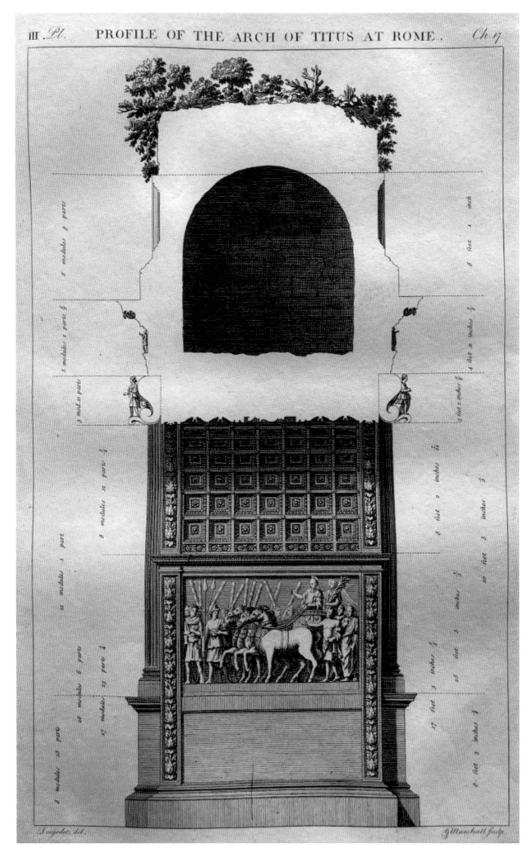

Fig. 4.4 Section of the Arch of Titus displaying the chariot relief in a folio copper plate by Antoine Desgodetz (published in London in 1795 for *Les Edifices Antiques de Rome*). Courtesy of the UC Berkeley Historical Slide Library (est. 1938–2018), Baxandall & Partridge Collection, Doe Memorial Library in Berkeley, California, USA.

Fig. 4.5 Arena Chapel, *Jonah Swallowed by the Whale* in context. Courtesy of Steven Zucker.

painted to be decorated with faux relief sculpture, ornaments, and two medallions with half figures.[15] The left-hand figure with tentacle-like extensions emerging from her eyes has been interpreted, among other suggestions, as *Circumspectio* in the same tradition that informed Francesco da Barberino's *Documenta amoris*; the right-hand figure as a wild man (see Fig. 4.10).[16] While the tentacles look more like clubs, it is clear that this figure opposes the brutishness of the wild man and signifies some kind of superior power of sight. This visual commentary on prudence, spiritual vision, and the idea of a supernatural gaze aligns with the chapel's interplay of different perceptual modes – especially as this is Scrovegni's own, privileged door. Such a figuration of a comprehensive, all-encompassing view of the chapel might be seen as a challenge or as a compliment to those who would not be tricked into a deception of the eye but would instead look further for the true,

deeper meaning beyond the surface of what they were seeing. Pisani undertakes a specialized study on the extensions within an Augustinian frame of reference, where the emanations become even more readable as clubs, and the figuration as a message to Scrovegni.[17] Once again, a detail condenses the visual discussion of visibility and matter. It constitutes a witty criticism of optical-artistic illusion similar to the visual disturbances of the *rotoli*-rolling apocalyptic angels; those of the systematically illusionistic incrustation; and those of the eye-deceiving *coretti*. The system of doors and the *Last Judgment* frame the entire narrative of the lives of Mary and Jesus with eschatological urgency. At these liminal points, Giotto keeps checking in with the viewer spatially, as if to suggest shared realms of experience in world history, time, and space.

Beyond the ultimate limits, in the large judgment day scene, the figures attain a very generous

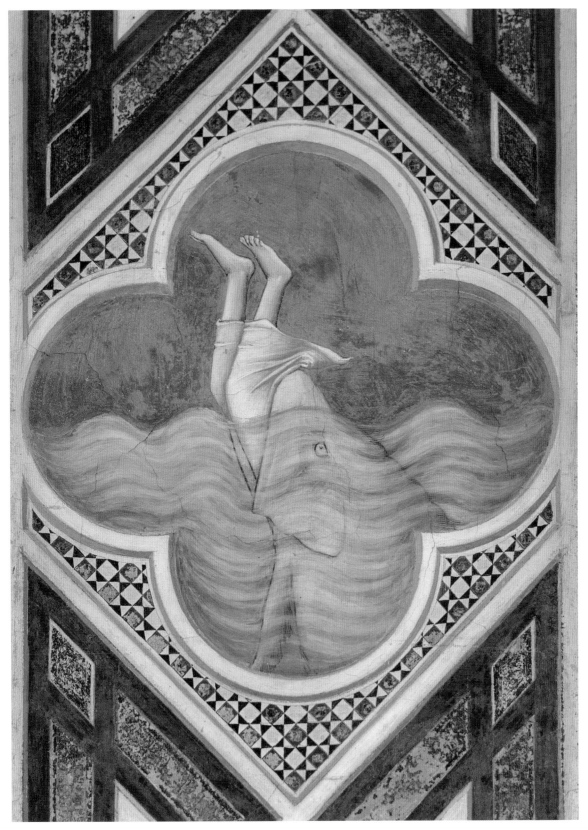

Fig. 4.6 Arena Chapel, detail of *Jonah Swallowed by the Whale*. Courtesy of Steven Zucker.

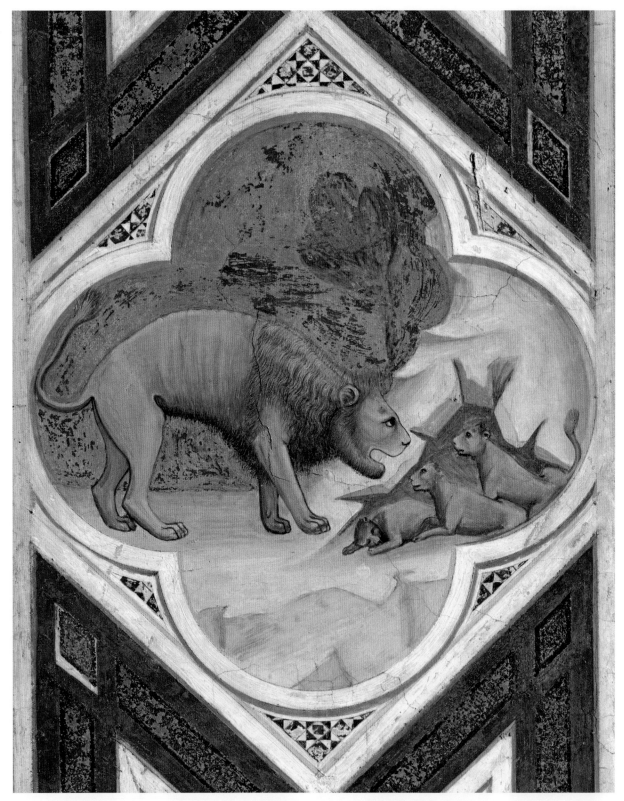

Fig. 4.7 Arena Chapel, detail of the *Lioness Reviving her Cubs*. Courtesy of Steven Zucker.

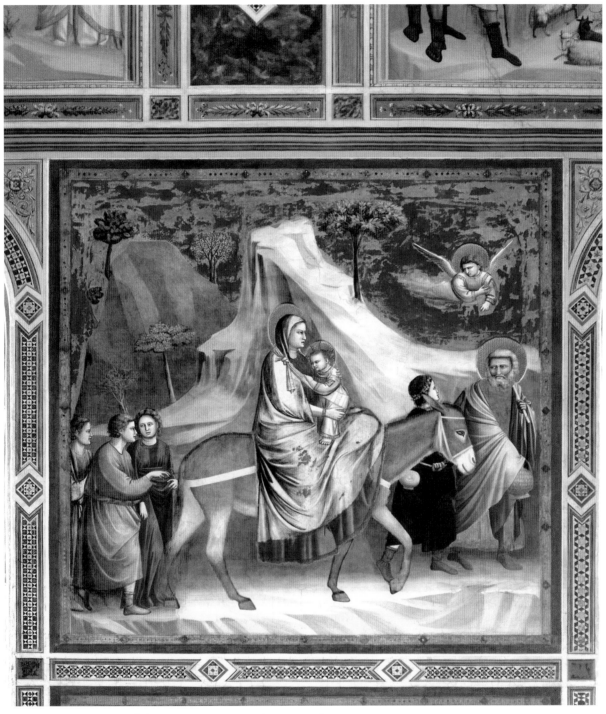

Fig. 4.8 Arena Chapel, *Flight into Egypt*. Courtesy of Steven Zucker.

scale and a more scattered positioning with increased space around them. Having escaped the constrictions of the relief-like areas of representation on the sidewalls, they display what we can think of as Giotto's intuitive figural style (see Appendix I, *Assisi Revisited*), whereas the figures in the scenes on the walls are filtered through the lens of relief. The Blessed in the *Last Judgment* have lost their lower border's union with the plane, and some of them seem to hover in

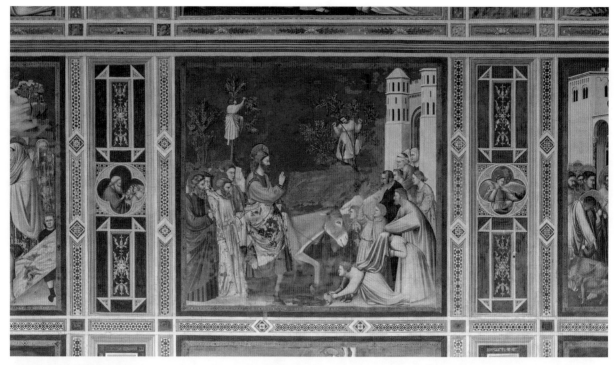

Fig. 4.9 *Entry into Jerusalem*. Courtesy of Steven Zucker.

Fig. 4.10 Arena Chapel, fictive relief lintel painted over Scrovegni's private entrance door in the north-east corner. Courtesy of Steven Zucker.

space mid-level, forming a concave projection. Around the colossal apparition of Christ in his apocalyptic mandorla adorned with flaming ornaments and four chimeric beasts, the Apostles sit on curved benches and the realms of the Blessed to Christ's right and the Damned to our right are as clearly divided. As the largest picture field in the chapel, the *Last Judgment* is demarcated, like the other fields, by the same system of marble incrustations that rises from the socle zone into the two pilasters on each side. These carry

buttresses, and the buttresses carry blocks that support an arch with architectural relief: floral ornaments on red and blue ground as well as incrustations of polychrome marble.

Central in this fictive opening of the wall, the mandorla around the stentorian Christ deserves special attention. As in the east vault's flaming circles around the *Pantocrator*, the ornaments of Christ in Judgement oscillate from green to white to yellow to red; the small and regular ornaments appear to fold themselves around the inner edge

of the mandorla, standing up around the fringe.[18] The white, painted as a thick, opaque substance, stands on the folding edge, its ornamental line doubled from the inside to the outside. Within this frame, one recognizes Christ's restored festive garment from the earlier scenes of his entry to Jerusalem and the scenes of the Passion, where it is taken from him and bartered away under the cross. Especially in the scene under the cross, the outspread robe catches the eye as though it, too, were a character in the story, its hollow neck empty and forlorn. Here, the body of Christ fills it again, whole anew, and richer, so tell his stigmata, for fulfilled experience.

Christ pierces the limits of the mandorla delicately, only with the fingertips of a single hand and the toes of one foot. Since these are the fingertips of his left hand and the toes of his right foot, however, these microscopic trespasses are enough to dynamize his pose into an oblique diagonal and charge it with powerful movement, while the animated hybrid apocalyptic beasts with their wings and hoofs below him simmer within the flatness of the oval frame. Out of this loosely sketched passage – contrasting so starkly with the chapel's faux relief elements – a lion's face, a centaur, an angel's face on the body of an eagle, and something that looks like a large fish seem to emerge, vibrant like a rainbow, all cropped at some sides and left in apparently deliberate undecipherable colorism.[19] Compositionally, these beasts' onrushing vigor brings to mind three of the four apocalyptic horsemen painted in the frames in the Lower Church of San Francesco in Assisi, those who drive their animals obliquely out of the lozenge-shaped frame, front hoofs trespassing as do Christ's fingers and toes here.[20]

Christ emerges frontally between the double procession of the Blessed to his sides in the nondescript apocalyptic blue. The large and serene figures are evenly directed towards Him.[21] Their movement remains in synchrony with the plane, giving them an even more thoroughly removed, untouchable air. First in the procession is Mary

in a squirrel-fur-lined cloak, hovering as if effortlessly transported by the large mandorla around her. That oval disk is imagined so materially that it needs to be held by an angel like a shield.[22] Mary seems to be pulling a kneeling Eve up with her.[23] Directly below, in the first row of the lower procession and spotlighted by his gilded ancient Roman gear, we see a centurion – probably Cornelius from the Acts of the Apostles 10:1–43.[24] Further below, the pictorial plane of the *Judgment's* landscapes clashes with the fictive doorframe of the west entrance. A few centuries later Shakespeare will write that "Hell is empty / all devils are here."[25] Here, all devils are returned to hell, taking the recently damned with them. Everyone occupies their designated, definite place. Only the spectators find themselves in a flexible present. If they are anywhere, the devils are indeed here, on the side of the real space in front of the wall. The frame itself is populated by a small frieze-like procession of grim demons and damned, emphasizing its function as a bridge between chapel and Apocalypse (Fig. 4.11).[26]

In contrast, the blessed side – because it is *not* directly connected to the real space of the chapel, but freely hovering in space – maintains its solemnity, keeping the elevated figures in their own, larger-dimensioned and spacious equilibrium. The small and compressed elements of hell destabilize all too easily the threshold of the painted architecture. Almost a dozen little figures animate this access to damnation, some of them drawn in pornographic detail, sadistic caricatures of pain.[27] There is nothing of the realism and empathy that, as we will see below, informs a depiction of assault in the miniature throne relief under *Injustice*. Only one subtle sign of hope signals permeability of these borders around the landscapes of hell, as small and elusive as a fragment of textile belonging to the other side: Held together by its even structure and stitches while falling over the semiotic border, the hem of the Augustinian canon's habit is the only connection between the viewer's space

Fig. 4.11 Arena Chapel, detail from the *Last Judgment* with demons and damned walking over the fictive doorframe of the west entrance. Courtesy of Steven Zucker.

and that of the *Last Judgment*'s blessed half (Fig. 4.12). The conceptual palpability of this little piece of fabric charges such a tiny detail with the power of a relic and changes the status of the representation in relation to the viewers. Just as the canon shoulders Scrovegni's model of the chapel, assisting with his donation, this same figure is approachable.

Crowning the *Last Judgment* to the left and right of the large triforium window, the two famous apocalyptic angels are shown in the act of wrapping up the old sky, sun, and moon (Figs. 4.13–4.14). The angels stand, as Whitney Davis put it, "in the doorway of eternal invisible truth beyond representation."[28] Caught in the act of removing the wall's surface, with its typical background blue of the scenes from the lives of Mary and Jesus, these figures' depiction offers a much more precise interpretation of their action than simply initiating the end of the world – this apocalyptic moment also is the end of art and the end of the chapel, that is, of Giotto's work. The

angels' cheeks gently rest against the inside of a large red scroll that they seem to peel from the wall's surface, left towards right and right towards left. Behind them, metallic objects appear, corresponding in height to the scroll's extension but of distant, undetermined scale. The simulated removal of the plaster surface of the fresco is conventionally understood as a meta-commentary on fresco painting. In addition to this layer of meaning, I want to suggest that the angels' act of rolling up the old sky is conceptually fit to play with another idea of transformation – that of the entire wall into a relief plane, declaring everything blue to be a plane and everything represented on that plane to be represented in relief.

This *Last Blue Ground* can be seen as a final statement on all the blue grounds in the chapel, holding each of the smaller narrative scenes to a larger statement of both aesthetic and eschatological significance. Put simply, this would suggest that everything depicted on the blue grounds below can and will be detached

Fig. 4.12 The canon's hem falling over the fictive threshold. Courtesy of the UC Berkeley Historical Slide Library (est. 1938–2018), Baxandall & Partridge Collection, Doe Memorial Library in Berkeley, California, USA.

eventually; the manifestation of objects and figures in historical space and time will cede to whatever stands beyond those symbolic doors in the realm of the invisible and eternal. While its materiality is decidedly ambivalent throughout the frescoed walls, the famous Arena Chapel blue can now be understood not as infinite depth but as solid plane, with confirmation of this interpretation arising from the authority of these angelic guards. Their quasi-realism is recanted by the mildly smiling man-in-the-moon face painted into the pale, silvery-white circle, familiar from Romanesque lunar iconographies.

Here is another key to the chapel, rendered in fresco: The medium itself consists of layers thickly applied onto surfaces, projecting images through pigments sunk into wet plaster. This interplay of projection and matter plays with

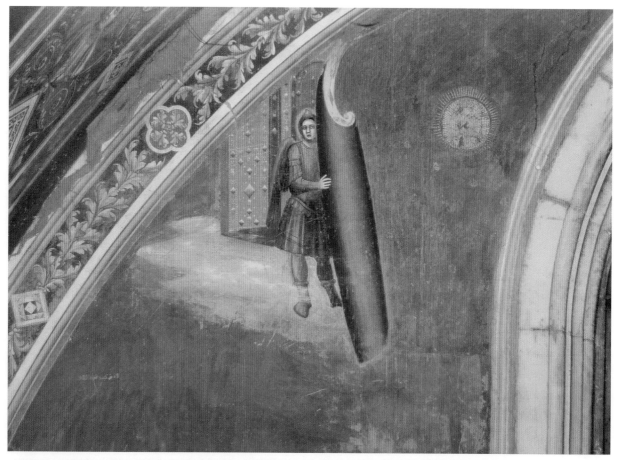

Fig. 4.13 Arena Chapel, the apocalyptic angel and the sun. Courtesy of the UC Berkeley Historical Slide Library (est. 1938–2018), Baxandall & Partridge Collection, Doe Memorial Library in Berkeley, California, USA.

the contrast between blue and red. All that appears on a blue ground has a red back, like the red bolus applied to the lower layers of panel paintings in Giotto's time. This calls into question the possible significance of other alternating blue and red grounds and backgrounds, from the oxblood wall in the corners of the space to the narratives, the red-grounded bands, and the extended apocalyptic blue ground of the chapel. In addition to these contrasts, there is the smallest of green bands around each scene; highlighting the detached patches of blue ground, inserting yet another layer into the constantly shifting play that creates and crushes the illusion of stone and materiality. The angels' removal of the very plane that contains their own visual presence stems from the Byzantine apocalyptic tradition, an iconography with deep roots in

biblical and patristic texts.[29] In medieval Italy, such cosmic scrolls would have been known from mosaics at Torcello or – already identified as an important point of reference at the center of Giotto's medieval Rome and related to the Arch of Titus – once again in the Cappella di San Silvestro at the Santi Quattro Coronati.

Decades earlier, Giotto had already shown himself as a playful illusionist able to transform the material world with well-calculated design and application of paint at Assisi. Once he had authority over the entire interior for Scrovegni's project, he created a realm in which angels could perform this cosmic scroll iconography in productive competition with the illusionistic style of their own fictionality. Having arrived at the limits of representation, whatever it is that stands behind sealed doors exceeds human and artistic

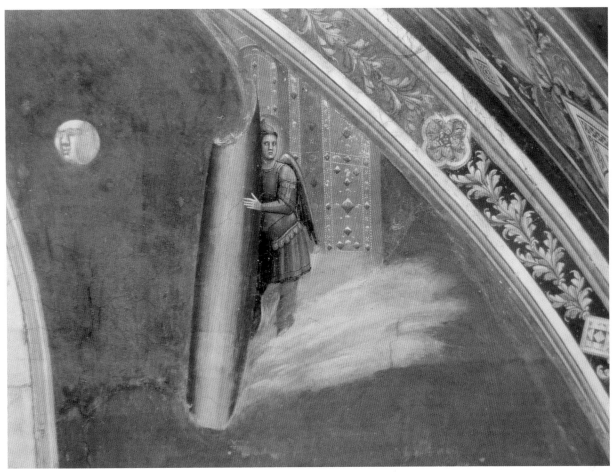

Fig. 4.14 The apocalyptic angel and the moon. Courtesy of the UC Berkeley Historical Slide Library (est. 1938–2018), Baxandall & Partridge Collection, Doe Memorial Library in Berkeley, California, USA.

imagination: "the *terribilità* of the divine abode from which the very cosmos emanates," in the words of Claude Gandelman.[30] As if relating the idea of the Byzantine *rotulus* to these door-like objects, Gandelman interprets them as book covers.[31]

Maybe the hermetic, impenetrable objects are supposed to be undecipherable, their potential representative value ranging from book covers to bejeweled doors or gates in remembrance of Heavenly Jerusalem. Wolfgang Kemp focuses on the status of this purposefully arcane image–symbol in his study on beginnings and endings in Dante and Giotto, registering the abyss – a large breach of blue – between the angels and the rest of the west wall: The two divine figures appear not only in a different place in the syntagma, but in a different syntagma altogether.[32] The gap between these apocalyptic angels and the armed choirs of angels below around the mandorla is one of the most significant voids in the chapel's system. As Kemp suggests, if ever the concept of *horror vacui* resonates, it is for this iconography that antici-pates of a future, post-apocalyptic void.[33]

These angels, therefore, can be understood to remove the very plane of representation, open to multiple interpretations as sky, as the thick plaster ground of the frescoes itself, and as a relief plane. This self-destruction happens for a reason. Wolfgang Kemp describes this as the difference between *implicare* and *explicare*: The angels next to the sun and moon begin to roll up a text (*implicare*), while the narration on the walls was laid out (*explicare*).[34] The just-achieved

transubstantiation of the material plane, as Imdahl would see it, here negates this central achievement by the very detachability of the technique of *buon fresco* – an intentional 'disillusion' summoned up via the painter's supreme use of illusionism. It emerges especially from those achievements that Giotto has been praised for most throughout the centuries: volumes, *rilievo*, tactile values, *valori plastici*.

By now it has become apparent that Giotto not only inaugurates a particular kind of image in the narrative cycle's single scenes but also – with these angels, whose scale bears no relation to the scene beneath them – adds a deliberately self-destructive and dissonant last chord to his symphony. The angels' act emblematizes the cautious containment of the lifelike, classicizing Roman images from the long walls into a system of Byzantine symbols. The public door under the *Last Judgment*, which emphasizes the canon's hem (see Fig. 4.12), likewise, puts into question the borders between painted appearance and physical reality. His habit, by hanging over the semiotic border, reinforces the fictive architecture below as much as it insists on its own, palpable corporeality. The real textile is casually slipping over the real stone, or so the fresco claims. These instances connect with the chapel's inherent theory of vision versus matter so that, over both doors, the liminal status of painting between architecture and reality is put to test: symbolically with the faux relief figures over Scrovegni's door and palpably over the public passage to the arena.

The apocalyptic vision of the *Last Judgment* gives further weight to the importance of the simulated relief plane erected with thick, high, impermeable blue skies that assume their own eschatological significance in the narrative context of the whole chapel. They form a system from Alpha to Omega, with the meaningful exclusion of the Fall of Man and of time *ante legem*. Everything that appears on azurite is part of a specific spiritual moment in history. This program focuses on the span of world time that constitutes a single eon and contains the lifetimes of Jesus, of Scrovegni, and of the viewer, all held together within one grand pair of Giotto blue brackets. This era is the long interim *sub gratia* between eternity and eternity. The final scene of the entire narrative, the *Last Judgment*, is spread over the counterfaçade, three times wider and higher than any of the single history scenes. Ultimately, each and every component of the chapel is oriented towards this massive, last iconography and contained in it, too – including the bottom level with the *Virtues* and *Vices* where *Hope* herself rises up towards the corner of the Blessed.

VIRTUES AND VICES AT HAND- AND EYE-LEVEL

The next stop on our tour of the chapel's classicizing elements and reliefs is the frescoed dado zone, where a host of ancient elements appear in the pale, muted, lusterless optics of the stone underneath lost polychromy (Figs. 4.15–4.30). The *Virtues* on the south and the *Vices* on the north wall simulate the sharpness and shadows of the fictive architectural edges as perfectly as the interjacent marbled panes imitate veins in stone placed in open-book fashion. To create an open-book effect in actual stone panels, two slices cut from the same block are placed adjacently so that they appear as one another's mirror image – as in the incrustations of the Pantheon, which were adapted by Christians in sacred spaces such as San Vitale in Ravenna, Torcello Cathedral, and San Marco in Venice. Between Giotto's framed panels of imitated marble, the *Virtues* and *Vices*, themselves mounted on stone, are each accompanied by a seemingly chiseled medieval Latin titulus above and lengthy inscription below in Gothic calligraphy.[35]

As painted imitations of relief sculpture, the figures of the *Virtues* and the *Vices* seem to be at once the most present and the most withdrawn embodiments of meaning in the chapel. Present as suggestions of palpable reliefs at hand- and eye-level, yet withdrawn in their "stoniness," if one accepts their claim to material existence.[36] Krieger describes the figures' existence as oscillating between a materially lower rank and a perceptionally heightened actuality for the spectator.[37] While the figures have often been misnamed *grisaille*, and scholars have wondered whether they might have been painted as cheaper substitutes for actual sculpture, I argue, rather, that they set the standard for transforming and transubstantiating the entire room through painting by signaling their own illusionism and fictive materiality.[38] Michael Viktor Schwarz's careful description of these fields, ranging from their classification as intarsia to the figures' mediated presence, is more in keeping with the period. Schwarz is interested not so much in the quality as in the agency of the dado. He concludes that the perfection of lithic illusionism ultimately reinforces the presence of the mode of representation as much as the absence of the object of representation.[39] Such correlation of absence and presence is the dado zone's main distinction from other parts of the chapel. Schwarz describes the technique as "Marmor-Reliefintarsien," coming to the conclusion that Giotto seems to have invented a theretofore unknown, extremely sophisticated sculptural technique within the medium of painting.

The fourteen dado figures' perplexing ambiguities are clearly demarcated between the strongly mineral-colored marble backgrounds and the pale stone of the figures, the intentional yellow and red interruptions in the monochrome, and their elaborate postures and acts of allegory. Framed by the lines of *Virtues* and *Vices*, spectators in the nave find themselves caught seven times over between two alternative ethical choices that physically force the visitor into a situation of moral-emotional conflict and reflection. The *pavimento* of the Cappella degli Scrovegni thus becomes a battleground that stages, in faux relief sculpture, a traditional psychomachia, much like the *De Consolatione Philosophiae* by Boëthius.

Entering the chapel from the original public door, the common visitor would have experienced the sequence beginning with *Hope* and *Despair*. Coming from the palace entrance, as Scrovegni or his guests might have done, the spectator commences with *Prudence* a theologically privileged sequence from inside to outside. This order emphasizes a crescendo through the sevenfold sequence from the cardinal to the theological virtues and vices, with variations in the choice of vices that seem to stem from an Augustinian source, in contrast to the tradition of Gregory and Dante.[40] Starting from the east, the antithetical pairs are: *Prudentia* (Prudence) and *Stultitia* (Folly); *Fortitudo* (Fortitude) and *Incostantia* (Inconstancy); *Temperantia* (Temperance) and *Ira* (Ire); the central *Iusticia* (Justice) and *Iniusticia* (Injustice); and then three highest *virtù* and their counterparts: *Fides* (Faith), *Caritas* (Charity), and *Spes* (Hope) opposing *Infidelitas* (Idolatry), *Invidia* (Envy), and *Desperatio* (Despair). The standoff between the trios of Faith, Charity, Hope and of *Idolatry, Envy, Despair* contains some of the most powerful contrasts in the cycle, with angels, God, and heavenly love appearing as if they were animated corbel figures in the corners of their respective virtue's niches on the south wall. On the north wall, a tiny corbel prophet appears over *Idolatry*, wielding his scroll like a veil. For *Ire* and *Despair* there is no such figure; the voids of their corners seem to emphasize the sense of an irredeemable remoteness from God. The bodies of *Hope* and *Despair* subsequently demonstrate their respective extremes – the lightness and relief of spiritual hope contrasts the weight of deepest, debilitating sorrow. As if building up to the final act, the pairing of *Hope* and *Despair* frames the main iconography and destination of the chapel, the *Last Judgment*, all

in accordance with the distribution of *Virtues* and *Vices* as good and bad models of an *itinerarium mentis in Deum*. This concurrence illustrates the crucial distinction between a life of hope in *imitatio Christi* and a life of despair leading to damnation.[41] Even the coloration of the abstract marble below the two sides of the *Last Judgment* reflects this difference in light pink shades with a small cross *intarsia* under the Blessed and in dark hues as a bare slab of marble under the damned.

Prudence (see Fig. 4.15) is the only virtue shown in profile; she keeps her head lowered attentively for an intense look into a handheld mirror. Her focused, introspective gaze suggests the ethical dimensions of the ancient *Gnothi seauton*, of self-awareness and self-control. This turn to profile also serves to show the back of her head, from which a male, bearded profile emerges behind her headbands.[42] On the other side, a loud and crass *Folly* stares vacantly into space (see Fig. 4.16), acting as the opposite of the calm and focused scholar *Prudence*.

Gazes are one clue for moral conditions, postures another: Delineating itself against an intense ground of porphyry, *Fortitude*'s massive, armed, stable figure (see Fig. 4.17) clashes with the image of *Inconstancy*'s tumbling (see Fig. 4.18) towards a bending landscape of purple, beige, and blood-colored marble, while *Fortitude*'s shield is, as Ladis writes, "riddled with the points of spears and arrows and wielding a broken sword that, in an astonishing and appropriately aggressive attempt at foreshortening, seems to project into the very space of the chapel."[43] *Temperance*, calm and composed, stands in front of a slab of dark green *serpentino* (see Fig. 4.19). The only virtue on a slim plinth, this removed figure keeps her words and actions tamed: Her weapon is bound and her mouth closed by a gag. Her slight S-curved stance suggests no pain in keeping these objects in serene retention. Contrastingly, *Ire* is frozen in the forceful act of tearing her own dress apart in

utter rage (see Fig. 4.20). Performing one of the most violent and unclassical physical movements in the chapel, this figure appears directly on the naked pink base of the niche. Unmitigated by any plinth or object base, her bare chest, painfully deformed facial features, and loose hair create the impression of complete abandonment into aggression directed both outwards and inwards. *Nota bene* the striking detail of her long hair, falling down well past her waistline and her bent arm: As noted above, her hair is colored at its lengths alone, blonde locks painted with traces of yellow and brown just like fading polychromy on an actual relief of this shape would disappear first from the head of the figure, and only later from the better-protected, undercut areas.

The central pair of moralizing figures, *Justice* and *Injustice*, are both seated in a throne architecture that fills their niches (see Figs. 4.21–4.22). Above, between the dado marble and the cosmatesque bands, there is a classical dentil border above the painted revetment; its center coincides perspectively above these figures in a manner similar to the "empirically perceived convergent perspective molding [...] at Assisi," as Edgerton notes.[44] While *Justice* sits in a throne with three trefoils behind her and to her sides, *Injustice* reigns under a Romanesque arch that is hewn out of a rugged and porous lithic landscape. At his feet, miniature trees grow up over the height of his lap. The step below him is likewise uncultivated, a rough landscape hosting small figures in a scene of ambush and merciless violence (see Fig. 4.23).[45] Its unusual impasto chiaroscuro led Valerio Mariani to suggest a nocturnal interpretation for the scene.[46] The tiny figures of the internal relief on the throne are outlined against a rough step – a cliff very unlike the field of simulated relief sculpture on *Justice*'s uncorrupted throne (see Fig. 4.24). On the side of *Justice*, the violent scene is contrasted by an image of peaceful conduct among men and women. Noblemen out riding with falcons and

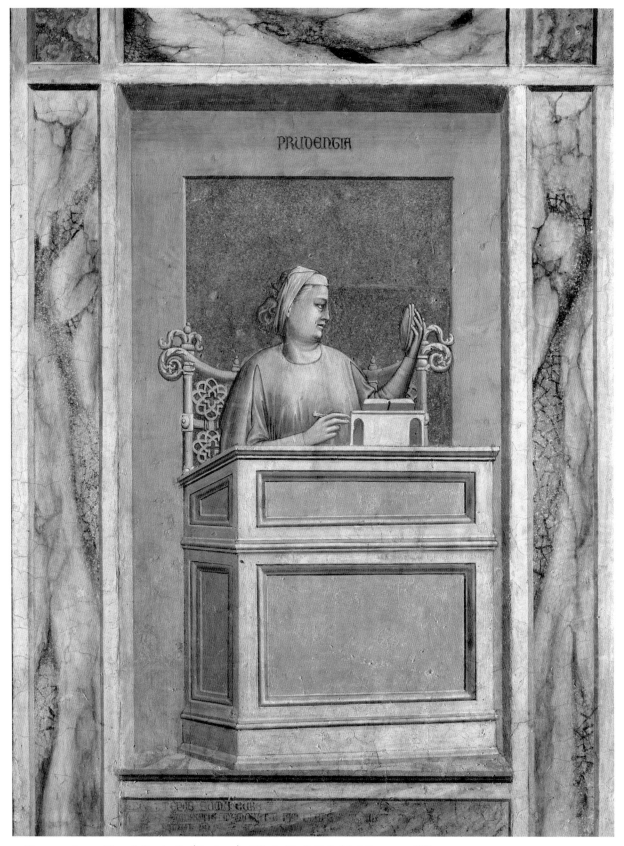

Fig. 4.15 Arena Chapel, *Prudentia* (*Prudence*). Alfredo Dagli Orti / Art Resource, NY.

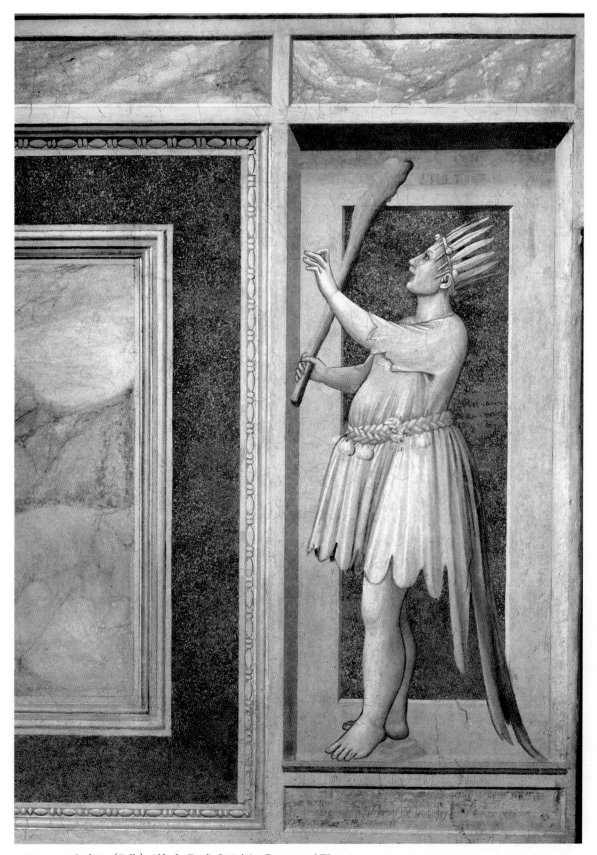

Fig. 4.16 *Stultitia (Folly)*. Alfredo Dagli Orti / Art Resource, NY.

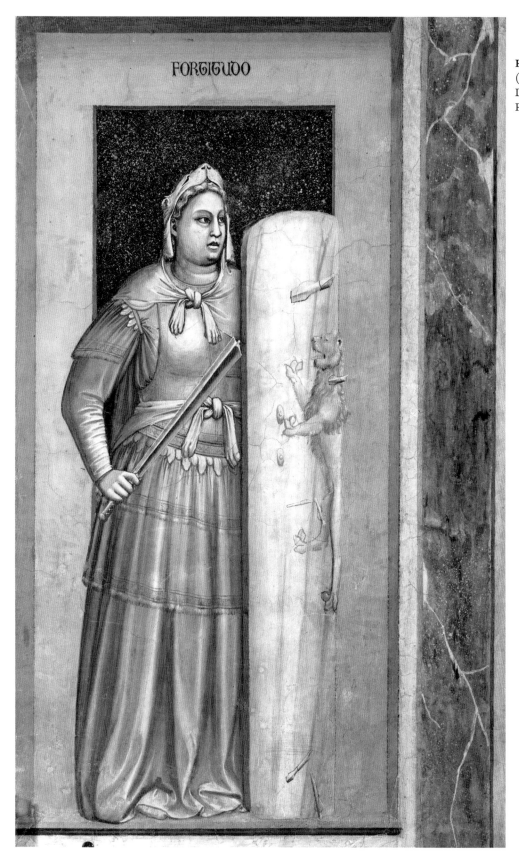

FORTITVDO

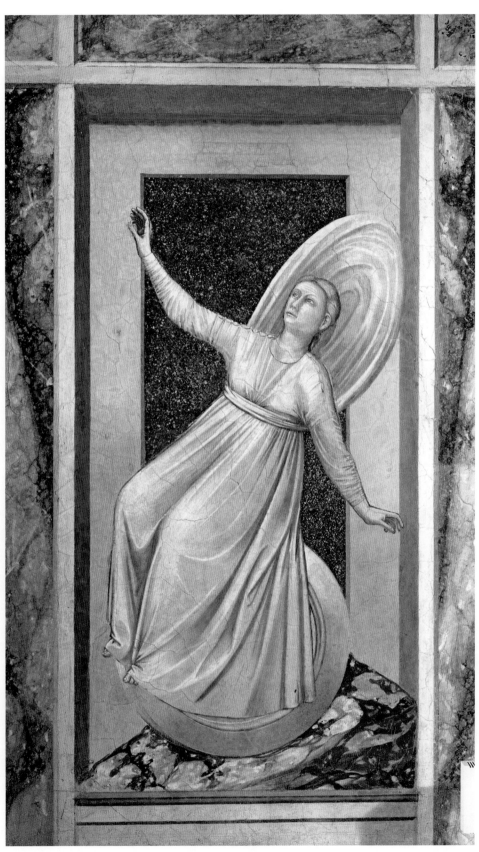

Fig. 4.18 *Incostantia*
(*Inconstancy*).
Alfredo Dagli Orti /
Art Resource, NY.

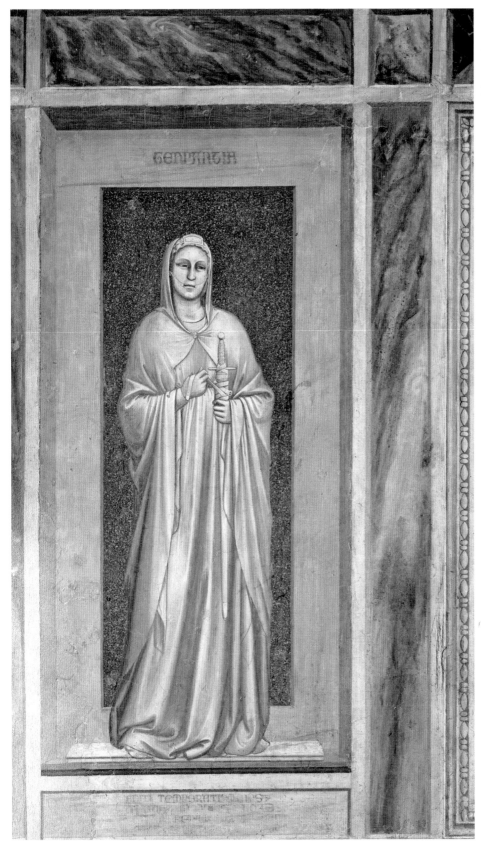

Fig. 4.19 *Temperantia*
(*Temperance*). Alfredo
Dagli Orti / Art Resource,
NY.

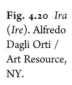

Fig. 4.20 *Ira*
(*Ire*). Alfredo
Dagli Orti /
Art Resource,
NY.

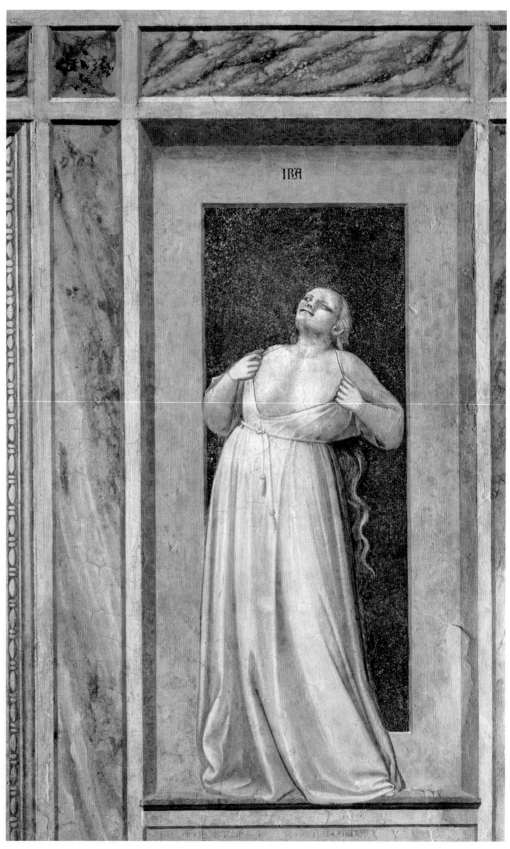

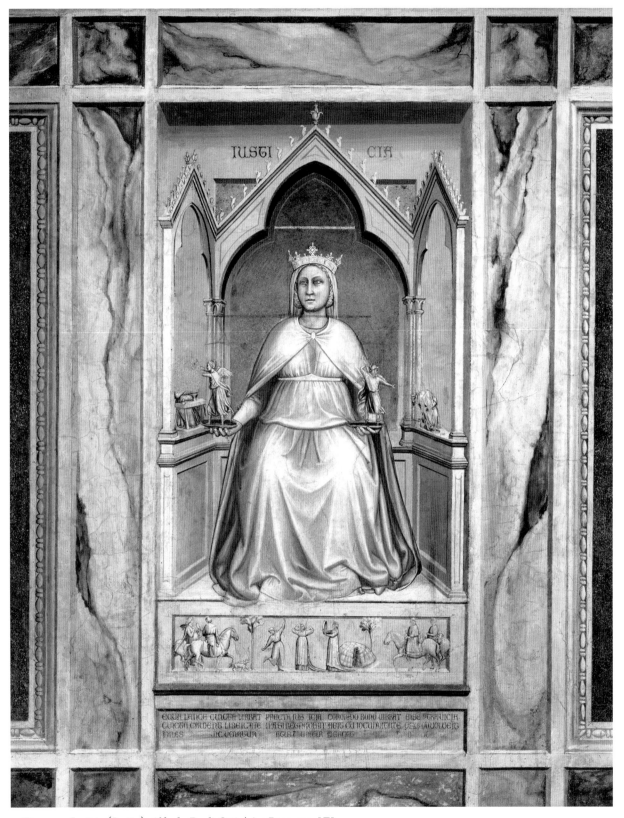

Fig. 4.21 *Iusticia* (*Justice*). Alfredo Dagli Orti / Art Resource, NY.

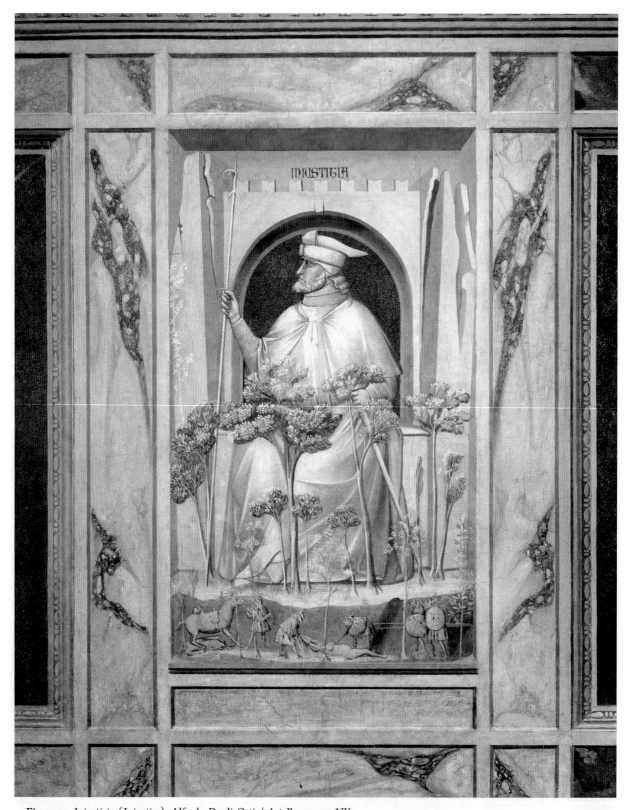

Fig. 4.22 *Iniusticia* (*Injustice*). Alfredo Dagli Orti / Art Resource, NY.

Fig. 4.23 Detail of the relief on the throne of *Injustice*. Courtesy of the UC Berkeley Historical Slide Library (est. 1938–2018), Baxandall & Partridge Collection, Doe Memorial Library in Berkeley, California, USA.

hunting dogs, dancing and music-making maidens appear in a cultivated exterior with two small, manicured trees that stay within the frame of the relief field. The igloo-shaped object next to the dancers might be interpreted as a tent in the tradition of the garden of love; to the right, the composition is rounded off with another pair of noblemen on horseback. These scenes' autonomy as artworks is so strong that Sélincourt even invents little titles for them: "*Music and Dancing*, and *Security in Travelling*."[47] Instead of aggression, assault, and murder, there is serene togetherness – "Giotto's Harmony," to quote Eleonora M. Beck on the particular importance of music for this scene:[48] "In a just world there is music."[49]

Justice and *Injustice* feature the designs of their respective throne reliefs in two distinctive styles. In the relief under the throne of *Injustice*, the rank growth of the large trees boasts the dado zone's thickest application of painterly impasto. Sketching the assault in a rapidly painted, almost graphic mode seems appropriate for its brutal violence. The stylistic differences here deliver yet another indication that Giotto was consciously working with juxtaposing different art-historical styles to make a historical, theological, or ethical statement.

Next to *Justice* appears the trio of the theological virtues. Under two adoring angelic busts in the angles of her niche, the figure of *Faith* (see Fig. 4.25) stands upright, holding a cross that seems to be made of *marmo rosso* mounted on a

Fig. 4.24 Detail of the relief on the throne of *Justice*. Courtesy of the UC Berkeley Historical Slide Library (est. 1938–2018), Baxandall & Partridge Collection, Doe Memorial Library in Berkeley, California, USA.

long rod in her right hand, and a scroll in her left. Vanquishing the force of gravity, the scroll spirals upwards. Parts of its inscription is decipherable, as are some writings, annotations, and drawings under her left foot that are usually interpreted as magical, kabalistic, or astronomical texts.[50] Next to her right foot, the tip of the rod appears to pierce the classical idol that lies shattered on the ground (as discussed above, in Chapter 2). Her eyes are bright, clear, and focused on something high and distant, almost suggesting physical blindness and inner sight or clairvoyance. Her counterpart,

Infidelity or *Idolatry* (see Fig. 4.26), is the opposite of *Faith's* uprightness and clarity. The uncoordinated figure tumbles sideways, one eye closed and the other consuming a miniaturized woman that he holds in his hand, making her the idol of blind desire. This statuette dominates the *Vice* with a rope around the neck. Their circular, self-contained symbiosis remains untouched by the small prophet mentioned above, who is desperately waving a scroll from the upper right corner. A fire burns bright red in quasi-sculpted, thickened flames.

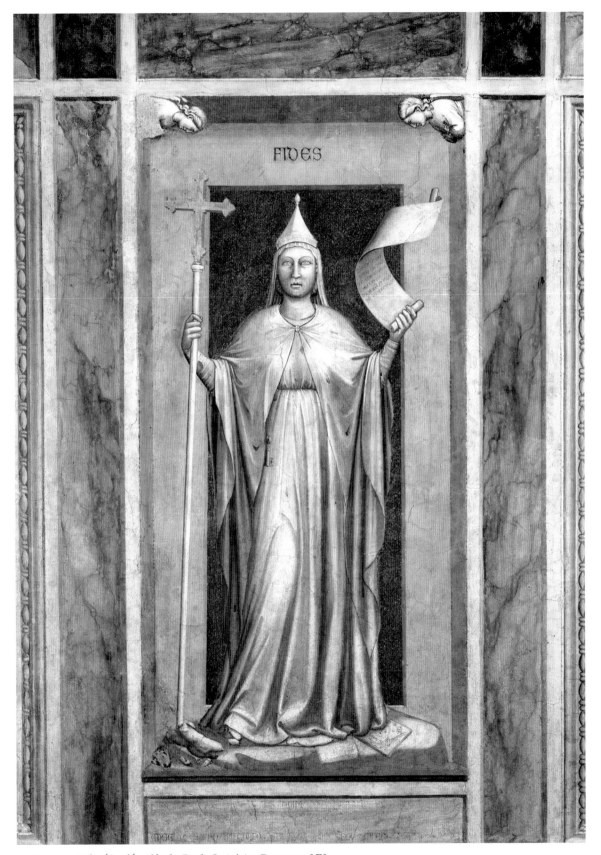

Fig. 4.25 *Fides* (*Faith*). Alfredo Dagli Orti / Art Resource, NY.

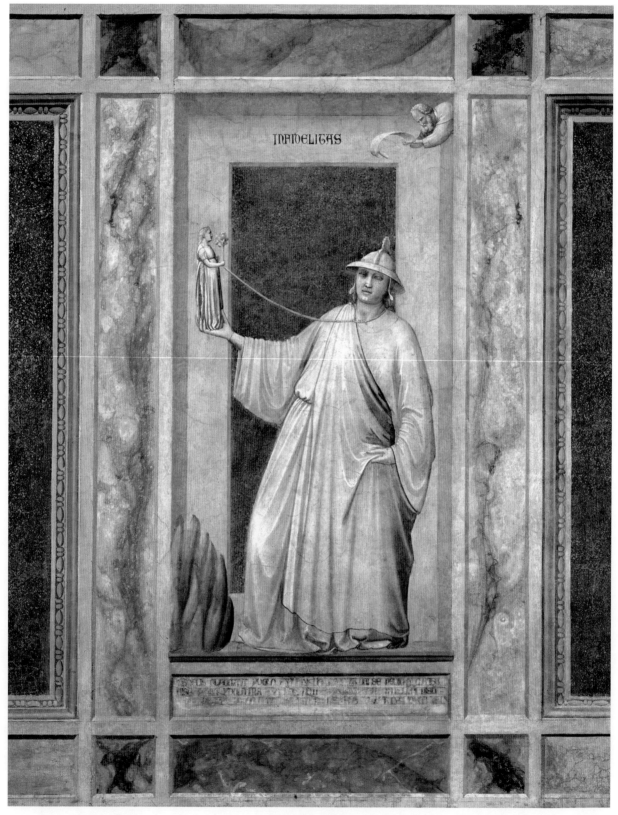

Fig. 4.26 *Infidelitas* (*Idolatry*). Alfredo Dagli Orti / Art Resource, NY.

Similar tongues of self-inflicted flames have already lit a fire under the adjacent vice, that of *Envy* (see Fig. 4.27). This figure, fully standing in the flames, clutches a moneybag while reaching out with her other claw-like hand to yet something else she begrudges. She is characterized by a grotesquely overdrawn ear and a snake that emerges from her mouth only to turn around and bite her between her own eyes or maybe hypnotize her. Interpreted as the ultimately self-destructive sin of defamation, the self-involvement, spitefulness, and hatred of this figure makes her an absolute contrast to *Charity*, who is not only crowned with a wreath of roses but also the only virtue with a halo (see Fig. 4.28).[51] Circled as perfectly as Giotto's O, it is executed in finest transparency while three flames radiate from the even compass of her head: next to her eye, behind her ear, and from the crest of her head. *Charity* gives her heart to a Christ-like bust in the upper right corner. The socle on which she stands is formed by moneybags like the one held by *Envy*, but here the figure appears to be absolutely disinterested in that kind of currency. Rather, *Charity*'s hands hold warm, blood- and juice-filled organs and fruits: her heart and a bowl of pomegranates, along with a rich harvest of wheat or rye ears, and roses. The bounty of luscious fruit combined with the nurturing grains and the beauty of the roses makes this bowl a rural harvest festival's emblem. If this Roman-Christian *Charity* had an older sister in the ancient imagination, it would be the goddess of abundance Pomona.

This procession of the *Virtues* and *Vices* ends with *Hope* and *Despair*, the dramatic culmination of all the above (see Figs. 4.29–4.30): *Hope* surpasses the condition of her own statuesque and material limitations, levitating and reaching upwards with soft, red-hued hands to a heavenly crown that waits for her in divine hands in the upper right corner; *Despair* is presented in a harrowing struggle with death. Fists cramped and clenched, hanging and dying slowly, she is being tormented by a small demonic creature that seems to jab a barbed hook into her left temple. Over time, both the demon and the figure of suicide have been defaced by iconoclasts (as have *Envy*, *Injustice*, one of the figures in the *Brazen Serpent* quatrefoil, and the figurines on *Justice*'s balance). The increasingly willful destructiveness of the vices echoes their inherent theme: From offhand *Folly* to fatal *Despair*, "the quality of self-destruction" (Sélincourt), opposing the quality of self-transformation towards self-salvation, culminates in this dark corner.[52]

This study's focus on the expressiveness of spatial phenomena in an ethically informed iconographical system highlights some additional visual information from the figures' demeanor in space as they communicate their moral condition. Most of the vices are unstable or, if not, crushingly heavy. On the little hill, *Folly* is misbalanced with unclassical proportions, long rags hanging down, bells and feathers clouding the forehead, and a club in one hand that threatens to fall, every second, on the vice's own head. *Inconstancy* helplessly glides from a polychrome marble disk, or inclined plane. Finally, in the most dismal corner of the chapel below the *Last Judgment*'s darkest regions of hell, *Desperatio*, echoing Judas who is painted above, drops downwards to hang heavily – to the rod's breaking point. Contrastingly, the determined lightness of the virtues is anchored in equilibrium and stability, with a calm energy that could not be more dissimilar to the vertiginous impermanence of *Inconstancy*'s decline. Regarding relief effects, it is noteworthy how the visualization of weight and lightness operates in this simulated spatial zone, here inaugurated in painting, as it opens up a limited space of representation in which the force of gravity does apply.

The *Virtues* are all steadier in their appearance, more securely bound to the relief ground. Exuding calm agency, they seem either grounded

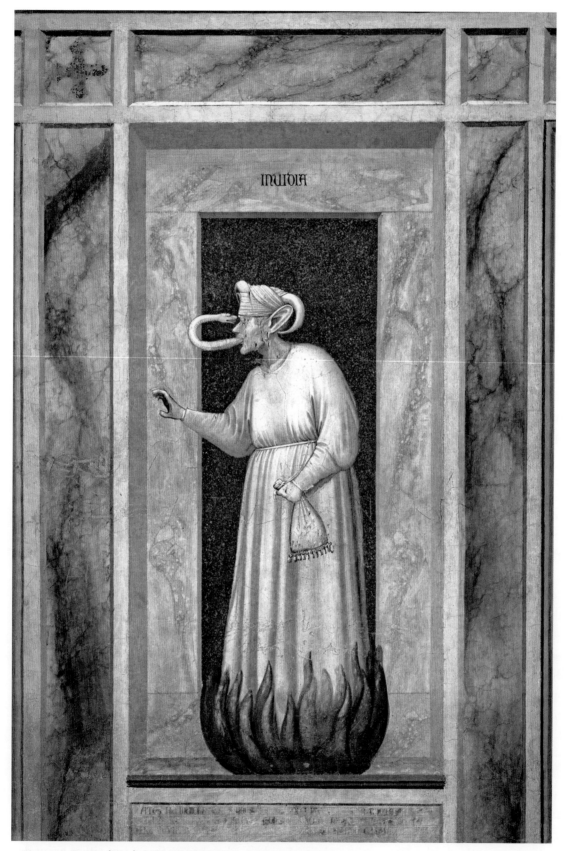

Fig. 4.27 *Invidia* (*Envy*). Alfredo Dagli Orti / Art Resource, NY.

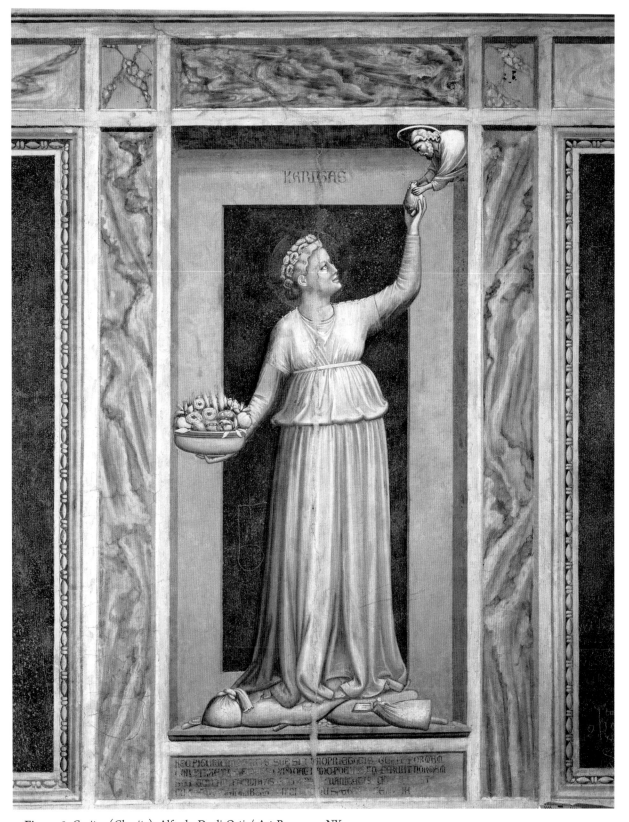

Fig. 4.28 *Caritas* (*Charity*). Alfredo Dagli Orti / Art Resource, NY.

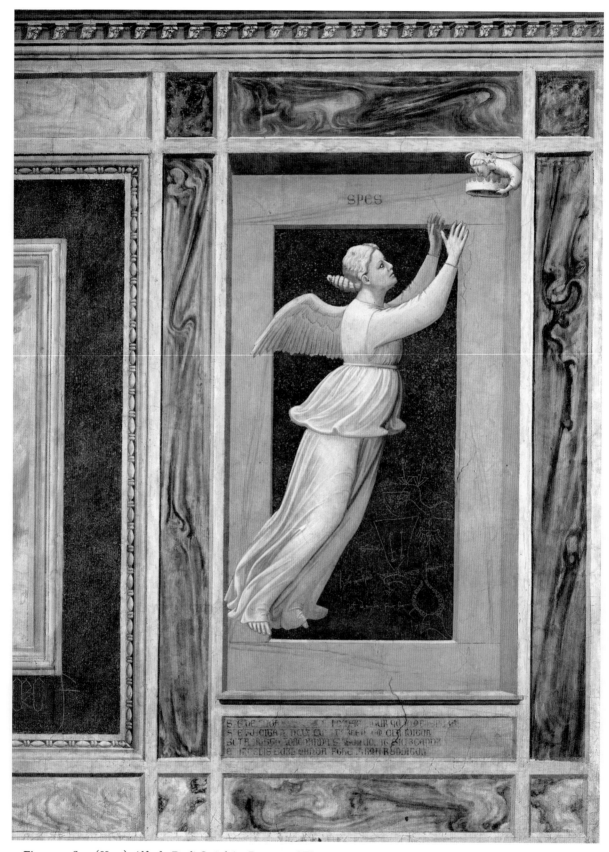

Fig. 4.29 *Spes* (*Hope*). Alfredo Dagli Orti / Art Resource, NY.

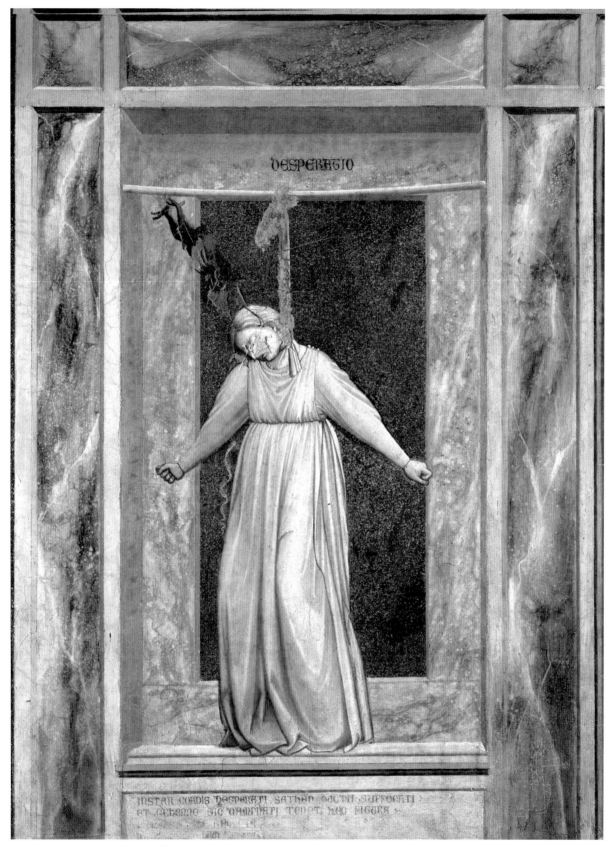

Fig. 4.30 *Desperatio* (*Despair*). Alfredo Dagli Orti / Art Resource, NY.

or distinctly light, almost weightless like rising *Hope* in contrast to the grave image of neck-breakingly heavy *Despair*. Moral images with emotional dimensions, the *Virtues* complete their stable and solid movements with facial expressions of serene determination. It is not by chance that these are precisely the attributes that are typically used to describe classical sculpture. Here more than in any other group of figures in the chapel's diverse registers of representation, Giotto capitalizes on the monumental aspect of classical sculpture. Hercules reappears as *Fortitude*, Nike as *Hope*. The *Virtues* start with two profiles directed towards the west wall in *Prudence* and *Fortitude*, followed by three firm frontal views in *Temperance*, *Justice*, and *Faith*, while the fluttering scroll in the hand of *Faith* transports her with uprising movement. Two further profiles, *Charity* and *Hope*, express unwavering focus towards the grace given to the blessed side of the *Last Judgment* on the west wall.[53] *Hope* is also elevated, not only in her exceptional classicism but also in her exceptional yearning: "A young woman in a classic chiton," she "rises a short distance from the ground, floating upward, as though borne by her great longing."[54] Sirén conclusively substantiates the combination of her classicism and inner qualities as "related to the classical genii or Victories, but [as having] more spiritual quality, more aspiration than the ancient figures. Her soaring seems to free her from all material bonds, despite her markedly plastic form."[55]

The walls communicate in oppositional didactics of good and evil, and even their postures associate the quasi-sculptural personifications with the ranks of the blessed or damned spirits. Instances of parallelisms and mirrored figures among the chapel's different realms have often been noted since Alpatoff's seminal study. However, earlier scholarship connected such forms and gestures without considering the figures' volumes, yet Giotto gives their postures real

space and real gravity that in turn determine the figures' availability for diagonal readings across the registers and levels of the painted interior. Figures do not abstractly cross-reference other figures as if they were signs or symbols, but their representation in fictive relief makes their mutual enhancement even more vivid. It is a mode established in this pedestal zone at eye-level and in touchable closeness to the spectator, providing a first hint on how to look at the rest of the chapel. Like the typological vistas between the scenes of the Passion, the *Virtues* and *Vices* serve as the footnotes to the user's manual for the chapel.

As mentioned above – and in tune with the theological typologies of the triumph of humility – I consider this part of the chapel a contribution from the *spolia* of the Arch of Constantine. We have seen this collaging of remnants, combined with new elements, as a necessary step between the abandonment of ancient artistic standards and an integration into a new Christian art. In effect, this eclecticism would, in a Trinitarian manner, triple the Arch of Titus, piecing together an omnium gatherum of material relief *spolia* from earlier imperial monuments, including from the time of Marcus Aurelius. Is it possible that the Arena Chapel, circa 1300, aimed at outperforming even the Constantinian project, both artistically and ideologically? Instead of physically incorporating pieces of broken marble, Giotto creates optical *spolia* and extends their presence into the entire space by echoing the ancient arch as a whole with the design of the chapel's building. By virtue of being illusionary rather than actual material fragments, these visual *spolia* seem to make a point about the fundamentally different understanding of matter, word, and vision that is defined by Christian doctrine (see Chapter 5).

In the end, the *Virtues* and *Vices* are more than footnotes. The coding of the program for the entire chapel depends on the dado zone as a

quasi-material standard against which the upper scenes – in full polychromy and in a different stylistic key of optical relief, with fore-, middle-, and background – oscillate between relief and painting. In relating to the principles below them, the scenes above employ the abstract ethics of the virtues and vices through Giotto's immaterially material *Virtues* and *Vices*. They insert themselves into specific places on a historical timeline that details the Christian vision as a Mariological and Christological family narrative – one that every viewer is invited to partake in by recognizing the universal stories that are being told, starting with the introspective gaze of *Prudence* speaking, in the fragments of her inscription, of times and things to remember.[56] The principles are extracted from Giotto's observation of life as much as they, in turn, model ways of reentering life, manifesting in moments, scenes, and narratives above the dado zone.

RELIEF EFFECTS IN THE *LIVES OF MARY AND JESUS*

Nothing defines the immediate impression of the Arena Chapel as powerfully as its brilliant blue. Julia Kristeva calls this calm, solid, reliable shade "Giotto's Joy": "a colored substance, rather than form or architecture."[57] Kristeva goes on to describe the color from a psychoanalytical point of view,[58] yet by characterizing Giotto's painting as a substance, she has already touched upon its essence. The notion of this uniform "ungradated colour" (Sélincourt) is consistent in discussions of the chapel, the "main action [...] designed in immediate relief against it";[59] the blue "envelop[ing] the whole, like deep sea about an island."[60] With the surprising exception of Wolfram Prinz, who compares the coloristic effects to glass windows,[61] authors usually agree on the impermeability of this particular Arena Chapel azurite. Paul Hills describes the

difference between glass and fresco thus: "The light of stained glass is immanent in the substance of its color: In fresco the light of the setting and the pictorial light are distinct and yet they interact."[62] He justly notes, furthermore, why the early afternoon light is ideal for visiting the chapel: "By natural light the blue appears less harsh; the figures stand out in greater relief and the pale tones appear more frankly to receive light as an external force."[63]

The opaque blue ground works like a relief plane for the figures that it outlines, mirroring the function of gold ground in so far that it organizes the reciprocal delineation of figures and plane. On a qualitative level, the material makes all the difference: The opacity of gold ground is definite by its capacity to reflect light, whereas Giotto's blue has the potential to evoke infinite distance as well as to block the view and emphasize the foregrounded figures. Human senses struggle trying to perceive infinity; one can maybe try to conceive of it in spiritual or poetical dimensions, thus the chapel's rich blue makes for an intriguingly ambivalent relief plane for the figures. Focusing the gaze on the blue, its almost infinite potential of depth or closeness makes it appear suggestively indeterminable. Alternatively, the blue approaches the limit in space set by the material wall and plaster when the gaze falls on the figures and landscapes of each individual scene. It is in relation to those other pigments that the blue ultimately stabilizes all inner pictorial elements.

This effect of solidification has often been noted. Giotto's blue has been described as *Überblau*, as consolidated blue, as hermetic blue, as massive blue.[64] It unifies the narrative cycle's scenes, the chancel arch, and the west wall. Moreover, it contrasts strongly with the pale blue in the architectural still lives of the *coretti*, the two famous little fictive side chapels. The blue behind their slim windows is that of daylight, each of those fictive windows distinct even from one

another and both vastly different from the darker *Überblau* that serves as relief plane. This differentiation between the blue of natural daylight in the *coretti* and the azurite in the narrative scenes stresses the artificiality of the fields. While we cannot know if, or if not, traces of original or later blue may have been present and remained on the Arch of Titus reliefs in Giotto's time, there is the possibility that Giotto's Arena blue emerged directly from that of Greco-Roman antiquity. In the manner of other Hellenic models emulated by Roman artists, the Titus reliefs seem to be most likely to have borrowed the Greek convention of uniform blue backgrounds.[65]

The *quadri*-like narrative scenes from the lives of Mary and Jesus on the walls above the *Virtues* and *Vices* are traditionally understood as being closer to the world of everyday perception – closer than the ground-level allegories.[66] I agree that the stylistic variety among the registers indicates different levels of meaning, a well-noted concept throughout the literature and obvious to any visitor: One immediately experiences the narrative scenes as categorically distinct from the allegorical figures. With the possibility of the Roman arches and their multiple reliefs as models for the Arena Chapel now more firmly established, I want to push this medial difference a little bit further: For theological reasons that will be further addressed in Chapter 5, I consider the polychrome fields of the upper registers to be closer to the idea of reliefs as simulated in the dado zone than has been hitherto discussed. Relating, in their design, to the illusionistic standard set by the system of marble bands, frames, and bas-reliefs in the socle, these fields optically assume qualities of polychrome relief sculpture. The "mock marble"[67] of the dado zone seems to set the tone for the entire room's predetermined surface and, under the addition of a thick layer of shining polychromy on the upper levels, gives the narratives their universally noted relief-like design. As much as the format of the scenes foreshadows painted *quadri*, the latter flourished only a century later as a format for paintings, probably in the response of Giotto's pupils and compatriots to these innovative fields.

Though one tends to look at reproductions of the scenes as if they were easel paintings – a mode forced upon the images by most printed layouts[68] – there is no reason why one should expect paintings on this chapel's walls to function conventionally. Why would they not, in some way, engage with the idea of being integrated like reliefs in the armature of a system that indicates absolutely coherent sculptural formulations around them, from the bottom to the top?[69] Therefore, I suggest, the narrative scenes of the *Lives of Mary and Jesus* cycle seem to play with the illusionism in greater harmony and coherence with the sculptural key of the *Virtues* and *Vices* than has been hitherto acknowledged. One can consequently consider the narrative scenes to be purposefully suggesting fictive polychrome reliefs, establishing themselves as paintings oscillating between the *modi* of painting and painted polychrome relief sculpture. This does not mean that they imitate polychrome relief sculpture with the same veracity that the dado zone imitates fading polychrome relief sculpture. Their being refilled with colors and more ambivalently set between fresco painting and painted polychrome relief sculpture opens a visual dialogue between both media conditions and materialities, merging the competing forces from the sides of ancient pagan sculpture and modern Christian mural painting.

Numerous canonical descriptions of the frescoes from nearly two hundred years of scholarship have noted such relief-likeness in the Arena Chapel scenes. The stony and voluminous qualities of Giotto's work constitute a commonplace in art history. One immediately thinks of the influential formulation of "tactile values" presented with the celebration of Giotto in Berenson's introduction to his *Italian Painters of the Renaissance*, where the connoisseur moves from the Ognissanti Madonna to the Paduan

scenes.[70] Core aspects of the controversy around Offner's "Giotto, Non-Giotto" revolve around the optics of relief sculpture. According to Creighton Gilbert, Giotto scholarship after Berenson worked with the simplistic substitution of "tactile values" with other terms, namely those of "mass or relief."[71] Following scholarly relief references state plainly that the scenes look similar to reliefs.[72] Sirén writes that "[several] of the frescoes seem composed rather for execution in sculpture than in painting"[73] and that

> [the] figures are placed by preference in clear silhouette against the background, the outline is unbroken, the fundamental form is not disturbed by any accentuation of detail. Definite layers, one behind the other, indicate the depth dimension, almost as in reliefs.[74]

To give a more recent example, Anne Mueller von der Haegen in 2000 formulated the importance of the Arena frescoes precisely in terms of volumes, space, figures, and action.[75] Interestingly, the votes for a general affinity of the narrative scenes with relief appear separate from the many equally well-known and obvious references to actual ancient and contemporary relief sculpture that Giotto made the sources of his inspiration.[76] The disconnect of these two approaches in traditional scholarship implies that Giotto, on the one hand, expressed himself artistically in "tactile values," and, on the other, inserted individual figures from antiquity. In the Arena Chapel, however, both practices work hand in hand. In light of the Roman arches that I propose as potential models, it is once again possible to consider the coherence of Giotto's approach, which follows an inherent logic and leads to a change in the medial status of these narrative fields. They oscillate between the modes of murals and polychrome relief sculpture as evoking the idea of frescoed simulated painted reliefs in the chapel's elaborate *trompe-l'oeil* context. Not only do these frescoes look like reliefs in

the sense that they are paintings that simulate reality in relief-like style. Instead, the painting here simulates relief that, in turn, simulates reality, allowing for a give-and-take between various realms: that of painting, relief sculpture, painted relief sculpture, painted polychrome relief sculpture, the wall, and visible reality itself.

Pictorial relief appears in the vast bodies of artistic reception and historiography concerned with Giotto's "volumes," his "relief," his "tactile values." The following pages investigate the language around Giotto's light and volume, eventually turning to their relevance for the Assisi question here and in the Appendix. Giotto's relief is anchored in two essential properties that are widely addressed in scholarship on the Scrovegni murals: volume and surface, specifically in terms of the wall's own surface and its interplay and correlation with the simulated two- and three-dimensional components.[77]

How exactly does the tension between volume and surface generate optical relief, one of Giotto's pictorial strategies that would ultimately become so central for the transformation of the image in early modern Western visual culture and its after-life in the writing of art history? My conceptualization of relief effects as a problem of media and materiality in Giotto's Arena Chapel encompasses several interconnected categories: First, the qualities of pictorial relief (everything traditionally called *rilievo*) in any fields displaying figures; second, the simulation of relief sculpture in the colorful variety of faux marble and architectural relief in the socle zone; third, the presence of the transverse arches, and the relevance of the doorways to the overall program as establishing ultimate limits between real space and painted surface qualities. It further includes both the dormant sculptural and inherent painterly possibilities of the medium as well as the traditional shift of relief between plane and volumes – hence the qualification of such effects in a wider sense as medium effects. David Summers' attention to the

"secondary plane" is a helpful concept for this understanding of planes, the "invisible virtual coordinate plane" that subtends as a perpendicular to the upright parallel planes.[78] In regard to Giotto's Arena Chapel scenes, Whitney Davis has pointed out that the throne reliefs under *Justice* and *Injustice* in particular are in a position to alert Giotto's beholders and analysts that he is fully capable of working with the "virtual coordinate plane" as a pictorial parameter.[79]

Giotto had to walk a fine line with his illusionistically created neoclassicism for the Scrovegni Chapel. He had to frame his painted reliefs in a way that would distinguish them from the concrete ancient version of the material world as expressed in the sculpted physicality of the gods and the cult of the idol. He also had to find a way to integrate the early Christian and Byzantine counter-model that focused on the sacred in more symbolic ways yet without entirely espousing those ideals, since they would not allow for the whole to deceive the eye – as Giotto's painted representation of relief sculpture does. As a result, his new *maniera latina* takes from both – the concrete sensuality of antiquity as well as a Byzantine spirituality of sublimated sensual experiences. Giotto's imitation of stone incrustations can be best understood within this cultural-artistic triangle between ancient Rome, Byzantium, and the Christian Rome of 1300. Giotto adopts painted, illusionistic incrustations of polychrome and monochrome carved stones for one complete, coherent, and unified frescoed interior space, a perfect simulation of lithic surfaces – the only breaks in the system are calculated. The most important and defining difference from earlier arch-inspired Christian interiors is the completeness of Giotto's illusionistically convincing simulation of stone for Scrovegni in Padua. This distinguishes Giotto's chapel from the arch bay of San Silvestro Chapel (and from other examples in the long history of the triumph of humility in arch-inspired spatial iconographies) as an architectural concept that responds to the triumph and triumphal arch of Titus. The Cubiculum Leonis in the Domitilla Catacombs from the late fourth century displays the first image of Christ with beard and halo in the position and rectangular frame of the Titus relief in the apex of the Arch's vault (see Fig. 1.5). Again the reference functions on the level of spatial symbolism; only Giotto goes so far as to set a spatial-symbolic response to the Arch of Titus in a self-conscious illusionistic key.

I define relief effects in painting as an intra-pictorial phenomenon that organizes the relation *between* two- and three-dimensional elements *within* the representation *in relation to* the picture plane, and therefore in relation to the viewer. Relief effects in specific paintings or graphic works differ in nearness or distance to the plane, in total or partial correlation with the pictorial field, and in varying degrees of illusionism. The singular term "relief effect in painting" subsumes all of the above; as for Giotto in Padua, these effects are more specific than in other places but they appear as bearers of meaning both before Giotto – an example would be Cimabue – long after him, such as in the case of Mantegna.[80] The common denominator among such effects is a unique, spatially intruding appeal to the spectator by ways of their apparent emergence into real space.[81] This invasive quality challenges the spectators to estimate how far or close the represented matter is supposed to be positioned in relation to the real space and thereby to them. The relief effect moves between two extremes – on the one hand that of total dissociation between figure and ground (the area around a figure traditionally known as *campo*) and, on the other hand, the recession of purely central perspectival images that avoid any intrusion into real space (such as the famous 1470s *Ideal City* in Urbino's Galleria Nazionale delle Marche). Indeed, later images of this type usually rely on the inclusion of at least some partial relief effects

into their overall central perspective construction in order to deliver a meaningful *storia* or introduce friezes of figures into a foreground (see Perugino's *Christ Giving the Keys to Peter* in the Sistine Chapel). Their extremely successful application by Giotto in the Arena Chapel cycle depends on its relief-like staging of dramatic moments. Yet as we are looking at relief represented by painting, the final triumph of painting (to simulate fictive relief as well as, by implication, the applied pigments painted onto the surface of the fictive relief) opens the definition of "relief effects" towards "medium effects," not only via spatial theories by Davis and Summers as mentioned above, but also in considering more directly, as equals, the two components of polychrome relief sculpture: paint-in-painting and sculpture-in-painting.

Giotto's volumes are legendary. Some authors refer to so-called proto-perspectival qualities, to a general narrative scheme, or to constitutive moments forged by a triad of action, figure, and space. At the same time, Giotto was panegyrically described by his contemporaries in terms of *ingegno* (genius) rather than through a detailed account of his works,[82] and it has long been noted that he foreshadowed the *storia* of the fifteenth-century Florentine theorist Leon Battista Alberti through a new volumetric representation that allowed an artist to draw together the dynamics among figures, emotions, and actions. The lasting, self-renewing modernity of Giotto's works consists in the artful and subtle synthesis of all these factors – figures, space, action – brought into the neat and rational nearness of a spectator-centered relation. The word "relief" itself serves as an umbrella term for these phenomena of volume, emotional charge, space, and interaction. All of these features can be described in relation to the surface, the spectator, the content, and one another within an image. As a traditional pictorial term – but also as a comprehensive description of matter in relation to surface, narrative, and movement – "relief" (*rilievo*) captures Giotto's most powerful achievements in the medium of painting. Of course, pigments and polychromy also maintain their unique importance for Giotto's scenes independently from their contributions to optical volumes. His works' most subtle finishing touches require a layer of paint, as for example the eyes that create those famously intense gazes, like the memorable silent exchange between Mother Mary and baby Jesus in the *Nativity* or the camels' striking blue eyes in the *Adoration of the Magi*.

Relief-like designs in the chapel's narrative cycle are most dominant in exterior scenes, such as *Joachim Entering the Wilderness*, the *Sacrifice of Joachim*, the *Dream of Joachim*, the *Flight into Egypt*, the *Entry into Jerusalem*, the *Lamentation*, and the *Noli Me Tangere*.[83] Two of the most famous scenes from the chapel's lowest tier are particularly powerful in visualizing their tension between surface and relief-like volumes. One is the *Arrest of Christ* on the south wall (Fig. 4.31) with the uniform line of burning torches, sticks, clubs, lanterns, and halberds recalling the Titus procession under Roman *fasces*. Christ's head is the center of attention; the vectors in that diagram all point towards him. Two fists are clenched around weapons just over Christ's halo, emphasizing his isolation amidst a hostile crowd. As Zucker puts it, "all that remains of the ten cowardly apostles, fleeing behind the frame at the left, are a fragment of a cloak, [. . .] and a fragment of a haloed head."[84] There is a sense of slowed-down movement towards the central gesture of betrayal as if it forms the eye of a hurricane – deafening silence and dissociating trauma.[85] Relief planes within the composition establish themselves through hands and gestures, performing with the clarity of shadow theatre and appearing in front of large zones of color.[86]

Another strong pictorial relief design governs the *Lamentation* on the north wall (see Fig. 3.6)

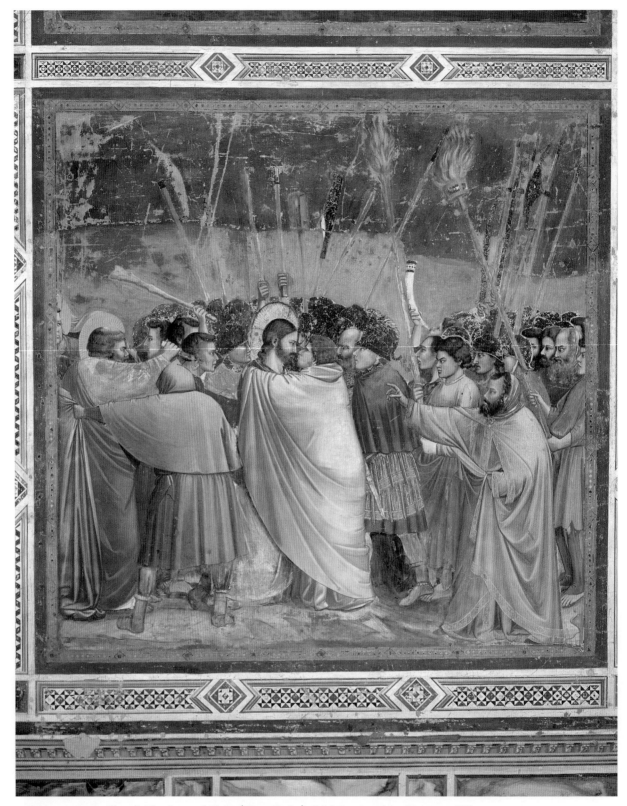

Fig. 4.31 Arena Chapel, *The Arrest of Christ* (*Kiss of Judas*). Erich Lessing / Art Resource, NY.

and its barren landscape with rocks under the familiar blue. The congregation of mourners has gathered around the horizontally placed body in front of the grey slabs. The figures of Mary, mother of Joseph, and of John echo the desperate angels in plain, helpless gestures. Often characterized as "simple,"[87] the gravity of these particular figures has a source in sculptural relief with the widely available *Pathosformel* of Meleager as another potential ancient model for Giotto, visible in several examples in Rome at his time.[88] In this context, the child witnessing the scene of *Jesus Chasing the Merchants and Moneychangers from the Temple* comes to mind, in a long shadow of the famous Capitoline marble of the *Girl Saving a Dove from a Snake* (Figs. 4.32–4.33), indicating that Giotto may have included additional ancient Roman sculptural references in various ways. Something curious has happened here in the process of translating an emotionally charged visual trope, a deeply Warburgian *Pathosformel*: We can identify two formal references to the statue in the same scene, namely the clutching of a dove in a child's chest and the *Pathosformel* of the dramatically raised hand, its vulnerable palm exposed with all fingers extended in horror. But these two traces of the ancient sculpture are not simply repeated within the figure of the child; they are split between two immediately adjacent figures in Giotto's version – the child and the closest adult figure directly behind the smaller figure, so that the hand still remains closely associated to the child, but gains visibility by its raised height. More importantly, by splitting the figure's two main features in half and keeping them separate in two figures for his painted scene, Giotto appears to correct a flaw in the ancient sculptor's figural logic. In Giotto's understanding of a scene like that, retranslating it into the reality of everyday observations, he seems to have considered that the natural gesture of a child saving a dove would usually not entail such an exaggerated and overly dramatic

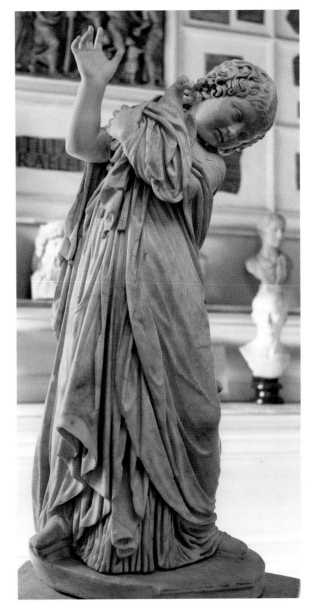

Fig. 4.32 Ancient sculpture of a girl saving a dove from a snake, Rome, Capitoline Museums. Photo by the author.

extended hand movement, but rather adopt the secure grasp of the small animal that itself would be agitated. Giotto takes the motif of a child saving a dove from some sudden and immediate physical danger (the snake in the ancient sculpture, the chaos around the tables of the moneychangers and escaping sacrificial animals in Giotto's scene in the temple), reorganizes, and corrects the ancient model. If this was the case, the detail of the children from the scene of *Jesus Chasing the*

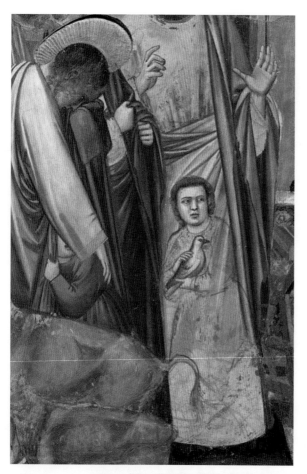

Fig. 4.33 Arena Chapel, detail of the child saving a dove from the chaos in *Jesus Chasing the Merchants and Moneychangers from the Temple*. Courtesy of the UC Berkeley Historical Slide Library (est. 1938–2018), Baxandall & Partridge Collection, Doe Memorial Library in Berkeley, California, USA.

Merchants and Moneychangers from the Temple is a miniature cosmos of his precise yet critical, thorough reworking of the best components of ancient and Christian artmaking. He simplified the figure of the child, keeping it real and natural, while not giving up the powerful intensity of the gesticulation that is more appropriate for the secondary figure in the background who is not trying to hold and protect a small animal. The quasi-disappearance of a second small child under a bystander's cloak next to the child with the dove is only another of many examples of Giotto's subtle commentaries on human behavior and the physical, bodily expression of emotions made visible.

The relationship of Giotto's pictorial relief in the chapel to the fields of the Arch of Titus can also be framed in terms of relief-generating light and illumination – natural in Rome, artificially produced by Giotto on the walls in Padua. What Hills describes as characteristic of the chapel's pictorial light (*rilievo*) applies equally to the Arch of Titus, its reliefs catching the same direction and amount of natural light as Giotto produced in paint with proportions of light to shadow of two thirds to one third.[89] The relative and limited depth of the Arena Chapel's narrative fields corresponds to the virtuous mix of high, middle, and low relief inside Titus's arch. Here and there, figures and action generate depth between the three levels of relief, revealing themselves only where substance and matter connect to other substance and matter. This triple layer amounts to a coherent depiction in which every detail is clearly and precisely related to other details as well as to the whole.

Scholars have found telling words for this balanced tension and its visual potency. Giotto's famous "simplicity" (Fry, Rintelen), clarity of action, and "necessity" (Rintelen) seem to rely on the effective compression of the narrative into these relief zones, evoking Giotto's acclaimed "unity" (Ueberwasser, Smart, Carrà).[90] This unity depends on the capacity of the image as a system to embrace the inner pictorial and inner spatial systems represented upon its fictive plane. Hetzer noted that the individual of the figure is dominated by the individuum of the limited-depth, metope-relief-type image. Similarly, Euler characterizes the plane in Giotto's work as carrier of and mediator between plastic and planar values, stating that the union of figure and architecture – together with the activity unfolding between them – turns general space into a specific place, creating a new narrative factor that combines the functions of body and space, place and scene.[91] All forms of depth seem to be pushed outwards from the blue grounds; there is no sense of recession beyond the

Fig. 4.34 Arch of Titus, detail showing the various levels of depth in the Menorah relief from a tilted point of view. Courtesy of the UC Berkeley Historical Slide Library (est. 1938–2018), Baxandall & Partridge Collection, Doe Memorial Library in Berkeley, California, USA.

physical, material limit of the wall. Subtle elements that would have been hard to carve in relief can be better rendered in "medium effects" – in paint, of which fine traces were applied on the fictive surface of the fictive relief: the thread spun by the fatelike maid of the *Annunciation to Anne*; the thug's saliva spat into Christ's face in the *Mocking*; the Virgin's pale tear. The other crucial factor for the emergence of forms is the very ground on which the figures stand. So often noted as a fundamental invention in Giotto's new art – like the ground of the corresponding Titus reliefs – it provides just the right amount of room for bodies to stand in high relief (Figs. 4.34–4.35).

Giotto develops a fragmentary way of showing only parts of the Temple in the uppermost tier, depicted in slight recession related to its architectural features (Fig. 4.36). The representation of architecture in the Titus relief follows the same simple rules of projecting a corner of a built structure outwards, as in the *mise-en-abyme* of the miniature Arch of Titus itself embedded within the same arch's triumphal relief (Fig. 4.37). Similarly, studies on architecture in Giotto unanimously note the stark difference between the architectural features of the wall scenes as opposed to those of the *Annunciation*.[92] The architecture represented in the former scenes, often described as proto-perspectival, looks very different – and better aligns itself with other architectures in Giotto's oeuvre – if it is considered as an optical equivalent to painted relief sculpture with architectural elements. In contrast to other scenes, these are conceptualized and designed from the outset to remain in flat zones even in places where the implicit groundplan would suggest depth.[93] Mueller von der Haegen observes that these architectures

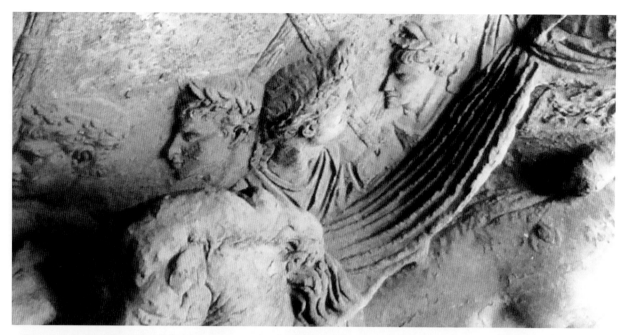

Fig. 4.35 Arch of Titus, detail showing the various levels of depth in the chariot relief from a tilted point of view. Courtesy of the UC Berkeley Historical Slide Library (est. 1938–2018), Baxandall & Partridge Collection, Doe Memorial Library in Berkeley, California, USA.

Fig. 4.36 Arena Chapel, detail from the wall curving into the vault around the stories of Joachim. Courtesy of the UC Berkeley Historical Slide Library (est. 1938–2018), Baxandall & Partridge Collection, Doe Memorial Library in Berkeley, California, USA.

generate a plastic effect though they are neither bodies in space nor do they create space. This is, in fact, an eloquent definition of the hybridity of relief.[94]

In accordance with the Roman models, there is no sense of spatial nesting or interlacing, as Wolfgang Kemp describes for later Northern painting.[95] This contrast is fruitful to consider:

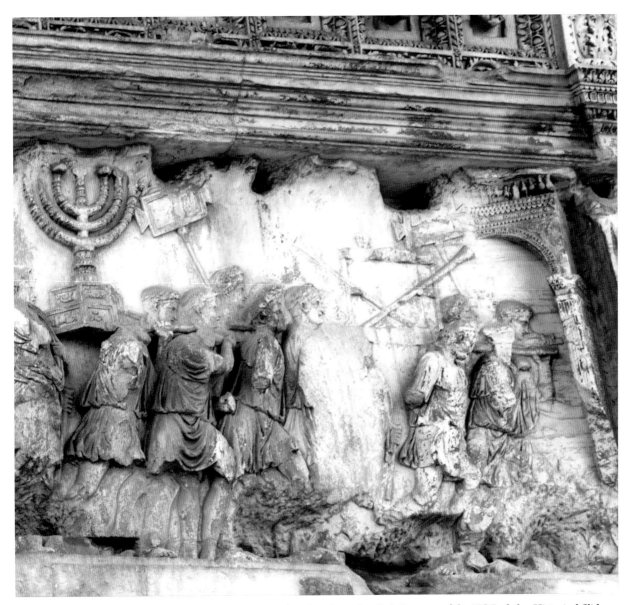

Fig. 4.37 Arch of Titus, detail of the miniature arch within the Menorah relief. Courtesy of the UC Berkeley Historical Slide Library (est. 1938–2018), Baxandall & Partridge Collection, Doe Memorial Library in Berkeley, California, USA.

Kemp emphasizes a strong distancing element in the perspectively nested early Netherlandish rooms, where the pull into lengthy room layouts is strengthened into the distance and figures are potentially drawn back and away into tunnels and corners of the depth of the image. The relief effect, especially in Giotto's scenes, offers a different model – quite the opposite to the Netherlandish receding systems of depths and coordinated planes, Giotto's figures and matter remain always relatively close to the beholder. The optical association between figures and planes within the images emphasizes this proximity as they have nowhere to go but towards the outside – beyond the semiotic border or veil between fictive and real space. The sculptural relief model enables Giotto to operate visually on both sides of the wall's material membrane so that images seem to recede and project to a defined and limited degree of depth and protrusion. The placing of figures is heightened to produce a stronger suggestion of presence. As a result, there are few boundaries

between the figures and the spectator either spatially or psychologically. A representational system that remains strictly within the four corners of the fictive space, as in later Northern painting, favors spatial connections deeply embedded within its box-like imagined worlds, often distancing the viewer. By contrast, the relief system subtly moves the matter of representation into real space so that it emerges into a sense of participation in the viewer's realm.[96]

Within the massive literature on Giotto's spatial solutions, many authors emphasize the importance of relief. Jantzen recognizes Giotto's synthetic approach,[97] the voluminous swelling caused by chiaroscuro,[98] and the composition as relief-like side-by-side,[99] the whole scene developed through the idea of relief.[100] Basile notes the spatiality of figures that almost seem to emerge from the frame and a specific "'tactile' characterization of the colours."[101] We will return to these authors in the Appendix, which discusses how the Assisi problem has a special place in the descriptions of pictorial relief in Padua and how, consequently, the question of fictive relief can also help to explain some of the differences between Padua and Giotto's work in the Upper Church of San Francesco in Assisi – suffice it to note here that the three main scholars addressing relief in relation to the Assisi controversy are Richard Offner, John White, and Luciano Bellosi (see Appendix I, *Assisi Revisited*).

The careful carving out of volumes by means of painting is so successful that Giotto could reproduce multiple kinds of stone in the chapel. A dozen types of marble is imitated, portrayed, in the *Virtues* and *Vices*, in the marble bands with relief ornaments and cosmati work, and – to a certain degree playing with the idea of polychrome relief – within figures and objects embedded in the main scenes that shift between *fresco* and *rilievo*, some of them crystallizing as if made of colored marble and embedded ready-mades such as the synthetic marble for the tomb of Lazarus and for Christ's tomb in the *Noli me tangere*. This

study posits that the purposeful oscillation between painting and polychrome relief sculpture determines the meaning of these murals. This is where it connects with the Giotto literature of the late nineteenth and early twentieth century, when there was notable interest in these simplified stony forms and in the idea of crystallization. Scholars describe Giotto's Paduan work formally in terms of stone, blocks of marble, and crystal.[102] The image of the crystal also appears quite consistently in the twentieth-century literature on Giotto: Sirén uses it;[103] Hetzer uses it in German in relation to Giotto's Arena Chapel figures, describing them as angular and as edged like crystals.[104] Modern aspects figure in Maginnis' 1997 discussion of "Giotto's Profundity" as a connection between the formal simplicity of the Paduan figures in the light of contemporary artistic interest in abstraction.[105] An overwhelming majority of twentieth century critics such as Roberto Longhi relate Giotto and modern artists via the question of volumes or *valori plastici*.[106] Even earlier, Rintelen would state that Giotto reminds him of Cézanne's still lifes,[107] while Clive Bell would demand: "Go to Santa Croce or the Arena Chapel and admit that if the greatest name in European painting is not Cézanne it is Giotto."[108] In summary, Flores d'Arcais calls Giotto a "very modern, avant-garde artist."[109] As Hetzer did about a century ago regarding Giotto and Cézanne, recent conferences and exhibitions followed the inherent modernity of Giotto's volumes and colors by engaging his legacy with abstract works by artists such as Malevich, Rothko, even allowing "side-glances" at Joseph Beuys, as Michael Viktor Schwarz writes, or the critical commentary on Giotto as "Shakespeare of painting" with quasi-Malevich black square behind the stone-like sleeping Joachim in T.J. Clark's recent *Heaven on Earth: Painting and the Life to Come*.[110]

The specific mechanism of cognition in Giotto's frozen-moment frescoes that attracted

so much modern attention has to unfold not only in stillness but also in motion. Time and place are the commanding elements in Giotto's famous conception of an image in narrative specificity, unity, recognizability, and comprehensibility. But they are also key for the beholder, who is held in place and motivated to move by those parameters. In an image that engages the viewer by the way of relief effects, there is more than one ideal point of view. But in order to understand the relationship between the single units they see, spectators must move around the whole chapel with its many diversely staged images placed at different heights and viewed from different angles. Giotto succeeds, thus, in interweaving an ideally situated, stable spectator with one who is mobile. On the one hand, there is a single and precise designated place in the middle of the chapel where the framing architecture and the *coretti* cohere, where the illusionistic effect is most powerful.[111] On the other, the spectator's task seems to consist precisely in finding this place, recognizing its perfected illusionism as such, and then giving it up again for a different kind of fullness of perception and understanding that arises from viewing the other scenes. The original division between the palace and public precincts in the chapel – the former choir screen at the center of the double arch that divides the two realms – complicates the matter, allowing different groups of visitors to enjoy alternative modes of perception. The potential physical-spatial mobility in the act of looking for viewers, with or without the special privileges required to enter the area behind the choir screen, is also key for easing or perhaps even resolving any apparent contradiction between a relief effect that would have to be seen from a frontal viewing position, in true Hildebrandian fashion, and the reality of a view from the ground that displays the figures in a sequence of increasingly steep raking lines of sight. Maybe the sense of "locomotion" that Bernard Berenson mentioned as the chapel's

other evocative force, together with its images' "tactile values" (the classic topos in Giotto scholarship), destabilize the viewing situation enough to negotiate these two spatial systems.[112] But Giotto is celebrating his painterly craft. After all, we are still looking at a triumph in painting – of painting as humility over sculpture as pride. The perspectival and optical illusionism is but one part of a systematic self-reflective commentary by the interior on its own "made-ness" and on the maker of the world. As argued above, the two strong apocalyptic angels over the *Last Judgment* make their point not only explicit but palpable as they literally remove the ground of the relief of existence – the very plane of the fresco.

THE CHANCEL ARCH, THE *CORETTI*, AND A VAULT WITH A VIEW

In the standard vocabulary of church architecture, the chancel arch is traditionally called the "triumphal arch." In Padua, this part of the building hosts the Annunciation iconography in its apex and spandrels (Figs. 4.38–4.39 and see Figs. P.25 and I.10–I.12). The common usage of the term reveals the deep roots of the arch-turned-church formula in the conventional terminology of architectural building types – the basilical "triumphal arch," "arco trionfale," "arc de triomphe," or "Triumphbogen."[113] The proemial scene at its apex has been called *Prologue in Heaven, Mission,* or *Dispatch of Gabriel*: God's throne hovers among a host of angels as he entrusts the kneeling archangel with his message. The figure of God the Father is painted on a wooden door panel; its state of conservation is highly compromised.[114] The light-filled scene of the mission leads to the lower part of the *Annunciation* in the two simulated rooms projecting off the arch's spandrels. Paradoxically, the continuity between the upper portion and the lower regions is achieved through two dividing

Fig. 4.38 Arena Chapel, detail of the Angel Gabriel in the *Annunciation*. Courtesy of the UC Berkeley Historical Slide Library (est. 1938–2018), Baxandall & Partridge Collection, Doe Memorial Library in Berkeley, California, USA.

lines that half separate, half open the space between the *Mission* and the *Annunciation*. These lines are the uppermost ledges of the angel's and Mary's cubicles; their position forms a tangent to the apex of the inner arch.

The settings around Gabriel and Mary reach, via their fictive protrusion, into the spectator's space, achieving a much stronger and more immediate presence than do the narrative scenes. Gabriel and Mary's composite image is the least strictly integrated, framed *storia*. Giotto acknowledges its particular prominence in the Mariological tradition of the site as well as the crucial moment of the Incarnation – the hinge of Salvation history – as

the shift in his framing system from ancient-pagen to modern-Christian.[115] The cubicles' position is maximally opened towards the real space. These architectural elements are the most highly protruding ones in the entire chapel's fiction; they retain the angelical and virginal interior spaces behind the line of the curtain – that is, between the projecting alcoves on an almost quadratic ground plan, a secure virtual box. The slabs of their roofs project into the chapel while maintaining a sense of a shared space between the messenger and the Virgin. The alcoves and the poles, with swelling white linen, then dynamically connect the spandrels' space with that of the spectator.

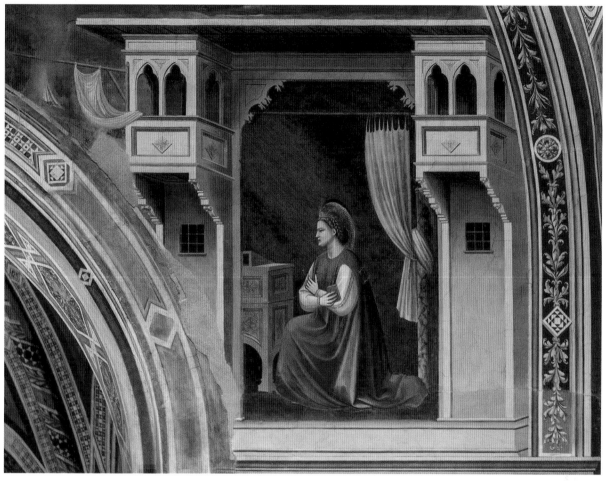

Fig. 4.39 Detail of Mary in the *Annunciation*. Courtesy of the UC Berkeley Historical Slide Library (est. 1938–2018), Baxandall & Partridge Collection, Doe Memorial Library in Berkeley, California, USA.

Thanks to these spatial refinements, this *Annunciation* is much more than a diptych in the spandrels of an otherwise uninterrupted broad Romanesque arch. With their thin line of roofs, they form a kind of inverse pedestal that demarcates their distance from the heavenly scene above. Again, this is an instance where Giotto needs to set a limit to his own realism, marking the difference between the *Annunciation* and the scene on high, of God painted on a door.

The two rooflines stop in the middle, leaving a visual pause – an open space of communication or even, perhaps, of insemination, suggested by the notion of God himself reaching for Mary rather than for the messenger angel. I would argue, furthermore, that the open space between the rooflines could also be understood as a window through which light falls into Mary's world directly from Heaven, as in later renderings by artists such as Gentile da Fabriano. She is addressed by the invisible, spiritual realm in a strict diagonal, while the angelic messenger below communicates with her via a direct horizontal line at her eye level. The other connection between Gabriel and Mary is a curve of painted cosmatesque ornaments that resonate with the arch. The arch, in turn, physically connects both figures across the sanctuary. These embedded diagrams of Mary's simultaneous communication with Angel and God are drawn in a system of inner pictorial relief planes that purposefully establish and clarify their connections.

The profiles of Gabriel and Mary are completely symmetrical in their delineation against the back wall of their twin architectures, appearing with the same *rilievo* against the saturated oxblood ground. Again, the red ground offers a complementary color contrast to all the blue ground in the chapel and emphasizes the importance of the Annunciation in the story of Salvation, and the red of the *Annunciation* seems to reappear in the red bands that frame the rest of the story around the faint green inner frame in all the individual narrative scenes from *Visitation* to *Pentecost*. This oxblood ground is illuminated by a glow of *sgraffito* rays around the angel that falls towards Mary and onto her face, halo, and shoulders, thus reinforcing the planar-diagrammatic aspect of the image. In features, posture, and gravity, the two profile figures mirror one another across the space, with light emanating evenly from the angel and falling precisely on the Virgin.

The chancel arch is the site of clashing elements from three layered registers that fundamentally differ in form and content. This space combines two crucial narrative scenes in the established polychrome fictive relief mode but, as noted above, in a tighter and smaller format: This is the famous juxtaposition of the *Visitation* and the *Pact of Judas*, a scene of love installed against a scene of betrayal. Despite their compact format, these images are recognizable as belonging to the familiar scenes from the walls. Figure scale, figure depth, and sense of compression remain the same. In general, Giotto keeps figures bound to a unified scale in all the chapel narratives, which would align with the echoing of the uniformly sized figures across the Titus reliefs. There are no receding figures and the few small figures that occasionally appear are either children, spiritual appearances (angels and the *Ascension*'s miniature patriarchs), or purposefully diminished servants. The miniaturized figures, in other words, all have an iconographic

reason to be small – a reason other than the optical rendition of distance, so that the coherence in scale is a valid basis of comparison between the scenes on the walls and those on the chancel arch. In keeping with this system, the fields with the *Pact* and *Visitation* on the chancel arch, containing each a group of five figures, appear in strong formal correspondence to each other.[116]

Like a diptych, the *Visitation* and the *Pact* also contain fine ornamental reliefs in the background architecture that show, in terms of painterly style, variations of captured light over bright and shadowed planes above the baldachin and the loggia. These reach the upper edge of the field with precision, forming obtuse triangles of blue between the features' upper ledges and the field's limit. Adjusting their pictorial light to the position on the east wall, the appearance of the *Visitation* and *Pact* differs from the light defining the figures on the walls but is coherent between these two scenes.[117] The wrap-around disposition of the thirty-four narrative scenes on the long walls allows the spatial opposition of these moments to the chronological ordering of their level – while still appearing in their correct places within their cycles' chronology. Their pairing, the *Pact* on the left and the *Visitation* on the right, allows for the remarkable response of love to betrayal from left to right, the reading direction of the diptych's own level reversing the temporal order of events. The physical association between Judas and the devil appears before the women's embrace widens to reverse the betrayer's evil act. Such an interpretation coheres with an understanding of a predetermined story of Salvation that assigned to Judas his sad place on the west wall as much as it assigned to Mary her role as the blessed one, all to turn the Fall of Man into a *felix culpa*.[118]

Scholarship agrees that the isolation of these two moments from the cycle singles them out in order to create a juxtaposition between love and

betrayal. But what makes the diptych's appearance at the chapel's east end truly significant is not these images' separation from the other scenes as much as their repositioning within two alternative image forms above and below their level. One is the narratively charged superstructure of redemption in the *Dispatch of Gabriel* and the *Annunciation* above; the other is the narratively emptied substructure of the *coretti* below that can be understood as both disrupting and enriching the meaning of the cycle. The three separate levels with one spatial design are each exemplary: On the lowest level, we have the reach of the *coretti*'s perspectival depth and distance; at mid-level, the narrative fields in their relief zones reveal an interplay of depth and emergence; and on the upper level we see the spandrel *Annunciation* and the realm of God's throne in reverse perspective.

Before analyzing the *coretti*, I want to formulate the thesis that the insertion of the polychrome relief mode of the *Pact* and *Visitation* between the inward-pushing empty spaces below and the outward-pushing elements of heavenly scenes around the Incarnation above, complementing the arcuation into the vault and the all-embracing incrustations, constitutes a viewer's manual for the chapel. These visual relationships, in effect, describe how to see the entire chapel as the interior of a triumphal arch and how to understand its spiritual claims about vision, history, ethics, fatality, hope, and redemption. To this end, the highest achievement of Giotto's realism consists in making evident traces of the invisible in the visible; in visualizing the very limits of representation when approaching something incommensurable with the limited means of the human perception of space and time. Giotto's murals represent figures and events in temporal-spatial terms, but their framing and their purposefully constructed condition in medium and materiality always contain a consciousness of the inherent limits of representation. Limits and

edges – borderline situations – are the true artistic theme of the Arena Chapel. This is what Roberto Longhi describes as the affirmation of a different *limit* ("affermazione di un *limite* diverso"):[119] The assertion of this limit happens in relief zones. Longhi seems undecided about how to address issues of depth and relief in relation to the later, more fully established Renaissance perspective.[120] However, the connection to the Titus reliefs explored here encourages the claim that relief is the secret ingredient connecting abstract margins and enlivened depth in a productive tension. Without developing the pictorial plane for the careful calibration of relief zones, neither naturalism nor *storia* would have been conceivable in such a vivid yet restrained way.

Conscious acts of perception are essential for activating the presence of relief effects, as I discuss in more detail in Appendix 1. The parallel images and mirroring figures, whose recognition unlocks some of the chapel's most urgent meanings, confirm this need for active participation. The juxtaposition of the *Pact* and the *Visitation* contains the chapel's moral compass and the expression of a deep hope: The act of love not only generously opposes that of betrayal but also emerges victorious from it. The complete visualization of this redemptive reversal happens in graduated levels of relief. From high relief with limited reverse perspective in the throne to the *Annunciation*, which projects forwards into real space, the eye moves down to the time-bound polychrome reliefs of the *Pact* and the *Visitation*, and down again to the pre-Albertian windows into a world that is factually not there but exists in an exquisite artistic illusionism believably rendered behind the wall into the fictive *coretti*. On this level, the composition's three-dimensionality projects outwards, leaving the nave's interior behind. Visualizing the *lux eterna* in different states of aggregation through these three levels, the chancel arch completes the optical manual. Its seemingly random levels call into question what is real

and what is represented, on the wall as in the world. The world itself seems to be unmasked as an illusion for the sake of spiritual instruction, as is explored further in Chapter 5.

A crucial factor for the functioning of the scenes from the lives of Mary and Christ is the impression of slow movement arrested and then frozen in its progress. In the *Procession of the Virgin*, a group of women moves behind Mary, all following two men and attended by musicians. Rather fitting for this stage of the triumph of humility, Giotto's *pentimenti* document how he changed long trumpets to reedlike instruments in the design process, symbolically toning down the drama, as Beck posits.[121] The image depends on the feel of slow motion. Giotto "has softened the tone of the scene to better fit the solemnity of the depictions" in "choosing to truncate the trumpets, not only in the *Procession* but also in the *Annunciation*."[122] Historiography has linked this same solemnity with a number of other sculptural friezes – such as Arnolfo's relief from the Annibaldi monument of circa 1277, which features friezes of clerics performing the exequies – but the scene is also reminiscent of classical isocephalic relief friezes.[123] Ruskin and, later, Stubblebine draw a connection to the style of the Parthenon.[124] However, a close comparison of the scenes with the extended Parthenon frieze on the one hand, and the compact Titus reliefs on the other, shows the latter's stronger affinities to the chapel: the same relational height, interwoven relief planes, embeddedness in the walls, and lateral truncation of the scenes; the same insertion of shallow dioramas into the framing profiles; the same way in which the lateral ornamental pilasters run from the floor up to the cornice.

Among all the scenes, young Mary's *Procession*, the *Flight into Egypt*, Christ's *Entry into Jerusalem*, and the *Procession to Calvary* with their measured slow motion are most directly related to the form and content of the Titus reliefs. In their sideways drift in the *Flight*, the figures reinforce the relief-like composition, moving "from left to right, in pure profile and fully parallel to the wall," as Barasch remarks.[125] Such a combination of profile parallelism and movement enhances the scene's coherence as arrested motion – or, more accurately, as the narrowing of three zones of motion set against one another in order to show the difficulty of the flight.[126] Indeed, Mary's face is stoically calm – or perhaps petrified – portraying a mother fleeing danger with her newborn baby. Imdahl notes the inherent temporal charge of the donkey's slow drag between Joseph and the couple's small companions. He introduces this carefully animated mode as the major achievement of Giotto's imagery: the balanced but dynamic representation of movements – of a "here" between "where from" and "where to" and of a "now" between "not anymore" and "not yet."[127]

The Christian prototype of a humble triumph is, of course, Christ's own *Entry into Jerusalem*, the scene particularly mentioned in the chapel's inscription, with its emphasis on the importance of Palm Sunday for the dedication feast in March 1303 ("When this place is solemnly dedicated to God, the year of the Lord is thus inscribed: / In the year 1303, when March had conjoined the feast of the blessed Virgin and the rite of the Palm."). Imdahl describes this scene, too, as a temporally significant junction of two moments that correspond to two impulses towards motion,[128] the "just here" and "just now" of the rider[129] – the actualization of the figure in the very process of moving between a point of departure and a point of arrival.[130] This might not be worth quoting but for the parallel relevance that Imdahl's pointed analysis has for the Roman processional reliefs on the one hand, and for the measuredly animated image that has come to epitomize Giotto on the other.

Given my interest in the specific representative capacities of relief, this tension between a here and a there becomes a question of actualizing a narrative-in-motion for perception by a

viewer. This particular act of perception, I argue, can happen only via relief effects. Imdahl ultimately delivers a very suggestive notion of the transitional draw and pull of these images, as if they reinforce the inevitability with which time and the story of Salvation must move forward from this point into doom – namely, in the context of the chapel itself, into the Passion cycle.[131] The mob forces Christ out of Jerusalem onto the *Procession to Calvary*.[132] To the left, the monumental figure of Mary keeps herself as upright as *Fortitude* in the dado zone.[133] The absolute isolation of Christ with the cross against the blue ground keeps him trapped in horizontal motion: The visual interlocking of the iconically frontal head and halo of Christ with the bent and foreshortened cross is the only variation in space in this otherwise evenly processing parallel frieze of figures. Mirroring the *Procession* and the Titus processional reliefs, the scene moves in stark contrast to the arresting frontal positioning of the adjacent *Crucifixion*. A scene of absolute horror, the image of Christ on the cross stops the *Way to Calvary*'s deliberate processional movement.

The Titus reliefs might have influenced Giotto's relief-like, processional mode for the scenes of the *Lives* with figures striding or adopting a slow pace in epic quietude,[134] but the spatial extension and agency of the large figures in the *Last Judgment* is very different. As if they have been liberated, they look more animated and awake than the figurines on the walls. The slow, commanding, and dignified pace delivers the intended actualization of the biblical story in the painted scenes: The processional mode arises against *horror vacui* to produce a stance of equilibrium between left and right, between backwards and forwards, between here and there. It freezes the fleeting moment, arresting the action for the moment of its perception and setting it into motion again by way of the active eye of the beholder. This processional tenor suggests an arrested slow motion rather than a snapshot of quick movement;[135] it may be the origin for many musical metaphors in Giotto scholarship: "pictorial rhythm," "spatial music," and "harmony."[136] The processional mode is key for images depicting a slow passage or an action stopped in the moment of the image. The point is to hold the tension between freeze and passage, harmonized by the unifying, relief-enhancing direction of pictorial light.[137]

On a philosophical level, an image arrested in a sense of gravity raises the issue of preserving the movement of living things in an image, which is probably best achievable in the processional mode. The well-measured rendering of natural things has often been described as Giotto's great achievement;[138] of course this resonates with the practical workshop approach of Cennino Cennini's *Libro*. A student of Giotto's students, Cennini defines the essence of the act of painting thus: "This is an art that is called painting, for which it is best to have imagination and a good hand, to find unseen things, capturing them under the shadow of natural [things], and to arrest them with the hand, in order to show that which is not there [so that] it may be there."[139] This crucial passage at the beginning of the *Libro* indispensably unites the work of the mind and the eye ("fantasia") with the work of the hand in learned skillfulness ("operazione di mano"), explaining that the creative act is one of finding ("trovare") and arresting ("fermare") images that are invisible but indisputably there, existing "under the shadow of natural [things]," as Cennini puts it in one of the most strikingly theoretical passages of his otherwise so practical book.[140] These hidden things are tenebrous ("cacciandosi sotto ombra") but can be rendered bright and clear by halting them: "fermarle con la mano." It would be worthwhile discussing these "shadows" in relation to Warburg's conception of dark, spectral images and the ideal moment of

sophrosyne that makes them stand still.[141] Cennini goes on to compare the "poeta" with the "dipintore," indicating an understanding of the imagination required by both creative acts – writing and painting. A similar notion is expressed by Villani, who connects Giotto's creative work with the "fictions of the poets."[142]

By simulating relief, Giotto does more than just capture the shadow of an appearance: He captures the image of an imagined artwork that captures an appearance, adding a layer of representation and thereby of interpretation. The sense of slow movement is as important as the visual *gravitas*. The conquest of gravity is one of Giotto's boldest statements in distinguishing his scenes from the classical images as well as from the images produced by his contemporaries.[143] Charles Till Davis notes how this determines the powerful image of *Hope*: "Hope for salvation [was] related to the conquest of gravity, which is very different from the denial of gravity found in many Byzantine and early Italian works."[144] Heaviness, as we have seen in the dado zone, is most powerfully embodied in suicidal *Despair*. The explicit acknowledgment and subsequent uplifting of all that is heavy – rather than denial of it – proves the final and most important point the chapel can make, namely that there is hope; that both the creative act of the artist and the approach of the triumph of humility for grasping the human condition and experience can point ways out of the chaos of existence and failed representation.[145] The painted representation of biblical narrative in stylistic correlation with fictive polychrome relief sculpture not only strikes a glancing blow at Roman antiquity but also is yet another reinforcement of the spectator's own positioning in time and space. While the allegories underlying the *Virtues* and *Vices* are timeless concepts, the narrative scenes have a specific and precise place in the past. Their figures act as historical characters in a determined yesteryear, as active or passive players in the story of Salvation. As will be further discussed in Chapter 5, details in the *Noli me tangere* and in the *Ascension* thusly unsettle the very notion of representability of sacred things.

In the broader context of Christian art and naturalism, such details prompt the beholder to raise questions about the nature of the visible. Though empty, the *coretti* are fully present spaces, and the heavenly scenes in reverse perspective arc over all of the chapel's time-transcending imagery. The little choirs are removed but controlling, almost as if they constitute the juncture between the *primo mobile* and the human world of temporal-spatial appearances. With these mysterious empty side chapels, Giotto once again invites the viewer to pay attention to spatial phenomena. Opening up two distinct views into illusionistically simulated adjacent rooms, the famous *coretti* appear in a direct line two stories below under the *Annunciation*. Two sets of vaults and walls each harbor a lancet window looking towards pale blue exteriors, a metal lantern with oil lamps, and a perpendicular rope with fixing rings dangling from its end.[146] "Figures, not one," as Longhi writes laconically.[147] Afternoon silence languishes under the fictive cross vaults. The *coretti*'s lower regions and their implicit floors are hidden by the fictive marble screens that generate Schlegel's problematic thesis on the *coretti* as funerary wall monuments.[148] One could argue, rather, that their yearning void enfolds the suggestion of potential presences in the half-disclosed, half-concealed fictive chapels to both sides of the altar room. These frescoes suggest a significant extension of space below the picture field.

The *coretti*'s suggested spatiality is optically set into motion with the coiled loops and hoops of the chandeliers consisting of three large, separate, and detached rings, each carrying three lamps at different heights. The superimposition of these foreshortened and overlapping circles results in

an optical effect that evokes a spiral, or helix, the oil lamps mediating between the ascending circles.[149] What makes the *coretti* appear so dynamic is their radical reduction to the maximum of their once symbolic potential – if one can call them symbolic at all in their perfect illusionism. But even these little choirs' spatiality is tamed: The imaginary interiors of the *coretti* are held at bay by plan-parallel marble screens and inserted into not one but two framing systems of simulated paneled pilasters. The inner system relates to the fictive rooms' deep space; the outer, stronger one projects subtly into the chapel's interior. The recessed paneled pilasters form the largest framing device, which contains small panels of cosmatesque decoration below and a large panel of rectangular fictive bas-relief sculpture.

In this field, an ornamental rank grows in perfect symmetry out of a relief vase that stands on the lowest edge of the fictively recessed paneled pilaster. The pilaster itself is shaped with lateral cannelures, introducing yet another slight gradation between the visual regime of the nave and the independent realms of the fictive chapels. The *coretti*'s peculiar quality inspired Euler to speak of "Architektur*bilder*," expressing a purely aesthetic notion of "*images* of architecture."[150] His comparison of the *coretti* to the ever present backwards facing figures in the narrative scenes seems to be more fruitful.[151] For Puttfarken, Giotto's alignment of his "pictorial worlds with the bounded and centralized surfaces on which these were painted" are examples of a purposeful oblique perspective that was almost excessively successful.[152] Recognizing a triumphal arch theme and scheme in the chapel suggests that the *coretti*'s seemingly pure and empty aestheticism is purposeful (further interpretative possibilities arising from this stance are discussed in the Epilogue). Intended as a visual guideline, this aesthetic choice leads to a consideration of the other frescoes' materiality and illusionism. The two *coretti* share one ideal point of view in the

middle of the nave; the viewer is invited to engage with the illusion when assuming that exact position. At the same time, a complete reading of the chapel's program requires constant movement – in and out of focus, in and out of illusionism – if one is to notice the destabilizing elements that comment on the status of relief as painted fiction.

As mentioned above, the *coretti*'s blue differs markedly from the chapel's iconic blue. Longhi distinguishes between the abstract ultramarine blue grounds ("oltremarino 'astratto'") and the realistic sky blue ("azzurro biavo") that shimmers through the *coretti*'s fictive windows.[153] In one fell swoop, he thus concatenates the chapel skies, the nearby garden site of the Eremitani, the birds in the *Predica agli uccelli*, and the birds outside.[154] He then focuses on what he calls Giotto's "affirmation of a different limit," dividing precisely the different levels of the chancel arch by contrasting first the deep *coretti*'s proto-perspective and the profile-dominated *Annunciation*'s "antiprospettiva."[155] He further compares this reverse perspective to the illusionistic setting of the marginal figures inside the flanking fictive marble bands.[156] Within the Roman frame of reference reestablished herein, I argue that everything painted in the chapel plays with the illusion of belonging to the effective reality of the chapel itself, with the vault – situated somewhere between artificiality and starry sky – given a key role in Giotto's play with spectators.

In all its paradoxical beauty, the chapel's visual regime is closed, completed, and finished by the open vault. The core themes of the Incarnation and Resurrection around the triumph of humility are most clearly enunciated in that contradictory painted non-sky. The affinities of the chapel's two barrel vault sections to their most likely model – the relief understood to show the apotheosis of Titus inside his arch on the Via Sacra – become evident when one compares their structure to that of the Roman arch's "ceiling"[157] (see Figs. I.24 and

1.7): The grid-like coffering consists of 105 frames, each of them containing one rosette, while the central relief is framed by garlands and garland-sporting putti. This third panel, showing Titus carried upwards by an eagle, relates to the two side scenes below in a triangulation of the deeds, triumph, and apotheosis in relief fields that are effectively distributed between walls and apex. The same causal relationship between initial expenditure and final reward also exists in the Arena Chapel between the scenes on the wall and the visions in the vault, relating narrative and allegorical registers. This scheme is doubled in Padua by the chapel's two vaults, created by the faux transverse arch that divides east from west right in the middle, and two crowns, each holding a central divine image. In my understanding, this doubling represents the dualism of Incarnation and Resurrection. The varied degrees of fictive materiality in the vault's two sections play a key role in depicting the materialization of Jesus Christ in a human body active in the temporality and spatiality of this world.

Scholars have long recognized the painted band in the middle of the vault as being in some way architectonic.[158] Rintelen, for instance, discerns that the resulting doubled vault is only partially inspired by the Byzantine; it removes icons from their context and arranges them in a new way.[159] Rintelen does not, however, take into account the possibility that Byzantine icons and ornamental forms are here being aligned so as to fit into a strictly organized classical Roman design. Giotto built a painted vault of architectural illusionism that doubles the interior of the Via Sacra, turning 105 rosettes into more than 400 stars twice over (see Figs. P.6 and Figs. 1.8–1.11). He then added four prophetic or apostolic eye-witnesses in each vault, each framed in the same materiality as their respective central apparition. Simultaneously, the shift from cassettes to stars opens the optical possibility of viewers looking into and through a

broken vault, as if the fictive arch were in a state of ruination between the skeletal marble bands. Francesco Benelli has underscored the real architectural significance of this form: The vault's covering would crumble first, while the structure of the arches would remain standing as empty frames.[160] Such stages of ruination in actual ancient monuments, as suggested in earlier chapters, might have inspired this contradiction in terms of vault, arch, and sky.

In the vault's minimalism, each of the eight-pointed stars is shaped by an inner and an outer circle. A similar simplicity characterizes the two vault sections' general design. A striking display of gilded dark blue, the star-studded barrel vault distinguishes itself from the lower walls. The interspersion of stars does not allow for the blue to crystallize into the same opacity that characterizes the backgrounds below. However, the framing marble arches with lines of prophets, two at each end and one in the middle, are a constant reminder of the artificiality of this barrel sky. This simple device keeps the stars in a diagrammatic frame and invites the viewer to consider the differences between the equally sized and equally spaced west and east vault. Their orderly screens of blue with stars contain five *tondi* each, showing the four prophets on each field surrounding the medallion of a Madonna and Child in the center of the west vault, towards the *Judgement*, and one of Christ Pantocrator in the center of the east vault, towards the altar. The essential differences between both sides – in the frames and the figures' interactions on either side – usually go unnoticed. As mentioned above, the most significant contrast is that Christ Pantocrator and his prophets appear in circles of flaming ornaments, while Mary with the Child and their prophets are set into fictive stone frames.

Each one of the four prophets around the *Madonna and Child* (see Figs. 1.8 and 1.11) holds

a scroll with partially legible inscriptions.[161] Making eye contact with the viewer down on the floor of the nave, they gesticulate towards the scrolls with different degrees of intensity. Malachi, with half-closed eyes, seems to be exhausted; he points towards the back of his scroll, which spirals down into the nave's space. A similar curve is described by the scroll of Baruch, whose gaze beams down from two wide-opened eyes. Isaiah is the third white-haired prophet; he has placed his scroll onto the edge of his frame. As if speaking from a lectern, his position resists the force of gravity. This also describes the image of the only young prophet, Daniel: He, too, has placed his scroll onto the frame's edge, which results in the document's simple S-curve. Each of the prophets inhabit a smaller version of the central *Madonna and Child* frame: concentric circles of bright marble; red, white, and green inlays; white; a thick red circle with golden ornaments and internally interlacing quatrefoils in gold on blue; another round of the marble-like white circle, inlays, and white; closed by the innermost circle of green with small golden ornaments strung together in tiny quadrates between two golden lines that form four elongated cartouches. This inner circle is also interspersed with four small golden circles.

These frames' finely drawn solidity could not be in greater contrast to the flaming frames on the other side, which resemble the ornaments of the apocalyptic mandorla that surrounds Christ in the *Last Judgment*. Their fiery rhythm is neither naturalistic nor symbolic, but evokes some unspeakably dazzling light and hallucinatory flashes as if through a visual onomatopoeia (see Figs. 1.9–1.10). The eastern frame's ornaments, bound to the circle and ebbing outwards from white to beige into red, have a clear direction: The white is doubled in inner circles pointing inwards and into the plane. The outermost red, unmitigated, stands in high contrast to the blue

ground with sharp edges on each stroke in place of the rounded tips of the inner ornaments. This system, though with less dramatic emphasis on the fringe, is repeated in the four frames around the east vault prophets. Only one of them holds an inscription: Ezekiel, and he holds it not in the form of a long scroll but in the compact format of a writing tablet. Keeping this object steady, Ezekiel's eyes are fixed on the Pantocrator. John the Baptist, Jeremiah, and Micah are likewise mesmerized by the central apparition, and neither acknowledge nor invite the spectator as do their four counterparts on the west vault. Each of these easterly four receives the Divine directly with hands and eyes, while the Pantocrator's own eyes are fixed on the beholder, his mouth open as if speaking. With one hand he holds the scripture; with the other he extends a blessing into the chapel's interior space.

In accordance with the material differences between their frames, the visual cues in the west and east vaults seem to distinguish between two kinds of vision, as if dividing *ciels* from *cieux*:[162] the material body of the *Madonna della Carità* with her child from the ethereal Vision of the *Pantocrator*, two distinct models of spiritual *trompe l'oeil*. The chiasm of the vaults formulates a paradox. One apparition is stabilized in marble frames, itself enunciating a vocabulary of concrete naturalism, emphasizing the nature of the plane as material wall; the other occurs in framing flames. This vision's symbolic vocabulary emphasizes the concretization of the sky and the disappearance of the plane. Contrasting with that flaming apparition of Christ, the simulated stone frame around the *Madonna and Child* declares the plane a material place onto which one can attach architectural ornaments such as heavy-set, highly decorated objects. This apparition, in short, is bound to an earthly, material time and place; the figures wave their scrolls into the chapel's interior.

This double vision of the vaults inserts itself seamlessly into the chapel's other discontinuities in spatial and temporal order, which exhibits a program of changing eons from Alpha to Omega.[163] World-time-bound events *sub lege* and *sub gratia* are on display for a spectator who stands within the world time *sub gratia. Gratia*, yes – however, the dado-zone didactics of the *Virtues* and *Vices* demonstrate what the spectator has to learn and to do before the final words are spoken and things can finally come to an end. The flaming frame around *Christ Pantocrator* declares the plane a non-material realm, where an incommensurable vision is happening in that very moment. This vision of grace reveals itself to the four prophets and to the viewer either in a direct and sudden way or not at all. The visitor to the chapel is made witness to this spectacle. No scrolls, no prophet's eye contact mitigate the abyss between world and vision of unlimited eternity. In the east vault's illusionistic regime, solid frames register the level of material Incarnation. – the Son of Man, an approachable God. Contrastingly, in the east vault, flames blaze abroad an artistically more abstract but spiritually more lucid dimension.

The double arch of the chapel might be one attempt to resolve the paradoxical corporeal seeing of a spiritual vision. The arches, two broken circles, are made one. A possible explanation for the respective east–west positioning of vault and vision is, on the one hand, the association of the approachable and forgiving Maria della Carità of the chapel's own name with the iconography of the *Last Judgement*. On the other hand, the mystery of the *Pantocrator*'s flaming vision connects to the mysteries on the east wall – those of God's mission to the Angel Gabriel and of the *Annunciation*. The altar in the choir was ideated to feature transubstantiation *in perpetuum* until Judgment Day, every time Mass was performed, setting in motion what the west and east sections of the barrel vault monumentalize as the union of two arches: both natures of Christ, or the Marian and Christian ingredients of the Trinity.

The hitherto unexplained curvature of the pictorial plane in the uppermost scenes that ends about one third into the vault of the fields from the *Expulsion of Joachim from the Temple* to the *Procession of Mary* (that is, the entire *sub lege* portion of the narrative) is also framed in ornaments *all'antica*, in colors of rich ocher, saffron, and turquoise, contrasting the silvery faux cosmati work below.[164] These scenes' architecture has been recognized as different from that of the lower scenes, not only in its classical-Romanesque features (as opposed to the Gothic architecture following the *Annunciation*) but also in its unique design: slightly tilted houses that curve with the surface while leaving large blue gaping voids in each field. None of the upper register's scenes contains a straight-on central view of an interior.

Contrastingly, the scenes below fit central views into evenly spanned interiors on the flat wall, while the uppermost fields acknowledge their concave upper edge by letting the curve start over the figures' isocephalic line of heads. Beyond that edge, the curve continues into the star-studded vault, reinforcing once more its material fiction of being of stone and of partaking in a carved and painted arch rather than on a plaster-covered and painted wall. This unusual curvature is tied in with the all-embracing framework of fictive stone ornaments, raising the question of the reach and limits of simulated material reality; of the painted scenes as shallow niches of polychrome relief sculpture carved into the wall. The visual anomaly of the architectural curve into an upper relief field typically happens only in one other position: in the curved background of reliefs inside the bays of arches – as occurs prominently in the two large Titus reliefs (Figs. 4.40–4.41).

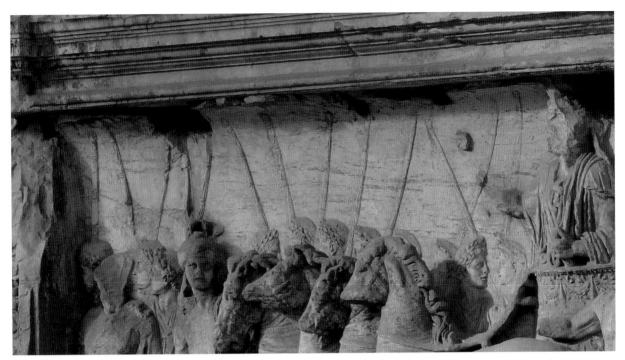

Fig. 4.40 Arch of Titus, detail of the curved relief background blending wall and vault in the bay of the arch (2018). Photo by the author.

Above, looking up into the vault, comparisons with the Byzantine and Gothic traditions emphasize how unusual the linear pattern of the eight-pointed stars is. In the Mausoleum of Galla Placidia in Ravenna (Fig. 4.42), for instance, golden stars arrange themselves in concentric circles around a central, overcutting cross; even closer to Giotto we can think of the more spaciously set starry vaults in Assisi's Upper Church (see Fig. 1.17). The Paduan vault rather seems to echo the organized distribution of eight-petal rosettes in an ancient cassette vault such as the one in the Arch of Titus (see Fig. 1.7). In Assisi, the stars of the vault are cut by the cross-vault buttresses; the stars in Padua are arranged in an even pattern without cuttings or overlays. Their pattern integrates the vaults' medallions just as evenly as the rosette-bearing cassettes frame the deification relief in the Arch of Titus. As mentioned in Chapter 3, the two

closest comparisons to the vault as a response to the bay of the Arch of Titus are both Roman, close to the Forum, and span many centuries: the fourth-century Cubiculum Leonis (see Fig. 1.5) and the Duecento San Silvestro Chapel at the Santi Quattro Coronati (see Fig. 1.6). The biggest difference between the Arena Chapel and the latter is its lack of transverse arches and the visible connection of its murals to mosaics; in the Arena Chapel murals imitating relief effectuate a drastically different approach to illusionism – only Giotto goes that far.[165] Another earlier comparison for the metaphysical theme in the Arch of Titus might connect to the ancient Roman triumphal "Arch of Pula" (Fig. 4.43): In the Arch of the Sergii in Pula, Croatia (ca. 29 BC), the apex relief shows the archetypical victory over death in the image of an eagle killing a snake – another theme of spiritual triumph in this prominent position.

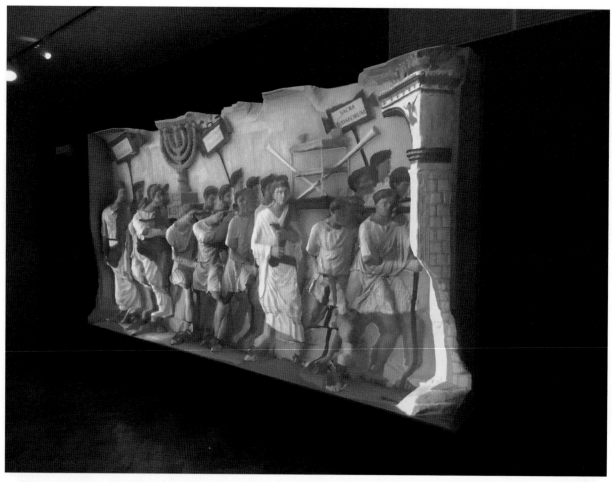

Fig. 4.41 Replica of the Menorah relief with a projection of changing reconstructions of polychromy focusing on the right corner in 2017 in the Yeshiva University Museum, New York City. Photo by the author.

The *Madonna and Child* relief painted on the west vault has caught scholars' attention (see Fig. 1.8). Ronald Kecks, for instance, considers the possibility that Giotto's Madonna medallion has foundational importance for the early Trecento's increasingly monumental Madonna and Child *tondi*.[166] With iconographic and liturgical links to the Arch of Titus, I reconnect this fictive *tondo* by position, context, and iconography back to the deified Roman emperor's relief, framed by garlands and putti: Giotto has his Mary with the infant Jesus and Christ Pantocrator respond together to that ancient pagan model, offering an entirely different vision of the cosmos and the relationship between human beings and the Divine (see Figs. 1.8–1.11).

In summary, our tour of the chapel, focused on relief and on the Roman-classicizing elements gathered under the arch system of the interior, has revealed the care with which Giotto created distinct optics of stone, volumes, and colored, as well as discolored, surfaces. In many places, his references go beyond the quarry of Roman antiquity, integrating early Christian, Byzantine, and contemporary Italian elements. Calibration, therefore, is not only an optical principle for Giotto and for his fine relief effects in the chapel's fictive architectural decoration. It is also

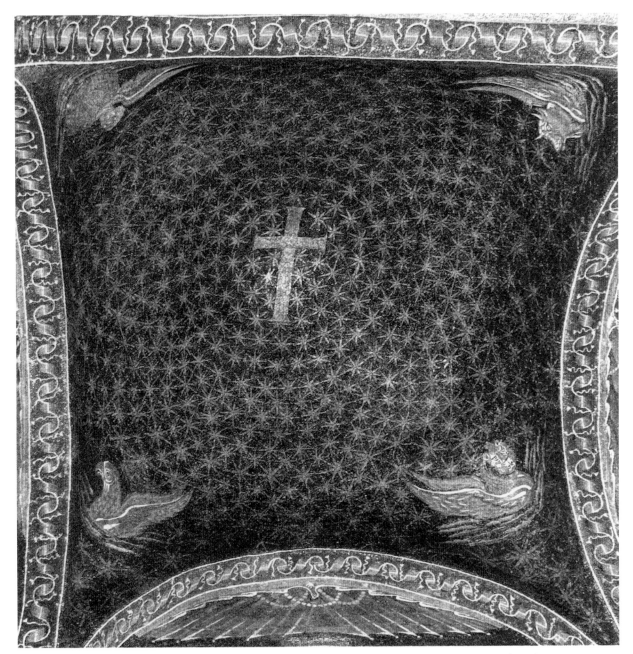

Fig. 4.42 Mosaic of the cross within the vault of the Mausoleum of Galla Placidia, Ravenna, 425–450 (2006). Photo by the author.

a way for viewers to consider the merging of theological elements and the moving of them on historical and spiritual scales for the creation of an all-encompassing system that celebrates all time periods as indispensable chapters in a long history of Salvation. The inclusion of additional styles and themes, then, is not at all surprising.

The chapel's insistence on keeping connected the different eons of the Old and New Testament, the inscription's rhetoric of changing historical times and conversion, and Giotto's varied acts of appropriation, translation, and transformation are all part of this eclectic icono-graphical system. Indeed, at least since the

Fig. 4.43 Relief with the *Triumph of the Eagle over the Snake* from the bay of the Arch of the Sergii in Pula, Croatia. Courtesy of the UC Berkeley Historical Slide Library (est. 1938–2018), Baxandall & Partridge Collection, Doe Memorial Library in Berkeley, California, USA.

Constantinian shift, medieval Christianity in Italy was dealing on an ongoing basis with a combination of Roman, ancient, pagan, Byzantine, and specifically Italian Christian stylistic and physical materials. We will see more of this in the next chapter, which explores the importance of *spolia* for the reading of this painted-relief chapel as a triumph of humility and the historical significance of this theme in the age of Giotto and Dante.

Chapter 5

TRIUMPH AND APOTHEOSIS, AUGUSTINE TO DANTE

uis itaque praepollentior oculorum erit illorum, non ut acrius uideant, quam quidam perhibentur uidere serpentes uel aquilae – quantalibet enim acrimonia cernendi eadem quoque animalia nihil aliud possunt uidere quam corpora – , sed ut uideant et incorporalia.

In the world to come, then, the power of our eyes will greatly surpass what it is now. It will not do so merely in respect of the keenness of sight which serpents or eagles are said to have, for these creatures, no matter how keenly they see, can discern nothing but corporeal substances. Rather, our eyes will then have the power of seeing incorporeal things.

AUGUSTINE, *THE CITY OF GOD AGAINST THE PAGANS, 22,29 (OF THE BEATIFIC VISION): DE QUALITATE VISIONIS, QUA IN FUTURO SAECULO SANCTI DEUM VIDEBUNT*

A CHAPEL IN SEARCH OF ITS AUTHORS

THIS CHAPTER ADDRESSES textual and spiritual "spolia," a term used in art history to describe any material or immaterial remnant from the past purposefully taken and inserted into a new context. Here the term is considered with its textual and spiritual resonances in

Augustine (354–430), Giotto (†1337), and Dante (1265–1321), examining how they relate their works to the legacy of the ancients – both the Hebrew Bible and Greco-Roman letters, arts, and architecture. From its beginnings, Christianity had to develop a means for recuperating, relating to, and using the legacy of the pagan imperial past. In the early fourteenth century, particularly in Italy, questions that the early Christians had pondered reemerged in new forms – the Roman elements of Giotto's chapel and Dante's *Comedy*, under the guidance of Virgil, are exemplary of this complex relationship, as is Augustinianism contemporary to Giotto. Augustine – channeled through the exegesis of his fourteenth-century readers – is the most important link to the ancient Roman past, for Giotto's chapel in particular, as Giuliano Pisani has shown, and in the larger historical context of the times.[1] Augustine's works were better known than those of any other church father, especially his *De doctrina* and *De rubibus*. His *City of God* foregrounds the issue of humility, installing Psalms of introspective intensity against the vainglorious character of the Romans. In Augustine, Dante, and Giotto, there is a celebration of the triumph of Christianity over paganism even while, or especially as, these figures make explicit use of the legacy of the pagans.

Scholars have devoted much energy to searching for textual sources that might have informed the highly complex iconography of the Arena Chapel, trying to identify the main authors of this project's ancestry in the long history of Christian thought. Central to the theological and philosophical context of the frescoes are Augustine's writings – or rather, their amplification in Duecento Augustinianism, which contrasted the world of sensual appearances with higher spiritual truth. Giotto's schema, in which the Christian story triumphs over the worldliness and hubris of an ancient emperor with a classical, sculpted, and eventually failed apotheosis, is entirely consistent with Augustinian tradition.

The issue of *spolia* is intimately connected to questions of pagan idolatry and Christian iconophobia reaching back to late antiquity and, fundamentally, all the way back to the first of the Ten Commandments in the Mosaic tradition (Exodus 20, 1–6). Anxieties around the use and appropriation of ancient spaces, music and musical instruments, architecture, artworks, and particularly sculpture in the form of statues, posed theological, psychological, conceptual, and artistic challenges for newly Christianized Romans. Because of an ongoing suspicion of idolatry on the basis of the First Commandment, this issue did not ebb away over the centuries. Given that the past could not be changed but only reframed in a meaningful Christian way, spoliation as the act of breaking ancient monuments and framing their remnants in a new visual or material system was the best way to integrate and, at the same time, neutralize pagan traditions.[2]

Giotto and his contemporaries were surely aware of the struggles with iconoclasm in the early Christian and, later, Byzantine contexts, and that such critiques could be countered by a naturalism based on ancient models. Giotto's self-reflective chapel draws attention to different levels of reality employing a naturalistic vocabulary that leaves room for symbolic understanding. As Alpatoff noted, there are parallels in the figural forms across the narratives and allegories that invite the viewer to discern a carefully crafted relationship between the moments of Mary's and Christ's lives and the symbolic register of the dado.[3] The chapel, therefore, is not simply a duplication of the famous Roman site in a different medium. The monument to Titus is instead transformed by painting into a double triumphal arch's broken bay, where the very materiality of the arch is constantly destabilized for a heightened sense of spiritual truth. The artistic momentum of the Arena Chapel project thus came to counter not only the hubris of ancient Roman self-deification but also the hubris

of naturalistic representation *per se*, its auctorial potency raising the problem of offending God, *Deus artifex*, and the use of material objects evoking the suspicion of idolatry. Matter and spirit appear in a productive competition comparable to that between triumph and humility. The act of idolatry, in the sense of praying to stones, can be seen as the opposite of that complex phenomenon of representation and essence that I define as relief effects.[4]

That idolatry was indeed an issue in the context of Boniface's Rome around 1300 is documented in the contemporary accusation of idolatry against the Pope himself.[5] Furthermore, a chapel with the personifications of *Fides* shattering an idol and of *Infidelitas* appearing as Idolatry points to the issue in an elegant way.[6] Suspicion of ancient sculptural idols was still common over a century later, when Ghiberti described superstitious dealings of the Sienese with an ancient statue of Venus.[7] Given that Giotto recruited a system of images – the triangle of wall and the apex reliefs of Titus – in its entirety as the archetype for his chapel's interior, it remains to question the extent to which the program had to position itself against the pagan origin of its models. Roman religion was centered around the material idol and the execution of ritualistic appearances rather than the cultivation of inner conviction, whereas the early Christians turned first to a more directly symbolic-figural art – such as in the typical imagery of the Catacombs – and later to images that were to encourage a highly interiorized spirituality.[8] Auerbach describes how early Christianity was condemned to struggle with the use of any naturalistic image to illustrate or memorialize the history of Christ. Indeed, the first images of the crucified Christ might have been cruel mocking sketches made by pagans.[9] To complicate the issue, symbolic crosses, sails, Jonah, Adam and Eve, the fish, the good shepherd, and other figurative imagery appeared on

medallions, rings, and lamps. There were also narrative sequences on tombs available for Giotto to see in Rome (most famously, the Junius Bassus tomb). Augustine remarked in 388 how many portraits he had seen of Peter and Paul with Jesus in Roman-veristic sculptural style. The accompanying narratives, however, helped to produce symbolic meaning.

Reviving ancient style on a large scale and with an unprecedented complexity of illusionism, Giotto seems to undermine the accusation of idolatry before it can become an issue. The fictive dado is crucial for the images' inherent self-criticism: Deep in the history of art, far back in the history of the Abrahamitic religions, the Synagogue of Dura Europos had already applied a similar approach to a socle zone imitating marble slabs as well as low-relief fields and *tondi*.[10] Christianity, of course, stems from this ancient Jewish heritage. In the context of this commission that invoked ancient reliefs in all self-conscious and self-reliant historical awareness, is it possible that the first and boldest move towards resurrecting ancient forms saw the figures' naturalism inserted into a safety net of illusionistic architecture?

In his study on Giotto's framing system, Isermeyer delivers a revealing description of the painted band around the room – which, he claims, acts to negate the architectural reality of the room's corners and the effect of hovering side walls that seem to be suspended in the wall's frame rather than attached to any part of the corners.[11] Isermeyer's conclusion – that Giotto was uninterested in mystification – conflicts with the fact that the artist creates and unmasks the illusionary power of his murals within the chapel in several substantial operations: in the dado zone, in the narrative scenes, in the vault's two distinct sections, in the *Last Judgment*, and on the chancel arch. Illusionism and structure, in relation to the world, seem to function here in a manner that is deeply rooted in Christian

doctrine from the beginning of the scriptures as well as in Augustine's *De videndo Deo* and his *De praesentia Dei*. In early Christian art, abstraction and divergence from classical standards usually had a purpose. The Christian story, in addition to its need to distance itself from antiquity and idolism, demands – uniquely – a high degree of imagination and reflection. Without the Resurrection – without belief in a higher, ulterior, and transcendent truth behind the appearances of the world – the story of Christ is without hope; without Easter, Christmas is meaningless. The very core of the Incarnation, Jesus's self-sacrifice on the cross, Resurrection, *noli me tangere*, and the afterlife speaks to this, demanding a uniquely complex clarification in figurative art; Christianity depends on paradox and demands inner reflection. The more Duecento art approaches classical, naturalistic, illusionistic forms, the more exigent the need for clarification, so that the products of artistic effort will be understood neither as an empty shell nor as the real thing, but rather as discerning witness to a complex reality – illustrating in material media, via inherent self-deconstruction, that the whole of the visible and invisible cosmos cannot be reduced to what we can see and touch.

It is in this context that I understand relief effects as a balancing act between animation and abstraction, between sensuality and spiritualization, as a central problem of both Christianity and art. Only apparently contradictory, this problem resolves itself in the act of dematerialization, which surpasses the very temporal character of any materialization. To make things visible rather than concretely palpable runs parallel to the belief in the participation of the soul in the redemption and realization of eternal life in Christian faith. Many hands helped build and decorate the chapel, and, as this chapter will show, as many authors ultimately stand behind its visualization of the triumph of humility; and yet, most powerfully, stands one in particular.

AUGUSTINE AND AUGUSTINIANISM IN THE ARENA CHAPEL

The Arena Chapel positions complex Christian dogma against the ancient religions, contrasting Christianity's own Hebraic roots with the protean and changeable sky of the Roman gods – all while exploring the visible world in relation to time, space, and invisible truth. Directly evoked in Giotto's *Prudence*'s fragmentary inscription as well as in the figure of *Circumspection* over Scrovegni's entrance door, the chapel's theological program constantly challenges the power of human vision. These specific references recall passages from *The City of God against the Pagans*, particularly echoing an increased power of vision in the afterlife:

> In the world to come, then, the power of our eyes will greatly surpass what it is now. It will not do so merely in respect of the keenness of sight which serpents or eagles are said to have, for these creatures, no matter how keenly they see, can discern nothing but corporeal substances. Rather, our eyes will then have the power of seeing incorporeal things.[12]

This text unites biblical and apocryphal narratives with dogmatic theology. It leads us back to the Augustinian context that Bouwsma and Oberman have shown to be relevant to the historical context around 1300, and that, on a more personal level, is already documented in Scrovegni's history of donations to the Agostini and in the image of the Augustinian canon shouldering the chapel's model in the *Last Judgment*. Most likely identifiable as Alberto da Padova, according to Giuliano Pisani's studies, it very much looks like the Augustinian canon had a role in the production of the oratory, such as in devising the program, as he appears so prominently with Scrovegni before Mary and the Saints. Any Augustinian would

naturally have read and reflected upon the relevant writings and teachings with great care, building his personal and liturgical life around the order and Augustine's living heritage.

Augustine the historical figure – a prolific thinker and autobiographer – embodies in himself the epochal break that is visualized in the Arena Chapel. Living the synthesis between the classical past and the new Christian empire, the Virgil-schooled author famously converted to Christianity and, in *The City of God*, applied all the might of classical rhetoric to defending Christianity against accusations during the barbarian invasions. There are good reasons to read the Arena Chapel's system as a visual analogue of Augustine's theology – a painted paraphrase. His own dilemma about how to turn the pagan rhetorical heritage of his style to the benefit of Christianity and the solutions that he finds in order to do so with text foreshadow that same dilemma we see resolved in physical space with the Arena Chapel's grand synthesis. Both explore the tensions between corporeal and immaterial appearances and values.

The most important concordances of the chapel's program with Augustine appear in his *Confessiones, De Civitate Dei, De doctrina christiana, De fide rerum quae non videntur, De genesi ad litteram, De musica, De vera religione, De videndo Deo, De praesentia Dei*, and, finally, in crucial thoughts from the *Enchiridion, De genesi contra Manichaeos, De libero arbitrio*, and *In Psalmum 46*. In the following, I will present a number of plausible sources for the chapel's program in these texts, all of which were written by the church father who most embodies the chapel's classical-Christian synthesis. The extraordinary efflorescence of contemporary Duecento and Trecento Augustinianism around Scrovegni in Padua and in North Italy strengthens the relevance of these sources as shown, for instance, by Eric Leland Saak in *Creating Augustine: Interpreting Augustine and Augustinianism in the later Middle Ages*.[13]

It should also be noted that another connection to Augustine occurs via the topos of a Christian *chiesa triumphans*; with this notion in mind, we can once again relate the Titus reliefs from the end of the Roman-Jewish war to the ethical dimensions of religious triumphalism. The Augustinian doctrine of the Jewish witness helps to approach this question, as shown in Chapter 3 during our consideration of this doctrine in relation to the drastically different portraits of the family of Christ versus Judas and the Pharisees. Addressing this doctrine means discussing the issue of triumphalism and trauma, as the complex role of Judaism in the chapel must be approached with recognition of the universal dangers associated with religious triumphalism.[14] Tracing the program's Augustinian affiliations is crucial for understanding the degree of potential Christian triumphalism over the ancient religions in the highly typological and moralistic program of the murals.[15]

A standard association in medieval Christian art is that of Judas Iscariot with the Jewish people.[16] The chapel has been noted for its poignant juxtapositions of Judas and Mary.[17] With recognition of the triumphal schema and connection to Scrovegni's interest in installing indulgences, one can read the figure of Judas either as figuring the antithesis of love and prosperity or, more specifically, as the negative image of moneylending and moneymaking elites. Self-accusation would not have been in Scrovegni's interest. Instead, the chapel he funded makes an implicit accusation against the Jews. Linking Judas and the Jews more generally in the chapel's iconography conforms not only with Scrovegni's personal stakes as a moneylender but also with the much broader issue of the Jewish community's increasingly marginalized and endangered position during the late Middle Ages in Europe. This topic can be approached in three major ways: from the historical context, from the characterization of Jewish groups in the frescoes, and

from the Augustinian tradition in the light of his biography and writings.

Born in then-Roman Tagaste in North Africa as son of a Christian mother and pagan father, Augustine was schooled in Virgilian-classical rhetoric and converted to Christianity after a long phase of spiritual meandering through other competing beliefs of late antiquity, most prominently engaging with Manichaeism.[18] Augustine describes the struggle of his spiritual-intellectual searching in the *Confessions,* a personal account of the watershed moment between classical antiquity and the new Christian empire. In his *De Civitate Dei* from 414, he gives a spiritual answer to the fall of Rome against the accusation that the new state religion was responsible for the ongoing attacks against the empire beginning with Alaric in 406. Both texts are thorough meditations on history, memory, spiritual-intellectual pilgrimage, and enlightenment in addition to the distinct realms of spiritual and worldly subjugations of time and space. From an Augustinian point of view, the insistence on ethical self-reflection that is suggested at spectatorial eye-level by the moral allegories of the *Virtues* and *Vices* in the Arena Chapel unites visual images with the theme of personal struggle and conversion as described in Augustine's *Confessions.*

Augustine's emphasis on the division of the eons *ante legem, sub lege, sub gratia,* and *in pace* has a direct analogue on the chapel's walls. The period *sub lege* is framed in warm-colored ancient ornaments; the period *sub gratia,* following the Incarnation, is framed in silvery faux cosmati work.[19] The concept of linear time is particularly important for Augustine's thought, just as it is for Giotto's distinction between the stories from the *Lives* framed *all'antica* and *alla christiana,* and the spectacular moments that shift eons or shatter historical time – the *Annunciation* and the *Last Judgement.*[20] The chapel reveals striking similarities to Augustine's *De Civitate Dei* not only through its presentation of Christian triumph over paganism[21] but also in terms of the visually

thematized corporeal and spiritual visions of the chapel's central content:[22] divine providence,[23] the virtues and the vices,[24] the supremacy of Christian thought,[25] the mediating double nature of Jesus Christ,[26] time and space,[27] and the Trinity.[28] In light of the connection between the Arena Chapel, the Arch of Titus, and the Arch of Constantine, other relevant chapters in *The City of God* are those addressing the Constantinian shift[29] as well as the rejection of "DIVO TITO,"[30] of vainglory,[31] and of pride.[32]

With Augustine in mind, Giotto's brilliant commentaries on invisibility and visual deception painted on the short walls and *supraporte* – the *coretti* and the faux relief with the figure of sight – also attain new relevance. Do they relate to Augustine's thoughts on physical and spiritual sight? As mentioned above, this question leads us to two other, lesser-known texts on God's vision and presence: *De videndo Deo* and *De praesentia Dei.*[33] Their content may be seen as echoed in the chapel's double arch system, which sets physical apparitions in stone frames in the west against metaphysical apparitions in abstract ornaments in the east. At this juncture, the conceptual and representational issues raised are the biblical theophanies – apparitions of the invisible God in visible form – visions of Moses, Isaiah, and Ezekiel as well as manifestations of the dove at the baptism of Christ and the tongues of fire at Pentecost; most prominently, the concept of theophany "includes the vision of God in Jesus Christ, the Word made flesh."[34] Augustine formulated a doctrine of three human visions – corporeal, intellectual, and spiritual – distinguishing between "oculi mentis," "oculi cogitationis," and "oculi cordis."[35] Thinking about such distinctions might have helped produce the chapel's layout of decreasing materiality from bottom to top. Indeed, Augustine's distinguishing of the eyes of the body from those of the intellect and those of the spirit corresponds to Giotto's three distinct representational modes of dado, walls,

and vault. Considering Augustine's importance for the concepts of allegory and history in the chapel, he could indeed be the secret, idea-generating 'author' behind the chapel's historical author. If this is so, we might encounter his thought as it was visualized in the mind of the project's theological advisor; and thus, of course, through the mind and hand of Giotto himself.

The Arena Chapel's program has often been described in terms that relate to Augustine's notion of human existence being oriented towards achieving the blessing of wisdom. Cary summarizes Augustine's beliefs as follows:

> Therefore what morality is all about is purifying the mind's eye, healing it of its defects and equipping it with the virtues it needs to see the Truth clearly. Hence the goal of human life is defined epistemologically (wisdom and understanding), the road is defined in ethical terms (virtue and purification), and the whole process must be understood psychologically (as a turning and journey of the soul).[36]

The Augustinian references mentioned earlier in the present book elucidate the sequence of Giotto's *Virtues* and *Vices* in relation to *De genesi contra Manichaeos* (II, 10, 13) and to *De doctrina Christiana* (I, 37, 41).[37] These details now appear in the larger frame of Augustine's writings and his own personal history of conversion. The idea of a triumph of Christianity, after all, commands his autobiography.[38] And yet the program is Augustinian not only in its inherent generic triumphal imagery but also in its details – such as *Faith* explicitly triumphing over the other ancient schools of thought and spiritual traditions, stabbing with her cross a shattered idol and standing on manuscripts that evoke non-Christian texts. The dado zone intimates that the Augustinian tendencies of the chapel are not about visualizing the cognitive process of the *Confessions* nor about personalizing the message as an exclusively

Augustinian journey of the spirit. The chapel's program, rather, seems to unite several doctrinal details from a multitude of Augustine's writings that detail his view of history and historical change, offering them to the individual viewer for repersonalization, a visual process here that encourages the merging of authorial individuality with abstract concepts and, finally, the viewer's own life experience.

I am not the first to connect the Arena Chapel to Augustine's thought: Beck discusses Augustine's *De Musica* in regard to music and justice in *Iusticia*'s throne relief.[39] Pisani focuses on Augustine as the source for the choice and order of the virtues[40] as well as the theme of the moral "therapy of contraries"[41] and free will.[42] Particularly important is *caritas* in the chapel's name – Santa Maria della Carità – in relation to Augustine's "Deus caritas est."[43] However, Pisani notes, *Caritas* precedes *Spes* in the chapel, and there is a passage from *De doctrina christiana* that states: "Hope stands higher than love, because love depends on hope."[44] Pisani concludes that the direct reference for the chapel's theologian must have been Augustine's therapy of contraries and his ordering of the virtues. This would also explain why Gregory's later system of cardinal vices does not figure here.[45] Finally, it is Augustine who categorizes despair as the ultimate sin, which conforms with its distressing representation in Giotto's chapel under the corner of Hell.[46]

While these analyses lay important groundwork, the Augustinian bent of the fundamental theme of vision in the chapel merits closer analysis. Indeed, besides the obvious classics – such as *De Civitate Dei* and the *Confessiones* – the Paduan Biblioteca Antoniana's catalogue lists numerous works by Augustine including a copy of *De videndo Dei*.[47] This text is crucial for the connection between Augustine and the chapel in terms of its optical illusionism. The doctrine of three kinds of human vision sheds new light on the suggested differences in media between the

chapel's vaults, walls, and dado; the chancel arch's gradations; and the more general allusions to visibility along with *trompe l'oeil*. Augustine's concept of corporeal, intellectual, and spiritual vision is not unique to him; instead, it seems to be a requirement for reconciling the discrepancies between the visible world viewed through historical time and the Christian doctrine of a larger, invisible world and sacred history. Two writers from Augustine's own classical heritage – Plotinus (ca. 205–270) and Porphyry (ca. 234–305) – agree with him that ultimate happiness for human beings consists in an interior vision of God.[48]

According to Augustine, such a vision of God is, firstly, a gift and cannot, secondly, be obtained permanently. The first of these qualifications is related to grace and exceeds the individual role of the spectator. The second, temporal limitation seems crucial for the extent to which the chapel's visual regime depends on individual, personal reflection. Vision needs to be *constantly readjusted* to achieve an understanding of the entire system. For example, the chancel arch's vertical stacking of: 1. freely hovering figures on top of the projecting *Annunciation*; 2. the intermediary level with relief-style scenes of the *Visitation* and the *Pact of Judas*; and 3. the zone of the receding spaces of the *coretti* create the complex calibration of relief effects. Perplexing visual experiences in the chapel call for a certain flexibility of vision and concomitant reconsideration of what is being seen.

Augustine's explanation in *De consensu evangelistarum* (Epistulae 147 and 148) begins from the account of the vision of God given to Moses, to Paul, and to the Apostles.[49] This first discourse explains how the grace of a heavenly vision has to be gifted and cannot be forced. In this context, the abstraction of the east vault with the Pantocrator and his surrounding saints in flaming ornament invites the common visitor to the chapel to an artistic, symbolic representation of something that he has not seen, nor is likely to see. In their relief-like form, the scenes on the walls and the faux reliefs of Mary and her surrounding saints in relief frames in the west vault all maintain their intermediary status of Salvation folded into world time and history. The dado is the most coherently illusionistic zone and extends the most direct call to the viewer.

The zone's purifying personal virtues,[50] in addition to charity and grace, are essential for "seeing God."[51] Grace alone would allow for a *raptus*-like vision of God – an *excessus* or ekstasis.[52] How then would Giotto go about reconciling the three visions of God with the strong dualism of the chapel's double arch in a way that would visualize the potential ecstasy that the soul can achieve through the right way of seeing? The key themes of the Trinity, the Incarnation, charity, hope, and humility all relate, in the chapel, to the spectator's experience of different degrees of virtual reality. Whereas the three zones of the chapel show the transcendent *aldilà* in the vault, the linear vision of history in the middle, and the most earthly, most illusionistic and appellative stance in the dado, both vaults together unite this spectacle with the humble triumph of the Son of Man and Son of God. The zones can be represented with arrows indicating their relative position to the realms of the material (\downarrow) and immaterial (\uparrow):

↑ INCARNATION (VAULTS), *apparitions from beyond the this-worldly time and space*

→ LIVES (LONG WALLS), *linear world-time-bound historical experience in personal specificity*

↓ ALLEGORIES (DADO), *universal principles with moral imperative for the here and now, shown as to appear in the context of the world-time-bound scenes above*

These vectors also indicate how the chapel interweaves linear time (along the walls) with the vertically conceived time of eras (e.g., the phases

of the *Life of Christ*, such as infancy and Passion cycle, which are embedded in the linearity of his life story *and* positioned on different levels of the walls) as well as with the eons that structure Salvation history. Such a division appears in *De videndo Dei*, where Augustine discusses personal judgment of visible and invisible things.[53] This discernment presupposes not only personal individuality but also responsibility of vision to be critical of the things one sees.[54] *De videndo Dei* argues that God, in fact, cannot be seen, using words similar to the grisaille *Circumspectio* over Scrovegni's door: "nec circumscribitur uisu."[55] Augustine's system binds the possibility of a vision of God to emotions, virtues, and gifts of the spirit.[56]

All this aligns with the insistence on the careful use of vision and memory under *Prudence* – the first virtue to be seen by visitors entering through Scrovegni's door – as quoted above: "RES ET TEMPUS SUMMA CURA [...] / [...]UIDENTIS MEMORATU[R] [...];" "Things and time with the greatest care [Prudence] notes and [...] remembers the eyewitnesses [...]."[57] Indeed, it is Augustine who first ponders, in Wilken's words, "two of the most mysterious and elusive aspects of human experience, memory and time."[58] He is also responsible for consolidating, in writing, a psychology of philosophical soliloquy, as Brian Stock explores in *Augustine's Inner Dialogue*.[59] Stock's contribution on the "integrated self" echoes the direction taken by the chapel's setting up of an intellectual stage for self-knowledge, self-differentiation, and self-integration.[60] The Arena Chapel is but one of many examples of the Augustinian thought system visualized in Italian art.[61] However, as unique as the outcome is visually, conceptually Giotto's work at the Arena just runs closely in parallel to Augustine's own struggle with the spolia of antiquity.

At the heart of the chapel seems to rest a specifically Augustinian way of relating to the classical heritage without compromising the new and fundamentally different Christian spirit. Augustine, of course, had to address this difficult problem head on: As a schoolboy, he had won a contest in Virgilian rhetoric. How could he appropriately employ the harmonious and extremely effective forms of his familiar, admired, and beloved ancient rhetoric in service of his new love of Christianity? His answer was a recognition that the problem is not *whether* but *how* to deal with the remains – the spolia – of antiquity.[62] The term stems from the Latin *spoliare* (to strip, skin, or despoil), and usually refers to architectural fragments, sculptures, inscriptions, or glyptic objects.[63] Far from being random left-overs, spolia are trophies: signs of victory, and triumph. Their installation as fragments and reminders of past battles involves a process of translocation in three steps – from the original context via a mode of transfer to a new context or usage. This process can emerge from local tradition or aim to transplant the *genius loci*, as the Arena Chapel seems to do.

Focusing on architecture and rhetoric, a study by Maria Fabricius Hansen points to Augustine's unmatched relevance for the history of spolia, which she defines as "a vehicle of triumph" and as an "instrument for recollecting the past."[64] While she distinguishes destructive practices of spoliation from productive uses, she also discusses how "older elements might be incorporated in new structures in a way that annihilated them by making them invisible."[65] The Cappella degli Scrovegni as a double triumphal arch seems rather to document the opposite construction – of visually inserting new elements into an old structure. With its iconoclastic image of *Faith* and its idol-bound representation of *Infidelity/Idolatry*, the chapel tackles one of the central issues of early Christian thinkers. In practice, the Christian late antique compromise with the pagan legacy, – whether in art, architecture, or scripture – for the most part took the pragmatic approach of

giving old structures new meaning. Letters such as the second and third Epistles of John, for instance, utilized ancient structures, filling them with the new Christian message.[66] It is in *De doctrina Christiana*, completed in 426, that Augustine employs architectural examples to frame his "manifesto on how to relate to the heritage of the pagan past."[67] As a result, a "widespread debate on worldly studies and their compatibility with Christianity was on the agenda both before and during the time of Augustine."[68] In the *doctrina*, "often characterised as the first Christian theory of rhetoric,"[69] Augustine sets the Bible's clear "primitive" language as a new standard of eloquence. However, he also recognizes the importance of cultivating ancient heritage in order to maintain anything that could help further the Christian cause, appropriating classical standards of music, the alphabet, and rhetorical style, as well as virtues like justice that had already appeared in pagan philosophy.[70] It should be possible, Augustine hoped, to "profit from the culture of the past without being seduced by idolatry."[71]

This hope complements Augustine's notion from *De vera religione*, which stated that Christ achieved what Plato sought in terms of opposing polytheism and idolatry.[72] The old and the new are not irreconcilable: "The matter – or *material* – of pagan learning and culture was harmless or even valuable in itself; only the perversion of its use was problematic."[73] Spolia and pagan structures were fair game if they could be used to make the spectator increasingly aware of the substance of things: "The ultimately successful building consisted of the kind of architecture that promoted an awareness in the spectator of how petty material things were and how they failed in comparison with the ideal beauty of spirituality," Hansen concludes from *De musica* and *De vera religione*:[74]

> Using a parable of architectural appreciation to describe the way of letting the physical world

function as a pointer to higher truth, Augustine defined the spectator informed by the proper awareness as a man with inward eyes, capable of seeing the invisible: 'virum [. . .] intrinsecus oculatum et invisibiliter videntem'. [*De vera religione*, XXXII.59] The most 'beautiful' architecture, then, was a structure that succeeded in leading the mind towards a vision of true harmony.[75]

These Augustinian ideas relate to many issues raised by the Arena Chapel's geographical location and historical position, not to mention stylistic synthesis. Hansen's interpretation of Augustine's *De fide rerum quae non videntur* (On Faith in Things Unseen) has particular relevance: "The false gods have been abandoned, their images everywhere dashed to pieces, their temples razed or converted to other uses, and so many vain rites rooted out from the most stubborn human customs."[76] Ultimately, Augustine's view of God exhausts the limits of historical time and place: Only God was "not extended in space or unstable in time," while all sensual experiences of creatures, in nature and in art, have only a limited "spatial or temporal beauty."[77] Consequentially, the Arena Chapel states visually how everything and everyone created has a place in the space and time of this system, with God alone exceeding it.

In the context of art-historical tradition, Giotto's relationship to antiquity invites a reconsideration of the Renaissance principles of junction or disjunction as in Erwin Panofsky's familiar argument in *Renaissance and Renascences in Western Art* on the many partial stylistic or iconographic "renascences" that took place throughout the European Middle Ages.[78] The conscious, systematic references to Rome in this architectural ensemble at the ancient arena in Padua open up a new perspective on the very concept of "Renaissance and Renascences." This particular case of adapting ancient form *and* meaning – a kind of commingled material immaterial

spoliation – presents an artistic triumph in Giotto's play with the classical formal language of historical reliefs and their former colors.

In a future study, Giotto's classicism merits a reading with Panofsky's theory of disjunction articulated in *Renaissance and Renascences* as well as Richard Brilliant's and Salvatore Settis' views on historicity, in particular the way in which the middle ages would triumphantly lay claim on "a particular kind of Roman past."[79] The densest concentration of time and matter in the Arena Chapel's frescoes is compressed into the faux cosmati work, which imitates in painted mosaic the Roman arch spolia technique that frames and covers new Christian artworks and monuments with tiny fragments of ancient polychrome marble. Giotto does not take the actual material from his monumental Roman models but replicates its visual authority while claiming a triumph of mural painting as an omnipotent medium that conquers both architecture and relief sculpture. Giotto's practice in Padua is a call back to the roots that is different from what scholarship has hitherto conceptualized for either the Trecento or Quattrocento. In the Arena Chapel's biblical scenes as well as in the *Virtues* and *Vices*, Giotto does bring the classical body back into Christian art – as Timothy Verdon notes in relation to spiritual vocation[80] – but only halfway, for serving a new purpose: Giotto's simulated relief-sculpture displays figures cut in half.[81]

THE TRIUMPH OF HUMILITY AND THE *NOLI ME TANGERE*

The triumph of humility is a triumph amid ruins. It requires broken things to engage the paradoxical message of Christ's reversal of power, human and divine empathy, and involves the Christian approach to spolia as championed conceptually by Augustine and originally practiced by early Christians in Rome and elsewhere.

The triumph of humility depends on looking at ruins and seeing through to their former pristine state as well as to their ultimate irrelevance in light of eternal values; it further depends on understanding higher truths and values, transcending the realms of the temporal, the material, and, more than anything else, suffering – *passio* and passion.

The triumph literature of the decades following Giotto's project produces regular and conscious references to ancient Rome. Dante not only dreams of reviving the Roman Empire by imagining in the beginning of *Inferno* the pagan author Virgil as his teacher, his author, and his guide through the existential *aldilà* (*Inferno* I, 85, "Tu se' lo mio maestro e 'l mio autore"); Dante, Boccaccio, and Petrarch also revisit Augustine. Petrarch in particular invokes *romanitas* in his imaginary correspondence with the philosophers and authors of antiquity in the *Familiares* (*Letters on Familiar Matters*) and his famous invective *Contra eum qui maledixit Italie*.[82] Most importantly, Petrarch engages with Augustine as a silent interlocutor in a written, dialogical examination of his own faith in his *Secretum*, or *My Secret Book*, as in Nicholas Mann's recent translation, a trilogy of dialogues in Latin written in the years between 1347 and 1353.[83] It is symptomatic of the new Italy that Petrarch insists on receiving his poetic *laurea* in Rome on the Capitoline Hill and not in Paris. These authors, in other words, continue to struggle with the Giotto-Scrovegni problem of invented, reinvented, reestablished, and reformulated origins, and they do not give up on Rome as an idea, as a style, and as a work of art.

As shown in Chapter 3, the programmatically new attitude towards the ancient ruins of the arena and their genius loci helped Scrovegni rise above the medieval Paduan nobility represented by the Dalesmanini in the Veneto so he could claim for his own dynasty a status similar to that of the Roman Frangipani in Lazio – the families

occupying the spaces around their city's respective Roman arena in those two Italian regions. An ideological act, expressed in the lost inscription as a matter of making good use of the remains of antiquity, this move is also promoted as one of moral superiority and personal excellence – and as an exorcism of the demons of the pagan past.

Scrovegni needed the arena in order to declare his chapel a renovated temple, tackling the ancient issue of containing God in a sacred space.[84] No one would gain as much personal profit from the palimpsest of places and religions as Scrovegni did with his chapel. But the connection between ancient Patavium and Trecento Padova was always there: The whole city sits on the *castrum romanum* grid, its urban plan, squares, streets, and, of course, the arena reinforcing those ancient planimetric lines.[85] The chapel's references to the pagan Arch of Titus and the Christian Arch of Constantine make it a first Renaissance triumphal project. There is one difference, though: This triumph does not come, like a Quattrocento or Cinquecento Renaissance triumph, with a reassociation and reemergence of ancient forms and ideas. Instead, it systematically combines structure, form, and media simulation in order to create new meaning. Panofsky's model of a reactive Renaissance that responds to earlier art is not sufficient to account for the performative and intermedial iconographies of the chapel.

There is one parallel phenomenon in early Christian literature – an example of triumphal rhetoric circling around precisely the same monument, namely the Arch of Titus. It is the Epistle to the Hebrews. Ellen Bradshaw Aitken notes that the Roman "subjugation of Judea stood at the center of Flavian propaganda."[86] This triumph followed a Roman victory that, for the Jews, was not only a military defeat but the irremediable destruction of Jerusalem and its Temple. When the Romans took sacred objects and seven hundred prisoners of war,[87] among them General Simon bar Giora,[88] the military defeat disclosed

also its religious dimensions. The triumph, "one of the most prominent features in the religio-political landscape of Flavian Rome," was,

> at its heart concerned with the return of the general or emperor to the temple of the Roman gods and with acclaiming the epiphany of the god in the person of the triumphator. In other words, the apotheosis of Titus depicted on the ceiling of the Arch has already been displayed – in his lifetime – on the day of the triumph. The Arch celebrates his consecration.[89]

Again the passageway reliefs stand in the focus of referential attention, displaying a different kind of spolia – that is, spoils taken in war – most devastatingly, here, the Menorah. Bradshaw Aitken convincingly argues that the epistle

> makes use of some of the elements of the triumph – both the customary rites of the triumph and the key elements of the Flavian triumph – in order to articulate resistance to imperial rule and ideology. It does so by depicting to whom the 'real' triumph belongs and where the 'real' temple is.[90]

The proposed reading of Hebrews recognizes the depiction of Jesus as emulating the Roman-Flavian triumph. This happens in specific motifs as well as with regard to the general issues of sonship, succession, and rule that were at the core of Flavian propaganda. The succession from victorious father and victorious son, celebrated as gods by the Romans in the historical figures of Vespasian and Titus, now relates to God the Father and his Son – and their ultimate power over the eons as they return, triumphant, to the heavenly Temple.[91] When Bradshaw Aitken writes: "Jesus is, in my view, depicted in Hebrews as the triumphator in procession to the temple. The text displays the apotheosis of Jesus, rather than the apotheosis of Titus, but both are portrayed as the son who rightfully rules

alongside his father in victory,"[92] she could be describing the Arena Chapel. The Son appears as the ultimate high priest in Hebrews 4:14, "offering himself. We may recall that in the Roman triumph the triumphator is also the sacrificer, the priest of Jupiter Capitolinus, who makes the concluding sacrifice of the triumph."[93] Bradshaw Aitken concludes:

> As a response to these articulations of the political theology of the Flavian emperors, as they were experienced in the city of Rome, Hebrews creates its own political theology out of the building materials available in its immediate civic context. The scriptures of Israel and the traditions available to this early Christian community then provide the means to fill out this depiction of Jesus as triumphator and divine ruler enthroned in heaven, but as triumphator whose journey is marked by suffering, struggle, and solidarity with those in need.[94]

The Arena Chapel consciously responds to the ancient hubris of a self-proclaimed apotheosis with the dual stance of Jesus, who came from God yet debased himself with humility in human physicality, exposure to fellow human beings, and finally the brutal and merciless limits of space, time, and brittle human loyalty in order to provide Salvation for all. This humanized divine son of a divinized human Mother becomes, through Giotto's tactile values, an approachable and palpable God; as Smart noted, in Giotto's Arena Temple "Christ is no longer the unapproachable Judge and heavenly King of Byzantine art, but one with whom it would be possible to converse – still the divine Son of God, but also a man wearing the vesture of humanity."[95]

As discussed in Chapter 3, the chapel's inscription highlights the connection between Palm Sunday, Easter, and the Feast of the Annunciation: "ANNORUM DOMINI TEMPUS TUNC TALE NOTATUR: / ANNIS MILLE

TRIBUS TERCENTUM MARCIUS ALME / VIRGINIS IN FESTO CONIUNXERAT ORDINE PALMAE."[96] This association constitutes a double triumph of humility, with Mary's answer in the Annunciation as the prime example of humility and with Christ's Palm Sunday entry into Jerusalem (the first day of Holy Week and the Sunday before Easter). Palm Sunday begins the Passion cycle with the reversal of the ancient triumph: Jesus, the emperor of humility, rides on a jennet, accompanied by children, the jennet accompanied by her foal.

By recognizing the visual regime around the *Lives of Mary and Jesus* in its spiritual dimensions, we come to see that Giotto offers, in the Arena Chapel, a spatial-optical-intellectual experience of the mystery of Incarnation. By definition, such an endeavor surpasses any historical periodization and ultimately demands, as argued above, its own disappearance into invisibility. As Dante concluded at the end of *Paradiso*, no earthly matter is fit to represent the mystery – the word and the flesh of the *logos* – but with its synthesis of time and medium, the chapel takes up the challenge in a most profound and complete way.

There are indeed two seemingly paradoxical themes conjoined here: the materialization of the immaterial, and the celebration of a triumph of humility.[97] With the bright and stunning coloristic effects of the *Crucifixion*, so concludes Flores d'Arcais, "Giotto transforms the tragic scene into a moment of glory."[98] A humble triumph, however, is as emblematic of the Christian message as the perplexing double nature of Christ, or perhaps even more: Christ's extraordinary humility both reveals and enables the dynamics of his simultaneous status as Son of God and Son of Man. Examples of Christ's humility are represented on the chapel's walls, such as the washing of the feet (John 13) and of course the Crucifixion – the ultimate humble act that he takes upon himself (see Philippians 2:5–11). For

the first generations of early Christians, Christ's selfless humility – which exposed him to suffering, mocking, beating, and the unbearable conditions of his death – could initially only be symbolized by the cross and Christograms such as the Chi-Rho (☧), superimposing the Greek letters chi (X) and rho (P), the first two letters of Greek χριστός ("Christ"). The subsequent development of a realistic iconography of that scene, with figures and instruments of torture, opens up the kinds of questions that Giotto ultimately tries to answer – what is the nature of the world in history and in eschatology, and where is hope?[99] Without a firm belief in the invisible plan of God, life would be senseless for the Disciples of Christ after the Crucifixion. Christians had to turn to the unwavering hope that God's plan will ultimately transform the Fall of Man into a *felix culpa* and the terrible death of the Son into even greater joy with Father and Mother in Eternity.

The Bible accepts pride when it is defined as a positive, grateful experience of God[100] and condemns pride that stems from an excessive feeling of self-worth or superiority.[101] Humility is characterized by gratefulness and by a balanced, realistic perspective on the ego and on others.[102] The biblical criticism of pride aligns with the visual rendition of Giotto's self-destructive *Envy* in the chapel. By definition, humble human beings are indeed not consumed by envy.[103] For Jesus, as for God, greatness stems from humility, not from pride – for Giotto, it is even the hope for Salvation.[104] This is a constitutive element of the life stories shown on the chapel's walls. It creates conflict with the Pharisees, whose pride and pettiness would keep them in spiritual darkness.[105] Countering their proverbial hypocrisy, the Bible rather sets humility as a principle that furthers learning and knowledge, both particularly relevant to the intellectual university environment of Padua.[106]

Humility, as lived by Christ through elation and suffering, defines itself as strength, not weakness.[107] The chapel's dedication to Mary also frames her humility in such terms: her answer to the Lord and the moment of the Incarnation being understood as the prime example of humility. Lines from the *Magnificat* (Luke 1:46–55) emphasize the ultimate judgment of pride and humility: "He hath showed strength with his arm: He hath scattered the proud in the imagination of their hearts. He hath put down the mighty from their seat: and hath exalted the humble and meek."[108]

The fundamental importance of humility for Christianity lies in its power as the counterforce to pride and in the role both pride and humility play in the story of Salvation. Pride was the motor for the Fall of Man, following the initial sin of Lucifer and the Fall of the Rebel Angels. In this account of redemption, the sin of Titus and Vespasian is identical with the arch sin of Lucifer that was undone by Mary. Her son would later declare in his Sermon on the Mount: "Blessed are the meek: for they shall inherit the earth."[109] Marian-Christian humility is an outright rejection of hubris; a balanced attitude that neither debases nor elevates the self but rather finds a more truthful and sustainable relation to God the Creator, recognizing him as an ethical ideal and model for emulation.[110]

The triumph set amidst ruins serves to reconcile the seemingly paradoxical relationship between power and humility. Centuries later, when the modern mystic Simone Weil described the exceptional power of humility in her section on "The Self" in *Gravity and Grace*, she gathered her thoughts about suffering, humiliation, humility, and space in Giotto's frescoes all at once: "The agony of extreme affliction is the destruction of the 'I' from outside: [...] / 'Niobe also, of the beautiful hair, thought of eating.' That is sublime, in the same way as space in Giotto's frescoes. / A humiliation which forces us to renounce even despair."[111] This is why Weil, as mentioned above, describes humility as a lever. Not only Scrovegni and the theological expert behind the chapel's program enabled Giotto to

produce a lever of history, but the Paduan arena in 1300 offered itself as an Archimedean point: "Give me a place to stand, and I shall move the Earth with it," as Archimedes stated. On Scrovegni's construction site, Giotto was indeed given a place to stand – one solid point – and therewith a lever long enough to extend Augustine's theology to a visual cosmology that continues to speak to pilgrims, visitors, writers, and artists.

The extent to which the Arena Chapel serves as a lever of history becomes most evident when we consider these aspects of pride and humility as well as the religious sacrifice following Christ's ultimate self-sacrificial act. The supersession of the older religions' blood sacrifices is fundamental to the New Testament's message of peace, which replaces animal blood with *Caritas*.[112] The rejection of Joachim and his little lamb from the Jewish Temple, which excluded him from the Old Covenant sacrifice, is the first Arena Chapel scene in the *Lives of Mary and Christ* sequence – another trace of Hebrew heritage. The Old and New Covenants likewise set an agreement based on physical promises against one based on spiritual promises.[113] As Jesus replaces the body of the lamb with his own body, it may not be irrelevant that the chapel's only actual, physical relief sculpture is a small tabernacle with a *Man of Sorrows* (see Fig. 3.4) that depicts little more than Jesus Christ's tortured body as a half figure in a niche below, with sun and moon in the spandrels and, in the upper portion, a mandorla with a smaller figure of the Judging Christ among angels – a miniature of the chapel's passion and apocalypse, just without all the narratives.[114] The Scrovegni *Man of Sorrows* is the silent core of the project and would be a sufficient as an image for unpacking its complex painted environment: Jesus's sacrifice through pain and passion engages both the Jewish-Christian discourse of the chapel and Scrovegni's role as a donor, making his personally adapted triumph over pagan rites worth thinking about in the context of words from the

prophet Micah. Rejecting all earlier forms of material sacrifices, Micah asks:

> With what shall I come before the Lord and bow down before the exalted God? Shall I come before him with burnt offerings, with calves a year old? Will the Lord be pleased with thousands of rams, with ten thousand rivers of olive oil? Shall I offer my firstborn for my transgression, the fruit of my body for the sin of my soul?[115]

His ultimate offer is the great sacrifice of the ego: "He has shown you, O mortal, what is good. And what does the Lord require of you? To act justly and to love mercy and to walk humbly with your God."[116] Nothing in the historical tradition suggests that Scrovegni was walking humbly, but for his chapel, Giotto conjured up all the artistic, intellectual, and theological might of the time to suggest that he was.

Giotto's response to pagan materiality, sacrificial rites, and relief sculpture ultimately required the visual sharpening of his argument around a specific iconography that is most relevant for the themes of Resurrection (fulfilling the Incarnation) as well as for touch and palpability. "Tactile values" are probably the most famous topos in Giotto scholarship;[117] in the chapel's scenes, these values surpass mere matters of style as there is an extraordinary emphasis on touch, with carefully drawn details of fingertips and toes fine enough to bear meaning. Two examples with the greatest theological significance are the *Noli me tangere* and the Christ of the *Ascension* in relation to the figure of *Hope*.[118] The chapel's famous *Noli me tangere* (Figs. 5.1–5.2) shows the typical relief-like staggered arrangement of figures against solid fields of stone against blue. The field contains two angels on the empty grave, five sleeping soldiers, and a figural pair locked into an exchange of gazes and gestures: Mary Magdalene and the resurrected Christ. Remarkably, like the dado zone's mock marble, the sepulcher itself is created with a more polished surface.[119] As in the earlier landscapes, the line

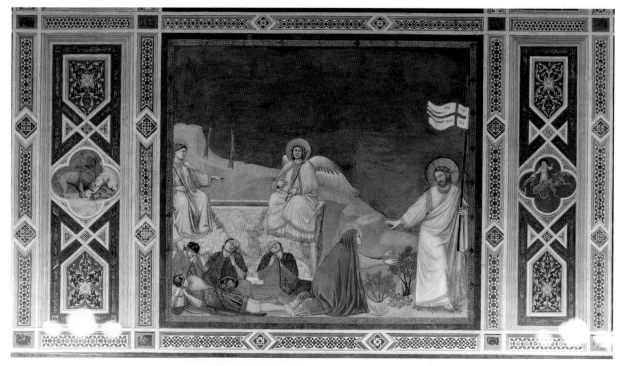

Fig. 5.1 Arena Chapel, *Noli me tangere*. Courtesy of Steven Zucker.

separating blue and grey – that is, separating the plane and the fictive matter of paint and relief – contributes to the story. Here the eye is directed along the smooth suite of gestures that connects Christ's physical absence to his new appearance. From the angel's hand to the angel's ornamental wing, the downward sway of the mountain, Christ's arm, and the flag, the gaze's path connects all these elements. The sweep of the wings is answered by the triumphal banner's flexible fabric, as if feathers and rags are drawn to one another, prolonging the moment of departure.

Metered and measuredly distributed across the flag's four partitions, which are formed by the cross, the syllables "VIC" "TOR" "MOR" "TIS" announce Christ's victory.[120] As if Giotto aimed to depict distant longing as the most extreme form of desire,[121] not as hunger but as thirst, the figure of the Magdalene has been plausibly connected to the contemporary relief of a thirsty woman from Arnolfo di Cambio's fountain in Perugia.[122] Jean-Luc Nancy investigates the meaning of the "Mè mou haptou"

considering that the prohibition of touch as a parable is

> not to be situated in the relation of the "figure" to the "proper," or in the relation of "appearance" to "reality," or in the mimetic relation: It is in the relation of the image to sight [*la vue*]. The image is seen if it is sight, and it is sight when vision creates itself in and through it, just as vision only sees when it is given with the image and in it. Between the image and sight, then, there is not imitation but participation and penetration.[123]

The parable takes into account that the "resurrection is not a return to life. It is the glory at the heart of death: a dark glory, whose illumination merges with the darkness of the tomb. Rather than the continuum of life passing through death, it is a matter of the discontinuity of another life in or of death."[124] Mary's exceptional role and sensuality[125] raise the issue not of the image but of touchable sculpture.[126] For Nancy, the image's prohibition results in a positive statement – an

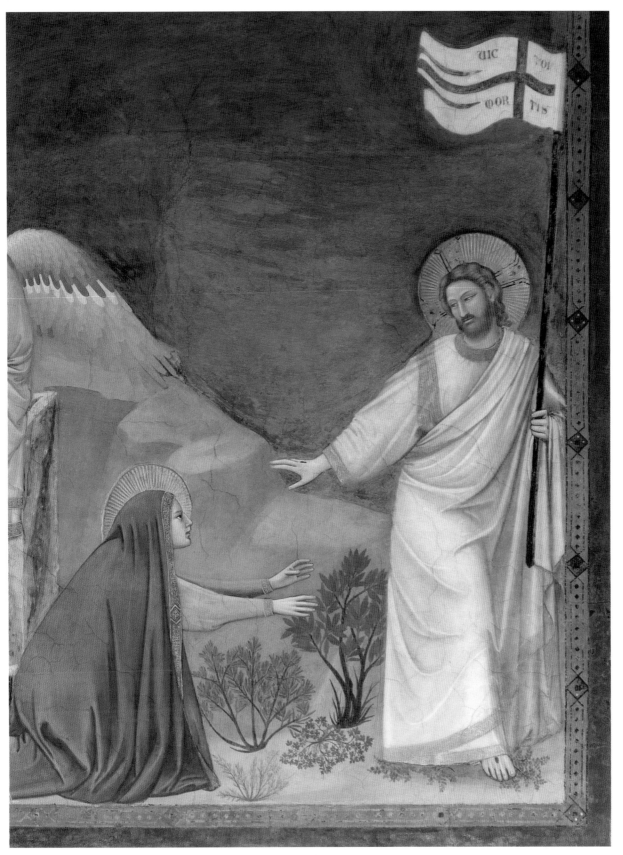

Fig. 5.2 Christ in the *Noli me tangere*. Courtesy of Steven Zucker.

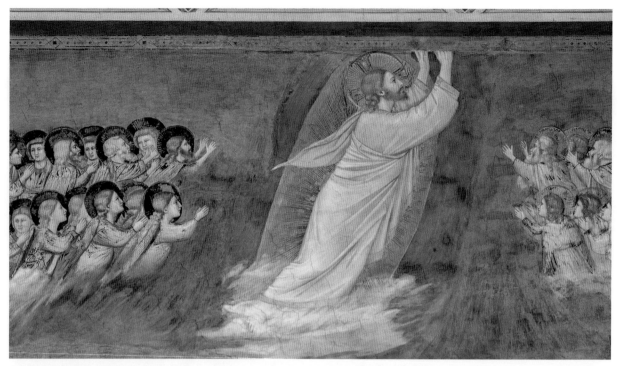

Fig. 5.3 Christ in the *Ascension*. Courtesy of Steven Zucker.

invitation.[127] So this movement, as it withdraws itself, is about presence: "Presence is only given in this arising and in this stepping beyond, which accedes to nothing but its own movement."[128]

Nancy links the visualization of Mary's longing hands and Christ's disappearing body with his fingertips in the adjacent *Ascension* (Fig. 5.3).[129] Bystanders among clouds – angels, patriarchs, Apostles – assist the movement of Christ out of the upper frame's limits.[130] Christ in the *Ascension* and *Hope* in the blessed corner of the *Last Judgment* (Fig. 5.4) rhyme as silhouettes. But Christ's fingertips are occluded, cropped by the frame as he reaches the sacred invisible, unrepresentable, impalpable. There is a long-standing iconography for disappearances of Christ out of the frame throughout the Middle Ages. In Giotto's version, Christ's fingertips are already beyond the upper limits of the representational frame, and we see his eyes looking upwards, following his own vanishing fingertips into nowhere. *Hope*'s fingertips poignantly breach the dark marble background. Directly over her, we can see Saint

Augustine's author portrait. Palpability and invisibility are thematized in an iconography that captures exactly this difference between where Christ is going and where the others remain. True to their functions in narrative and allegory, Christ's figure and that of *Hope* illustrate an energized yearning on two levels – parallel moves, one closer to the goal than the other.

While Christ's fingertips disappear beyond the frame, his toes are visible through the cloud.[131] Below, the five Apostles' pairs of hands, shielding their eyes, are foreshortened. Exactly those parts of the fingers that disappear from the hands of Christ protrude from their shadowed palms. Appropriately, the viewer does not see Christ touch the sky, as his touch is already beyond the sensual realm. His performance within and outside the frame produces an act of visible invisibility, reaching and spiritual seeing made palpable. His fingertips arrive where *Hope* directs her focus; her fingertips, contrastingly, delineate themselves against the brighter marble frame, while the rest of her hands and thumbs are set against the dark green of the simulated *serpentino*

Fig. 5.4 *Hope* ascending in the context of the blessed corner of the *Last Judgment* (comparative figure to Christ in the *Ascension*). Courtesy of Steven Zucker.

marble panel.[132] *Hope* depends on the bas-relief effect, expressing serenity, animation, and visible consciousness of purpose.[133] Christ's body breaks through the system of Giotto's volumes, leaving it behind as his flattened figure escapes the ficitve relief field's spatial logic.

GIOTTO AND DANTE, REVERSING THE ANXIETIES OF INFLUENCE

The *fortune critiche* experienced by Augustine and Dante in relation to the Scrovegni Chapel are diametrically opposed: Dante was habitually associated with the chapel until, during

the past few decades, scholarship has recognized the lack of documents among the popular legends of later centuries. On the other hand, Augustine has not been mentioned until, recently, scholars like Giuliano Pisani have registered the extremely strong and systematic relevance of his thought and specific writings for the dado zone and *Last Judgment*, among other aspects. I argue that there are further networks of connections with both authors that, directly and through Dante to Augustine, ultimately reassociate the poet with Giotto's Arena Chapel in unexpected ways.

Augustine and Dante have been tightly linked in Dante scholarship. Dante is also, obviously,

connected to Virgil and Livy, but the relationship between Dante and Giotto, who were contemporaries and compatriots, remains vague. Fiction tends to fill inconvenient historical gaps. One of the most extreme excesses in the sentimental spinning of artists' legends is the story of Dante visiting Giotto in the Arena Chapel, a ninenteenth-century dream of two old friends from Florence reuniting in Padua that is, in Fiocco's view, as unfounded as it is absurd.[134] Benvenuto da Imola appears to have disseminated the idea by 1379 in his *Commentum super Dantis Aldigherii Comoediam*, and the anecdote multiplied itself in romanticizing writing for centuries to come.[135] Written accounts were further transformed in the painterly tradition of the nineteenth century, which produced its own pictorial version of their imagined meetings. Marcellan convincingly suggests that these forced connections were attempts to associate the founding fathers of Italian painting and of Italian literature in the collective memory of the Risorgimento.[136] As a historiographical antidote, therefore, in more recent times the goal has become "to distance Giotto from Dante."[137] However, scholarship has never stopped to look for other links between the poet and the painter. In their study of the Arena Chapel's program, Derbes and Sandona come to the valid conclusion that its "pictorial microcosm bespeaks a consistency and symmetry comparable to Dante's *Divine Comedy*."[138] Ladis tries to save the Giotto-Dante association with a focus on general "formal qualities as balance, symmetry, mirroring, and inversion" as well as "measure, rhythm, and rhyme,"[139] but we might well ask where and how these encyclopedic works really compare. Neither allegorical structure nor detail are equal in those two grand sacral systems.[140] Giotto's *Last Judgment* contains *Inferno* and *Paradiso* but *Purgatorio* is not represented on the walls. Instead, one could argue, Dante's concept of Purgatory equals the entirety of Giotto's chapel, bottom to top. Situated between Hell and Heaven, it is a space

in which souls enjoy the mobility of bettering themselves – a place of experiencing, learning, and atoning. This major iconographic and organizational difference suffices to illustrate the immense structural gap between Giotto's and Dante's great allegorical works.

Could the two Florentines perhaps have been friends, as so often imagined? Giotto and Dante, after all, filled at different moments parallel administrative, political, and architectural positions as, respectively, Director of the Opera del Duomo (appointed in 1334) and Superintendent of Street Widening (appointed in 1301); both "participated in the new civic reorganization"; and both were indeed exponents of "the sense of communality and an urban mentality."[141] The historical links between Giotto and Dante, then, are those of compatriots: In Florence, the two Tuscans share their local heritage of visual-imaginative formation.[142] Central influences such as the Baptistery reverberate in Giotto's visions of Hell as well as in Dante's memories of Florence, the latter famously calling the compact building his "bel San Giovanni" in *Inferno* XIX, 17.[143] However, their respective political stance divides them along the lines of opportunism. Giotto worked for Pope Boniface while Dante's diplomatic hopes were bitterly disappointed, the same Pope contributing to his forced exile.[144] Their characters are also described very differently in the sources available through Boccaccio and Dante himself. Benvenuto da Imola may have associated them, picturing painter and poet in the chapel as friends, but from a distance of several decades, which compromises his text's authenticity as exact historical source.[145]

The documented, historically verifiable connection between Dante's *Commedia* and the Cappella degli Scrovegni is encapsulated in two precise instances, and both are disappointingly irrelevant in terms of aesthetic-poetic affinities. Established through the brief appearances of old Scrovegni and of Giotto himself in Dante's poem, the

connections suggest no particular personal involvement from Dante's side. First, the famous Scrovegni reference in *Inferno* XVII registers Enrico Scrovegni's potential hereditary guilt. Dante's *terzina* and Scrovegni's presumed feelings of guilt or shame have often been taken as constitutive factors in the chapel's history, but the text postdates the chapel and there is no historical record of young Scrovegni harbouring any such feelings. Second, in the famous *Purgatorio* XI passage on young artists surpassing their masters, Giotto is named as the most innovative painter of the time (who, however, also might be outperformed by some future hero, so Dante's implicit warning). This reference is usually understood as echoing Dante's own fame overshadowing the poets Guido Cavalcanti and Guido Guinizelli, but it does not contain any information whatsoever on Giotto's merits beyond implying a general excellence and superiority in his field.

Giotto's character furthermore appears rather different from that suggested by Dante's political convictions and ethical aspirations, at least as far as these are reported by Boccaccio, Benvenuto da Imola, and the historical facts of his potentially opportunistic papal association and work for Scrovegni. Ultimately, not only can we not document a meeting between Dante and Giotto. We can also not determine to what extent they were aware of one another's works. It is thus more fruitful to focus on points of elective affinity between either one's *magnum opus* as they are still available to us. Ways in which the chapel and the *Comedia* connect include their shared theological interests, poetic concepts, observation of human nature, empathy, and discourses on self and others – in particular on narcissism (chapel) and on depression and anxiety (*Comedia*); they are defined by the knowledge and sensitivity of their creators. These connections are so powerful and harmonious – or perhaps complementary – that their relevance transcends the question of whether the makers of these works were friends or not. Many strong affinities and correspondences mutually enrich their respective "readings." Mariani addresses these shared core themes and values in terms of human dignity, a category as important as it is aesthetically ambiguous and worthwhile reframing.[146]

Among the parallel lines running alongside these projects' uniquely interlocking allegorical and aesthetic affinities, maybe Dante's Augustinian tendencies were partly responsible for causing or furthering the legendary association between poet and artist, as a common source for both. The shared interest in antiquity certainly was such a factor. The remarkable precision and thoughtfulness in Giotto's work for Scrovegni seems to have been particularly encouraged by the rich intellectual environment of Paduan proto-Humanism, furthering the painter's already highly developed thinking about architecture, the sciences, and history.[147] In Padua, Giotto found everything already inserted in an ancient Roman frame. The locals took pride in celebrating the memory of Livy – the authoritative ancient Roman historian was born there in the mid-first century, when Padua was still Patavium. This important point of access to their respected roots is only one aspect of the enthusiastic Paduan proto-Renaissance, which was further encouraged by Dante's famous line in the *Comedia* on Livy never being wrong.[148] In the Augustinian context of the chapel's commission and of the present study in general, Livy stands as another bridge between Augustine, Dante, and, now, Giotto.

The common ground between Augustine and Dante lies in the theme of personal struggle as well as in the integration of measured aesthetics for approaching the invisible beauty of God,[149] all of which harbors the problem of mimesis and the conscious distinction made between different kinds of vision.[150] Augustine's thought, as shown above, is engaged with the organization of different manners of corporeal, intellectual, and spiritual sight as much as with the sequence of the virtues, the themes of free will, individualization,

and individual responsibility, a strong Trinitarian model; it is also a likely source for the distinction of Jewish witnesses representing groups of supporting and opposing contemporaries of Jesus. We have seen that these themes appear in the Arena Chapel; they are equally present in Dante's *Comedia*. A sense of communion with the Jewish ancestors is expressed when Dante imagines the *donne ebree* in *Paradiso*, who are not excluded from Paradise as is, for instance, Virgil, regardless of Dante's great love for the pagan poet. However, all things considered, the most powerful common denominator between Dante and Giotto, via Augustine, is an idea that arches across a millennium: the intellectual installation and reinstallation of a Roman-Christian Empire.[151]

Scholarship has recognized the centrality of the city of Rome for Dante, and the following quotations likewise resonate with Giotto's typologically Romanizing chapel. Giuseppe Mazzotta focuses on this "special mission of Rome and the Roman Empire in Dante's plot of Salvation history,"[152] the pilgrim's own "typological journey to that 'Roma onde Cristo è romano' (*Purgatorio* XXXII, 1. 102)."[153] As Ghisalberti concludes, Dante's Rome unites the pagan and the Christian city; imperial and papal Rome.[154] Giotto operates within that context via painterly style in a not dissimilar way as Dante does when developing his own poetic timbres. This has also long been recognized: Already the early Florentine chronicler Filippo Villani drew a line between Giotto's painting and literature. A lacuna, however, extends around the exact quality of the connection.[155] Wollesen noted that there is little debate or satisfying historical criticism besides Michael Baxandall's *Giotto and the Orators*:[156] "Except for Michael Baxandall's work, there has been little attempt to explain the 'style' of Giotto as a contemporary phenomenon, namely as literary vernacular in pictorial terms."[157] But the vernacular is also central for the study of visual qualities in Dante.[158] Dante and Giotto both operate with an "aesthetics of the ordinary" that ultimately transcends the described objects. Their awareness of reality and their appreciation of the seemingly insignificant details of life allows for such transcendence, forming an ethics of the everyday. Battisti called these features a capacity of tasting reality[159] – which, in turn, connects with Augustine's theology, immersed as it is in human experience.

Yet the singular importance of Augustinianism for the Arena Chapel does not sufficiently explain the chapel's revolutionary look in pictorial detail. The earthiness of Giotto's scenes connects instead with an interest in the real that informs the Provençal and Italian cultural circles around 1300 – and, more precisely, the poetics of the *dolce stil nuovo*. Both Giotto and Dante seem to share a prismatic vision that unites the highest and the lowest things, bliss and grief, chance and providence. The famous dictum of the "intelletto d'amore" (Dante, *Vita Nova* XIX), the intellect of love that he presupposes in his reader, captures the desired union of intellectual precision and abundance of human experience, tuning the fine, precise sensitivity of perception required for achieving such union. A quality comparable to Dante's gift of observation also determines Giotto's moments of everyday existence when he visually narrates a story larger than life through low but meaningful detail. As far as the surviving tradition and works suggest, Giotto and Dante were two of the most innovative minds of their time. Both reintegrated ancient themes with Christian dogma via the meticulous study of their contemporaries' hearts and intellects. Such an all-encompassing vision of micro- and macrocosm is what distinguishes Dante from his brothers-in-arms of the poetical avant-garde, Guido Guinizelli and Guido Cavalcanti, and Giotto from the painters around him, even from Cimabue, with all due credit to any theological advisers and other enabling initiators of his project.

One might argue that Dante was never offered a place and an occasion as perfect as the Paduan arena was in 1300 for Giotto, but, fascinatingly, the poet created his own occasion out of the same "Rome 1300" template while suffering the excruciating experience of exile. It is in the days before Easter in the Holy Year of the first Jubilee that Dante anchors his visionary journey to Hell, Purgatory, and Paradise. The papal Jubilee thus acts as a spark for his project on personal initiative just as it triggered the monumental project of the Giotto-Scrovegni team. Imagination engenders facts: The cultural impact of Dante's *Comedia* is such that Carlo Ciucciovino registers this imaginary event in the tone of historical fact in his *Cronaca del Trecento* in the beautifully pragmatic entry "Il viaggio ultraterreno di Dante Alighieri."[160] The realities of history and of artistic imagination impact one another, promoting the trend towards more naturalism around 1300.

Summarizing the aesthetic and iconographic connections between Dante and Giotto in the terms of this book, three main themes stand out: First, spolia as the appropriation of the pagan tradition; second, the issue of mimesis; and third, the question of relief, particularly as discourse on the illusion of life, experience, and perception in Dante's famous Purgatory reliefs, highly self-reflective instances in the medium of Italian language that are invested in synesthetic and spectatorial modes and are employed for greater verity and enlivenment.

It is Dante who delivers the most influential ekphrastic enactment of relief sculpture, which remains unsurpassed in its claims and influence on further generations of artists, writers, and theologians. Indeed, the reliefs described by Dante in *Purgatorio* X–XIII likewise show examples of humility and pride. Dante's description of these reliefs attest to the appreciation of the medium around 1300 as a matter of mimesis and poetry with some kind of moral investment that comes with their materiality as well as the degree of illusionistic perfection and inherent shadowboxing with their classical antecedents. Carved by God, these reliefs appear just over the Ante-Purgatory, on the lowest step of Mount Purgatory which is dedicated to the theme of pride. Each of the three major reliefs in *Purgatorio* XI displays an example of supreme humility: *Trajan's Justice towards the Widow*, *King David's Dance before the Ark of the Covenant*, and the *Annunciation*, the last scene transcending all humility in Christian history. This field in particular is described as conquering ancient artistic authorities and emanating an increasingly lifelike, vivid animation. The sequence moves from the wall reliefs of humility to the discourse around *fortuna* and *vanitas* (*Purg.* XI) and the floor reliefs with examples of pride (XII), ending with the striking negative image of blank walls and blindness (XIII). This sequence forms an arc of psychological tension for Dante that stretches from the pilgrim's pure enjoyment of the reliefs of humility to his increasing anxiety and remorse during the discussion of artistic pride, palpable fear and compassion before the examples of punished pride, and atonement, as well as pure compassion at the empty walls, which thematize the difference between envy and the love of the other – envy resulting in blindness and self-harm. It is the juxtaposition of *humilitas* and *superbia*, the latter being Lucifer's sin.[161] Only the supreme reliefs of humility in *Purgatorio* X made by God himself transform and transcend their own medium.[162]

These Purgatory reliefs enact some of the qualities that are most striking in the narrative fields from Giotto's chapel. Mueller von der Haegen identifies a shared task in Giotto's and Dante's allegories, seeing their closest relation in the new allegorical mode of their time – which they themselves help develop in their respective media – that saw a new integration of the *aldilà* into the realm of this world by the poetic-artistic efforts of their contemporaries' redoing of ancient art, rhetoric, and architecture. Dante's intermediary

position "midway upon the journey of our life" (in Longfellow's translation from 1867) can of course be read as situating us between the visible world of the living and an invisible world of the dead.[163] In this sense, the *Purgatory* sequence delivers not only reliefs in ekphrasis but a live relief effect – an activation of matter playing off a plane through the beholder's perception for an increased sense of presence, complexity, and intensified reality. First, this act serves to render a self-perpetuating meditation on morality and the human condition in each *canto* by Dante and in each ensemble of *giornate* by Giotto. Second, it entails a rejection of hubris that, however, contains the danger of once again engendering hubris. This could occur through the generation of a personal stance; empowered viewers are now themselves responsible for the multiplicity of perspectives generated by the medium relief. Third, it allows for a dramatization for the sake of a clear sense of reality and individual responsibility.

The Purgatory reliefs are described as single fields, one next to another, and they are imagined as such by later illustrators of the *Commedia*, who emphasize the individuality of their figures.[164] Ancient sculpture, such as the Titus reliefs, likewise exemplifies separate, self-sufficient scenes – predecessors to the unity of modern storiated scenes. The function of such unity can be interpreted as rendering visible a distinctive, focused moment.[165] The scene is evenly compressed and enlivened by a single thought or intention, a dramatically successful *mise en scène*. Such a sense of drama unites Dante's *tableaux vivants* and Giotto's scenes – it creates a spatial and organizational clarity that allows for the figures' energetic and significant action and interaction.[166] With freedom in virtual space comes movement, and the resulting intersection of space, movement, and narrative endows the commanding artist with the licence of a dramaturge and director.[167]

The discussion of Dante in relation to Giotto and to the Arena Chapel in particular involves a later wave of vernacular texts and themes. Surviving vernacular sources that mention or describe Giotto or his works include Filippo Villani, Boccaccio, Benvenuto da Imola, Francesco da Barberino, Riccobaldo Ferrarese, Petrarch, Antonio Pucci, and Ghiberti.[168] The involvement of Giotto in Assisi might theoretically make him something like a Franciscan painter by business association and iconography.[169] However, recent scholarship clearly divides Giotto and Saint Francis from a poetical and ethical point of view. These traditional accounts suggest that Giotto would have despised poverty instead of marrying her, as suggested by the model of Francis. Indeed, the only written source ascribed to Giotto himself, the "Chancon Giotti pintori de Florentia," an irreverent poem from after 1323, speaks against a Franciscan spiritual orientation.[170] If this is an authentic example of Giotto's speech or writing, then Giotto understood himself as a pragmatic and spirited court artist.[171] This consideration does not compromise the Arena Chapel's explicit eschatology, however. Giotto is a Christian painter, positioning himself as best he could with the Pope, just as Enrico Scrovegni did with the *curia*. None of this has to be an expression of a personal creed of the artist. In this sense, one might agree with Rintelen's matching of elective affinities in Giotto and Boccaccio rather than in Giotto and Dante.[172] Their fictions, in image and word, aim to relieve the chaos and horrors of life by lifting readers and viewers into a systematic, more cheerful, and more bearable representation – be it on the merry-go-round of stories in the *villeggiatura* while the Black Death extinguishes entire cities around the noble men and women of the *Decameron*, or be it in the explicit acknowledgement of evil deeds and human dispositions in the chapel along with graphic details in *Hell*, while everything is shielded by the Christian cosmology under the final triumph of Mary and Christ the Redeemer.

As Schwarz has shown, most of the prose sources on Giotto are of questionable historical veracity.[173] They cannot help define, in terms of contemporary language, what this study

introduces under the term of "relief effects" in the aftermath of Dante's animated ekphrasis. Situating the chapel in relation to canonical works of literature is here less relevant than the inclusion of lesser known mystical sources that engage with questions of relief, spirituality, visibility, and transcendence. Such a passage from circa 1320 appears in Ugo Panciera's *Trattato della perfezione della mental azione* (*Treatise on the Perfect Action of the Mind*). To achieve the goal of envisioning Christ, Panciera recommends a Franciscan practice of meditation inspired by imagining increasing *rilievo* – a term clearly understood here as pictorial relief – of the mind's image of Christ. The meditation should begin with outlines and, increasingly adding shading and colors for the simulation of volume, it finally reaches lifelike, animated perfection.[174] In the contemporary artistic vocabulary, the mystic speaks of outlines, shading, colours, volume (*disegnato, ombrato, colorato e incarnato, incarnato e rilevato*).[175]

The sequence of producing perfect mental images of Christ echoes that on the production of shadows in Cennino Cennini's *Handbook for Painters*, in which the painter–author discusses *rilievo* as the result of these exact steps in figuration.[176] Another spiritual background might be found in the famous, Franciscan Pseudo-Bonaventure's *Meditations on the Life of Christ*.[177]

These widely distributed, popular texts anchor Dante and Giotto in the mystical and art-theoretical history of their centuries. With the focus on relief, spolia, and mimesis, it has become apparent that the context of Augustinian thought and the Neo-Augustinian tradition in Dante and in Giotto connects to other authors in the vernacular mystic tradition.[178] Relief as a hybrid medium between the abstraction of the flat plane and the sensuality of the volumes had become a uniquely helpful visual metaphor for theological debates around pagan traditions, spoliation and transformation, triumphs of humility over ancient pride, modes of sight, and modes of representation.

There is, finally, a most pertinent text when looking for dialogues and echoes between Dante and Giotto. It is Dante's unfinished *De vulgari eloquentia* (*On eloquence in the vernacular*), written shortly after the beginning of his exile in 1302, before the *Divine Comedy*. Coinciding with the timeline for the chapel's generation, equivalences between this text and the Arena Chapel are many: a sophisticated level of theory and criticism; an engagement with questions of style; an historical awareness of languages and styles across time; an interest in the issue of genre; an engagement with the discourse of pride and humility in the separation of languages after the fall of the Tower of Babel; and an historical contextualization of the question of style and its fluidity. Finally, both projects bring to the fore the ancient Roman Latin heritage in Italy, emphasizing the meaning, value, and legitimacy both of Latin and of vernacular modernity.

When reading *De vulgari eloquentia* in relation to the Arena Chapel, one can see parallels between Giotto's measured aesthetic-historical stylistic adjustments conjoining ancient Latin Roman and new Christian iconographies and Dante's linguistic-historical search for an illustrious vernacular in the Italian language. As Steven Botterill has shown in his commented edition of the text, Dante claimed that the vernacular should assume a high status and sovereign dignity equal to Latin. There is a clear resonance with Giotto: the artist's new style was framed, and elevated, by the ancient Latin style. Lastly, Dante had planned to cover the comic genre and the mediocre style in the unfinished parts of *De vulgari eloquentia*. Can we not think of the mischievous shift in style for the tiny figures described by Cassidy in "Laughing with Giotto at Sinners in Hell," or the inclusion of comical figures that Andrew Ladis discusses in "The Legend of Giotto's Wit," as visual equivalents to that notion?

EPILOGUE

Relief, Triumph, Transcendence

E però odi la conclusione [. . .] Sopra tutte le grazie e doni dello Spirito Santo, le quali Cristo concede agli amici suoi, si è di vincere se medesimo e volentieri per lo amore di Cristo sostenere pene, ingiurie e obbrobri e disagi; imperò che in tutti gli altri doni di Dio noi non ci possiamo gloriare, però che non sono nostri, ma di Dio [. . .].

And now [. . .] listen to the conclusion. Above all the graces and all the gifts of the Holy Spirit that Christ grants to his own, is the grace of overcoming oneself, and accepting willingly, out of love for Christ, all suffering, injury, discomfort, and contempt. For in all other gifts of God we cannot glory, since they proceed not from ourselves but from God, [. . .].

SAINT FRANCIS OF ASSISI, *FIORETTI, ON PERFECT JOY*[1]

IN PADUA, WE HAVE seen a painter who leaves nothing to chance – someone who perspectivally adjusts each single tiny consoled dentil on the faux architectural cornice over the *Virtues* and *Vices*; someone who leaves traces of blonde polychromy on a fictive statue's undercut areas and not on

her head; someone who gives the head fragment of a fictive Bacchus a 180-degree rotation to show the force of a heavy triumphal cross falling like a hammer across his shoulders; someone who lets ancient garlands blossom around the *Kiss at the Golden Gate* even when those are barely visible from the ground. The details are as well-considered as the system in which they appear.

We set out to understand the specific relationship between ancient Roman triumphal arch reliefs and relief as a pictorial device in Christian art in Giotto's Scrovegni Chapel. Our starting point was to recognize that the chapel nave resembles two triumphal arches in succession, but the murals' details, their history, context, and ritual have far exceeded the initial possibilities of a simple echoing of ancient spatial-architectural iconographies. The evidence presented in this book indicates that the chapel's illusionism did not aim at reproducing its Roman models – Giotto's work is not a copy of nor a substitute for the ancient Arch of Titus. The interior was obviously not painted in default of an actual triumphal arch with actual relief sculpture; Scrovegni could have afforded to commission a sculpted version if he had wished to do so; such chapels exist.[2] Instead, by channeling architectural and figural relief in painting rather than in three-dimensional material form, Giotto's fictive double triumphal arch makes a point on divine medium in visualizing the Trinity. Only by subverting medium and materiality it can celebrate the humble triumph of Christ in, simultaneously, the ruins of the present world and the glory of eternal justice and peace to come. Giotto's multi-layered representational system invites the beholder to reflect upon its Christological implications: The visualization of figures in one layered medium (relief sculpture) by means of a different one (painting) echoes the earthly life stories of the Son of God in his own medium as simultaneously a human on earth and an image of God the Father (Colossians 1, 15:

"Christ who is the image of the invisible God, firstborn of all creation").[3] Playing with the idea of a representation of painted relief sculpture, Giotto's mural painting itself is in turn a representation of the subject (Jesus) that is, in yet a further unfolding, a representation of God (Jesus Christ in the Trinity). Jesus, as Giotto paints him in the chapel, appears as infant, child, young man, Last Judge, and Pantocrator; he is also at each of these moments Christ – the image of God. This divine layer of representation, overlaid upon Christ's humanity, is thus reflected concretely by Giotto's painting of relief on the walls, the fresco underlying and relaying an image of something more essential.

The triumph of humility thus becomes also a triumph over one's own limited medial condition. By illustrating the highest historicizing aspirations of the chapel's take on transcendent Christianity and Christian art, Giotto subverts monumentality, brutality, and hubris. Chapter 5 has shown how the suffering and humility of Mary and Christ is understood as their ultimate victory and how it presents a model for believers to follow through its reversal of those one-dimensional triumphs of antiquity in which emperors were believed to be deified. This might prove overwhelming for mortals. Such sentiment is eternalized in the final words of Titus' father Vespasian on his deathbed, who, whether in jest or in shock, reportedly uttered: "And now I will be a god?"[4]

* * *

In this book, I have argued that Giotto's relief effects complicate, enrich, and individualize processes of artistic appropriation and ethical reflection – engaging not only the historic appropriation of antiquity but also acts of conscious perception to be unfolded and experienced by the viewer. These acts – this overall activity of critical seeing – requires open-mindedness and curiosity even more than the recognition of the familiar biblical stories. Its

special form of mental acquisition fundamentally subverts the moneylender's gamble: to take hold of Giotto's chapel as a visual and intellectual experience; to take the work as a whole into one's possession via a personal investment of time and attention paid, pleasure gained, potential fulfilled. This means dealing in a business that involves physical and critical senses. The compound interest accrues as a timeless dialogue between the maker and the beholder that continues into other dialogues, similar to the mechanism of silent conversations between Petrarch's Augustinian *Secretum* and its future readership.

Medium relief effects in painting invite the beholder to become a critic both of matter and of illusion. In this sense, Giotto lived up to the art-historical hagiography that Michael Baxandall, in *Painting and Experience in Fifteenth-Century Italy*, famously summed up as Cimabue "prophet" and Giotto "savior."[5] In the Arena Chapel, Giotto set up a unique, mediatic *translatio imperii* before the eyes of the viewer, or rather *in* the eye of the beholder. Speaking to the Roman Jubilee pilgrim, his anti-imperial iconographic program performs the final overcoming of the visual empire of ancient Rome with the artistic promise of an increasing dissolution and ultimate annihilation of all matter – from the clearly mimetic relief figures in the dado zone to the more ambiguous polychrome relief-inspired scenes in the middle registers and up into the spiritualized apparitions of the immaterial star-studded vault.

The key to this critical vision of history and the material of the sublunary world is the individual spectator who is to decipher such an extraordinarily inventive and subtle visual regime, questioning the chapel's illusionism and the reasons for the creation and destruction of the interior's relief panels and architectural bands and ornaments, from the socle to the broken vault. Once aware of the multiple levels of illusionism that fictively depict the wall, multiple

techniques of mural painting, and stone and relief sculpture, the viewer is encouraged to continue questioning things visible beyond the program, perhaps even the quality and impermanence of substantive reality itself. The optical relief effects in the chapel help distinguish allegorical modes from modes of history painting on the one hand and from the iconic apparitions at the two centers of the vault on the other. These effects recognize distinctions between allegory, history, and visionary sight, while raising awareness of their conceptual integration. That such effects are issued in the form of painting imitating relief sculpture is no coincidence but rather an aesthetic act that is as bold as it is consequent. Even their painted versions point to the break in materiality between the cult of statuary in the ancient Roman state religion and the subsequent Christian anxiety about the worship of idols and idolatry.

Such relief effects represented in painting go far beyond recognizing the stark contrast between pagan and Christian attitudes to matter and visibility in their general aim to make the viewer responsible for the degree of illusion – such as the narrative form emerging from abstract ground. Relief effects also invite the viewer to consider the actual nature of what is represented. The motion-animated oscillation between abstract planarity and concrete volumes invites such reflection while presupposing, challenging, and creating an individualized form of spectatorship – the act of perception depends on the motion and active visual engagement of the spectators themselves.

Giotto's visual acts of rhetoric and metaphysics have shown multiple affinities to Dante as well as to Augustine. Studies on Dante and Augustine might serve as a model for further readings into Giotto's Augustine, established in the self-reflective, media conscious and highly historicized Arena Chapel.[6] As a place of painting in the context of jubilant Roman-

Christian triumphs and Augustinian theological intellect steeped in a Venetian-Byzantine local environment, Giotto's interior manifests and disassembles a simulated reality, including warnings not to take anything at face value – neither the depicted scenes nor the surrounding world. This process of informed viewing constantly checks for indicators of matter and illusion, requiring a more critical, self-reliant viewer comparable to the self-critical reader of the Augustinian tradition.

* * *

What this ultimately means for the traditional view of art-historical periodization is of course open to discussion. This is not about labelling Giotto and his work as "medieval," "proto-Renaissance," and so on; my goal, instead, is to bring critical attention to aspects of his work that deserve an inquisitive approach but are often overlooked simply because disciplinary traditions have not deemed them worthy of consideration in the context of standard periodizations. I draw attention to certain assumptions around the definition of newness for the Florentine early Renaissance of circa 1400–20 so that some of these can now be rethought in the light of Giotto's early imaginative, subtle, and triumphant recovery and transformation of ancient models in Padua.[7] Particular ways of relating to the ancient heritage that have traditionally served to define the Renaissance are there already in Giotto's work in 1300 within a context of theological thought and motivation. One of these is of course the topos of the triumph itself. Referencing the Arches of Titus and of Constantine, the Christian vernacular rebirth of the classical triumph in coherent form and function seems to have begun in the visual arts much earlier than previously thought (a quarter of a century if referenced to Petrarch, or even as much as a century earlier, if referenced, with Theodor Mommsen, to the fifteenth century).[8]

This shift in periodization and categorization can ease some of the discomfort that scholarship has had with the so-called proto-Renaissance. Considering the deep intellectual, spiritual, and visual wisdom of the chapel in response to specific ancient Roman monuments and in dialogue with contemporary-medieval Rome makes our image of what happened in Italy around 1300 – and, consequently, around 1400 – yet more complex and rich.

In his book on the Sistine Chapel, Ulrich Pfisterer draws an important connection between Michelangelo's ceiling program (1508–12) and the Arch of Constantine.[9] Pfisterer illustrates the importance of the Christian triumphal arch to the Sistine Chapel (Fig. E.1) as a "pathos formula" of architecture in the spirit of Aby Warburg. Warburg illustrated numerous arches on the panels for his *Bilderatlas Mnemosyne*, especially the Arch of Constantine and the reliefs from the Arch of Titus on Plate 7 of the Mnemosyne Atlas ("Triumphgefühl"). As "Pathosformeln," the arches can be detached from their actual historical position as forms of distinction, acting throughout their history of channeled reappropration in a variety of media as containers, mobiles, vehicles, and transporters of meaning. In the Sistine Chapel, we see again elements from triumphal arches arranged in the ceiling, in this case representing an attic zone, cornices, free-standing figures, and relief tondi as is appropriate for the Constantinian inspiration. Once again, the suggestion is not that Michelangelo represented an ancient arch in a picture, but that he recreated a series of triumphal arches in a manner that transforms the real space of the Sistine Chapel into a monument of triumph in which one can stand and through which one can process. In that sense, the Sistine Chapel recalls the structural mechanisms of the classical framework of the Arena Chapel. My findings on the earlier chapel and its relationship to ancient Roman arches complement Pfisterer's argument, extending it backwards in

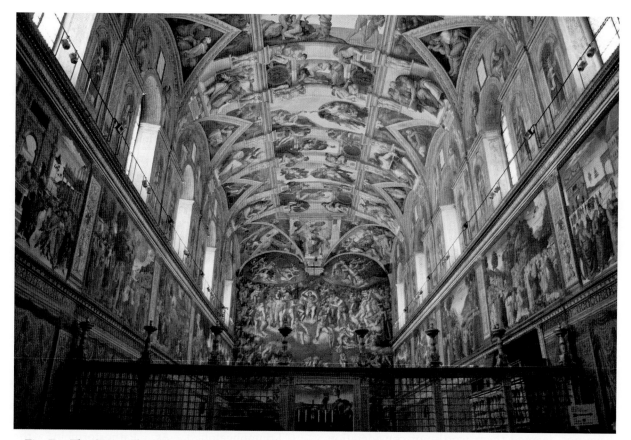

Fig. E.1 The Sistine Chapel in the Vatican, Rome (interior view showing some of the transformative ceiling murals by Michelangelo as well as his *Last Judgment*). Courtesy of Antoine Taveneaux, CC BY-SA 4.0.

time to an earlier phase or pre-history, inserting the Paduan Chapel into a specific tradition of artistic appropriations of ancient Rome. Giotto's contribution to this tradition is to have established an absolute coherence of medium and illusionism with an in-built self-referential criticism that had, as far as the surviving evidence suggests, not been explored before with such multi-layered conse-quence and in such completeness.

The set of references between the Arch of Titus, the Arch of Constantine, the Cubiculum Leonis, the San Silvestro Chapel, and the Arena Chapel, on the one hand, and the connections between the Arch of Constantine and the Sistine Chapel, on the other, can now spark a different conversation around the noted similarities between the chapels' two *Last Judgments* on blue ground: that by Giotto in Padua and that by Michelangelo in Rome. The affinities might not

surprise, considering that Michelangelo also expressed his admiration of Giotto in his drawings, as has been thoroughly discussed, with enlighten-ing results, by Alexander Nagel.[10] In light of this book's main argument, the Arena Chapel and the Sistine Chapel might be conceptually even closer than has already been sensed on the basis of their optical affinities. Both chapels are expositions on themes of a theology of history and spoliation within their own temporalities of reworking older models from pagan antiquity and late ancient/ early Christian times. As self-referential objects, they moreover rework and renew themselves for the spectator in real space via acts of perception – in perpetually shifting medium effects. Paradoxically, the chapels both deal with eternal things using the instruments of temporary artistic approaches to make a point about perman-ent, unresolvable, and unrepresentable questions –

in that sense, they offer "middle words in a process of understanding," as Steven Fine put it so well, declaring that he is not interested in having the "final" word in the scholarly discussion of the Arch of Titus.[11]

The stable record of prominent successors, such as Michelangelo, working and reworking Giotto's heritage, suggests that the act of Giotto's imagination in the chapel can be imagined as the initial impulse to a perpetual mobile, thereafter swinging back and forth between creating and breaking the illusion of matter, as the first pronunciation of conceptual issues that came to define the following centuries of Western art history. The program presents the visual in its complex and ever-changing relationship among artist, work, and viewer – a piece of the ever-new now as much as a fragment of history. The fields from the *Lives of Mary and Jesus* have been described in general terms of relief, volumes, and tactile values since the paintings were presented in the earliest monographs. Many of the images generate the solemn pace of the procession, some the dramatization of the background plane, some the commanding figure of the evil emperor; all together forming an extensive iconography of passion and human experience, they respond to ancient hubris with the triumph of humility.

The epochal importance of the paradigm shift effectuated by Giotto's so-called *maniera latina* has never been doubted. But its context of ancient reliefs, theological discourse, and the overall theme of the triumph of humility as a media problem is even richer, more complex, and more self-aware than is yet fully recognized: Giotto seems to have shifted more than one paradigm at once with this particular project, enabled by the lively intellectual environment of Padua, Scrovegni's theological advisors, and the finances and intentions of the shrewd moneylender in search of ancient, aristocratic, and yet local roots. The chapel has been recognized as occupying a unique place in the history of art – a portal to the Renaissance and to the modern world. Its complex relationships with antiquity and with the Jubilee suggest that this project is looking back and forth, into the past as much as into the future, crossing if not destabilizing art history's disciplinary borders and timelines. The arena in Padua – with its long history of victories and defeats; of dynasties; of conquests, buildings, rebuildings, and replacements – itself becomes a metaphor for those historical strata and dynamics (Figs. E.2–E.3). This seems appropriate for hosting a spiritual battle as an artistic challenge that involves the intersection of individual time with timeless allegorical modes, and biblical history, all on the grand scale of eons. Erosion and recuperation appear as the secret catalysts of history, the chapel's program argues, and so a pattern emerges from that strange colloid, from the quicksand of history that is always made of losses and recoveries: how each epoch takes from those earlier ones what it needs to retrieve in order to make its own unique statement in that long procession.

* * *

We have seen that the language of historical change and triumph over the ancient evil forces in Enrico Scrovegni's inscription clearly states in 1303 the celebration of the triumph of Christianity and humility over the pagan past in the Arena. Not only does the winner get to write history; his account of the historical and spiritual battle rewards him with even more status and satisfaction as he recalls the triumph over seemingly powerful oppressors, adversaries, antagonists, and enemies. But the donor's victory only came about in the long afterlife of the chapel. Despite the irony of dynastic ambition meeting the ambition of the painter, Scrovegni's plan was not entirely successful during his crisis-ridden lifetime. A contemporary of Scrovegni, Albertino Mussato – the former Paduan ambassador to Pope Boniface VIII during the 1300 Jubilee in

Fig. E.2 Historical illustration of the Arena and the Arena Chapel with former Loggia. Courtesy of the UC Berkeley Historical Slide Library (est. 1938–2018), Baxandall & Partridge Collection, Doe Memorial Library in Berkeley, California, USA.

Rome – explicitly distinguishes among a range of styles, albeit in a different context, recommending a purposefully less festive mode for certain occasions.[12] This local statesman, historian, poet, and dramatist attacked the rich decoration of churches in his *De obsidione Domini Canis Grandis de Verona circa moenia paduanae civitatis et conflictu ejus (Of Cangrande's Besieging the Walls of the City of Padua and of Its Fight)*. While Scrovegni had personally benefitted from a moment of great social mobility and a radically anti-tyrannical vein in local politics and taken advantage of all available artistic and rhetoric opportunities to proclaim his new status,[13] Mussato's work includes a general criticism of complex aesthetics on the basis of the reader's specific capacities of comprehension. Solicited by the Palatine Society of Paduan Notaries, the text was tasked with employing a specific, approachable style for the occasion. Its preface evaluates different levels of language:

> Whatever it is, the language should not be in the high style of tragedy, but sweet and within the comprehension of the common people. And just as much as our history, on a higher plane with its more elevated style, can serve the educated, this metric work, bent to the service of a simpler muse, can be of pleasure to notaries and the humble cleric. For usually one is delighted by what one understands. One rejects what one does not comprehend because it is boring.[14]

PADOVA — ARENA E CHIESA DI GIOTTO.

Fig. E.3 Historical postcard of the Arena in Padua with Roman arch. Courtesy of the UC Berkeley Historical Slide Library (est. 1938–2018), Baxandall & Partridge Collection, Doe Memorial Library in Berkeley, California, USA.

The crucial line, in the original Latin, is "plurimum enim unumquemque delectat, quod intellegit, respuitque fastidiens, quod non apprehendit,"[15] since this critical reflection on different rhetorical styles heightens the possibility of an enhanced sensitivity on the side of the local public to visual-artistic styles such as the Arena Chapel's distinctions between classical and Christian timbres. Even the latest research on the Arena Chapel focuses on rhetorical styles, for instance Romano's fruitful discussion of different levels of historical narrative in ancient relief sculpture.[16]

The decline of Scrovegni and his exiles took place around the same time that the formerly jubilant rhetorics were replaced with changing attitudes towards ancient Rome.[17] In 1337, more than half a lifetime after Boniface's Jubilee, Petrarch describes in a letter from Rome his walk through the Forum. Now the *genius loci* is saturated with nostalgia:

> As we walked over the walls of the shattered city or sat there, the fragments of the ruins were under our very eyes. Our conversation often turned on history, which we appeared to have divided up between us in such a fashion that in modern history you, in ancient history I, seemed to be more expert; and ancient were called those events which took place before the name of Christ was celebrated in Rome and adored by the Roman emperors, modern, however, the events from that time to the present.[18]

Giuseppe Mazzotta frames the writing of history in similarly sharpened models for the generations

following Petrarch: "The dual perspective on history, pagan and Christian, shows that history is not a homogeneous totality or a monolith: There are in the same theater of history, on the contrary, divergent lines, diversified chronologies, and residual layers buried under or scattered over the ground."[19] At the same time, Christianized arches throughout the empire resonate with the yearning of ruins that so much emphasizes the passage of time, at once jubilant and melancholic.[20] The figure of Petrarch wandering the dilapidated Forum Romanum in 1337 marks the end of the triumph of 1300. His melancholic account undermines the First Jubilee's optimism and its confident mode of overdetermined historical celebrations. Petrarch mapped out the path for a new time in which a cosmopoietic, all-inclusive project such as the chapel would make way for more limited, sequential visions of Christian triumphs in literature and in panel painting.[21] The theme of conversion associated with triumphs and the iconographic shift from their ancient monuments to topoi in Christian art would soon become a convention of Italian Renaissance art. In Domenico Ghirlandaio's *Adoration of the Shepherds* for the Sassetti Chapel in Santa Trinita in Florence, the arriving Magi are shown in the background riding through an ancient triumphal arch as if in its moment of transformation from a symbol of pagan triumph to one of humility: from the rule of a faceless ancient emperor to an all-encompassing grace.[22] Giotto – and, later, Dante, with the guidance of Virgil and Augustine – thus created an artistic cosmos for the future in which humility serves to transform trauma and triumphal humility is everything.[23]

* * *

There is still the issue of the missing transept in the Arena Chapel – missing, that is, when we compare the actual building as it still stands today in Padua and its painted image within the chapel itself, the architectural model on the canon's

shoulder in the *Last Judgment*'s donation scene with Scrovegni. A transept is portrayed there on the wall as part of the chapel's architectural model (Fig. E.4), yet a transept has never been part of Scrovegni's oratory with its simple exterior (Fig. E.5). I want to offer what might be a solution to that riddle in the context of this book's argument regarding painterly illusionism employed as a means of visualizing the triumph of humility in its rejection of the material world. Having identified so many signs of purposefully broken illusionisms throughout the interior up to this point, I now take the discrepancies between the architectural model and the actual building in combination with the *coretti* as a challenge: one final, ultimate test for the spectator's eyes and critical mind, set in deliberate antithesis to worldly representation and the materiality of the building. The deception would have been complete with the main body of the chapel hiding behind the large, shielded palace structure and the adjacent walls on the arena's elliptical ruins closed around the chapel's humble brick façade, shown in the earliest known illustrations, at that point covered by a loggia with a balcony (see Figs. 1.1 and E.2).[24]

If present in this or in a modified form at Giotto's time, his veiling of an unusually shaped architectural core would then have been similar to the surprise effect potential of the Roman Pantheon, the temple front masking the central-plan interior. Although it is hard to tell by exactly what kinds of walls or buildings the Rotonda was framed in the Duecento, with the idea of the masked Rotonda Giotto could have found a model for exterior building elements that deceive a spectator who enters a disguised sacred interior. The Pantheon's disjunction between exterior and interior happens between the standard temple façade and the round cupola interior.[25] As mentioned above, the Pantheon itself also famously represents one of the most complete models of the Christian appropriation of ancient temples since another Boniface – Pope Boniface IV, the

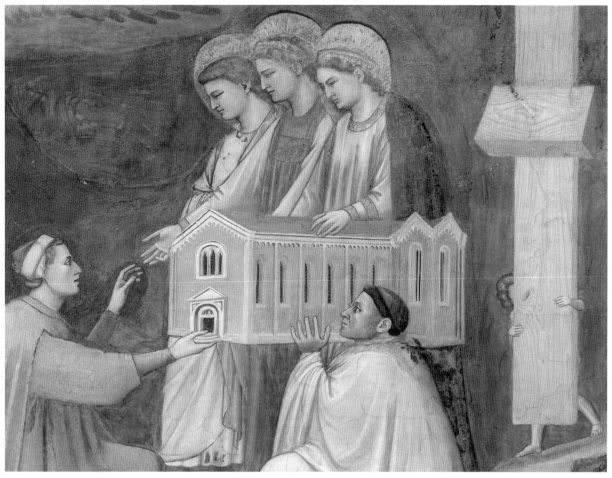

Fig. E.4 Arena Chapel, detail of the chapel's architectural model in the *Last Judgment*. Courtesy of the UC Berkeley Historical Slide Library (est. 1938–2018), Baxandall & Partridge Collection, Doe Memorial Library in Berkeley, California, USA.

fourth Bishop of Rome – turned it in the year 609 into a Christian church dedicated to Saint Mary and the Martyrs, Sancta Maria ad Martyres.

At the Paduan arena after 1307 – as far as one can tell from the oldest surviving visual records – the walls to the left and right of its façade would hide the chapel's lack of a transept. Spectators entering through the public entrance – through the arena portal – would have no visual evidence from the exterior that revealed what the chapel's actual shape might be. They would, instead, see the illusion of the faux *coretti* in the east leading into something like a transept and the image of the model-with-transept under the *Last Judgment* on the west wall. This would complete the *scherzo*, the inaccurate architectural model combined with the *coretti*

produce the illusion of a transept for a viewer who was to be fooled at first, then called to decipher the trick of the eye – a final pun in the chapel's pushing of faux matter, illusion, and temporary deception against the immaterial and eternal truth. This *scherzo* operates in the same context as does the material/illusionistic, corporeal/ spiritual vision set up by the chapel's apocalyptic angels, general illusionism and consequence of the faux marble system, and image of *Circumspection* over Scrovegni's portal. Pointedly, the barrier would stop commoners entering from the arena entrance at the point where the deception was at its strongest, whereas the privileged visitor from the Scrovegni palace side portal would have a more angled and therefore better informed view.

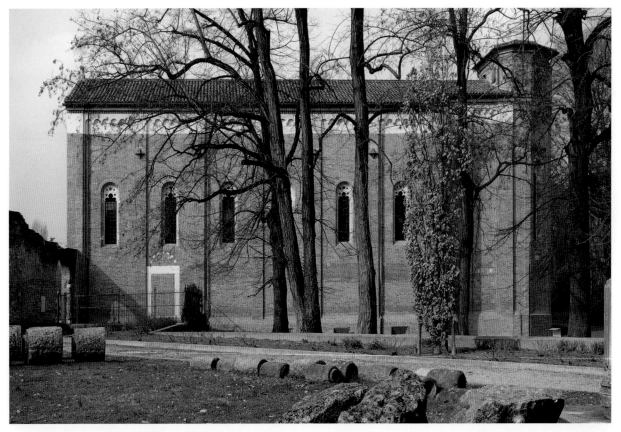

Fig. E.5 Arena Chapel, exterior. Courtesy of Steven Zucker.

Moschetti evocatively categorizes the *coretti* as "allegories" with an unknown meaning. I further extend this notion. In the context of the chapel, they are among the most concretely represented elements in the interior and their imaginary presence only emphasizes the intentionally artificial qualities of the painted relief-like simulacra in the frames on the walls. Yet together with the riddle of the transept depicted in the *Last Judgment*'s architectural model, they contribute to the larger allegory of the whole with their stillness and deceptive lifelikeness.[26]

Over the transept that was not there, the vault opens into a sky as if there were also no roof separating the interior from the firmament. Again the Pantheon comes to mind, especially its sun-filled *oculus* and the striking appearance of light from within (Fig. E.6), echoed in the chapel's east vault *tondo* with the appearance of Christ Pantocrator and Christ as a Judge in rainbow-like

flaming ornaments in the vault (see Fig. 1.9) and the *Last Judgment* respectively (Figs. E.7–E.8). This effect is both evoked and reversed, however, as the entire vault over the chapel side walls opens to the fictive sky. In unison with the apocalyptic angels, the sky at the arena intimates that there is a sky beyond the sky. Giotto has broken the vault, turning Augustinian aniconic rhetoric into an aniconic visual work of art and architecture that states its aniconism through the most refined visual spectacles in order to say: the essence is invisible. A broken vault closes the space over the hermetically sealed doors behind the two resolute apocalyptic angels removing sun and moon over the *Last Judgment*. Aniconism turned anarchitecture governs the final paradox in Giotto's *tour d'intelligence*. Are we looking with our eyes or with our memories? Giotto seems to have taken up the challenge of transforming the problematic model of the offensive Arch of Titus

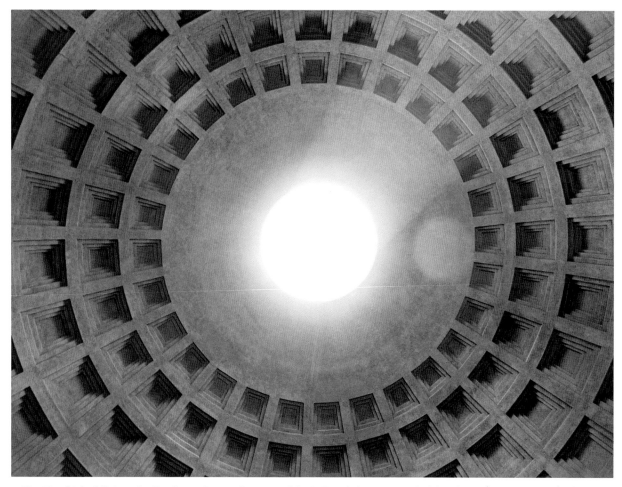

Fig. E.6 Light falls into the Pantheon, Rome. Courtesy of the UC Berkeley Historical Slide Library (est. 1938–2018), Hallett Collection, Doe Memorial Library in Berkeley, California, USA.

into what his time would consider a better, more lasting triumph, one with a metaphysical dimension: to show the world for what it is. The generative truth behind its matter only shimmers through, revealing itself in symbolic abstraction as through the spiritualized visionary spectacle in the Pantocrator's sector of the vault, eastwards, yet always in some way inextricably linked with the material bodies in time and space summoned in the Marian sector of the vault, westwards. By systematically differentiating among media, Giotto's Roman-referential and self-referential performance in mock marble is an unequalled poetic act – a *cosmopoiesis* of its own kind.[27] In fact, it seems not unthinkable that the chapel's program is again playing with the projective dualism of image and eternity that completes the typological sequence of Jesus being the image of the eternal God. Earthly humility is the projection of real and eternal triumph. The frail bodies of human beings in this life are understood to potentially be shadows of glorified beings of eternity – here represented in the *Last Judgment* as the Saints and Blessed, Scrovegni's perfected body, and the powerful Christ as Judge on the counterfaçade – and the chapel on earth is the image of its perpetually reconstructed and resurrected essence in eternity, where it stands perfected and complete with real transepts.

* * *

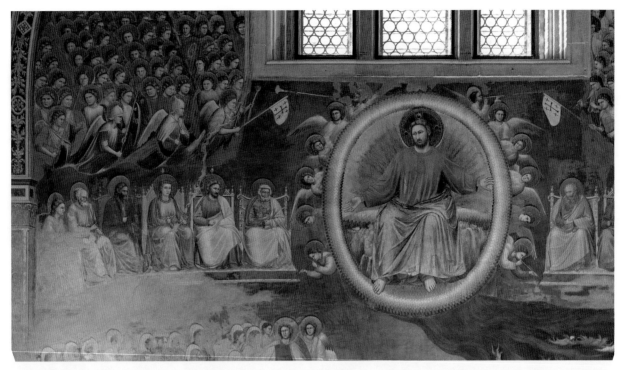

Fig. E.7 Arena Chapel, Giotto's *Last Judgment*, detail with the court of Heaven and Christ in Majesty. Courtesy of Steven Zucker.

Giotto's visual riddles dare the visitor to recognize a poetic synthesis that transcends both building and painting across time and across space. The chapel is an arch is a chapel is an arch – a self-consciously historicist hybrid with multi-form references to three buildings in three different yet intimately connected cities. Those cities belong together in the minds of their viewers, operating in the best medieval traditions of generously associating historical layers and topographies – a family church in Padua, a Christianized arch in Rome, and the biblical Temple in Jerusalem as it was never destroyed in either Jewish and Christian collective memory. The self-destabilizing illusionism guides viewers towards a broadening vision of world, art, visual truth, and apparent reality by the pictorial medium of Giotto's relief effects and painting effects "dynamically conjoined in tension."[28] To centuries of later visitors as well as to the early Trecento viewer – in the context of so many reappropriated sacred ruins of the past – the

representation of virtues, vices, and scenes from the life story of a family set before an apocalyptic vision in a perfectly broken illusionism of iconic-aniconic beauty may have made these walls suggest: Do not mistake any appearance – here or elsewhere – for the real thing. In making a wall look like a blue sky behind vivid scenes, just to undermine it with the radical wrapping up of the sky performed live in the vision of the *Last Judgment*, Giotto seems also to point out that the entire world may be nothing more than cosmic ashlar masonry. When divine union is the goal, the material image is merely the vehicle. And when painting becomes a medium that does away with the wall, simulating panels and relief, and that does away with the vault, filling a fictive void with a stylized starry sky and holy visions, this medium calls us to understand the act of visual perception as the realization of creativity and of several kinds of sights at once: This is where the two nearly parallel lines of humility and modernity converge.

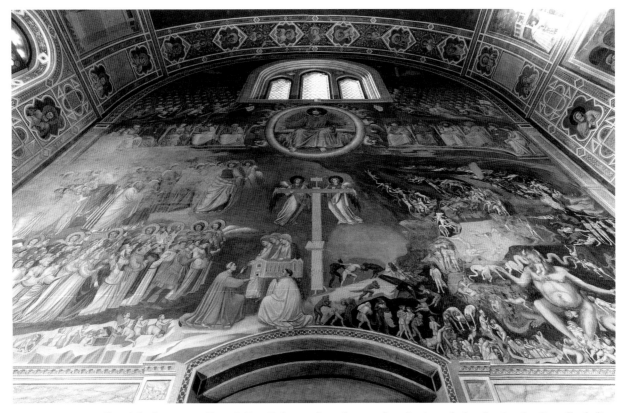

Fig. E.8 Arena Chapel, looking up at Giotto's *Last Judgment* from the portal to the Arena before leaving the *Cappella degli Scrovegni*. Courtesy of Steven Zucker.

Inherent in modernity, there can be the humble act of gathering, repurposing, and refiguring. Humility is modern here because Giotto uses the well-established discourse of painting as a medium that can figure both a self-effacing gesture and self-consciousness. And, finally, it is a visual analogue of Augustinian import as far as modern personhood depends on Augustine's concept of person, so Paula Fredriksen.[29] She even finds Augustine "to present, to the West, the first modern man: affirming embodied existence; psychologically complicated; turned towards history rather than eternity, and himself rather than the cosmos, for an answer to the question of the problem of evil."[30] This does not mean brushing over the distinct historical conditions that I have worked so carefully to present in this study. Yet the line of tradition indisputably connects images in words and pigments across the centuries, and

over the course of the two decades of work that led to this book I have come to find great continuites among the ages. The Arena Chapel's complexities, in dialogue with the Arch of Titus and the Arch of Constantine, engage nothing less than the human struggle with body and soul, time and permanence, the visible and invisible. Augustine's profound questioning of truth, personal freedom and free will, love, desire, knowledge, and fulfillment from the fifth century had hardly been resolved in the fourteenth century, or any of the following.

As picked up and transformed by so many modern artists and writers, this reworking of experience in visual, verbal, poetic, musical, cinematic, or other forms of expressive media is an inherently modern attitude no matter where it is pinned on the timeline of world history.[31] From the Archimedean point of the chapel, applying the

lever of a core idea of modernity can help avoiding a relativist stance towards any medieval/modern labels, which otherwise might risk collapsing into meaninglessness. Instead one can argue that Giotto's modernity is inherent in his productive dialogue with the thinkers of his own and earlier times, in his sensitivity to specific dilemmas of the human condition. As in Dante's *Divine Comedy*, it is the development of specificity in Giotto's observation that then translates into the universal, and retranslates in later, different specificities of circumstances. This Giottesque modernity most vividly concerns the mind and the body between sensuality and emotion, between the momentousness of life and the temporality of death that stretches from era to era. Reflections, sublimations, and transcendence run as markers of an everlasting renewal that we can track from Mary to Jesus to Monica and Augustine, Paul, Gregory, Robert Grosseteste, Thomas Aquinas, Duns Scotus, Brunetto Latini, Lovato Lovati, Albertino Mussato, Enrico Scrovegni, Alberto da Padova, Giotto, Dante, Guido Cavalcanti and Guido Guinizelli, Petrarch, Boccaccio, Michelangelo, and so on. Brian Stock has shown with great insight that the inherent modernity of Augustine's inner dialogues can still inform contemporary philosophy and practical applications in mind–body medicine, speaking across time to lasting conflicts and to ever-new promisings of redemption. Like Augustine's inner dialogues, Giotto's medium effects call on every follower of the "intellect of love," as Dante imagined the ideal union of body, mind, and soul – some ideal balance between challenge and surrender.

Replete with relief effects counterbalancing matter and illusion, the chapel's visual regime establishes different modes of vision under the strike of one arch. With Augustine, speaking as he did from yet another phase of decadence and anxiety, the ending of an empire is embraced with the crystal-clear certitude that there will be a New Heaven and a New Earth. In tune with the discourses of his time, Giotto as a thinker and as a painter creates in visual and spatial terms a medial paradox of a chapel that is no less inexhaustible than that of the cosmos in Dante.[32] Mediality involves space, time, and materiality, and these three are another secret Trinity venerated in the chapel's artistic core.

The many hands and minds involved with the Scrovegni Chapel turned the project of a humble triumph from apparent oxymoron to all-embracing synthesis. The Augustinian "Nos tempora sumus" (We are the times)[33] might never have been visualized so self-assertively yet so self-critically all at once. Through Giotto's chapel, the long procession of existences caught in the laws of physics and metaphysics between earth, sky, and heaven continuously refreshes its inherent modernity by finding and passing on bits and pieces of Revelation for discovery by the next reader, the next viewer, and the next voice in the chorus. *Triumphus humilis* is no oxymoron. Rather, the initial surprise of the chapel's carefully constructed yet self-destroying medialities opens a path of understanding from a core Christian belief to a creative concept. This creative concept invites possibilities of superseding the former system by transposition, transformation, and, indeed, transubstantiation. In this arena of history, Giotto promises that the effort of seeing is rewarded with the satisfaction of conceptually having this world firmly in hand – just in order to ultimately relinquish it with powerful humility for an eternity beyond the ruins, in the spirit of a greater and stronger, active hope.

APPENDICES

Invisibile Verbum Palpabitur

The invisible Word shall be felt

SIBILLA PERSICA[1]

Appendix I

ASSISI REVISITED

Padua, d. 26. September 1786
Marie von Giotto Hab ich nicht finden können.
Sakristey war zu.

Padua, 26 September, 1786
Mary by Giotto I could not find.
Sacristy was closed.

<div align="right">

JOHANN WOLFGANG VON GOETHE
IN A LETTER TO CHARLOTTE VON STEIN[2]

</div>

THE CONSIDERATION OF Giotto's response to ancient arch reliefs enables a fresh approach to the famous "Assisi problem." One of the biggest puzzles in Western art history, it began with historians of style trying to make sense of his few remaining works and scant sources to identify Giotto's hand and the chronology of his career. The artist's work at Padua presented numerous problems for scholars in the age of neoclassicism – the age of systematic assessment and categorization of European artworks and architecture. By the time such classifications had established themselves as a scholarly practice, many of Giotto's murals had been destroyed, drastically limiting the possibility of formulating a solid stylistic definition of what a real "Giotto" looks like. Moreover, the

historiographical-teleological system established by Giorgio Vasari that built momentum from Giotto towards more obviously neoclassical artists like Donatello and Michelangelo had become axiomatic. Johann Wolfgang von Goethe, the paragon of Weimar classicism, never entered the Arena Chapel during his travels in Italy. His ideal was ancient Rome and the southern Italian classicism of Carrara-marble white heroic sculpture and architecture. He had left Assisi quickly and unimpressed, thinking of Giotto as just another medieval painter. From Padua on 26 September 1786, he wrote a letter to Charlotte von Stein: "*Mary by Giotto* I could not find. Sacristy was closed."[3]

As it turns out, a tourist's misfortune can have epic consequences for the writing of art history. Though Goethe's visit to Padua introduced him to Mantegna and to the botanical garden, for reasons as banal as they were common, it also entailed a fatal disappointment: finding its doors locked, the influential poet never entered the Cappella degli Scrovegni. Since the chapel was little known at the time, Goethe did not realize what he was missing right next to the Eremitani church. The formulation of his note even suggests that he might have thought Giotto's *Marie* was a generic panel painting, while in fact the entire chapel carries the name of Santa Maria della Carità and is itself the monumental work in question. Goethe, therefore, missed the most securely attributed and most complete cycle of the Italian artist who, it is now widely believed, marks the earliest beginnings of early modern and Renaissance painting, in many ways of modern painting in general. As Vasari, too, only briefly noted the existence of something by Giotto in Padua, calling it the *Judgment*, both authors' images of Giotto were bound to other works – frescoes and panel paintings of sometimes questionable attribution that lacked the completeness and stylistic-iconographic complexity of the Arena Chapel.[4] In their respective historiographies,

Vasari and Goethe both associated Giotto with a vernacular late medieval world that had not yet awoken to the sophisticated classicism of later Renaissance recoveries embodied especially in ancient sculpture, which they both found most admirable.

This book is therefore also an attempt to redress the long-term effects of that closed sacristy door from almost a quarter millennium ago. Just as Goethe in later life changed his mind about Dante, he might have reconsidered his negative attitude towards Giotto and the late Middle Ages in Padua, had he but seen the fine and systematic references to Roman classicism harbored in the chapel. If these most influential writers had encountered Giotto's unique response to antiquity, it seems very likely that Renaissance historiography would have had a different beginning and would have operated within a different set of parameters. As so much Giotto scholarship after Vasari and Goethe was focused on stylistic questions, an insurmountable conflict emerged when the vastly different optics of scenes from the mural cycle of Saint Francis in Assisi's Upper Church of San Francesco such as the *Miracle of the Crib at Greccio*, the *Exequies of Saint Francis*, or the *Expulsion of the Demons from Arezzo* (Figs. A.1–A.3) were being compared to the relief-inspired *Lives of Mary and Jesus* from the Scrovegni Chapel.

The problem around Giotto's work in the Upper Church of San Francesco in Assisi is one of the biggest controversies in art history. Merely raising that "Homeric question" (Bellosi) engenders the second-longest note in this book.[5] Scholarship has been deeply and passionately divided between, roughly, Italian and German, Swiss, and Austrian scholars who refuse to concede Giotto's authorship of the Assisi cycle, and Anglo-American scholars (mostly working in the tradition established by Richard Offner's "Giotto, Non-Giotto" in the late 1930s) who then tended to reject the Assisi cycle as Giotto's due to the

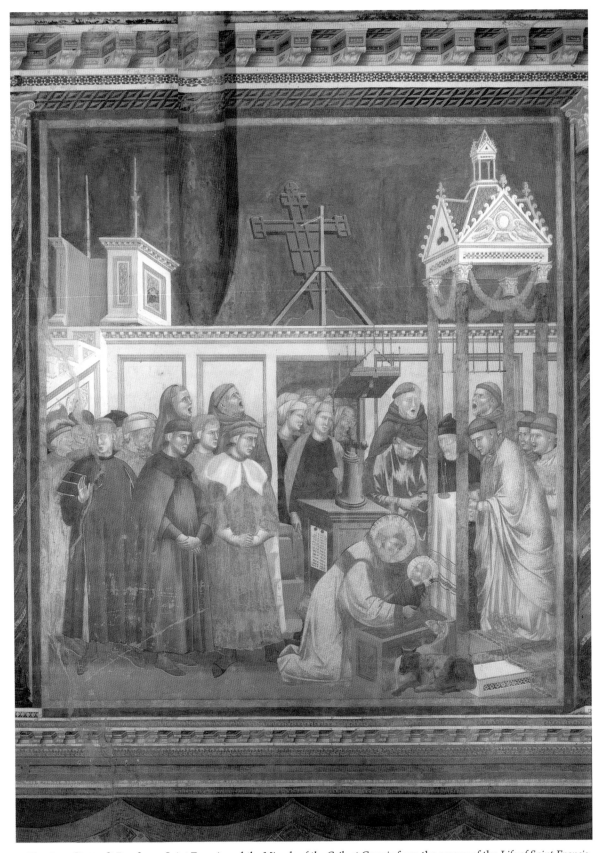

Fig. A.1 Giotto di Bondone, *Saint Francis and the Miracle of the Crib at Greccio* from the scenes of the *Life of Saint Francis*, Assisi, San Francesco Superiore. Erich Lessing / Art Resource, NY.

apparent stylistic contradictions raised by Offner that distinguish Giotto in Assisi from Giotto in Padua. Interestingly, the controversy manifests itself in Offner's text precisely around descriptions of pictorial relief in Padua that, he claimed, necessitate the de-attribution of the Assisi murals from Giotto's oeuvre.

Offner's focus on Giotto's relief is not unique: Jantzen considered *rilievo* to be crucial for Giotto's synthetic spatiality,[6] paying special attention to the voluminous swelling created by chiaroscuro[7] and the relief-like layering of compositional elements.[8] For Jantzen, Giotto's scenes were entirely developed through the idea of relief.[9] Giuseppe Basile described Paduan relief by focusing on the spatiality of the figures and a specific "'tactile' characterization of the colours."[10] Like Offner, John White and Luciano Bellosi tackled the question of relief as a central part of the Assisi controversy, though drawing the opposite conclusion.

It is critical to remember that Offner's influential "Giotto, Non-Giotto" was written with the goal of removing the frescoes in Assisi's Upper Church of San Francesco from Giotto's oeuvre on stylistic grounds. For Offner, the ultimate device for distinguishing the Francis cycle from Giotto's Paduan frescoes was the Paduan murals' optical closeness to relief. Attempting to establish an absolute distinction between Giotto and the hypothetical anonymous "Roman master" in Assisi, Offner built his argument with micro-stylistic analysis, moving literally from the underpaint to the contours:

[The Assisi cycle] takes on the three-dimensional quality and the density of round sculpture. The conception of form in Padua, on the other hand, is akin to that of relief. And this conception the painter expresses by beginning with a green underpainting which he proceeds to cover in the flesh-parts with a light color, thereupon laying on the shadows in a slightly darker pigment over it; just as in working a flat slab of marble, the sculptor starts with an evenly lighted surface and models by

chiseling into it. And, as in relief, a left-to-right plane variegated in light predominates, the shadow being for the most part relegated to a narrow band within the edges, at times limited to the heavy outer contour, which is made to serve also as a modeling agent.[11]

Describing the pictorial simulation of relief in great detail, Offner assumes that this autopsy documents a subconscious and defining characteristic of Giotto's style. What is not taken into consideration is the possibility that those formal characteristics could be present precisely to make these scenes *appear as* reliefs because they are intended to *recall* reliefs – in other words that they constitute a conscious decision rather than an accident or incongruity caused by a preconceived idea of late medieval style. I argue that Giotto transformed the chapel's notional wall surface just enough to transport pilgrims back under the Arch of Titus in their visual memory. Giotto also destabilized the walls by insisting on the themes of ruins and of optical deception, two devices that conceptually work hand in hand with the idea of the Christian, true, immaterial version of a triumph superseding the material ancient one (which visibly had lost its lustrous colors over the centuries).

The artist plays one level of representation against the other, turning differences of medium into an eschatological statement that divides historical, earthly time from some higher realm beyond time, space, and representation as for a kingdom that is not of this world. Eruptions and escapes from the relief frame seem to have had a programmatic purpose; the occluded fingertips of Christ in the *Ascension*, for instance, suggest the disappearance of his body into a spiritual realm. These murals ask for a second – and a third – good look. The beholder is confronted, eye to eye, by paintings that pretend to be sculptures in relief that pretend to be naturally moving figures that pretend to be moral-emotional concepts. We recall that the inscription under

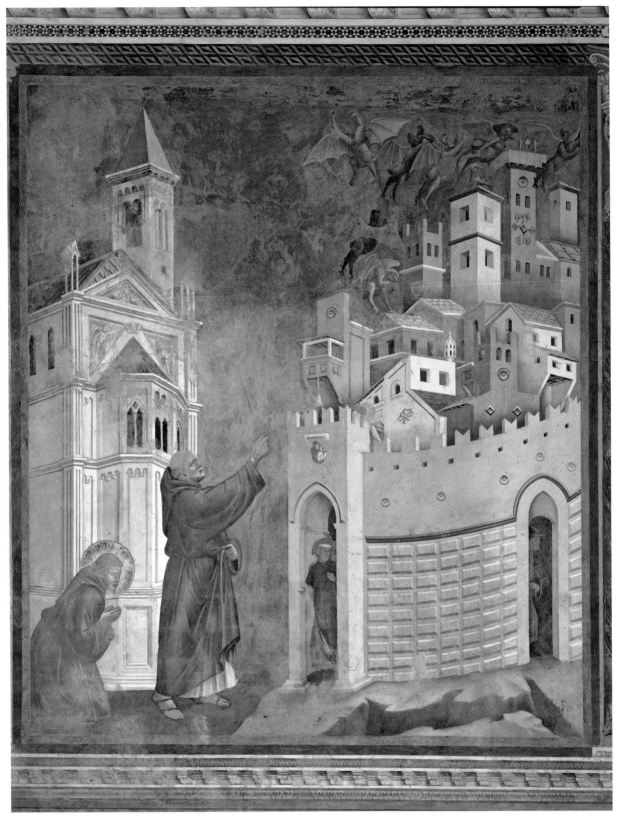

Fig. A.2 Giotto di Bondone, *The Expulsion of the Demons from Arezzo* from the scenes of the *Life of Saint Francis*, Assisi, San Francesco Superiore. Alfredo Dagli Orti / Art Resource, NY.

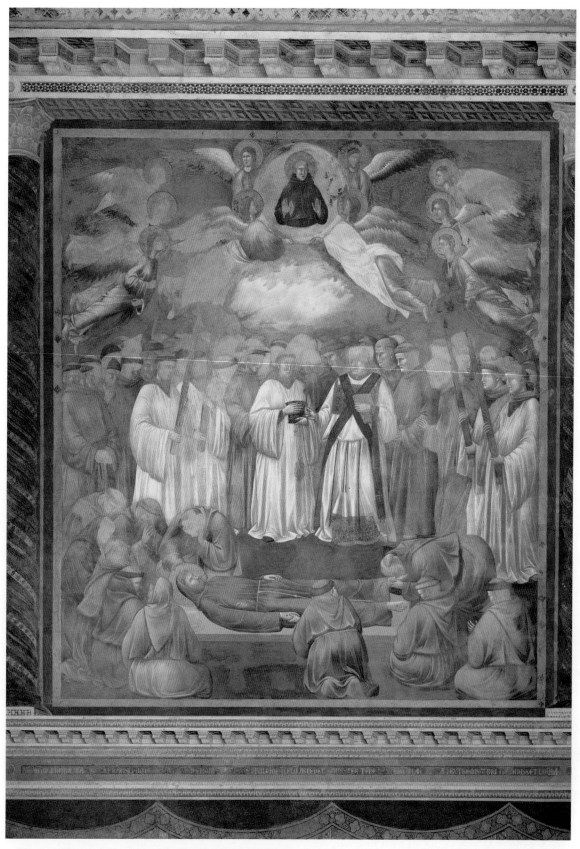

Fig. A.3 Giotto di Bondone, *The Exequies for Saint Francis* from the scenes of the *Life of Saint Francis*, Assisi, San Francesco Superiore. Erich Lessing / Art Resource, NY.

Prudence, the first virtue visible to the viewer entering from the door for the privileged from Palazzo Scrovegni, greets the guest with an inscribed cue for the chapel's all-governing discourse of things and times, of vision and *memoria*.[12] Contemporaries praised Giotto for his unsurpassed subtlety.[13] Why should anything above the Arena Chapel's dado zone be less sophisticated than the janus-headed *Prudence* herself combining male and female gaze, past and future, painted in supposedly sculptural relief that asks us to see carefully and well-consider not only objects and their qualities, but also their temporal dimension? That temporal dimension includes the recognition and purposeful application of historical style, as Giotto evidentiates in his juxtapposition of Gothic and Romanesque styles in the thrones of *Justice* and *Injustice* as well as in the shift from the Old Testament relief garlands of the upper tiers around Joachim, Anna, and Mary to the New Testament cosmati ornament around Mary, Joseph, and Jesus in the framework below.

A few decades after Offner, in his famous 1967 book *The Birth and Rebirth of Pictorial Space*, John White delineated the obvious differences between Padua and Assisi as follows: "The crispness and clarity of this imitation marbling, as competent realism and strictly limited depth, are as remarkable as its firm subordination to the needs of the narrative paintings which it frames":[14]

> [the] flatness of the painted architecture is most striking, particularly when compared with the heavy columns and projecting beams of S. Francesco [in Assisi]. Flat, painted, marble paneling lines the bases of the walls. Thin, flat mouldings, and cosmati work frame the individual scenes and form the horizontal and vertical divisions of the walls.[15]

White recognizes the innovative potential in these flattened forms by Giotto in Padua:

The trend of Giotto's ideas is equally stressed by the flat marbling and low relief of the architectural framework, which combines with the reality of the wall in a way that is entirely new. Realism is intensified, and at the same time an attempt is made to avoid the destruction of those qualities which the less realistic decorative art of earlier centuries possessed in such abundance.[16]

A third major voice in the scholarly conflict was that of Luciano Bellosi. Like most Italian scholars he disagreed with Offner's "Giotto, Non-Giotto" thesis, recognizing the kinship of illusionism and optical corrections in the highly sophisticated Umbrian framework with larger, but otherwise similar dentils in the faux cornice that compare to the miniature cornice over the *Virtues* and the *Vices* in Padua. As early as 1985, Bellosi had proposed the characteristic angels and demons as clearly recognizable links between Padua and Assisi.[17] Addressing the Assisi question briefly again in 2008,[18] Bellosi pointed to the recent discovery of a document confirming that the Upper Church's decoration was commissioned by Nicholas IV, who was Pope from 1288 to 1292. With this date set, the stylistic differences seem already more acceptable as the two works would have been undertaken at a temporal distance of over a decade. Explaining the differences between Assisi (1288–92) and Padua (1303–05), Bellosi notes the fundamental disparity between the spatial boxes in Assisi and the flat niches in Padua; between the "cube" (Assisi) and the "shallow dioramas" (Padua) – dioramas for which I now posit specific ancient Roman sculptural models.[19] The visual closeness of the scenes to relief sculpture has also been noted in an impressive number of sources from the 1830s to the present day by a diverse set of authors.[20] Similar to his multi-layered ancient models, Giotto's relief-inspired representational mode seems to be about rendering the story present with a narrative "ease" and "flow" (Stubblebine).[21]

Presence, distance, and the importance of relationships among figures are often debated in Giotto scholarship.[22] Hetzer, Gosebruch, Kemp, and Imdahl focus on "relation and individual."[23] In my view, the pictorial mode of relief in Giotto's practice is revealing itself as an ideal way for relating the individual presence within the story and its message as well as for relating the whole of the narrative to the viewer. Instead of simply showing the stories as diagrams or symbols – or as a naïve, seemingly realistic image of the world – Giotto seems to aim at showing both the world and the will behind it, an attempt that would have been true to the highly Augustinian program. It also conforms to Augustine's understanding of multiple kinds of vision. The program in Assisi, in contrast, is Franciscan in nature and narrative and does not have the totality of a newly designed and freshly built interior within an entire ensemble of buildings at an arena at its disposal. There are common features, such as the perfect illusionism of the walls, ledges, and columns; blue ground behind individual framed scenes; and the aesthetics of the starry vault. But the broken vaults in Assisi are defined by typical pointed Gothic skeletal transverse arches. The blue does not necessitate a unity with compressed relief-like volumes. And the sense of architectural and ephemeral simulations is different as, in Assisi, there are fictive drapes over the faux wall. Those drapes must be thought of as removable, unlike the Romanizing relief sculpture in the Paduan dado zone.

These differences make sense in light of the Roman model of the ancient arch and its polychrome reliefs for the Paduan project. As explored in this book, for reasons both historical and theological, in Padua, Giotto paradoxically displays the surface of the story in order to disclose its incommensurable dimensions. The hybrid qualities of relief transform matter and meaning through tensions between materialization and abstraction; intimacy and distance. Relief complicates the relationship between matter and illusion, and its visual effects render visible relations of space and time that could not be expressed otherwise. Relief effects also appear in Giotto's later work in Florence. Even the paintings that replace his lost works in Padua's Palazzo della Ragione build fictive niches and other categories of relief effects.[24] But in no other known place has Giotto arranged them to such great formal coherence and eschatological sophistication as in the Scrovegni Chapel.

Hans Belting notes that Rome and Assisi are not alternatives but form an indissoluble nexus.[25] Rome and Padua are at least as deeply connected, as we have seen. In his foundational study of medieval Rome, Krautheimer states quite rightly that the "peak of papal power at the beginning of the century and of Rome's place in the medieval world has left few visible traces in the urban fabric or in surviving monuments."[26] It seems, however, that medieval papal Rome has produced a very visible trace in Giotto's old Roman Padua, in one of the most famous and beloved monuments of very early modern art history: the Arena Chapel.

At this point, another, final leap into Giotto historiography is due for closing the scholarly panorama opened up in the *Preface*. Besides some disparate notes in Francesco da Barbarino's *Documenti d'amore* or Benvenuto da Imola's Dante commentary, the Cappella degli Scrovegni left very few traces in surviving local documents. A remarkable silence surrounds the chapel up into the nineteenth century. Following Vasari and Goethe, Schinkel and Rumohr dramatically underestimated the chapel's significance. Even Burckhardt is comparatively superficial when mentioning the frescoes in the *Cicerone*. Only after Selvatico and Ruskin, and consequently increasing tourism, did the writings multiply. It was with Berenson, Rintelen, and Hetzer that English- and German-speaking audiences came to discover the chapel. Excised from its original context of processions, now itself a ruin, the chapel increasingly became a center for

a different kind of pilgrimage: The passionate art pilgrim around 1900, having little in common with the penitent pilgrim to Rome in 1300, was no longer prepared to recognize either the jubilant original context and its far-reaching consequences for visual representation, or the key role of relief sculpture for Giotto's *rilievo* as a specific measure and tool for Christian art.[27] Marcel Proust included the allegorical Virtue of Charity in *À la recherche du temps perdu: du côté de chez Swann* (1913) in the form of an elusively monochrome early photograph of the stone-colored mural that would intimately insert the chapel reliefs into modern French culture, literature, and visual theory.[28] European and American research on Giotto since has multiplied and helped make the chapel as famous and well-studied as we now have encountered it, with a lion's share of research around the millennium of 2000, another Roman Jubilee year.

A century after the field got split into "Giotto," "non-Giotto" opponents, this book opens a way out of the entrenched controversy. Offner's precise description of the relief-like appearance of the Paduan scenes, which employs clear terms of the craft and labels the solid images as slabs of stone, is entirely correct. And yet it is possible now to come to a different attribution when the collection of data exceeds formalism and includes social aspects, thelological dimensions, and the liturgical importance of the Arch of Titus, its reliefs, and its lost polychromy. Considering the chapel's ancient models and looking at its scenes as simulacra, aware of their critical engagements with pagan models, I posit that the question of fictive relief can indeed explain the main differences in pictorial space and volume between Padua and Assisi. It can thereby support *both* sides – scholarship that argues for Giotto's responsibility for the general design and composition in Assisi on the one hand, *and*, on the other, scholarship that supports Giotto's authorship of the Scrovegni cycle while stressing the stylistic differences between the two sites – differences that are as obvious as they are significant. The understanding of the Arch of Titus in the equations around the "Assisi Problem" in Giotto studies produces an unexpected olive branch. This is one of the reasons why the importance of a Roman triumphal arch system potentially determining Giotto's Paduan style can hardly be overestimated: It reconfigures comparisons between Assisi and Padua, offering a scholarly reconciliation of the epic controversy that, almost a century ago, split the field into Italian-German and Anglo-American parties opposing or following Offner's thesis. Approaching the problem as a formalist and connoisseur, Offner overlooked the possibility that Giotto's stay in the eternal city and the influence on the artist of the Roman triumphal arches could have been the reason for his dramatic style-change in Padua after 1300. This difference in style, as it turns out, marked Giotto's conscious adaptation of classical, ancient pagan relief optics in their Christian-Roman historical moment.

Appendix II

FIORETTI DI SAN FRANCESCO, CAPITOLO VIII: *COME ANDANDO PER CAMMINO SANTO FRANCESCO E FRATE LEONE, GLI SPUOSE QUELLE COSE CHE SONO PERFETTA LETIZIA.*

(FLOWERS OF SAINT FRANCIS, CHAPTER VIII: *HOW SAINT FRANCIS, WALKING ONE DAY WITH BROTHER LEO, EXPLAINED TO HIM WHAT THINGS ARE PERFECT JOY.*)

Le Fonti Francescane: I Fioretti di San Francesco. Quaracchi 1926.

Come andando per cammino santo Francesco e frate Leone, gli spuose quelle cose che sono perfetta letizia.

Venendo una volta santo Francesco da Perugia a santa Maria degli Angioli con frate Lione a tempo di verno, e 'l freddo grandissimo fortemente il crucciava, chiamò frate Lione il quale andava innanzi, e disse così: « Frate Lione, avvegnadiochè li frati Minori in ogni terra dieno grande esempio di santità e di buona edificazione, nientedimeno scrivi e nota diligentemente che non è quivi perfetta letizia ». E andando più oltre santo Francesco, il chiamò la seconda volta: « O frate Lione, benchè il frate Minore allumini li ciechi e distenda gli attratti, iscacci le dimonia, renda l' udire alli sordi e l' andare alli zoppi, il parlare alli mutoli e, ch'è maggiore cosa, risusciti li morti di quattro dì; iscrivi che non è in ciò perfetta letizia ». E andando un poco, santo Francesco grida forte: « O frate Lione, se 'l frate Minore sapesse tutte le lingue e tutte le scienze e tutte le scritture, sì che sapesse profetare e rivelare, non solamente le cose future, ma eziandio li segreti delle coscienze e delli uomini; iscrivi che non è in ciò perfetta letizia ». Andando un poco più oltre, santo Francesco chiamava ancora forte: « O frate Lione, pecorella di Dio, benchè il frate Minore parli con lingua d'Agnolo e sappia i corsi delle istelle e le virtù delle erbe, e fussongli rivelati tutti li tesori della terra, e conoscesse le virtù

degli uccelli e de' pesci e di tutti gli animali e delle pietre e delle acque;

iscrivi che non è in ciò perfetta letizia ». E andando ancora un pezzo, santo Francesco

chiamò forte: « O frate Lione, benchè 'l frate Minore sapesse sì bene predicare, che

convertisse tutti gl' infedeli alla fede di Cristo; iscrivi che non è ivi perfetta letizia ».

E durando questo modo di parlare bene di due miglia, frate Lione con grande

ammirazione il domandò e disse: « Padre, io ti priego dalla parte di Dio che tu mi dica dove

è perfetta letizia ». E santo Francesco si gli rispuose: « Quando noi saremo a santa Maria

degli Agnoli, così bagnati per la piova e agghiacciati per lo freddo e infangati di loto e afflitti

di fame, e picchieremo la porta dello luogo, e 'l portinaio verrà adirato e dirà: Chi siete voi?

e noi diremo: Noi siamo due de' vostri frati; e colui dirà: Voi non dite vero, anzi siete due

ribaldi ch' andate ingannando il mondo e rubando le limosine de' poveri; andate via; e non

ci aprirà, e faracci stare di fuori alla neve e all' acqua, col freddo e colla fame infino alla

notte; allora se noi tanta ingiuria e tanta crudeltà e tanti commiati sosterremo pazientemente

sanza turbarcene e sanza mormorare di lui, e penseremo umilmente che quello portinaio

veramente ci conosca, che Iddio il fa parlare contra a noi; o frate Lione, iscrivi che qui è

perfetta letizia. E se anzi perseverassimo picchiando, ed egli uscirà fuori turbato, e come

gaglioffi importuni ci caccerà con villanie e con gotate dicendo: Partitevi quinci, ladroncelli

vilissimi, andate allo spedale, chè qui non mangerete voi, nè albergherete; se noi questo

sosterremo pazientemente e con allegrezza e con buono amore; o frate Lione, iscrivi che

quivi è perfetta letizia. E se noi pur costretti dalla fame e dal freddo e dalla notte più

picchieremo e chiameremo e pregheremo per l' amore di Dio con grande pianto che ci apra

e mettaci pure dentro, e quelli più scandolezzato dirà: Costoro sono gaglioffi importuni, io li

pagherò bene come son degni; e uscirà fuori con uno bastone nocchieruto, e piglieracci per

lo cappuccio e gitteracci in terra e involgeracci nella neve e batteracci a nodo a nodo con

quello bastone: se noi tutte queste cose sosterremo pazientemente e con allegrezza,

pensando le pene di Cristo benedetto, le quali dobbiamo sostenere per suo amore; o frate

Lione, iscrivi che qui e in questo è perfetta letizia. E però odi la conclusione, frate Lione.

Sopra tutte le grazie e doni dello Spirito Santo, le quali Cristo concede agli amici suoi, si è di

vincere se medesimo e volentieri per lo amore di Cristo sostenere pene, ingiurie e obbrobri e

disagi; imperò che in tutti gli altri doni di Dio noi non ci possiamo gloriare, però che non

sono nostri, ma di Dio, onde dice l'Apostolo: Che hai tu, che tu non abbi da Dio? e se tu l' hai

avuto da lui, perchè te ne glorii, come se tu l' avessi da te? Ma nella croce della tribolazione e

dell'afflizione ci possiamo gloriare, però che dice l'Apostolo: Io non mi voglio gloriare se

non nella croce del nostro Signore Gesù Cristo.

A laude di Gesù Cristo e del poverello Francesco. Amen.

How Saint Francis, walking one day with Brother Leo, explained to him what things are perfect joy.

Saint Francis, coming once from Perugia to Santa Maria degli Angeli with Brother Leo, suffering badly from the bitter cold, called to Brother Leo, who was walking before him, and said to him: "Brother Leo, even if the brothers of our Order would set an excellent example of holiness and edification everywhere, write down, and note carefully, that this would not yet be perfect joy."

Walking a bit further, Saint Francis then called to him a second time: "O Brother Leo, if the Friars Minor were able to make the lame walk, to heal the deformed, chase away demons, give sight to the blind, hearing to the deaf, speech to the dumb, and, what is the greatest work, if they should raise the dead after four days, write that this would not be perfect joy."

Shortly after, he exclaimed loudly again: "O Brother Leo, if the Friars Minor knew all the languages; if they were versed in all the sciences; if they could explain all of the Holy Scripture; if they had all gifts of prophecy, and could reveal not only all future things, but also the secrets of all consciences and all souls, write that this would not be perfect joy."

And a few steps further on, Saint Francis once again exclaimed loudly: "O Brother Leo, you little lamb of God! Even if the Friars Minor could speak with the tongues of angels; if they could explain the course of the stars; if they knew the virtues of all plants; if all the treasures of the earth were revealed to them; if they were acquainted with the various qualities of the birds, of the fish, of all the animals, of stones, and of waters – write that this would not be perfect joy."

Shortly after that, Saint Francis called strongly: "O Brother Leo, if the Friars Minor could preach so well that they would convert all the unfaithful to the faith of Christ, write that this would not be perfect joy."

And as Saint Francis had carried on this way for well over two miles, Brother Leo with great wonder questioned him and said: "Father, I ask you, for God's sake, wherein is perfect joy?" And Saint Francis answered him: "When we arrive at Santa Maria degli Angeli all drenched with rain and frozen with the cold, and covered with mud and exhausted from hunger and we knock at the convent-gate, and the porter comes angrily and asks us, 'Who are you?'; and we say, 'We are two of your brothers;' and he says, 'You are not speaking the truth; indeed, you are just two impostors who go about deceiving the world and robbing the alms of the poor. Go away!' And he does not open to us, and makes us stay outside, in the snow and rain, with cold and hunger until the night comes; then, if we accept such injustice, such cruelty and such contempt with patience, without being offended and without lamenting, believing truly with humility and charity that the porter really knows us, and that it is God who makes him speak against us, write down, O Brother Leo, that this is perfect joy.

And if we persevere in knocking and he comes out in even greater anger to drive us away, swearing, with kicks and blows, as if we were vile impostors, saying, 'Get going, miserable robbers! Go on to the hostel, for here you shall neither eat nor sleep!' And if we accept all this patiently and with joy and with charity, O Brother Leo, write that this indeed is perfect joy.

And when, urged by the cold and hunger and the dark of night, we still knock again, pleading with the porter and entreating him with many tears to open to us and give us shelter, for the love of God, and if he comes out more angry than before, exclaiming, 'These importunate thieves, I will give them what they deserve'; and he comes out with a knotted stick, he seizes us by the hood, throws us on the ground, rolls us in the snow, and beats us up and wounds us with the knots in the stick. If we bear all these injuries with patience and joy, thinking of the sufferings of our Blessed Lord, which we must share for love of him, write, O Brother Leo, write that this is perfect joy.

And now, brother, listen to the conclusion. Above all the graces and all the gifts of the Holy Spirit that Christ grants to his own, is the grace of overcoming oneself, and accepting willingly, out of love for Christ, all suffering, injury, discomfort, and contempt. For in all other gifts of God we cannot glory, since they proceed not from ourselves but from God, according to the words of the Apostle, 'What do you have that you do not have from God? And since you have received it, why do you glory in it as if you had it from yourself?' But in the cross of tribulation and affliction we may glory, because, as again the Apostle says, 'I will not glory save in the cross of our Lord Jesus Christ.'"

To the praise and glory of Jesus Christ and his poor servant Francis. Amen.

Appendix III

INSCRIPTION FROM THE ARENA CHAPEL, PADUA (1303)

Hic locus, antiquo de nomine dictus Arena, Nobilis ara Deo fit multo numine plena. Sic aeterna vices variat divina potestas, Ut loca plena malis, in res convertat honestas. Ecce domus gentis fuerat, quae maxima dire Diruta construitur per multos vendita mire. Qui luxum vitae per tempora laeta secuti, Dimissis opibus remanent sine nomine muti. Sed de Scrovegni Henricus miles honestum Conservans animum facit hic venerabile festum. Namque Dei matri templum solemne dicari Fecit, ut aeterna possit mercede beari. Successit vitiis virtus divina prohanis, Caelica terrenis, quae praestant gaudia vanis. Cum locus iste Deo solemni more dictatur, Annorum Domini tempus tunc tale notatur: Annis mille tribus tercentum Marcius alme Virginis in festo coniunxerat ordine palmae. [Bernardino Scardeone, *De Antiquitate urbis Patavii et claris civibus patavinis* (Basel, 1560), cols. 332–33.]

This ancient place, called by the name Arena, becomes a noble altar, full of divine majesty, to God. Thus God's eternal power changes [earthly] fortune, and converts places filled with evil to honest use. Behold, this was the home of abominable heathens, which was destroyed and sold over many years, and is [now] wondrously [re]built. Those who led a life of luxury in happy times, their wealth now lost, remain nameless and mute. But Enrico Scrovegni, the knight, saves his honest soul. He offers a revered festival here. And indeed he had this temple solemnly dedicated to the Mother of God, so that he would be blessed with eternal mercy. Divine virtue has replaced profane vices; heavenly joys, which are superior to earthly vanities, [have replaced them]. When this place is solemnly dedicated to God, the year of the Lord is thus inscribed: In the year 1303, when March had conjoined the feast of the blessed Virgin and the rite of the Palm. [English translation (with minor adjustments): Derbes and Sandona, *The Usurer's Heart*, 12–13.]

NOTES

PREFACE

1 See W. G. Sebald, *Schwindel; Gefühle* (Frankfurt am Main, 1998) and Ben Hutchinson, *W. G. Sebald: Die dialektische Imagination* (Berlin, 2009), 145–50. Recent literary responses include, inter alia, Orin Starn and Randolph Starn, *Giotto's Venetian Moor* (Berkeley, 2018). See also Maria Beatrice Autizi, *Le stelle di Giotto: Enrico Scrovegni e i Templari* (Treviso, 2017). For poetic approaches to Giorgio Vasari's "Life of Giotto," Jean Frémon's *The Real Life of Shadows*, and Tom Healy's poem "The View from Here," see Cole Swensen, "The Ekphrastic O," in *Fictions of Art History*, ed. Mark Ledbury (Williamstown, 2013), 162–72. See also the poem "Following the Animals" by Ishion Hutchinson in *Prairie Schooner* 87 (2013): 18–19.

2 Andrew Ladis, "The Legend of Giotto's Wit and the Arena Chapel," *Art Bulletin* 68 (1986): 581–96, reprinted in Ladis, *Studies in Italian Art* (London, 2001), 61–95.

3 See Hayden B. J. Maginnis, "The Problem with Giotto," in *Painting in the Age of Giotto: A Historical Reevaluation* (University Park, 1997), 99–102.

4 Norman Land, "Giotto's Eloquence," *Notes in the History of Art* 23 (2004): 15–19.

5 Eleonora M. Beck, *Giotto's Harmony: Music and Art in Padua at the Crossroads of the Renaissance* (Florence, 2005).

6 Eva Frojmovič, "Giotto's Circumspection," *Art Bulletin* 89 (2007): 195–210.

7 Michel Alpatoff, "The Parallelism of Giotto's Paduan Frescoes," *Art Bulletin* 29 (1947): 149–54, at 154.

8 Laurie Schneider, "Introduction," in *Giotto in Perspective* (Englewood Cliffs, NJ, 1974), 26.

9 See Giacomo Gaetani Stefaneschi, "Liber de Centesimo sive Jubileo," *Bessarione* 7 (1900): 299–317.

10 On the issue of "high iconography" in Michael Baxandall's method (especially in relation to Baxandall's 1985 review of previous interpretations of Piero della Francesca's *Baptism of Christ* and *Resurrection*), see Whitney Davis, "Art History, Re-Enactment, and the Idiographic Stance," in *Michael Baxandall: Vision and the Work of Words*, ed. Peter Mack and Robert Williams (Aldershot, 2015), 69–90, at 73–74. On the general availability of the core theological theme, see N. T. Wright, *Jesus and the Victory of God* (London, 1996).

11 Marvin Trachtenberg, "Giotto's Campanile," in *The Campanile of Florence Cathedral: "Giotto's Tower"* (New York, 1971), 21–48, at 33.

12 See Henrike Christiane Lange, "Relief Effects: Giotto's Triumph," PhD diss., Yale University, New Haven,

2015. See also Henrike Christiane Lange, "Giotto's Triumph: The Arena Chapel and the Metaphysics of Ancient Roman Triumphal Arches." *I Tatti Studies* 25 (2022): 5–38.

INTRODUCTION

1 See *Roma anno 1300: Atti della IV Settimana di Studi di Storia dell'Arte Medievale dell'Università di Roma "La Sapienza" (19–24 maggio 1980)*, ed. Angiola Maria Romanini (Rome, 1982). See also *Bonifacio VIII e il suo tempo: Anno 1300. Il primo giubileo*, ed. Marina Righetti Tosti-Croce (Milan, 2000). See also Giuliano Pisani, *I volti segreti di Giotto: Le rivelazioni della Cappella degli Scrovegni* (Milan, 2008), 38.

2 For a full account of the transhistorical and global reception history of the Arch of Titus, see *The Arch of Titus: From Jerusalem to Rome – and back*, ed. Steven Fine (Leiden and Boston, 2021).

3 "Hic locus, antiquo de nomine dictus Arena, / Nobilis ara Deo fit multo numine plena. / Sic aeterna vices variat divina potestas, / Ut loca plena malis, in res convertat honestas. / Ecce domus gentis fuerat, quae maxima dire / Diruta construitur per multos vendita mire. / Qui luxum vitae per tempora laeta secuti, / Dimissis opibus remanent sine nomine muti. / Sed de Scrovegni Henricus miles honestum / Conservans animum facit hic venerabile festum. / Namque Dei matri templum solemne dicari / Fecit, ut aeterna possit mercede beari. / Successit vitiis virtus divina prohanis, / Caelica terrenis, quae praestant gaudia vanis. / Cum locus iste Deo solemni more dictatur, / Annorum Domini tempus tunc tale notatur: / Annis mille tribus tercentum Marcius alme / Virginis in festo coniunxerat ordine palmae." Bernardino Scardeone, *De Antiquitate urbis Patavii et claris civibus patavinis* (Basel 1560), cols. 332–33. English translation (with minor adjustments): Anne Derbes and Mark Sandona, *The Usurer's Heart: Giotto, Enrico Scrovegni, and the Arena Chapel in Padua* (University Park, 2008), 12–13. For alternative translations see also Benjamin G. Kohl, "Giotto and His Lay Patrons," in *The Cambridge Companion to Giotto*, ed. Anne Derbes and Mark Sandona (Cambridge, 2004), 182, and Laura Jacobus, *Giotto and the Arena Chapel: Art, Architecture, and Experience* (Turnhout, 2008), 383–85.

4 I apply the term "metaphysics" here in the sense of Christian Moevs' conceptual reading of Dante in terms of "non-duality and self-knowledge." See Christian Moevs, *The Metaphysics of Dante's Comedy* (Oxford, 2005), 3.

5 For the most comprehensive critical overview of the historical Giotto, see Michael Viktor Schwarz and Pia Theis, *Giottus Pictor*, vol. 1, *Giottos Leben* (Vienna, 2004), in particular "Giottos Leben und Werk bei Ghiberti und Vasari," 13–33, and "Giottos Leben quellenkritisch," 35–76. See also Michael Viktor Schwarz's publications, *Giottus Pictor*, vol. 2, *Giottos Werke* (Vienna, 2008); *Giotto* (Munich, 2009); and "Poesia e verità: Una biografia critica di Giotto," in *Giotto e il Trecento: "Il più Sovrano Maestro stato in dipintura"; I saggi*, ed. Alessandro Tomei (Milan, 2009), 9–29.

6 See the well-balanced account given by Kohl, "Giotto and His Lay Patrons," 176–96, at 176: "In each case [Arena Chapel, Bardi Chapel, Peruzzi Chapel], the major patrons, or beholders, brought to the commission their own assumptions, preoccupations and purposes, just as Giotto brought his own power and skill. The results were, especially in the case of the Arena Chapel, mural paintings that transformed western art, based on the collaboration of the most talented and revolutionary painter of the early trecento with several of the most progressive, wealthy, and powerful merchant and banking families of Padua and Florence." For the sequence of *giornate* see *Giotto: The Frescoes of the Scrovegni Chapel in Padua*, ed. Giuseppe Basile (Milan, 2002), 24–29, and Jacobus, *Giotto and the Arena Chapel*, 94–97, figs. 8–11.

7 The idea that the Arena Chapel was the result of collaboration under Giotto's lead is widely accepted. See Andrew Ladis, *Giotto's O: Narrative, Figuration, and Pictorial Ingenuity in the Arena Chapel* (University Park, 2008), 9, where Ladis emphasizes Giotto's role as the director of the architectural and painterly project when noting that Giotto "made formal and iconographic decisions of his own. Certain solutions are essentially pictorial [...]."

8 See *Alberto da Padova e la cultura degli agostiniani*, ed. Francesco Bottin (Padua, 2014), especially Giuliano Pisani, "La concezione agostiniana del programma teologico della Cappella degli Scrovegni," 215–68. For Tommaso degli Aguselli, see Chiara Frugoni, *L'affare migliore di Enrico: Giotto e la cappella Scrovegni* (Turin, 2008), and Jacobus, *Giotto and the Arena Chapel*. See also Claudio Bellinati, *Padua Felix: Iconographic Atlas of Giotto's Chapel, 1300–1305* (Ponzano Veneto, Treviso, 2003), 11, and Pisani, *I volti segreti di Giotto*, 202–3. See also Anne Derbes and Mark Sandona, *The Usurer's Heart*.

9 See *Roma 1300–1875: La città degli anni santi; Atlante*, ed. Marcello Fagiolo and Maria Luisa Madonna (Milan, 1985). One possible Etruscan inspiration might appear in the depiction of Giotto's Satan in Padova as a "blue demon." Blue-skinned demons were featured

in Etruscan tomb painting and many Etruscan tombs were uncovered, explored and studied from the fall of Rome onward. On Giotto in connection to Charu, see Nancy De Grummond, "Rediscovery," in *Etruscan Life and Afterlife: A Handbook of Etruscan Studies* (Warminster, 1986), 21–23.

10 For the Arch of Titus, see Diana Kleiner, *Roman Sculpture* (New Haven, 1992), 185–91. Most likely emperor Domitian erected the Arch in 81 A.D. for his father Vespasian and his brother Titus, commemorating the latter's victory in the Roman-Jewish war. Covered in Greek marble, the single arch is supported by four semi-columns with capitals and surmounted by a high attic located above the trabeation. On the arch, see Michael Pfanner, *Der Titusbogen* (Mainz am Rhein, 1983). For the Arch's history, see Penelope J. E. Davies, *Death and the Emperor: Roman Imperial Funerary Monuments from Augustus to Marcus Aurelius* (Cambridge, 2000), 19. For medieval cartography illustrating the integration of the Arch of Titus into the walls of Frangipani Fortress, see *Roma 1300–1875: La città degli anni santi; Atlante*. For later vistas of the Arch of Titus in the context of the Forum see Christian Hülsen, *Il foro Romano: Storia e monumenti* (Rome, 1982). Hülsen illustrates Seicento and Settecento views on pages 35 and 212.

11 See also Canaletto, *Rome: The Arch of Titus* (1742), today in the Royal Collection, Windsor Castle, England. For more renditions in prints, drawings, and paintings, see Pfanner, *Der Titusbogen*, pls. 1–3.

12 See Hayden V. White, *The Content of Form: Narrative Discourse and Historical Representation* (London, 1990).

13 See Julia Kristeva, "Giotto's Joy," in *Desire in Language: A Semiotic Approach to Literature and Art* (New York, 1980), 210–36. First published in French as "La joie de Giotto," *Peinture* 2–3 (1972): 35–51.

14 For more recent approaches to spatial perception engaging with Giotto's Arena paintings, see R. E. Lubow, "Giotto's Applications of Embodied Perception: Lateral and Vertical Dimensions of Space," *Laterality: Asymmetries of Body, Brain and Cognition* 20 (2015): 642–57.

15 See Serena Romano, *La O di Giotto* (Milan, 2008).

16 See Frugoni, *L'affare migliore di Enrico*.

17 For the most comprehensive critical overview of the historical Giotto, see Schwarz and Theis, *Giottus Pictor*, vol. 1, *Giottos Leben*, in particular "Giottos Leben und Werk bei Ghiberti und Vasari," 13–33, and "Giottos Leben quellenkritisch," 35–76. See also Schwarz's publications *Giottus Pictor*, vol. 2, *Giottos Werke*; *Giotto*; and "Poesia e verità: Una biografia critica di Giotto."

18 See Francesco Benelli, *The Architecture in Giotto's Paintings* (Cambridge, 2012).

19 See Laura Jacobus, "Giotto's *Annunciation* in the Arena Chapel, Padua," *Art Bulletin* 81 (1999): 93–107. See also Jacobus, *Giotto and the Arena Chapel*.

20 Derbes and Sandona, *Usurer's Heart*.

21 See David Summers, *Real Spaces: World Art History and the Rise of Western Modernism* (London, 2003); and Whitney Davis, *Visuality and Virtuality: Images and Pictures from Prehistory to Perspective* (Princeton, 2017). See the culturally overdetermined analysis of the principles of relief in Adolf Hildebrand, *Das Problem der Form in der bildenden Kunst* (Strasbourg, 1893). See also Emanuel Löwy, *Die Naturwiedergabe in der älteren griechischen Kunst* (Heidelberg, 1900). On modern relief theory, especially for an Italian context, see Adrian Durham Stokes, *Stones of Rimini* (New York, 1969). See also Rosalind Krauss, *Passages in Modern Sculpture* (Cambridge, MA, 1998); and Alex Pott, *The Sculptural Imagination: Figurative, Modernist, Minimalist* (New Haven, 2009).

22 See Alexander Nagel, *Medieval Modern: Art Out of Time* (London, 2012), where the Arena Chapel appears in the chapter on "Topographical Instability," 97–114, and Giotto is critically addressed "as the threshold of modernity" in traditional modernist placement, i.e., by critics such as Hulme, Yeats, and McLuhan, see 196 and 294. See also Alexander Nagel and Christopher S. Wood, *Anachronic Renaissance* (New York and Cambridge, MA, 2010). See also *Medieval or Early Modern: The Value of a Traditional Historic Division*, ed. Ronald Hutton (Newcastle upon Tyne, 2015).

23 See Christopher R. Lakey, *Sculptural Seeing: Relief, Optics, and the Rise of Perspective in Medieval Italy* (New Haven, 2018).

24 See Robert Brennan, *Painting as a Modern Art in Early Renaissance Italy* (Turnhout, 2019).

25 See Péter Bokody: *Images–within–Images in Italian Painting (1250–1350): Reality and Reflexivity* (Farnham, 2015).

26 Offner's text was first published in two installments in *Burlington Magazine* 74 (1939): 258–69, and 75 (1939): 96–109; see also Richard Offner, "Giotto, non-Giotto," in *A Discerning Eye: Essays on Early Italian Painting by Richard Offner*, ed. Andrew Ladis (University Park, 1998), 61–88. Offner's study is essential for this discussion since his connoisseurship and decisions about Giotto's hand have been most influential regarding the Assisi problem as a conflict of international schools of art historians, his contemporary Anglo-Saxon tradition arguing contra Giotto in Assisi's Upper Church St. Francis cycle. In that sense Offner's "memorable demolition of a monolithic

painter of the Assisi *Legend*" is still relevant despite being "sadly dated," as Gardner wrote in 2011. See Julian Gardner, *Giotto and His Publics: Three Paradigms of Patronage* (Cambridge, MA, 2011), 21. Meiss notes "Giotto can look so different at different times;" Millard Meiss, *Giotto and Assisi* (New York, 1960), 2: "Historians are of course given powerful inducements to conceive of a Giotto so variable that he could have produced both the *Legend* and the frescoes in the Arena Chapel in Padua."

27 Brian Stock, *Augustine the Reader: Meditation, Self-Knowledge, and the Ethics of Interpretation* (Cambridge, MA, 1998).

28 See especially the role of the pagan poet Virgil as Dante's teacher and guide in *Inferno* and *Purgatory* as well as *Purgatory* X for the divine nature of the medium of relief. See *Purgatory* X–XII for the link between relief sculpture and humility in the discourse around the punishment of pride in the sgraffito-engraved, flat, tomb-marker-like stones displaying the pagan stories of the prideful such as Lucifer and classical Arachne and Niobe, while the examples of humility (Trajan, David, Mary) are richly integrated in their spatiality and corporality, combining several layers of relief that appear to Dante as if the figures come to life and step outside the realm of the artwork. See furthermore the triumphal chariot and its explicit connection to the Christian virtues in *Purgatory* XXIX, confirming the clear link between virtues and the triumph of humility in Dante's and Giotto's time and visual-poetic imaginaries.

29 See Susanna Elm, "Bodies, Books, Histories: Augustine of Hippo and the Extraordinary (civ. Dei 16.8 and Pliny, HN 7)" (forthcoming in Susanna Elm, *New Romans: Dress, Manliness, Display and the Extraordinary*): "The format of this object was the spine-hinged book or codex rather than the scroll, and we know that in composing the *City of God* Augustine paid careful attention to its shape so that the physical form of the codex reinforced his arguments about history. From the outset, Augustine had designed the *City of God* to fit into two codices (*Ep.* 1A*.1). [...] Augustine wrote the *City of God* such that its material shape furthered his cognitive intent: Thanks to the codex format, readers would be able to follow the histories of the two cities synoptically from beginning to end, just as it unfolded. Indeed, this history looks like a double-helix, one strand following the *civitas Dei*, the other the *civitas terrena*, which consists in fact of *two* cities, Rome and Babylon, but all three cities and their histories are always interwoven and intertwined."

30 See Erich Auerbach, "Sermo humilis," *Romanische Forschungen* 64 (1952): 304–64.

31 Translation: Ladis, *Giotto's O*, 149.

32 The Giotto space mission of 1986 was named in honor of his depiction of Halley's comet in the *Adoration of the Magi*, inspired by the passage of the comet in 1301, as identified by Roberta J.M. Olson. On Halley's comet in Giotto's fresco, see Olson: "Giotto's Portrait of Halley's Comet," in *Scientific American* 240 (1979), 160–170, and "Much Ado about Giotto's Comet," in *Quarterly Journal of the Royal Astronomical Society* 35 (1994), 145–148. See also Roberta J.M. Olson and Jay M. Pasachoff, *Cosmos: The Art and Science of the Universe* (Clerkenwell, 2019), 7 and 126–129.

CHAPTER 1

1 Scardeone, *De Antiquitate urbis Patavii et claris civibus patavinis*, cols. 332–33. English translation (with minor adjustments): Derbes and Sandona, *The Usurer's Heart*, 12–13. See also Chiara Frugoni, *Gli affreschi della Cappella Scrovegni a Padova*, (Turin, 2005) 10–11, and 110–11.

2 See Schwarz, *Giottus Pictor*, vol. 2, *Giottos Werke*, 19–20, with the *terminus post quem* for the building of 1300. For a detailed chronology, see also Pietro Toesca, *Giotto* (Turin, 1941), 16–23; Decio Gioseffi, *Giotto architetto* (Milan, 1963), 34–35; Luciano Bellosi, "Opus magistri Iocti," in *La pecora di Giotto* (Turin, 1985), 41–102, at 48–57; Francesca Flores d'Arcais, *Giotto* (New York, 1995), 67–80; and Frugoni, *L'affare migliore di Enrico*, 29–39. According to Bellinati, the frescoes were finished no later than 25 March 1305, the date of the chapel's consecration. See Claudio Bellinati, *La Cappella di Giotto all'Arena (1300–1306): Studio storico-chronologico su nuovi documenti* (Padua, 1967), 10. For the question of Giotto's architectural activities, see Gioseffi, *Giotto architetto*, 39–42, and Arturo Carlo Quintavalle, "Giotto architetto, l'antico e l'Île de France," in *Giotto e il Trecento*, 389–437. See also Romano's thorough notes on Paduan classicism: "Gli elementi 'classici' dell'architettura della cappella in essa sono stati considerati già insiti nella cultura architettonica padovana (Prosdocimi 1971, p. 135; Hueck 1973, p. 107 nota 10, che fa riferimento al sistema di lesene e finestre degli Eremitani; vedi più di recente Dal Piaz 2005) ovvero del tutto peculiari e semmai affiancati da quelli strettamente contemporanei che hanno luogo nella 'febbre di rinnovamento edilizio' della Padova del primo Trecento (Flores d'Arcais 2005, p. 71): Il panorama offerto dal Dellwing mostra la cappella alquanto isolata tra le imprese venete (Dellwing 1990, in particolare pp. 43–47)." Romano, *La O di Giotto*, 191n1.

3 The Arena Chapel measures about 29 meters in length including the apse, 21.5 meters without the apse, and its nave is about 8.5 meters in width, with a maximum height of 12.8 meters. Moschetti gives the full length of the chapel including the apse as 29.26 meters and its maximum width as 8.48 meters; Andrea Moschetti, *La cappella degli Scrovegni e gli affreschi di Giotto in essa dipinti* (Florence, 1904), 25. Gioseffi gives dimensions of 20.86 by 8.45 meters for the nave, with the height of the barrel's apex 12.80 meters; Gioseffi, *Giotto architetto*, 38. Bellinati gives measurements of 21.50 meters (length of nave) by 8.48 meters (width) by 12.80 meters (maximum height); Claudio Bellinati, "Iconografia, iconologia e iconica nell'arte nuova di Giotto alla Cappella Scrovegni dell'Arena di Padova," in *Padova e il suo territorio* 21 (1989): 16–21, at 17. Borsella gives the dimensions of the nave as 21.5 by 8.5 meters and the height of the walls (below the vault) as 8.5 meters; Serenella Borsella, "Principali caratteristiche costruttive della Cappella degli Scrovegni," in *Giotto: La Cappella degli Scrovegni*, ed. Anna Maria Spiazzi (Milan, 2002), 73–76, at 73.

4 For the location of the chapel in relation to the ancient arena, see *Padova: Il volto della città. Dalla pianta del Valle al fotopiano*, ed. Eugenia Bevilacqua and Lionello Puppi (Padua, 1987), pl. 13.

5 See Frugoni, *Gli affreschi della Cappella Scrovegni a Padova*, 105. See also Frugoni, *L'affare migliore di Enrico*, 33–48, and Schwarz, *Giottus Pictor*, vol. 2, *Giottos Werke*, 25–33. See also Jacobus, *Giotto and the Arena Chapel*, in particular the commentary in "Lost Elements of Giotto's Design," 105–31, and the proposal regarding a potentially lost hypothetical stained-glass window, 106. For later changes, see also Robin Simon, "Giotto and After: Altars and Alterations at the Arena Chapel, Padua," *Apollo* 142 (1995): 24–36. While the 2001 restorations showed that the murals stopped above floor level, it is hard to determine how much of the collusion between walls and floor was visible at times behind liturgical furnishings. See *Il restauro della Cappella degli Scrovegni: Indagini, progetto, risultati/ Restoration of the Scrovegni Chapel: Surveys, Projects, Results* (Milan, 2003). On the order of painterly execution, see Creighton Gilbert, "The Sequence of Execution in the Arena Chapel," in *Essays in Honor of Walter Friedlaender* (New York, 1965), 80–86. The scant documentation on the chapel comprises the purchase of the land in 1300; the bishop's permission to build the chapel in 1302; the dedication of the chapel in 1303 as reported by Enrico's inscription as transmitted through Scardeone; the papal bull of 1304 granting indulgences to visitors to the chapel; the complaint in 1305 by neighboring monks regarding the excessive luxuriousness of the new chapel; and the decision of the Venetian High Council in March 1305 to lend wall hangings or relics (the much-debated "panni di San Marco") for the consecration of the Arena Chapel. Between 1308 and 1312 Francesco da Barberino mentions Giotto's *Envy*; between 1312 and 1318 Riccobaldo Ferrarese includes the Arena Chapel in a brief list of places where Giotto had painted. See James Stubblebine, "Preface," in *Giotto: The Arena Chapel Frescoes* (New York, 1969), xi–xiii, at xi.

6 See Walter Euler, *Die Architekturdarstellung in der Arena-Kapelle: Ihre Bedeutung für das Bild Giottos* (Bern, 1967), 22.

7 Marcellan describes Enrico's investment in an ensemble of buildings as a masterly move: "La vera mossa da maestro fu quella di rilevare dall'antica famiglia dei Dalesmanini, a saldo di un debito insoluto, case e terreni presso l'Arena e anche una vecchia cappelletta dell'XI sec., meta di una processione religiosa cittadina." Francesca Marcellan, "L'artista, l'usuraio, il teologo: Tre voci nella Cappella degli Scrovegni," in *La Giustizia di Giotto*, ed. Francesca Marcellan and Umberto Vincenti (Naples, 2006), 1–68, at 31.

8 See Schwarz, *Giottus Pictor*, vol. 2, *Giottos Werke*, 19–20, with the *terminus post quem* for the building of 1300 and the time window for the frescoes of 1303–7. For the chronology see also Toesca, *Giotto*, 16–23; Gioseffi, *Giotto architetto*, 34–35; Bellosi, "Opus magistri Iocti," 48–57; Flores d'Arcais, *Giotto*, 67–80; Frugoni, *L'affare migliore di Enrico*, 29–39. See Romano, *La O di Giotto*, 175, with annotated bibliography at 191n1. According to Bellinati, the frescoes were with certainty finished by 25 March 1305, the date of the chapel's consecration. See Bellinati, *La Cappella di Giotto all'Arena (1300–1306)*, 10.

9 On the events from 14 January 1819 regarding the near-demolition and salvation of the chapel, see Pisani, *I volti segreti di Giotto*, 22, and Appendix B, doc. IIIa, 303–4.

10 For the history of the palace and the grounds of the arena, see Gabriella Giovagnoli, *Il palazzo dell'Arena e la Cappella di Giotto (secc. XIV–XIX): Proprietari, prepositi, beni* (Padua, 2008).

11 Pietro Estense Selvatico, *Sulla Cappellina degli Scrovegni nell'Arena di Padova e sui freschi di Giotto in essa dipinti* (Padua, 1836).

12 Mrs. Callcott, *Description of the chapel of the Annunziata dell'Arena; or, Giotto's chapel, in Padua* (London, 1835). Almost twenty years after Maria, Lady Callcott's 1835 booklet with pencil drawings, John Ruskin published the first extensive English description on Giotto's chapel in the context of his Arundel society project: John Ruskin, *Giotto and His*

Works in Padua: Being an Explanatory Notice of the Series of Woodcuts Executed for the Arundel Society after the Frescoes in the Arena Chapel (London, 1854), 34. Comments by Pierre-François Hugues d'Hancarville on the chapel appear to be lost. Crowe and Cavalcaselle were crucial for the chapel's increasing publicity, see J. A. Crowe and G. B. Cavalcaselle, *A New History of Painting in Italy from the Second to the Sixteenth Century*, vol. 1 (London, 1864), 271–95. See also *G. B. Cavalcaselle: Disegni da antichi maestri*, ed. Rodolfo Pallucchini (Vicenza, 1973); Susanne Müller-Bechtel, *Die Zeichnung als Forschungs-instrument: Giovanni Battista Cavalcaselle (1819–1897) und seine Zeichnungen zur Wandmalerei in Italien vor 1550* (Berlin, 2009); Karl Friedrich Schinkel, *Reisen nach Italien, Erste Reise 1803–1805* (Berlin, 1994). Disappointingly, the note on Giotto confirms nothing more than that the chapel was still integrated into the palace, see 79. Likewise laconic appear the practical notes recommending a morning visit for the best light in Jacob Burckhardt, *Der Cicerone: Eine Anleitung zum Genuss der Kunstwerke Italiens; Malerei*, ed. Bernd Roeck, Christine Tauber, and Martin Warnke (Munich, 2001), 30, see also 39–42 and 44–45. See also Lord Lindsay, "Second Period – Giotto's First Visit to Lombardy," in *Sketches of the History of Christian Art*, vol. 2 (London, 1847), 180–200, at 200.

13 Ruskin, *Giotto and His Works in Padua*, 34.

14 For a schematic illustration, see Marilyn Aronberg Lavin, *The Place of Narrative: Mural Decoration in Italian Churches, 431–1600* (Chicago, 1990), 43–51.

15 Most pertinently, these include Bauch, Euler, Flores d'Arcais, Fry, Gosebruch, Jantzen, Maginnis, Mather, Meiss, Oertel, Offner, Poeschke, Romano, Romdahl, Salvini, Selvatico, Sirén, Smart, Toesca, and Weigelt. Given the import of relief and its precise terminology to this argument I quote each in turn in the original language. "[Lo] studio grandissimo [di] antichi bassorilievi": Selvatico, *Sulla Cappellina degli Scrovegni nell'Arena di Padova e sui freschi di Giotto in essa dipinti*, 87, see also 88–89. "[The] space in which the figures move is treated almost as in a bas-relief": Roger Fry, "Giotto: The Church of S. Francesco of Assisi," in *Vision and Design* (New York, 1947), 108. "Die Darstellung [in der Marienreihe] bewegt sich in einem wenig tiefen Vordergrundplan und gewinnt dadurch etwas von der Klarheit des beherrschten Reliefstiles. Wie bequem lassen sich Kompositionen wie diese in Skulptur übertragen!": Axel L. Romdahl, "Stil und Chronologie der Arenafresken Giottos," *Jahrbuch der Königlich Preussischen Kunstsammlungen* 32 (1911): 3–18, at 5. See Curt H. Weigelt, *Giotto: Des Meisters Gemälde* (Berlin, 1925), XXVIII; "Die

Flachheit der Szenen": Weigelt, *Giotto*, XXIX, see also XXXVII. "Giotto hat auch in tieferem Verstande den Erdboden wiedererobert und den malerisch geformten Menschen neu auf die Beine gestellt. [...] Denn allen Räumen, die er gemalt hat, suchte er die gehörige Bodentiefe zu schaffen. Sie ist das tragende Fundament der Raumwirkung, die Giotto erreicht": Weigelt, *Giotto*, XXXII. The author employs vocabulary typical of his time "das Kubische der Leiber" (the cubic quality of the bodies); "das Kubisch-Geschlossene" (the cubically-enclosed): Weigelt, *Giotto*, XXXIV. "The conception of form in Padua [...] is akin to that of relief": Offner, "Giotto, non-Giotto," 86. "His pictorial space is more a 'pictorial relief'": Robert Oertel, *Early Italian Painting to 1400* (New York, 1968), 86. "The compositions in [...] the story of Joachim and Anna [...] are considerably more restrained than those below, more relief-like and more directly conforming with the demands of mural decoration": Osvald Sirén, *Giotto and Some of His Followers* (Cambridge, MA, 1917), 1:32. Sirén explicitly discusses a "relief plane" in *Giotto and Some of His Followers*, 1:35 and 40. See also his description of the *Lamentation*: "Again, in the celebrated representation of the mourning over the dead Christ [...], the stage arrangement is reduced to a minimum": Sirén, *Giotto and Some of His Followers*, 1:41. Toesca describes the "marblelike substance, in a light softened by shading": Toesca, *Giotto*, 107. See also Toesca, *Giotto*, 95: "Giotto sets his scene on a narrow shelf, one which is clearly defined and measured. The figures, accompanied by architecture or landscape, are invariably deployed in a left-to-right movement across the stage, and the consequent balance between depth and the surface plane is very Classical in feeling." "At Padua the construction is effected not by shading but by accents which often are merely an extension of the contours [...]. [...] virtually all the figures are robed in classical drapery": Frank Jewett Mather, "Giotto's St. Francis Series at Assisi Historically Considered," *Art Bulletin* 25 (1943): 97–111, at 110. On the flat stone bands, see Mather, "Giotto's St. Francis Series at Assisi Historically Considered," 108. On problems with the term "Reliefraum," see Euler, *Die Architekturdarstellung in der Arena-Kapelle*, 32. "Dieses reliefartige Nebeneinander plastisch modellierter Einzelfiguren läßt sich am ehesten den Figurenkompositionen in den Bogenfeldstreifen der französischen Portale des frühen 13. Jahrhunderts vergleichen": Hans Jantzen, "Giotto und der gotische Stil," in *Über den gotischen Kirchenraum und andere Aufsätze* (Berlin, 1951), 39. See also Hans Jantzen, "Die zeitliche Abfolge der Paduaner Fresken Giottos," in *Über den gotischen Kirchenraum*

und andere Aufsätze (Berlin, 1951), 21–33, at 33, "para-taktische Ordnung." Salvini describes Giotto's *plasticismo* as not naturalistic, since it unifies the different objects' materiality in a radical way: "Sicché la carne umana e la veste hanno talvolta la stessa durezza della roccia." Roberto Salvini, "Medioevo e rinascimento nell'arte di Giotto," *Civiltà moderna* 7 (1935): 355–69, at 359. The polychrome relief theory proposed in the present volume suggests that this unified appearance is a logical consequence of figures appearing simultaneously through the pictorial-material lenses of fresco and faux polychrome marble. Martin Gosebruch refers to a study by Tikkanen "der Giottos Bildkompositionen treu und trocken als ein flächenparalleles Figurenrelief beschrieb": Gosebruch, *Giotto und die Entwicklung des neuzeitlichen Kunstbewußtseins* (Cologne, 1962), 49. "[Giotto hat] immer nur das gemalt, was man auch meißeln könnte": Kurt Bauch, "Die geschichtliche Bedeutung von Giottos Frühstil," *Mitteilungen des Kunsthistorischen Institutes in Florenz* 7 (1953): 43–64, at 53. Meiss and Tintori describe the sculptural technique of rendering garments for the *Procession of the Virgin*, see Leonetto Tintori and Millard Meiss, "The Cycle as a Whole," in *The Painting of "The Life of St. Francis" in Assisi* (New York, 1962), 165. "The Arena chapel frescoes are unquestionably the work of a painter deeply versed in the art of sculpture, and the narrative scenes have much of the character of low reliefs. That the *Virtues* and *Vices* in the lowest register of the nave walls should actually simulate sculpture is no less significant": Alastair Smart, *The Assisi Problem and the Art of Giotto: A Study of the Legend of St. Francis in the Upper Church of San Francesco, Assisi* (New York, 1983), 94. "It is, however, the manner in which these pictorial elements are combined, the relations that are set between figure and figure, figure and setting, that determine the temper and the character of this world. [There] is a predominant impulse to compose in a relief-like manner. Thus figures and architecture must share deep affinities: As the figures are largely meditations on generalized shape, architectural structures are described with a minimum of ornament and indeed elaboration." Maginnis, "Problem with Giotto," 88.

For further language relating Giotto's Paduan figures to stone, see also Joachim Poeschke, *Wandmalerei der Giottozeit in Italien: 1280–1400* (Munich, 2003), 187, as quoted above. "[The] figure of Joachim has the violent power of a block of colored marble": Flores d'Arcais, *Giotto*, 173; "The figures [are] like blocks of stone": Flores d'Arcais, *Giotto*, 188. "In Padua, Giotto's figures are even grander than in previous works, as though they were sculpted from colored granite and

set within geometric forms": Flores d'Arcais, *Giotto*, 153. See also Romano, "Giotto e la scultura," in *La O di Giotto*, 194–238, in particular 208 and 210.

16 "Giotto is the creator of the modern, autonomous picture. By virtue of his *disegno*, the compositions take shape within the surrounding frame, the rectangular form of which represents a specific proportion, and at the same time contains two basic architectural directions, the vertical and the horizontal. The inner architecture of the picture is completed and limited by its frame, thereby gaining both in freedom and in discipline. Indeed the picture dominates the real space, whereas until then it had been controlled by the architecture." See Oertel, *Early Italian Painting to 1400*, 85.

17 For Imdahl, the most significant innovation of the Arena paintings is the creation of the *Ereignisbild* in relation to the biblical text as well as to the phenomenology of the world – to things in a spatial context. See Max Imdahl, *Giotto: Arenafresken. Ikonographie, Ikonologie, Ikonik* (Munich, 1988), 8, which distinguishes the chapel's spatial projection from the scenic choreography of the *dramatis personae* and its planimetry.

18 See Imdahl, *Giotto*, 17.

19 See Friedrich Rintelen, *Giotto und die Giotto-Apokryphen* (Munich, 1912), 87–88.

20 Oertel, *Early Italian Painting to 1400*, 85.

21 Smart, *Assisi Problem and the Art of Giotto*, 91.

22 The problem of surface tension was relevant for Rintelen; for Hetzer it merged with his simultaneous interest in Cézanne.

23 "Selbstverständlich meint Rintelen mit 'Fläche' nicht etwa 'Flächigkeit,' so wenig Cézanne plane Bilder gemalt hat, sondern Flächenspannung, welchem Zusammenhang mit der von Vasari gerühmten Körperplastik der Bild-Dinge erzeugt wird. 'Fläche' wäre somit die übergeordnete Macht des Bildes, das einzeln in den Raum Verteilte ins Ganze zu binden, welche Qualität sich nur dann sieghaft erweisen kann, wenn die Einzeldinge sich selber kräftig in den Raum hinein ausdehnen." Gosebruch, *Giotto und die Entwicklung des neuzeitlichen Kunstbewußtseins*, 57–58.

24 See Theodor Hetzer, "Vom Plastischen in der Malerei," in *Festschrift Wilhelm Pinder* (Leipzig, 1938), 28–64, at 35.

25 See Umberto Eco, "Possible Woods," in *Six Walks in the Fictional Woods* (Cambridge, MA, 1994), 75–96, at 95.

26 See Martin Warnke, "Italienische Bildtabernakel bis zum Frühbarock," *Münchner Jahrbuch der Bildenden Kunst* 14 (1968): 61–102.

27 See Cennino Cennini, *Il libro dell'arte*, ed. Fabio Frezzato (Vicenza, 2003), 61. Frezzato reports that Cennino is documented in Padua between 1398 and 1401. See Fabio Frezzato, "Introduzione," in Cennini,

Il libro dell'arte, 11–57, at 13. The author underscores that by c. 1400 there was a plethora of artists from other regions in Padua: "A Padova agiva almeno una trentina di pittori, comprendendo anche i miniatori e i cofanari, provenienti dall'area veneta, emiliana, toscana e anche oltremontana. Anche questo, dunque, era un ambiente aperto, come aperto e cosmopolita era l'ambito universitario padovano" (Frezzato, "Introduzione," 13–14).

28 See Alessandro Tomei, "Giotto's *Annunciation to the Virgin* in Arena Chapel in Padua between East and West," *IKON* 10 (2017): 73–82.

29 See Bissera V. Pentcheva, "The Performative Icon," *Art Bulletin* 88 (2006): 631–55. See also Bissera V. Pentcheva, *The Sensual Icon: Space, Ritual, and the Senses in Byzantium* (University Park, 2010).

30 The Arch of Titus has a total height of 15.40 meters, width of 13.50 meters, and depth of 4.75 meters, with the bay measuring 8.30 × 5.36 meters. L. Richardson, Jr., *A New Topographical Dictionary of Ancient Rome* (Baltimore, 1992), 30. We do not know what might have been the exact state of the Arch of Titus around 1300. Nor do we have definite information about its built environment within medieval walls. This lacuna is unfortunate: Without more specific sources, we cannot exactly reconstruct Giotto's experience of the arch. The wider architectural area around the arch, as will be further explored in this book, underwent several dramatic changes since the middle ages and especially since the early twentieth century. More specifically regarding the monument itself, the artistic and increasingly archaeological interest since the eighteenth century in the Arch of Titus had already caused its deconstruction and reconstruction in a slightly different place, impacting the accuracy of any measurements. For the complex history and environmental archaeology around the Arch of Titus, see the results of Steven Fine's research projects under and around the arch as published in *The Arch of Titus: From Jerusalem to Rome – and back* (Leiden and Boston, 2021).

31 There are some margins of error stemming from the multiple ground alterations impacting the interior height in both places and from the variations between the measurements given in different publications and practices of measuring (e.g., including the walls, measuring from the exterior).

32 For the differences between the scenes on blue ground and the two parts of the *Annunciation*, see Jacobus, "Giotto's *Annunciation* in the Arena Chapel, Padua," 93–107, and Benelli, *Architecture in Giotto's Paintings*. On the two sets of real stone and stucco reliefs at the border of the sanctuary, see Jacobus, *Giotto and the Arena Chapel*.

33 "Jede Linie ist also Gestaltung *aus* der Fläche oder in der Fläche, wie der Meißelhieb im Marmor gestaltet." Theodor Hetzer, *Giotto: Grundlegung der neuzeitlichen Kunst* (Stuttgart, 1981), 67.

34 "Wie ein 'schlafender Stein' in der Landschaft, so zugehörig ruht Joachim hingekauert am Boden." Walter Ueberwasser, *Giotto: Fresken* (Laupen, Bern, 1950), 12. "Like a 'sleeping rock' in the landscape, so one with it rests Joachim huddled on the ground."

35 "Fuoco come marmo." Riccardo Luisi: "Le ragioni di una perfetta illusione: Il significato delle decorazioni e dei finti marmi negli affreschi della cappella Scrovegni," in Frugoni, *L'affare migliore di Enrico*, 377–96, at 386. In his survey of Giotto's faux polychrome marble, Luisi describes the conglomerate of thick reddish flames under *Invidia* as "fiery."

36 See Leonetto Tintori and Millard Meiss, "Additional Observations on Italian Mural Technique," *Art Bulletin* 46 (1964): 377–80, at 379. The hypothesis of true *stucco romano* with wax proffered by Meiss and Tintori has been contradicted by results from the restoration campaigns in the early 2000s but still serves to indicate how polished the surface appears to the view and the touch.

37 Romano registers "rosso porfido" for *Fortitudo*, *Inconstantia*, *Iniustitia*, *Invidia*, and *Desperatio*; "rosso quasi azzurrato" for *Stultitia*; "azzurro" for *Prudentia*, *Temperantia*, *Ira*, *Iusticia*, *Fides*, and *Karitas*; "azzurro più violetto" for *Spes*; and "azzurro più verdastro" for *Infidelitas*. See Romano, *La O di Giotto*, 216.

38 Serena Romano, *Giotto's O* (Bologna, 2015), 221. "Un colore che non ha sfumature grigie ma beige-avorio, di un tono caldo accuratissimamente lavorato negli effetti di rilievo con sfumature più profonde bruno-ocra e con punte di bianco. È il colore di marmo": Romano, *La O di Giotto*, 216.

39 Romano, *La O di Giotto*, 226.

40 "Cosmati work" refers to the actual marble fragment mosaic named after the late medieval Roman artist-dynasty of the Cosmati.

41 See the frame of Gentile da Fabriano (Fabriano, circa 1370– Rome, 1427) *Adoration of the Magi* for Palla Strozzi from Santa Trinita, today in the Uffizi, Florence.

42 For a similar analysis of the two frames, see Derbes and Sandona 2008; 101–2. On Giotto's manifold relations to antiquity, see Anne Markham Telpaz, "Some Antique Motifs in Trecento Art," *Art Bulletin* 46 (1964): 372–76; Hanno-Walter Kruft, "Giotto e l'antico," in *Giotto e il suo tempo: Atti del congresso*

internazionale per la celebrazione del VII centenario della nascita di Giotto (Rome, 1971), 169–76, focusing mainly on the architectural framework of the Assisi cycle; Nicole Dacos, "Arte italiana e arte antica," in *L'Esperienza dell'antico, dell'Europa, della religiosità* (Turin, 1979), 3–68, figs. 2 and 3; Christopher Lloyd, "Giotto and the Calydonian Boar Hunt: A Possible Antique Source?" *Notes in the History of Art* 3 (1984): 8–11; Janetta Rebold Benton, "Some Ancient Motifs in Italian Painting around 1300," *Zeitschrift für Kunstgeschichte* 48 (1985): 151–76; Janetta Rebold Benton, "Antique Survival and Revival in the Middle Ages: Architectural Framing in Late Duecento Murals," *Arte medievale* 7 (1993): 120–45. See also Tronzo's examples of the Roman sculpture of Juno Sospita; the relief of Meleager on his deathbed (sarcophagus, second century, Ostia Antica, Mus. Inv. 101); and a Roman processional relief, now at the Villa Medici. See also Smart, *Assisi Problem and the Art of Giotto*, pls. 26a and b, pls. 18a and 20a, and pls. 22 and 23a; and for Smart's detailed description of the column reliefs in Assisi, see Smart, *Assisi Problem and the Art of Giotto*, 230. See also the classicism in the tondo detail in Giotto's Bardi chapel scenes: Alfred Frankfurter, "Old Myth and New Reality," *Portfolio and Art News Annual* 4 (1961): 60, 62, 68, 74–75, 174–80, at 180. Frankfurter illustrates "Giotto's New Reality" with a large detail of the relief tondo with St. Peter's bust, accompanied by figure caption 34: "The bold 'New Reality' of Giotto's late style epitomizes *The Confirmation of the Rule* as a Classic pageant: In contrast to the dark Byzantine castle hall in the earlier Assisi version [...] the scene becomes the spacious atrium of a Roman temple, in the pediment of which only the bust of St. Peter [...] – conceived as if to represent a Caesar – proclaims the locale actually to be the Vatican." Relief is also discussed in relation to Giotto as a hagiographer and as a historian by Rona Goffen, "Bonaventure's Francis," in *Spirituality in Conflict: Saint Francis and Giotto's Bardi Chapel* (University Park, 1988), 59–77 and 117–24. See Goffen, *Spirituality in Conflict*, 69: "The institution of the Church is evoked in another way as well. The *Approval of the Rule* is set in a building with a gabled roof; the pediment is decorated with a bust of Saint Peter, or more precisely, an *imago clipeata*." On Trecento classicism around Giotto see also Anita Fiderer Moskowitz, "Trecento Classicism and the Campanile Hexagons," *Gesta* 22 (1983): 49–65.

43 For the question of Giotto's architectural activities see Gioseffi, *Giotto architetto*, 39–42, and Quintavalle, "Giotto architetto, l'antico e l'Île de France," 389–437. See also Romano, *La O di Giotto*, 191n1.

44 See Selvatico, *Sulla Cappellina degli Scrovegni nell'Arena di Padova e sui freschi di Giotto in essa dipinti*; and Selvatico, "Visita di Dante a Giotto: Nell'Oratorio degli Scrovegni in Padova (1306)," in *L'arte nella vita degli artisti: Racconti storici* (Florence, 1870), 1–70. See also Antonio Tolomei, *La chiesa di S. Maria della Carità dipinta da Giotto nell'Arena* (Padua, 1880), 10.

45 See, in addition to the *Usurer's Heart* (as quoted above), the related articles: Anne Derbes and Mark Sandona, "Barren Metal and the Fruitful Womb: The Program of Giotto's Arena Chapel in Padua," *Art Bulletin* 80 (1998): 274–91; "'Ave charitate plena': Variations on the Theme of Charity in the Arena Chapel," *Speculum* 76 (2001): 599–637; and "Triplex Periculum: The Moral Topography of Giotto's Hell in the Arena Chapel, Padua," *Journal of the Warburg and Courtauld Institutes* 76 (2015): 41–70. Derbes and Sandona work with a date of death for Reginaldo Scrovegni in 1300.

46 Frugoni describes Enrico ascending the social ladder: "Both wives were noblewomen, well-connected to important people. His first wife was the daughter of Bonifacio da Carrara, and after her death he married Iacobina d'Este, daughter of Orsina degli Orsini. Iacobina's uncle, Duke Azzo VII of Ferrara, had first married Giovanna degli Orsini and then Beatrice." Frugoni, *L'affare migliore di Enrico*, 111.

47 The Scrovegni–Rome connection is well documented. See, among others, Hans Belting, *Die Oberkirche von San Francesco in Assisi: Ihre Dekoration als Aufgabe und die Genese einer neuen Wandmalerei* (Berlin, 1977), 235; Frugoni, *Gli affreschi della Cappella Scrovegni a Padova*, 110–11; and Romano, *La O di Giotto*, 150 and 158–59. On the Orsini connection and other links to families with high status, see also Hans-Michael Thomas, "Contributi alla storia della cappella degli Scrovegni a Padova," *Nuova rivista storica* 57, nos. 1–2 (1973): 109–28. For Enrico's ambitions, see Robert H. Rough, "Enrico Scrovegni, the *Cavalieri Gaudenti* and the Arena Chapel in Padua," *Art Bulletin* 62 (1980): 24–35. See also Kohl, "Giotto and His Lay Patrons," 176–96, at 176. For the Scrovegni family tree, see John Kenneth Hyde, *Padua in the Age of Dante* (Manchester, 1966), 189. For the will, see Benjamin G. Kohl, "The Scrovegni in Carrara Padua and Enrico's Will," *Apollo* 142 (1995): 43–47. For Giotto's Roman work, see Charles Mitchell, "The Lateran Fresco of Boniface VIII," *Journal of the Warburg and Courtauld Institutes* 14 (1951): 1–6; Wolfgang Kemp, "Zum Programm von Stefaneschi-Altar und Navicella," *Zeitschrift für Kunstgeschichte* 30 (1967): 309–20; Helmtrud Köhren-Jansen, "Giottos Navicella: Bildtradition, Deutung, Rezeptionsgeschichte," PhD diss., University of

Cologne (Worms am Rhein, 1993); and Herbert L. Kessler, "Giotto e Roma," in *Giotto e il Trecento*, 85–99. See also the historiographical overview in Maginnis, "Problem with Giotto," 79–102, and Hayden B. J. Maginnis, "In Search of an Artist," in *Cambridge Companion to Giotto*, 10–31.

48 See Silvia Maddalo, "Bonifacio VIII e Jacopo Stefaneschi: Ipotesi di lettura dell'affresco della loggia lateranense," *Studi romani* 31 (1983): 129–50. The painter seems to return briefly to Florence at the turn of the century (the Badia polyptych, now in the Uffizi, is dated 1301). See Francesca Flores d'Arcais, "Giotto after the Restoration," in *Giotto*, ed. Basile, 13–14, who sees the Scrovegni Chapel as Giotto's second Paduan project – the first being the work for the Santo and the third the frescoes for the Palazzo della Ragione between 1309 and 1312. See also Derbes and Sandona, *Usurer's Heart*. See most recently Giacomo Guazzini, "A New Cycle by Giotto for the Scrovegni: The Chapel of Saint Catherine in the Basilica of Sant'Antonio in Padua," *Mitteilungen des Kunsthistorischen Institutes in Florenz* 61 (2019): 169–201. See also Guazzini, "Un nuovo Giotto al Santo di Padova: La cappella della Madonna Mora," *Nuovi studi* 21 (2015): 5–40.

CHAPTER 2

1 See Joan M. Ferrante, "Boniface VIII, Pope," in *The Dante Encyclopedia*, ed. Richard Lansing (New York, 2000), 122–24. Giotto was in Rome to work for Boniface VIII around 1296–97, see Silvia Maddalo, "Bonifacio VIII e Jacopo Stefaneschi: Ipotesi di lettura dell'affresco della loggia lateranense," *Studi romani* 31 (1983); Giotto returns to Florence in 1301 (as documented with the Badia polyptych), and he was also at some point in Rimini between his work in Assisi and Padua.

2 "Sì come i peregrin pensosi fanno / giungendo per cammin gente non nota / che si volgono ad essa e non restano": Purgatorio cap. XXIII, 16–18; "Come i Roman per l'esercito molto / l'anno del Giubbileo, su per lo ponte / hanno a passar la gente modo tolto, / che dall'un lato tutti hanno la fronte / verso il Castello e vanno Santo Pietro, / dall'altra sponda vanno verso il monte": *Inferno* XVIII, 28–33. See also Arsenio Frugoni, "La Roma di Dante: Tra il tempo e l'eterno," in *Pellegrini a Roma nel 1300: Cronache del primo Giubileo*, ed. Felice Accrocca (Casale Monferrato, 1999), 97–122, at 98.

3 Pisani, *I volti segreti di Giotto*, 202–3 and 207–8, and Pisani, "La concezione agostiniana del programma teologico della Cappella degli Scrovegni," 215–68.

4 Derbes and Sandona, *Usurer's Heart*.

5 See Frugoni, *L'affare migliore di Enrico*, and Jacobus, *Giotto and the Arena Chapel*.

6 Romano, *La O di Giotto*, 202.

7 Romano, *La O di Giotto*, 203.

8 For Giotto's work in Naples, see Pierluigi Leone de Castris, *Giotto a Napoli* (Naples, 2006). See also Andrea de Marchi, *Maso di Banco in Giotto's Workshop in Naples and an Unpublished Saint Dominic* (Florence, 2013).

9 Indeed, Serena Romano illustrates the Benevento Arch as a comparison for the Arena Chapel's chancel arch. See Romano, *La O di Giotto*, figs. 192 and 193.

10 See Cesare d'Onofrio, *La papessa Giovanna: Roma e papato tra storia e leggenda* (Rome, 1979), 215–17.

11 Herbert L. Kessler and Johanna Zacharias, *Rome 1300: On the Path of the Pilgrim* (New Haven, 2000), 90.

12 Kessler and Zacharias, *Rome 1300*, 90–92.

13 Kessler and Zacharias, *Rome 1300*, 95 n. 88.

14 Kessler and Zacharias, *Rome 1300*, 92.

15 Kessler and Zacharias, *Rome 1300*, 92.

16 See the results of the "Arch of Titus Digital Restoration Project," which was conducted by an international team of scientists and historians under the leadership of Yeshiva University Professor Steven Fine. See Steven Fine, "Menorahs in Color: Polychromy in Jewish Visual Culture of Roman Antiquity," *Images* 6 (2013): 3–25. 3-D scanners, cameras, and UV-VIS (Ultra-Violet Visual) spectroscopy technique can detect traces of colors in a non-invasive way. More recently, Steven Fine hosted an international conference (29 October 2017, New York City) to accompany the display of a digitally recolored copy of the Menorah relief from the Arch of Titus in the exhibition "The Arch of Titus – from Jerusalem to Rome, and Back" (Yeshiva University Museum, NYC, 14 September 2017–14 January 2018). Around 1300, the much better preserved polychromy would also have facilitated the understanding of the images, see Barbara Eberhardt, "Wer dient wem? Die Darstellung des flavischen Triumphzuges auf dem Titusbogen und bei Josephus (*B.J.* 7.123–162)," in *Josephus and Jewish History in Flavian Rome and Beyond*, ed. Joseph Sievers and Gaia Lembi (Leiden, 2005), 257–77, at 265. For the polychromy of the Arch of Titus, see also Pfanner, *Der Titusbogen*, 56.

17 For the exhibition in the Yeshiva University Museum in New York City in autumn 2017, digital technology temporarily restored the relief's original polychromy by projecting a set of color reconstructions on top of

the marble surface. I am especially grateful to Donald Sanders (Tartessos Prize winner in virtual archaeology for 2015 and President, Learning Sites, Inc. – Digitally Reconstructed Ancient Worlds for Interactive Education and Research) for producing a hypothetical Giotto blue simulation as a visual aid.

18 For reconstruction research on ancient polychromy see Vinzenz Brinkmann, *Die Polychromie der archaischen und frühklassischen Skulptur* (Munich, 2003), for the main debate see pages 11–13. See also Brinkmann and Raimund Wünsche, *Bunte Götter: Die Farbigkeit antiker Skulptur* (Munich, 2004); *Gods in Color: Painted Sculpture of Classical Antiquity*, ed. Vinzenz Brinkmann et al. (Munich, 2007); *The Color of Life: Polychromy in Sculpture from Antiquity to the Present*, ed. Roberta Panzanelli et al. (Los Angeles, 2008). See also Ulrich Schiessl and Renate Kühnen, eds., *Polychrome Skulptur in Europa: Technologie, Konservierung, Restaurierung* (Dresden, 1999); Willibald Sauerländer, "'Quand les statues étaient blanches': Discussion au sujet de la polychromie," in *La couleur et la pierre polychromie des portails gothiques: Actes du colloque, Amiens, 12–14 octobre 2000*, ed. Denis Verret and Delphine Steyaert (Paris, 2002), 27–42; Jan Stubbe Øestergaard, "The Polychromy of Antique Sculpture: A Challenge to Western Ideals?" in *Circumlitio: The Polychromy of Antique and Mediaeval Sculpture*, ed. Vinzenz Brinkmann, Oliver Primavesi, and Max Hollein (Munich, 2010), 78–107; Ursula Mandel, "On the Qualities of the 'Colour' White in Antiquity," in *Circumlitio*, 303–23; and Salvatore Settis, "Schicksale der Klassik: Vom Gips zur Farbe," in *Zurück zur Klassik: Ein neuer Blick auf das Alte Griechenland*, ed. Vinzenz Brinkmann (Munich, 2013), 59–83. For the reconstruction of Giotto's colors in Assisi, see *I colori di Giotto: La Basilica di Assisi. Restauro e restituzione virtuale*, ed. Giuseppe Basile (Milan, 2010). Giotto's world was one of polychrome sculpture, see Michaela Krieger, *Grisaille als Metapher: Zum Entstehen der* Peinture en Camaieu *im frühen 14. Jahrhundert* (Vienna, 1995), 58. For medieval polychromy, see Jürgen Michler, "Die Einbindung der Skulptur in die Farbgebung gotischer Innenräume," *Kölner Domblatt* 64 (1999): 89–108; Jürgen Michler, "Materialsichtigkeit, Monochromie, Grisaille in der Gotik um 1300," in *Denkmalkunde und Denkmalpflege: Wissen und Wirken. Festschrift für Heinrich Magirius zum 60. Geburtstag*, ed. Ute Reupert, Thomas Trajkovits, and Winfried Werner (Dresden, 1995), 197–221; Jürgen Michler, "Altbekannte Neuigkeiten über die Farbigkeit der Kathedralen von Chartres, Amiens, Köln," *Kunstchronik* 62 (2009): 353–63. See also Bertrand Cosnet, "Les personifications dans la

peinture monumentale en Italie au XIVe siècle: La grisaille et ses vertus," in *Aux limites de la couleur: Monochromie et polychromie dans les arts (1300–1600)*, ed. Marion Boudon-Machuel, Maurice Brock and Pascale Charron (Turnhout, 2011), 125–31. On art theoretical issues of polychromy see Julius Lange, "Die Farbe und die Bildhauerkunst (1886)," in *Julius Lange's Ausgewählte Schriften*, vol. 2 *(1886–1897)*, ed. Georg Brandes and Peter Köbke (Strasbourg, 1912), 33–49.

19 Pfanner suspects early Christian iconoclasm. See Pfanner, *Der Titusbogen*, 9 and 12. The author also notes that the previous ten years of pollution and corrosion had already visibly damaged and changed the reliefs' appearance, leaving practically none of the original surface. This was in 1983.

20 The term "Flavian Baroque" can only be used as a term of convention given its inherent contradictions, as noted by Pfanner, *Der Titusbogen*, 59: "Wenn man die Reliefs als barock bezeichnen will, dann in dem Sinne, daß es sich bei der vollplastischen Figurenausbildung, bei den unruhigen und die Körperformen verunklärenden Gewändern, bei den vielen Schrägstellungen und den zahlreichen, oft verwirrenden Überschneidungen und Staffelungen vornehmlich um hellenistische Gestaltungsprinzipien handelt, die sich im klassischen Relief kaum finden. [...] Der 'barocke' Stil der Durchgangsreliefs ist nicht für die flavische Zeit typisch ('flavischer Barock')" (Pfanner, *Der Titusbogen*, 60). See also the critical approach to the concept of a Flavian style and its oft-discerned vividness in Volker Michael Strocka, "Der 'flavische Stil' in der römischen Kunst – Einbildung oder Realität?" in *Tradition und Erneuerung: Mediale Strategien in der Zeit der Flavier*, ed. Norbert Kramer and Christiane Reitz (Berlin, 2010), 95–132.

21 Noack names different arch functions, e.g., as demarcating a god's *pomerium*, indicating the privileges of a city, marking the entryway to marketplaces, commemorating the founding of colonies, or acting as an honorary monument for the living and the dead or for the celebration of a triumph, though the latter is only documented in one late example as an *arcus triumphalis*. See Ferdinand Noack, "Triumph und Triumphbogen," *Vorträge der Bibliothek Warburg* 5 (1928): 147–201.

22 *"Nicht einem Sterblichen* gilt der Bogen, sondern dem *zum Gott erhöhten*, – das war nirgends vordem so stark, nirgends in der Plastik des Bildes ausgesprochen worden." Noack, "Triumph und Triumphbogen," 198.

23 See also Henner von Hesberg, "Archäologische Denkmäler zum römischen Kaiserkult," in *Aufstieg und Niedergang der römischen Welt: Geschichte und

Kultur Roms im Spiegel der neueren Forschung, vol. 2, ed. Hildegard Temporini and Wolfgang Haase (Berlin, 1978), 911–95.

24 See Eberhardt, "Wer dient wem? Die Darstellung des flavischen Triumphzuges auf dem Titusbogen und bei Josephus (*B.J.* 7.123–162)," 262.

25 "die meisten Köpfe der Durchgangsreliefs, der Schlußsteine, der Victorien und des kleinen Frieses wurden abgeschlagen." Pfanner, *Der Titusbogen,* 9.

26 See Eberhardt, "Wer dient wem? Die Darstellung des Flavischen Triumphzuges auf dem Titusbogen und bei Josephus (*B.J.* 7.123–162)," 263–67.

27 See Kleiner, *Roman Sculpture,* 81, and oral communication with Diana E. E. Kleiner in New Haven, fall term 2014.

28 One might call the manner of the abstract ornaments Byzantine or Duecento-Roman modes of ornamentation reminiscent of Cavallini.

29 See Romano, *La O di Giotto,* 216. For illustrations of the frieze, see Eve d'Ambra, *Private Lives, Imperial Virtues: The Frieze of the Forum Transitorium in Rome* (Princeton, 1993).

30 Basil de Sélincourt, *Giotto* (London, 1905), 99.

31 Stubblebine, *Giotto,* 88.

32 See Krieger, *Grisaille als Metapher,* 4.

33 See Romano, *La O di Giotto,* 216.

34 Romano, *La O di Giotto,* 226.

35 Romano, *La O di Giotto,* 226.

36 For a discussion of polychromy, monochromy, and *Materialsichtigkeit,* see Michler, "Materialsichtigkeit, Monochromie, Grisaille in der Gotik um 1300," 197–221; on the *Materialsichtigkeit* of Giotto's dado zone in particular, see 210–11.

37 See Kleiner, *Roman Sculpture,* 453.

38 The arch is 21 m high, 25.9 m wide, and 7.4 m deep; the central archway is 11.5 m high and 6.5 m wide; and the lateral archways are each 7.4 m by 3.4 m. See Ernst Kitzinger, *Byzantine Art in the Making: Main Lines of Stylistic Development in Mediterranean Art, 3rd–7th Century* (Cambridge, MA, 1995), 7–14. Kitzinger notes that the "contrast in style between the second- and the fourth-century reliefs on the arch is violent," 7. See also Kleiner, *Roman Sculpture,* 444–55.

39 Based upon surviving objects and texts, Giotto seems to be the first since antiquity to represent the idea of fading polychromy in process and, it seems, the first to turn this subtle fading into an ethical allegory in the figurative arts. A passage in Euripides (*Helen,* 262–63) demonstrates that Giotto would have not been the first to take artistic advantage of the washed-out, worn look of polychromy in its distressed state. Helen of Troy decries her fatal beauty in terms of fading colors: "If only I might assume a plainer aspect [...], like an *agalma* made pristine again, its colors obliterated." Quoted as translated in Mary C. Stieber, "Wiped Clean" in *Euripides and the Language of Craft* (Leiden, 2011), 172, with a discussion of the Platonic problem of the relations between form, polychromy, and beauty on 172–78.

40 See Romano, *La O di Giotto,* 216.

41 See Selvatico, *Sulla Cappellina degli Scrovegni nell'Arena di Padova e sui freschi di Giotto in essa dipinti,* 51.

42 See Selvatico, *Sulla Cappellina degli Scrovegni nell'Arena di Padova e sui freschi di Giotto in essa dipinti,* 42.

43 See Selvatico, *Sulla Cappellina degli Scrovegni nell'Arena di Padova e sui freschi di Giotto in essa dipinti,* 43. See also Sirén, *Giotto and Some of His Followers,* 1:52.

44 I am grateful to Christopher Hugh Hallett for discussing these options with me.

45 Kleiner, *Roman Sculpture,* 444.

46 Kleiner, *Roman Sculpture,* 445.

47 See Richard Brilliant, "I piedistalli del giardino di Boboli: spolia in se, spolia in re," *Prospettiva* 31 (1982), 2–17.

48 See Richard Krautheimer, *Rome: Profile of a City, 312–1308* (Princeton, 2000), 33–58.

49 "imp · caes · fl · constantino · maximo · p · f · avgusto s · p · q · r · qvod · instinctv · divinitatis · mentis · magnitvdine · cvm · exercitv · svo · tam · de · tyranno · qvam · de · omni · eivs · factione · vno · tempore · ivstis · rempvblicam · vltvs · est · armis · arcvm · trivmphis · insignem · dicavit." "To the Emperor Caesar Flavius Constantinus, the greatest, pious, and blessed Augustus: Because he, by divine inspiration and the greatness of his mind, with his army and by just force of arms has delivered the state from the tyrant as well as all of his faction at the same time, the Senate and People of Rome have dedicated this triumphal arch." This inscription appears combined with the lauding dedications "liberatori vrbis" (to the liberator of the city) and "fundatori qvietis" (to the founder of peace).

50 Krautheimer, *Rome: Profile of a City,* 33–58.

51 On humility, see the passages in Luke 1:46–55: "He hath showed strength with his arm: / He hath scattered the proud in the imagination of their hearts. / He hath put down the mighty from their seat: and hath exalted the humble and meek." See also Psalm 47:7, Proverbs 22:4, Jeremiah 9:24, Jacobus 4:10 and 4:13–16, 2. Timothy 3:4, Matthew 12:46–50 and Matthew 23:5–7, the Acts of the Apostles 8:26–38 and the Second Epistle to the Thessalonians 1:3 as well as Philippians 2:3, Galatians 5:26, and 1. Corinthians 13.

52 On the Arch of Titus, see Pfanner, *Der Titusbogen;* R. R. Holloway, "Some Remarks on the Arch of

Titus," *L'Antiquité classique* 56 (1987): 183–91; Fred S. Kleiner, "The Arches of Vespasian in Rome," *Römische Mitteilungen* 97 (1990): 127–36; Diana Kleiner, *Roman Sculpture*. For the medieval history of the Arch, see Davies, *Death and the Emperor*, 19: "It was still visible in the sixth or seventh century, when an apprentice scribe recorded its inscription. By the thirteenth century the Frangipani had incorporated it into their fortress, and it was subsequently enveloped in the Santa Maria Nuova building complex [. . .]; by 1715, monks were using its attic chamber as a retreat."

53 See Kessler and Zacharias, *Rome 1300: On the Path of the Pilgrim*, 90: "The *Acheropita* approaches its destination."

54 See Peter Gercke, *Antike Bauten: Korkmodelle von Antonio Chichi 1777–1782* (Kassel, 2001), and Martin Eberle, *Monumente der Sehnsucht: Die Sammlung Korkmodelle auf Schloss Friedenstein Gotha* (Heidelberg, 2017).

55 The old urban Roman noble dynasty of the Frangipani probably stood in the line of the Roman De Imperatore family and played an important role in the eleventh-century conflicts between papal and imperial rule during the Investiture Controversy. The center of their fortress was situated in the ruins of the Forum, between the Palatine Hill and the Colosseum, containing the homes of all three branches of the family (Frangipani de Cartolaria, Frangipani de Septemsoliis, Frangipani de Gradellis), and Santa Maria Nova as their family church. See *Enciclopedia cattolica*, vol. 5, *Ea–Gen.* (Vatican City, 1950), 1696–97; *Enciclopedia italiana di scienze, lettere ed arti*, vol. 16, *Franck–Gian.* (Milan, 1932), 23–24; *Lexikon für Theologie und Kirche*, vol. 4, *Franca bis Hermenegild* (Freiburg et al., 1995), 14–5; Franz Ehrle, "Die Frangipani und der Untergang des Archivs und der Bibliothek der Päpste am Anfang des 13. Jahrhunderts," in *Mélanges offerts à Emile Châtelain* (Paris, 1910), 448–85; Hans-Walter Klewitz, "Das Ende des Reformpapsttums," *Deutsches Archiv für Geschichte des Mittelalters* 3 (1939): 371–412. For the history of the Frangipani in the urban Roman context see also Chris Wickham, *Roma medievale: Crisi e stabilità di una città, 900–1150*, ed. Alessio Fiore and Luigi Provero (Rome, 2013), in particular chapter 4, "Le aristocrazie urbane," 221–306. Contrastingly, for Padua, see Hyde, *Padua in the Age of Dante*, 185–86, on the three moneylending families that held the most power and financial impact: the Dalesmanini, Lemici, and Scrovegni. See Hyde, *Padua in the Age of Dante*, 188: "The Scrovegni [. . .] can be traced back no further than the early thirteenth century, and make their first appearance in the circle of the bishops of Padua." Despite charging 20 percent interest rates, rather than suffering "any censure by the church" the

Scrovegni "seem to have had powerful friends in ecclesiastical circles, Renaldo was the trusted agent of Bishop Giovanni Forzatè, and Enrico was described as *familiarius noster* by the Trevisan Pope, Benedict XI." Hyde, *Padua in the Age of Dante*, 190. A Paduan thesis from 2003 focuses on the forgotten family of Manfredo Dalesmanini, see Babet Taschera, "I Dalesmanini: Una famiglia magnatizia nella Padova dei secoli XII–XIV," Laurea vecchio ordinamento, Padua, 2003.

56 Questioning Jacobus, Chiara Frugoni doubts that Scrovegni would have wanted to demolish the earlier palace and proposes, therefore, that the center of the arena might not have been occupied by the palace. Frugoni, *L'affare migliore di Enrico*, 86n18: "Jacobus [. . .] ritiene che il palazzo Dalesmanini sorgesse al centro dell'Arena ('in medio ipsius Arene') e che lo Scrovegni l'avesse raso al suolo costruendo il proprio, in modo scenografico, al perimetro dell'Arena [. . .]. Inoltre perché distruggere un palazzo che doveva essere splendido, solo per creare un punto prospettico migliore da cui contemplarlo?" The answer to this question might be that the opened field in the arena would have strengthened its similarity to the Colosseum. In light of the plausible intention to mirror the Velia's surroundings and the Frangipani's building complex, a conscious reinforcement of the spatial-optical correspondence between the Paduan arena and the Roman arena (the Colosseum) could have been a factor in the otherwise surprising "piazza pulita" approach.

57 On the processional history of the arena, see Michael Viktor Schwarz, "Padua, Its Arena and the Arena Chapel: A Liturgical Ensemble," *Journal of the Warburg and Courtauld Institutes* 73 (2010): 39–64. On the processional and theatrical dimensions of the chapel and the arena see also Jacobus, *Giotto and the Arena Chapel*.

58 See Victor Turner, *Ritual Process: Structure and Anti-Structure* (London, 1969).

59 See Frugoni, *L'affare migliore di Enrico*, 145–6, 186–7n15–7.

60 See Julia Miller and Laurie Taylor-Mitchell, "Humility and Piety: The Annunciation in the Church of Ognissanti in Florence," *Studies in Iconography* 30 (2009), 42–71.

61 Collodo notes that Scrovegni, according to Giovanni da Nono, habitually "usava fingere commozione e pianto per catturare l'approvazione dei *viri consules paduani*." Silvana Collodo, "Enrico Scrovegni," in *La Cappella degli Scrovegni a Padova: The Scrovegni Chapel in Padua*, ed. Davide Banzato et al. (Modena, 2005), 9–18, at 14.

62 Frugoni, *L'affare migliore di Enrico*.

63 For the logic of triumphal appropriation in the following centuries, see Randolph Starn and Loren Partridge, *Arts of Power: Three Halls of State in Italy, 1300–1600* (Berkeley, 1992), 162–68, and Randolph Starn, "Renaissance Triumphalism in Art," in *The Renaissance World*, ed. John Jeffries Martin (New York, 2007), 326–46.

64 For the Paduan crucifix, see *La Croce di Giotto: Il restauro*, ed. Davide Banzato (Milan, 1995), in particular Davide Banzato, "La Croce di Giotto dei Musei Civici di Padova: Ipotesi di collocazione originaria e precedenti restauri," 26–40. See also Pinin Brambilla Barcilon, "Notizie e risultati del restauro," in *La Croce di Giotto: Il restauro*, 57–75, and Ciro Castelli, Mauro Parri, and Andrea Santacesaria, "Technique of Execution, State of Conservation and Restoration of the Crucifix in Relation to Other Works by Giotto: The Wooden Support," in *Giotto: The Santa Maria Novella Crucifix*, ed. Marco Ciatti and Max Seidel (Florence, 2002), 247–72, where it is noted (on page 257) that the "*Padua Crucifix* differs from the others in its smaller size, 223 x 164 cm, in the fact that it is painted on the back as well as on the front, and in the absence of a structural support to prevent warping." For Giotto's other crucifixes and their specific religious meaning, see Joanna Cannon, "Giotto and Art for the Friars: Revolutions Spiritual and Artistic," in *Cambridge Companion to Giotto*, 103–34.

65 The nineteenth-century imagery of the Arch of Titus across media was produced by artists such as Joseph Mallord William Turner, Ferdinand Piloty, George Peter Alexander Healy, Frederic E. Church, Jervis McEntee, and Robert Macpherson.

66 See Pfanner, *Der Titusbogen*, figs. 3 and 4, with an earlier example that set the tone for the academy, Bellori's drawings of 1690, and Jean-Guillaume Moitte's reliefs from around 1791.

67 On the liturgical drama described in the Codice Zabarella (1306), later rules (1550–57), and the abolition in 1600, see Bruno Brunelli, *I teatri di Padova: Dalle origini alla fine del secolo XIX* (Padua, 1921), 15–18. See also Schwarz, *Giottus Pictor*, vol. 2, *Giottos Werke*, 20–22, and Schwarz, "Padua, Its Arena and the Arena Chapel."

CHAPTER 3

1 Scardeone, *De Antiquitate urbis Patavii et claris civibus patavinis*, cols. 332–33. English translation (with minor adjustments): Derbes and Sandona, *The Usurer's Heart*, 12–13.

2 See Sergio Lucianetti, "Lo sviluppo della città medioevale," in *La città di Padova: Saggio di analisi urbana*, ed. Carlo Aymonino et al. (Rome, 1970), 71–125, at 71. For Padua's urban development in the context of its ancient Roman roots and Venetian surroundings, see Aldo Rossi, "Caratteri urbani delle città venete," in *La città di Padova*, 421–90.

3 The legends around the origins of Padua with their embedded Christian prophecies are recorded in Giovanni Da Nono's *De aedificatione urbis Patavie (Phatolomie)*, *Visio Egidii regis Patavie*, and *Liber de generatione aliquorum civium urbis Padue*. See Carrie E. Beneš, *Urban Legends: Civic Identity and the Classical Past in Northern Italy, 1250–1350* (University Park, 2011), especially "Appropriating a Roman Past," 13–36, and "Rehousing the Relics of Antenor," 39–60. On additional ancient references, see Mary D. Edwards, "Cross-Dressing in the Arena Chapel: Giotto's Virtue Fortitude Re-Examined," in *Receptions of Antiquity, Constructions of Gender in European Art, 1300–1600*, ed. Marice Rose and Alison C. Poe (Leiden, 2015), 37–79.

4 Romano, *La O di Giotto*, 206–7.

5 On the monument, see Simon, "Giotto and After: Altars and Alterations at the Arena Chapel, Padua." See also Robin Simon, "'The Monument Constructed for Me.' Evidence for the First Tomb Monument of Enrico Scrovegni in the Arena Chapel, Padua," in *Venice and the Veneto during the Renaissance: The Legacy of Benjamin Kohl*, ed. Michael Knapton et al. (Florence, 2014), 385–404. See also Laura Jacobus, "The Tomb of Enrico Scrovegni in the Arena Chapel, Padua," *Burlington Magazine* 154 (2012): 403–9. At the College Art Association's Annual Conference in 2014, Louise Bourdua of the University of Warwick presented new research with alternative models of reconstruction, "Enrico Scrovegni's Tomb in the Arena Chapel, Padua: A Reconstruction," in the panel "Art, Architecture, and the Artist in Renaissance Venice III: Patronage and Devotional Practice," New York City, 28 March 2014. The sculptural portraiture in the chapel has also been analyzed with digital tools, indicating the use of mechanical means. This procedure has uncovered the extent of planning and effort that went into producing a copy across media and materials. Created twenty-five years apart and by different artists, the two sculpted portraits share identical underlying bone structures. See Laura Jacobus "'Propria Figura': The Advent of Facsimile Portraiture in Italian Art," *Art Bulletin* 99 (2017): 72–101. On the fluid concepts of portraiture and likeness with an important critique of the traditional emphasis on presumed individuality and

selfhood in visual modes of portraiture, see Stephen Perkinson, "Rethinking the Origins of Portraiture," *Gesta* 46 (2007): 135–57. On the orchestration of Scrovegni's three likenesses, see also Henrike Christiane Lange, "Portraiture, Projection, Perfection: The Multiple Effigies of Enrico Scrovegni in Giotto's Arena Chapel". In *Picturing Death 1200–1600*, ed. Stephen Perkinson and Noa Turel (Leiden, Boston, and Paderborn, 2020), 36–48.

6 See Pisani, *I volti segreti di Giotto*, 209–11.

7 See Sandra Baragli, *European Art of the Fourteenth Century* (Los Angeles, 2007), 51, suggesting that "Giotto was probably the first artist to portray the true features of the person represented. The only surviving example is his portrait of Enrico Scrovegni, who is shown as a donor in The Last Judgment fresco in the Scrovegni chapel at Padua (1306–7)." See also Patricia Rubin, "Understanding Renaissance Portraiture," in *The Renaissance Portrait: From Donatello to Bellini*, ed. Keith Christiansen, Stefan Weppelmann, and Patricia Lee Rubin (New York, 2011), 2–25, with the inclusion of Scrovegni's likeness on pages 3–4.

8 See Schwarz, *Giottus Pictor*, vol. 2, *Giottos Werke*, 34.

9 The sculptures in the chapel stem from different times in the commission. See also Kohl, "The Scrovegni in Carrara Padua and Enrico's Will." On the importance of the Carrarese influences, see Benjamin G. Kohl, "Chronicles into Legends and Lives: Two Humanist Accounts of the Carrara Dynasty in Padua," in *Chronicling History: Chroniclers and Historians in Medieval and Renaissance Italy* (University Park, 2007), 223–48. These sculptures were the result of his heirs' initiatives perhaps fifteen years after Scrovegni's death in 1336. For the sculptural portraits see Clario di Fabio, "Memoria e modernità: Della propria figura di Enrico Scrovegni e di altre sculture nella cappella dell'Arena di Padova, con aggiunte al catalogo di Marco Romano," in *Medioevo: Immagine e memoria: Atti del Convegno internazionale di studi*, ed. Arturo C. Quintavalle (Milan, 2009), 532–46. See also Laura Jacobus, "A Knight in the Arena: Enrico Scrovegni and His 'True Image,'" in *Fashioning Identities in Renaissance Art*, ed. Mary Rogers (Aldershot, 2000), 17–31. For the attribution to the sculptor Marco Romano, see Roberto Paolo Novello, "Statua di Enrico Scrovegni," in *La Cappella degli Scrovegni a Padova*, 279–81. See also Frugoni, *L'affare migliore di Enrico*, 55, and Volker Herzner, "Giottos Grabmal für Enrico Scrovegni," *Münchener Jahrbuch der bildenden Kunst* 33 (1982): 39–66. For Scrovegni's portraits in general, see Anne Derbes and Mark Sandona, "Enrico Scrovegni: I ritratti del mecenate," in *Giotto e il Trecento*, 129–41.

10 For discussions of illusionism, e.g. of the doorframe marble and overhanging textile see Frojmovič, "Giotto's Circumspection." See also Luisi, "Le ragioni di una perfetta illusione." See also Philippe Cordez, "Les marbres de Giotto: Astrologie et naturalisme à la Chapelle Scrovegni," *Mitteilungen des Kunsthistorischen Institutes in Florenz* 55 (2013): 9–25, and Lange, "Relief Effects: Giotto's Triumph."

11 See Enrico Castelnuovo, "Les portraits individuels de Giotto," in *Le portrait individuel: Réflexions autour d'une forme de représentation, XIIIe–XVe siècles*, ed. Dominic Olariu (Bern, 2009), 103–20. For the debates around Giotto as portraitist, see Kurt Bauch, "Giotto und die Porträtkunst," in *Giotto e il suo tempo: Atti del congresso internazionale per la celebrazione del VII centenario della nascita di Giotto*, 299–309; P. C. Claussen, "Enrico Scrovegni, der exemplarische Fall: Zur Stiftung der Arenakapelle in Padua," in *Für irdischen Ruhm und himmlischen Lohn: Stifter und Auftraggeber in der mittelalterlichen Kunst*, ed. Hans-Rudolf Meyer, Carola Jäggi, and Philippe Büttner (Berlin, 1995), 227–46; Harald Keller, "Die Entstehung des Bildnisses am Ende des Hochmittelalters," *Römisches Jahrbuch für Kunstgeschichte* 3 (1939): 227–365; Dirk Kocks, "Die Stifterdarstellung in der italienischen Malerei des 13. – 15. Jahrhunderts," PhD diss., Universität Köln, Cologne, 1971; Wolfram Prinz, "Ritratto istoriato oder das Bildnis in der Bilderzählung: Ein frühes Beispiel von Giotto in der Bardikapelle," *Mitteilungen des Kunsthistorischen Institutes in Florenz* 30 (1986): 577–81; Peter Seiler, "Giotto als Erfinder des Porträts," in *Das Porträt vor der Erfindung des Porträts*, ed. Martin Büchsel and Peter Schmidt (Mainz am Rhein, 2003), 153–72.

12 See Robert H. Rough, "Enrico Scrovegni, the *Cavalieri Gaudenti* and the Arena Chapel in Padua," *Art Bulletin* 62 (1980): 24–35. For further notes on the bibliography of Scrovegni's family, see Edwards, "Cross-Dressing in the Arena Chapel: Giotto's Virtue Fortitude Re-Examined," 37–38.

13 See Hyde, *Padua in the Age of Dante*. On Scrovegni in exile, see Kohl, "Giotto and His Lay Patrons," 190–91. For the portraits, see Derbes and Sandona, "Enrico Scrovegni: I ritratti del mecenate," 129–41.

14 Enrico Scrovegni ultimately left Padua in 1320 during a period of major civil strife. Settling in Venice, he was formally banished from Padua in 1328. For the testament, see Attilio Bartoli Langeli, "Il testamento di Enrico Scrovegni (12 marzo 1336)," in Frugoni, *L'affare migliore di Enrico*, 397–539.

15 See Derbes and Sandona, "Barren Metal and the Fruitful Womb." See also Jacobus, "Propria Figura."

16 See Scardeone, *De Antiquitate urbis Patavii et claris civibus patavinis*.

17 The Carraresi, a powerful family on a level with the Visconti of Milan or the Scaligeri of Verona, rose to power in Northern Italy beginning in the 12th century to become signori of Padua (1337–1405) and patrons of Petrarch (1304–1374) as well as of the painter Guariento di Arpo (1310–1370). The fact that Petrarch bequeathed to Francesco his painting of the Virgin by Giotto is indicative of the close connections in this circle of influential patrons and artists linked the Duecento/Trecento cultural landscape.

18 See Frugoni, *L'affare migliore di Enrico*, 111.

19 See Hans Belting, "Assisi e Roma: Risultati, Problemi, Prospettive," in *Roma anno 1300: Atti della IV settimana di Studi di Storia dell'Arte medievale dell'Università di Roma "La Sapienza,"* 93–101.

20 See Rough, "Enrico Scrovegni, the *Cavalieri Gaudenti* and the Arena Chapel in Padua."

21 Scardeone, *De Antiquitate urbis Patavii et claris civibus patavinis*, cols. 332–33. English translation (with minor adjustments): Derbes and Sandona, *The Usurer's Heart*, 12–13.

22 Lubbock appropriately calls one of the chapters in his book on visual narrative "Giotto: Scrovegni's Temple." See Jules Lubbock, *Storytelling in Christian Art from Giotto to Donatello* (New Haven, 2006), 39–83.

23 See Peter Brown, *The Ransom of the Soul: Afterlife and Wealth in Early Western Christianity* (Cambridge, MA, 2015).

24 Simone Weil, *Gravity and Grace* (New York, 1952), 84.

25 See Arsenio Frugoni, *Il giubileo di Bonifacio VIII* (Rome, 1999), and Chiara Frugoni, *Due Papi per un giubileo: Celestino V, Bonifacio VIII e il primo Anno Santo* (Milan, 2000). See also Arnaldo di Medio, *Le prime Grandi Perdonanze: Celestino V e Bonifacio VIII, due papi innovatori* (Barzago, 2002).

26 Emphasis mine.

27 See Schwarz, "Padua, Its Arena and the Arena Chapel."

28 "When you were dead in your sins and in the uncircumcision of your flesh, God made you alive with Christ. He forgave us all our sins, having canceled the charge of our legal indebtedness, which stood against us and condemned us; he has taken it away, nailing it to the cross. And having disarmed the powers and authorities, he made a public spectacle of them, triumphing over them by the cross." See Colossians 2:13–15, including the Christian triumphal theme. See also Lange, "Relief Effects: Giotto's Triumph."

29 "He will change our lowly body to conform with his glorified Body by the power that enables him also to bring all things into subjection to himself." Philippians 3:19. See also Paul in 1. Corinthians 15:35–55: "The first man was of the dust of the earth; the second man is of heaven. As was the earthly man, so are those who are of the earth; and as is the heavenly man, so also are those who are of heaven. And just as we have borne the image of the earthly man, so shall we bear the image of the heavenly man. [. . .] Listen, I tell you a mystery: We will not all sleep, but we will all be changed – in a flash, in the twinkling of an eye, at the last trumpet. For the trumpet will sound, the dead will be raised imperishable, and we will be changed. For the perishable must clothe itself with the imperishable, and the mortal with immortality. When the perishable has been clothed with the imperishable, and the mortal with immortality, then the saying that is written will come true: 'Death has been swallowed up in victory.' 'Where, O death, is your victory? Where, O death, is your sting?'"

30 See Marcellan, "L'artista, l'usuraio, il teologo: Tre voci nella Cappella degli Scrovegni," 31.

31 On Giotto and Scottish theologian and scholar Duns Scotus (ca. 1265–1308), see Michelle A. Erhardt, "The Immaculate Kiss Beneath the Golden Gate: The Influence of John Duns Scotus on Florentine Painting of the 14th Century," *Franciscan Studies* 66 (2008): 269–80. On the English scholar, theologian, and medieval scientist Robert Grosseteste (ca. 1168–1253), bishop of Lincoln from 1235 to 1253, in a panorama of medieval and modern science and humanities discourses, see Tom McLeish, *The Poetry and Music of Science: Comparing Creativity in Science and Art* (Oxford, 2019).

32 See Flores d'Arcais, *Giotto*, 179.

33 See William J. Bouwsma, "The Two Faces of Humanism: Stoicism and Augustinianism in Renaissance Thought," in *A Usable Past: Essays in European Cultural History* (Berkeley, 1990), 19–64, at 45.

34 The Universitas Studii Paduani has a history that predates the official founding date of 1222, and is preceded in Europe only by the Universities of Bologna (1088), Oxford (1167), Cambridge (1209), and Salamanca (1218).

35 Padua had the first collection in the world to be affiliated with a college or university, followed in 1683 by the Ashmolean Museum in Oxford and 1832 by the Yale Art Gallery in New Haven, Connecticut.

36 Pietro d'Abano exemplifies the extent to which Giotto's sophistication was received, see Johannes Thomann, "Pietro d'Abano on Giotto," *Journal of the Warburg and Courtauld Institutes* 54 (1991): 238–44. Note also the importance of the patron saint of students, St. Catherine, for the chapel: Personifying wisdom, perseverance, and Christian triumph,

Catherine was venerated at the side altar and, as noted above, has plausibly been shown to stand with Mary and John to accept the model of the chapel in the dedication portrait. See Pisani, *I volti segreti di Giotto*, 210.

37 This is mentioned in contrast to the traditionally expected Franciscan heritage in Giotto. See Michael W. Alpatow, *Geschichte der Kunst*, vol. 2, *Die Kunst der Renaissance und der Neuzeit* (Dresden, 1964), 12.

38 See Lenka Karfíková, *Grace and the Will According to Augustine* (Leiden, 2012), 246; see also the passage on "*Grace Excluding Pride* (De virginitate)," 124–26.

39 Pseudo-Augustine, as quoted in *Manipulus Florum* (c. 1306), edited by Thomas Hibernicus in 1306, see Paris, Bibl. Nat., MS. No. 16533.

40 See Margaret Ann Zaho, *Imago Triumphalis: The Function and Significance of Triumphal Imagery for Italian Renaissance Rulers* (New York, 2004), 27.

41 Zaho, *Imago Triumphalis*, 92–93.

42 On the Jewish objects in the shrine of San Giovanni in Laterano, see Kessler and Zacharias, *Rome 1300*, 39: "The idea of constructing a Holy of Holies at the Lateran was particularly appropriate because the Lateran church of St. John had long been compared to the Sinai, where Moses received the laws, or, despairingly, to the synagogue. This comparison originated in part because the basilica's altar enshrined not only relics of Christ and the two saints John but also the Temple implements captured by Vespasian and Titus in 70 C.E.: Aaron's rod, the seven-branched candlestick, the altar of incense, the jar of manna, and the shew-bread table." See also Christopher S. Wood, *Forgery, Replica, Fiction: Temporalities of German Renaissance Art* (Chicago, 2008).

43 I am grateful to Marie Champagne for discussing these aspects with me at the Yeshiva University Center for Israel Studies, New York City, 29 October 2017.

44 See John F. Baldovin, *The Urban Character of Christian Worship* (Chicago, 1987), which includes a map of Rome with the stational churches on page 274.

45 See Tommaso Marani, "The Relics of the Lateran According to *Leiðarvísir*, the *Descriptio Lateranensis ecclesiae*, and the Inscription outside the Sancta Sanctorum," *Medium Ævum* 81 (2012): 271–88. See also Eivor Andersen Oftestad, *The Lateran Church in Rome and the Ark of the Covenant: Housing the Holy Relics of Jerusalem; with an Edition and Translation of the* Descriptio Lateranensis Ecclesiae *(BAV Reg. Lat. 712)* (Woodbridge, 2019).

46 Oftestad, *The Lateran Church in Rome and the Ark of the Covenant*, 94. See also Kessler and Zacharias, *Rome 1300*, 94–96.

47 See also Assisi's Minerva Temple / S. Maria sopra Minerva as an architectural portrait in the background of the *Homage of a Simple Man* in the Francis cycle. The precision of this image is crucial to the much-debated Assisi controversy: Bellosi notes that the Minerva Temple portrait helps stabilize a *terminus ante quem* for the fresco, as another level was added to the temple in 1305. Luciano Bellosi, "Giotto, l'Angelico e Andrea del Castagno," in *Mugello Culla del Rinascimento: Giotto, Beato Angelico, Donatello e i Medici*, ed. Barbara Tosti (Florence, 2008), 71–97, at 76. See also Francesco Benelli, "The Medieval Portrait of Architecture: Giotto and the Representation of the Temple of the Minerva in Assisi," in *Some Degree of Happiness: Studi di storia dell'architettura in onore di Howard Burns*, ed. Maria Beltramini and Caroline Elam (Pisa, 2009), 31–42 and 634–35.

48 See Richard Krautheimer, "Introduction to an 'Iconography of Medieval Architecture,'" in *Studies in Early Christian, Medieval, and Renaissance Architecture* (New York, 1969), 115–50.

49 The road from North Germany, for instance, alignes Stade, Celle, Augsburg, Schongau, Innsbruck, Brenner, Treviso, Venice, Ravenna, Forlì, Arezzo, Orvieto, Bolsena, Rome.

50 Marcellan, "L'artista, l'usuraio, il teologo: Tre voci nella Cappella degli Scrovegni," 31. See also Kohl, "Chronicles into Legends and Lives: Two Humanist Accounts of the Carrara Dynasty in Padua," 184.

51 Marcellan, "L'artista, l'usuraio, il teologo: Tre voci nella Cappella degli Scrovegni," 32.

52 See the eponymous catalogue of triumphal arches assembled by Tanja Itgenshorst, *Tota illa pompa: Der Triumph in der römischen Republik; mit einer CD-ROM, Katalog der Triumphe von 340 bis 19 vor Christus* (Göttingen, 2005).

53 To mention two of many musical examples, *In dir ist Freude in allem Leide (Freudenlied)* contains the line "Wir jubilieren und triumphieren" (Cyriakus Schneegaß, 1546–1597). Likewise, *Adeste fideles* includes the triumphal theme with the first line "læti triumphantes," possibly stemming from a medieval text source. The jubilant musical score, probably composed by John Francis Wade, has this motif transported into English as "O come, all ye faithful, joyful and triumphant" and into German "Herbei, o ihr Gläub'gen, fröhlich triumphieret" (1826, Friedrich Heinrich Ranke).

54 See Peter Dronke, "Riuso di forme e immagini antiche nella poesia," in *Ideologie e pratiche del reimpiego nell'alto medioevo* (Spoleto, 1999), 1:283–312, at 283: "Nella poesia latina dell'alto medioevo il riuso di elementi classici può manifestarsi come citazione oppure come imitazione. Ma nei casi più affascinanti [. . .] si tratta piuttosto di *trasformazione* – di un uso nuovo, un cambiamento creativo

della forma, che va al di là della forma esterna. Perciò, quando parlo di 'forma' d'ora in avanti, non voglio limitarmi agli aspetti più ovviamente 'formali' della poesia, quali metro, ritmo e rima. Penso sopratutto alla forma interna, a tutti i modi in cui un poema è organizzato."

55 One example of this continuity are Carolingian triumphal arch reliquaries. See Linda Seidel, *Songs of Glory: The Romanesque Façades of Aquitaine* (Chicago, 1981). Seidel illustrates (172–73, fig. 17) a folded paper model of the lost *Arch of Einhard*: "drawing of a lost Carolingian reliquary base," Bibliothèque nationale, Paris, Fr. 10440 f. 45 (Photo, Bibl. nat. Paris). See also Jens T. Wollesen, "'Ut poesis pictura?' Problems of Images and Texts in the Early Trecento," in *Petrarch's Triumphs: Allegory and Spectacle*, ed. Konrad Eisenbichler and Amilcare A. Iannucci (Ottawa, 1990), 183–210, at 194, fig. 7.

56 See Paul Zanker, *Die Apotheose der römischen Kaiser* (Munich, 2004).

57 On Rome's *Nachleben*, see *Der Fall Roms und seine Wiederauferstehungen in Antike und Mittelalter*, ed. Henriette Harich-Schwarzbauer and Karla Pollmann (Berlin, 2013); for the Augustinian argument on Rome see, in particular, Therese Fuhrer, "Rom als Diskursort der Heterodoxie und Stadt der Apostel und Märtyrer: Zur Semantik von Augustins Rombild-Konstruktionen," in *Der Fall Roms und seine Wiederauferstehungen in Antike und Mittelalter*, 53–75. See also Marie-Claire Berkemeier-Favre, "Das Schöne ist zeitlos: Gedanken zum Herimannkreuz," in *Das Denkmal und die Zeit: Alfred A. Schmid zum 70. Geburtstag*, ed. Bernhard Anderes et al. (Lucerne, 1990), 258–334. See also Herbert Bloch, "The New Fascination with Ancient Rome," in *Renaissance and Renewal in the Twelfth Century*, ed. Robert L. Benson and Giles Constable (Cambridge, MA, 1982), 615–36; Arnold Esch, "Reimpiego dell'antico nel medioevo: La prospettiva dell'archeologo, la prospettiva dello storico," in *Ideologie e pratiche del reimpiego nell'alto medioevo*, 73–108; and Arnold Esch, "Spolien: Zur Wiederverwendung antiker Baustücke und Skulpturen im mittelalterlichen Italien," *Archiv für Kulturgeschichte* 51 (1969): 1–64, on the Cosmati, the imitation of spolia, and the *interpretatio christiana*. See also Anthony Cutler, "Reuse or Use? Theoretical and Practical Attitudes Toward Objects in the Early Middle Ages," in *Ideologie e pratiche del reimpiego nell'alto medioevo*, 1055–79; William Tronzo, "On the Role of Antiquity in Medieval Art: Frames and Framing Devices," in *Ideologie e pratiche del reimpiego nell'alto medioevo*, 1085–1111; Gisella Cantino Wataghin, "*. . .ut haec aedes Christo Domino in Ecclesiam consecretur*: Il riuso Cristiano di edifici

antichi tra tarda antichita e alto medioevo," in *Ideologie e pratiche del reimpiego nell'alto medioevo*, 673–750; Arnold Esch, "L'uso dell'antico nell'ideologia papale, imperiale e comunale," in *Roma antica nel Medioevo: Mito, rappresentazioni, sopravvivenze nella "Respublica Christiana" dei secoli IX–XIII*, ed. Pietro Zerbi (Milan, 2001), 3–25.

58 Proposing that chants ("III idus Maias dedicatio basilicae sanctæ Mariæ ad martyres") might have been composed for the Pantheon's rededication in 609, Rankin underscores the specific *romanità* expressed in "the directness of the communication from the people of Rome to God, their only intercessor the pope." Susan Rankin, "Terribilis est locus iste: The Pantheon in 609," in *Rhetoric Beyond Words: Delight and Persuasion in the Arts of the Middle Ages*, ed. Mary Carruthers (Cambridge, 2010), 281–310, at 302. See also Francesco Stella, "Roma antica nella poesia mediolatina: Alterità e integrazione di un segno poetico," in *Roma antica nel Medioevo*, 277–308; Jean-Loup Lemaître, "La présence de la Rome antique dans la liturgie monastique et canoniale du IX^e au XIII^e siècle," in *Roma antica nel Medioevo*, 93–129.

59 See Zaho, *Imago Triumphalis*, 18.

60 See Noack, "Triumph und Triumphbogen," 168. Noack takes the celebration of the triumph as the starting point for his investigation of the arch's meaning; similarly, each celebration of worship prefigures the ultimate triumph: "So wird der Weg zu einem tieferen Verständnis nach allen Seiten frei: kein Ehrenmal für Menschen, sondern ein Weih- und Dankgeschenk an die Gottheit, die man zur Siegverleihung, auspicato, verpflichtet wie sich selbst zum Siegesdank." See Noack, "Triumph und Triumphbogen," 150: "[in unklarer Tradition herrscht jedoch sogar Unklarheit wie es sich verhält zum] Sieg über den Feind, sei es denn errungenen oder – was eines der frühesten Beispiele zu sagen scheint – den noch zu erringenden Siege."

61 Kleiner, *Roman Sculpture*, 189.

62 Kleiner, *Roman Sculpture*. 189.

63 Kleiner, *Roman Sculpture*, 190.

64 Michael Victor Schwarz, "Image as Spectacle, Image as Event," Talk at Yale University (Department of the History of Art), New Haven, 24 September 2013.

65 Kleiner, *Roman Sculpture*, 190.

66 On Scrovegni's portraits, see Prinz, "Ritratto istoriato oder das Bildnis in der Bilderzählung: Ein frühes Beispiel von Giotto in der Bardikapelle," 577–78, and di Fabio, "Memoria e modernità." The testament also ensured that the divine Office would always be celebrated in the chapel: Scrovegni ordered the construction of a large residence for the appointed clergy with

their servants. See Derbes and Sandona, "Enrico Scrovegni: I ritratti del mecenate," 192.

67 See Derbes and Sandona, "Barren Metal and the Fruitful Womb."

68 See the nuanced perspective on Jewish aniconism during the Second Temple period in Jason von Ehrenkrook, *Sculpting Idolatry in Flavian Rome: (An) Iconic Rhetoric in the Writings of Flavius Josephus* (Atlanta, 2011). See Daniela di Castro, "Gli ebrei romani all'epoca del giubileo di Bonifacio VIII," in *Bonifacio VIII e il suo tempo*, 69–72. See also Giuseppa Z. Zanichelli, "Manoscritti Ebraici Romani," in *Bonifacio VIII e il suo tempo*, 111–16.

69 See *Money and Beauty: Bankers, Botticelli and the Bonfire of the Vanities*, ed. Ludovica Sebregondi and Tim Parks (Florence, 2011). See also the 2014 New England Renaissance Conference, "Cultures of Credit and Debt in Medieval and Early Modern Europe," 11 October 2014, at the University of New Hampshire.

70 Virginia L. Bush, "The Sources of Giotto's *Meeting at the Golden Gate* and the Meaning of the Dark-Veiled Woman," *Bollettino del Museo Civico di Padova* 61 (1972): 7–29.

71 Bush, "Sources of Giotto's *Meeting at the Golden Gate* and the Meaning of the Dark-Veiled Woman," 28.

72 See Benedikt Oehl, "Die *Altercatio Ecclesiae et Synagogae*: Ein antijudaistischer Dialog der Spätantike," PhD diss., Rheinische Friedrich-Wilhelms-Universität, Bonn, 2012.

73 See Steven Fine, "The Menorah and the Cross: Historiographic Reflections on a Recent Discovery from Laodicea on the Lycus," in *New Perspectives on Jewish-Christian Relations in Honor of David Berger*, ed. E. Carlebach and J. J. Schacter (Leiden, 2012), 31–50.

74 See the portal sculptures of the Cathedrals in Strasbourg, Bamberg, Freiburg, Bourges, Chartres, Metz, and Burgos. See Wolfgang S. Seiferth, *Synagoge und Kirche im Mittelalter* (Munich, 1964); Franz Böhmisch, "Exegetische Wurzeln antijudaistischer Motive in der christlichen Kunst," *Das Münster* 50 (1997): 345–58; Herbert Jochum, "Ecclesia und Synagoga: Alter und Neuer Bund in der christlichen Kunst," in *Der ungekündigte Bund? Antworten des Neuen Testaments*, ed. Hubert Frankemölle (Freiburg, 1998), 248–76; Ursula Homann, "Vergessene Concordia: Ecclesia und Synagoga," *Die Zeichen der Zeit: Lutherische Monatshefte* 1 (1999): 25–28.

75 See Nina Rowe, *The Jew, the Cathedral, and the Medieval City: Synagoga and Ecclesia in the Thirteenth Century* (Cambridge, 2011), 12.

76 For the broken triumphal banner as a sign of Synagoga in a wood relief sculpture from Bremen Cathedral, see Bernhard Blumenkranz, *Le juif médiéval au miroir de l'art chrétien* (Paris, 1966), 65, fig. 70, and also 64, fig. 68, for the detail from the *Livre d'heures de Rohan*. For further illustrations, see also Seiferth, *Synagoge und Kirche im Mittelalter*, figs. 19, 20, 22, 26–28, 42, 58, and 60.

77 See Jacobus, *Giotto and the Arena Chapel*, 209–11.

78 Jacobus, *Giotto and the Arena Chapel*, 209.

79 Galatians 3:28.

80 See *Nach der Verurteilung von 1277: Philosophie und Theologie an der Universität von Paris im letzten Viertel des 13. Jahrhunderts, Studien und Texte = After the Condemnation of 1277: Philosophy and Theology at the University of Paris in the Last Quarter of the Thirteenth Century, Studies and Texts*, ed. Jan A Aertsen, Kent Emery, and Andreas Speer (Berlin, 2001). Special thanks to Randolph Starn for sharing his insights on these texts.

CHAPTER 4

1 Frugoni, *Gli affreschi della Cappella Scrovegni a Padova*, 160.

2 Bruce Cole, "Virtues and Vices in Giotto's Arena Chapel Frescoes," in *Studies in the History of Italian Art, 1250–1550* (London, 1996), 337–63, at 370.

3 Christian-Adolf Isermeyer, "Rahmengliederung und Bildfolge in der Wandmalerei bei Giotto und den Florentinern Malern des 14. Jahrhunderts," PhD diss., Göttingen, Würzburg, 1937, 5–6.

4 Krieger, *Grisaille als Metapher*, 65. For illustrations of the Bardi niche figures, see Rona Goffen, *Spirituality in Conflict: Saint Francis and Giotto's Bardi Chapel* (University Park, 1988), figs. 59–61.

5 See Krieger, *Grisaille als Metapher*, 66–67.

6 For exact identifications of the Saints, see Bellinati, *Padua Felix*.

7 When Poeschke writes that there were no illusionistic architectural elements in the chapel, he seems to underestimage the committment to the fiction of relief throughout the entire framing system, from the faux dentils to the faux architrave. See Poeschke, *Wandmalerei der Giottozeit in Italien*, 185.

8 The prefiguration vignettes show the *Blinding of Satan*, the *Brazen Serpent* and so forth.

9 For the direct impact on the local schools, see Davide Banzato, "L'impronta di Giotto e lo sviluppo della pittura del Trecento a Padova," in *Giotto e il Trecento*, 143–55.

10 See Chapter 2, footnote 20.

11 See Bruschi, "Prima del Brunelleschi: verso un'architettura sintattica e prospettica," 51, who notes the

unification through the lower register. See also Fry who assumes a single coordinated scheme would only be thinkable for Michelangelo in the Sistine ceiling: Fry, *Vision and Design*, 108.

12 See Irene Hueck, "Giotto und die Proportion," in *Festschrift Wolfgang Braunfels zum 65. Geburtstag*, ed. Friedrich Piel and Jörg Traeger (Tübingen, 1977), 145.

13 Hueck, "Giotto und die Proportion," 147.

14 See Euler, *Die Architekturdarstellung in der Arena-Kapelle*, 23–24.

15 See Gosbert Schüßler, "Giottos visuelle Definition der 'Sapientia Saeculi' in der Cappella Scrovegni zu Padua," in *Opere e giorni: Studi su mille anni di arte europea dedicati a Max Seidel*, ed. Klaus Bergdolt and Giorgio Bonsanti (Venice, 2001), 111–22, and Irene Hueck, "Sovrapporta con figure allegoriche," in *La Cappella degli Scrovegni a Padova*, 211–14.

16 See Frojmovič, "Giotto's Circumspection," 200, for the miniature in the *Documenta amoris* (Francesco da Barberino, *Circumspectio*, Biblioteca Apostolica Vaticana MS Barb. Lat. 4076, fol. 101r). For "Visual Rhetoric and Visual Knowledge" in relation to Pietro Abano, see Frojmovič, "Giotto's Circumspection," 204–7. See also Sven Georg Mieth, "Giotto: Das mnemotechnische Programm der Arenakapelle in Padua," PhD diss., Universität Tübingen, 1990. Frojmovič proposes that the female figure of *Circumspection* inspects the entire cosmos with multiple eyes, perhaps indicating some sense of emission or extramissive vision. See Frojmovič, "Giotto's Circumspection," 203.

17 See Giuliano Pisani, "La fonte agostiniana della figura allegorica femminile sopra la porta palaziale della Cappella degli Scrovegni," *Bollettino del Museo Civico di Padova* 99 (2014): 35–46. See also Giuliano Pisani, "Le figure allegoriche dipinte da Giotto sopra la porta laterale d'accesso alla Cappella degli Scrovegni," in Pisani, *I volti segreti di Giotto*, 67–77. See also Pisani, *I volti segreti di Giotto*, 267.

18 A similar ornament appears on the large angels' wings as well as on the angels' wings in Giotto's *Dormitio Virginis* in Berlin's *Gemäldegalerie*.

19 The beasts and their complex iconography are best illustrated and carefully discussed in Pisani, *I volti segreti di Giotto*, see "Il centauro di Cristo," 240–45 and figs. 20–22. Though not as well distinguishable, the colorful creatures foreshadow Giusto's illustrations in the Paduan baptistery.

20 Accepting Creighton Gilbert's thesis on Giotto's lost Milan *Glory* frescoes, we can add yet another comparison to a frontal figure emerging from the plane in Giotto's work. See Creighton Gilbert, "The Fresco by Giotto in Milan," *Arte Lombarda* 47–48 (1977): 31–72.

21 In her study of biblical and apocryphal sources for the chapel's program, Maria von Nagy interprets the Blessed and the damned in their difference of scale and appearance. See Maria von Nagy, *Die Wandbilder der Scrovegni-Kapelle zu Padua: Giottos Verhältnis zu seinen Quellen* (Bern, 1962), 38.

22 The large figure of Mary is so distinctive that, in her monumentalized garments, Schmidt anchors an "eigene Entelechie der Haarnadelfalte." See Gerhard Schmidt, "Probleme der Begriffsbildung: Kunsthistorische Terminologie und geschichtliche Realität," in *Gotische Bildwerke und ihre Meister (Textband)* (Vienna, 1992), 313–56, at 342.

23 On Jerome's "Mors per Evam, vita per Mariam," see Dorothy C. Shorr, "The Role of the Virgin in Giotto's *Last Judgment*," *Art Bulletin* 38 (1956): 207–14.

24 See Pisani, *I volti segreti di Giotto*.

25 *The Tempest*, Act I, Scene 2.

26 This detail compares to the innerpictorial acknowledgment of the frame in the Naumburg screen, see Jacqueline E. Jung, *The Gothic Screen: Space, Sculpture, and Community in the Cathedrals of France and Germany, circa 1200–1400* (Cambridge, 2012), 37–43.

27 See Brendan Cassidy, "Laughing with Giotto at Sinners in Hell," *Viator* 35 (2004): 355–86, and Assaf Pinkus, "A Voyeuristic Invitation in the Arena Chapel," in *Sehen und Sakralität in der Vormoderne*, ed. David Ganz and Thomas Lentes (Berlin, 2011), 106–19.

28 Whitney Davis, "Medium Effects: On Henrike Lange's *Giotto's Triumph*," conference paper, University of California, Berkeley, February 2020.

29 See the related passages in Isaiah 34:4 and Revelation 6:13–14 ("The sky vanished like a scroll that is being rolled up, and every mountain and island was removed from its place"). See also the passage "Nevertheless we, according to his promise, look for new heavens and a new earth, wherein dwelleth righteousness," 2 Peter 3:13; "And I saw a new heaven and a new earth: For the first heaven and the first earth were gone; and there was no more sea," Revelation 21:1; "And he will put an end to all their weeping; and there will be no more death, or sorrow, or crying, or pain; for the first things have come to an end," Revelation 21:4; "And he who is seated on the high seat said, See, I make all things new. And he said, Put it in the book; for these words are certain and true," Revelation 21:5. See also Augustinus, *Confessiones* XIII, 15, and Fredriksen, *Augustine and the Jews*, 190.

30 "The glorious abode of God [...] looks very much like a leather and wood Bible cover, inset with diamonds. Thus the sky seems the emanation of the

celestial architecture, that is, the Bible." See Claude Gandelman, *Reading Pictures, Viewing Texts* (Bloomington, 1991), 135, in particular chapter 10, "Peeling Off Skins," 131–40.

31 Gandelman, *Reading Pictures, Viewing Texts*, 135.

32 "[Die Engel] stehen nicht nur an einer anderen Stelle im Syntagma, sondern sie stehen in einem anderen Syntagma, das auch im Angesicht der letzten Dinge die Koordinaten einer natürlichen Ordnung aufrechterhält." See Wolfgang Kemp, "Das letzte Bild: Welt-Ende und Werk-Ende bei Giotto und Dante," in *Das Ende: Figuren einer Denkform*, ed. Karlheinz Stierle and Rainer Warning (Munich, 1996), 415–34, at 423.

33 "Wenn horror vacui einen Sinn macht, dann in Anwendung auf die mittelalterliche Bildtradition dieses Sujets, die in Antizipation zukünftiger Leere noch einmal zusammenrafft, was an Bildzeichen der christlichen Ikonographie teuer gewesen war." Kemp, "Das letzte Bild," 423.

34 Kemp further discusses the counteraction of rolling *up* the cosmic text in the *Last Judgment* after having rolled *out* the stories on the walls, see Kemp, "Das letzte Bild," at 426; see also 416 and 433–34. Similarly, on the *incipit* and the volume as *cilindro* and *rottolo*, see Giuseppe Mazzotta, "La Metafisica della Creazione," in *Confine quasi orizzonte: Saggi su Dante* (Rome, 2014), 97–114, at 107.

35 For transcripts of the remaining inscriptions, see Bellinati, *Padua Felix*, 132–37, and Schwarz, *Giotto*, 133–58. There may have been another line of transmission from these kinds of figures from antiquity to the Christian tradition: An early, full-length portrait of Saint Francis in S. Francesco a Subiaco is painted as if standing like a polychrome sculpture in front of a similar framing stone background bearing his title and name. This fresco seems to be datable before 1224 since the figure bears neither stigmata nor halo.

36 For the general concept in the visual arts, see Adolf Katzenellenbogen, "Die Psychomachie in der Kunst des Mittelalters von den Anfängen bis zum 13. Jahrhundert," PhD diss., Univ. Hamburg, 1933, and Adolf Katzenellenbogen, *Allegories of the Virtues and Vices in Medieval Art: From Early Christian Times to the Thirteenth Century* (London, 1939). See Selma Pfeiffenberger, "The Iconology of Giotto's Virtues and Vices at Padua," PhD diss., Bryn Mawr College, 1966; Thomas Dittelbach, *Das monochrome Wandgemälde: Untersuchungen zum Kolorit des frühen 15. Jahrhunderts in Italian* (Hildesheim, 1993). See also the excellent account in Schwarz, "Lieder und Bilder: Die Allegorien," in *Giottus Pictor*, vol. 2, *Giottos Werke*, 133–58; Krieger, *Grisaille als Metapher*, especially

54–67; Cole, "Virtues and Vices in Giotto's Arena Chapel Frescoes"; and Cosnet, "Les personifications dans la peinture monumentale en Italie au XIVe siècle." See also Jonathan B. Riess, "Justice and Common Good in Giotto's Arena Chapel Frescoes," *Arte Cristiana* 72 (1984): 69–80; Douglas P. Lackey, "Giotto in Padua: A New Geography of the Human Soul," *The Journal of Ethics* 9 (2005): 551–72; Andrea Lermer, "Planetengötter im Gotteshaus: Zur Ikonographie von Guarientos Freskenzyklus der Sieben Planeten und Lebensalter in der Eremitanikirche zu Padua," *Arte Medievale* 11 (1997): 151–69; and Andrea Lermer, "Giotto's Virtues and Vices in the Arena Chapel: The Iconography and the Possible Mastermind Behind It," in *Out of the Stream: Studies in Medieval and Renaissance Mural Painting*, ed. Luís Urbano Afonso and Vítor Serrão (Newcastle, 2007), 291–317. On the iconology of the selection and sequence, see Pisani, *I volti segreti di Giotto*. For a focus on the simulated materiality and astrological implications, see Cordez, "Les marbres de Giotto."

37 See Krieger, *Grisaille als Metapher*, 55–56.

38 See Euler, *Die Architekturdarstellung in der Arena-Kapelle*, 68. See also Serena Romano, "Giotto e la nuova pittura: Immagine, parola e tecnica nel primo Trecento Italiano," in *Il secolo di Giotto nel Veneto*, ed. Federica Toniolo and Giovanna Valenzano (Venice, 2007), 7–43. Historiographic trends of the 1980s and 90s problematically isolated the dado zone in order to include it in later discourses of painted art theories. See Reinhard Steiner, "Paradoxien der Nachahmung bei Giotto: Die Grisaillen der Arenakapelle zu Padua," in *Die Trauben des Zeuxis: Formen künstlicher Wirklichkeitsaneignung*, ed. Hans Körner et al. (Hildesheim, 1990), 61–86.

39 See Schwarz, *Giottus Pictor*, vol. 2, *Giottos Werke*, 137. See also Michael Viktor Schwarz, "Goldgrund im Mittelalter – 'Don't ask for the meaning, ask for the use!'" in *Gold*, ed. Agnes Husslein-Arco and Thomas Zaunschirm (Munich, 2011), 28–37.

40 See Pisani, *I volti segreti di Giotto*, 184. Pisani mentions a passage in Augustine's *De genesi contra Manichaeos* (II, 10, 13) which refers to Genesis 2:10–14. See also Pisani, *I volti segreti di Giotto*, 187, on Augustine's *De doctrina Christiana* I, 37, 41.

41 Alpatoff, "The Parallelism of Giotto's Paduan Frescoes."

42 This Janus-like head type is even more pronounced later in the first set of baptistery doors by Andrea Pisano in Florence.

43 Ladis, *Giotto's O*, 34.

44 Samuel Y. Edgerton, *The Heritage of Giotto's Geometry: Art and Science on the Eve of the Scientific Revolution* (Ithaca, NY, 1991), 76.

45 The woman on the ground, stripped naked by one man, is being attacked with a sword by another man

who stands at her feet. See also Miklós Boskovits, "Giotto: Un artista poco conosciuto?" in *Giotto: Bilancio critico di sessant'anni di studi e ricerche*, ed. Angelo Tartuferi (Florence, 2000), 75–95, at 84.

46 See Valerio Mariani, *Giotto* (Rome, 1937), 37.

47 Sélincourt, *Giotto*, 157.

48 See the chapter "Music and Justice in Giotto's Scrovegni Chapel Frescoes" in Beck, *Giotto's Harmony*, 107–29, at 110. For the theme of Justice, see also Umberto Vincenti, "La Giustizia di Giotto," in Umberto Vincenti and Francesca Marcellan, *La Giustizia di Giotto* (Naples, 2006), 69–92.

49 Beck, *Giotto's Harmony*, 107–8.

50 For a large detail illustration, see Frugoni, *L'affare migliore di Enrico*, 322.

51 The crown of roses might recall the Paduan festival of flowers during which the prettiest girls gathered under a silken canopy to be garlanded with flowers and fruit by the young men. See Hélène Nolthenius, *Duecento: The Late Middle Ages in Italy* (New York, 1968), 66.

52 Sélincourt, *Giotto*, 162.

53 See Riess, "Justice and Common Good in Giotto's Arena Chapel Frescoes": The diagram in fig. 3 connects the line of the virtues from *Prudence* to *Hope* with an ascending vector.

54 Sirén, *Giotto and Some of His Followers*, 1:50.

55 Sirén, *Giotto and Some of His Followers*, 1:50.

56 "RES ET TEMPUS SUMMA CURA [...] / [...] UIDENTIS MEMORATU[R] [...]."

57 Kristeva, "Giotto's Joy," 224.

58 Kristeva discusses the mirror stage: "Blue in particular [...] would have a noncentred or decentering effect, lessening both object identification and phenomenal fixation"; "Giotto's Joy," 225.

59 Sélincourt, *Giotto*, 101.

60 Sélincourt, *Giotto*, 102.

61 Wolfram Prinz, *Die Storia oder die Kunst des Erzählens in der italienischen Malerei und Plastik des späten Mittelalters und der Frührenaissance 1260–1460; Textband* (Mainz, 2000), 77.

62 Paul Hills, *The Light of Early Italian Painting* (New Haven, 1987), 41.

63 Hills, *Light of Early Italian Painting*, 43. See also Gardner's criticism of the viewer's experience today, "the internal space [...] brutally falsified by raising the original floor level and bathing the frescoes in a uniform, ahistorical light." Gardner, *Giotto and His Publics*, 7. Natural light determined the chapel's design on several levels: The movements of sunlight across the space at certain times of the year has been of scholarly interest, especially in relation to the Feast of the Annunciation, when sunlight strikes the dedication scene, connecting Enrico Scrovegni, the chapel, and Mary between the hours of ten and eleven every 25 March. See, among others, Frugoni, *L'affare migliore di Enrico*, 149, and Cordez, "Les marbres de Giotto," 20–21.

64 See Imdahl, *Giotto*, 15, quoting Hausenstein.

65 For blue ground in the Greek relief tradition, see Brinkmann, *Die Polychromie der archaischen und frühklassischen Skulptur*, 41. See also Elena Walter-Karydi, "The Coloring of the Relief Background in Archaic and Classical Greek Sculpture," in *Gods in Color*, 172–77.

66 See Ladis, *Giotto's O*, 17–18.

67 Flores d'Arcais, *Giotto*, 140.

68 The photos are usually cut uncomfortably narrow, still disclosing at least at the top or at the bottom edges that they are not rectangular images; in the case of the large edition of the 1997 *Padua felix*, the upper scenes are even digitally stretched and deformed to fit into the rectangular layout. See Claudio Bellinati, *Giotto: Padua felix; Atlante iconografico della Cappella di Giotto 1300–1305* (Treviso, 1997).

69 Puttfarken illustrates this issue with Hetzer's description of a visit to the chapel being like one to a modern picture gallery. See Thomas Puttfarken, *The Discovery of Pictorial Composition: Theories of Visual Order in Painting 1400–1800* (New Haven, 2000), 11. See also the subsequent discussion of frame/border and plane/surface: "The easel-picture mode of seeing cuts off not a connection or continuity between figures and viewers, but between the planimetric relationships of each scene and those of the decoration as a whole." Ibid., 16–17.

70 Berenson's studies first appeared in New York as *The Venetian Painters of the Renaissance* (1894), *The Florentine Painters of the Renaissance* (1896), *The Central Italian Painters of the Renaissance* (1897), and *North Italian Painters of the Renaissance* (1907). In 1930, he published in London a collection of these introductory essays as *The Italian Painters of the Renaissance*.

71 Creighton Gilbert, "Florentine Painters and the Origins of Modern Science," in *Arte in Europa: Scritti di Storia dell'Arte in onore di Edoardo Arslan* (Milan, 1966), 333–40, at 335.

72 Without naming any specific comparanda, Ladis calls the *Massacre of the Innocents* as "dense" and "furious" as an ancient battle relief. See Ladis, *Giotto's O*, 89.

73 Sirén, *Giotto and Some of His Followers*, 1:55.

74 Sirén, *Giotto and Some of His Followers*, vol. 1.

75 See Anne Mueller von der Haegen, "Die Darstellungsweise Giottos mit ihren konstitutiven Momenten, Handlung, Figur und Raum im Blick auf das mittlere Werk," PhD diss., Universität Würzburg (Braunschweig, 2000), 33–34.

76 See Cesare Gnudi, "Sugli inizi di Giotto e i suoi rapporti col mondo gotico," in *L'arte gotica in Francia e in Italia* (Torino, 1982), 55–76.

77 See the classical accounts of the wall's surface in Rintelen, *Giotto und die Giotto-Apokryphen* (1912), Berenson, *The Florentine Painters of the Renaissance*, and Offner, "Giotto, non-Giotto."

78 See Summers, *Real Spaces*, and see Davis, *Visuality and Virtuality*.

79 Davis, "Medium Effects." With his distinction of "looking at images" versus "looking at pictures," in *Visuality and Virtuality*, Davis importantly calls attention to a crucial fact of "a particular recursion of images": "The very introduction of pictures into visual space – the 'presence of pictoriality' [...] integrates features into visual space that often would not otherwise be part of it. That is, features are introduced that would not be aspects of the visible world, and indeed are not aspects of it for any agents of vision who have not fully succeeded to the form of life in which the pictures as such were made to be used, whatever else might be visible to these people. For one succeeds to the 'visuality' of a picture, and indeed to any item of visual culture, by way of the forms of likeness – emergent networks of both the visual and the non visual analogies of visible things – that make it salient in particular ways. [...] In this sense depictions might be said to supervene in the visible world. In the recursion of pictoriality in visuality, they virtualize the visual world in partly invisible ways." Davis, *Visuality and Virtuality*, 10. See also Whitney Davis, *A General Theory of Visual Culture* (Princeton, 2011).

80 See Henrike Christiane Lange, "Relief Effects in Donatello and Mantegna," in *The Reinvention of Sculpture in Fifteenth-Century Italy*, ed. Amy Bloch and Daniel M. Zolli (Cambridge, 2020), 327–343. See also Henrike Christiane Lange, "Cimabue's True Crosses in Arezzo and Florence," in *Material Christianity: Western Religion and the Agency of Things*, ed. Christopher Ocker and Susanna Elm (Cham, 2020), 29–67.

81 The only use of the term "relief effects" previous to Lange's "Relief Effects" might be found in Sirén's 1917 study of Giotto, *Giotto and Some of His Followers*, which, however, contains an abundant use of the word "effect" (143 times in more than 35 variations in the English translation from the Swedish by Frederic Schenck). Sirén uses the exact words "relief effects" (1:49) to characterize the Arena frescoes when generalizing from a discussion of the *Virtues* and *Vices*: "These paintings are executed in grisaille, imitating reliefs carved in stone, and thus in color as in position form a base for the pictures above. Such treatment naturally adapts itself to Giotto's artistic style, for it gives full scope for the *relief effects* [emphasis mine] that the artist so often sought in his compositions, and is the most advantageous medium for his unusual skill in bringing out the plastic form values of the human figure." However, Sirén uses the word "effect" descriptively and without introducing any theoretical stakes; his use of the term has not been noted or taken up by other scholars. As mentioned above, Serena Romano discusses relief for Giotto brilliantly and extensively in the Italian text of her 2008 *La O di Giotto*; the English translation by Sarah Melker (*Giotto's O*, Bologna, 2015) then includes the expression "relief effect."

82 See Boccaccio, *Decamerone, giornata VI, novella 5*. See also Michael Baxandall, *Giotto and the Orators: Humanist Observers of Painting in Italy and the Discovery of Pictorial Composition, 1350–1450* (Oxford, 1971), 74–75. In her account of constitutive moments, Mueller von der Haegen divides Giotto's space-generating figures and figure-embracing space in terms of narrative, allegorical, and hierarchical inventions. Offner characterizes "Giotto's tight organization of plastic, spatial and psychological elements"; see Richard Offner, "A Great Madonna by the St. Cecilia Master," *Burlington Magazine* 1 (1927): 90–104, at 97.

83 The distribution of isolated landscape elements appears as if designed for an execution in relief sculpture: In *Joachim's Dream*, the nine tiny elements of vegetation stand on the surface of the stone-grey land between Joachim and the animals. They appear as isolated as those later, clearly demarcated miniature plants on the bronze surfaces of Andrea Pisano's relief landscapes on the Florentine baptistery's south door. See *Young John in the Wilderness, Ecce Agnus Dei*, and the Baptism scenes (*Baptism of the Multitude* and *Baptism of Christ*).

84 Mark J. Zucker, "Figure and Frame in the Paintings of Giotto," *Source* 1 (1982): 1–5, at 5. Martin Gosebruch emphasizes the obvious relief qualities of this scene in terms of the "vorderen Ebene des Figurenreliefs," see Martin Gosebruch, "Figur und Gestus in der Kunst des Giotto," in *Giotto di Bondone*, ed. Gosebruch et al. (Constance, 1970), 7–125 at 63.

85 See Smart, *Assisi Problem and the Art of Giotto*, 90. The kiss of Judas emphasizes here the corruption of the companionship and intimacy from the earlier two scenes (*Last Supper, Washing of the Feet*).

86 See Moshe Barrasch, *Giotto and the Language of Gesture* (Cambridge, 1987).

87 Fry, "Giotto: The Church of S. Francesco of Assisi," 87–116, at 109.

88 See William Tronzo, "Giotto's Figures," in *Cambridge Companion to Giotto*, 63–75, at 68. For sarcophagi available in the Trecento see Phyllis Pray Bober and Ruth Rubinstein, *Renaissance Artists & Antique Sculpture: A Handbook of Sources* (Oxford, 1986), 143–47, figs. 117–18. On the anchoring and echoing of emotional-psychological relations among the figures in the prominent line of a background crag, see also Rintelen, *Giotto und die Giotto-Apokryphen* (1912), 42–43.

89 Hills integrates a discussion of a "metope type of high relief" and relief sculpture in general into his analysis of the frescoes and their illumination: "Just how far Giotto was prepared to envisage a raking light remains within the limits of angle that a relief, or a figure in the round placed against a wall, might be satisfactorily illuminated. [...] The proportions of light to shadow on Giotto's figures is generally two-third to one-third, and figures are only very rarely more than two-third shaded. If the grisailles of the dado were not evidence enough, the proportion of light to shadow in the modelling tells of Giotto's eye for the revelation of sculptural form by the stable *lume*." Paul Hills, "Light and Colour in the Scrovegni Chapel" and "Giotto and the Students of Optics: Bacon, Pecham and Witelo" in *Light of Early Italian Painting*, 41–71, at 52.

90 "Klarheit der Aktion," see Friedrich Rintelen, *Giotto und die Giotto-Apokryphen: Zweite, verbesserte Auflage* (Basel, 1923), 62. "Notwendig," "einfach," see Rintelen, *Giotto und die Giotto-Apokryphen* (1923), 15. "Notwendig oder, was dasselbe ist, einfach," see Theodor Hetzer, "Über Giottos Einfachheit," in Hetzer, *Giotto*, 253–57. "Ganzheit," see Ueberwasser, *Giotto*, 21. "Unity," see Smart, *Assisi Problem and the Art of Giotto*, 90, here in relation to the *Kiss of Judas*. "Unità costruttiva," see Carlo Carrà, "Parlata su Giotto," in *Tutti gli scritti*, ed. Massimo Carrà (Milan, 1978), 63–72, at 66, first published in *La Voce*, 162–74.

91 See Euler, *Die Architekturdarstellung in der Arena-Kapelle*, 20.

92 See Benelli, *Architecture in Giotto's Paintings*, at xv. Benelli, implying the importance of relief sculpture, traces these architectural features back to their sources in Roman ruins, low reliefs, and coins.

93 See Jaroslav Pešina, *Tektonický prostor a architektura u Giotta* (Prague, 1945). The findings offered in the present study allow revisiting Pešina's drawn reconstruction of spaces. He does not consider the well-defined, relief-like shallowness of the dioramas. Pešina's idealized ground planes show the spatial consequences we can deduce from the reliefs' perspective cues, retranslating them into their real-world models. Therefore Pešina's spatial models fail to illustrate how the fiction of the reliefs works. But even without

recognizing the scenes' indebtedness to the three-zone relief models from the so-called Flavian Baroque, Pešina clearly senses its effect on the figures, which he draws as if they were compressed onto an oval ground plan. See also the drawings by Friedrich Schmersahl, "Die Architektur in Giottos Bildern, betrachtet von einem Architekten," in *Giotto di Bondone*, 253–85.

94 See Mueller von der Haegen, "Die Darstellungsweise Giottos mit ihren konstitutiven Momenten, Handlung, Figur und Raum im Blick auf das mittlere Werk," 52. Indeed, the inner depth of the represented rooms appears to be more shallow than the number of included figures would require.

95 Wolfgang Kemp, *Die Räume der Maler: Zur Bilderzählung seit Giotto* (Munich, 1996).

96 This works in accordance with the optical section system identified by Rohlfs-Von Wittich for Giotto's unusual casements in Padua. See Anna Rohlfs-Von Wittich, "Das Innenraumbild als Kriterium für die Bildwelt," *Zeitschrift für Kunstgeschichte* 18 (1955): 109–35. For the opposite concept in Assisi, see Steffen Bogen, "Die Schauöffnung als semiotische Schwelle: Ein Vergleich der Rolin-Madonna mit Bildfeldern des Franziskuszyklus in Assisi," in *Porträt – Landschaft – Interieur: Jan van Eycks Rolin-Madonna im ästhetischen Kontext*, ed. Christiane Kruse and Felix Thürlemann (Tübingen, 1999), 53–72.

97 Jantzen, "Giotto und der gotische Stil," 35–40.

98 Jantzen, "Giotto und der gotische Stil," 36.

99 "reliefartige[s] Nebeneinander," Jantzen, "Giotto und der gotische Stil," 39.

100 See Jantzen, "Giotto und der gotische Stil," 40.

101 See Giuseppe Basile, "Giotto's Pictorial Cycle," in *Giotto*, ed. Basile, 13–20.

102 Poeschke expresses this coincidence of concentration and stoniness when he characterizes the difference between Giotto and Lorenzetti, who lacks "das Konzentrierte und Lapidare [entscheidend für Giottos Figurensprache]." See Joachim Poeschke, *Die Kirche San Francesco in Assisi und ihre Wandmalereien* (Munich, 1985), 51.

103 See Sirén, *Giotto and Some of His Followers*, 1:42–43: "The scenes have the same abstract nature as before. The representations of Joachim's return to the shepherds [...], and Joachim's offering, and his dream are located in mountain landscapes of an exceedingly simplified type, consisting of sharply cut, gray rocks of crystalline formation. Sometimes they remind us more of furrowed lava-beds than of real rocks. It is the solidity of the mass and the rhythmic value of the contours which are of importance to the artist, not so much the characterization of the material itself. Giotto never tries

to produce a naturalistic landscape. He does not attempt to create a beautiful and charming setting for the action, only backgrounds, or complements, to the figures, intended to explain the subject and enhance the space effect. Like the figures, the landscapes serve merely as building stones. The artistic impression is mainly dependent on the rhythmic division of the picture in clearly defined dimensions of width and depth. Giotto's compositions are preëminently picture-architecture; not abstractions, but filled with feeling for reality, finding expression in intense values of rhythm and form. In as far as it is the mission of art to create rhythmic form – strong, convincing, compelling – for emotions or mental states, Giotto is one of the greatest artists that ever lived."

104 "Die Menschen der Arena [...] sind oft wuchtig wie Blöcke und kantig wie Kristalle, zwischen der Vorstellung Mensch und der Vorstellung Figur ergab sich eine Spannung." Hetzer, *Giotto*, 121.

105 See Maginnis, "Problem with Giotto," 99–102. For the chapel as "a twentieth-century discovery," see Maginnis, "In Search of an Artist," 15, following the lines of Longhi's argument: "the general character of early twentieth-century painting, so determined by the renunciation of the devices of high naturalism, that made it possible to see the Arena frescoes in an entirely new light. Once mimesis was dethroned, it became possible to see the expressive power of minimal settings and of figures that are often described as metaphors of themselves."

106 Artists who rediscovered Giotto's murals and critics like Longhi celebrated the affinities between the early Italians and the early twentieth-century avant-garde: "From Bloomsbury to Montparnasse, Enrico di Tedice and Matisse, Coppo di Marcovaldo and Rouault, Catalan antependia and Picasso are mentioned in the same breath." See Roberto Longhi, *"Giudizio sul Duecento" e ricerche sul Trecento nell'Italia centrale, 1939–1970* (Florence, 1974), 3. See also Flores d'Arcais, *Giotto*, 7: "So if we are accustomed to read Giotto's language in a predominantly spatial and volumetric key, I believe that we must emphasize – as have such sensitive scholars as Zeri, Volpe, and above all Lisner – the innovative significance of Giotto's coloristic intuitions [...] which make him a very modern, avant-garde artist."

107 See Rintelen, *Giotto und die Giotto-Apokryphen* (1912), 143.

108 Clive Bell, *Art* (London, 1914), 14. The critic criticizing the critic, Kenneth Clark marks the transition from overly formalist to formative approaches: "At Padua I had my first real experience of Giotto [...]. It was strong, but not nearly as strong as my response to Giotto has since become. I suppose that I was still looking for 'significant form' and 'tactile values,' and did not understand how these pictorial qualities arose out of Giotto's desire to make me believe more intensely in the truth of each episode. I do not know how many times I have been to the Arena Chapel since then, certainly more than a dozen, and each time I am more deeply moved. Clive Bell's *Art* may be two thirds rubbish, but at least it had the merit of stressing the greatness of Giotto." Kenneth Clark, *Another Part of the Wood: A Self Portrait* (London 1971), 145.

109 Flores d'Arcais, *Giotto*, 7. See also Matthew Plampin, "'A Stern and Just Respect for Truth': John Ruskin, Giotto and the Arundel Society," *Visual Culture in Britain* 6 (2005): 59–78; and Robin Simon, "'A Giotto conviene far ritorno': The Arena Chapel, the British, a Futurist, and the Reputation of Giotto (c1267–1337)," *The British Art Journal* 16 (2015): 3–19. Simon interweaves the discussion of Ruskin's Giotto with other "key individuals in the history of the appreciation of Giotto" including Dante, Petrarch, Marchese Pietro Selvatico, Alexis-François Rio, Lord Lindsay, John Flaxman, William Hilton, Charles Eastlake, David Wilkie, Thomas Phillips, Henry Cole, Baron d'Hancarville, Carlo Carrà, and Maria, Lady Callcott.

110 For Malevich, see *Da Giotto a Malevič: La reciproca meraviglia*, ed. Cristina Garbagna (Milan, 2004). For Rothko, see *Rothko/Giotto*, ed. Stefan Weppelmann (Munich, 2009). See also Stefan Weppelmann, "'Giotto's Rumblings': Mark Rothko and the Renaissance as a Rhetoric of Modernism," in *Rothko/Giotto*, 41–66. See also Stephen H. Watson, "Hermeneutics and the Retrieval of the Sacred: Hegel's Giotto (with an Eye toward Mark Rothko)," *The Review of Metaphysics* 72 (2019): 741–65. See also *Magister Giotto*, ed. Alessandro Tomei and Giuliano Pisani (Villanova di Castenaso, 2017). For Beuys, see the original critical approach in Michael Viktor Schwarz, "Figure of Memory and Figure of the Past: Giotto's Double Life – with a Side-Glance at Joseph Beuys," *Taidehistoriallisia Tutkimuksia Konsthistoriska Studier – Studies in Art History* 46 (2013): 14–23. See T. J. Clark, *Heaven on Earth: Painting and the Life to Come* (London, 2018).

111 On that median vantage point, see Toesca as quoted in *Cambridge Companion to Giotto*, 200 and 280n8. See also Giuseppe Basile, *Giotto: La Cappella degli Scrovegni* (Milan, 1992), 271. The common viewer entering from the Arena was kept at bay by the barrier that used to divide private from public precinct, where the illusions worked most powerfully for the two deepest and most distant places in the Arena Chapel:

the *coretti* on the chancel wall. On this barrier in particular, see Alessandro Prosdocimi, "Osservazioni sulla partitura delle scene affrescate da Giotto nella Cappella degli Scrovegni," in *Giotto e il suo tempo: Atti del congresso internazionale per la celebrazione del VII centenario della nascita di Giotto*, 135–42; on barriers in general, see Jacqueline E. Jung, "Beyond the Barrier: The Unifying Role of the Choir Screen in Gothic Churches," *Art Bulletin* 82 (2000): 622–57, and Jung, *The Gothic Screen*. See also Ingrid Sjöström, *Quadratura: Studies in Italian Ceiling Painting* (Stockholm, 1978).

112 See Lubbock, *Storytelling in Christian Art from Giotto to Donatello*. See Berenson, *Florentine Painters of the Renaissance*. Berenson would have encountered these thoughts first in William James' lectures at Harvard with James shifting emphasis to an association of central nervous processes caused by overlapping or immediately successive stimuli. See William James, *The Principles of Psychology* (New York, 1890).

113 See, for instance, "triumphal arch" in Lavin, *Place of Narrative*, 45; Stubblebine, "Giotto and the Arena Chapel Frescoes," 80, also speaks in a broad sense of "triumphal arches." Euler speaks of the "Triumphbogenwand" (Euler, *Die Architekturdarstellung in der Arena-Kapelle*, 24); Oertel of the "triumphal arch" (Oertel, *Early Italian Painting to 1400*, 86; Pisani, *I volti segreti di Giotto*, of the "arco trionfale," 57). Serena Romano illustrates, in *La O di Giotto*, the Arch of Trajan in Benevento so as to underscore the affinities of its system of composition and overall structure to that of the chapel (Romano, *La O di Giotto*, fig. 192).

114 See Jacobus, "Lost Elements of Giotto's Design," 105–31; for hypothetical reconstructions illustrating where a window might be imagined see 106. Andrea de Marchi dismisses Jacobus' thesis by affirming the panel's authenticity in *Giotto e compagni*, ed. Dominique Thiébaut (Milan, 2013), 102.

115 Giuseppe Mazzotta, *Dante, Poet of the Desert: History and Allegory in the Divine Comedy* (Princeton, 1979), 5.

116 This has been noted by Alpatoff, Schlegel, Derbes, and Sandona, among others. See Ursula Schlegel, "Zum Bildprogramm der Arena Kapelle," *Zeitschrift für Kunstgeschichte* 20 (1957): 125–146, at 125–26.

117 See Cesare Brandi, *Giotto* (Milan, 1983), 97.

118 See Augustine, *Enchiridion*, VIII, and Thomas Aquinas, *Summa Theologica*, III, 1, 3.

119 Roberto Longhi, "Giotto spazioso," *Paragone* 31 (1952): 18–24, at 21.

120 Longhi, "Giotto spazioso," 22.

121 See Beck, *Giotto's Harmony*, 23, and 141–42.

122 Beck, *Giotto's Harmony*, 144.

123 Implicitly acknowledging the musical theme, Wilhelm Messerer calls the general impression one of pictorial rhythm ("*Bildrhythmus*"). Wilhelm Messerer, "Giottos Verhältnis zu Arnolfo di Cambio," in *Giotto di Bondone*, 211. Romdahl notes the "ruhigen Vertikalismus der Marienfolge," in "Stil und Chronologie der Arenafresken Giottos," 6. Flores d'Arcais recognizes the Paduan classicism in similar terms, discussing the architecture's "classical grandeur" (Flores d'Arcais, *Giotto*, 139) and "[the cycle's] sense of quiet equilibrium and classical measure" (Flores d'Arcais, *Giotto*, 141). Music in the Christian tradition of worship relates to the chapel's engagement with the material versus the immaterial. Marchetto da Padova's motet *Ave regina celorum / Mater innocencie* was written specifically for the opening ceremonies of the Scrovegni Chapel. Scholars have established that there is a relationship between the composition of the motet and the structure of Giotto's murals. See Beck, *Giotto's Harmony*, 23. All such connections to the immaterial stand in the context of hope and evidence as expressed poignantly in Hebrews 11:1: "Now faith is the substance of things hoped for, the evidence of things not seen."

124 "In one of his moments of keen insight in regard to these frescoes, John Ruskin compared *The Virgin's Return Home* to the Parthenon frieze. Certainly Giotto understood those same compositional ideas which make the classical relief one of the most impressive creations in the history of art." See Stubblebine, "Giotto and the Arena Chapel Frescoes," 93. Of course, the Parthenon was most likely unavailable to Giotto in Italy around the year 1300.

125 Barasch, *Giotto and the Language of Gesture*, 112.

126 Weigelt describes the field as an image of arrested movement. See Weigelt, *Giotto*, XXXIX.

127 See Imdahl, *Giotto*, 49.

128 Imdahl, *Giotto*, 62.

129 Imdahl, *Giotto*, 64.

130 Imdahl, *Giotto*, 64.

131 Imdahl strengthens the idea of the inevitably transitional key right before the cycle drops into the scenes of betrayal with the beginning of the Passion scenes, see Imdahl, *Giotto*, 65.

132 This field, the first on the north wall's last narrative register, is heavily water-damaged.

133 See Ladis, *Giotto's O*, 34.

134 See Weigelt, *Giotto*, XXXIV. For further metaphors on the acoustics of the visual space, see also Hetzer, *Giotto*, 168.

135 See, as a pre-photographic example of a snapshot aesthetic, the images of broken idols in the Northern tradition of the Limbourg brothers' *Flight into Egypt* or Broederlam's side panel for the altarpiece in Dijon.

136 "Bildrhytmus," "Raummusik," and "Harmonie" in Weigelt, *Giotto*, XXXIV. See Wölfflin's musical metaphors, *Die klassische Kunst* (1948), 294: "Wo das erreicht ist [also Wandfüllung und Raum zusammenzustimmen], da entsteht eine Art von Raummusik, ein Eindruck von Harmonie, der zu den höchsten Wirkungen gehört, die der bildenden Kunst vorbehalten sind." Other examples: Rintelen, *Giotto und die Giotto-Apokryphen* (1912), 12: "Die Bildfläche soll voll und hell erklingen [...]. Rhythmus [...] Melodik [...] Wohllaut [...] Zauber." Hetzer, *Giotto*, 110, describes the scene of Joachim in the wilderness as "andante maestoso." Hetzer sets this harmony over all other elements of the image: "Es gibt einen Einklang ganz unmittelbarer Art, der über das Inhaltliche und das Menschliche oder Dingliche sich hinwegsetzt, einen Einklang von Linie zu Linie, von Fläche zu Fläche, von Farbe zu Farbe," Hetzer, *Giotto*, 117. The *Flight into Egypt* is described as "erfüllt von linearer Rhythmik und Melodik," Hetzer, *Giotto*, 117. This culminates in Hetzer's claim that, before Giotto, neither language nor tone could be seen. "Wir behaupten also, daß *vor* Giotto Sprache und Ton in der bildenden Kunst nicht anschaulich geworden sind," Hetzer, *Giotto*, 161. See Puttfarken, *Discovery of Pictorial Composition*, 11: For the first time "in the Arena Chapel, that each picture affects us 'with the one sound in which it had been conceived by Giotto.' This is a harmonious sound, 'a unison of a quite immediate kind, which transcends matters of content or of human or objective nature, a unison between line and line, between plane and plane, between colour and colour... The whole picture is filled with rhythm and melody.'" See also Lene Østermark-Johansen, *Walter Pater and the Language of Sculpture* (Farnham, 2011), 77, on Pater's approach to the processional in the Panathenaic frieze "like liturgic music."

137 See Hills, *Light of Early Italian Painting*, 52.

138 See Rintelen, *Giotto und die Giotto-Apokryphen* (1912), 62. See also Sebald, *Schwindel; Gefühle*, 100.

139 "quest'è un'arte che si chiama dipingere, che conviene avere fantasia e operazione di mano, di trovare cose non vedute, cacciandosi sotto ombra di naturali, e fermarle con la mano, dando a dimostrare che non è, sia." Cennino Cennini, *Il libro dell'arte*, ed. Franco Brunello (Vicenza, 1971), 3–4.

140 For aspects of Cennini's usually underestimated complexity and originality, see Christiane Kruse, "Fleisch werden – Fleisch malen: Malerei als 'incarnazione'; Mediale Verfahren des Bildwerdens im Libro dell'Arte von Cennino Cennini," *Zeitschrift für Kunstgeschichte* 63 (2000): 305–25; and Mary Pardo, "Giotto and the 'Things Not Seen, Hidden in the Shadow of Natural Ones'," *Artibus et Historiae* 18 (1997): 41–53.

141 See Dorothée Bauerle, *Gespenstergeschichten für ganz Erwachsene: Ein Kommentar zu Aby Warburgs Bilderatlas Mnemosyne* (Münster, 1988), 9–15, on "Denkraum," "Orientierung," "Distanzbewußtsein" ("Bilder sind geronnene Denkräume," 15). On pathos in Giotto's frescoes, see Maurizio Ghelardi, *Aby Warburg: La lotta per lo stile* (Turin, 2012), 32. See also Emily J. Levine, *Dreamland of Humanists: Warburg, Cassirer, Panofsky, and the Hamburg School* (Chicago, 2013).

142 See Villani, *De origine civitatis Florentie et de eiusdem famosis civibus*, as quoted in "Filippo Villani: 'Giotto's Revival of Ancient Art,'" in *Images of Quattrocento Florence*, ed. Stefano Ugo Baldassarri and Arielle Saiber (New Haven, 2000).

143 On gravity, see Rintelen, *Giotto und die Giotto-Apokryphen* (1912), 88: "Giottos starkem Gefühl für das Tragende des Erdbodens"; "dass eine Reihe der besten Effekte auf Giottos Bildern mit der Schwere der Gestalten unzertrennlich zusammengehören," Rintelen, *Giotto und die Giotto-Apokryphen* (1912), 95.

144 Charles Till Davis, *Dante and the Idea of Rome* (Oxford, 1957), 374.

145 See also Hans Blumenberg, *Beschreibung des Menschen*, ed. Manfred Sommer (Frankfurt am Main, 2006); in particular "Trostbedürfnis und Untröstlichkeit des Menschen," 623–55, and "Leib und Wirklichkeitsbewußtsein," 656–776.

146 See Schlegel, "Zum Bildprogramm der Arena Kapelle," 142 n20.

147 "Figure, nessuna." Longhi, "Giotto spazioso," 18.

148 See Schlegel, "Zum Bildprogramm der Arena Kapelle," 130–31, at 134–36. Considered in relation to the exterior niches of the long wall around the *chiostro* of Santa Maria Novella in Florence, this interpretation matches neither the *coretti*'s position to the left and right of the altar room – itself already supposed to enclose the funerary monument to Enrico Scrovegni – nor the visual evidence that suggests little rooms, not flat niches. Euler thinks that the spaces are rather relatively high and deep rooms, see Euler, *Die Architekturdarstellung in der Arena-Kapelle*, 69. See also the discussion in the Epilogue of the present volume, 208–210.

149 Similar lamps appear in the Francis cycle in Assisi's Upper Church in the *Vision of the Thrones* and the *Verification of the Stigmata*; see the virtual restoration in *I colori di Giotto*, 81 and 107.

150 See Euler, *Die Architekturdarstellung in der Arena-Kapelle*, 69.

151 Euler, *Die Architekturdarstellung in der Arena-Kapelle*.

152 Puttfarken, *Discovery of Pictorial Composition*, 81.

153 See Longhi, "Giotto spazioso," 20.

154 Longhi, "Giotto spazioso."

155 Longhi, "Giotto spazioso," 21.

156 Longhi, "Giotto spazioso," 21–22.

157 Richardson, *A New Topographical Dictionary of Ancient Rome*, 30.

158 Rintelen, *Giotto und die Giotto-Apokryphen* (1912), 5.

159 Rintelen, *Giotto und die Giotto-Apokryphen* (1912), 4.

160 Francesco Benelli, personal conversation with the author, Columbia University, New York City, 10 March 2014.

161 For transcripts, see Bellinati, *Padua Felix*, 19.

162 See Delphine Deveaux, "In Heaven and on Earth," in *Noli me tangere: On the Raising of the Body*, ed. Jean-Luc Nancy et al. (New York, 2008), 71–85, at 71.

163 See also the insightful article by Mario D'Onofrio, "I cieli di Giotto agli Scrovegni tra immagine e memoria," in *Medioevo: Immagine e memoria: Atti del Convegno internazionale di studi*, 519–31.

164 For these and other signs of redemption in the cycle, see Laurine Mack Bongiorno, "The Theme of the Old and the New Law in the Arena Chapel," *Art Bulletin* 50 (1968): 11–20. For ancient wall painting in comparison to Giotto's ancient framework, see the fragments from Room L of the Villa of P. Fannius Synistor at Boscoreale, circa 50–40 BC, a Late Republican Roman wall painting today at the Metropolitan Museum of Art, or the colors in the Caldarium in the Villa of Poppaea Oplontis. Even though these exact examples would not have been available to Giotto given their later excavation history, they provide good models of a common style and color scheme that he could have seen at other, now lost sites in Rome.

165 Comparing the Arena Chapel and San Silvestro Chapel, the most striking difference is that the latter is overall smaller and wider, so the San Silvestro Chapel's interior does not retain proportions as precisely as does the Arena Chapel. The similarities extend to the barrel vault, the curvature of walls into vault, the presence of a starry sky, the golden stars, the distinctive levels (walls vs. vault), the narratives on the side walls, a Last Judgment (with the centrality, respective scale, and posture of the Judging Christ), the Angels with scrolls, the presence of a sanctuary, and three windows. The major differences are in the apex, the overall color schemes, the buildings' sizes, and, in San Silvestro, the presence of maiolica, the more mosaic-like pictorial style, the portrait medallions, the ornamental frames, the wrap-around structure of the ceiling's division, and the single vault. On S. Silvestro in general, see Maria Giulia Barberini, *I Santi Quattro Coronati a Roma* (Rome, 1989). See also *Gli affreschi dell'Aula gotica nel Monastero dei Santi Quattro Coronati: Una storia ritrovata*, ed. Andreina Draghi (Milan, 2006); and Thomas Noll, *Die Silvester-Kapelle in SS. Quattro Coronati in Rom: Ein Bilderzyklus im Kampf zwischen Kaiser und Papst* (Munich, 2011).

166 Ronald G. Kecks, *Madonna und Kind: Das häusliche Andachtsbild* (Berlin, 1988), at 45.

CHAPTER 5

1 See Heiko A. Oberman, "The Augustinian Renaissance," in *The Dawn of the Reformation* (Grand Rapids, 1992), 8–12, and Bouwsma, "The Two Faces of Humanism" 19–64, and *Nach der Verurteilung von 1277*.

2 Maria Fabricius Hansen's work on Augustine and *spolia* is very fruitful for this approach, especially when considering Giotto's frescoed version of one of the classic *spolia* techniques of Christian Rome – the framing around the scenes from the *Life of Jesus* in the fictive cosmati mosaic of marble fragments that is situated in didactic opposition to the ancient garland frames for the *Life of Mary*. See Maria Fabricius Hansen, *The Eloquence of Appropriation: Prolegomena to an Understanding of Spolia in Early Christian Rome* (Rome, 2003).

3 See Alpatoff, "The Parallelism of Giotto's Paduan Frescoes." On juxtapositions and paired antithetical images, see Anne Derbes and Mark Sandona, "Reading the Arena Chapel," in *Cambridge Companion to Giotto*, 197–220. Another source for the antithetical images can be found in Augustine, *De Civitate Dei*, Book XI, 18: "Of the beauty of the universe, which, by the disposition of God, is made all the more magnificent by the opposition of contraries."

4 On the limits of sculpture, see Giovanni Fallani, *La Poetica Dantesca e le Arti: Unità e Diversità* (Florence, 1965), 22. For Christian meanings of stone, see James T. Chiampi, "Visible Speech, Living Stone, and the Names of the Word," *Rivista di Studi Italiani* 14 (1996): 1–12. On the motif of the breaking of stone, see Ronald R. Macdonald, *The Burial-Places of Memory: Epic Underworlds in Vergil, Dante, and Milton* (Amherst, 1987), 106. On the necessary material limits and fictiveness of sculpture, see Peter Rockwell, "Some Reflections on Tools and Faking," in *Marble: Art Historical and Scientific Perspectives on Ancient Sculpture*, ed. Marion True and Jerry Podany (Malibu, 1990), 207–22.

5 See Peter Seiler, "Die Idolatrieanklage im Prozeß gegen Bonifaz VIII," in *Bild/Geschichte: Festschrift für*

Horst Bredekamp, ed. Philine Helas et al. (Berlin, 2007), 353–74.

6 On iconoclasm, see Bazon Brock, "Der byzantinische Bilderstreit," in *Bildersturm*, ed. Martin Warnke (Frankfurt am Main, 1977), 30–40; Horst Bredekamp, *Kunst als Medium sozialer Konflikte: Bilderkämpfe von der Spätantike bis zur Hussitenrevolution* (Frankfurt, 1975); *Iconoclasm*, ed. Anthony Bryer and Judith Herrin (Birmingham, 1977); *Der byzantinische Bilderstreit: Sozialökonomische Voraussetzungen, ideologische Grundlagen, geschichtliche Wirkungen*, ed. Johannes Irmscher (Leipzig, 1980); Robin Cormack, *Writing in Gold: Byzantine Society and its Icons* (London, 1985), 95–140; Hans Belting, *Bild und Kult: Eine Geschichte des Bildes vor dem Zeitalter der Kunst* (Munich, 1990), 166–84. See also *Iconoclasm from Antiquity to Modernity*, ed. Kristine Kolrud and Marina Prusac (Farnham, 2014). For continuing forms of iconoclasm, see Dario Gamboni, *The Destruction of Art: Iconoclasm and Vandalism since the French Revolution* (London, 2013). On cult images in Duecento and Trecento Italy, see also Puttfarken, *Discovery of Pictorial Composition*, 32; and Margit Lisner, *Holzkruzifixe in Florenz und in der Toskana von der Zeit um 1300 bis zum frühen Cinquecento* (Munich, 1970), 10.

7 See Creighton E. Gilbert, "Ghiberti on the Destruction of Art," *I Tatti Studies* 6 (1995): 135–44, at 140. For magical approaches to works of art in the Renaissance, see Horst Bredekamp, *Repräsentation und Bildmagie in der Renaissance als Formproblem* (Munich, 1995), here in particular on arches, see 37–46. For perpetual art historical exorcism, see Michael W. Cole, "Perpetual Exorcism in Sistine Rome," in *The Idol in the Age of Art: Objects, Devotions and the Early Modern World*, ed. Michael W. Cole and Rebecca Zorach (Farnham, 2009), 57–76. See also Hartmut Böhme, *Fetischismus und Kultur: Eine andere Theorie der Moderne* (Reinbek, 2006), 170–78. See also the discussion of the "modern age of belief" in Ethan Shagan, *The Birth of Modern Belief: Faith and Judgment from the Middle Ages to the Enlightenment* (Chicago, 2018).

8 See *Picturing the Bible: The Earliest Christian Art*, ed. Jeffrey Spier and Herbert L. Kessler et al. (New Haven, 2007).

9 See Christian Beutler, *Der Gott am Kreuz: Zur Entstehung der Kreuzigungsdarstellung* (Hamburg 1986), 30–31, and 31, fig. 11.

10 See Herbert L. Kessler, *Spiritual Seeing: Picturing God's Invisibility in Medieval Art* (University Park, 2000), 3.

11 See Isermeyer, "Rahmengliederung und Bildfolge in der Wandmalerei bei Giotto und den Florentinern Malern des 14. Jahrhunderts," 10.

12 Augustine, *The City of God against the Pagans*, ed. E. W. Dyson (Cambridge, 1998), 1174–75.

13 See Eric Leland Saak, *Creating Augustine: Interpreting Augustine and Augustinianism in the later Middle Ages* (Leiden and Boston, 2012). See also Bernard McGinn, "Ordering the Times: The Theology of History in Augustine's *De civitate Dei* and Joachim of Fiore's *Concordia Novi ac Veteris Testamenti*," *Essays in Medieval Studies* 35 (2020): 1–20. On messianic themes in the Pauline letters see Giorgio Agamben, *The Time That Remains: A Commentary on the Letter to the Romans*. Stanford 2005.

14 On Jews and Judaism in Christian art, see Blumenkranz, *Le juif médiéval au miroir de l'art chrétien*, which was published with improved illustrations as Blumenkranz, *Il cappello a punta: L'ebreo medievale nello specchio dell'arte cristiana*, ed. Chiara Frugoni (Bari, 2003). See also *Judaism and Christian Art: Aesthetic Anxieties from the Catacombs to Colonialism*, ed. Herbert L. Kessler and David Nirenberg (Philadelphia, 2011); and *Beyond the Yellow Badge: Anti-Judaism and Antisemitism in Medieval and Early Modern Visual Culture*, ed. Mitchell B. Merback (Leiden, 2008). For the particular role of the Arch of Titus, see Steven Fine, "'When I went to Rome, there I Saw the Menorah...': The Jerusalem Temple Implements between 70 C.E. and the Fall of Rome," in *The Archaeology of Difference: Gender, Ethnicity, Class and the "Other" in Antiquity Studies in Honor of Eric M. Meyers*, ed. Eric M. Meyers, Douglas R. Edwards, and C. Thomas McCollough (Boston, 2007), 169–80. See also Fergus Millar, "Last Year in Jerusalem: Monuments of the Jewish War in Rome," in *Flavius Josephus and Flavian Rome*, ed. Jonathan Edmondson, Steve Mason, and J. Rives (Oxford, 2005), 101–28.

15 Augustine had a more nuanced idea of Judaism than the other church fathers, defending his doctrine of the Jewish witness against their radically anti-Judaic views (see the Sermon on Psalm 58, chapter 18 of *De Civitate Dei* and chapter 12 of *Contra Faustum Manichaeum*). Augustine's doctrine in general opposed the persecution of Jews. Prior to Giotto's time, persecution had increased under Pope Innocent III (1198–1216), who excluded Jews from public office and forced them to wear yellow badges. See Jeremy Cohen, "The Doctrine of Jewish Witness," in *Living Letters of the Law: Ideas of the Jew in Medieval Christianity* (Berkeley, 1999), 23–65. See also Paula Fredriksen, "*Excaecati Occulta Justitia Dei*: Augustine on Jews and Judaism," *Journal of Early Christian Studies* 3 (1995): 299–324; and Fredriksen, *Augustine and the Jews*. See also Michael Signer, "Jews and Judaism," in *Augustine*

Through the Ages: An Encyclopedia, ed. Allan D. Fitzgerald (Grand Rapids, 1999), 470–74.

16 See Mirjam Kübler, *Judas Iskariot: Das abendländische Judasbild und seine antisemitische Instrumentalisierung im Nationalsozialismus* (Waltrop, 2007).

17 This relationship has been explored in detail by Alpatoff, Schlegel, Derbes, and Sandona. See Alpatoff, "The Parallelism of Giotto's Paduan Frescoes"; Schlegel, "Zum Bildprogramm der Arena Kapelle"; and Derbes and Sandona, "Barren Metal and the Fruitful Womb."

18 On Augustine's life, see Peter Brown, *Augustine of Hippo: A Biography* (Berkeley, 2000). See also *Augustine: From Rhetor to Theologian*, ed. Joanne McWilliam (Waterloo, 1992). On sight and beauty in Augustine, see also Hans Urs von Balthasar, *Herrlichkeit: Eine theologische Ästhetik*, vol. 2, *Fächer der Stille*, part 1, *Klerikale Stille* (Einsiedeln, 1984), 97–144. See also Sabine MacCormack, "Vergil," in *Augustine through the Ages*, 865–66.

19 Fredriksen, *Augustine and the Jews*; Fredriksen, "*Excaecati Occulta Justitia Dei*: Augustine on Jews and Judaism," at 305, on Salvation history as set into "a single, telescoped development: The Law of the Old Testament *is the same* as the Law of Christ." See also Fredriksen, *Augustine and the Jews*, 345, on Augustine pursuing in the *City of God* a single theme: "the history of love" that divides humanity according to the orientation of their love, the carnal love versus the love of God.

20 See Theodor E. Mommsen, "St. Augustine and the Christian Idea of Progress: The Background of 'The City of God,'" *Journal of the History of Ideas* 12 (1951): 346–74. Mommsen shows Augustine's linear time opposing the Greek tradition and alternative Christian views, as those held by Origen (356). This concept assigns not only a place to every occurrence, but also a meaning: "To Augustine [. . .] history takes its course, not in cycles, but along a line. That line has a most definite beginning, the Creation, and a most definite end, the Last Judgment. [. . .] From Augustine's conception of the course of history it follows that every particular event that takes place in time, every human life and human action, is a unique phenomenon which happens under the auspices of Divine Providence and must therefore have a definite meaning" (355). The link between Augustine's concept of time and the issue of invisibility is best expressed in 2. Corinthians 4:18: "While we look not at the things which are seen, but at the things which are not seen: For the things which are seen are temporal; but the things which are not seen are eternal."

21 Relevant chapters explicitly against paganism in *The City of God* are Book I, 3: "How Imprudent the Romans were in believing that they might derive any benefit from the gods who could not protect Troy"; Book II, 3: "That history must be consulted in order to show what evils befell the Romans when they still worshipped the gods, before the Christian religion grew up"; Book II, 4: "That the worshippers of the gods never received from the gods any wholesome precepts, and in their rites celebrated all manner of disgraceful things"; Book II, 29: "An exhortation to the Romans to abandon the worship of the gods"; Book VIII, 26: "That the religion of the pagans had to do entirely with dead men." See also the passages on idols, Book III, 11: "Of the statue of Apollo at Cumae, whose tears are believed to have portended disaster to the Greeks, whom he was unable to help," on the multiplicity yet uselessness of Roman gods Book III, 12: "How many gods the Romans added in addition to those established by Numa, and that such a quantity of gods helped them not at all."

22 On invisibility and vision, see Book X, 13: "Of the invisible God, Who has often made Himself visible, not as He truly is, but in a way which those who saw Him could bear"; and Book XXII, 29: "Of the kind of vision with which the saints will see God in the world to come." It is significant that both Augustine as an ancient author and Duecento Augustinianism interlock all the themes that have been documented as defining for Giotto's chapel: questions of time and antiquity, materiality, matter, visibility, and true essence of being, self recognition and reflection, as well as discourses on virtuous or vicious behavior.

23 Book V, 11: "Of the universal providence of God, in Whose laws all things are contained"; Book V, 21: "That the Roman realm was established by God, from Whom all power comes, and by Whose providence all things are ruled"; Book X, 14: "That the one God is to be worshipped not only for the sake of eternal blessings, but also for that of temporal benefits; for all things are subject to the power of His providence."

24 Book V, 13: "Of the love of praise which, though a vice, is reckoned a virtue because greater vices are restrained by it."

25 Book VIII, 10: "That the excellence of the Christian religion surpasses all the arts of the philosophers"; on its relation to ancient philosophy Book VIII, 11: "Where Plato was able to acquire the understanding by which he came so close to Christian knowledge"; and on sacrifice, the major division between the Judaic and Christian tradition in Book X, 4: "That sacrifice is due to the one true God"; and Book X, 5: "Of the

sacrifices which God does not require but has desired to be offered as symbols of those things which He does require"; Book X, 6: "Of the true and perfect sacrifice."

26 Book IX, 15: "Of the mediator between God and men, the man Christ Jesus."

27 Book XI, 5: "That we are not to try to conceive of infinite ages of time before the world, nor of infinite realms of space outside the world; for, just as there are no periods of time before it, so also are there no spatial locations outside it." On time, Book I, 10: "That the saints suffer no loss in losing temporal things"; Book I, 11: "Of the end of this temporal life, and whether it matters if it comes later or sooner"; Book II, 23: "That the vicissitudes of the temporal world depend not upon the favour of opposition of demons, but upon the judgment of the true God."

28 Book XI, 10: "Of the simple and immutable Trinity, God the Father, God the Son and God the Holy Spirit, one God, in whom quality and substance are one and the same."

29 Book V, 25: "Of the prosperity which God bestowed upon the Christian emperor Constantine."

30 Against the "DIVO TITO, DIVO VESPASIANO," Book III, 4: "Of the opinion of Varro, who said that it is advantageous to men to claim falsely that they are the offspring of the gods."

31 Book V, 14: "Of the banishment of the love of human praise; for all the glory of the righteous resides in God."

32 Book XIV, 14: "Of the pride of the transgressor, which was worse than the transgression itself."

33 Augustinus, *Über Schau und Gegenwart des unsichtbaren Gottes*, ed. Erich Naab (Stuttgart-Bad Cannstatt, 1998). For Latin and German versions of the texts see *De videndo Deo* and *De praesentia Dei* in Augustinus, *Über Schau und Gegenwart des unsichtbaren Gottes*, 118–91 and 214–59, respectively. See also "Inward Turn and Intellectual Vision" in Phillip Cary, *Augustine's Invention of the Inner Self: The Legacy of a Christian Platonist* (Oxford, 2000), 63–76. See also Cary on Augustine expressing, in *Confessions* 7:23, how he "saw intellectually your 'invisible things, by means of the things that are made,'" Cary, *Augustine's Invention of the Inner Self*, 65.

34 Kari Kloos, *Christ, Creation, and the Vision of God: Augustine's Transformation of Early Christian Theophany Interpretation* (Leiden, 2011), 3. See Kloos, *Christ, Creation, and the Vision of God*, 163, on the changes in Augustine's theophany narrative circa 400, and 169–70 on the confusing denominations of the "spiritale" as relating to mind and the "intellectuale" relating to faith.

35 See Frederick Van Fleteren, "*Acies mentis* (gaze of the mind)," in *Augustine through the Ages*, 5–6. "*Acies mentis* is equivalent to intellectual vision by which human beings can intuit truth directly. Corporeal and spiritual vision are two other types of vision. According to Augustine, every person in this life has an indirect vision of the divine, that is, the principles of truth. [...] Some perceive these truths clearly, others not as well, each to the extent his mind has been trained (*exercitatio animae*)," Van Fleteren, "*Acies mentis* (gaze of the mind)," 6. "This doctrine is of the utmost importance in the history of Western Christian theology, since by it Augustine, like Plotinus and Porphyry, defines human happiness in terms of satisfaction of the human intellect, rather than in terms of any other human power such as the will," Van Fleteren, "*Acies mentis* (gaze of the mind)," 6. *Acies mentis* needs purification, which can be provided by Faith. See also Jared C. Calaway, "'Show Me Yourself': Corporeal, Spiritual, and Intellectual Vision in Augustine of Hippo (354–430 CE)," in *The Christian Moses: Vision, Authority, and the Limits of Humanity in the New Testament and Early Christianity* (Montreal, 2019), 213–34.

36 Cary, *Augustine's Invention of the Inner Self*, 72.

37 See Pisani, *I volti segreti di Giotto*, 184 and 187.

38 The famed crucial moment of conversion happened in a garden in Milan: Augustine was reflecting when he heard a child's voice chanting "take and read." Opening his book, his eyes fell upon Romans 13:13–14.

39 See Beck, *Giotto's Harmony*, 125: "A knowledge of Augustine is particularly important in the reading of music and *Justice* in the Scrovegni Chapel because Augustine's theories of music as pronounced in his *De Musica* also link justice to charity – with a musical accompaniment. Augustine wrote extensively on the subject of music, and his theories appear dispersed throughout treatises on the Psalms."

40 See Pisani, *I volti segreti di Giotto*, 171, 184–85 on the order of Prudence, Fortitude, Temperance, and Justice. See Augustine's reference to Genesis 2, 10–14 in *De genesi contra Manichaeos* II, 10, 13: "Flumen autem quod procedebat ex Eden [...] dividitur in quatuor partes, et quatuor virtutes significat, prudentiam, fortitudinem, temperentiam, iustitiam."

41 See Pisani, *I volti segreti di Giotto*, 159, referring to Augustine, *De libero arbitrio*, I, 13, 27: "Temperantia est affectio coercens et cohibens appetitum ab iis rebus quae turpiter appetuntur. [...] virtus quae libidines cohibet" and to Augustine's *De moribus Ecclesia catholicae* 19, 35, "Munus enim eius est in coercendis sedandisque cupiditatibus, quibus inhiamus in ea quae

nos avertunt a legibus Dei et a fructu bonitatis eius, quod est, ut brevi explicem, beata vita."

42 See Pisani, *I volti segreti di Giotto*, 150. See Augustine, *De libero arbitrio*, III, 3, 8: "Voluntas igitur nostra nec voluntas esset, nisi esset in nostra potestate. Porro, quia est in potestate, libera est nobis. Non enim est nobis liberum, quod in potestate non habemus, aut potest non esse quod habemus. Ita fit ut et Deum non negemus esse praescium omnium futurorum, et nos tamen velimus quod volumus. Cum enim sit praescius voluntatis nostrae, cuius est praescius ipsa erit. Voluntas ergo erit, quia voluntatis est praescius. Nec voluntas esse poterit, si in potestate non erit. Ergo et potestatis est praescius. Non igitur per eius praescientiam mihi potestas adimitur, quae propterea mihi certior aderit, quia ille cuius praescientia non fallitur, adfuturam mihi esse praescivit."

43 See Pisani, *I volti segreti di Giotto*, 171. See Augustine, *Enchiridion* 32, 121: "Omnia igitur praecepta divina referuntur ad caritatem [...]. Omnis itaque praecepit finis caritas est, id est ad caritatem refertur omne praeceptum. [...] Caritas quippe ista Dei est et proximi, et utique in his duobus praeceptis tota Lex pendet et Prophetae: adde Evangelium, adde Apostolos: non enim aliunde vox ista est: Finis praecepti est caritas, et: Deus caritas est. Quaecumque ergo mandat Deus [...] tunc recte fiunt cum referuntur ad diligendum Deum, et proximum propter Deum."

44 See Pisani, *I volti segreti di Giotto*, 186. See Augustine, *De doctrina Christiana* I, 37, 41: "Asserendo enim temere quod ille non sensit quem legit, plerumque incurrit in alia quae illi sententiae contexere nequeat. Quale si vera et certa esse consentit, illud non possit verum esse quod senserat; fitque in eo, nescio quomodo, ut amando sententiam suam Scripturae incipiat offensior esse quam sibi. Quod malum si serpere siverit, evertetur ex eo. Per fidem enim ambulamus, non per speciem; titubabit autem fides, si divinarum Scripturarum vacillat auctoritas; porro fide titubante, caritas etiam ipsa languescit. Nam si a fide quisque ceciderit, a caritate etiam necesse est cadat. Non enim potest diligere quod esse non credit. Porro si et credit et diligit, bene agendo et praeceptis morum bonorum obtemperando efficit ut etiam speret se ad id quod diligit esse venturum."

45 See Pisani, *I volti segreti di Giotto*, 187.

46 See Fredriksen, "*Excaecati Occulta Justitia Dei*: Augustine on Jews and Judaism," 308.

47 See *Codici e Manoscritti della Biblioteca Antoniana*, ed. Giuseppe Abate et al. (Vicenza, 1975), 145: "S. Augustinus, De videndo Deum. ff. 99v–112r. *Rubrica*: 'Augustinus ad Paulinam: De videndo Deum.' Textus *Incipit*: 'Inter videre et credere hoc distrare dicimus,

quia praesentia videntur, creduntur absentia.'" See also Maria Cristina Zanardi, *Catalogo degli Incunaboli della Biblioteca Antoniana di Padova* (Florence, 2012), 23–26.

48 See Frederick Van Fleteren, "*Videndo Deo, De* (On Seeing God)," in *Augustine through the Ages*, 869.

49 The epistles were written against the Anthropomorphites (Audians), a sect that arose in fourth-century Syria. Taking the text of Genesis 1:27 literally, their founder Audius held that God has a human form and that the final vision of God would be seen with corporeal eyes. See also Phillip Cary, *Outward Signs: The Powerlessness of External Things in Augustine's Thought* (Oxford, 2008), at 61.

50 For the virtues and the Trinity, see Augustinus, *Über Schau und Gegenwart des unsichtbaren Gottes*, 30 and 131 for the virtues: "Selig sind, die reinen Herzens sind." See also Phillip Cary, *Inner Grace: Augustine in the Traditions of Plato and Paul* (Oxford, 2008). Cary discusses Augustine's concept of ethics and grace as leading to intellectual understanding in terms of "natural connection with the divine," the "innate ability to see the eternal Truth," and the "intellect [as] the locus of our true happiness," Cary, *Inner Grace*, 8. Cary underscores the importance of purification by faith as "something more specifically Platonist: a turning away from bodily desires as well as a withdrawing from habits of sensible imagination. The pure 'mind's eye,' for Augustine, is intellect, not imagination," Cary, *Inner Grace*, 13. See also Cary, *Augustine's Invention of the Inner Self*, 69, on Augustine's essay "On Ideas": "It is the nature of the mind's eye, when purified of sin and lust for sensible things, to see the Ideas in the divine Mind."

51 Augustinus, *Über Schau und Gegenwart des unsichtbaren Gottes*, 46–47.

52 See Augustinus, *Über Schau und Gegenwart des unsichtbaren Gottes*, 60.

53 See Augustinus, *Über Schau und Gegenwart des unsichtbaren Gottes*, 171, for the question of the personal judgment of things seen in relation to individual responsibility.

54 See Augustinus, *Über Schau und Gegenwart des unsichtbaren Gottes*, 173, for the carefulness of perception.

55 See Augustinus, *Über Schau und Gegenwart des unsichtbaren Gottes*, 150.

56 See Augustinus, *Über Schau und Gegenwart des unsichtbaren Gottes*, 174 on feelings and virtues as gifts of the spirit and the gift of the virtues.

57 Translation: Ladis, *Giotto's O*, 149.

58 Robert Louis Wilken, *The First Thousand Years: A Global History of Christianity* (New Haven, 2012), 183. For an Augustinian reading of the chapel, I find also relevant two more books from the *City of God*:

Book XI, 27: "Of existence, and the knowledge of it, and the love of both" and Book XX, 16: "Of the new heaven and the new earth."

59 Brian Stock, *Augustine's Inner Dialogue: The Philosophical Soliloquy in Late Antiquity* (Cambridge, 2010).

60 Brian Stock, *The Integrated Self: Augustine, the Bible, and Ancient Thought* (University Park, 2017).

61 A prominent example directly after Giotto in the nearby Eremitani church's choir is Guariento's frescoes, which imitate marble in a manner very similar to the Arena Chapel's dado. See *Art and the Augustinian Order in Early Renaissance Italy*, ed. Louise Bourdua and Anne Dunlop (Aldershot, 2007), in particular Janis Elliott, "Augustine and the New Augustinianism in the Choir Frescoes of the Eremitani, Padua," in *Art and the Augustinian Order in Early Renaissance Italy*, 99–126, and Catherine Harding, "Time, History and the Cosmos: the Dado in the Apse of the Church of the Eremitani, Padua," in *Art and the Augustinian Order in Early Renaissance Italy*, 127–42. See also Cordez, "Les marbres de Giotto," 22–24. From the allegorical details to the general themes of personal responsibility, humility, and history, Augustine's writings deliver an extensive set of references for the chapel's unusual Roman-Classical appearance. See Pisani, *I volti segreti di Giotto*, 187. Other details in the chapel that Pisani relates to Augustine is the presence of the Centurion Cornelius in the *Last Judgment*, the throne, and the fish as sign for I(esùs) X(ristòs) Th(eoû) Y(iòs) S(otèr). On Cornelius, see the discussion in Pisani, *I volti segreti di Giotto*, 343, Augustine, *De doctrina Christiana, Prologo, 6*, on the throne see Pisani, *I volti segreti di Giotto*, 245, Augustine, *In Psalmum 46*, 10, and on the *Ichthys* see Pisani, *I volti segreti di Giotto*, 246, Augustine, *De civitate Dei*, XVIII, 23, 1: "Iesus Christus Dei Filius Salvator, si primas litteras iungas, erit ἰχθύς, id est piscis, in quo nomine mystice intellegitur Christus, eo quod in huius mortalitatis abysso velut in aquarum profunditate vivus, hoc est sine peccato, esse potuerit." Cornelius also appears in Augustine's *De praesentia Dei liber*, see Augustinus, *Über Schau und Gegenwart des unsichtbaren Gottes*, 253.

62 See Mommsen, "St. Augustine and the Christian Idea of Progress." See also Alexander Lee: *Petrarch and St. Augustine: Christian Theology and the Origins of the Renaissance* (Leiden and Boston, 2012), and Giuseppe Mazzotta, *The Worlds of Petrarch* (Durham, 1993), at 21–22.

63 See Arnold Esch, "Spolien: Zur Wiederverwendung antiker Baustücke und Skulpturen im mittelalterlichen Italien," *Archiv für Kulturgeschichte* 51 (1969): 1–64. See also *Antike Spolien in der Architektur des Mittelalters*

und der Renaissance, ed. Joachim Poeschke (Munich, 1996). The line of interpretation that has contributed to the field's underestimation of Giotto's sources in ancient polychrome relief is exemplified in Bernard Berenson, *The Arch of Constantine or The Decline of Form* (New York, 1954). For recent scholarship on various issues of spoliation see *The Fragment: An Incomplete History*, ed. William Tronzo (Los Angeles, 2009); and *Reuse Value: Spolia and Appropriation in Art and Architecture, from Constantine to Sherrie Levine*, ed. Richard Brilliant and Dale Kinney (Farnham, 2011).

64 Hansen, *Eloquence of Appropriation*, 9.

65 Hansen, *Eloquence of Appropriation*, 24.

66 To give one example, the pattern of rhetorical spoliation for Christian purposes also appears in the second and third Epistles of John, structured in the classical sequence of ancient letters with *superscriptio*, *adscriptio*, and *salutatio*. This *modus operandi* is similar to the Arena Chapel's model of filling the structure of the Roman arch with new elements illustrating Christian stories and doctrines.

67 Hansen, *Eloquence of Appropriation*, 36.

68 Hansen, *Eloquence of Appropriation*, 188.

69 Hansen, *Eloquence of Appropriation*, 193.

70 See *De doctrina christiana* II.xviii.28, II.xxxix.58, II.xl.60, and IV.ii.3. See also Erich Auerbach, *Literary Language and Its Public in Late Latin Antiquity and in the Middle Ages* (Princeton, 1993). See also Ramsay MacMullen, "A Note on 'Sermo Humilis,'" *The Journal of Theological Studies* 17 (1966): 108–12.

71 Hansen, *Eloquence of Appropriation*, 194.

72 *De vera religione* i.1–vi.11.

73 Hansen, *Eloquence of Appropriation*, 194. See also Hansen, *Eloquence of Appropriation*, 248.

74 Hansen, *Eloquence of Appropriation*, 214. See *De vera religione*, XXXIII.62; XXXIV.63; id., *De musica libri sex*, VI.XI.30.

75 Hansen, *Eloquence of Appropriation*, 214.

76 Hansen, *Eloquence of Appropriation*, 237. See Augustine, *De fide rerum quae non videntur* VII.10.

77 Augustine, *De vera religione* XXX.56. See Hansen, *Eloquence of Appropriation*, 260.

78 Erwin Panofsky, *Renaissance and Renascences in Western Art* (Stockholm, 1960).

79 See Tronzo, "Giotto's Figures," 66. See Brilliant, "I piedistalli del giardino di Boboli: spolia in se, spolia in re." See also Salvatore Settis, "Continuità, distanza, conoscenza: Tre usi dell'antico," in *Memoria dell'antico nell'arte italiana* (Turin, 1986), 375–486. Between *spolia* in re and *spolium in se*, between physical reuse and essential citation, these classical categories can be reconsidered for the multiple relations between the

Arena Chapel and the Arches of Titus and of Constantine, the latter being itself a major monument and classic example in the history of spoliation.

80 "Il corpo, che per molti secoli era stato disatteso dall'arte cristiana, come se fosse antitetico alla vocazione spirituale dell'uomo, qui diventa invece il luogo privilegiato dell'umana santificazione." Timothy Verdon, *L'arte sacra in Italia: L'immaginazione religiosa dal paleocristiano al postmoderno* (Milan, 2001), 78.

81 See Gert von der Osten, "Plato über das Relief," *Wallraf-Richartz-Jahrbuch* 25 (1962): 15–20.

82 Francesco Petrarca, *In difesa dell'Italia (Contra eum qui maledixit Italie)*, ed. Giuliana Crevatin (Venice, 1995). Speaking of triumphs, Petrarch is, of course, also the author who, in *Africa* (1338/43), details the ancient triumphal procession following the victory of Scipio Africanus over Hannibal, as well as the author who transposes the system of triumphs into the realm of emotive virtuosity with his *Triumphi* series from love to eternity. The antiquarian interest in triumphal arches and ancient monuments in general was famously continued by Ciriaco d'Ancona, Francesco di Giorgio Martini, Poggio Bracciolini, and Raphael's appointment as commissioner of antiquities in the papal Rome of the early sixteenth century.

83 See Francesco Petrarca, *My Secret Book*, ed. Nicholas Mann (London, 2016).

84 See Virginio Sanson, "L'edificio sacro cristiano nella bibbia," in *Lo Spazio Sacro: Architettura e liturgia* (Padua, 2002), 23–36. On the origins of the Christian sacred space through the Old-Testament problem of habitation and presence of God, see Sanson, "L'edificio sacro cristiano nella bibbia," 26–30: "Dio abita nel cielo [...] Dio si manifesta [...] Dio si accompagna al suo popolo [...] Dio vuole la tenda," 27, the necessities of the Messianic temple, 28–29, "Immanenza trascendente di Jhwh," 29, on the Christian reinterpretation of the temple, see 33–36.

85 See Donatella Torresini, *Padova 1509–1969: Gli effetti della prassi urbanistica borghese* (Padua, 1975), 40.

86 Ellen Bradshaw Aitken, "Portraying the Temple in Stone and Text: The Arch of Titus and the Epistle to the Hebrews," in *Religious Texts and Material Contexts*, ed. Jacob Neusner and James F. Strange (Lanham, 2001), 73–88, at 78. See also 79: "The Flavian rulers exploited the one-time event of the triumph as the defining point for the public display of their rule. [...:] in 71 the celebration of the triumph with prayers, procession, executions, and sacrifices; Vespasian's building of the Temple of Peace, dedicated in 75, next to the Roman Forum and in which were housed the spoils from the Jerusalem temple (Josephus *J. W.* 7.158–61); in 81 or shortly thereafter,

following Titus's death, and the erection of the Arch of Titus at the highest point of the Via Sacra, and [...] another, earlier arch in the Circus Maximus."

87 Josephus, *Jewish War*, 7.118, 137–38.

88 Josephus, *Jewish War*, 7.153–55.

89 Aitken, "Portraying the Temple in Stone and Text," 82–83.

90 Aitken, "Portraying the Temple in Stone and Text," 74.

91 Aitken, "Portraying the Temple in Stone and Text," 83. See Hebrews 9:11–12.

92 Aitken, "Portraying the Temple in Stone and Text," 83.

93 Aitken, "Portraying the Temple in Stone and Text," 83.

94 Aitken, "Portraying the Temple in Stone and Text," 88.

95 Smart, *Assisi Problem and the Art of Giotto*, 89.

96 Scardeone, *De Antiquitate urbis Patavii et claris civibus patavinis*.

97 Biblical references to humility include: Matthew 11:28–30: "Come to Me, all who are weary and heavy-laden, and I will give you rest. Take My yoke upon you and learn from Me, for I am gentle and humble in heart, and you will find rest for your souls. For My yoke is easy and My burden is light." See also 1 Peter 5:5: "All of you, clothe yourselves with humility toward one another, for God is opposed to the proud, but gives grace to the humble." Proverbs 29:23: "A man's pride shall bring him low: but honour shall uphold the humble in spirit." Luke 9:23–25: "And He was saying to them all, 'If anyone wishes to come after Me, he must deny himself, and take up his cross daily and follow Me. For whoever wishes to save his life will lose it, but whoever loses his life for My sake, he is the one who will save it. For what is a man profited if he gains the whole world, and loses or forfeits himself?'" See also Luke 9:48: "Whoever receives this child in My name receives Me, and whoever receives Me receives Him who sent Me; for the one who is least among all of you, this is the one who is great." See also Proverbs 22:4 ("Humility is the fear of the Lord; its wages are riches and honor and life"); Proverbs 15:33 ("The fear of the Lord is the instruction of wisdom; and before honour is humility"); Paul's Letter to the Philippians 2:3 ("Do nothing out of selfish ambition or vain conceit. Rather, in humility value others above yourselves"); Proverbs 18:12 ("Before destruction the heart of man is haughty, and before honour is humility"); Proverbs 11:2 ("When pride comes, then comes disgrace, but with humility comes wisdom").

98 Flores d'Arcais, *Giotto*, 188.

99 See Beutler, *Der Gott am Kreuz*, 30–31. See also Erich Auerbach, *Mimesis: Dargestellte Wirklichkeit in der*

Abendländischen Literatur (Bern, 1959), 495: "es war die Geschichte Christi, mit ihrer rücksichtslosen Mischung von alltäglich Wirklichem und höchster, erhabenster Tragik, die die antike Stilregel überwältigte."

100 See Psalm 47:7 as well as Jeremiah 9:24 and the Second Epistle to the Thessalonians 1:3–4.

101 See Jacobus 4:13–16 and 2. Timothy 1:7.

102 See Philippians 2:3.

103 See Galatians 5:26.

104 See Jacobus 4:10. Solomon named humility as worthy of riches and life, see Proverbs 22:4.

105 See Matthew 23:5–7.

106 See Acts of the Apostles 8:26–38.

107 See his cleansing of the Temple (John 2:13–17) and his answer to his mother (Matthew 12:46–50), both represented on the chapel's north wall.

108 "Fecit potentiam in bracchio suo: dispersit superbos mente cordis sui. Deposuit potentes de sede, et exaltavit humiles." Luke 1:46–55.

109 Matthew 5:5.

110 See Nicolai Hartmann, *Ethik* (Berlin, 1949), 476.

111 Weil, *Gravity and Grace*, 30.

112 Jesus: "But go and learn what this means: 'I desire mercy, not sacrifice.'" Matthew 9:13. For the relationship of this aspect to the chapel's Augustinian tendencies, see Karfíková, *Grace and the Will according to Augustine*, 228–232, on *"The Grace of the New Testament* (De gratis Novi testamenti)."

113 Compare, for example, the role of the sacrifice in Leviticus 1–7 with the sacrifice of Christ in Hebrews 9:10, 10:12, 13:15; Galatians 5:22–24; Ephesians 2:10; Romans 12:1–2; Matthew 19:17; and Mark 15:15–18.

114 On this small object, which was recovered only in 1982, see Claudio Bellinati, *Nuovi studi sulla Cappella di Giotto nell'Arena di Padova: 25 marzo 1303–2003* (Padua, 2003).

115 Micah 6:6–7.

116 Micah 6:8.

117 See Berenson, *Florentine Painters of the Renaissance*.

118 There is also the gap between the *Washing of the Feet* and the *Kiss of Judas*. On physical intimacy perverted in the latter, see Norman Bryson, *Vision and Painting: The Logic of the Gaze* (New Haven, 1983), 62–63. With fruitful theoretical approaches to the themes of touch and on the *Noli me tangere* moment (in particular by Nancy, Bieringer, and Baert), some scholars refer specifically to the details of Giotto's Paduan version of the iconography. For more recent scholarship on touch, see Jennifer M. Barker, *The Tactile Eye: Touch and the Cinematic Experience* (Berkeley, 2009); Mark Paterson, *The Senses of Touch: Haptics, Affects, and Technologies* (Oxford, 2007); *Touching Space, Placing Touch*, ed. Mark Paterson (Farnham, 2012); Laura

U. Marks, *Touch: Sensuous Theory and Multisensory Media* (Minneapolis, 2002); and Victor I. Stoichita, *The Pygmalion Effect: From Ovid to Hitchcock* (Chicago, 2008), 5–6, and 203–4, "20 Theses on the Question of the Simulacrum." See also *Das haptische Bild: Körperhafte Bilderfahrung in der Neuzeit*, ed. Markus Rath, Jörg Trempler, and Iris Wenderholm (Berlin, 2013). For the *Noli me tangere*, see Jean-Luc Nancy, *Noli me tangere: Essai sur la levée du corps* (Paris, 2003), in English: Jean-Luc Nancy, *Noli me tangere: On the Raising of the Body* (New York, 2008). See also Noli me tangere: *Mary Magdalene: One Person; Many Images*, ed. Barbara Baert, Reimund Bieringer, Karlijn Demasure, and Sabine Van Den Eynde (Leuven, 2006); cat. no. 27, 4: A devotional image of Giotto's *Noli me tangere*, "Jésus apparaissant à Marie-Madeleine." For nuances in the translation, see Reimund Bieringer, "*Noli me tangere* and the New Testament: An Exegetical Approach," in Noli me tangere: *Mary Magdalene*, 13–27. On the artistic stakes of the iconography, see Barbara Baert, "Touching with the Gaze: A Visual Analysis of the *Noli me tangere*," in Noli me tangere: *Mary Magdalene*, 43–52. For the contemporary reception of Giotto's version, see Claudio Bellinati, "La Cappella di Giotto all'arena e le miniature dell'antifonario 'Giottesco' della cattedrale (1306)," in *Da Giotto al Mantegna* (Milan, 1974), 23–30.

119 See Pisani, *I volti segreti di Giotto*, 10.

120 Comparing this composition to the Assisi *Noli me tangere*, Sélincourt uses the language of relief to describe the difference between the rendition of the scenes in Padova and in Assisi: "Giotto, as before [in the Arena scenes], sets his principal figure in relief against the sky." Sélincourt, *Giotto*, 146.

121 See Stubblebine, "Giotto and the Arena Chapel Frescoes," 94.

122 See Messerer, "Giottos Verhältnis zu Arnolfo di Cambio," 210.

123 Nancy, Noli me tangere: *On the Raising of the Body*, 7. See also Nancy, Noli me tangere: *Essai sur la levée du corps*, 14–15.

124 Nancy, Noli me tangere: *On the Raising of the Body*, 17. See also Nancy, Noli me tangere: *Essai sur la levée du corps*, 32. "*Noli me tangere* does not simply say 'Do not touch me'; more literally, it says 'Do not wish to touch me.' The verb *nolo* is the negative of *volo*: it means 'Do not want.' In that, too, the Latin translation displaces the Greek *mē mou haptou* (the literal transposition of which would be *non me tange*). *Noli*: do not wish it; do not even think of it. Not only don't do it, but even if you do it (and perhaps Mary Madgalene does do it, perhaps her hand is already placed on the hand of the

one she loves, or on his clothing, or on the skin of his nude body), forget it immediately. You hold nothing; you are unable to hold or retain anything, and that is precisely what you must love and know. That is what there is of a knowledge and a love. Love what escapes you. Love the one who goes. Love that he goes." Nancy, Noli me tangere: *On the Raising of the Body*, 37. See also Nancy, Noli me tangere: *Essai sur la levée du corps*, 60–61. Nancy concludes: "The dead are deceased, but as deceased, they do not cease accompanying us, and we do not cease leaving with them." Nancy, Noli me tangere: *On the Raising of the Body*, 38–39. See also Nancy, Noli me tangere: *Essai sur la levée du corps*, 64.

125 "[Mary Magdalene's] abandonment stems as much from love as it does from despondency, without the one relieving, restoring, or sublating [relève] the other. Rather, the simultaneity of the two constitutes the raising [la levée] of this very moment – a lifting that disappears as it arises." Nancy, Noli me tangere: *On the Raising of the Body*, 42–43. See also Nancy, Noli me tangere: *Essai sur la levée du corps*, 71–72.

126 "It is essential that painting not be touched. It is essential that the image in general not be touched. Therein lies its difference from sculpture, or at least sculpture can offer itself up to the eye and, in turn, to the hand – as when one walks around it, approaching to the point of touching and moving back in order to see. What is seeing if not a deferred touch? But what is a deferred touch if not a touching that sharpens or concentrates without reserve, up to a necessary excess, the point, the tip, and the instant through which the touch detaches itself from what it touches, at the very moment when it touches it? Without this detachment, without this recoil or retreat, the touch would no longer be what it is, and would no longer do what it does [. . .]. It would begin to reify itself in a grip, in an adhesion or a sticking." Nancy, Noli me tangere: *On the Raising of the Body*, 49–50. See also Nancy, Noli me tangere: *Essai sur la levée du corps*, 81–82. Similarly, Baert, "Touching with the Gaze," 46: "'Do not touch me' echoes, becoming 'Touch me with your eyes.' The expression of the touch through the gaze is a parallel that the early Church Fathers drew. What happens in the *Noli me tangere* is the flash of insight. By not touching Christ, Mary Magdalene can generate the gaze of insight. A transformation occurs."

127 "There would be identification, fixation, property, immobility. 'Do not hold me back' amounts to saying 'Touch me with a real touch, one that is restrained, nonappropriating and nonidentifying.' Caress me, don't touch me. It is not that Jesus refuses Mary Magdalene. The true movement of giving oneself is not to deliver up a thing to be taken hold of but to permit the touching of a presence and consequently the eclipse, the absence, and the departure according to which a presence must always give itself in order to present itself." Nancy, Noli me tangere: *On the Raising of the Body*, 50. "The painter painting Mary's outstretched hands, thus painting his own hands stretched out toward his picture – toward the right touch, made up of patience and chance, made up of a living withdrawal of the hand that sets it down – holds his image out to us, not for us to touch it or retain it in a perception but, to the contrary, so that we will step back to the point of putting back into play the entire presence of and within the image. This painter puts the truth of 'resurrection' to work: the approach of the parting, in the ground of the image [au fond de l'image], of the singular of truth. It is thus that he *paints* (but here the verb can unfold its meaning to the point of touching on all other modes of art), which is primarily to say that he 'represents' in the proper sense of the word: 'to intensify the presence of an absence as absence.'" Nancy, Noli me tangere: *On the Raising of the Body*, 51. See also Nancy, Noli me tangere: *Essai sur la levée du corps*, 83–84. See also Baert, "Touching with the Gaze," 51–52: "Maybe the *Noli me tangere* is fundamentally about art. The relationship between the picture and the observer is not (usually) a tactile relationship, but it operates in the field of energy of the gaze. The work of art is also a manifestation in transit. Art that presents itself as apparent reality, even when – in its most mimetic form – it inspires the forbidden desire to touch, is also the image that constantly slips away from us. Once released by their creator, pictures become their own masters, no longer seeking to belong to our reality, but to the order of their own medium, something that we created, loved and then had to let go. This autonomy of visuality means that the pictures speak to us, saying 'do not holding [sic] on to me,' because I now belong to a different order from your reality, I belong to the order of visible invisibility. In that sense, *Noli me tangere* is a statement about the truth of art. Christ must disappear untouched in order to make the *vera icon* possible."

128 See Jean-Luc Nancy, *The Birth to Presence* (Stanford, 1993), 3.

129 See Nancy, Noli me tangere: *On the Raising of the Body*, especially 13 and 15. The figures' diverse spiritual rank is spatially evident, as Gosebruch notes laconically: "Also alles Himmlische schwebt und alles der Erde verhaftete kniet." Gosebruch, "Figur und Gestus in der Kunst des Giotto," 70.

130 The small figures gathering in cloud-like groups to his left and right are the freed patriarchs "in

kindlicher Gestalt und beflügelte Kinderseelen."
Henry Thode, *Giotto* (Bielefeld, 1899), 119. Four of
the child-like figurines have white hair and beards,
with one brown beard for today's spectator reminis-
cent of the archetypal *puer senex*, the graceful figure
of the "re fanciullo" from Natalia Ginzburg's *Lessico
famigliare*. "– Come vorrei essere un re fanciullo, –
diceva mia madre con un sospiro e un sorriso, perché
le cose che più la seducevano al mondo erano la
potenza e l'infanzia, ma le amava combinate insieme,
così che la seconda mitigasse la prima con la sua
grazia, e la prima arricchisse la seconda di autonomia
e di prestigio." Natalia Ginzburg, *Lessico famigliare*
(1963), in *Opere: Volume primo* (Milan, 1986), 1041.
This detail has already been pointed out by Meiss,
see Meiss, *Giotto and Assisi*, see fig. 71: *Christ* (detail
of *Ascension*), and fig. 72: *Hope*.

131 For this iconography, see 429, fig. 15, in Herbert
L. Kessler, "Turning a Blind Eye: Medieval Art and
the Dynamics of Contemplation," in *The Mind's Eye:
Art and Theological Argument in the Middle Ages*, ed.
Jeffrey F. Hamburger and Anne-Marie Bouché
(Princeton, 2006), 413–39. On the spiritual importance
of frames, see Hans Holländer, "Bild, Vision und
Rahmen," in *Zusammenhänge, Einflüsse, Wirkungen:
Kongressakten zum ersten Symposium des
Mediävistenverbandes in Tübingen, 1984*, ed. Joerg
O. Fichte, Karl Heinz Göller, and Bernhard
Schimmelpfennig (Berlin, 1986), 71–94.

132 For the Augustinian view on body and soul, see Paula
Fredriksen, "Beyond the Body/Soul Dichotomy:
Augustine on Paul against the Manichees and the
Pelagians," *Recherches augustiniennes* 23 (1988): 87–114.

133 See Sélincourt, *Giotto*, 162–63: "Crowe and
Cavalcaselle remark that 'In the costume, the drapery,
the cast of the profile and dress of the hair, Giotto
almost attains to the severe elegance of an antique bas-
relief.' This, to these critics, was the highest praise that
they could give. But however just and true, it directs
attention after all to what is only a secondary quality in
the work. Perhaps the most pronounced characteristic
of all *The Virtues* is the ordered restraint which marks
their action and their attire: And if this is emphasised
in the figure of Hope, the reason may be that it was
the artist's intention to distinguish her from the inef-
fective aspiration, which looks idly for good in the
future though careless of it in the present. Yet the
classic severity of the figure, suggestive as it is, is
wholly subservient to a spirit little dreamed of in the
earlier art. The perfect precision of handling and
orderliness of design, characteristic of Greek work,
are here used to express an unearthly grace and ten-
derness. Giotto pictures Hope winged, in the act to

rise heavenwards, Christ stooping to offer her a crown.
But it is not to her wings that she owes her aspiring
power, so much as to the trustful serenity, which,
animating her features and her limbs, springs from
her visible consciousness of purposes 'accomplished
in repose, too great for haste, too high for rivalry.' She
is, and was designed to be, the fruit of the preceding
virtues, and their coping-stone."

134 See Giuseppe Fiocco, "Giotto e Arnolfo," *Rivista d'arte*
19 (1937): 221–39, at 221–22.

135 See Schwarz and Theis, *Giottus Pictor*, vol. 1: *Giottos
Leben*, 362–64.

136 See Marcellan, "L'artista, l'usuraio, il teologo: Tre voci
nella Cappella degli Scrovegni," 6. For the Giotto–
Dante association see also, affirmingly, Hetzer,
Giotto, 32; critically Maginnis, "Problem with Giotto,"
83; romantically, Anna Jameson, *Memoirs of the Early
Italian Painters* (Boston, 1896), 25–48, and James
J. Jarves, *Art Studies: The "Old" Masters of Italy,
Painting* (New York, 1861), 133; realistically Curt
H. Weigelt, *Giotto: Des Meisters Gemälde* (Berlin,
1925), XLIV, and Moschetti, *La Cappella degli
Scrovegni*, 144. See also E. H. Gombrich, "Giotto's
Portrait of Dante?" *Burlington Magazine* 121 (1979):
471–83, on "the unlikely story of a friendship between
Dante and Giotto" (479). See Pier Liberale Rambaldi,
"Dante e Giotto nella letteratura artistica," *Rivista
d'Arte* 4 (1937): 286–384; André Chastel, "Giotto coe-
tano di Dante," in *Studien zur Toskanischen Kunst:
Festschrift für Ludwig Heinrich Heydenreich* (Munich,
1963), 37–44; Enid T. Falaschi, "Giotto: The Literary
Legend," *Italian Studies* 27 (1972): 1–27, at 10–11; H. M.
Thomas, "Contributi alla storia della Cappella degli
Scrovegni a Padova," in *Nuova Rivista Storica* 57
(1973): 111–128, at 114–16; Corrado Gizzi, *Giotto e
Dante* (Milan, 2001). The friendship myth appears to
have received a major boost from the account in
Selvatico 1870. Even Lord Lindsay found this associ-
ation suspicious, see Lord Lindsay, "Second Period –
Giotto's First Visit to Lombardy," 200. See also Fabio
Rosa, "Dante y Giotto: Notas al margen de una
leyenda," *Revista de Humanidades* 15–16 (2007):
131–41, and Maickol Quarena, *Giotto letto da Dante*
(Padua, 2010). See most recently Michael Viktor
Schwarz, "Giottos Dante, Dantes Giotto," in *Dante
und die bildenden Künste: Dialoge – Spiegelungen –
Transformationen*, ed. Maria Antonietta Terzoli and
Sebastian Schütze (Berlin, 2016), 163–84.

137 Gardner, *Giotto and His Publics*, 117. Not to forget,
though, that the later reception history of Giotto and
Dante has formed fascinating and fruitful relationships
across the centuries, e.g. between Giotto, Dante,
Ruskin, Pater, Berenson, Offner, and Proust. For visual

examples of the Romanticized image of Dante and Giotto in the nineteenth century, see the paintings by Leopoldo Toniolo, *Visita di Dante a Giotto nell'oratorio degli Scrovegni* (Padua, Musei Civici agli Eremitani, see Pisani, *I volti segreti di Giotto*), or Giovanni Mochi's *Dante presenting Giotto to Guido da Polenta* (Casa di Dante, Florence). See also *Dante in the Nineteenth Century: Reception, Canonicity, Popularization*, ed. Nick Havely (Oxford, 2011). Artistic examples are *Dante's meeting with Beatrice* by John William Waterhouse and Doré's *Inferno, Purgatory,* and *Paradise* illustrations. On Proust and Dante, see Walter A. Strauss, "Proust – Giotto – Dante" *Dante Studies* 96 (1978): 163–85. These connections are so varied that they demand future attention: In addition to the explicit passion for relief and volumes, the most important connections between the fourteenth and nineteenth centuries remain those of Giotto–Proust, Giotto–Ruskin, and the Pre-Raphaelites' artistic reinvention of the so-called Italian Primitives, contributing to the growing interest in Italian art of the Trecento and Quattrocento. See Camillo von Klenze, "The Growth of Interest in the Early Italian Masters: From Tischbein to Ruskin," *Modern Philology* 4 (1906): 207–74; Michael Levey, "Botticelli and Nineteenth-Century England," *Journal of the Warburg and Courtauld Institutes* 23 (1960): 291–306; Gail S. Weinberg, "Ruskin, Pater, and the Rediscovery of Botticelli," *Burlington Magazine* 129 (1987): 25–27. All go back not only to Giotto, but also to Dante, and neither last nor least via the timeless questions of individuation, personal agency, and empathy. See the discussion of Giotto's "individuation" in Erwin Rosenthal, *Giotto in der mittelalterlichen Geistesentwicklung* (Augsburg, 1924). See also Messerer, "Giottos Verhältnis zu Arnolfo di Cambio," 209. Both the *Divine Comedy* written and completed by Dante in his bitter exile and the faux interior of a double triumphal arch in the medium of fresco painted by Giotto signify artistic and human "victory of spirit over matter." Ladis, *Giotto's O*, 164. See also the parallel in Dante as discussed in Herbert D. Austin, "Dante Notes III: From Matter to Spirit," *Modern Language Notes* 38 (1923): 140–48. See also Felix Thürlemann, *Mehr als ein Bild: Für eine Kunstgeschichte des* hyperimage (Munich, 2013), 111.

138 Derbes and Sandona, "Barren Metal and the Fruitful Womb," at 274.

139 Ladis, *Giotto's O*, 4.

140 See "Allegorien im kirchlichen Bereich: Dante und die Gewölbe in Assisi," 48–50, in Hans Belting, "Das Bild als Text: Wandmalerei und Literatur im Zeitalter Dantes," in *Malerei und Stadtkultur in der Dantezeit: Die Argumentation der Bilder*, ed. Hans Belting and Dieter Blume (Munich, 1989), 23–64.

141 Julie F. Codell, "Giotto's Peruzzi Chapel Frescoes: Wealth, Patronage and the Early City," *Renaissance Quarterly* 41 (1988): 583–613, at 601. On "the logic of the painter architect," see Marvin Trachtenberg, *Building-in-Time: From Giotto to Alberti and Modern Oblivion* (New Haven, 2010), 279.

142 Tradition has it that Giotto was born in the Mugello: he is usually considered Tuscan as well as Florentine as a result of his positions and activity. Bellosi, for instance, follows Ghiberti in considering Vespignano, or perhaps even Florence, as possible places of Giotto's birth around the year 1266. But there is no substantial evidence to endorse or dispute these claims. See Bellosi, "Giotto, l'Angelico e Andrea del Castagno," 71.

143 For the mosaics, see Michael Viktor Schwarz, *Die Mosaiken des Baptisteriums in Florenz: Drei Studien zur Florentiner Kunstgeschichte* (Cologne, 1997). For further artistic implications of this canto, see Mark Musa, "E questo sia suggel ch' ogn' uomo sganni (Inferno XIX, 21)," *Italica* 41 (1964): 134–38. For Dante and the Florentine Baptistery, see Ernest Hatch Wilkins, "Dante and the Mosaics of his Bel San Giovanni," *Speculum: A Journal of Mediaeval Studies* 2 (1927): 1–10; for Giotto and Florentine Baptistery, see Edward F. Rothschild and Ernest H. Wilkins, "Hell in the Florentine Baptistery Mosaic and in Giotto's Paduan Frescoes," *Art Studies* 6 (1928): 31–35.

144 On Boniface's Lateran fresco and Giotto in Rome, see Charles Mitchell, "The Lateran Fresco of Boniface VIII," *Journal of the Warburg and Courtauld Institutes* 14 (1951): 1–6, and Herbert L. Kessler, "Giotto e Roma," in *Giotto e il Trecento*, 85–99.

145 From an art theoretical point of view, Peter Murray notes that the appearance of Giotto and Dante paired in Boccaccio's *Amorosa visione* presents them "as only modern artists who could truly be called famous, and who could be compared with the Ancients." See Peter Murray, "On the Date of Giotto's Birth," in *Giotto e il suo tempo: Atti del congresso internazionale per la clebrazione del VII centenario della nascita di Giotto*, 25–34, at 29.

146 See Mariani, *Giotto*, 32–33.

147 For the accuracy of Giotto's architecture, see Francesco Benelli, "The Medieval Portrait of Architecture: Giotto and the Representation of the Temple of the Minerva in Assisi," 31–42. On Paduan proto-humanism and the sciences, see Hubert Steinke, "Giotto und die Physiognomik," *Zeitschrift für Kunstgeschichte* 59 (1996): 523–47.

148 *Inferno* XXVIII. Carrying the town of his birth Patavium (ancient Padua) in his name, Titus Livius Patavinus lived likely between 59 BC and 17 AD. He wrote a monumental history of Rome and the Roman people, *Ab Urbe Condita Libri*, covering the period from the earliest legends of Rome through his own time, the reign of Augustus. See also Kurt Latte, "Livy's Patavinitas," *Classical Philology* 35 (1940): 56–60. For the context of the Paduan proto-Renaissance, see Zdravko Blažeković, "Crossovers in Paduan Narratives: Music and Visual Art Between Antiquity and the Renaissance," in Beck, *Giotto's Harmony*, 7–17. On the papal ideological use of such continuities, see also Esch, "L'uso dell'antico nell'ideologia papale, imperiale e comunale," in particular 18–19.

149 On the drama of "self-loss" that is so fundamental for both Dante and Augustine, see John Took, "Dante, Augustine and the Drama of Salvation," in *Word and Drama in Dante: Essays on the* Divina Commedia, ed. John C. Barnes and Jennifer Petrie (Dublin, 1993), 73–92.

150 See Nancy Enright, "Dante's *Divine Comedy*, Augustine's *Confessions*, and the Redemption of Beauty," *Logos* 10 (2007): 32–56.

151 See Davis, *Dante and the Idea of Rome*, here "Dante and the Papal City," 195–235. The modern reception of the Arch of Titus deals with issues similar to the chapel's appropriation (or reuse) of the past for reinterpretation of a brutal past as a sign of victory for the formerly victimized. Both the Arch of Titus and the Arena Chapel rank as major architectural, artistic, cultural, and political-religious touchstones in world history, offering themselves to a multitude of later artistic, poetic, and architectural modernities – in the "modern" time of Dante's new style as well as in the following centuries across many media, often with Dante forming a link between the ancient and medieval traditions and later premodern and modern worlds. The arch has been painted, sung, and politicized, from Franz von Lenbach's 1860 *The Triumphal Arch of Titus in Rome* featuring a peasant procession to the 1871 *Arch of Titus Henry Wadsworth Longfellow and his daughter Edith* complete with a self group portrait by the three artists Frederic E. Church, George Peter Alexander Healy, and Jervis McEntee. Written forms include de Vere's melancholic poem "Rome, Ruins of The Arch of Titus." Aubrey Thomas de Vere (1814–1902): "Rome, Ruins of The Arch of Titus / I stood beneath the Arch of Titus long; / On Hebrew forms there sculptured long I pored; / Till fancy, by a distant clarion stung, / Woke; and methought there moved that arch toward / A Roman triumph. Lance

and helm and sword / Glittered; white coursers tramped and trumpets rung: / Last came, car-borne amid a captive throng, / The laurelled son of Rome's imperial lord. / [...] Titus! a loftier arch than thine hath spanned / Rome and the world with empery and law; / Thereof each stone was hewn from Israel!" See *Poems of Places: An Anthology in 31 Volumes; Italy*, vols. 11–13, ed. Henry Wadsworth Longfellow (1876–79). A short text printed in the 6 May 1944 issue of *la-Ḥayyal*, the daily Hebrew newspaper of the Jewish Battalion of the British army, addresses the enduring conflicts around the arch, Nero, and Mussolini's Fascist Italy in a global context: "Historians find that there is no ethnic connection between ancient Rome and modern Italy, between Nero and Mussolini. Yet many Jews continue to see contemporary Rome as the symbol of the same kingdom that killed our freedom and destroyed our Temple. The Arch of Titus stands there still today. If for the whole world its value is only art-historical, for Fascist Italy it served as a source of inspiration for imperialistic and aggressive education. This modern Rome that sought to renew the war of ancient Rome against Jerusalem, to continue the thread that was first spun in the days of Pompeii and Titus, now is nothing before the Allies, and in these armies are many, many Jews. History gets its revenge." "Al ha-Pereq: Al Shiḥrur Roma," *la-Ḥayyal: Alon-Yomi le-Ḥayyilim be-Yaveshet Europa* 79 (May 6, 1944): 2, translation by Steven Fine. For important contextualization, see Steven Fine, The Menorah: *From the Bible to Modern Israel* (Cambridge, MA, 2016), 131.

152 Mazzotta, *Dante, Poet of the Desert*, 152–53.

153 Mazzotta, *Dante, Poet of the Desert*, 152–53.

154 Alessandro Ghisalberti, "Roma antica nel pensiero politico da Tommaso d'Aquino a Dante," in *Roma antica nel Medioevo: Mito, rappresentazioni, sopravvivenze nella "Respublica Christiana" dei secoli IX–XIII*, ed. Pietro Zerbi (Milan, 2001), 347–64, at 348.

155 Villani, *De origine civitatis Florentie et de eiusdem famosis civibus*, in "Filippo Villani," 185–87. See also Filippo Villani, *De origine civitatis Florentie et de eiusdem famosis civibus*, ed. Giuliano Tanturli (Padua, 1997), 411–13, in particular 412: "Fuit sane Giottus, arte picture seposita, magni vir consilii et qui multarum 'rerum' usum habuerit; hystoriarum insuper notitiam plenam habens, ita poesis extitit emulator, ut ipse pingere que ipsi fingere subtiliter considerantibus perpendatur."

156 See Baxandall, *Giotto and the Orators*.

157 See Wollesen, "'Ut poesis pictura?' Problems of Images and Texts in the Early Trecento," at 199.

158 On sight and beauty in Dante, see Hans Urs von Balthasar, *Herrlichkeit: Eine theologische Ästhetik*, vol. 2, *Fächer der Stille*, part 2, *Laikale Stille* (Einsiedeln, 1984),

365–462. For an overview and further bibliography on Dante and antiquity, see Craig Kallendorf, "Classical Antiquity," in *Dante Encyclopedia*, 172–75.

159 Eugenio Battisti, *Giotto* (Genève, 1960), 22.

160 Carlo Ciucciovino, *La cronaca del trecento italiano: Giorno per giorno l'Italia di Giotto e Dante*, vol. 1, *1300–1325* (Rome, 2007), 12, 13: "Dante Alighieri collocherà l'inizio del suo viaggio spirituale alla ricerca della fede, sublimemente descritto nella *Commedia*, nell'aprile di quest'anno."

161 Karlheinz Stierle, "Das System der schönen Künste im 'Purgatorio,'" In *Ästhetische Rationalität; Kunstwerk und Werkbegriff* (Munich, 1996), 389–416.

162 Kablitz also focuses on the overcoming of materiality in the *visibile parlare* that Dante describes when he sees the relief of the Annunciation as an emblem of the Incarnation. Andreas Kablitz, "Jenseitige Kunst oder Gott als Bildhauer: Die Reliefs in Dantes Purgatorio (Purg. X–XII)," in *Mimesis und Simulation*, ed. Andreas Kablitz and Gerhard Neumann (Freiburg, 1998), 309–56. Similarly, Heffernan concludes that "Dante's ekphrasis brings the incarnation full circle. The World is made flesh, which in turn is made stone, which in turn is made to speak, to become Word again: [...] Word and figure are interchangeable." James Heffernan, *Museum of Words: The Poetics of Ekphrasis from Homer to Ashbery* (Chicago, 1993), 38. See also Ulrich Pfisterer, "Phidias und Polyklet von Dante bis Vasari: Zu Nachruhm und künstlerischer Rezeption antiker Bildhauer in der Renaissance," *Marburger Jahrbuch für Kunstgeschichte* 26 (1999): 61–97, and Ulrich Pfisterer, *Donatello und die Entdeckung der Stile, 1430–1445* (Munich, 2002), 562, app. C, no. 4. See also James H. McGregor, "Reappraising Ekphrasis in Purgatorio 10," *Dante Studies* 121 (2003): 25–41.

163 See Mueller von der Haegen, "Die Darstellungsweise Giottos mit ihren konstitutiven Momenten, Handlung, Figur und Raum im Blick auf das mittlere Werk," 372. See also Martin Gosebruch, "Vom Aufragen der Figuren in Dantes Dichtung und Giottos Malerei," in *Festschrift für Kurt Badt zum 70. Geburtstag* (Berlin, 1961), 32–65.

164 See *La Divina commedia di Dante Alighieri nell'arte del cinquecento (Michelangelo, Raffaello Zuccari, Vasari, ecc.)*, ed. Corrado Ricci (Milan, 1908); Corrado Gizzi, *Federico Zuccari e Dante* (Milan, 1993); *Dante historiato da Federigo Zuccaro*, ed. Andrea Mazzucchi (Rome, 2005); Walter Mauro, *Il doppio segno – visioni di artisti che hanno illustrato la Divina Commedia: Signorelli, Botticelli, Michelangelo, Raffaello, Stradano, Zuccari, Füssli, Blake, Koch, Scaramuzza, Martini, Dalí, Sassu* (Rome, 2006). See also John Pope-Hennessy,

A Sienese Codex of the Divine Comedy (Oxford, 1947). See also J. J. G. Alexander, *Italian Renaissance Illuminations* (New York, 1977), for Federigo da Montefeltro's Dante, *La Divina Commedia*, fol. 127 *Purgatorio*, Canto XIII "He has represented the carving described by Dante as a classical relief *al antica*, [sic]" as Alexander notes laconically (*Italian Renaissance Illuminations*, 90). This example shows relief sculpture and figures carrying stones, while Gustave Doré reserves a special white-on-gray timbre for the representation of God's artwork. See *Dante's Purgatory and Paradise*, illustrated by Gustave Doré (New York, 1883).

165 This has already been noted by early Giotto scholars such as Rintelen and Hetzer and fully explored by Imdahl.

166 Rintelen, *Giotto und die Giotto-Apokryphen*, 62–63. See also Hetzer, "Vom Plastischen in der Malerei," 31.

167 See Imdahl, *Giotto*, 12; Toesca, *Giotto*, 19; and Hetzer, "Vom Plastischen in der Malerei," 122n6. See also Ivan Nagel, *Gemälde und Drama; Giotto, Masaccio, Leonardo* (Frankfurt am Main, 2009).

168 On the sources, see Schwarz and Theis, *Giottus Pictor*, vol. 1, *Giottos Leben*. On Giotto's and Dante's relationship to vernacular narratives see also James H. S. McGregor, "Classical and Vernacular Narrative Models for Art Biography in Vasari's *Lives*," in *Writers Reading Writers: Intertextual Studies in Medieval and Early Modern Literature in Honor of Robert Hollander*, ed. Janet Levarie Smarr (Newark, 2007), 183–200.

169 On the Franciscan connection via Santa Croce see Goffen, "Bonaventure's Francis." See Donal Cooper, "Giotto et les Franciscains," in *Giotto e compagni*, 29–47, and Massimo Cacciari, *Doppio ritratto: San Francesco in Dante e Giotto* (Milan, 2012). See also Bruce Cole, "Giotto's Apparition of St. Francis at Arles: The Case of the Missing Crucifix?" *Simiolus* 7 (1974): 163–65; Henk van Os, "St. Francis of Assisi as a Second Christ in Early Italian Painting," *Simiolus* 7 (1974): 3–20. See also Rintelen, *Giotto und die Giotto-Apokryphen* (1912), 9–10.

170 Schwarz and Theis, *Giottus Pictor*, vol. 1: *Giottos Leben*, 63–69 and 270–73.

171 On the concept of the Baroque court artist foreshadowed in Giotto's stalwart pragmatism, see Martin Warnke, *Hofkünstler: Zur Vorgeschichte des modernen Künstlers* (Cologne, 1996).

172 See Rintelen *Giotto und die Giotto-Apokryphen* (1912), 114.

173 See Schwarz, *Giotto*, and Schwarz, "Poesia e verità: una biografia critica di Giotto."

174 As quoted in Chiara Frugoni, "Female Mystics, Visions and Iconography" in *Women and Religion in*

Medieval and Renaissance Italy, ed. Daniel Bornstein and Roberto Rusconi (Chicago, 1996), 130–64, at 130. For an alternative English translation see Lars R. Jones, "Visio Divina? Donor Figures and Representations of Imagistic Devotion: The Copy of the 'Virgin of Bagnolo' in the Museo dell'Opera del Duomo, Florence," in *Italian Panel Painting of the Duecento and Trecento*, ed. Victor M. Schmidt (Washington, DC, 2002), 31–55, at 44: "In the first moment when the mind begins to think about Christ, Christ seems written in the mind and in the imagination; in the second, Christ seems to have been sketched; in the third, he seems to have been under-drawn and under-painted; in the fourth, he seems to have been colored and his flesh to have been painted; in the fifth he seems incarnate and *rilevato*."

175 As quoted in Arrigo Levasti, *Mistici del duecento e del trecento* (Milan, 1960), 273.

176 See Cennino Cennini, *Das Buch von der Kunst oder Tractat der Malerei des Cennino Cennini da Colle di Valdelsa*, ed. Albert Ilg (Vienna, 1871), chapters 9, 67, and 71.

177 See Joseph Polzer, "Concerning the Origin of the Meditations on the Life of Christ and its Early Influence on Art," *Franciscan Studies* 74 (2016): 307–51.

178 See Bernard McGinn, *The Varieties of Vernacular Mysticism: 1350–1550* (New York, 2012).

EPILOGUE

1 See *Le Fonti Francescane: I Fioretti di San Francesco* (Quaracchi, 1926), n.p., VIII: "Come andando per cammino santo Francesco e frate Leone, gli spuose quelle cose che sono perfetta letizia." See Appendix for the full text of Chapter VIII, "How Saint Francis, walking one day with brother Leo, explained to him what things are perfect joy." See Appendix II.

2 Enrico Scrovegni had already ordered Giovanni Pisano to sculpt his monument, the chapel's sculptures, and the painted crucifix; there could have been a larger relief cycle if desired. In a later example in the Pellegrini Chapel in Sant'Anastasia, Verona, the interior walls are still covered by Michele da Firenze's terracotta cycle of the life of Christ in twenty-four scenes, executed before 1436 and now long deprived of polychromy and gilding.

3 "ὅς ἐστιν εἰκὼν τοῦ Θεοῦ τοῦ ἀοράτου, πρωτότοκος πάσης κτίσεως" see David Bentley Hart, *The New Testament: A Translation* (New Haven, 2017), 398.

4 See Henry Fairfield Burton, "The Worship of the Roman Emperors," *The Biblical World* 40 (1912): 80–91.

5 See Michael Baxandall, *Painting and Experience in Fifteenth-Century Italy: A Primer in the Social History of Pictorial Style* (Oxford, 1972), 111.

6 For the important connections between Dante and Augustine, see Simone Marchesi, *Dante and Augustine: Linguistics, Poetics, Hermeneutics* (Toronto, 2011), with additional literature on 197. See also John Freccero, *In Dante's Wake: Reading from Medieval to Modern in the Augustinian Tradition*, ed. Danielle Callegari and Melissa Swain (New York, 2015), and the classic collection of essays by John Freccero, *Dante: The Poetics of Conversion* (Cambridge, MA, 1986). In the introduction, Rachel Jacoff considers Dante and Augustine as commentators on the self and the rebirth of the new self through more learning and consciousness, "the story of how the self that was becomes the self that is," Freccero, *Dante*, xii. See also John Took, "Dante and the 'Confessions' of Augustine," *Annali d'Italianistica* 8 (1990): 360–82.

7 On periodization, see Randolph Starn, "Who's Afraid of the Renaissance?" in *The Past and Future of Medieval Studies*, ed. John van Engen (Notre Dame, 1994), 129–47. See also Randolph Starn, "The Early Modern Muddle," *Journal of Early Modern History* 6 (2002): 296–307.

8 See Zaho, *Imago Triumphalis*. See also Mary Beard, *The Roman Triumph* (Cambridge, MA, 2009). See also Theodor Mommsen, "Petrarch and the Decoration of the Sala Virorum Illustrium in Padua," *Art Bulletin* 34 (1952): 95–116, at 113.

9 Ulrich Pfisterer, "Triumphtor und Vorhalle zur Gottesstadt: Michelangelos Deckenfresken und Julius II," in *Die Sixtinische Kapelle* (Munich, 2013), 42–80. Many thanks to Ulrich Pfisterer for his contribution to my Berkeley Giotto conference ("Transformation & Modernity around 1300: Medium, Spirituality, Experience in Giotto's Arena Chapel") in February 2020.

10 See Alexander Nagel, "Michelangelo's Work as an Art Historian," in *Michelangelo and the Reform of Art* (Cambridge, 2000), 1–22.

11 Steven Fine, oral communication, Yeshiva University Center for Israel Studies, New York City, 29 October 2017.

12 On Mussato's context, see Ronald G. Witt, *"In the Footsteps of the Ancients": The Origins of Humanism from Lovato to Bruni* (Leiden, 2000). Mussato attacks "gilded Churches" in general and the Carraresi in particular, see the 1320 *De obsidione domini Canis Grandis de Verona ante civitatem Paduanam* by

Albertino Mussato, ed. Giovanna M. Gianola (Padua, 1999).

13 See Marcellan, "L'artista, l'usuraio, il teologo: Tre voci nella Cappella degli Scrovegni," 13.

14 See Witt, *"In the Footsteps of the Ancients": The Origins of Humanism from Lovato to Bruni*, 131.

15 Witt, *"In the Footsteps of the Ancients": The Origins of Humanism from Lovato to Bruni*, 41. For the history of Duecento Padua, see Hyde, *Padua in the Age of Dante*.

16 See Romano, "Giotto e la scultura," in *La O di Giotto*, 194–238. Romano describes Giotto's dialogue with ancient relief sculpture as follows: "Per di più, cambia il formato dei rilievi. Il sistema delle lunghe lastre a rilievo continuo [...] deve frequentemente cedere il passo all'esigenza di avere lastre rettangolari più alte che larghe, ognuna contenente una scena che lo spazio relativamente limitato tende a rendere forzatamente centripeta. Sono formati che nascono specialmente in rapporto proprio alla decorazione degli archi trionfali, di cui vanno a decorare gli attici; come una sorta di pale d'altare, contengono ognuna un soggetto, e sono 'appese' come quadri negli spazi loro destinati," Romano, "Giotto e la scultura," 208. She also explains the precise relationship between Giotto and the Roman reliefs in terms of rhetorical register and expressive timbre: "non è la narrazione funeraria il [modello di Giotto], e non è la narrazione storica antica *tout court*: le superficie affollate e i ritmi di massa della scultura dei sarcofagi, o anche delle colonne Traiana e Antonina non smurano conquistarlo, cercando il pittore, evidentemente, un diverso registro retorico e un diverso timbro espressivo," Romano, "Giotto e la scultura," 210.

17 See Pisani, *I volti segreti di Giotto*, 16. On Enrico's second exile in 1319, see Pisani, *I volti segreti di Giotto*, 22. A few decades after the Venetian conquest of Padua in 1405, the chapel was confiscated by the Consiglio dei Dieci in 1443. There was some local interest in the chapel, see Alessandro Prosdocimi, "Il Comune di Padova e la Cappella degli Scrovegni nell'Ottocento: Acquisto e restauri degli affreschi," *Bollettino del Museo Civico di Padova* 49 (1960): 69–120.

18 English translation from Theodor E. Mommsen, "Petrarch's Conception of the 'Dark Ages,'" *Speculum* 17 (1942): 226–42, at 232.

19 Mazzotta, *Worlds of Petrarch*, 20–21.

20 Inspired by the Arch of Augustus in Aosta, a passage from Stendhal's *Vie de Henri Brulard* embraces both the triumphal key as well as the languor of ancient ruins: "D'ailleurs, j'étais si heureux en contemplant ces beaux paysages et l'arc de triomphe d'Aoste que je n'avais qu'un vœu à former, c'était que cette vie durât toujours." Stendahl, *"Vie de Henri Brulard,"* in *Œuvres completes* (Paris, 1927), 4: 300. On the significance of Roman ruins for the Western history of ideas see Walter Rehm, *Der Untergang Roms im abendländischen Denken: Ein Beitrag zur Geschichtsschreibung und zum Dekadenzproblem* (Leipzig, 1930), and *Erinnerungen Träume Gedanken von C. G. Jung*, ed. Aniela Jaffé (Zurich, 1963), 292. For the Christianized Arch of Titus in particular, see the views of Rome in the context of pilgrimage maps, prints, and papal bulls, prominently featuring the arch close to the Colosseum alongside the major churches published in *Roma 1300–1875: La città degli anni santi; Atlante*.

21 See Bernhard Huss, "Petrarca, Giotto e le illustrazioni ai 'Trionfi': Tra testo e immagine," in *Parola all'immagine: Esperienze dell'ecfrasi da Petrarca a Marino*, ed. Andrea Torre (Lucca, 2019), 21–38.

22 The golden inscription on the arch reads: "Gn[eo] Pompeo Magno Hircanus Pont[ifex] P[osuit]" ("The priest Hircanus erected [this arch] in honor of Gnaius Pompey the Great"). After the executions during his Sicilian campaign, the late Roman Republican military leader (106 BC–48 BC) was known as *adulescentulus carnifex* (adolescent butcher), and seems to be an excellent choice for contrasting the message of peace offered by the infant Jesus in the foreground. I am grateful to Martin Warnke for bringing this detail to my attention.

23 On humility in the artistic context with Arachne as the textual correlative of Ulysses, see also Teodolinda Bartolini, *The Undivine Comedy* (Princeton, 1992), 64.

24 See the rendition in the *Cenni storici sulle famiglie di Padova e sui monumenti dell'università* (Padua, 1842).

25 See William L. MacDonald, *The Architecture of the Roman Empire*, vol. 1, *An Introductory Study* (New Haven, 1982), 96–99 and 98, fig. 8.

26 See Moschetti, *La Cappella degli Scrovegni e gli affreschi di Giotto in essa dipinti*, 54.

27 See Giuseppe Mazzotta, *Cosmopoiesis: The Renaissance Experiment* (Toronto, 2001).

28 Davis, "Medium Effects."

29 Fredriksen, "Beyond the Body/Soul Dichotomy," at 113.

30 Fredriksen, "Beyond the Body/Soul Dichotomy," 114.

31 Giotto inspired modern and abstract artists as diverse as Vincent Van Gogh and the Pre-Raphaelites such as Edward Burne-Jones, Henri Matisse and Kazimir Malevich, Diego Rivera and Sol LeWitt, Yves Klein and Mark Rothko. Artistic reactions are as varied as they are numerous, from the movement "Valori plastici" (with the eponymous magazine published

between 1918 and 1922) to the first photographic takes of the chapel by the Alinari and by Carlo Naya, to romanticizing images like the Giotto portrait for the South Kensington Museum by John Callcott Horsley (c. 1872). On Carlo Naya, see Dana MacFarlane, "'Arresting strangeness': Walter Benjamin's Proust and Carlo Naya's Giotto," *History of Photography* 31 (2007): 134–50. Van Gogh mentions Giotto in several letters, such as 683 (To Theo van Gogh), Arles, Tuesday, 18 September 1888 ("Giotto touched me the most – *always suffering* and always full of kindness and ardour as if he were already living in a world other than this") [online source: http://vangoghletters.org/vg/letters/let683/letter.html, last accessed 24 December 2019]; 655 (To Emile Bernard), Arles, on or about Sunday, 5 August 1888 (We, artists in love with order and symmetry, isolate ourselves and work to define *one single thing*) [online source: http://vangoghletters.org/vg/letters/let655/letter.html, last accessed 24 December 2019]; RM21 (To Joseph Jacob Isaäcson), Auvers-sur-Oise, Sunday, 25 May 1890 [online source: http://vangoghletters.org/vg/letters/RM21/letter.html, last accessed 24 December 2019]. On Van Gogh's wish to travel so that he could copy Giotto (he calls Giotto his only source of true comfort, *Briefe an seinen Bruder*, vol. 2 [1914], no. 605), see Gosebruch, *Giotto und die Entwicklung des neuzeitlichen Kunstbewußtseins*, 52. Matisse was not interested in the sentiment of the Paduan stories, only in their formal qualities ("le sentiment qui s'en dégage, car il est dans les lignes, dans la composition, dans la couleur, e le titre ne fera que confirmer mon impression"). See Henri Matisse, "Notes d'un Peintre," *La Grande Revue*, Paris, 25 December 1908, 471. Victorians such as Edward Burne-Jones had formulated their own unique responses to the "human realism as achieved in the Arena Chapel by Giotto," the chapel being "one of the sacred places of Pre-Raphaelite art," as Fiona MacCarthy puts it, see Fiona MacCarthy, *The Last Pre-Raphaelite: Edward Burne-Jones and the Victorian Imagination* (Cambridge, MA, 2012), 79. See also MacCarthy, *The Last Pre-Raphaelite*, 142. British narrative artist Stanley Spencer famously declared, before WWI, "'If I go to war, I go on condition I can have Giotto, the Basilica of Assisi book, Fra Angelico in one pocket, and Masaccio, Masolino and Giorgione in the other,' Stanley Spencer wrote to the artist Henry Lamb in 1914. [...] 'What ho, Giotto!' was Spencer's response to the news [when given the green light on painting Sandham Memorial Chapel in 1927]." See Laura Gascoigne, "When Soldiers Have Golden Helmets and the Wounded Have Wings," *The Spectator*, 14 December 2013, online

resource: www.spectator.co.uk/2013/12/what-ho-giotto/, last accessed 24 December 2019. See also Fiona MacCarthy, *Stanley Spencer: An English Vision* (New Haven, 1997). On Spencer's Sandham Memorial Chapel as a response to the Arena Chapel, see "Why Stanley Spencer is the English Giotto," online resource: www.telegraph.co.uk/culture/art/10550823/Why-Stanley-Spencer-is-the-English-Giotto.html, last accessed 24 December 2019. See also Nigel Rapport, *Distortion and Love: An Anthropological Reading of the Art and Life of Stanley Spencer* (Dorchester, 2016), 18. On Giotto as "genius of the people" and on the importance of Giotto for Diego Rivera and Élie Faure in relation to pre-Columbian art, see Patrick Marnham, *Dreaming with His Eyes Open: A Life of Diego Rivera* (Berkeley, 1998), 144–45. To quote Sol LeWitt: "I would like to produce something I would not be ashamed to show Giotto"; see Andrea Miller-Keller, "Excerpts from a Correspondence, 1981–1983," in Susanna Singer et al., *Sol LeWitt Wall Drawings 1968–1984* (Amsterdam, 1984), 25. On Yves Klein, see Barbara Bolt, "Whose Joy? Giotto, Yves Klein and Neon Blue," *The International Journal of the Image* 1 (2011): 58–67. In the realm of the temporal arts, Jean-Luc Godard's *Histoire(s) du cinema* (1988–98) blends in and out of Giotto's *Noli me tangere*. See Kriss Ravetto-Biagioli, "*Noli me tangere*: Jean-Luc Godard's *Histoire(s) du cinema*," in *A Companion to Jean-Luc Godard*, ed. Tom Conley and T. Jefferson Kline (Chichester, 2014), 456–87. See also Kriss Ravetto-Biagioli, *Mythopoetic Cinema: On the Ruins of European Identity* (New York, 2017), 205–6. See also the cinematic reference by Pier Paolo Pasolini in his 1971 film version of Boccaccio's *Il Decameron* with Pasolini staging himself in a self-portrait role as Giotto, and the dream-vision of a Marxist *Last Judgment* with a peasant boy shouldering the chapel in place of the canon, surrounded by humble peasant girls in place of Mary and the Saints. See Naomi Greene, *Pier Paolo Pasolini: Cinema as Heresy* (Princeton, 1990), 185–88.

32 See John Freccero, *Dante's Cosmos* (Binghamton, NY, 1998). "Two ancient traditions concerning God's relationship to the universe come together in this image. On one hand, God is the ruler of the heavens, like the creator in Platonic myth, giving motion to the spheres from the outside. On the other, God is the center of the spiritual world, moving the soul from within. If one could imagine the deity in both of these roles at the same time, one would have the representation of a celebrated mystic definition of God as both center and circumference, maximum and minimum, centering and encompassing all of reality," Freccero, *Dante's Cosmos*, 9.

33 "Abundant mala, et deus voluit ut abundarent mala. Utinam non abundarent mali, et non abundarent mala. Mala tempora, laboriosa tempora, hoc dicunt homines. Bene vivamus, et bona sunt tempora. Nos sumus tempora: Quales sumus, talia sunt tempora." Augustine, *Sermo* 80, 8.

APPENDICES

1 Mariana Monteiro, *"As David and the Sibyls Say": A Sketch of the Sibyls and the Sibylline Oracles* (Edinburgh, 1905), 2.

2 *Goethes Briefe an Charlotte von Stein*, ed. Jonas Fränkel, vol. 1 (Berlin, 1960), 238. Goethe does not mention Giotto's work in Padua in the *Italienische Reise*, see Goethe, *Italienische Reise,* ed. Herbert von Einem (Munich, 1981), 58–63 on Padua, 26 and 27 September 1786. Translation mine. We find the note on Giotto's Paduan "Mary" only in the letters to Charlotte Stein.

3 *Goethes Briefe an Charlotte von Stein*, 238.

4 On the Vasarian Giotto, see the first chapter, "The Sorcerer's 'O' (and the Painter Who Wasn't There)" in Andrew Ladis, *Victims and Villains in Vasari's Lives* (Chapel Hill, 2008), 1–30.

5 While this is the second-longest note, the longest reference in this book is note 15 on pages 236–37, covering the bibliography for the related theme of sculptural qualities in Giotto that has been so defining for the Assisi controversy. See Willibald Sauerländer, "Giotto, Assisi e la crisi dei conoscitori," in *Giotto e Pietro Cavallino: La questione di Assisi e il cantiere medievale della pittura a fresco,* ed. Bruno Zanardi (Milan, 2002), 7–12. See the literature pro and contra quoted in Bruno Zanardi, "Giotto and the St. Francis Cycle at Assisi," in *Cambridge Companion to Giotto,* 32–62, with the traditional line of opponents to Giotto's activity in Assisi Guglielmo Della Valle, Richard Offner, Viktor Lazarev, John White, Millard Meiss, Alastair Smart, Federico Zeri, and that of the "Giottisti," Luigi Lanzi, Pietro Toesca, Roberto Longhi, Giovanni Previtali, Luciano Bellosi. See in particular Tintori and Meiss, "Cycle as a Whole." Zanardi's technical results are summed up in Zanardi, "Giotto and the St. Francis Cycle at Assisi," 61. See also Bruno Zanardi, "L'organizzazione del cantiere," in *Il cantiere di Giotto: Le Storie di san Francesco ad Assisi* (Milan, 1996), 19–20, 34–36, 38–40, 42–44, 46–58; Zanardi, *Giotto e Pietro Cavallino: La questione di Assisi e il cantiere medievale della pittura a fresco.* See in particular Bauch, "Die geschichtliche Bedeutung von Giottos Frühstil," 43–64; Peter Murray, "Notes on Some Early Giotto Sources," *Journal of the Warburg and Courtauld Institutes* 16 (1953): 58–80; on the Assisi Problem, see Murray, "Notes on Some Early Giotto Sources," 66–75, as well as Meiss, *Giotto and Assisi.* See also Alastair Smart, "Ghiberti's 'quasi tutta la parte di sotto' and Vasari's Attributions to Giotto at Assisi," *Renaissance and Modern Studies* 8 (1963): 5–24; Smart, *Assisi Problem and the Art of Giotto,* and Belting, "Assisi e Roma: Risultati, Problemi, Prospettive," which discusses Assisi's Roman touch. See also Bellosi, "'Opus magistri Iocti,'" 94. See also the dated but mostly common-sense consideration of reasons for local differences between Umbria and the Veneto in Mather, "Giotto's St. Francis Series at Assisi Historically Considered," 107, that concludes that "many of the differences noted by Offner between Assisi and Padua are not, as he alleges, stylistic differences but compositional and decorative differences generally dictated by: 1) the nature of the two interiors; 2) the size of the picture panels – about 11 x 10 ft. at Assisi, about 7 x 8 ft. at Padua [. . .]; 3) the widely different character of the subject matter – at Assisi, virtually contemporary subjects in surroundings familiar to the public; and with little iconographical precedent; at Padua, far-off legendary subjects with abundant iconographic precedent of an idealizing and Hellenizing sort." See Boskovits, "Giotto: Un artista poco conosciuto?" See also Carl Brandon Strehlke's review of the exhibition *Giotto: Bilancio critico di sessant'anni di studi e ricerche* at the Galleria dell'Accademia, Florence, in *Burlington Magazine* 142 (2000): 591–93, supporting Luciano Bellosi's criticism dismantling "Offner's arguments for denying Giotto authorship of the St. Francis cycle in Assisi," 591. See also Cannon, "Giotto and Art for the Friars: Revolutions Spiritual and Artistic." For a concise overview, see Thomas De Wesselow, "The Date of the St Francis Cycle in the Upper Church of S. Francesco at Assisi: The Evidence of Copies and Considerations of Method," in *The Art of the Franciscan Order in Italy,* ed. William R. Cook (Leiden, 2005), 113–67. See also Alessandro Tomei, "La decorazione della Basilica di San Francesco ad Assisi come metafora della questione giottesca," in *Giotto e il Trecento: 'Il più Sovrano Maestro stato in dipintura.' I saggi,* 31–49. For further literature, see the more recent contribution by Donal Cooper and Janet Robson, *The Making of Assisi: The Pope, the Franciscans and the Painting of the Basilica* (New Haven, 2013).

6 See Jantzen, "Giotto und der gotische Stil," 35–40.

7 Jantzen, "Giotto und der gotische Stil," 36.

8 "reliefartige[s] Nebeneinander," Jantzen, "Giotto und der gotische Stil," 39.

9 See Jantzen, "Giotto und der gotische Stil," 40.

10 See *Giotto: The Frescoes of the Scrovegni Chapel in Padua.* Basile describes this for the *"Resurrection of Christ,* where some of the soldiers sleeping in front of the sarcophagus look like they are ready to emerge from the frame, or the *Massacre of the Innocents,* where the heap of slain bodies is about to slide over the fragile barrier of the frame, or, lastly, the *Kiss of Judah,* where the central group of soldiers 'breaking through' in the background is in opposition to Caiaphas who advances towards and illusionistically over the front line of the scene." *Giotto: The Frescoes of the Scrovegni Chapel in Padua,* 30.

11 Offner, "Giotto, non-Giotto," 86.

12 See Schwarz, *Giottus Pictor,* vol. 2, *Giottos Werke.*

13 See Benvenuto da Imola's commentary on the *Comedia,* circa 1376: "And note that Giotto still holds the field, since no one has yet surpassed him in subtlety." Anne Derbes and Mark Sandona, "Giotto Past and Present: An Introduction," in *Cambridge Companion to Giotto,* 1–9, at 3. See also Poeschke, *Wandmalerei der Giottozeit in Italien,* 13 on a related passage in Boccaccio on Giotto working for informed, not uninformed viewers (*Decameron VI, 5*).

14 John White, *The Birth and Rebirth of Pictorial Space* (Boston, 1967), at 58. See in particular White's chapter "Giotto – the Arena Chapel," *Birth and Rebirth of Pictorial Space,* 57–71.

15 White, "Giotto – the Arena Chapel," 57–58.

16 White, "Giotto – the Arena Chapel," 65–66.

17 Bellosi, "'Opus magistri Iocti,'" 90.

18 See Bellosi, "Giotto, l'Angelico e Andrea del Castagno."

19 "The spaces [Giotto] created are not very deep, no deeper than a stage, and yet, they give the impression they could easily be measured." See Bellosi, "Giotto, l'Angelico e Andrea del Castagno," 75. The Assisi *Apparition to Gregory IX* "takes place inside a convincing cube in perspective," Bellosi, "Giotto, l'Angelico e Andrea del Castagno," 75.

20 For specific quotes on Giotto's relief by Bauch, Euler, Flores d'Arcais, Fry, Gosebruch, Jantzen, Maginnis, Mather, Meiss, Oertel, Offner, Poeschke, Romano, Romdahl, Salvini, Selvatico, Sirén, Smart, Toesca, and Weigelt, see note 15 for Chapter 1, 236–37.

21 Stubblebine, "Giotto and the Arena Chapel Frescoes," 74.

22 See Hetzer, *Giotto,* 128, "[zu] vergegenwärtigen [. . .,] als *Vorgang* eindrücklich zu machen." For distance ("mittlere Distanz"), see Strauss as quoted in Imdahl, *Giotto,* 15: "Ernst Strauss beschreibt die Farbigkeit der Figuren und Dinge und bestimmt sie kategorial als Fernbildfarbe aus mittlerer Distanz: 'Zu einem genaueren Verständnis des Kolorismus Giottos ist erforderlich, seine Schattengebung nicht nur als ein neues Modellierungsverfahren anzusehen, sondern sie in ihrem folgerichtigen Zusammenhang mit der reliefmäßigen Darstellungsweise der Formen zu begreifen. [. . .] Diese Sicht setzt ein Distanzverhältnis des Anschauenden zur Erscheinungswelt voraus: erst die in reinem Gegenüber angesehenen Dinge weisen die optischen Merkmale auf, welche zum Zustandekommen eines spezifischen Reliefeindrucks unerläßlich sind. Erst im 'Fernbild', beim Anblick aus einer mittleren Distanz, entziehen sich die Dinge der 'abtastenden' Erfassung durch das Auge, verlieren sie das Aufdringliche ihrer Plastizität, erscheinen sie nivelliert und beginnen sich flächenmäßig, in 'Plänen', dem Blickfeld einzufügen; erst im Fernbild wird der Kontur zur Scheidelinie, kann Überschneidung zu einem einheitlichen räumlichen Eindruck führen.' [Ernst Strauss: *Koloritgeschichtliche Untersuchungen zur Malerei seit Giotto.* Munich and Berlin 1972, p. 50f.]"

23 Such relations are discussed in Gosebruch et al., *Giotto di Bondone,* 18: "Jedenfalls wird das Oben und Unten, das Vor und Zurück, das Hin und Her für das Handeln der Figuren wichtig." See Imdahl, *Giotto,* 10: "'Beziehung und Individuum' – das ist die knappste Formel, in der Hetzer die Bildleistung Giottos zusammengefaßt hat." See also Kemp, "Erzählraum wird durch Räume und durch Beziehungen zwischen diesen konstituiert – durch die Beziehungen zwischen Innenräumen, zwischen Innenraum und Außenraum und zwischen Bildraum und Betrachterraum. Erzählraum ist Bezugsraum" in Kemp, *Die Räume der Maler,* 9. "Raum gibt es hier nur als Relationsbegriff," so Kemp quoting Cassirer: "Raum und Zeit sind keine Substanzen, sondern vielmehr 'reale Relationen'; sie haben ihre wahrhafte Objektivität in der 'Wahrheit von Beziehungen', nicht an einer absoluten Wirklichkeit." Kemp, *Die Räume der Maler.* See Kemp, *Die Räume der Maler,* 11, for the concept of "Zwischenraum" (Simmel). Kemp discusses spatial concepts with Spengler's *Untergang des Abendlandes*: "Spenglers Abheben auf die 'wahre Dimension' der Tiefe dynamisiert dieses allgemeine Merkmal der Ausgedehntheit alles Räumlichen: Die Momente des Subjektbezugs und der 'Bewegtheit,' sprich der Zeithaltigkeit eines Raumbilds, treten so deutlicher zuvor. Spenglers 'Zwischen' würde danach

nicht im Wechselverkehr der Räume und ihrer Repräsentanten lebendig werden, sondern zwischen einem Wahrnehmungssubjekt und den von ihm aus konzipierten Perspektivraum entstehen. Dazu gehört [. . .] notwendig der Zeitaspekt." Kemp, *Die Räume der Maler*, 13. On the concept of distance see Kemp, *Die Räume der Maler*, 46, for Heidegger's "Entfernung," see Martin Heidegger, *Sein und Zeit* (Tübingen, 1967), 141.

24 See *Il Palazzo della Ragione di Padova*, ed. Carlo Guido Mor (Venice, 1964); Claudio Bellinati, "Giotto dipinse nel Palazzo della Ragione a Padova?" in *Il Palazzo della Ragione di Padova: La storia, l'architettura, il restauro*, ed. Ettore Vio (Padua, 2008), 327–31; Anna Maria Spiazzi, "La decorazione del Salone," in *Il Palazzo della Ragione di Padova: La storia, l'architettura, il restauro*, 315–25; Eva Frojmovič, "Giotto's Allegories of Justice and the Commune in the Palazzo della Ragione in Padua: A Reconstruction," *Journal of the Warburg and Courtauld Institutes* 59 (1996): 24–47.

25 See Belting, *Die Oberkirche von San Francesco in Assisi*, 235–36.

26 Krautheimer, *Rome: Profile of a City*, 203.

27 See E. M. Forster, *A Room with a View* (London, 1908). On Berenson, see Romano, *La O di Giotto*, 9.

28 See Marcel Proust, *A la Recherche du Temps perdu*, ed. Clarac and Ferre, 3 vols. (Paris, 1954), 3:648. On Proust on Giotto, see Willibald Sauerländer, "Marcel Proust und die Malerei," *Jahrbuch der Bayerischen Akademie der Schönen Künste* 10 (1996): 3–26. Republished in *Willibald Sauerländer: Geschichte der Kunst – Gegenwart der Kritik*, ed. Werner Busch, Wolfgang Kemp, Monika Steinhauser, Martin Warnke (Cologne, 1999), 174–89. See also Eric Karpeles, *Paintings in Proust: A Visual Companion to In Search of Lost Time* (London, 2008).

SELECT BIBLIOGRAPHY

Agamben, Giorgio. *The Time That Remains: A Commentary on the Letter to the Romans*. Redwood City, 2005.

Aitken, Ellen Bradshaw. "Portraying the Temple in Stone and Text: The Arch of Titus and the Epistle to the Hebrews." In *Religious Texts and Material Contexts*, edited by Jacob Neusner and James F. Strange. Lanham, 2001, 73–88.

Alpatoff, Michel. "The Parallelism of Giotto's Paduan Frescoes." *Art Bulletin* 29 (1947): 149–54.

Auerbach, Erich. *Literary Language and Its Public in Late Latin Antiquity and in the Middle Ages*. Princeton, 1993.

Austin, Herbert D. "Dante Notes III: From Matter to Spirit." *Modern Language Notes* 38 (1923): 140–48.

Autret, Jean. *L'influence de Ruskin sur la vie, les idées et l'œuvre de Marcel Proust*. Geneva and Lille, 1955.

Baldovin, John Francis. *The Urban Character of Christian Worship*. Chicago, 1987.

von Balthasar, Hans Urs. *Herrlichkeit: Eine theologische Ästhetik. Vol. 2, Fächer der Stille, part 1, Klerikale Stille; and part 2, Laikale Stille*. Einsiedeln, 1984.

Banzato, Davide (ed.). *La Croce di Giotto: Il restauro*. Milan, 1995.

Banzato, Davide. "La Croce di Giotto dei Musei Civici di Padova. Ipotesi di collocazione originaria e precedenti restauri." In *La Croce di Giotto: Il restauro*, edited by Davide Banzato. Milan, 1995, 26–40.

"L'impronta di Giotto e lo sviluppo della pittura del Trecento a Padova." In *Giotto e il Trecento: "Il più Sovrano Maestro stato in dipintura"; I saggi*, edited by Alessandro Tomei. Exh. cat., Complesso del Vittoriano, Rome. Milan, 2009, 143–55.

Barasch, Moshe. *Giotto and the Language of Gesture*. Cambridge, 1987.

Barberini, Maria Giulia. *I Santi Quattro Coronati a Roma*. Rome, 1989.

Barcilon, Pinin Brambilla. "*Notizie e risultati del restauro*." In *La Croce di Giotto: Il restauro*, edited by Davide Banzato. Milan, 1995, 57–75.

Barker, Jennifer M. *The Tactile Eye: Touch and the Cinematic Experience*. Berkeley, 2009.

Basile, Giuseppe. *Giotto: La Cappella degli Scrovegni*. Milan, 1992.

(ed.). *Giotto: The Frescoes of the Scrovegni Chapel in Padua*. Milan, 2002.

"Giotto's Pictorial Cycle." In *Giotto: The Frescoes of the Scrovegni Chapel in Padua*, edited by Giuseppe Basile. Milan, 2002, 13–20.

(ed.). *Il restauro della Cappella degli Scrovegni: Indagini, progetto, risultati / Restoration of the Scrovegni Chapel: Surveys, Projects, Results*. Milan, 2003.

(ed.). *I colori di Giotto: La Basilica di Assisi. Restauro e restituzione virtuale*. Exh. cat., Basilica di San Francesco and Palazzo del Monte Frumentario, Assisi. Milan, 2010.

Battisti, Eugenio. *Giotto*. Geneva, 1960.

Bauch, Kurt. "Die geschichtliche Bedeutung von Giottos Frühstil." *Mitteilungen des Kunsthistorischen Institutes in Florenz* 7 (1953): 43–64.

——— "Giotto und die Porträtkunst." In *Giotto e il suo tempo: Atti del congresso internazionale per la celebrazione del VII centenario della nascita di Giotto*. Rome, 1971, 299–309.

Bauerle, Dorothée. *Gespenstergeschichten für ganz Erwachsene: Ein Kommentar zu Aby Warburgs Bilderatlas Mnemosyne*. Münster, 1988.

Baxandall, Michael. *Giotto and the Orators: Humanist Observers of Painting in Italy and the Discovery of Pictorial Composition, 1350–1450*. Oxford, 1971.

Beard, Mary. *The Roman Triumph*. Cambridge, MA, 2009.

Beck, Eleonora M. *Giotto's Harmony: Music and Art in Padua at the Crossroads of the Renaissance*. Florence, 2005.

Bellinati, Claudio. *La Cappella di Giotto all'Arena (1300–1306): Studio storico-chronologico su nuovi documenti*. Padua, 1967.

——— "La Cappella di Giotto all'arena e le miniature dell'antifonario 'Giottesco' della cattedrale (1306)." In *Da Giotto al Mantegna*, edited by Lucio Grossato. Exh. cat., Palazzo della Ragione, Padua. Milan, 1974, 23–30.

——— "Iconografia, iconologia e iconica nell'arte nuova di Giotto alla Cappella Scrovegni dell'Arena di Padova." *Padova e il suo territorio* 11 (1989): 16–21.

——— *Giotto: Padua felix; Atlante iconografico della Cappella di Giotto 1300–1305*. Treviso, 1997.

——— *Nuovi studi sulla Cappella di Giotto nell'Arena di Padova: 25 marzo 1303–2003*. Padua, 2003.

——— *Padua Felix: Iconographic Atlas of Giotto's Chapel 1300–1305*. Ponzano, 2003.

——— "Giotto dipinse nel Palazzo della Ragione a Padova?" In *Il Palazzo della Ragione di Padova: La storia, l'architettura, il restauro*, edited by Ettore Vio. Padua, 2008, 327–31.

Bellosi, Luciano. *La Pecora di Giotto*. Turin, 1985.

——— "Giotto, l'Angelico e Andrea del Castagno." In *Mugello culla del Rinascimento: Giotto, Beato Angelico, Donatello e i Medici*, edited by Barbara Tosti. Exh. cat., Museo d'arte sacra e religiosità popolare "Beato Angelico," Vicchio; Convento di San Bonaventura a Bosco ai Frati, San Piero a Sieve; Museo della Manifattura Chini, Borgo San Lorenzo; Palazzo dei Vicari, Scarperia; Palazzo Medici Riccardi, Florence. Florence, 2008, 71–97.

Belting, Hans. *Die Oberkirche von San Francesco in Assisi: Ihre Dekoration als Aufgabe und die Genese einer neuen Wandmalerei*. Berlin, 1977.

——— "Assisi e Roma: Risultati, Problemi, Prospettive." In *Roma anno 1300: Atti della IV settimana di Studi di Storia dell'Arte medievale dell'Università di Roma "La Sapienza,"* edited by Angiola Maria Romanini. Rome, 1983, 93–101.

——— "Das Bild als Text: Wandmalerei und Literatur im Zeitalter Dantes." In *Malerei und Stadtkultur in der Dantezeit: Die Argumentation der Bilder*, edited by Hans Belting and Dieter Blume. Munich, 1989, 23–64.

——— *Bild und Kult: Eine Geschichte des Bildes vor dem Zeitalter der Kunst*. Munich, 1990.

Benelli, Francesco. "The Medieval Portrait of Architecture: Giotto and the Representation of the Temple of the Minerva in Assisi." In *Some Degree of Happiness: Studi di storia dell'architettura in onore di Howard Burns*, edited by Maria Beltramini and Caroline Elam. Pisa, 2009, 31–42.

——— *The Architecture in Giotto's Paintings*. Cambridge, 2012.

Beneš, Carrie E. *Urban Legends: Civic Identity and the Classical Past in Northern Italy, 1250–1350*. University Park, 2011.

Benton, Janetta Rebold. "Perspective and the Spectator's Pattern of Circulation in Assisi and Padua." *Artibus et Historiae* 10 (1989): 37–52.

——— "Antique Survival and Revival in the Middle Ages: Architectural Framing in Late Duecento Murals." *Arte medievale* 7 (1993): 120–45.

Berenson, Bernhard. *The Florentine Painters of the Renaissance*. 3rd ed. New York, 1909.

Berenson, Bernard. *The Arch of Constantine; or, The Decline of Form*. New York, 1954.

Bevilacqua, Eugenia and Lionello Puppi (eds). *Padova: Il volto della città. Dalla pianta del Valle al fotopiano*. Padua, 1987.

Bloch, Herbert. "The New Fascination with Ancient Rome." In *Renaissance and Renewal in the Twelfth Century*, edited by Robert L. Benson and Giles Constable. Cambridge, MA, 1982, 615–36.

Blumenkranz, Bernhard. *Il cappello a punta: L'ebreo medievale nello specchio dell'arte cristiana*. Edited by Chiara Frugoni. Bari, 2003.

Bogen, Steffen. "Die Schauöffnung als semiotische Schwelle: Ein Vergleich der Rolin-Madonna mit Bildfeldern des Franziskuszyklus in Assisi." In *Porträt – Landschaft – Interieur: Jan van Eycks Rolin-Madonna im ästhetischen Kontext*, edited by Christiane Kruse and Felix Thürlemann. Tübingen, 1999, 53–72.

Bongiorno, Laurine Mack. "The Theme of the Old and the New Law in the Arena Chapel." *Art Bulletin* 50 (1968): 11–20.

Bokody, Péter. *Images-within-Images in Italian Painting (1250–1350): Reality and Reflexivity*. Farnham, 2015.

Boskovits, Miklós. "Giotto: Un artista poco conosciuto?" In *Giotto: Bilancio critico di sessant'anni di studi e ricerche*, edited by Angelo Tartuferi. Florence, 2000, 75–95.

Botterill, Steven (ed.). *Dante: De Vulgari Eloquentia*. Cambridge, 1996.

Bottin Francesco (ed.). *Alberto da Padova e la cultura degli agostiniani*. Padua, 2014.

Bourdua, Louise and Anne Dunlop (eds.). *Art and the Augustinian Order in Early Renaissance Italy*. Aldershot, 2007.

Brandi, Cesare. *Giotto*. Milan, 1983.

Bredekamp, Horst. *Kunst als Medium sozialer Konflikte: Bilderkämpfe von der Spätantike bis zur Hussitenrevolution*. Frankfurt, 1975.

Repräsentation und Bildmagie in der Renaissance als Formproblem. Munich, 1995.

Brilliant, Richard. "I piedistalli del giardino di Boboli: spolia in se, spolia in re," *Prospettiva* 31 (1982): 2–17.

Brilliant, Richard and Dale Kinney (eds). *Reuse Value: Spolia and Appropriation in Art and Architecture, from Constantine to Sherrie Levine*. Farnham, 2011.

Brinkmann, Vinzenz, and Raimund Wünsche. *Bunte Götter: Die Farbigkeit antiker Skulptur*. Exh. cat., Staatliche Antikensammlungen and Glyptothek München. Munich, 2004.

Brinkmann, Vinzenz et al. (eds.). *Gods in Color: Painted Sculpture of Classical Antiquity*. Exh. cat., Arthur M. Sackler Museum, Harvard University Museums, Cambridge, MA. Munich, 2007.

Brock, Bazon. "Der byzantinische Bilderstreit." In *Bildersturm*, edited by Martin Warnke. Frankfurt am Main, 1977, 30–40.

Bruschi, Arnaldo. "Prima del Brunelleschi: Verso un'architettura sintattica e prospettica." In *Bruschi, L'antico, la tradizione, il moderno: Da Arnolfo a Peruzzi, saggi sull'architettura del Rinascimento*, edited by Maurizio Ricci and Paola Zampa. Milan, 2004, 18–84.

Bryer, Anthony and Judith Herrin (eds.). *Iconoclasm*. Birmingham, 1977.

Bryson, Norman. *Vision and Painting: The Logic of the Gaze*. New Haven, 1983.

Burckhardt, Jacob. *Der Cicerone: Eine Anleitung zum Genuss der Kunstwerke Italiens; Malerei*. Edited by Bernd Roeck, Christine Tauber, and Martin Warnke. Munich, 2001.

Busch, Werner et al. (eds.). *Willibald Sauerländer: Geschichte der Kunst – Gegenwart der Kritik*. Cologne, 1999.

Bush, Virginia L. "The Sources of Giotto's *Meeting at the Golden Gate* and the Meaning of the Dark-Veiled Woman." *Bollettino del Museo Civico di Padova* 61 (1972): 7–29.

Cacciari, Massimo. *Doppio ritratto: San Francesco in Dante e Giotto*. Milan, 2012.

Callcott, Maria (Mrs.). *Description of the Chapel of the Annunziata dell'Arena; or, Giotto's Chapel, in Padua*. London, 1835.

Cannon, Joanna. "Giotto and Art for the Friars: Revolutions Spiritual and Artistic." In *The Cambridge Companion to Giotto*, edited by Anne Derbes and Mark Sandona. Cambridge, 2004, 103–34.

Carrà, Carlo. "Parlata su Giotto." In *Carrà, Tutti gli scritti*, edited by Massimo Carrà. Milan, 1978, 63–72.

Cary, Phillip. *Augustine's Invention of the Inner Self: The Legacy of a Christian Platonist*. Oxford, 2000.

Inner Grace: Augustine in the Traditions of Plato and Paul. Oxford, 2008.

Outward Signs: The Powerlessness of External Things in Augustine's Thought. Oxford, 2008.

Cassidy, Brendan. "Laughing with Giotto at Sinners in Hell." *Viator* 35 (2004): 355–86.

Castelli, Ciro, with Mauro Parri and Andrea Santacesaria. "Technique of Execution, State of Conservation and Restoration of the Crucifix in Relation to Other Works by Giotto. The Wooden Support." In *Giotto: The Santa Maria Novella Crucifix*, edited by Marco Ciatti and Max Seidel. Florence, 2002, 247–72.

Castelnuovo, Enrico. "Les portraits individuels de Giotto." In *Le portrait individuel: Réflexions autour d'une forme de représentation, XIIIe–XVe siècles*, edited by Dominic Olariu. Bern, 2009, 103–20.

Cenni storici sulle famiglie di Padova e sui monumenti dell'università. Padua, 1842.

Cennini, Cennino. *Das Buch von der Kunst; oder, Tractat der Malerei des Cennino Cennini da Colle di Valdelsa*. Edited by Albert Ilg. Vienna, 1871.

Il libro dell'arte. Edited by Fabio Frezzato. Vicenza, 2003.

Chastel, André. "Giotto coetano di Dante." In *Studien zur toskanischen Kunst: Festschrift für Ludwig Heinrich Heydenreich*. Munich, 1963, 37–44.

Chernowitz, Maurice E. *Proust and Painting*. New York, 1945.

Chiampi, James T. "Visible Speech, Living Stone, and the Names of the Word." *Rivista di studi italiani* 14 (1996): 1–12.

Ciucciovino, Carlo. *La cronaca del trecento italiano: Giorno per giorno l'Italia di Giotto e Dante. Vol. 1, 1300–1325*. Rome, 2007.

Claussen, P. C. "Enrico Scrovegni, der exemplarische Fall: Zur Stiftung der Arenakapelle in Padua." In *Für irdischen Ruhm und himmlischen Lohn: Stifter und Auftraggeber in der mittelalterlichen Kunst*, edited by Hans-Rudolf Meyer, Carola Jäggi, and Philippe Büttner. Berlin, 1995, 227–46.

Cohen, Jeremy. "The Doctrine of Jewish Witness." In *Cohen, Living Letters of the Law: Ideas of the Jew in Medieval Christianity.* Berkeley, 1999, 23–65.

Cole, Bruce. "Virtues and Vices in Giotto's Arena Chapel Frescoes." In *Cole, Studies in the History of Italian Art, 1250–1550.* London, 1996, 337–63.

Cole, Michael W. "Perpetual Exorcism in Sistine Rome." In *The Idol in the Age of Art: Objects, Devotions and the Early Modern World*, edited by Michael W. Cole and Rebecca Zorach. Farnham, 2009, 57–76.

Collodo, Silvana. "Enrico Scrovegni." In *La Cappella degli Scrovegni a Padova: The Scrovegni Chapel in Padua*, edited by Davide Banzato et al. Modena, 2005, 9–18.

Cooper, Donal, and Janet Robson. *The Making of Assisi: The Pope, the Franciscans and the Painting of the Basilica.* New Haven, 2013.

Cooper, Donal. "Giotto et les Franciscains." In *Giotto e compagni*, edited by Dominique Thiébaut. Exh. cat., Louvre, Paris. Milan, 2013, 29–47.

Cordez, Philippe. "Les marbres de Giotto: Astrologie et naturalisme à la Chapelle Scrovegni." *Mitteilungen des Kunsthistorischen Institutes in Florenz* 55 (2013): 9–25.

Cosnet, Bertrand. "Les personifications dans la peinture monumentale en Italie au XIVe siècle: La grisaille et ses vertus." In *Aux limites de la couleur: Monochromie et polychromie dans les arts (1300–1600)*, edited by Marion Boudon-Machuel, Maurice Brock and Pascale Charron. Turnhout, 2011, 125–31.

Crowe, J. A., and G. B. Cavalcaselle. *A New History of Painting in Italy from the Second to the Sixteenth Century.* Vol. 1. London, 1864.

Curzi, Gaetano. "Giotto, la scultura, gli scultori." In *Giotto e il Trecento: "Il più Sovrano Maestro stato in dipintura." I saggi*, edited by Alessandro Tomei. Exh. cat., Complesso del Vittoriano, Rome. Milan, 2009, 253–69.

Cutler, Anthony. "The Pathos of Distance: Byzantium in the Gaze of Renaissance Europe and Modern Scholarship." In *Reframing the Renaissance: Visual Culture in Europe and Latin America 1450–1650*, edited by Claire Farago. New Haven, 1995, 23–45.

"Reuse or Use? Theoretical and Practical Attitudes toward Objects in the Early Middle Ages." In *Ideologie e pratiche del reimpiego nell'alto medioevo.* Spoleto, 1999, vol. 2: 1055–79.

Czarnecki, James G. "The Significance of Judas in Giotto's Arena Chapel Frescoes." *The Early Renaissance* 5 (1978): 35–47.

Dante's Purgatory and Paradise. Illustrated by Gustave Doré. New York, 1883.

Davies, Penelope J. E. *Death and the Emperor: Roman Imperial Funerary Monuments from Augustus to Marcus Aurelius.* Cambridge, 2000.

Davis, Charles Till. *Dante and the Idea of Rome.* Oxford, 1957.

Davis, Whitney. *A General Theory of Visual Culture.* Princeton, 2011.

"Art History, Re-Enactment, and the Idiographic Stance." In *Michael Baxandall: Vision and the Work of Words*, edited by Peter Mack and Robert Williams. Aldershot, 2015, 69–90.

Visuality and Virtuality: Images and Pictures from Prehistory to Perspective. Princeton, 2017.

De Sélincourt, Basil. *Giotto.* London, 1905.

De Wesselow, Thomas. "The Date of the St Francis Cycle in the Upper Church of S. Francesco at Assisi: The Evidence of Copies and Considerations of Method." In *The Art of the Franciscan Order in Italy*, edited by William R. Cook. Leiden, 2005, 113–67.

Derbes, Anne. "Triplex Periculum: The Moral Topography of Giotto's Hell in the Arena Chapel, Padua." *Journal of the Warburg and Courtauld Institutes* 76 (2015): 41–70.

Derbes, Anne, and Mark Sandona. "Barren Metal and the Fruitful Womb: The Program of Giotto's Arena Chapel in Padua." *Art Bulletin* 80 (1998): 274–91.

"'Ave charitate plena': Variations on the Theme of Charity in the Arena Chapel." *Speculum* 76 (2001): 599–637.

(eds.). *The Cambridge Companion to Giotto.* Cambridge, 2004.

"Giotto Past and Present: An Introduction." In *The Cambridge Companion to Giotto*, edited by Anne Derbes and Mark Sandona. Cambridge, 2004, 1–9.

"Reading the Arena Chapel." In *The Cambridge Companion to Giotto*, edited by Anne Derbes and Mark Sandona. Cambridge, 2004, 197–220.

The Usurer's Heart: Giotto, Enrico Scrovegni, and the Arena Chapel in Padua. University Park, 2008.

"Enrico Scrovegni: I ritratti del mecenate." In *Giotto e il Trecento: "Il più Sovrano Maestro stato in dipintura." I saggi*, edited by Alessandro Tomei. Exh. cat., Complesso del Vittoriano, Rome. Milan, 2009, 129–41.

di Castro, Daniela. "Gli ebrei romani all'epoca del giubileo di Bonifacio VIII." In *Bonifacio VIII e il suo tempo: Anno 1300 il primo giubileo*, edited by Marina Righetti Tosti-Croce. Milan, 2000, 69–72.

di Fabio, Clario. "Memoria e modernità: Della propria figura di Enrico Scrovegni e di altre sculture nella cappella dell'Arena di Padova, con aggiunte al catalogo di Marco Romano." In *Medioevo: Immagine e memoria: Atti del Convegno internazionale di studi*, edited by Arturo C. Quintavalle. Milan, 2009, 532–46.

di Medio, Arnaldo. *Le prime Grandi Perdonanze: Celestino V e Bonifacio VIII, due papi innovatori.* Barzago, 2002.

Dittelbach, Thomas. *Das monochrome Wandgemälde: Untersuchungen zum Kolorit des frühen 15. Jahrhunderts in Italian.* Hildesheim, 1993.

D'Onofrio, Cesare. *La papessa Giovanna: Roma e papato tra storia e leggenda.* Rome, 1979.

D'Onofrio, Mario. "I cieli di Giotto agli Scrovegni tra immagine e memoria." In *Medioevo: Immagine e memoria: Atti del Convegno internazionale di studi*, edited by Arturo C. Quintavalle. Milan, 2009, 519–31.

Draghi, Andreina (ed.): *Gli affreschi dell'Aula gotica nel Monastero dei Santi Quattro Coronati: Una storia ritrovata*. Milan, 2006.

Dronke, Peter. "Riuso di forme e immagini antiche nella poesia." In *Ideologie e pratiche del reimpiego nell'alto medioevo*. Spoleto, 1999, vol. 1: 283–312.

Dyson, R. W. (ed.). Augustine. *The City of God against the Pagans*. Cambridge, 1998.

Eberhardt, Barbara. "Wer dient wem? Die Darstellung des Flavischen Triumphzuges auf dem Titusbogen und bei Josephus (*B.J. 7.123–162*)." In *Josephus and Jewish History in Flavian Rome and Beyond*, edited by Joseph Sievers and Gaia Lembi. Leiden, 2005, 257–77.

Eco, Umberto. "Possible Woods." In *Eco, Six Walks in the Fictional Woods*. Cambridge, 1994, 75–96.

Edgerton, Samuel Y. *The Heritage of Giotto's Geometry: Art and Science on the Eve of the Scientific Revolution*. Ithaca, 1991.

Edwards, Mary D. "Cross-Dressing in the Arena Chapel: Giotto's Virtue Fortitude Re-Examined." In *Receptions of Antiquity, Constructions of Gender in European Art, 1300–1600*, edited by Marice Rose and Alison C. Poe. Leiden, 2015, 37–79.

von Ehrenkrook, Jason. *Sculpting Idolatry in Flavian Rome: (An)Iconic Rhetoric in the Writings of Flavius Josephus*. Atlanta, 2011.

Ehrle, Franz. "Die Frangipani und der Untergang des Archivs und der Bibliothek der Päpste am Anfang des 13. Jahrhunderts." In *Mélanges offerts à Emile Châtelain*. Paris, 1910, 448–85.

Elliott, Janis. "Augustine and the New Augustinianism in the Choir Frescoes of the Eremitani, Padua." In *Art and the Augustinian Order in Early Renaissance Italy*, edited by Louise Bourdua and Anne Dunlop. Aldershot, 2007, 99–126.

Elm, Susanna. "Bodies, Books, Histories: Augustine of Hippo and the Extraordinary (civ. Dei 16.8 and Pliny, HN 7)." Forthcoming in Susanna Elm, *New Romans: Dress, Manliness, Display and the Extraordinary*.

Enright, Nancy. "Dante's *Divine Comedy*, Augustine's *Confessions*, and the Redemption of Beauty." *Logos* 10 (2007): 32–56.

Esch, Arnold. "Spolien: Zur Wiederverwendung antiker Baustücke und Skulpturen im mittelalterlichen Italien." *Archiv für Kulturgeschichte* 51 (1969): 1–64.

"Reimpiego dell'antico nel medioevo: La prospettiva dell'archeologo, la prospettiva dello storico." In *Ideologie e pratiche del reimpiego nell'alto medioevo*. Spoleto, 1999, vol. 1: 73–108.

"L'uso dell'antico nell'ideologia papale, imperiale e comunale." In *Roma antica nel Medioevo: Mito, rappresentazioni, sopravvivenze nella "Respublica Christiana" dei secoli IX–XIII*, edited by Pietro Zerbi. Milan, 2001, 3–25.

Euler, Walter. *Die Architekturdarstellung in der Arena-Kapelle: Ihre Bedeutung für das Bild Giottos*. Bern, 1967.

Fagiolo, Marcello and Maria Luisa Madonna (eds.). *Roma 1300–1875: La città degli anni santi. Atlante*. Milan, 1985.

Falaschi, Enid T. "Giotto: The Literary Legend." *Italian Studies* 27 (1972): 1–27.

Fallani, Giovanni. *La poetica dantesca e le arti: Unità e diversità*. Florence, 1965.

Ferrante, Joan M. "Boniface VIII, Pope." In *The Dante Encyclopedia*, edited by Richard Lansing. New York, 2000, 122–24.

Fine, Steven. "'When I went to Rome, there I Saw the Menorah...': The Jerusalem Temple Implements between 70 C.E. and the Fall of Rome." In *The Archaeology of Difference: Gender, Ethnicity, Class and the "Other" in Antiquity Studies in Honor of Eric M. Meyers*, edited by Douglas R. Edwards and C. Thomas McCollough. Boston, 2007, 169–80.

"Menorahs in Color: Polychromy in Jewish Visual Culture of Roman Antiquity." *Images* 6 (2013): 3–25.

The Menorah: From the Bible to Modern Israel. Cambridge, MA, 2016.

(ed.). *The Arch of Titus: From Jerusalem to Rome – and Back*. Leiden and Boston, 2021.

Flores d'Arcais, Francesca. *Giotto*. New York, 1995.

"Giotto after the Restoration." In *Giotto: The Frescoes of the Scrovegni Chapel in Padua*, edited by Giuseppe Basile. Milan, 2002, 13–20.

Forster, E. M. *A Room with a View*. London, 1908.

Fränkel, Jonas (ed.). *Goethes Briefe an Charlotte von Stein*. Vol. 1. Berlin, 1960.

Frankfurter, Alfred. "Old Myth and New Reality." *Portfolio and Art News Annual* 4 (1961): 60, 62, 68, 74–75, 174–80.

Freccero, John. *Dante: The Poetics of Conversion*. Cambridge, MA, 1986.

Dante's Cosmos. Binghamton, 1998.

In Dante's Wake: Reading from Medieval to Modern in the Augustinian Tradition. Edited by Danielle Callegari and Melissa Swain. New York, 2015.

Fredriksen, Paula. "Beyond the Body/Soul Dichotomy: Augustine on Paul against the Manichees and the Pelagians." *Recherches augustiniennes* 23 (1988): 87–114.

"*Excaecati Occulta Justitia Dei*: Augustine on Jews and Judaism." *Journal of Early Christian Studies* 3 (1995): 299–324.

Augustine and the Jews: A Christian Defense of Jews and Judaism. New Haven, 2010.

Frojmovič, Eva. "Giotto's Allegories of Justice and the Commune in the Palazzo della Ragione in Padua: A Reconstruction." *Journal of the Warburg and Courtauld Institutes* 59 (1996): 24–47.

———. "Giotto's Circumspection." *Art Bulletin* 89 (2007): 195–210.

Frugoni, Arsenio. *Il giubileo di Bonifacio VIII*. Rome, 1999.

———. "La Roma di Dante: Tra il tempo e l'eterno." In *Pellegrini a Roma nel 1300: Cronache del primo Giubileo*, edited by Felice Accrocca. Casale Monferrato, 1999, 97–122.

Frugoni, Chiara. "Female Mystics, Visions, and Iconography." In *Women and Religion in Medieval and Renaissance Italy*, edited by Daniel Bornstein and Roberto Rusconi. Chicago, 1996, 130–64.

———. *Due Papi per un giubileo: Celestino V, Bonifacio VIII e il primo Anno Santo*. Milan, 2000.

———. *Gli affreschi della Cappella Scrovegni a Padova*. Turin, 2005.

———. *L'affare migliore di Enrico: Giotto e la cappella Scrovegni*. Turin, 2008.

Fuhrer, Therese. "Rom als Diskursort der Heterodoxie und Stadt der Apostel und Märtyrer: Zur Semantik von Augustins Rombild-Konstruktionen." In *Der Fall Roms und seine Wiederauferstehungen in Antike und Mittelalter*, edited by Henriette Harich-Schwarzbauer and Karla Pollmann. Berlin, 2013, 53–75.

Gamboni, Dario. *The Destruction of Art: Iconoclasm and Vandalism since the French Revolution*. London, 2013.

Gandelman, Claude. *Reading Pictures, Viewing Texts*. Bloomington, 1991.

Garbagna, Cristina (ed.). *Da Giotto a Malevič: La reciproca meraviglia*. Exh. cat., Scuderie del Quirinale, Rome. Milan, 2004.

Gardner, Julian. *Giotto and His Publics: Three Paradigms of Patronage*. Cambridge, MA, 2011.

Ghelardi, Maurizio. *Aby Warburg: La lotta per lo stile*. Turin, 2012.

Ghisalberti, Alessandro. "Roma antica nel pensiero politico da Tommaso d'Aquino a Dante." In *Roma antica nel Medioevo: Mito, rappresentazioni, sopravvivenze nella "Respublica Christiana" dei secoli IX–XIII*, edited by Pietro Zerbi. Milan, 2001, 347–64.

Gilbert, Creighton. "The Sequence of Execution in the Arena Chapel." In *Essays in Honor of Walter Friedlaender*. New York, 1965, 80–86.

———. "Florentine Painters and the Origins of Modern Science." In *Arte in Europa: Scritti di Storia dell'Arte in onore di Edoardo Arslan*. Milan, 1966, 333–40.

———. "The Fresco by Giotto in Milan." *Arte Lombarda* 47–48 (1977): 31–72.

———. "Ghiberti on the Destruction of Art." *I Tatti Studies* 6 (1995): 135–44.

———. *How Fra Angelico and Signorelli Saw the End of the World*. University Park, 2003.

Gioseffi, Decio. *Giotto architetto*. Milan, 1963.

Giovagnoli, Gabriella. *Il palazzo dell'Arena e la Cappella di Giotto (secc. XIV–XIX): Proprietari, prepositi, beni*. Padua, 2008.

Gizzi, Corrado. *Giotto e Dante*. Milan, 2001.

Gnudi, Cesare. "Sugli inizi di Giotto e i suoi rapporti col mondo gotico." In Gnudi, *L'arte gotica in Francia e in Italia*. Turin, 1982, 55–76.

Goffen, Rona. "Bonaventure's Francis." In Goffen, *Spirituality in Conflict: Saint Francis and Giotto's Bardi Chapel*. University Park, 1988, 59–77 and 117–24.

Gombrich, E. H. "Giotto's Portrait of Dante?" *Burlington Magazine* 121 (1979): 471–83.

Gosebruch, Martin. "Vom Aufragen der Figuren in Dantes Dichtung und Giottos Malerei." *Festschrift für Kurt Badt zum 70. Geburtstag*, edited by Martin Gosebruch. Berlin, 1961, 32–65.

———. *Giotto und die Entwicklung des neuzeitlichen Kunstbewußtseins*. Cologne, 1962.

Hansen, Maria Fabricius. *The Eloquence of Appropriation: Prolegomena to an Understanding of Spolia in Early Christian Rome*. Rome, 2003.

Harich-Schwarzbauer, Henriette and Karla Pollmann (eds.). *Der Fall Roms und seine Wiederauferstehungen in Antike und Mittelalter*. Berlin, 2013.

Harding, Catherine. "Time, History and the Cosmos: The Dado in the Apse of the Church of the Eremitani, Padua." In *Art and the Augustinian Order in Early Renaissance Italy*, edited by Louise Bourdua and Anne Dunlop. Aldershot, 2007, 127–42.

Hartmann, Nicolai. *Ethik*. Berlin, 1949.

Haug, Walter. "Francesco Petrarca – Nicolas Cusanus – Thüring von Ringoltingen: Drei Probestücke zu einer Geschichte der Individualität im 14./15. Jahrhundert." In *Individualität*, edited by Manfred Frank and Anselm Haverkamp. Munich, 1988, 291–324.

Havely, Nick (ed.). *Dante in the Nineteenth Century: Reception, Canonicity, Popularization*. Oxford, 2011.

Heffernan, James. *Museum of Words: The Poetics of Ekphrasis from Homer to Ashbery*. Chicago, 1993.

Heidegger, Martin. *Sein und Zeit*. Tübingen, 1967.

Herzner, Volker. "Giottos Grabmal für Enrico Scrovegni." *Münchener Jahrbuch der bildenden Kunst* 33 (1982): 39–66.

von Hesberg, Henner. "Archäologische Denkmäler zum römischen Kaiserkult." In *Aufstieg und Niedergang der römischen Welt: Geschichte und Kultur Roms im Spiegel der neueren Forschung*, edited by Hildegard Temporini and Wolfgang Haase. Berlin, 1978, vol. 2: 911–95.

Hetzer, Theodor. *Giotto: Grundlegung der neuzeitlichen Kunst*. Stuttgart, 1981.

Hills, Paul. *The Light of Early Italian Painting*. New Haven and London, 1987.

Holländer, Hans. "Bild, Vision und Rahmen." In *Zusammenhänge, Einflüsse, Wirkungen: Kongressakten zum ersten Symposium des Mediävistenverbandes in Tübingen, 1984*, edited by Joerg O. Fichte, Karl Heinz Göller, and Bernhard Schimmelpfennig. Berlin, 1986, 71–94.

Holloway, R. R. "Some Remarks on the Arch of Titus." *L'Antiquité classique* 56 (1987): 183–91.

Homann, Ursula. "Vergessene Concordia: Ecclesia und Synagoga." *Die Zeichen der Zeit: Lutherische Monatshefte* 1 (1999): 25–28.

Hueck, Irene. "Sovrapporta con figure allegoriche." In Davide Banzato et al., *La Cappella degli Scrovegni a Padova/The Scrovegni Chapel in Padua*. Modena, 2005, 211–14.

Hülsen, Christian. *Il foro Romano: Storia e monumenti*. Rome, 1982.

Hutchinson, Ben. *W. G. Sebald: Die dialektische Imagination*. Berlin, 2009.

Hutton, Ronald (ed.). *Medieval or Early Modern: The Value of a Traditional Historic Division*. Newcastle upon Tyne, 2015.

Hyde, John Kenneth. *Padua in the Age of Dante*. Manchester, 1966.

Imdahl, Max. *Giotto: Arenafresken. Ikonographie, Ikonologie, Ikonik*. Munich, 1988.

Irmscher, Johannes (ed.). *Der byzantinische Bilderstreit: Sozialökonomische Voraussetzungen, ideologische Grundlagen, geschichtliche Wirkungen*. Leipzig, 1980.

Iser, Wolfgang. "Das Individuum zwischen Evidenzerfahrung und Uneinholbarkeit." In *Individualität*, edited by Manfred Frank and Anselm Haverkamp. Munich, 1988, 95–98.

Isermeyer, Christian-Adolf. "Rahmengliederung und Bildfolge in der Wandmalerei bei Giotto und den Florentinern Malern des 14. Jahrhunderts." PhD diss., Univ. Göttingen. Würzburg, 1937.

Itgenshorst, Tanja. *Tota illa pompa: Der Triumph in der römischen Republik. Mit einer CD-ROM, Katalog der Triumphe von 340 bis 19 vor Christus*. Göttingen, 2005.

Jacobus, Laura. "Giotto's *Annunciation* in the Arena Chapel, Padua." *Art Bulletin* 81 (1999): 93–107.

———. "A Knight in the Arena: Enrico Scrovegni and His 'true image.'" In *Fashioning Identities in Renaissance Art*, edited by Mary Rogers. Aldershot, 2000, 17–31.

———. *Giotto and the Arena Chapel: Art, Architecture and Experience*. Turnhout, 2008.

———. "The Tomb of Enrico Scrovegni in the Arena Chapel, Padua." *Burlington Magazine* 154 (2012): 403–9.

———. "'Propria Figura': The Advent of Facsimile Portraiture in Italian Art." *Art Bulletin* 99 (2017): 72–101.

Jaffé, Aniela (ed.): *Erinnerungen Träume Gedanken von C. G. Jung*. Zurich 1963.

Jameson, Anna. *Memoirs of the Early Italian Painters*. Boston, 1896.

Jantzen, Hans. "Die zeitliche Abfolge der Paduaner Fresken Giottos" and "Giotto und der gotische Stil." In *Jantzen, Über den gotischen Kirchenraum und andere Aufsätze*. Berlin, 1951, 21–33 and 35–40.

Jarves, James J. *Art Studies: The "Old" Masters of Italy, Painting*. New York, 1861.

Jochum, Herbert. "Ecclesia und Synagoga: Alter und Neuer Bund in der christlichen Kunst." In *Der ungekündigte Bund? Antworten des Neuen Testaments*, edited by Hubert Frankemölle. Freiburg, 1998, 248–76.

Jones, Lars R. "Visio Divina? Donor Figures and Representations of Imagistic Devotion: The Copy of the 'Virgin of Bagnolo' in the Museo dell'Opera del Duomo, Florence." In *Italian Panel Painting of the Duecento and Trecento*, edited by Victor M. Schmidt. Washington, DC, 2002, 31–55.

Jung, Jacqueline E. "Beyond the Barrier: The Unifying Role of the Choir Screen in Gothic Churches." *Art Bulletin* 82 (2000): 622–57.

———. *The Gothic Screen: Space, Sculpture, and Community in the Cathedrals of France and Germany, ca. 1200–1400*. Cambridge, 2012.

Kablitz, Andreas, "Jenseitige Kunst oder Gott als Bildhauer: Die Reliefs in Dantes Purgatorio (Purg. X–XII)." In *Mimesis und Simulation*, edited by Andreas Kablitz and Gerhard Neumann. Freiburg, 1998, 309–56.

Kallendorf, Craig. "Classical Antiquity." In *The Dante Encyclopedia*, edited by Richard Lansing. New York, 2000, 172–75.

Kantorowicz, Ernst H. *The King's Two Bodies: A Study in Mediaeval Political Theology*. Princeton, 1957.

Karfíková, Lenka. *Grace and the Will According to Augustine*. Leiden, 2012.

Karpeles, Eric. *Paintings in Proust: A Visual Companion to In Search of Lost Time*. London, 2008.

Katzenellenbogen, Adolf. "Die Psychomachie in der Kunst des Mittelalters von den Anfängen bis zum 13. Jahrhundert." PhD diss., University of Hamburg. Hamburg, 1933.

———. *Allegories of the Virtues and Vices in Medieval Art: From Early Christian Times to the Thirteenth Century*. London, 1939.

Kecks, Ronald G. *Madonna und Kind: Das häusliche Andachtsbild*. Berlin, 1988.

Keller, Harald. "Die Entstehung des Bildnisses am Ende des Hochmittelalters." *Römisches Jahrbuch für Kunstgeschichte* 3 (1939): 227–365.

Kemp, Wolfgang. "Zum Programm von Stefaneschi-Altar und Navicella." *Zeitschrift für Kunstgeschichte* 30 (1967): 309–20.

—— "Das letzte Bild: Welt-Ende und Werk-Ende bei Giotto und Dante." In *Das Ende: Figuren einer Denkform*, edited by Karlheinz Stierle and Rainer Warning. Munich, 1996, 415–34.

—— *Die Räume der Maler: Zur Bilderzählung seit Giotto.* Munich, 1996.

Kessler, Herbert L. "Turning a Blind Eye: Medieval Art and the Dynamics of Contemplation." In *The Mind's Eye: Art and Theological Argument in the Middle Ages*, edited by Jeffrey F. Hamburger and Anne-Marie Bouché. Princeton, 2006, 413–39.

—— "Giotto e Roma." In *Giotto e il Trecento: "Il più Sovrano Maestro stato in dipintura."* I saggi, edited by Alessandro Tomei. Exh. cat., Complesso del Vittoriano, Rome. Milan, 2009, 85–99.

Kessler, Herbert L. and David Nirenberg (eds). *Judaism and Christian Art: Aesthetic Anxieties from the Catacombs to Colonialism.* Philadelphia, 2011.

Kessler, Herbert L. and Johanna Zacharias. *Rome 1300: On the Path of the Pilgrim.* New Haven, 2000.

Kitzinger, Ernst. *Byzantine Art in the Making: Main Lines of Stylistic Development in Mediterranean Art, 3rd–7th Century.* Cambridge, MA, 1995.

Kleiner, Diana E. E. *Roman Sculpture.* New Haven and London, 1992.

Kleiner, Fred S. "The Arches of Vespasian in Rome." *Römische Mitteilungen* 97 (1990): 127–36.

von Klenze, Camillo. "The Growth of Interest in the Early Italian Masters: From Tischbein to Ruskin." *Modern Philology* 4 (1906): 207–74.

Klewitz, Hans-Walter. "Das Ende des Reformpapsttums." *Deutsches Archiv für Geschichte des Mittelalters* 3 (1939): 371–412.

Kloos, Kari. *Christ, Creation, and the Vision of God: Augustine's Transformation of Early Christian Theophany Interpretation.* Leiden, 2011.

Kocks, Dirk. "Die Stifterdarstellung in der italienischen Malerei des 13.–15. Jahrhunderts." PhD diss., University of Cologne. Cologne, 1971.

Kohl, Benjamin G. "The Scrovegni in Carrara Padua and Enrico's Will." *Apollo* 142 (1995): 43–47.

—— "Giotto and His Lay Patrons." In *The Cambridge Companion to Giotto*, edited by Anne Derbes and Mark Sandona. Cambridge, 2004, 176–96.

—— "Chronicles into Legends and Lives: Two Humanist Accounts of the Carrara Dynasty in Padua." In *Chronicling History: Chroniclers and Historians in Medieval and Renaissance Italy.* University Park, 2007, 223–48.

Köhren-Jansen, Helmtrud. "*Giottos Navicella: Bildtradition, Deutung, Rezeptionsgeschichte.*" PhD diss., University of Cologne. Worms am Rhein, 1993.

Kolrud, Kristine and Marina Prusac (eds.). *Iconoclasm from Antiquity to Modernity.* Farnham, 2014.

Krautheimer, Richard. "Introduction to an 'Iconography of Medieval Architecture.'" In *Krautheimer, Studies in Early Christian, Medieval, and Renaissance Architecture.* New York, 1969, 115–50.

—— *Rome: Profile of a City, 312–1308.* Princeton, 2000.

Krieger, Michaela. *Grisaille als Metapher: Zum Entstehen der Peinture en Camaieu im frühen 14. Jahrhundert.* Vienna, 1995.

Kristeva, Julia. "Giotto's Joy." In *Kristeva, Desire in Language: A Semiotic Approach to Literature and Art.* New York, 1980, 210–36.

Kruft, Hanno-Walter. "Giotto e l'antico." In *Giotto e il suo tempo: Atti del congresso internazionale per la clebrazione del VII centenario della nascita di Giotto.* Rome, 1971, 169–76.

Kruse, Christiane. "Fleisch werden – Fleisch malen: Malerei als 'incarnazione'. Mediale Verfahren des Bildwerdens im Libro dell'Arte von Cennino Cennini." *Zeitschrift für Kunstgeschichte* 63 (2000): 305–25.

Kübler, Mirjam. *Judas Iskariot: Das abendländische Judasbild und seine antisemitische Instrumentalisierung im Nationalsozialismus.* Waltrop, 2007.

Ladis, Andrew. "The Legend of Giotto's Wit and the Arena Chapel." *Art Bulletin* 68 (1986): 581–96. Reprinted in Andrew Ladis, *Studies in Italian Art.* London, 2001, 61–95.

—— *Giotto's O: Narrative, Figuration, and Pictorial Ingenuity in the Arena Chapel.* University Park, 2008.

Land, Norman E. "Giotto's Eloquence." *Notes in the History of Art* 23 (2004): 15–19.

Lange, Henrike Christiane. "Relief Effects: Giotto's Triumph." PhD diss., Yale University, New Haven, 2015.

—— "Cimabue's True Crosses in Arezzo and Florence." In *Material Christianity: Western Religion and the Agency of Things*, edited by Christopher Ocker and Susanna Elm. Cham, 2020, 29–67.

—— "Portraiture, Projection, Perfection: The Multiple Effigies of Enrico Scrovegni in Giotto's Arena Chapel." In *Picturing Death 1200–1600*, edited by Stephen Perkinson and Noa Turel. Leiden, Boston, and Paderborn, 2020, 36–48.

—— "Relief Effects in Donatello and Mantegna." In *The Reinvention of Sculpture in Fifteenth-Century Italy*, edited by Amy Bloch and Daniel M. Zolli. Cambridge, 2020, 327–343.

—— "Giotto's Triumph: The Arena Chapel and the Metaphysics of Ancient Roman Triumphal Arches." *I Tatti Studies* 25 (2022), 5–38.

Lange, Julius. "Die Farbe und die Bildhauerkunst (1886)." In *Julius Lange's Ausgewählte Schriften (1886–1897)*, edited by Georg Brandes and Peter Köbke. Strasbourg, 1912, vol. 2: 33–49.

Langeli, Attilio Bartoli. "Il testamento di Enrico Scrovegni (12 marzo 1336)." In Chiara Frugoni, *L'affare migliore di Enrico: Giotto e la cappella Scrovegni.* Turin, 2008, 397–539.

Latte, Kurt. "Livy's Patavinitas." *Classical Philology* 35 (1940): 56–60.

Lavin, Marilyn Aronberg. *The Place of Narrative: Mural Decoration in Italian Churches, 431–1600.* Chicago, 1990.

Lee, Alexander. *Petrarch and St. Augustine: Christian Theology and the Origins of the Renaissance.* Leiden and Boston, 2012.

Lemaitre, Jean-Loup. "La présence de la Rome antique dans la liturgie monastique et canoniale du IXe au XIIIe siècle." In *Roma antica nel Medioevo: Mito, rappresentazioni, sopravvivenze nella "Respublica Christiana" dei secoli IX–XIII,* edited by Pietro Zerbi. Milan, 2001, 93–129.

Leone de Castris, Pierluigi. *Giotto a Napoli.* Naples, 2006.

Lermer, Andrea. "Planetengötter im Gotteshaus: Zur Ikonographie von Guarientos Freskenzyklus der Sieben Planeten und Lebensalter in der Eremitanikirche zu Padua." *Arte medievale* 11 (1997): 151–69.

 "Giotto's Virtues and Vices in the Arena Chapel: The Iconography and the Possible Mastermind behind It." In *Out of the Stream: Studies in Medieval and Renaissance Mural Painting,* edited by Luís Urbano Afonso and Vítor Serrão. Newcastle, 2007, 291–317.

Levasti, Arrigo. *Mistici del Duecento e del Trecento.* Milan, 1960.

Levey, Michael. "Botticelli and Nineteenth-Century England." *Journal of the Warburg and Courtauld Institutes* 23 (1960): 291–306.

Levine, Emily J. *Dreamland of Humanists: Warburg, Cassirer, Panofsky, and the Hamburg School.* Chicago, 2013.

Lindsay, Coutts, Sir. "Second Period – Giotto's First Visit to Lombardy." In Lord Lindsay, *Sketches of the History of Christian Art.* London, 1847, vol. 2: 180–200.

Lisner, Margit. *Holzkruzifixe in Florenz und in der Toskana von der Zeit um 1300 bis zum frühen Cinquecento.* Munich, 1970.

Lloyd, Christopher. "Giotto and the Calydonian Boar Hunt: A Possible Antique Source?" *Notes in the History of Art* 3 (1984): 8–11.

Longhi, Roberto. "Giotto spazioso." *Paragone* 31 (1952): 18–24.

 "Giudizio sul Duecento" e ricerche sul Trecento nell'Italia centrale, 1939–1970. Florence, 1974.

 Eine kurze aber wahre Geschichte der Malerei. Cologne, 1996.

Lubbock, Jules. *Storytelling in Christian Art from Giotto to Donatello.* New Haven, 2006.

Lucianetti, Sergio. "Lo sviluppo della città medioevale." In *La città di Padova: Saggio di analisi urbana,* edited by Carlo Aymonino et al. Rome, 1970, 71–125.

Lusanna, Enrica Neri. "L'eredità di Giotto nella scultura." In *L'eredità di Giotto: Arte a Firenze 1340–1375,* edited by Angelo Tartuferi. Exh. cat. Uffizi, Florence. Florence, 2008, 39–55.

Macdonald, Ronald R. *The Burial-Places of Memory: Epic Underworlds in Vergil, Dante, and Milton.* Amherst, 1987.

MacDonald, William L. *The Architecture of the Roman Empire. Vol. 1, An Introductory Study.* New Haven, 1982.

MacMullen, Ramsay. "A Note on 'Sermo Humilis.'" *The Journal of Theological Studies* 17 (1966): 108–12.

Maddalo, Silvia. "Bonifacio VIII e Jacopo Stefaneschi: Ipotesi di lettura dell'affresco della loggia lateranense." *Studi Romani* 31 (1983): 129–50.

Maginnis, Hayden B. J. "The Problem with Giotto." In *Maginnis, Painting in the Age of Giotto: A Historical Reevaluation.* University Park, 1997, 79–102.

 "In Search of an Artist." In *The Cambridge Companion to Giotto,* edited by Anne Derbes and Mark Sandona. Cambridge, 2004, 10–31.

Mandel, Ursula. "On the Qualities of the 'Colour' White in Antiquity." In *Circumlitio: The Polychromy of Antique and Mediaeval Sculpture,* edited by Vinzenz Brinkmann, Oliver Primavesi, and Max Hollein. Munich, 2010, 303–23.

Marcellan, Francesca. "L'artista, l'usuraio, il teologo: Tre voci nella Cappella degli *Scrovegni.*" In *La Giustizia di Giotto,* edited by Francesca Marcellan and Umberto Vincenti. Naples, 2006, 1–68.

Marchesi, Simone. *Dante and Augustine: Linguistics, Poetics, Hermeneutics.* Toronto, 2011.

Mariani, Valerio. *Giotto.* Rome, 1937.

Markham Telpaz, Anne. "Some Antique Motifs in Trecento Art." *Art Bulletin* 46 (1964): 372–76.

Marks, Laura U. *Touch: Sensuous Theory and Multisensory Media.* Minneapolis, 2002.

Mather, Frank Jewett. "Giotto's St. Francis Series at Assisi Historically Considered." *Art Bulletin* 25 (1943): 97–111.

Matisse, Henri. "Notes d'un peintre." In *La Grande Revue (Paris),* 25 December 1908.

Mauro, Walter. *Il doppio segno – visioni di artisti che hanno illustrato la Divina Commedia: Signorelli, Botticelli, Michelangelo, Raffaello, Stradano, Zuccari, Füssli, Blake, Koch, Scaramuzza, Martini, Dalí, Sassu.* Rome, 2006.

Mazzotta, Giuseppe. *Cosmopoiesis: The Renaissance Experiment.* Toronto, 2001.

 Dante, Poet of the Desert: History and Allegory in the Divine Comedy. Princeton 1979.

 "La Metafisica della Creazione." In *Confine quasi orizzonte: Saggi su Dante.* Rome, 2014, 97–114.

The Worlds of Petrarch. Durham, 1993.

Mazzucchi, Andrea (ed.). *Dante historiato da Federigo Zuccaro.* Rome, 2005.

McGinn, Bernard. *The Varieties of Vernacular Mysticism: 1350–1550.* New York, 2012.

"Ordering the Times: The Theology of History in Augustine's *De civitate Dei* and Joachim of Fiore's *Concordia Novi ac Veteris Testamenti.*" *Essays in Medieval Studies* 35 (2020): 1–20.

McGregor, James H. S. "Reappraising Ekphrasis in Purgatorio 10." *Dante Studies* 121 (2003): 25–41.

"Classical and Vernacular Narrative Models for Art Biography in Vasari's *Lives.*" In *Writers Reading Writers: Intertextual Studies in Medieval and Early Modern Literature in Honor of Robert Hollander,* edited by Janet Levarie Smarr. Newark, 2007, 183–200.

McWilliam, Joanne (ed.). *Augustine: From Rhetor to Theologian.* Waterloo, 1992.

Meiss, Millard. *Giotto and Assisi.* New York, 1960.

Merback Mitchell B. (ed.). *Beyond the Yellow Badge: Anti-Judaism and Antisemitism in Medieval and Early Modern Visual Culture.* Leiden, 2008.

Messerer, Wilhelm. "Giottos Verhältnis zu Arnolfo di Cambio." In Martin Gosebruch et al., *Giotto di Bondone.* Constance, 1970, 209–27.

Michler, Jürgen. "Materialsichtigkeit, Monochromie, Grisaille in der Gotik um 1300." In *Denkmalkunde und Denkmalpflege: Wissen und Wirken. Festschrift für Heinrich Magirius zum 60. Geburtstag,* edited by Ute Reupert, Thomas Trajkovits, and Winfried Werner. Dresden, 1995, 197–221.

"Die Einbindung der Skulptur in die Farbgebung gotischer Innenräume." *Kölner Domblatt* 64 (1999): 89–108.

"Altbekannte Neuigkeiten über die Farbigkeit der Kathedralen von Chartres, Amiens, Köln." *Kunstchronik* 62 (2009): 353–63.

Mieth, Sven Georg. "Giotto: Das mnemotechnische Programm der Arenakapelle in Padua." PhD diss., Universität Tübingen, 1990.

Millar, Fergus. "Last Year in Jerusalem: Monuments of the Jewish War in Rome." In *Flavius Josephus and Flavian Rome,* edited by Jonathan Edmondson, Steve Mason, and J. Rives. Oxford, 2005, 101–28.

Mitchell, Charles. "The Lateran Fresco of Boniface VIII." *Journal of the Warburg and Courtauld Institutes* 14 (1951): 1–6.

Moevs, Christian. *The Metaphysics of Dante's Comedy.* Oxford, 2005.

Mommsen, Theodor E. "Petrarch's Conception of the 'Dark Ages.'" *Speculum* 17 (1942): 226–42.

"St. Augustine and the Christian Idea of Progress: The Background of 'The City of God.'" *Journal of the History of Ideas* 12 (1951): 346–74.

"Petrarch and the Decoration of the Sala Virorum Illustrium in Padua." *Art Bulletin* 34 (1952): 95–116.

Mor, Carlo Guido (ed.). *Il Palazzo della ragione di Padova.* Venice, 1964.

Moschetti, Andrea. *La Cappella degli Scrovegni e gli affreschi di Giotto in essa dipinti.* Florence, 1904.

Moskowitz, Anita Fiderer. "Trecento Classicism and the Campanile Hexagons." *Gesta* 22 (1983): 49–65.

Mueller von der Haegen, Anne. *Die Darstellungsweise Giottos mit ihren konstitutiven Momenten, Handlung, Figur und Raum im Blick auf das mittlere Werk.* PhD diss., Universität Würzburg. Braunschweig, 2000.

Murray, Peter. "Notes on Some Early Giotto Sources." *Journal of the Warburg and Courtauld Institutes* 16 (1953): 58–80.

"On the Date of Giotto's Birth." In *Giotto e il suo tempo: Atti del congresso internazionale per la clebrazione del VII centenario della nascita di Giotto.* Rome, 1971, 25–34.

Musa, Mark. "E questo sia suggel ch' ogn' uomo sganni (Inferno XIX, 21)." *Italica* 41 (1964): 134–38.

Naab, Erich (ed.). *Augustinus. Über Schau und Gegenwart des unsichtbaren Gottes.* Stuttgart, 1998.

Nagel, Alexander. *Michelangelo and the Reform of Art.* Cambridge, 2000.

Medieval Modern: Art Out of Time. London, 2012.

Nagel, Alexander, and Christopher S. Wood. *Anachronic Renaissance.* New York, 2010.

Nagel, Ivan. *Gemälde und Drama: Giotto, Masaccio, Leonardo.* Frankfurt am Main, 2009.

von Nagy, Maria. *Die Wandbilder der Scrovegni-Kapelle zu Padua: Giottos Verhältnis zu seinen Quellen.* Bern, 1962.

Nancy, Jean-Luc. *The Birth to Presence.* Stanford, 1993.

Noli me tangere: Essai sur la levée du corps. Paris, 2003.

Niebuhr, Gustav. "Mea Culpa: The Pope Apologizes for His Church." *New York Times,* 12 March 2000.

Noack, Ferdinand. "Triumph und Triumphbogen." *Vorträge aus der Bibliothek Warburg* 5 (1930): 147–201.

Noll, Thomas. *Die Silvester-Kapelle in SS. Quattro Coronati in Rom: Ein Bilderzyklus im Kampf zwischen Kaiser und Papst.* Munich, 2011.

Nolthenius, Hélène. *Duecento: The Late Middle Ages in Italy.* New York, 1968.

Novello, Roberto Paolo. "Statua di Enrico Scrovegni." In *La Cappella degli Scrovegni a Padova,* edited by Davide Banzato et al. Modena, 2005, 279–81.

Oberman, Heiko A. "The Augustinian Renaissance." In *The Dawn of the Reformation.* Grand Rapids, 1992, 8–12.

Oehl, Benedikt. "Die *Altercatio Ecclesiae et Synagogae:* Ein antijudaistischer Dialog der Spätantike." PhD diss., Rheinische Friedrich-Wilhelms-Universität Bonn. Bonn, 2012.

Oertel, Robert. *Early Italian Painting to 1400.* New York, 1968.

Øestergaard, Jan Stubbe. "The Polychromy of Antique Sculpture: A Challenge to Western Ideals?" In *Circumlitio: The Polychromy of Antique and Mediaeval Sculpture,* edited by Vinzenz Brinkmann, Oliver Primavesi, and Max Hollein. Munich, 2010, 78–107.

Offner, Richard. "A Great Madonna by the St. Cecilia Master." *Burlington Magazine* 1 (1927): 90–104.

"Giotto, non-Giotto I." *Burlington Magazine* 74 (1939): 258–69.

"Giotto, non-Giotto II." *Burlington Magazine* 75 (1939): 96–109.

"Giotto, non-Giotto." In *A Discerning Eye. Essays on Early Italian Painting by Richard Offner,* edited by Andrew Ladis. University Park, 1998, 61–88.

Olson, Roberta J.M. "Giotto's Portrait of Halley's Comet," in *Scientific American* 240 (1979): 160–170.

"Much Ado about Giotto's Comet." in *Quarterly Journal of the Royal Astronomical Society* 35 (1994): 145–148.

Olson, Roberta J.M., and Jay M. Pasachoff. *Cosmos: The Art and Science of the Universe.* Clerkenwell, 2019.

van Os, Henk. "St. Francis of Assisi as a Second Christ in Early Italian Painting." *Simiolus* 7 (1974): 3–20.

von der Osten, Gert. "Plato über das Relief." *Wallraf-Richartz-Jahrbuch* 25 (1962): 15–20.

Pallucchini, Rodolfo (ed.). *G. B. Cavalcaselle: Disegni da antichi maestri.* Vicenza, 1973.

Panofsky, Erwin. *Renaissance and Renascences in Western Art.* Stockholm, 1960.

Tomb Sculpture: Four Lectures on Its Changing Aspects from Ancient Egypt to Bernini. New York, 1967.

Panzanelli, Roberta et al. (eds.). *The Color of Life: Polychromy in Sculpture from Antiquity to the Present.* Exh. cat., The J. Paul Getty Museum, Los Angeles. Los Angeles, 2008.

Pardo, Mary. "Giotto and the 'Things Not Seen, Hidden in the Shadow of Natural Ones.'" *Artibus et Historiae* 18 (1997): 41–53.

Parker, John Henry. *The Archæology of Rome, Part 6, The Via Sacra in Rome.* London, 1883.

Paterson, Mark. *The Senses of Touch: Haptics, Affects, and Technologies.* Oxford, 2007.

(ed.). *Touching Space, Placing Touch.* Farnham, 2012.

Pentcheva, Bissera V. "The Performative Icon." *Art Bulletin* 88 (2006): 631–55.

The Sensual Icon: Space, Ritual, and the Senses in Byzantium. University Park, 2010.

Perkinson, Stephen. "Rethinking the Origins of Portraiture." *Gesta* 46 (2007): 135–57.

Pešina, Jaroslav. *Tektonický prostor a architektura u Giotta.* Prague, 1945.

Petrarca, Francesco. *In difesa dell'Italia (Contra eum qui maledixit Italie),* edited by Giuliana Crevatin. Venice, 1995.

Pfanner, Michael. *Der Titusbogen.* Mainz am Rhein, 1983.

Pfeiffenberger, Selma. "The Iconology of Giotto's Virtues and Vices at Padua." PhD diss., Bryn Mawr College, 1966.

Pfisterer, Ulrich. "Phidias und Polyklet von Dante bis Vasari: Zu Nachruhm und künstlerischer Rezeption antiker Bildhauer in der Renaissance." *Marburger Jahrbuch für Kunstgeschichte* 26 (1999): 61–97.

Donatello und die Entdeckung der Stile, 1430–1445. Munich, 2002.

Die Sixtinische Kapelle. Munich, 2013.

Philippi, Adolf. *Über die römischen Triumphalreliefe und ihre Stellung in der Kunstgeschichte.* Leipzig, 1872.

Pinkus, Assaf. "A Voyeuristic Invitation in the Arena Chapel." In *Sehen und Sakralität in der Vormoderne,* edited by David Ganz and Thomas Lentes. Berlin, 2011, 106–19.

Pisani, Giuliano. *I volti segreti di Giotto: Le rivelazioni della Cappella degli Scrovegni.* Milan, 2008.

"La concezione agostiniana del programma teologico della Cappella degli Scrovegni." In *Alberto da Padova e la cultura degli agostiniani,* edited by Francesco Bottin. Padua, 2014, 215–68.

Poeschke, Joachim. *Die Sieneser Domkanzel des Nicola Pisano: Ihre Bedeutung für die Bildung der Figur im "stile nuovo" der Dante-Zeit.* Berlin, 1973.

Die Kirche San Francesco in Assisi und ihre Wandmalereien. Munich, 1985.

(ed.). *Antike Spolien in der Architektur des Mittelalters und der Renaissance.* Munich, 1996.

Wandmalerei der Giottozeit in Italien: 1280–1400. Munich, 2003.

Pope-Hennessy, John. *A Sienese Codex of the Divine Comedy.* Oxford, 1947.

Prinz, Wolfram. "Ritratto istoriato oder das Bildnis in der Bilderzählung: Ein frühes Beispiel von Giotto in der Bardikapelle." *Mitteilungen des Kunsthistorischen Institutes in Florenz* 30 (1986): 577–81.

Die Storia oder die Kunst des Erzählens in der italienischen Malerei und Plastik des späten Mittelalters und der Frührenaissance 1260–1460; Textband. Mainz, 2000.

Prosdocimi, Alessandro. "Il Comune di Padova e la Cappella degli Scrovegni nell'Ottocento: Acquisto e restauri degli affreschi." *Bollettino del Museo Civico di Padova* 49 (1960): 69–120.

"Osservazioni sulla partitura delle scene affrescate da Giotto nella Cappella degli Scrovegni." In *Giotto e il suo tempo: Atti del congresso internazionale per la cleb-razione del VII centenario della nascita di Giotto.* Rome, 1971, 135–42.

Proust, Marcel. *À la recherche du temps perdu*. Edited by Pierre Clarac and André Ferre. 3 vols. Paris, 1954.

Puttfarken, Thomas. *"Masstabsfragen: Über die Unterschiede zwischen grossen und kleinen Bildern."* PhD diss., Universität Hamburg. Hamburg, 1971.

Quintavalle, Arturo Carlo. "Giotto architetto, l'antico e l'Île de France." In *Giotto e il Trecento: "Il più Sovrano Maestro stato in dipintura."* I saggi, edited by Alessandro Tomei. Exh. cat. Complesso del Vittoriano, Rome. Milan, 2009, 389–437.

——— "La *Croce* di Ognissanti. Giotto e la scultura del XIII secolo in occidente." In *L'officina di Giotto: Il restauro della Croce di Ognissanti*, edited by Marco Ciatti. Florence, 2010, 29–46.

Rambaldi, Pier Liberale. "Dante e Giotto nella letteratura artistica." *Rivista d'arte* 4 (1937): 286–384.

Rankin, Susan. "Terribilis est locus iste: The Pantheon in 609." In *Rhetoric Beyond Words: Delight and Persuasion in the Arts of the Middle Ages*, edited by Mary Carruthers. Cambridge, 2010, 281–310.

Rath, Markus et al. (eds.). *Das haptische Bild: Körperhafte Bilderfahrung in der Neuzeit*. Berlin, 2013.

Rehm, Walter. *Der Untergang Roms im abendländischen Denken: Ein Beitrag zur Geschichtsschreibung und zum Dekadenzproblem*. Leipzig, 1930.

Ricci, Corrado (ed.). *La Divina commedia di Dante Alighieri nell'arte del cinquecento (Michelangelo, Raffaello Zuccari, Vasari, ecc.)*. Milan, 1908.

Richardson, L., Jr. *A New Topographical Dictionary of Ancient Rome*. Baltimore, 1992.

Riegl, Alois. *Spätrömische Kunstindustrie*. Vienna, 1901.

Riess, Jonathan B. "Justice and Common Good in Giotto's Arena Chapel Frescoes." *Arte Cristiana* 72 (1984): 69–80.

Rintelen, Friedrich. *Giotto und die Giotto-Apokryphen: Zweite, verbesserte Auflage*. Basel, 1923.

Rockwell, Peter. "Some Reflections on Tools and Faking." In *Marble: Art Historical and Scientific Perspectives on Ancient Sculpture*, edited by Marion True and Jerry Podany. Malibu, 1990, 207–22.

Rohlfs-Von Wittich, Anna. "Das Innenraumbild als Kriterium für die Bildwelt." *Zeitschrift für Kunstgeschichte* 18 (1955): 109–35.

Romanini, Angiola Maria (ed.). *Roma anno 1300: Atti della IV Settimana di Studi di Storia dell'Arte Medievale dell'Università di Roma "La Sapienza" (19–24 maggio 1980)*. Rome, 1983.

Romano, Serena. "Giotto e la nuova pittura: Immagine, parola e tecnica nel primo Trecento Italiano." In *Il secolo di Giotto nel Veneto*, edited by Federica Toniolo and Giovanna Valenzano. Venice, 2007, 7–43.

——— *La O di Giotto*. Milan, 2008.

Romdahl, Axel L. "Stil und Chronologie der Arenafresken Giottos." *Jahrbuch der Königlich Preussischen Kunstsammlungen* 32 (1911): 3–18.

Rosenthal, Erwin. *Giotto in der mittelalterlichen Geistesentwicklung*. Augsburg, 1924.

Rossi, Aldo. "Caratteri urbani delle città venete." In *La città di Padova: Saggio di analisi urbana*, edited by Carlo Aymonino et al. Rome, 1970, 421–90.

Rothschild, Edward F., and Ernest H. Wilkins. "Hell in the Florentine Baptistery Mosaic and in Giotto's Paduan Frescoes." *Art Studies* 6 (1928): 31–35.

Rough, Robert H. "Enrico Scrovegni, the *Cavalieri Gaudenti* and the Arena Chapel in Padua." *Art Bulletin* 62 (1980): 24–35.

Rowe, Nina. *The Jew, the Cathedral, and the Medieval City: Synagoga and Ecclesia in the Thirteenth Century*. Cambridge, 2011.

Rubin, Patricia. "Understanding Renaissance Portraiture." In *The Renaissance Portrait: From Donatello to Bellini*, edited by Keith Christiansen, Stefan Weppelmann, and Patricia Lee Rubin. Exh. cat., Metropolitan Museum of Art, New York. New York, 2011, 2–25.

Ruskin, John. *The Stones of Venice*. London, 1851–53.

——— *Giotto and His Works in Padua: Being an Explanatory Notice of the Series of Woodcuts Executed for the Arundel Society after the Frescoes in the Arena Chapel*. London, 1854.

——— *The Art Criticism of John Ruskin*. Edited by Robert L. Herbert. New York, 1964.

Salvini, Roberto. "Medioevo e rinascimento nell'arte di Giotto." *Civiltà moderna* 7 (1935): 355–69.

Saak, Eric Leland. *Creating Augustine: Interpreting Augustine and Augustinianism in the later Middle Ages*. Oxford, 2012.

Sandström, Sven. *Levels of Unreality: Studies in Structure and Construction in Italian Mural Painting during the Renaissance*. Uppsala, 1963.

Sanson, Virginio. "L'edificio sacro cristiano nella bibbia." In *Lo spazio sacro: Architettura e liturgia*, edited by Virginio Sanson. Padua, 2002, 23–36.

Sauerländer, Willibald. "Giotto, Assisi e la crisi dei conoscitori." In Bruno Zanardi, *Giotto e Pietro Cavallini: La questione di Assisi e il cantiere medievale della pittura a fresco*. Milan, 2002, 7–12.

——— "Marcel Proust und die Malerei." *Jahrbuch der Bayerischen Akademie der Schönen Künste* 10 (1996): 3–26.

——— "'Quand les statues étaient blanches': Discussion au sujet de la polychromie." In *La couleur et la pierre polychromie des portails gothiques: Actes du colloque, Amiens, 12–14 octobre 2000*, edited by Denis Verret and Delphine Steyaert. Paris, 2002, 27–42.

"Von Wiligelmo zu Giotto: Mediävistische Aphorismen zum Thema Frankreich und Italien." In *"Il se rendit en Italie": Études offertes à Andrè Chastel*. Paris, 1987, 5–16.

Scardeone, Bernardino. *De Antiquitate urbis Patavii et claris civibus patavinis*. Basel, 1560.

Scharioth, Barbara. *Arnolfo di Cambio und Giotto*. PhD diss., Bochum, 1975. Essen, 1976.

Schiessl, Ulrich and Renate Kühnen (eds.). *Polychrome Skulptur in Europa: Technologie, Konservierung, Restaurierung*. Dresden, 1999.

Schinkel, Karl Friedrich. *Reisen nach Italien: Erste Reise 1803–1805*. Berlin, 1994.

Schmersahl, Friedrich. "Die Architektur in Giottos Bildern, betrachtet von einem Architekten." In Martin Gosebruch et al., *Giotto di Bondone*. Constance, 1970, 253–85.

Schmidt, Gerhard. "Giotto und die gotische Skulptur: Neue Überlegungen zu einem alten Thema" and "Probleme der Begriffsbildung: Kunsthistorische Terminologie und geschichtliche Realität." In *Schmidt, Gotische Bildwerke und ihre Meister (Textband)*. Vienna, 1992, 9–27 and 313–56.

Schöne, Wolfgang. "Studien zur Oberkirche von Assisi." In *Festschrift Kurt Bauch: Kunstgeschichtliche Beiträge zum 25. November 1957*, edited by Berthold Hackelsberger, Georg Himmelheber, and Michael Meier. Munich, 1957, 50–116.

Schüßler, Gosbert. "Giottos visuelle Definition der 'Sapientia Saeculi' in der Cappella Scrovegni zu Padua." In *Opere e giorni: Studi su mille anni di arte europea dedicati a Max Seidel*, edited by Klaus Bergdolt and Giorgio Bonsanti. Venice, 2001, 111–22.

Schwarz, Michael Viktor. *Die Mosaiken des Baptisteriums in Florenz: Drei Studien zur Florentiner Kunstgeschichte*. Cologne, 1997.

Giottus Pictor, vol. 2, *Giottos Werke*. Vienna, 2008.

Giotto. Munich, 2009.

"Poesia e verità: Una biografia critica di Giotto." In *Giotto e il Trecento: 'Il più Sovrano Maestro stato in dipintura.' I saggi*, edited by Alessandro Tomei. Exh. cat., Complesso del Vittoriano, Rome. Milan, 2009, 9–29.

"Padua, Its Arena and the Arena Chapel: A Liturgical Ensemble." *Journal of the Warburg and Courtauld Institutes* 73 (2010): 39–64.

"Goldgrund im Mittelalter: 'Don't ask for the meaning, ask for the use!'" In *Gold*, edited by Agnes Husslein-Arco and Thomas Zaunschirm. Exh. cat., Belvedere, Vienna. Munich, 2011, 28–37.

"Figure of Memory and Figure of the Past: Giotto's Double Life – with a Side-Glance at Joseph Beuys."

Taidehistoriallisia Tutkimuksia Konsthistoriska Studier – Studies in Art History 46 (2013): 14–23.

Schwarz, Michael Viktor, and Pia Theis. *Giottus Pictor*, vol. 1: *Giottos Leben*. Vienna, 2004.

Sebald, W. G. *Schwindel; Gefühle*. Frankfurt am Main, 1998.

Sebregondi, Ludovica and Tim Parks (eds.). *Money and Beauty: Bankers, Botticelli and the Bonfire of the Vanities*. Exh. cat., Palazzo Strozzi, Florence. Florence, 2011.

Seidel, Linda. *Songs of Glory: The Romanesque Façades of Aquitaine*. Chicago, 1981.

Seiferth, Wolfgang S. *Synagoge und Kirche im Mittelalter*. Munich, 1964.

Seiler, Peter. "Giotto als Erfinder des Porträts." In *Das Porträt vor der Erfindung des Porträts*, edited by Martin Büchsel and Peter Schmidt. Mainz am Rhein, 2003, 153–72.

"Die Idolatrieanklage im Prozeß gegen Bonifaz VIII." In *Bild/Geschichte: Festschrift für Horst Bredekamp*, edited by Philine Helas et al. Berlin, 2007, 353–74.

Selvatico, Pietro Estense. *Sulla Cappellina degli Scrovegni nell'Arena di Padova e sui freschi di Giotto in essa dipinti*. Padua, 1836.

"Visita di Dante a Giotto: Nell'Oratorio degli Scrovegni in Padova (1306)." In *Selvatico, L'Arte nella vita degli artisti: Racconti storici*. Firenze, 1870, 1–70.

Settis, Salvatore. "Continuità, distanza, conoscenza: Tre usi dell'antico." In *Memoria dell'antico nell'arte italiana*, edited by Salvatore Settis. Turin, 1986, 375–486.

"Schicksale der Klassik: Vom Gips zur Farbe." In *Zurück zur Klassik: Ein neuer Blick auf das Alte Griechenland*, edited by Vinzenz Brinkmann. Exh. cat., Liebieghaus Skulpturensammlung, Frankfurt am Main. Munich, 2013, 59–83.

Shorr, Dorothy C. "The Role of the Virgin in Giotto's *Last Judgment*." *Art Bulletin* 38 (1956): 207–14.

Signer, Michael. "Jews and Judaism." In *Augustine through the Ages*, edited by Allan D. Fitzgerald. Grand Rapids, 1999, 470–74.

Simon, Robin. "Giotto and After: Altars and Alterations at the Arena Chapel, Padua." *Apollo* 142 (1995): 24–36.

"'The Monument Constructed for Me.' Evidence for the First Tomb Monument of Enrico Scrovegni in the Arena Chapel, Padua." In *Venice and the Veneto during the Renaissance: The Legacy of Benjamin Kohl*, edited by Michael Knapton et al. Florence, 2014, 385–404.

von Simson, Otto. "Über Giottos Einzelgestalten." In Martin Gosebruch et al., *Giotto di Bondone*. Constance, 1970, 229–41.

Sirén, Osvald. *Giotto and Some of His Followers*. Vol. 1. Cambridge, 1917.

Sjöström, Ingrid. *Quadratura: Studies in Italian Ceiling Painting.* Stockholm, 1978.

Smart, Alastair. "Ghiberti's 'quasi tutta la parte di sotto' and Vasari's Attributions to Giotto at Assisi." *Renaissance and Modern Studies* 8 (1963): 5–24.

——— *The Assisi Problem and the Art of Giotto: A Study of the Legend of St. Francis in the Upper Church of San Francesco, Assisi.* New York, 1983.

Spiazzi, Anna Maria. "La decorazione del Salone." In *Il Palazzo della Ragione di Padova: La storia, l'architettura, il restauro,* edited by Ettore Vio. Padua, 2008, 315–25.

Starn, Randolph. "Renaissance Triumphalism in Art." In *The Renaissance World,* edited by John Jeffries Martin. New York, 2007, 326–46.

Starn, Randolph, and Loren Partridge. *Arts of Power: Three Halls of State in Italy, 1300–1600.* Berkeley, 1992.

Steiner, Reinhard. "Paradoxien der Nachahmung bei Giotto: die Grisaillen der Arenakapelle zu Padua." In *Die Trauben des Zeuxis: Formen künstlicher Wirklichkeitsaneignung,* edited by Hans Körner et al. Hildesheim, 1990, 61–86.

Steinke, Hubert. "Giotto und die Physiognomik." *Zeitschrift für Kunstgeschichte* 59 (1996): 523–47.

Stella, Francesco. "Roma antica nella poesia mediolatina: Alterità e integrazione di un segno poetico." In *Roma antica nel Medioevo: Mito, rappresentazioni, sopravvivenze nella "Respublica Christiana" dei secoli IX–XIII,* edited by Pietro Zerbi. Milan, 2001, 277–308.

Stieber, Mary C. *Euripides and the Language of Craft.* Leiden, 2011.

Stierle, Karlheinz. "Das System der schönen Künste im 'Purgatorio.'" In Stierle, *Ästhetische Rationalität; Kunstwerk und Werkbegriff.* Munich, 1996, 389–416.

Stock, Brian. *Augustine the Reader: Meditation, Self-Knowledge, and the Ethics of Interpretation.* Cambridge, MA, 1998.

——— *Augustine's Inner Dialogue: The Philosophical Soliloquy in Late Antiquity.* Cambridge, 2010.

——— *The Integrated Self: Augustine, the Bible, and Ancient Thought.* University Park, 2017.

Stöhr, Jürgen. *Auch Theorien haben ihre Schicksale: Max Imdahl, Paul de Man, Beat Wyss.* Bielefeld, 2010.

Stoichita, Victor I. *The Pygmalion Effect: From Ovid to Hitchcock.* Chicago, 2008.

Strauss, Ernst. *Koloritgeschichtliche Untersuchungen zur Malerei seit Giotto.* Munich, 1972.

Strauss, Walter A. "Proust – Giotto – Dante." *Dante Studies* 96 (1978): 163–85.

Strehlke, Carl Brandon. "*Giotto: Bilancio critico di sessant'anni di studi e ricerche* at the Galleria dell'Accademia, Florence." *Burlington Magazine* 142 (2000): 591–93.

Strocka, Volker Michael. "Der 'flavische Stil' in der römischen Kunst – Einbildung oder Realität?" In *Tradition und Erneuerung: Mediale Strategien in der Zeit der Flavier,* edited by Norbert Kramer and Christiane Reitz. Berlin, 2010, 95–132.

Summers, David. *Real Spaces: World Art History and the Rise of Western Modernism.* London, 2003.

Taschera, Babet. "I Dalesmanini: Una famiglia magnatizia nella Padova dei secoli XII–XIV." Laurea vecchio ordinamento, Padua, 2003.

Thiébaut, Dominique (ed.). *Giotto e compagni.* Exh. cat., Louvre, Paris. Milan, 2013.

Thode, Henry. *Giotto.* Bielefeld, 1899.

Thomann, Johannes. "Pietro d'Abano on Giotto." *Journal of the Warburg and Courtauld Institutes* 54 (1991): 238–44.

Thomas, Hans-Michael. "Contributi alla storia della cappella degli Scrovegni a Padova." *Nuova Rivista Storica* 57, nos. 1–2 (1973): 109–28.

Thürlemann, Felix. *Mehr als ein Bild: Für eine Kunstgeschichte des hyperimage.* Munich, 2013.

Tintori, Leonetto, and Millard Meiss. *The Painting of The Life of St. Francis in Assisi: With Notes on the Arena Chapel.* New York, 1962.

——— "Additional Observations on Italian Mural Technique." *Art Bulletin* 46 (1964): 377–80.

Toesca, Pietro. *Giotto.* Turin, 1941.

Tolomei, Antonio. *La chiesa di S. Maria della Carità dipinta da Giotto nell'Arena.* Padua, 1880.

Tomei, Alessandro (ed.). *Giotto e il Trecento: "Il più Sovrano Maestro stato in dipintura." I saggi.* Exh. cat., Complesso del Vittoriano, Rome. Milan, 2009.

Tomei, Alessandro. "La decorazione della Basilica di San Francesco ad Assisi come metafora della questione giottesca." In *Giotto e il Trecento: "Il più Sovrano Maestro stato in dipintura." I saggi,* edited by Alessandro Tomei. Exh. cat., Complesso del Vittoriano, Rome. Milan, 2009, 31–49.

Tomei, Alessandro and Giuliano Pisani (eds.). *Magister Giotto.* Villanova di Castenaso, 2017.

Took, John. "Dante and the 'Confessions' of Augustine." *Annali d'Italianistica* 8 (1990): 360–82.

——— "Dante, Augustine and the Drama of Salvation." In *Word and Drama in Dante: Essays on the Divina Commedia,* edited by John C. Barnes and Jennifer Petrie. Dublin, 1993, 73–92.

Torresini, Donatella. *Padova 1509–1969: Gli effetti della prassi urbanistica borghese.* Padua, 1975.

Tosti-Croce, Marina Righetti (ed.). *Bonifacio VIII e il suo tempo: Anno 1300. Il primo giubileo.* Exh. cat. Palazzo di Venezia, Rome. Milan, 2000.

Trachtenberg, Marvin. *The Campanile of Florence Cathedral: "Giotto's Tower."* New York, 1971.

Building-in-Time: From Giotto to Alberti and Modern Oblivion. New Haven, 2010.

Tronzo, William. "On the Role of Antiquity in Medieval Art: Frames and Framing Devices." In *Ideologie e pratiche del reimpiego nell'alto medioevo*. Spoleto, 1999, vol. 2: 1085–1111.

"Giotto's Figures." In *The Cambridge Companion to Giotto*, edited by Anne Derbes and Mark Sandona. Cambridge, 2004, 63–75.

(ed.). *The Fragment: An Incomplete History*. Los Angeles, 2009.

Van Fleteren, Frederick. "*Acies mentis* (Gaze of the Mind)" and "*Videndo Deo, De* (On Seeing God)." In *Augustine through the Ages: An Encyclopedia*, edited by Allan D. Fitzgerald. Grand Rapids, 1999, 5–6, and 869.

Van Gogh, Vincent. Letter 655 (To Emile Bernard), Arles, on or about Sunday, 5 August 1888. Online source http://vangoghletters.org/vg/letters/let655/letter .html, last accessed 24 December 2019.

Letter 683 (To Theo van Gogh), Arles, Tuesday, 18 September 1888. Online source http://vangoghletters.org/vg/letters/let683/letter.html, last accessed 24 December 2019.

Letter RM21 (To Joseph Jacob Isaäcson.), Auvers-sur-Oise, Sunday, 25 May 1890. Online source http://vangoghletters.org/vg/letters/RM21/letter.html, last accessed 24 December 2019.

Villani, Filippo. *De origine civitatis Florentie et de eiusdem famosis civibus*. Edited by Giuliano Tanturli. Padua, 1997.

"Giotto's Revival of Ancient Art." In *Images of Quattrocento Florence*, edited by Stefano Ugo Baldassarri and Arielle Saiber. New Haven, 2000, 185–87.

Vincenti, Umberto. "La Giustizia di Giotto." In *Umberto Vincenti and Francesca Marcellan, La Giustizia di Giotto*. Naples, 2006, 69–92.

Walter-Karydi, Elena. "The Coloring of the Relief Background in Archaic and Classical Greek Sculpture." In *Gods in Color: Painted Sculpture of Classical Antiquity*, edited by Vinzenz Brinkmann et al. Exh. cat., Arthur M. Sackler Museum, Harvard University Museums, Cambridge, MA. Munich, 2007, 172–77.

Warburg, Aby. *Tagebuch der Kulturwissenschaftlichen Bibliothek Warburg: Mit Einträgen von Gertrud Bing und Fritz Saxl*. Edited by Karen Michels and Charlotte Schoell-Glass. Berlin, 2001.

Warnke, Martin. "Italienische Bildtabernakel bis zum Frühbarock." *Münchner Jahrbuch der Bildenden Kunst* 14 (1968): 61–102.

Hofkünstler: Zur Vorgeschichte des modernen Künstlers. Cologne, 1996.

Wataghin, Gisella Cantino. "...ut haec aedes Christo Domino in Eccelesiam consecretur. Il riuso Cristiano di edifici antichi tra tarda antichita e alto medioevo." In *Ideologie e pratiche del reimpiego nell'alto medioevo*. Spoleto, 1999, vol. 2: 673–750.

Weigelt, Curt H. *Giotto: Des Meisters Gemälde*. Berlin, 1925.

Weil, Simone. *Gravity and Grace*. New York, 1952.

Weise, Georg. *Die geistige Welt der Gotik und ihre Bedeutung für Italien*. Halle an der Saale, 1939.

Wenderholm, Iris. *Bild und Berührung: Skulptur und Malerei auf dem Altar der italienischen Frührenaissance*. Munich, 2006.

Weppelmann, Stefan and Gerhard Wolf (eds.). *Rothko/ Giotto*. Exh. cat., Gemäldegalerie, Berlin. Munich, 2009.

"'Giotto's Rumblings': Mark Rothko and the Renaissance as a Rhetoric of Modernism." In *Rothko / Giotto*, edited by Stefan Weppelmann and Gerhard Wolf. Exh. cat., Gemäldegalerie der Staatlichen Museen zu Berlin. Munich, 2009, 41–66.

White, Hayden V. *The Content of Form: Narrative Discourse and Historical Representation*. London, 1990.

White, John. *The Birth and Rebirth of Pictorial Space*. Boston, 1967.

Wickham, Chris. *Roma medievale: Crisi e stabilità di una città, 900–1150*. Edited by Alessio Fiore and Luigi Provero. Rome, 2013.

Wiener, Jürgen. "Rahmen und Ranke in der italienischen Skulptur um 1300." In *Format und Rahmen: Vom Mittelalter bis zur Neuzeit*, edited by Hans Körner and Karl Möseneder. Berlin, 2008, 41–68.

Wilkins, Ernest Hatch. "Dante and the Mosaics of his Bel San Giovanni." *Speculum: A Journal of Mediaeval Studies* 2 (1927): 1–10.

Witt, Ronald G. *"In the Footsteps of the Ancients": The Origins of Humanism from Lovato to Bruni*. Leiden, 2000.

Wollesen, Jens T. "'Ut poesis pictura?' Problems of Images and Texts in the Early Trecento." In *Petrarch's Triumphs: Allegory and Spectacle*, edited by Konrad Eisenbichler and Amilcare A. Iannucci. Ottawa, 1990, 183–210.

Pictures and Reality: Monumental Frescoes and Mosaics in Rome around 1300. New York, 1998.

Wood, Christopher S. *Forgery Replica Fiction*. Chicago and London, 2008.

Zaho, Margaret Ann. *Imago Triumphalis: The Function and Significance of Triumphal Imagery for Italian Renaissance Rulers*. New York, 2004.

Zanardi, Bruno. "L'organizzazione del cantiere." In *Il cantiere di Giotto: Le storie di san Francesco ad Assisi*. Milan, 1996, 19–20, 34–36, 38–40, 42–44, 46–58.

Giotto e Pietro Cavallino: La questione di Assisi e il cantiere medievale della pittura a fresco. Milan, 2002.

"Giotto and the St. Francis Cycle at Assisi." In *The Cambridge Companion to Giotto*, edited by Anne Derbes and Mark Sandona. Cambridge, 2004, 32–62.

Zanardi, Maria Cristina. *Catalogo degli Incunaboli della Biblioteca Antoniana di Padova.* Florence, 2012.

Zanichelli, Giuseppa Z. "Manoscritti Ebraici Romani." In *Bonifacio VIII e il suo tempo: Anno 1300 il primo giubileo*, edited by Marina Righetti Tosti-Croce. Milan, 2000, 111–16.

Zanker, Paul. *Die Apotheose der römischen Kaiser.* Munich, 2004.

Zöllner, Frank. "Policretior manu: Zum Polykletbild der frühen Neuzeit." In *Der Bildhauer der griechischen Klassik*, edited by Herbert Beck. Exh. cat., Liebieghaus, Museum alter Plastik, Frankfurt am Main. Mainz, 1990, 450–72.

Zucker, Mark J. "Figure and Frame in the Paintings of Giotto." *Source* 1 (1982): 1–5.

Zucker, Mark J. "Al ha-Pereq: Al Shiḥrur Roma," *la-Ḥayyal: Alon-Yomi le-Ḥayyilim be-Yaveshet Europa* 79 (May 6, 1944): 2.

INDEX